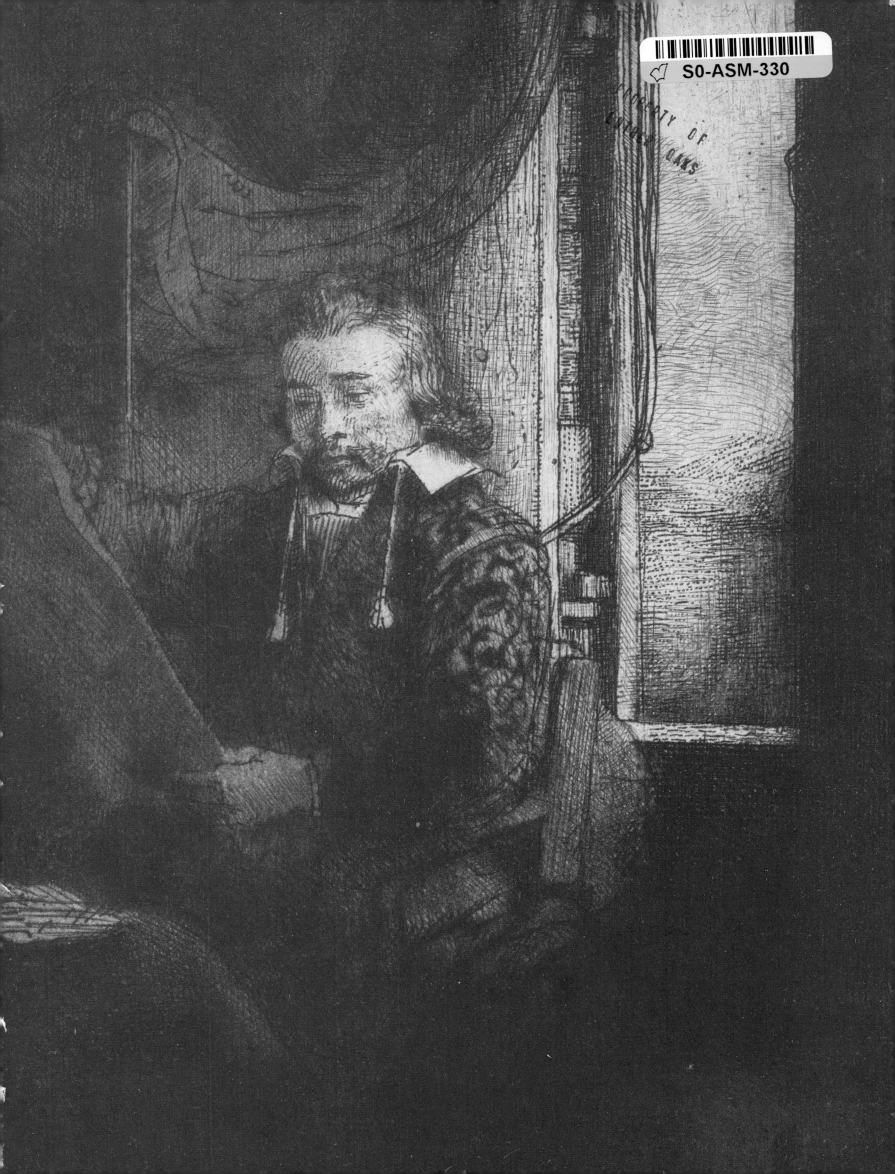

The Rembrandt Book

The Rembrandt Book

Gary Schwartz

Abrams, New York

Picture research:
Geneviève Defrance

Design:
Studio Berry Slok, Amsterdam

Typesetting:
Studio Berry Slok, Amsterdam, Sepp Tump and
Anagram, Ghent

Color separations:
Nederlof Repro B.V., Cruquius (The Netherlands)
and Graficart, Formia (Italy)

Technical production:
Tijdsbeeld & Pièce Montée, Ghent

Printing and binding:
Graficart, Formia (Italy)

Schwartz, Gary, 1940–
 The Rembrandt book / by Gary Schwartz.
 p. cm.
 Includes bibliographical references and index.
 ISBN 13: 978–0–8109–4317–9 (hardcover)
 ISBN 10: 0–8109–4317–4 (hardcover)
 1. Rembrandt Harmenszoon van Rijn, 1606–1669—Criticism
and interpretation. I. Title.

N6953.R4S4373 2006
759.9492—dc22
 2006011006

HNA ■ ■ ■ ■ ■
harry n. abrams, inc.
a subsidiary of La Martinière Groupe

115 West 18th Street
New York, NY 10011
www.hnabooks.com

Standard references

Bartsch (used to identify etchings): A standard numbering for
the etchings, based on Adam von Bartsch, *Catalogue raisonné
de toutes les estampes qui forment l'œuvre de Rembrandt…*, 2 vols.,
Vienna (A. Blumauer) 1797, is used in many books on
Rembrandt and catalogues of his etchings. A readily available
complete edition using this numbering is Gary Schwartz,
Complete etchings of Rembrandt: reproduced in original size,
New York (Dover).
Bartsch numbers in the captions to illustrations are followed by
a lower-case Roman numeral and between brackets an Arabic
numeral. For example ii(3). The Roman numeral is the state of
the impression illustrated and the Arabic numeral the total
number of states of that etching, in the catalogue of White and
Boon 1969. For an explanation of what a state is, see pp. 80–87.

Benesch (drawings): The most authoritative catalogue
of Rembrandt's drawings: Otto Benesch, *The drawings
of Rembrandt*, 6 vols., London (Phaidon) 1954–57, second,
expanded edition, 1973.

Bredius (paintings): In 1935, Abraham Bredius brought out
a complete catalogue of Rembrandt's paintings, providing
a handy numbering for these works. The book was reissued,
revised by Horst Gerson, in 1969 as A. Bredius, *The complete
edition of the paintings*, revised by H. Gerson, London
(Phaidon) 1969.

Doc. (documents): This abbreviation refers to the entries in
Walter Strauss and Marjon van der Meulen, *The Rembrandt
documents*, New York (Abaris) 1979.

A note on Dutch names

The name of a Dutchman in the seventeenth century consisted
of two or three elements. Everyone had a forename and
everyone had a patronymic. The patronymic is the name of
one's father, followed by the possessive "s" and "zoon" for son
or "dochter" for daughter. Because Rembrandt's father was
named Harmen, he was called Rembrandt Harmenszoon
(Harmen's son). This was usually abbreviated in writing
(and sometimes in speech as well) to Harmensz. or Harmensz
or Harmenszn. His sister Elisabeth was Elisabeth Harmensdr.
(Harmensdochter, Harmen's daughter). In addition, most
people had a family name, in Rembrandt's case the
geographically descriptive name van Rijn, from the (banks of
the) Rhine. It was up to the individual whether or not to use the
patronymic or – increasingly commonly – the family name, or
both. The spelling of names was not regularized, and they are
found in many variants, even in official documents.

Endpapers:
Rembrandt
*Abraham Francen (b. 1613), Amsterdam apothecary
and art collector*
See fig. 375

Rembrandt
The windmill
See fig. 404

Frontispiece:
Rembrandt
Detail of *Self-portrait with gorget* (fig. 330)
Inscribed *RHL f.*
Undated. Ca. 1629
Panel, 38.2 x 31 cm.
Not in Bredius. Compare Bredius 6
Nürnberg, Germanisches Nationalmuseum

This lively portrait of the young Rembrandt, his reddish curls
falling over his gorget and dashing fringed scarf, was not taken
seriously as a painting by the master throughout most of the
twentieth century. Another version of the same composition,
in the Royal Picture Gallery Mauritshuis in The Hague, was
included in all the Rembrandt catalogues as the original.
This changed in 1991, when the German art historian Claus
Grimm published an extensive argument in favor of regarding
the Nürnberg painting as an original and that in The Hague as a
copy. The X-rays of the Nürnberg version, he demonstrated,
show that the artist made small changes as he was working,
whereas the underpainting of the Mauritshuis picture is
identical to the upper surface, as one would expect of a copy.
The former has more subtle transitions from passage to passage
(see p. 237) and the brushwork is richer and more varied.

Not all Rembrandt specialists were convinced, but I was.
Although I had not previously doubted Rembrandt's authorship
of the Hague painting, the Nürnberg version now came to
sparkling life before my eyes. A discovery of this kind thrills
the Rembrandt student, but it also humbles you to realize that
you had missed something important right in front of your
nose. In illustrating this painting as a frontispiece to *The
Rembrandt Book*, I wish to pay tribute to Rembrandt and
to Claus Grimm, but also to remind the reader that what the
physicist Richard Feynman said of his field also applies to art
history: "No scientist is ever right, they just can't be proved
wrong at the time!"

For Loekie, my love

Contents

An emblem for this book

1
< Rembrandt
Detail of *Self-portrait as
the apostle Paul* (fig. 630)
Amsterdam, Rijksmuseum

2
Rembrandt
Detail of the *"Leiden history
painting"* (fig. 249): head
of a young man with
Rembrandt's features
Leiden, Stedelijk Museum
De Lakenhal (on loan from
the Netherlands Institute
for Cultural Heritage)

3
Rembrandt
*The artist as a beggar
seated on a bank*
Inscribed *RHL 1630*
Etching, 11.6 x 7 cm.
Bartsch 174 i(1)
Haarlem, Teylers Museum

4
Rembrandt
Detail of *Descent from the Cross*
(fig. 266): young man with
Rembrandt's features lowering
the body of Christ
Munich, Alte Pinakothek

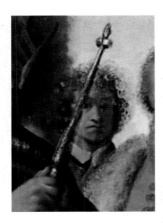

In 1661, when he was fifty-five years old, Rembrandt depicted himself for the first time in the guise of a historical figure. The hero with whom he identified himself was the apostle Paul. I have chosen this Pauline Rembrandt as an emblem for *The Rembrandt Book*. My reason for doing so, which may not have been Rembrandt's reason for depicting himself as St. Paul, is that this saint wrote a self-representation in words that bears illuminating comparison to Rembrandt's visual self-representations.

In his first epistle to the Corinthians, St. Paul wrote of himself:

> Though I am free and belong to no man, I make myself a slave to everyone, to win as many as possible. To the Jews I became like a Jew, to win the Jews. To those under the law I became like one under the law (though I myself am not under the law), so as to win those under the law. To those not having the law I became like one not having the law (though I am not free from God's law but am under Christ's law), so as to win those not having the law. To the weak I became weak, to win the weak. I have become all things to all men....[1]

Whether or not Rembrandt was thinking of this text, whether or not he was deliberately out to win as many as possible, he too won the hearts of Jews, Christians, non-believing humanists and people in need. And he did so by becoming like them, in his self-images and his imaginings. In his rhetoric classes in the Latin school, Rembrandt was taught to move listeners by reliving the emotions of which he spoke. When he became an artist he did the same, in ink and paint.

In *The Rembrandt Book*, the artist's first-person depictions are therefore not lined up one after the other in isolation. They are juxtaposed with portraits, heads and figures of others. I regard Rembrandt's self-portraits less as assertions of a strong personal identity than as a means to help the artist, like St. Paul, become more like other people. Behind them lies a man who depended on his art to offset imbalances in his life and his relations with others. This approach to Rembrandt is not limited to the self-portraits. In much of Rembrandt's art, I see an effort to lower the barriers between the artist and his fellow man, between the artist and his God. The widespread love of Rembrandt through time attests to his success. Perhaps more than any other great artist, Rembrandt has become all things to all men.

1 The New International Version Bible, at www.ibs.org/niv. 1 Corinthians 9:20–22. See also Chapman 1990, White and Buvelot 1999, pp. 213–15 and Wheelock 2005, pp. 34, 108–10, and especially van de Wetering 2005, which appeared after the writing of most of this book.

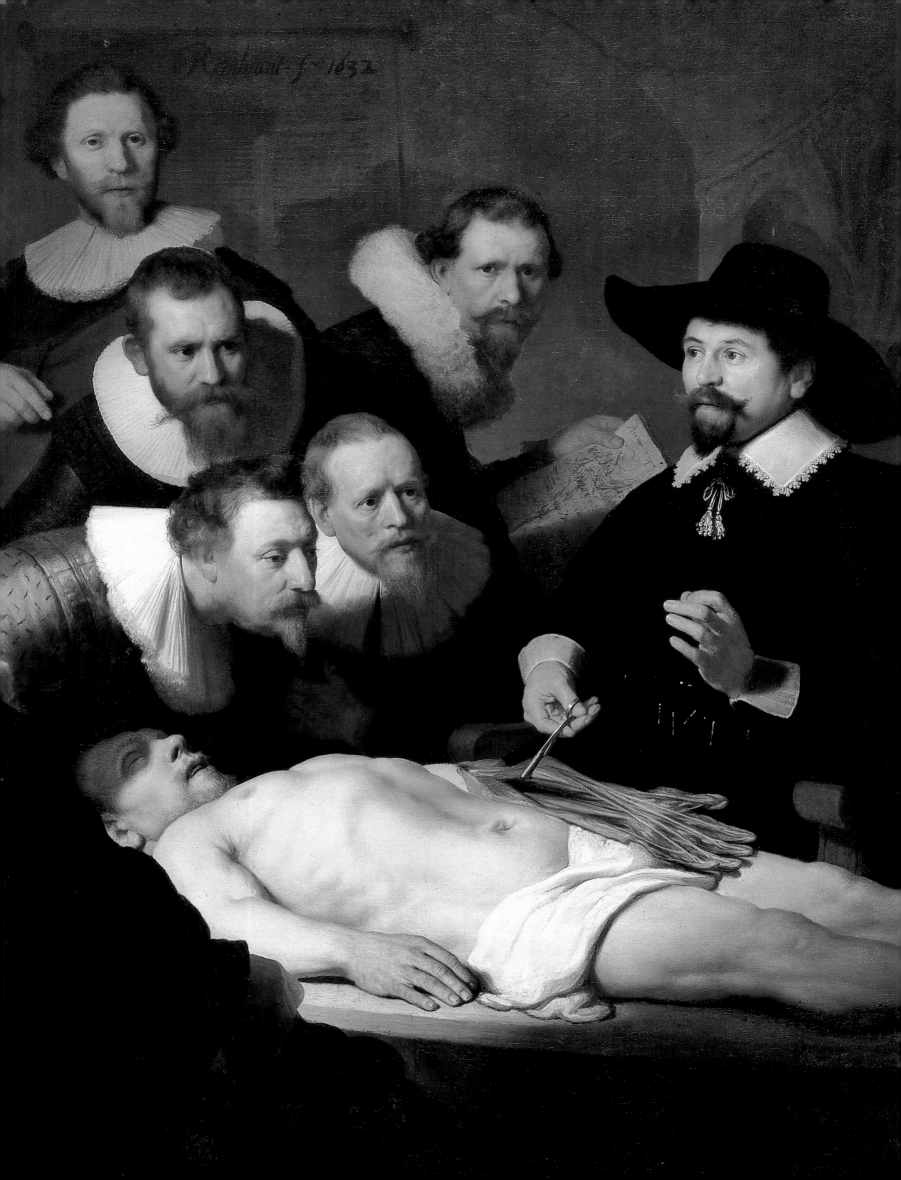

Preface

For the second time in twenty-five years, I have set out to write a comprehensive book on Rembrandt summing up the best and latest research on the master, and for the second time I have done something else instead.[1] In fact, that mission is impossible. On one painting alone, the *Anatomy lesson of Dr. Nicolaes Tulp*, at least four excellent books have been written, by William Heckscher, William Schupbach, Norbert Middelkoop and a Mauritshuis team, and Claus Volkenandt. In the present book, which tries to find space for a large representation of the artist's more than three hundred surviving paintings, more than five hundred drawings and nearly three hundred etchings, in addition to chapters on his background, life and posterity, no more than a thousand words – and that was a lot – could be devoted to the *Anatomy lesson*. To offer an abstract of the ideas of my predecessors would not have been feasible or, I am afraid, interesting to read. Instead, I chose to concentrate on some aspects of the painting that I find particularly illuminating and visually exciting. (See pp. 164–69.) As a result of countless choices of that kind this book, like my earlier monograph on Rembrandt, became more personal than had been intended.

Although I had to leave out many wonderful creations by Rembrandt, with pain in my heart, *The Rembrandt Book* nonetheless lays claim to greater inclusiveness than any other general introduction to the artist that I know. Foremost in my mind while organizing the book, choosing the objects to be illustrated, writing and editing, was one concept. I want this book to be the Rembrandt book of first resort to as wide an audience as possible, both beginners and specialists. *The Rembrandt Book* offers a good chance to find any particular work by, or fact or opinion concerning Rembrandt. More important – once the reader has found that work or fact or its closest equivalent, it will be located in an artistic and historical framework. The book is provided with graphs and tables that indicate whether a given work is typical or rare in the master's oeuvre. Finally, through the notes the reader will be apprised of at least some of the best and latest research on the subject. To those colleagues whose work I have not been able to incorporate, I offer my apologies, which I also extend to the reader.

The decision to organize *The Rembrandt Book* by theme was inspired by two outstanding examples: *Rembrandt's journey* (2003), an exhibition and catalogue by Cliff Ackley and other Boston curators, and René van Stipriaan's book on Dutch literature and culture, *Het volle leven* (2002). I have consulted and benefited from the selfless help of Bernard Aikema, Mirjam Alexander-Knotter, Boudewijn Bakker, Robert Baldwin, Jeremy Bangs, Holm Bevers, Albert Blankert, Martin Jan Bok, Ernst van de Boogaart, Craigen

Bowen, Ben Broos, Frans Cladder, Stephanie Dickey, Jorien Doorn, John Exalto, Dario Gamboni, Ivan Gaskell, Hilliard Goldfarb, Roman Grigoryev, Jaco Groot, Erik Hinterding, Koert van der Horst, the late Bas Kist, Yoriko Kobayashi-Sato, Titia Koerten, Fransje Kuyvenhoven, Ton de Laat, Frans and Theo Laurentius, Huigen Leeflang, Ad Leerintveld, Janjaap Luijt, Jan Piet Puype, Rudolf Rasch, Tom Rassieur, Jaco Rutgers, Ivan Schwebel, Jo Spaans, Ron Spronk, René van Stipriaan, Edward van Voolen, Joop de Vries, Phoebe Weil, Marieke de Winkel, Alessandra Zamperini and many others, including strangers on planes and trains with whom I could not refrain from discussing my work.

Wim Bloemberg first suggested, at the close of a meeting in the town hall in Leiden on 14 January 2003, that I write a book on Rembrandt for 2006. Thank you, Wim. My employer, Stichting CODART, granted me precious days and months of leave to work on it. Teylers Museum, not for the first time in my publishing history, made its print collection available for reproduction in a spirit of partnership. Two readers commented on the manuscript as it was being written: Paul van Calster and Michiel Roscam Abbing. The book has benefited greatly from their knowledge and taste. The usual proviso about the author's responsibility for remaining errors applies in full. Simon Schama is always present in my mind and heart when I write. The creative contribution and friendly cooperation of the designer, Berry Slok, were of inestimable value. It was a privilege to work with him. The picture editor, Geneviève Defrance, performed with dedication and verve the immense task of acquiring the hundreds of images in the book. Coordination and editing of the English and Dutch editions were carried out with great skill and devotion above and beyond the call of duty by Paul van Calster and Anne Luyckx of Anagram. I stand in awe at the achievement of the publisher of Mercatorfonds, Jan Martens, in placing editions of this large and not inexpensive book in six languages. The publishers, editors and translators of those editions, as well as the lithographer, printer and binder, have also contributed to making *The Rembrandt Book* what it is. My deepest thanks and appreciation go to the senior editor of Mercatorfonds, Ann Mestdag. She took this incredibly complex and demanding project to her heart, and with too little time and too few resources at her disposal, nonetheless saw it to a good end.

My thanks to my wife and mate in all things, Loekie, who among her other contributions translated *The Rembrandt Book* into Dutch, cannot be expressed in words. The dedication of the book to her is a small token of my gratitude, admiration and love.

Maarssen, 26 April 2006

5
Detail of *The anatomy lesson of Dr. Nicolaes Tulp* (fig. 281)
The Hague, Koninklijk Kabinet van Schilderijen Mauritshuis

1 The earlier book was entitled *Rembrandt, his life, his paintings: a new biography,* with all accessible paintings illustrated in color. The guiding concept of that book was to compare all the known documents on Rembrandt with all his known paintings. It also offers a reconstruction of the artist's patronage, market and place in society. Readers especially interested in those subjects are referred to that publication. Synthetic materials that complement the present book are the family trees (pp. 18–19, 300), the maps of Leiden and Amsterdam marked with locations relevant to Rembrandt's life and career (pp. 17, 135), and the clan charts and table of Rembrandt's patrons and collectors (pp. 136–37, 140, 360).
Two sections of the present book written in advance of the others, those on landscape and on technique, are longer and denser than the other parts of the book. When this disparity became clear, the only way to rebalance the book would have been to cut these chapters by half. It was decided not to do this, and to let them stand for what they are worth and as examples of the kind of dysfunction to which ambitious projects are prone.

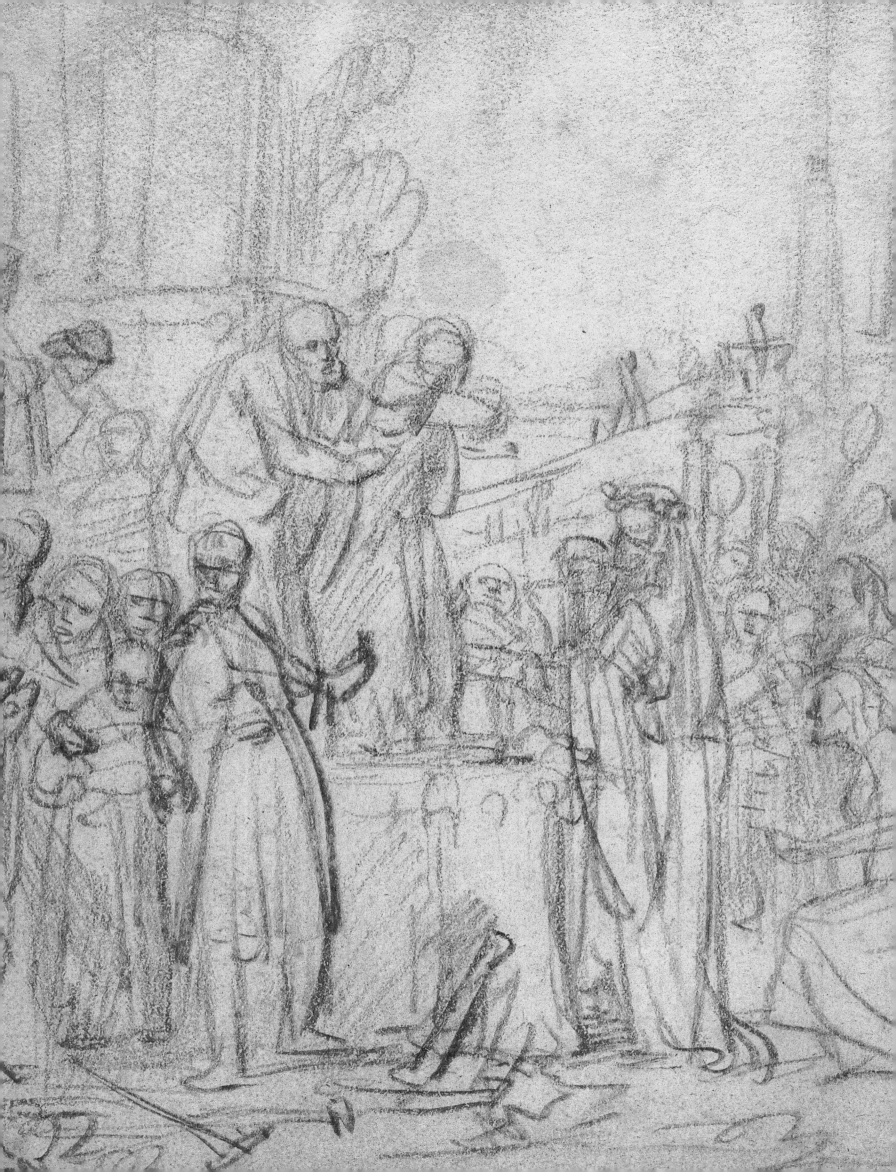

I

Introduction

The Rembrandt facts

ABOUT FIVE HUNDRED documents from his time tell us about Rembrandt and his art. They praise his work while raising doubt about his character. Scholars agree on the attribution to Rembrandt of about 285 etchings. Of the 1,575 drawings in the last catalogue of Rembrandt's drawings (1973), about half are now doubted, but in the absence of a new catalogue the overall situation is unclear. Opinion regarding his authorship of some 150 paintings out of four hundred contenders remains divided. The traditional practices of connoisseurship make for continued disagreement and instability.

Although his own archives have not been preserved, Rembrandt left a wider paper trail than almost any other Dutch artist of his time. Parts of his correspondence with patrons have been preserved. His contracts with an early pupil have survived. The presence of his works in Dutch and foreign collections is recorded in nearly two hundred documents during his lifetime.

His fame as an artist is reflected in more than forty contemporaneous books and manuscripts. In nearly all of them, his art is praised, sometimes in the highest terms. Sixty documents contain appraisals or sales prices of his work. They show that the praise lavished on Rembrandt by poets and writers was not just lip service. Much of his work commanded prices at the top of the market, both new and upon resale. (See below, pp. 121–23.)

The documents concerning Rembrandt as a person are less flattering. His conflicted family life and troubled financial affairs generated more than 150 documents in the archives of the courts, tax authorities and notarial registers of Amsterdam, Leiden, The Hague, Leeuwarden and elsewhere. Rembrandt was involved in more than twenty-five legal battles of various kinds. Even when he was not the one who started the fight, his involvement made it more likely that a dispute would turn bitter. In some of these affairs, which could stretch out over decades, he was capable of sneaky and sometimes cruel behavior. There is a notable lack in the Rembrandt documents of the trust and warmth that are often encountered in the papers recording other Dutch

Rembrandt documents

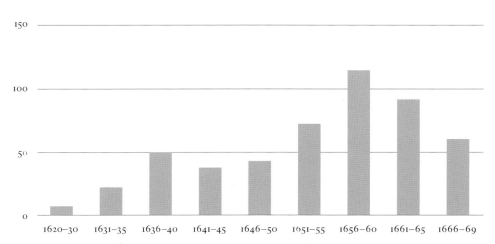

| | 1620–30 | 1631–35 | 1636–40 | 1641–45 | 1646–50 | 1651–55 | 1656–60 | 1661–65 | 1666–69 |

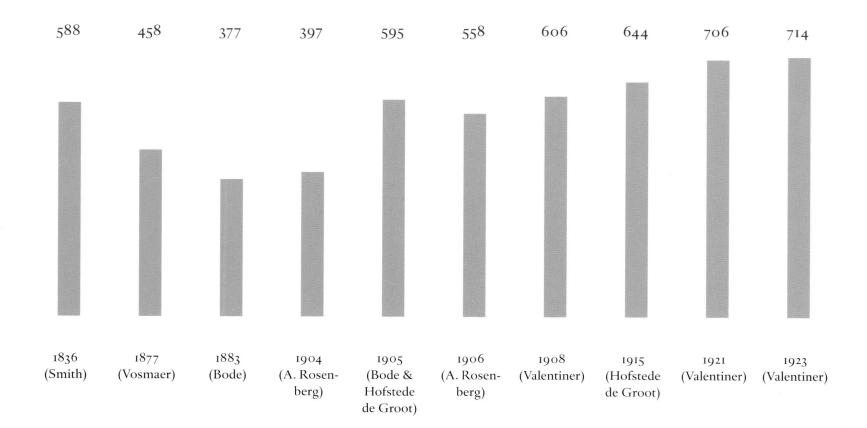

| 588 | 458 | 377 | 397 | 595 | 558 | 606 | 644 | 706 | 714 |

| 1836 (Smith) | 1877 (Vosmaer) | 1883 (Bode) | 1904 (A. Rosenberg) | 1905 (Bode & Hofstede de Groot) | 1906 (A. Rosenberg) | 1908 (Valentiner) | 1915 (Hofstede de Groot) | 1921 (Valentiner) | 1923 (Valentiner) |

Graph 2
Number of Rembrandt paintings in catalogues from 1836 to 1992

lives. The same is true of most posthumous mementoes of Rembrandt by people who knew him and who portray him as arrogant and insensitive.

Beside the paper trail, Rembrandt's art also provides a source of knowledge about him. Before we can call a particular work a Rembrandt fact, however, we do have to know whether he actually made it. In terms of scholarly opinion, which is the accepted forum for deciding these issues, the three media in which he worked present very different pictures. Judgments concerning the etchings are relatively stable. In 1797 the Viennese print curator Adam Bartsch catalogued 375 etchings as the work of Rembrandt. Since then only three additional prints have been added to the standard catalogues. With some relatively minor disagreement along the way, there has been a paring down of the number of accepted etchings to about 285. This is a hyperbolic curve, starting high and swooping down to a fixed axis.

The first catalogues of the drawings were compiled by Carel Vosmaer in 1869, when in an admittedly incomplete listing he included about 320 sheets. In 1877, in the second edition of his book on Rembrandt, he listed about seven hundred.[1] In a book of 1893, Emile Michel increased this number to about nine hundred. The prize-winning catalogue of 1906 by Cornelis Hofstede de Groot has 1,613 entries. Wilhelm Valentiner, in 1916, reduced the number to 824. Between 1954 and 1957 Otto Benesch brought out the most complete and ambitious catalogue to date of Rembrandt's drawings. He listed 1,384 main numbers, but the actual total, including versos and supplementary numbers, was 1,467. The enlarged edition of his book brought out

in 1973 by Benesch's widow Eva included about 1,575 drawings. Since then no one has taken on the monumental task of compiling a new complete catalogue. However, in the collection catalogues that have appeared since Benesch, there has been a steady decline in the number of drawings accepted. In an excellent catalogue of the Rembrandt drawings in Dresden, more than half of his attributions are rejected.[2] The graph of accepted drawings climbs, declines, climbs and is now going into the hyperbolic mode that signifies growing consensus among specialists.

The picture with regard to Rembrandt's paintings is different yet. This is a similarly cyclical curve as that of the drawings, with one important difference. The last dip is not hyperbolic. It has bottomed out and is once more on the rise. A curve of this kind is unusual in art-historical studies. In those parts of the field that benefit from the accumulation of new information and the crystallization of methodologies, one sees a convergence of opinion, not the see-saw of the chart of accepted Rembrandt paintings. Why has increased knowledge not led to greater certainty? In my judgment, this is due to a mismatch between two essential factors: Rembrandt's working practice and the mindset of the latter-day connoisseur. The connoisseur looks for authentic originals conceived and executed entirely by one master. Rembrandt did not produce very many works of this kind. The majority of paintings attributed to him (and this may apply more to the drawings and etchings as well than is generally realized) have features that get in the connoisseur's way. They show artistic borrowings from here and there and an unnerving inconsistency in design and brushwork, not to speak

1 Hofstede de Groot 1906b, pp. v–ix.
2 Dittrich and Ketelsen 2004. Concerning the majority of drawings in private collections in Benesch's catalogue there have been no new publications. Hundreds of sheets are in limbo.

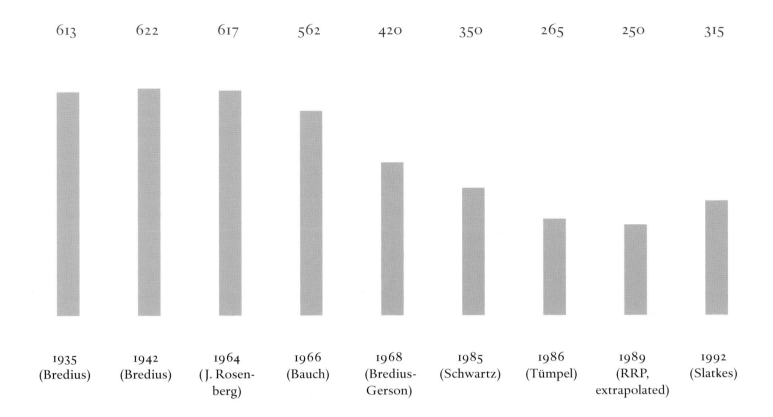

613	622	617	562	420	350	265	250	315
1935 (Bredius)	1942 (Bredius)	1964 (J. Rosen-berg)	1966 (Bauch)	1968 (Bredius-Gerson)	1985 (Schwartz)	1986 (Tümpel)	1989 (RRP, extrapolated)	1992 (Slatkes)

of later interventions that can alter the appearance of a work dramatically. There are also large numbers of paintings that emerged from his studio, under his artistic supervision, but which were executed entirely by pupils or assistants. According to the mood of the time, these works wash in and out of the corpus. A solution to at least part of this problem would be to include in one set all the paintings that have ever been published by serious scholars as the work of Rembrandt. A sympathetic study of the mutual ties between these works and their place in the history of Dutch art, freed from the imperative to grade every painting as Definitely By or Definitely Not By the Master, should bring new clarity into a muddy field.[3]

Soft facts

"REMBRANT van RIIN
Son of Harmen Gerrits zoon van Rijn' and Neeltgen Willems van Suydtbrouck, was born in the city of Leiden on the 15th of July in the year 1606." Spelling aside, the names and place in this statement, published in 1641, are confirmed by so much other evidence that they cannot reasonably be doubted. The date however is not and there-fore should be doubted. No other evidence from his lifetime supplies Rembrandt with a birthday of 15 July or any other day of the year. As for the year 1606, it is in conflict with three other sources. When Rembrandt was inscribed in the student registry of Leiden University on 20 May 1620, his age was given as fourteen, which if his birth-day was 15 July means he was born in 1605. On 10 June 1634, when he registered his marriage in Amsterdam, Rembrandt declared that he was twenty-six years old, giving a year of 1607. And on 16 September 1653 an Amsterdam notary took a deposition from "the honorable Rembrant van Rijn, renowned painter of this city, about forty-six years old." This too works out to 1607, but it is half-hearted evidence. If we judge the sources critically, we have to admit that we do not know when Rembrandt was born.[4] Many other "facts" cited in this book have their soft side as well.

3 For many years the Rembrandt Research Project, with its categor-ical, chip-on-the-shoulder division of paintings into Grade A, Grade B and Grade C, had a destabilizing effect on the formation of consensus in the field. Volume 4 of its *Corpus of Rembrandt paintings*, which appeared when the present book was largely completed, has brought a much-desired change in this respect. However, the spate of new attributions by the Project of a bewildering variety of paintings has led to fresh confusion.
4 Vogelaar 1991, pp. 26–27.

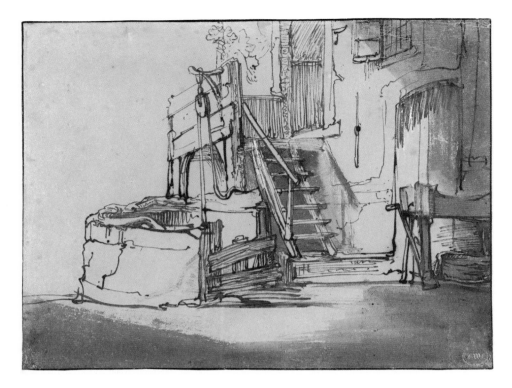

7
Rembrandt
Entrance of a cottage,
with a draw well
Unsigned, undated, ca. 1633–36
Pen and ink, brush and wash,
18 x 23.3 cm.
Benesch 462
Hamburg, Hamburger
Kunsthalle

Caveat lector: an instructive case

Apparently insoluble difficulties frustrate the best attempts to analyze the relation between one drawing, one etching and one painting. They are related to each other – but how? Were they made by Rembrandt or not? Are they the work of one artist or hybrid creations? One example stands in for many.

In 1954 Otto Benesch, in his indispensable catalogue of Rembrandt's drawings, stated confidently of a drawing in Hamburg of a well in front of a farmhouse with a wooden staircase leading to the front door that it was "used for the painting The Good Samaritan, London, Wallace Collection, … and also for the etching B[artsch]. 90 [of the same subject], which is signed and dated 1633."

That seemed like a sensible supposition until 1969, when Horst Gerson cast doubt on Rembrandt's authorship of the painting in the Wallace Collection.[5] If the painting was not by Rembrandt, then how could a Rembrandt drawing have served as a preparatory study for it? Before that question was addressed, Gerson's judgment was contradicted in 1976 by Kenneth Clark. Following a cleaning of the painting that brought to light a monogram and the date 1630,[6] Clark triumphantly reasserted Rembrandt's authorship of the panel.

The worm turned once more in 1986 when the Rembrandt Research Project, rejecting the authenticity of the monogram and date, attributed the painting to the eighteen-year-old Govert Flinck, dating it to 1633, the year of the etching.[7] This theory was initially embraced by the Wallace Collection, which in its catalogue of Dutch and Flemish paintings published the painting as "Attributed to Flinck." "Such an attribution," wrote John Ingamells, the curator of the Wallace Collection, "presupposes that the workshop assistant had access to a (now lost) design by Rembrandt…. It is reasonable to suppose that the common source was a sketch, probably a grisaille, of c. 1632 made by Rembrandt for his etching of the following year."[8] A missing link entered the picture.

8
After Rembrandt
The good Samaritan bringing
the wounded man to an inn
(Luke 10:25–37)
Monogrammed and dated
RHL 1630
Panel, 25 x 21 cm.
Bredius 545
London, Wallace Collection

9
Rembrandt
The good Samaritan bringing
the wounded man to an inn
(Luke 10:25–37). Inscribed in the plate (in the fourth state of four only) *Rembrandt · inventor · et · feecit 1633*
Etching, 25.8 x 21.8 (in first state, in fourth state reduced to 25.7 x 20.8 cm.)
Bartsch 90 i(4)
Haarlem, Teylers Museum

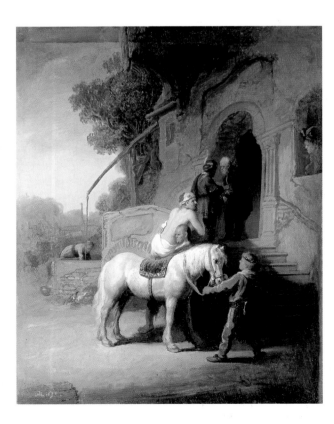

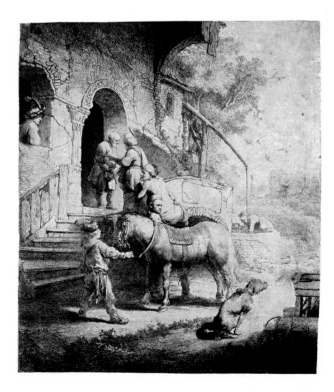

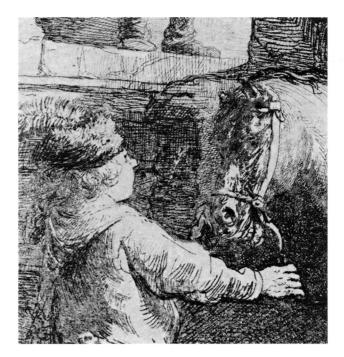

10–11
Rembrandt
Enlarged details of *The good
Samaritan bringing the wounded
man to an inn* (fig. 9)
Haarlem, Teylers Museum

5 Bredius-Gerson 1969, no. 545:
"… the execution is so timid and the
(architectural) details so insecure,
that the picture must be considered
an old copy after a (lost) original."
Gerson was not the first one to
doubt Rembrandt's authorship.
He was preceded by Willem Martin
and J.C. van Dyke. (See Ingamells
1992, p. 123.)
6 Clark 1976, p. 806: "Not only
has the picture regained its former
brilliance of colour, but cleaning
(by Mr John Hargrave) has revealed
a signature, RL, and a most impor-
tant date, 1630. The doubts as to the
authenticity of the *Good Samaritan*
… must surely now be abandoned."
7 Bruyn et al. 1982– , vol. 2 (1986),
pp. 607–16, no. C48.
8 Ingamells 1992, p. 123.
9 Voûte 1989.
10 With thanks to Theo Laurentius.
11 Schröder and Bisanz-Prakken
2004, p. 316, no. 153.
12 Röver-Kann 2000, p. 112,
no. 60.
13 Singer 1906, pp. 199, 276.
Münz 1952, vol. 2, p. 93, no. 196.
14 Wilson 1836, p. 90, no. 95.
15 Boogert et al. 1999, p. 29.

The viability of that notion was undermined in 1989
by the Dutch collector J.R. Voûte.[9] He noticed that
before etching the horse we now see, Rembrandt had
blocked in another horse further left. Its head is still
plainly visible in the masonry of the stairway.
Moreover, the original position of the man helping the
victim off the horse must have been further to the right.
The trousered legs beneath the horse are too far away
and at the wrong angle to belong to the helper we now
see, who has only a head and shoulders. Since the paint-
ing in London reproduces the end result of this messy
process, it must have been painted after the etching.[10]
Apparently unaware of Voûte's argument, the Wallace
Collection once more displays the painting as an origi-
nal work by Rembrandt, predating the etching.

Doubts about Rembrandt's authorship of the paint-
ing did not affect Benesch's point about the role of the
drawing of the well in relation to the composition of
painting and etching. This was however brought into
doubt in 2004, by Marian Bisanz-Prakken of the
Albertina.[11] She finds the resemblance between the two
wells too general to speak of dependence of one on the
other. Moreover, she prefers a later date for the draw-
ing, around 1635–40, on account of a forcefulness that
she does not see in the print. Her move highlights the
circumstance that none of Rembrandt's early drawings
– in fact very few of his drawings at all – is dated.
Opinion on the date of the drawing of the well varies
widely, from the early 1630s to the early 1640s. The
insecurity is increased when we learn, from an exhibi-
tion catalogue of 2000 by Anne Röver-Kann of the
Rembrandt drawings in Bremen and Hamburg, that the
eminent authority on Dutch landscape art Wolfgang
Stechow thought the drawing of the well was not by
Rembrandt at all. Röver-Kann insists that the drawing
is by Rembrandt, but she thinks that the wash in the

foreground, which is so important for the composition-
al effect, was added later, presumably by another hand.[12]
This judgment brings to mind the doubts expressed
about the authorship of the etching, which in 1906
H.W. Singer called "a reproduction of the painting in
the Wallace Collection by a pupil," and was catalogued
in 1952 by Ludwig Münz as "executed with the assis-
tance of pupils."[13] Heinrich Wölfflin was only one
of the critics who took Rembrandt to task for placing
a defecating dog in the foreground. An earlier delicate
soul was Thomas Wilson, who in his catalogue of
Rembrandt's etchings of 1836 links this indecorous
touch to Rembrandt's nationality: "The introduction
of a dog, towards the right corner, in an attitude in the
true Dutch style, is an injury to the composition (con-
sidered as a piece of sacred history)…"[14]

Offsetting these considerations of scholars and critics
is the enraptured judgment of Goethe, who in his essay
"Rembrandt der Denker" (Rembrandt the thinker)
singles out *The good Samaritan* as a powerful proof
of Rembrandt's grasp of human emotions, intellect
and physical expression.[15]

12
Rembrandt
*The good Samaritan bringing the
wounded man to an inn* (fig. 9)
Haarlem, Teylers Museum

13
Jan van de Velde (1593–1641)
*The good Samaritan
(Allegory of Night)*
Inscribed *I.V.Velde fecit*, with
poem and other inscriptions.
Undated. 1610s.
Etching, 19.3 x 17.4 cm.
The conception and setting for
Rembrandt's *Good Samaritan*
seem to have been inspired
by this print by an older
contemporary from Haarlem.
The well (and the dog) are
not in the model.
Haarlem, Teylers Museum[16]

This summary of conflicting opinions is far from
complete. One factor that makes the issue so complicat-
ed is that all the works in question have a certain hybrid
quality. Two hands have been detected in the Hamburg
drawing, one hand carrying out the thoughts of some-
one else's mind in the painting in London. The etching,
even if designed and executed by Rembrandt, is a varia-
tion on a theme by another artist, Jan van de Velde.
It may be asked whether the available evidence will ever
enable us to come up with a satisfying theory about the
relations between this drawing, etching and painting.

16 Münz 1952, vol. 2, pp. 93–94,
no. 196.

The critical question is whether this case is typical
or exceptional. If exceptional, we need not expect to
find conundrums of this kind in other constellations
in Rembrandt's oeuvre. However, as everyone in the
field knows, comparable problems of attribution,
chronology, influence, internal inconsistency and condi-
tion are encountered in nearly every group of works by
Rembrandt and his circle. This chronic uncertainty
suggests strongly that in those cases as well we are
dealing with hybrid products like the various *Good
Samaritans*, indeed with a certain innate instability in
Rembrandtness itself. Whereas here this is close to the
surface, in many other examples it may not be acknow-
ledged or recognized. Following the traditions of con-
noisseurship, scholars usually attach a simple Yes or
No label to individual works.

In many instances the material lends itself to a com-
mon-sense explanation to which specialists find it
convenient to subscribe. If we are strict with ourselves,
however, we have to admit that these opinions are based
on too little solid evidence to be worth very much.
Many of the paintings, etchings and drawings published
in this book as the work of the artist Rembrandt van
Rijn may well have a compound authorship. This is
reflected by the tremendous diversity of opinion among
scholars concerning their authenticity, dating and
mutual relations. It would be tedious to point this out
time and again, with names and dates and arguments,
but it does need to be said every so often, clearly.
Reader, be aware!

Taking our terms from Rembrandt

In 1719, in his book on the painters of the Netherlands,
Arnold Houbraken brings to life a moment then seven-
ty years in the past, a turning point in the career of the
young Silesian artist Michael Willmann (1630–1706):

> His father was a common painter born in Lubeck.
> Once he turned toward art he made such progress
> that at the age of twenty he surpassed his contempo-
> raries and countrymen. This was not enough for him,
> so he left for Holland, where his courteous behavior
> and art made him welcome among practitioners of art
> and art-lovers. He mostly associated, when in society,
> with J. Backer and Rembrandt, whose art, company
> and discourses ("Redenvoeringen") gave him so much
> pleasure that he gave up his intention to travel to
> Italy.[17]

Rembrandt's discourses… How passionately have
students of Rembrandt and his work longed for them.
What wouldn't we give to experience a day in the life of
Michael Willmann in the year 1650? The wish to hear
Rembrandt explain himself is so great that everything
resembling a first-person statement on his art has been
seized and squeezed for all it is worth, and often more.
After his death, writers on art credited Rembrandt with
somewhat crabby assertions about his philosophy of art
("Nature is my only guide"), his rough brushstroke
("I'm a painter, not a dyer"), his relation to customers

14
Rembrandt, after
Pieter Lastman
Paul and Barnabas at Lystra
Unsigned, undated. Ca. 1637.
Inscribed by Rembrandt: *een
vrouw wijst op een jonck kind*
(A woman points at a young
child)
Red chalk, 29.5 x 44.3 cm.
Benesch 449
Bayonne, Musée Bonnat

17 Houbraken 1718–21, vol. 2, p. 233.
See also Horn 2000, vol. 1, p. 267.
On pp. 343–44 the author confuses
the generations of Willmann
painters.
18 Gerson 1961, pp. 33–40. Doc.
1639/2. See below, pp. 155–59.
19 Gerson 1961, p. 5.
20 Walter Strauss and Christian
Tümpel deserve credit for having
garnered most of these dispersed
notes. Tümpel discussed those on
history subjects. Strauss and van der
Meulen 1979, pp. 591–615. Tümpel
2003.

("Don't get too close, the smell of the paint might
annoy you") and his way of life ("when I want to ease
my spirit, it isn't honor that I seek but freedom").
We will return below to these and other attributed
expressions.

That is posthumous evidence. When it comes to
undisputed statements in Rembrandt's own hand, only
a single one has so far been the object of general atten-
tion. This is contained in a letter of 12 January 1639,
in which the artist speaks of attaining "the greatest
and most natural (e)motion" (opinion is divided as
to the meaning of the Dutch word) in two paintings
of the *Entombment* and the *Ascension of Christ*.[18] The
perceived lack of writings by Rembrandt has fostered
a general belief "that Rembrandt had no particular
urge to discuss his art, or to write about it."[19]

Willmann had a different impression, and so do I.
Aside from his now silent discourses, Rembrandt actu-
ally left quite a precious legacy of writings on his own
art. He did so however in such modest and informal
fashion that art historians have largely ignored them.
I am referring to the words, phrases and occasionally
whole sentences jotted on his drawings and prints.
There are more than forty such notes, most of which
can be deciphered and interpreted. In a way, they offer
something better than the kind of self-conscious formu-
lation that art historians miss and that all too often are
restatements of accepted wisdom. The jottings catch
Rembrandt in unguarded moments, writing private
memos to himself or to his pupils.[20] They comment on
matters that were important enough to him to make
him stop and take note. Some are disarmingly simple.

On a copious, multi-figured drawing of *Paul and
Barnabas at Lystra*, Rembrandt wrote, "a woman points
at a young child," revealing not only his attention to
small details but also his special interest in children as
actors in history compositions. (For surprising statis-
tics on this, see p. 61.) Some of the jottings are clearly
addressed to pupils, correcting their own work. Others
seem to be quotations from travel books or devotional
literature, singling out specific features that interested
the artist. Several concern financial affairs, the sale
of students' work, mortgage negotiations. One is an
enlightening and impressive list of part of Rembrandt's
print collection. The jottings refer to more than twenty
personalities from life and history and thirty dates
ranging from 1630 to 1661. They identify subjects and
motifs and provide inside studio information on the
making and printing of etchings.

In this book, Rembrandt's jottings are used as a kind
of index to the artist's values. They are marshalled
as evidence for his state of mind, his intellectual con-
cerns and his artistic impulses. Wherever they occur,
the reader will be brought into touch with the artist
on a verbal level, as Rembrandt's own running com-
mentary, if a bit more mumblingly than in a proper
discourse, on his art and life.

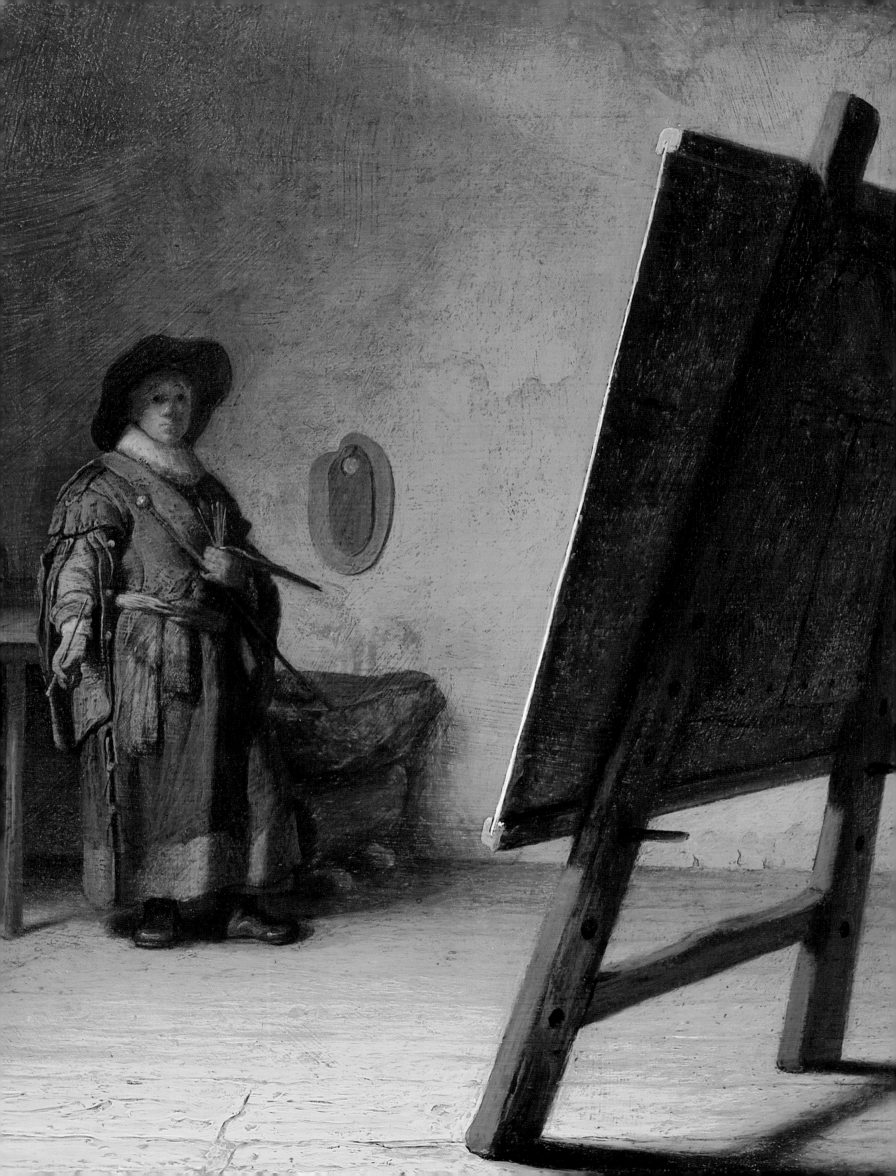

2

A Dutch artist's life

The Republic

THE DUTCH REPUBLIC in Rembrandt's time, a country that launched a thousand artistic careers, was an opaque system whose workings were understood only by the insiders who were pulling the strings. But you did not have to understand it to benefit from its blessings.

If ever an artist was born in the right place at the right time, it was Rembrandt. His parents were born at the beginning of a highly chancy revolt against Habsburg Spain that might well have ended in total disaster for Holland and the other rebellious provinces of the Netherlands. When Rembrandt came into the world, that revolt was a famous military success, an epic that thrilled Protestants and threw fear into Catholics all over the world. Although Spain was able to retain control over ten of the seventeen provinces of the Netherlands, a proud new Republic of the Seven United Provinces proclaimed and protected its independence. In 1609, before Rembrandt was three years old, the United Provinces signed a twelve-year truce with Spain that amounted to *de facto* independence.

The United Provinces were a prodigy not only in a military sense. The process of nation-forming was more than a series of battles. It was also a chain of meetings, proclamations and treaties through which the new country accumulated a set of institutional forms, religious values and political principles that were woven into the fabric of the nation. These measures tended to incorporate high-level compromises that were not always crystal-clear.

The Pacification of Ghent (1578) established a higher degree of mutual Protestant–Catholic toleration than existed anywhere else while recognizing Calvinist supremacy in Holland and Zeeland. In 1579 the rebels adopted a constitution (the Union of Utrecht) that preserved the privileges of the individual provinces while providing for overriding joint security measures under the States-General. A republican form of government emerged in the 1580s, while command over the armed forces was left in the hands of a quasi-monarchical stadholder, the deputy of a king whose rule had been forsworn. While formal decisions were taken only in the meetings of the Provincial States and the States-General in The Hague, no important measures could be adopted without the approval of the regents of Amsterdam. These formal and informal check-and-balance constructions are typical of power-sharing throughout the Republic at all levels.

With a bit of bad luck, the failure of any of these precarious balancing acts could have brought the Republic down like a house of cards in a breeze. In the event, the Republic turned out to have the supple stability of an earthquake-proof Japanese skyscraper. Mutual interests were so well matched that the system lasted in basically unchanged form, less two stadholderless

17
Rembrandt
The concord of the state
Inscribed *Rembrandt f. 164[.]*.
Opinions concerning dating
range from 1635 to 1642
Panel, 74.6 x 101 cm.
Bredius 476
Rotterdam, Museum
Boijmans Van Beuningen

periods, until the end of the *ancien régime* in 1795. By way of comparison, not until 2031 will the present Kingdom of the Netherlands, founded in 1815, have lasted as long as did the United Provinces between 1579 and 1795. Who knows if before 2031 the Netherlands might once more become a republic, with a stadholder from the House of Orange?

As important as the military and political might of the Dutch Republic was its financial and mercantile power. The basis of this wealth was earned in what was called the "mother trade" in Baltic grain and in the North Sea fishery. In the 1580s, after the Dutch strangled Antwerp by closing its access to the North

Sea, they took over the Mediterranean and New World networks built up by the Flemish, who emigrated *en masse* to the north. Add to this the new Asiatic trade of the Dutch East India Company and the slave-and-sugar commerce of the Atlantic Triangle (spiked by piracy), all tied up in the unrivalled banking house and stock exchange of Amsterdam, and you have the ingredients for what Jonathan Israel has called Dutch world trade primacy.[1] Israel distinguishes between bulk goods and the increasingly important rich trade in precious materials and manufactures. As producers and traders of luxury goods, the Dutch enjoyed primacy in the arts as well as in oats and herring.

In a word, there was no better springboard available for a career in art than the Dutch Republic in the early 1600s. When Rembrandt opened his eyes on 15 July 1606, the light he saw was the Dawn of the Golden Age.

The concord of the state

This intriguing painting has always been regarded as no. 106 in the 1656 inventory of Rembrandt's possessions: "De eendragt van 't lant, vanden selven" (The concord of the state, by the same – that is, painted by Rembrandt). The armed force in *De een-dragt van 't lant* seems indeed to represent the most indispensable binding feature of the Union – the States Army – but not all the symbols are expressive of concord. Moreover, there are clearer references to the province of Holland and the city of Amsterdam than to the state itself. Scholars are in complete disagreement as to the meaning of the work and the occasion for which it was painted – or even *if* it was made for an occasion.[2]

Although there is no reason to think this was intended by Rembrandt, the very indecipherability of *De eendragt van 't lant* is an excellent emblem of the Dutch state.

Leiden

Rembrandt's home town was proud of its history, its university and its textile manufacturing, but was unable to live from pride.

On 3 October 1942 the Dutch historian Johan Huizinga addressed his fellow internees at the camp of Sint Michielsgestel. His audience consisted of Dutch intellectuals who were being held hostage by the Germans. The subject of his talk was "The relief of Leiden." On that same day nearly 370 years earlier the Spanish siege of Leiden, the most traumatic episode of the

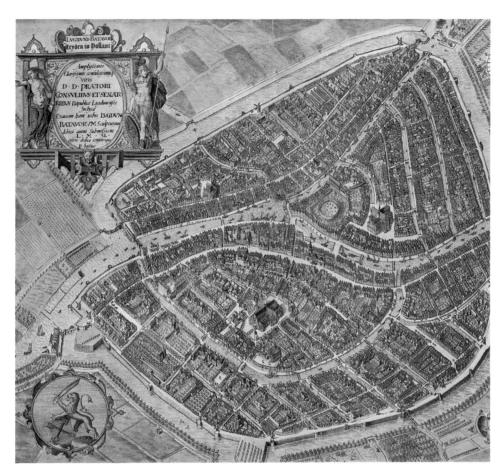

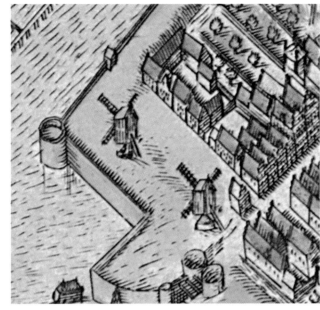

18
Pieter Bast
Map of Leiden
Inscribed *petrus bastium aut,
sculp. et excudit / 1600*
(Designed, engraved and
published by Pieter Bast, with
title, dedication, legend, etc.)
Engraving, hand-colored,
37.5 x 44.5 cm.
Leiden, Regionaal Archief
Leiden

19
Pieter Bast
Detail of map of Leiden (fig. 18)
Leiden, Regionaal Archief
Leiden

The Weddesteeg, with
Rembrandt's birth house and
his father's windmill.

20
The Latin School in the
Lockhorststraat, attended by
Rembrandt according to his
first biographer, Jan Jansz.
Orlers.

1 Israel 1989.
2 Bruyn et al. 1982–, vol. 3, no. A 135.

Eighty Years War for the northern Netherlands, had
been lifted. The siege had been going on for four and a
half months, and a full third of the inhabitants had died
of hunger and disease. Resistance had been about to
collapse, and if it had, the Spaniards would have cleaved
Holland in two and crushed the rebellion for good. The
last rations were almost gone when the rebels broke the
dikes and breached the Spanish lines in boats, blown by
storm winds over the inundated polders. The land had
been devastated but the country was saved. Huizinga
did not have to draw a moral for his listeners. They
knew it would take the same courage and sacrifice to
drive out the Germans, and that the lives of hostages
like themselves might have to be forfeited in the
struggle. In closing, he asked them to sing with him
a song of the rebellion that compared Leiden to
Jerusalem, saved by God from Sennacherib's army.

From 1574 on Leiden was a byword to the Dutch for
perseverance, bravery and victory. October 3rd is still
celebrated in the city with white bread and herring, the
breakfast of the survivors of 1574.

Within months of the end of the siege, upon the pro-
posal of William of Orange, Leiden became the seat of
the first Protestant university in the Netherlands. The
humanist Jan van der Does, governor of Leiden and one
of the main opponents of capitulation during the siege,
was appointed dean. Leiden never forgot that its univer-
sity was born out of blood. It was called an academy,
but with none of the belittling overtones that often
cling to things academic. Even the curriculum was

heroic. Classics, theology, law, medicine, engineering – in Leiden they were treated as matters of national importance.

And international. Leiden soon became a leading European center of learning. The community of scholars and the thousands of Flemish and Walloon refugees from the southern Netherlands, many of them cultivated people, gave Leiden a sophistication it never had before the war. Most of the newcomers were Protestants.

The traditional mainstay of the Leiden economy was the manufacture of textiles. In the third quarter of the sixteenth century the industry, after a gradual decline, had been practically wiped out, and when the rebellion began Leiden was an impoverished city. After the siege, it recruited skilled textile workers from the southern Netherlands and maneuvered itself into position to take advantage of a new period of growth.

When Rembrandt was born, Leiden was still the walled medieval town it was in 1400, with a population of about 17,000 living in 5,000 houses. An attractive new extension was added in the 1610s, but the planners could not keep up with the demands of the boom.

Speculators split houses into the smallest possible units, and those unable to pay the rent even for those cramped quarters were forced to put up huts illegally outside the walls. By 1625, when Rembrandt began his career as an artist, there were 45,000 Leideners – four times as many as in 1574 – living in not quite 7,000 houses. Around the time the artist moved to Amsterdam, his home town was desperate again. In the winter of 1633, nearly half the population was on relief. Leiden had become the second largest city in the country after Amsterdam, but it had grown beyond its strength, and was not to recover economic health during Rembrandt's life.

Artistic traditions inherited

Along with Caravaggio, Rembrandt was said to respect no master but Nature. That charge is belied by Rembrandt's extraordinarily extensive appropriations of the art of his predecessors, especially the Italians. In his contemporary countrymen he had little interest.

As if it were made for him, around the time Rembrandt was fifteen years old and was embarking on his professional training as an artist, a remarkable print of a fifteen-year-old Leiden artist one hundred years his senior was brought out.

"The portrait of Lucas van Leiden," the Latin caption reads, "the incomparable painter and engraver, when he was fifteen years old, depicted from a portrait of himself by his own hand. He died in Leiden in the year 1533 at the age of thirty-nine." Within a few years Rembrandt too was painting and etching portraits

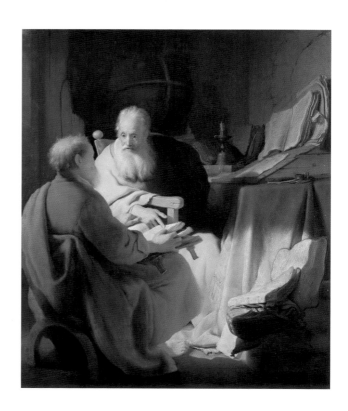

23
Andries Jacobsz. Stock
(ca. 1572/82–after 1648)
Self-portrait of Lucas van Leyden
Inscribed *Ands. Stokius fecit*,
with Latin inscription on the
painting
Undated. Ca. 1620
Engraving, 21.8 x 16.7 cm.
Amsterdam, Rijksmuseum

24
Rembrandt
*Self-portrait in a cap and scarf
with the face dark*
Inscribed *Rembrandt f. 1633*
Etching, 13.2 x 10.3 cm.
Bartsch 17 ii(2)
Haarlem, Teylers Museum

25
Lucas van Leyden (1494–1533)
*Man with spectacles with pen
and paper*
Unsigned, undated. Ca. 1512
Black chalk, 27 x 27 cm.
London, British Museum
(from an album inscribed
Lucas Teeckeninge 1637)

26
Rembrandt
*Titia Uylenburgh (1605–41), the
sister of Rembrandt's wife Saskia*
Unsigned. Inscribed *Tijtsija
van Ulenburch 1639*
Brown ink and wash,
17.8 x 14.6 cm.
Benesch 441
Stockholm, Nationalmuseum

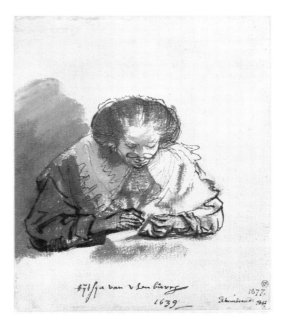

3 Vos 1978, pp. 115–19. In a lovely
little piece of historical whimsy,
the author arrives at a price of
8000 golden ducats. For an excellent
presentation of the subject of this
chapter, see Broos 1985.

of himself by his own hand, an activity that was to
become a lifelong practice. Whatever Rembrandt's
reasons for portraying himself so often, for the initial
inspiration we need look no further than the proud
image of the young man who put Leiden on the map
of artistic Europe.

Lucas's most famous painting became part of the
story of the Revolt itself. During the iconoclastic riots
of 1566 and the threat of a reprisal in 1572, his *Last
Judgment* was saved from destruction by the city.
It was moved in stages from the Pieterskerk to the bur-
gomasters' chamber in the town hall, where it could
be seen by visitors for nearly three hundred years.
In 1602 the township added to the glory of the painting
by turning down a very generous offer for it from

Emperor Rudolf II.[3] The man who moved the painting
to the town hall was an artist who served important
positions in the Leiden city government for half a cen-
tury, Isaac Claesz. van Swanenburg (1537–1614), the
father of Rembrandt's first master, Jacob Isaacsz. van
Swanenburg. An early painting by Rembrandt of two
scholars disputing contains echoes of Lucas's envision-
ing of a heated discussion between the two apostles.

These are symptoms of what I would diagnose as
a case of incurable hero worship on Rembrandt's part
for Lucas van Leyden (1494–1533). Motifs from Lucas's
prints abound in Rembrandt, from early to late. Lucas's
nearly two hundred prints gave Rembrandt access to
a broad scale of traditional subjects from the Bible.
The inventory of Rembrandt's collection lists albums

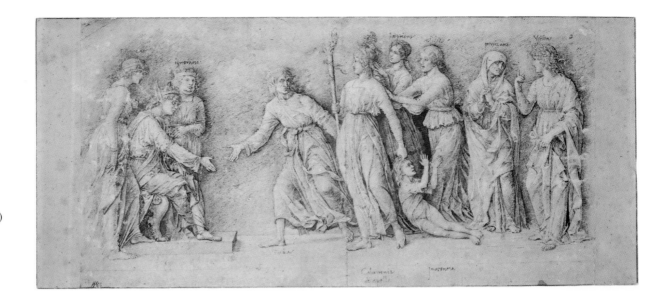

27
Andrea Mantegna (1431–1506)
The calumny of Apelles
Unsigned, undated.
Ca. 1504–06
Pen and ink, 20.6 x 37.9 cm.
London, British Museum

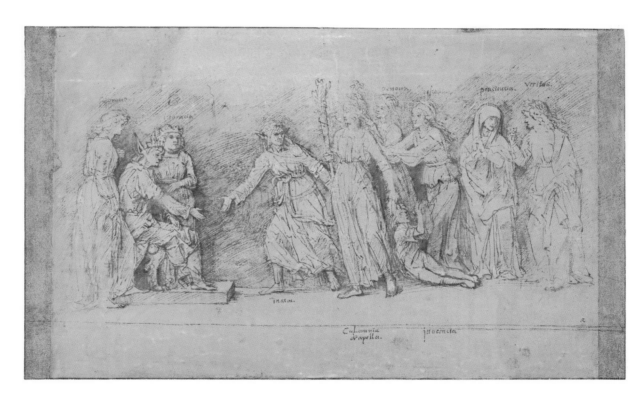

28
Rembrandt
*Andrea Mantegna's Calumny
of Apelles*
Unsigned. Inscribed *CaLomnia
d'apella | Inocencia |
Susp[ic]ione | I[g]nora[n]cia |
acnoni | Ins[s=v]idia | Penitencia
| Veritas*
Undated. Ca. 1656
Brown ink, 26.3 x 29.4 cm.
Benesch 1207
London, British Museum

4 See under Doc. 1639/13. In March
1637 "1 konstboeck van Lucas" was
sold to Rembrandt's apprentice
Leendert van Beijeren at the auction
in Amsterdam of the major art
collection of Jan Basse. See
Docs. 1637/1–2.
5 Doc. 1642/10. Van Hoogstraten
1678, p. 212, says that he saw the
transaction, which must have been
a public auction. He gives the price
as 80 *rijksdaelders*, 200 guilders.
See Roelof van Gelder and Jaap van
der Veen in Van den Boogert 1999,
pp. 40, 42–43. They refer to
Sandrart's report that Rembrandt
had "paid 1400 guilders for fourteen
good impressions of Lucas prints."

of prints and woodcuts by Lucas as well as a painting
of a "perspective," a painting in which architecture
predominates. In 1668, Rembrandt owned a valuable
album of prints and drawings by Lucas. It has been
suggested that this might be an album in the British
Museum marked "Lucas Teeckeninge 1637," which
contains a small portrait in black chalk that resembles
a Rembrandt pen drawing of 1639.[4] Seeing his sister-
in-law Titia at her needlework, spectacles on her nose,
Rembrandt would have been reminded of his recent
acquisition and have sketched her in the same concen-
trated pose. Even if this imagined scene did not take
place and the resemblance is coincidental, we know that
the example of Lucas was important to Rembrandt not
only for the grand tradition but also for the observation
of daily life and lowlife. Rembrandt dramatized this
in public when in 1642 he caused a sensation by paying

179 guilders for a print by Lucas of a beggar family on
the road.[5]

Part of the Lucas van Leyden legend concerned the
high esteem in which he was held by his older contem-
porary Albrecht Dürer (1471–1528). Although modern
scholarship doubts the story, everyone in Leiden in
Rembrandt's time thought that Dürer paid Lucas the
honor of visiting him in his own city. Even without
that mark of distinction, Rembrandt felt that Dürer
belonged to him.

In his appropriation of Dürer's strident *Christ driving
the money changers from the Temple*, Rembrandt looks
past the differences in technique between woodcut
and etching and the differences in spatial construction
and figure placement that distinguish early sixteenth-
century from mid-seventeenth-century art to Dürer's
conception of the theme. He lets himself be convinced

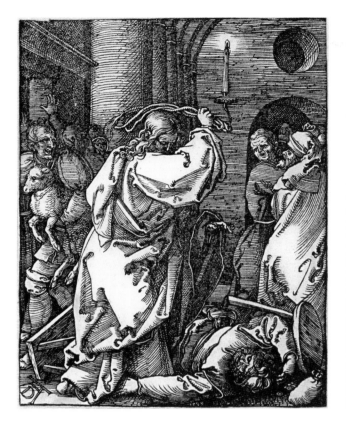

29
Albrecht Dürer (1471–1528)
Christ driving the money changers from the Temple,
from the *Small Passion Series*
Monogrammed *AD*, undated.
Ca. 1508–09
Woodcut, 12.7 x 9.7 cm.
Bartsch 23
Haarlem, Teylers Museum

30
Rembrandt
Detail of *Christ driving the money changers from the Temple*
Inscribed *Rembrandt f. 1635*
Etching, 13.6 x 16.9 cm.
Bartsch 69 i(2)
Haarlem, Teylers Museum

by the German master that Christ was acting not out of personal anger, as Rembrandt showed him in his early painting of the subject, but with contained violence. The age-blind Rembrandt regards Dürer and Lucas not as figures from a closed-off past but as fellow artists taking on the same challenges with which Rembrandt was wrestling. This was nearly literally the case. Aside from differences in emphasis, there is little

in Rembrandt's themes as of the time of his death in 1669 that Dürer or Lucas would have considered innovative in 1500. Only the independent landscapes represented a new departure from the kind of art they practiced.

What Rembrandt, like all the world, saw in the first place in Dürer and Lucas was technical mastery. They will have inspired him to exploit the possibilities of

31
Dirck Volckertsz. Coornhert
(1522–90) after Maarten van
Heemskerck (1498–1574)
The return of the prodigal son
Inscribed *MVHeemskerck*
Undated. Ca. 1547
Woodcut, 24.5 x 18.5 cm.
Hollstein 53
Amsterdam, Rijksmuseum

32
Rembrandt
The return of the prodigal son
Inscribed *Rembrandt f 1636*
Etching, 15.6 x 13.6 cm.
Bartsch 91 i(1)
Haarlem, Teylers Museum

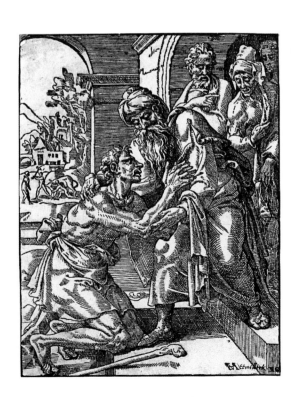

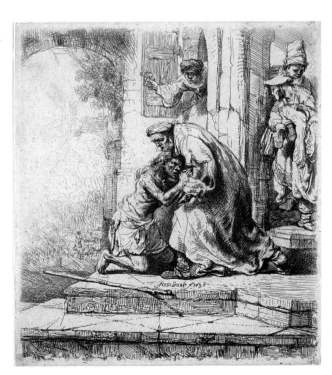

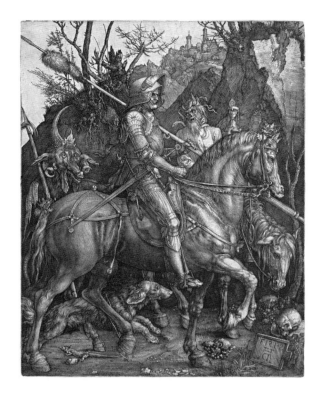

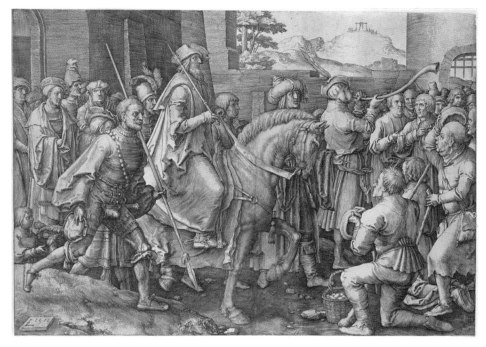

33
Albrecht Dürer (1471–1528)
Knight, Death and Devil
(illustrated in reverse)
Inscribed *AD 1513*
Engraving, 24.6 x 19 cm.
Bartsch 98
Haarlem, Teylers Museum

34
Lucas van Leyden (1494–1533)
The triumph of Mordechai
Inscribed *L 1515*
Engraving, 21 x 28.7 cm.
Bartsch 32
Haarlem, Teylers Museum

35
Pieter Lastman (1583/84–1633)
The triumph of Mordechai
Inscribed *PLastman fecit 1624*
Panel, 51 x 71.5 cm.
Amsterdam, Rembrandt House
Museum (on loan from the
Netherlands Institute for
Cultural Heritage)

etching as brilliantly as they did with engraving. Rembrandt's appreciation of Dürer, it must be said, was commercial as well as artistic. At the estate auction of the deceased art dealer Gommer Spranger on 9 February 1638, Rembrandt bought multiple sets of Dürer series, which can only have been intended for resale.[6] Rembrandt did not consider it beneath his dignity to mediate not only in the ideas of his predecessors but also in their production.

Leiden chauvinism and association with a young hero of art helped Rembrandt establish transhistorical contact with Lucas. But contingencies of that kind were not necessary to kindle Rembrandt's interest in art of the past. He looked with equal intensity at the prints of the Haarlem master Maarten van Heemskerck (1498–1574). The prints bearing his name, many of which were carved or cut by others, do not display the same level of technical mastery as those of Lucas and Dürer.

6 Doc. 1638/2.

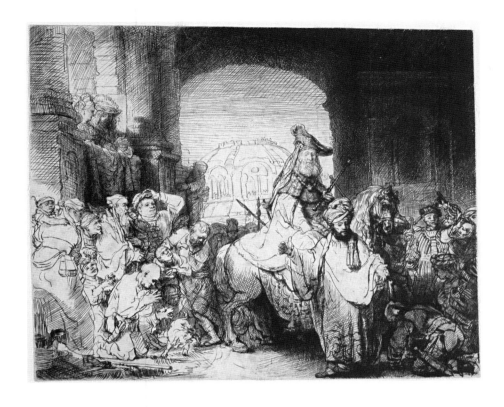

narrative and compositional terms from an engraving by Lucas that in turn is based in part on Dürer's famous engraving *Knight, Death and Devil*. This invocation by his master of great northern European engravers of the previous century was not lost on Rembrandt. He picked up the ball after Lastman's death, with his own etching of the *Triumph of Mordechai*. Aside from the motif of the equestrian procession, one other feature that persists through the four compositions is the sequence of background elements, especially the mid-scene view through to a monumental building on the horizon. Rembrandt's variation on the *mise-en-scène* played into the *Night watch* (fig. 177), on which he was working when he etched his *Mordechai*.

While intensifying Rembrandt's engagement with the Dutch and German tradition, Lastman also had untold riches to offer him from Italy. The Amsterdamer had spent the years from 1602 to 1607 in Rome and Venice, soaking up the architectural and painterly glories of antiquity and the Renaissance. Lastman's work is full of references to the buildings of Rome and to Raphael's tapestries and wall paintings in the Vatican. Although no drawn copies by him of Italian art have survived, he must have come back from Italy with suitcases full of them, which he would have used as teaching material. An inscription on a Raphael drawing sold in Amsterdam in 1778 bore an inscription saying that it had been brought back from Italy by Lastman.[7] When a Raphael painting came under the hammer in Amsterdam in 1639, Rembrandt was on hand to sketch it. Like every other artist in Europe Rembrandt also knew Raphael's works from their widespread publication in print form.

36
Rembrandt
The triumph of Mordechai
(illustrated in reverse)
Unsigned, undated.
Ca. 1641
Etching and drypoint,
17.4 x 21.5 cm.
Bartsch 40 i(1)
Haarlem, Teylers Museum

Rembrandt studied Heemskerck more for compositional solutions, the body language of emotion, architectural backgrounds, costume (figs. 31–32).

In his advanced training with the Amsterdam artist Pieter Lastman (1583–1633), Rembrandt's fascination with Lucas van Leyden and Dürer can only have been strengthened. In 1624, by which time Rembrandt knew well what Lastman was producing, the older artist painted a *Triumph of Mordechai* that takes its basic

37
Raphael (1483–1520)
The Italian courtier Baldassare Castiglione (1478–1529)
Unsigned, undated. Ca. 1514–15
Canvas, 82 x 66 cm.
Paris, Musée du Louvre

38
Rembrandt
Sketch of Raphael's portrait of Baldassare Castiglione
Inscribed *de Conten batasar de kastijlijone van raefael / verkoft voor 3500 gulden / het geheel cargesoen tot Luke van Nuffelen heeft gegolden f59456:- Ao 1639*
Brown ink, some white body color, 16.3 x 20.7 cm.
Benesch 451
Vienna, Albertina

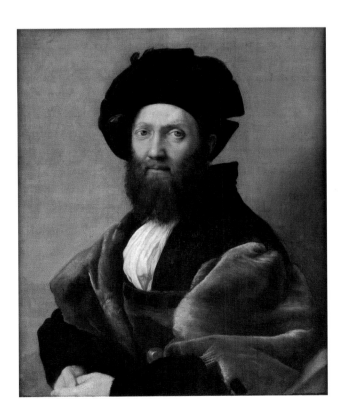

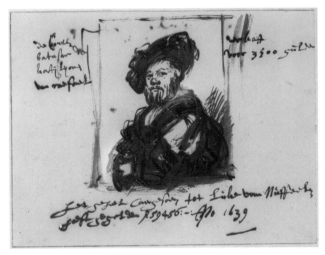

7 Freise 1911, p. 8. The inscription is however problematic. It says that Lastman brought the drawing to Holland in 1605, though he was still in Italy in that year.

39
Andrea Mantegna (1431–1506)
or engraver working for him
Virgin and child
Unsigned, undated.
Ca. 1475–80
Engraving, 39 x 28.2 cm.
Bartsch 8
Amsterdam, Rijksmuseum

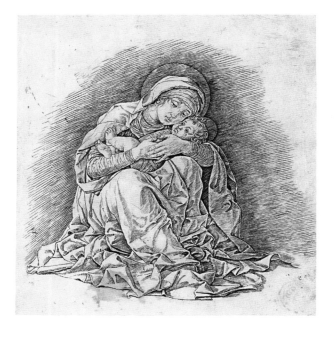

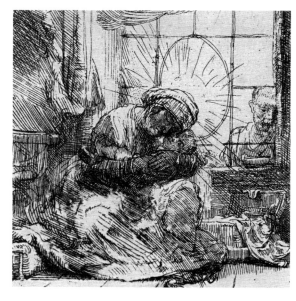

40
Rembrandt
Detail of *The Virgin and Child
with the cat and snake*
Inscribed *Rembrandt. f. 1654*
Etching, 9.5 x 14.5 cm.
Bartsch 63 ii(2)
Haarlem, Teylers Museum

The presence of original paintings by Italian masters in a trading and collecting country like the Netherlands was not all that exceptional. In the inventory of his own belongings, taken in 1656, Rembrandt listed eight paintings by and after six sixteenth-century Italian artists. Far more extensive and comprehensive were his collections of prints by and after the Italians. From an item called "the precious book of Andrea Mantegna," Rembrandt could draw on a print like Mantegna's tender *Madonna and child*. Four volumes of prints by Antonio Tempesta (1555–1630) provided materials that served Rembrandt well throughout his career.

There are strong indications that Rembrandt owned at least three of the four known etchings by Federico Barocci, whose name is mentioned in the 1656 inven-

tory. Two are listed in an autograph document (fig. 240) and a third was adapted for an etching (figs. 43–44).

While falling for sweet Madonnas in the sky by Barocci, Rembrandt did not turn his back on Barocci's funky younger contemporary Michelangelo Merisi da Caravaggio (1571–1610). Lastman's imports will have included copies after the work of this notorious and revolutionary artist. Although in the literature of art Caravaggio was played off against artists like Barocci and Raphael, with the older artists standing for balance and classic beauty and Caravaggio for disruption and anti-classical rawness, an omnivorous artist like Rembrandt did not see things that way. He was after what he could get from anyone, in his own way.

41
Antonio Tempesta
(1555–1630)
Detail from *The lion hunt*
1590
Engraving, ca. 19 x 28 cm.
Bartsch 1132
Amsterdam, Rijksmuseum

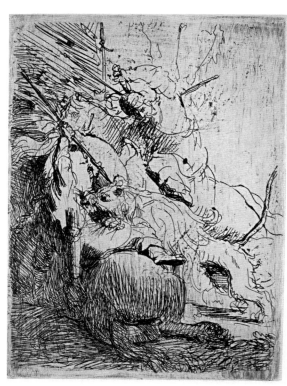

42
Rembrandt
The lion hunt
Unsigned. Undated.
Ca. 1629
Etching, 15.8 x 11.7 cm.
Bartsch 116 i(1)
Haarlem, Teylers Museum

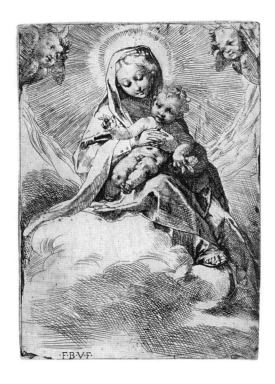
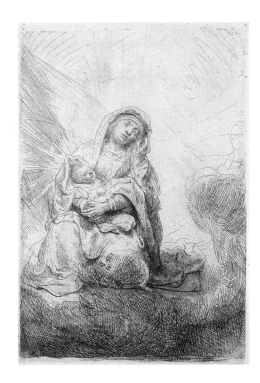

43
Federico Barocci (1528–1612)
Virgin and Child in the clouds
Inscribed *F.B.V.F.* Undated.
Ca. 1570–80
Etching, 15.3 x 10.6 cm.
Bartsch 2
Amsterdam, Rijksmuseum

44
Rembrandt
Virgin and Child in the clouds
Inscribed *Rembrandt f. 1641*
Etching and drypoint,
16.8 x 10.6 cm.
Bartsch 61 i(1)
Haarlem, Teylers Museum

45
Caravaggio (1571–1610)
Madonna of the Rosary
Unsigned, undated.
Ca. 1606–07, present in
Amsterdam in 1616
Canvas, 364 x 249 cm.
Vienna, Kunsthistorisches
Museum

46
Pieter Lastman
Detail of *Odysseus and Nausicaa*
(fig. 47)
Munich, Alte Pinakothek

Caravaggio's fame in the Netherlands reached a climax in 1616 when his largest painting, the *Madonna of the Rosary*, was brought to Amsterdam by the artist and art dealer Abraham Vinck (1580–1619). From there it went to Antwerp, where Rubens and some colleagues presented it to the church of the Dominicans. While the general impression of Caravaggio's altarpiece painting may seem very distant from our image of Lastman and Rembrandt, it was not without impact on them. Lastman responded to the dramatic gesticulation and physical exertion of Caravaggio's figures and the powerful gazes they exchange. He adopted certain devices such as the silhouetting of open hands and placing kneeling figures, seen from the back, in the foreground. Bob Haak made the delightful discovery that the soles of Odysseus's feet are an exact copy of those of the middle foreground figure in the *Madonna of the Rosary*.[8]

Rembrandt's work is imbued with certain qualities we can call Caravaggesque even if they are not directly derived from the Italian master's work. The highly conscious use of dark and light in constructing compositions is considered part of Caravaggio's legacy. This method was known to Rembrandt through the mediation of Utrecht painters like Gerard van Honthorst, who brought stylistic Caravaggism from Italy to Holland.

A more intrinsic form of Caravaggesque influence on Rembrandt may be sought in Rembrandt's abiding fascination with intense, personal contact between God and man. The down-to-earthness for which Caravaggio was famous also became a central value for Rembrandt. In fact, whatever the historical accuracy of the statements may be, Rembrandt came to be credited with exactly the same sentiments concerning the relation of art to nature – "Follow Nature Alone" – as Caravaggio. It was first written down as early as 1675, by the artist and writer Joachim von Sandrart, who knew Rembrandt at the time of the *Night watch*. The relation between Rembrandt and Caravaggio was made explicit in the eighteenth century, when Arnold Houbraken called Caravaggio and Rembrandt "two great stars of painting" with the same philosophy: "follow nature alone, with everything that falls outside [this law] being suspect."[9]

Dutch artists who had worked in Italy brought back knowledge of another famous contemporary as well, Adam Elsheimer (1578–1610), a German painter who may have been regarded even more highly than Caravaggio. He too was considered a realist, but in a more poetic vein than Caravaggio. His night scenes in particular provided lasting inspiration to Rembrandt and his contemporaries. (See below, figs. 400–02.)

During his apprenticeship with Pieter Lastman in Amsterdam, Rembrandt encountered a highly concentrated group of artists with whom he had a natural affinity. Because of that affinity, which resulted in early Rembrandts that resemble their art, they have become known under the unfortunate denomination of "Pre-Rembrandtists," which I mention here once for the record. Of course they saw themselves as nothing of the kind. Lastman was the most prominent figure

47
Pieter Lastman (1583/84–1633)
Odysseus and Nausicaa
Inscribed *PL fecit Anno 1619*
Panel, 90 x 115 cm.
Freise 99
Munich, Alte Pinakothek

8 Haak 1984, pp. 191–92.
9 Hofstede de Groot 1906a, p. 393, no. 329. Houbraken 1718–21, vol. 1, p. 262. Because van Mander credits the statement to "Michael Angelo," it has sometimes been taken to have come from Michelangelo Buonarotti.

48
Rembrandt
The money-changer
Inscribed *RH(L) 1627*
Panel, 32 x 42 cm.
Bredius 420
Berlin, Staatliche Museen,
Gemäldegalerie

49
Gerard van Honthorst
(1592–1656)
Old woman examining a coin
Inscribed *G v Honthorst fc |
162[3?]* (abraded)
Canvas, 75 x 60 cm.
The Netherlands, Fondation
Aetas Aurea

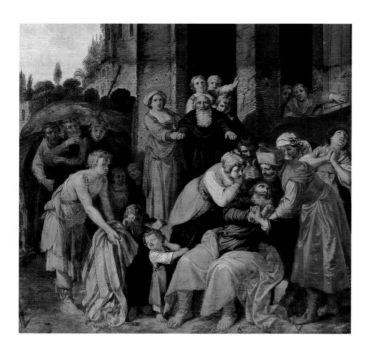

50
Jan Pynas (1581/82–1631)
Detail of *Jacob is shown Joseph's bloody coat*
Inscribed *Jan Pynas fecit 1618*
Panel, 90 x 119 cm.
St. Petersburg,
State Hermitage Museum

51
Rembrandt
Jacob is shown Joseph's bloody coat
Unsigned, undated. Ca. 1655
Brown ink, corrected in white,
13.3 x 17.9 cm.
Benesch 991
Rotterdam, Museum
Boijmans Van Beuningen

52
Hans von Aachen (1552–1616)
The artist laughing, with wine glass in hand, in the company of a smiling courtesan
Unsigned, undated.
Between 1575 and 1582
Canvas, 114 x 87.5 cm.
Verona, private collection

in a group that included his brother-in-law François Venant (1591–1636), the brothers Jan (1581/82–1631) and Jacob Pynas (1592/93–1640), their brother-in-law Jan Tengnagel (1584–1635) and Nicolaes Moeyaert (1592/93–1655). Although only Moeyaert is reckoned to belong to the "International Caravaggesque Movement," as it was dubbed by Benedict Nicolson, all can be called fellow travelers of that movement. Arnold Houbraken, writing fifty years after Rembrandt's death, reports that he studied under Jacob Pynas in Amsterdam and that he imitated the brown tone of Jan. Although there is no confirmation for this, Rembrandt owed evident debts to the group in terms of subject matter – notably the shared interest in

the Jewish Bible – and of a penchant for narrative full of human interest and historical research. A drawing by Rembrandt of about 1655 is a variation on a theme by Jan Pynas of nearly forty years earlier.

The street in Amsterdam where Rembrandt studied with Lastman and to which he later moved, the Sint Antoniesbreestraat, was a veritable colony of Dutch and Flemish artists and art dealers. It can be thought of as the Amsterdam equivalent to the via Margutta in Rome, where a similar concentration of northern European artists took form. In fact, they were often the very same people. And this group overlapped with the denizens of the Zlatá Ulicka (Golden Lane) in Prague, where Emperor Rudolf II maintained an international circle of artists, including Dutchmen and Flemings as well as Germans and Italians. One artist who was highly influential in all three milieux was the Rhinelander Hans von Aachen (1552–1616). The daringness of von Aachen's laughing self-portrait with courtesan, described with admiration by Karel van Mander as the artist's best work, instills Rembrandt's similar subject, painted twenty years after von Aachen's death.[10] For an artist to paint himself with a toothy grin was so exceptional that we may assume Rembrandt was alluding to his predecessor.

An artistic tradition that all Dutch artists of Rembrandt's time inherited was that of their great Netherlandish forebears in the southern Netherlands. The fifteenth- and sixteenth-century masters of Bruges, Ghent and Antwerp, canonized by Giorgio Vasari and Karel van Mander, were the common inheritance of all the artists of Europe. It must be admitted, however, that the accessibility of their art, spiritually, artistically and even physically, diminished greatly after the Reformation, the iconoclastic outbursts of the Netherlands and the Counter-Reformation. The ease

53
Rembrandt
The artist laughing, with wine
glass in hand, in the company
of a smiling courtesan
(detail of *Rembrandt and Saskia
as the prodigal son in the tavern*
[fig. 79])
Dresden, Gemäldegalerie
Alte Meister

10 Van Mander 1604, fol. 290,
lines 7–11. Miedema 1994–99,
vol. 5, pp. 246–67.

with which Rembrandt assimilated motifs of a
fifteenth-century Italian artist like Andrea Mantegna
(ca. 1431–1506) is not matched by similar familiarity
with the work of a Netherlandish contemporary like
Hans Memling (1430/40–1494). Rembrandt was more
at home with the Italian Michelangelo (1475–1564)
than with the Fleming Quentin Matsys (1466–1530).
He showed more interest in the Venetian Jacopo
Bassano (1510–92) than in the Amsterdamer Pieter
Aertsen (1507/08–1575).

With the exception of Lucas van Leyden and
Maarten van Heemskerck, we can say that the needle
of Rembrandt's compass does not swing back north
until the very generation before his own. And in that
generation the towering figure is the Antwerp master

Peter Paul Rubens (1577–1640). Rembrandt knew of
Rubens from the time he was a boy. When he was
a child, Rubens hired the brilliant young Leiden
engraver Willem Isaacsz. van Swanenburg (1580–1612)
to reproduce his compositions in print. Any art lover
who took himself seriously would have had a print
or two after Rubens on the wall. Rembrandt's first
master, Jacob Isaacsz. van Swanenburg (1571–1638),
was the brother of Willem, who died young. The father
and teacher of Willem and Jacob, Isaac Claesz. van
Swanenburg, we have already met as the town painter,
the city father who moved Lucas van Leyden's *Last
Judgment*. He had another important distinction:
his pupil Otto van Veen (1556–1629), from a prominent
Leiden family, became the master, after moving to the

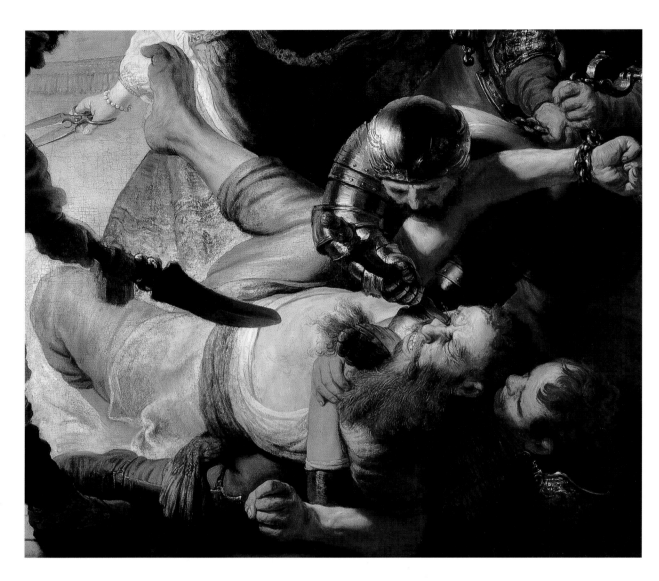

54
Rembrandt
Detail of *The blinding of Samson*
(fig. 634)
Frankfurt, Städelsches
Kunstinstitut und Städtische
Galerie

55
Peter Paul Rubens (1577–1640)
and Frans Snijders (1579–1657)
Detail of *Prometheus bound*
Unsigned, undated. Ca. 1611–12
Canvas, 243 x 210 cm.
Philadelphia, Philadelphia
Museum of Art

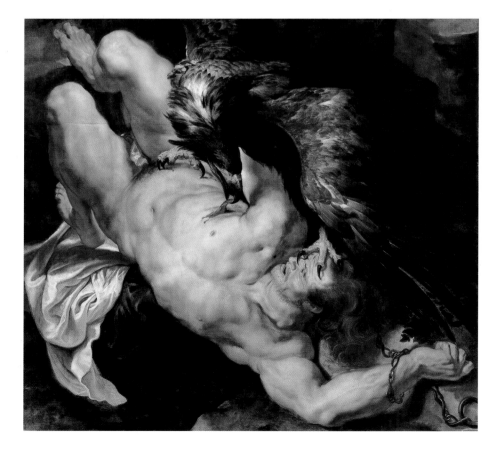

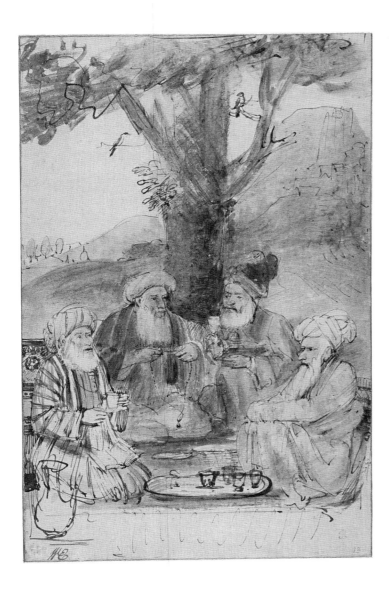

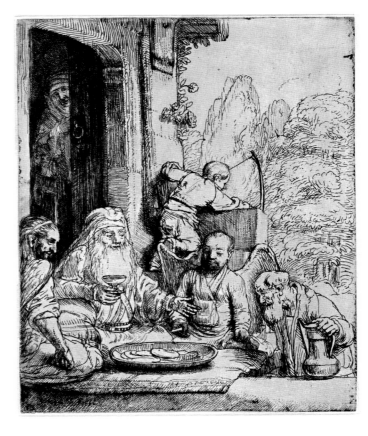

56
Rembrandt
Four Orientals seated beneath a tree, adapted from an Indian miniature
Unsigned, undated.
Ca. 1654
Brown ink and wash,
19.4 x 12.5 cm.
Benesch 1187
London, British Museum

57
Rembrandt
Abraham entertaining the Lord and two angels
Inscribed *Rembrandt f. 1656*
Etching and drypoint,
15.9 x 13.1 cm.
Bartsch 29 i(1)
Haarlem, Teylers Museum

southern Netherlands, of Peter Paul Rubens. If we translate master–pupil relations into family terms, when Rembrandt entered the studio of Jacob Isaacsz. van Swanenburg as a pupil he became a first cousin to Rubens, with Isaac Claesz. van Swanenburg as their common grandfather.

It is possible to write Rembrandt's entire biography in terms of response to Rubens. Simon Schama's splendid book, *Rembrandt's eyes*, goes far in that direction, showing how Rembrandt identified with Rubens and competed with him. Evidence of this will come up in the pages below. Suffice it to say here that references to Rubens have been found in Rembrandt's work from the 1620s to the 1650s, that Rembrandt was once the owner of an important painting by Rubens and that his inventory

58
Anonymous Indian miniaturist
Shaykh Husayn Jâm, Shaykh Husayn Admîrî, Darvîsh Muhammad Mâzanderâni and Shaykh Miyân Mîr: the four sufis
Unsigned, undated. Ca. second quarter of the seventeenth century
Body color, 17.7 x 10.2 cm.
Vienna, Schloss Schönbrunn,
Millionenzimmer

Graph 3
Analyzing Rembrandt's
adaptations and borrowings
in five-year periods by school,
we see the following patterns:

**Instances of borrowing from
Dutch and Flemish art**

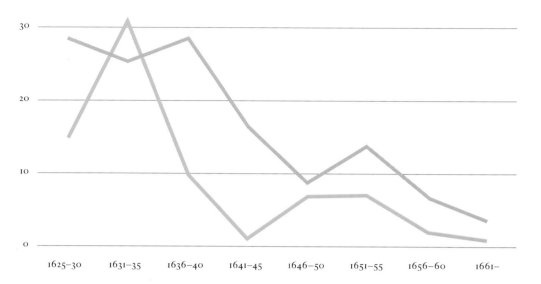

- Northern Netherlands
- Southern Netherlands

Graph 4

**Instances of borrowing from
Italian, German and French art**

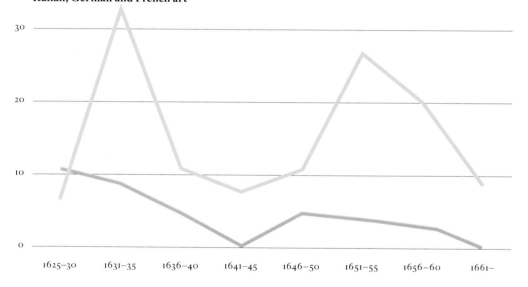

- Italy
- Germany/France

Graph 5
And by period:

**Instances of borrowing from
European art before and after 1600**

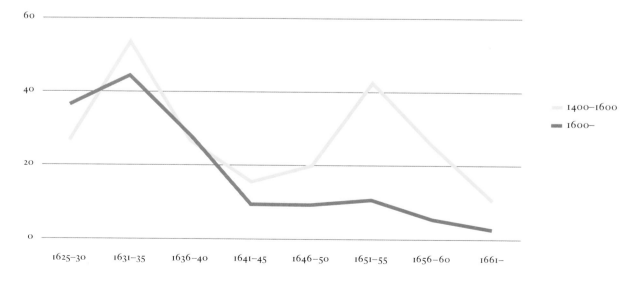

- 1400–1600
- 1600–

included a book of "trial proofs" of prints after Rubens and Jordaens. Jacob Jordaens (1593–1678) and Adriaen Brouwer (1605/06–1638) are the only other Flemish artists of his own time in whom Rembrandt showed detectable interest. Both had closer ties to the northern Netherlands than most of their contemporaries.

The northern European and Italian traditions dealt with until now were the common fare of any artist of Rembrandt's generation. There is one area that he explored entirely on his own. Rembrandt had a fascination for miniature paintings from the Mughal court of India. While he hardly ever made faithful copies of the work of other artists, he did draw a series of some twenty-five copies of Mughal miniatures that he may have owned. However, his familiarity with Indian painting of his own time began in the 1630s.

Rembrandt's sensitivity to the qualities and subjects of Indian painting marks his work in more ways than the obvious adaptations and borrowings illustrated here. It recurs as well in certain unexpected iconographic and stylistic choices. It also shows him to have been curious about the world beyond Europe not only as a collector of exotic items, as were many of his contemporaries, but as an artist. In all the schools and artists mentioned here, Rembrandt found common denominators with his own interests. The examples illustrated here, which can be multiplied many times, form a stylistic equivalent to the self-portraits in the Pauline, chameleonic sense. Using not his outward appearance but his artistic inclinations, Rembrandt transformed himself into personalities of the past and of distant places.

Thanks to the work of Ben Broos in his invaluable *Index to the formal sources of Rembrandt's art*, we can quantify Rembrandt's borrowings from other artists. In the writings of more than 150 art historians from the eighteenth century to the 1970s, he found references to borrowings by Rembrandt from more than 250 known and fifty anonymous artists. If all their hypotheses were correct, we would have to picture Rembrandt as a unique savant of world art. For the adjoining tables, I eliminated all suggestions that were broached only once or only by a single author. The examples tallied are accepted by the field. The numbers are still quite high. In 277 paintings, drawings and etchings by Rembrandt, art historians have detected varying degrees of influence of more than 110 artists.

Even for an age when the adaptation of work by other artists was the norm, Rembrandt shows an exceptional penchant for transforming into Rembrandts the art of contemporaries and forebears – very many of them. There is a kind of generosity in this behavior, a lack of jealousy, a willing acknowledgment of the qualities of others. At the same time, it suggests a certain instability in Rembrandt. Instead of drawing throughout life on a small group of selected models, Rembrandt was always looking for something other than what he had. If he did not find it, he was capable of returning to the source he had just abandoned or of going on to something completely different.

The Broos graphs show us a Rembrandt who began his artistic life with a burning interest in the art of his own time and place. In the early 1630s, this was matched by a nearly promiscuous openness to the art of the southern Netherlands, of Italy and of the preceding century. As his own century progressed, Rembrandt became increasingly less interested in it. After 1640 the traceable influences of seventeenth-century art decline in his work. His attention for Netherlandish art – in which north and south show parallel lines – dropped suddenly in the 1630s and never recovered. A revival of concentration on the outside world in the 1650s is restricted nearly entirely to Italian art of the sixteenth century. This can be interpreted to mean that Rembrandt was growing increasingly out of touch with his own time, but not necessarily. Analysis of the prices of painting in the Amsterdam market in this period reveals that the market leader was Italian art of the later sixteenth century. Rembrandt's behavior might have been fairly extreme in terms of his relation to contemporary artists, but he was a representative member of his generation as a collector and judge of European art.

Rembrandt's appropriations from the art of his predecessors are intense as well as extensive. Fascinatingly, they are completely at odds with the philosophy of art put into his mouth by his critics and biographers. For an artist whose only master was nature, he had an awful lot of others beside.

A brief life of Rembrandt

The young Rembrandt took his destiny into his own hands to become an artist. He made good on the daring move, becoming one of the most successful European artists of his generation in terms of earnings and international reputation. However, after the age of thirty-five he relaxed his grip on his finances and headed toward a disastrous insolvency at fifty. His personal and professional lives too were marked by dramatic contrasts. He was a family man whose wife Saskia and common-law wife Hendrickje both died young; three of his five children died in infancy and the one son to reach maturity preceded his father to the grave. Born into a crowd of ten children, he died in a small, griefstricken household. Although he was widely acclaimed throughout life, early on he began losing his purchase on patronage and the market, so he did not reap the full benefits of his fame.

"His parents sent him to school so that in the course of time he would learn the Latin language and go to the Leiden academy [University] so that when he reached adulthood he could serve and advance the city and the community with his knowledge. However, he showed absolutely no enthusiasm or inclination in this direction. His natural bent being for painting and drawing alone, his parents had no choice but to take him out of school and apprentice him to a painter for training in the fundamentals and basic principles of the same."

Key dates

Year	Age, assuming that Rembrandt was born on 15 July 1606	
1606		Born in Leiden on 15 July, according to Jan Jansz. Orlers.
1610s	(6)–14	Educated in Leiden, according to Orlers at the Latin School.
1620	13	Matriculated on 20 May in Leiden University, "aged fourteen," although on that date, according to Orlers's information, he was still thirteen.
1620–23 or 1625	14–19	Apprenticed first to Jacob Isaacsz. van Swanenburg in Leiden and then Pieter Lastman in Amsterdam.
1625–33	19–27	On the evidence of their art and of the remarks of Constantijn Huygens, works closely in Leiden with his contemporary Jan Lievens.
1627 or 1628–33	21–27	Receives commissions, often in combination with commissions to Lievens as well, for at least fourteen paintings from the stadholder, Frederik Hendrik, in person and through his secretary, Constantijn Huygens.
1628	21	The Utrecht humanist Aernout van Buchell writes on a visit to Leiden, probably in May, that "a lot is expected of a miller's son from Leiden, but that is premature."
1628	21	14 February: Gerard Dou becomes Rembrandt's pupil, presumably the first; many were to follow.
1628	21	15 June: the Amsterdam patrician Joan Huydecoper pays twenty-nine guilders for a head by Rembrandt, the earliest documented purchase of a work by Rembrandt.
1630	24	Constantijn Huygens praises Rembrandt and Jan Lievens to the skies in a manuscript autobiography in Latin, not published until 1891.
1631	24	20 June: lends 1000 guilders to Hendrick Uylenburgh.
1631	24–25	June or July: the Utrecht attorney Carel Martens pays 2 guilders and 8 stuivers for six etchings by Rembrandt. Martens was married in 1627 to a niece by marriage of Buchelius. This is the first recorded purchase of Rembrandt etchings.
1631 or 1633	25–27	Moves from Leiden to Amsterdam, where he lives with Hendrick Uylenburgh as head of his studio.
1632–36	26–30	Height of painting production, including portraits of Amsterdamers of all religious persuasions.
1633	26	18 February: Constantijn Huygens pens a series of nasty squibs on a Rembrandt portrait of Huygens's friend Jacob de Gheyn.
1634	27	22 June: marriage to Saskia Uylenburgh.
1634	28 or 29	Joins Amsterdam guild of St. Luke.
1635	28	22–29 February: purchases prints, drawings and a mannekin at Amsterdam art auction, the first record of its kind.
1635	29	15 December: birth of first child, Rumbartus, who lived for only two months. Two other children born and died in 1638 and 1640.
1636	30	By February moved out of Uylenburgh's house.
1636–39	30–33	Correspondence with Constantijn Huygens concerning delivery and payment of paintings of Christ ordered by the stadholder in 1633 or earlier.
1636	29	6 April: successful lawsuit against relative of Saskia's in Friesland, the first of many legal conflicts, most of which were disadvantageous to Rembrandt.
1639	32	5 January: purchase for 13,000 guilders of large house on the Sint Antoniesbreestraat.
1640	34 or 35	Named for the first time in the writing of a non-Dutchman. The Englishman Peter Mundy cites Rembrandt in a manuscript not published until 1924, as being excellent in "the art off Painting."
1641	35 or 36	First mentions of Rembrandt in printed books. In Leiden he is praised by Jan Jansz. Orlers and Philips Angel, in Frankfurt by Matthäus Merian.
1641	35	22 September: baptism of Titus, the only child of Rembrandt and Saskia to live past infancy.
1642	35	28 March: first dated purchase abroad of Rembrandt etchings, by Stefano della Bella, who in Paris pays sixteen sols for four small prints. In the summer of the following year the Polish aristocrat Krzysztof Opalinski promises to send Rembrandt etchings to his brother Lukasz.
1642	35	19 June: Saskia buried.
1642	36 or 37	*The night watch* is completed and delivered.

Year	Age	
1642–68	36–62	Ongoing tension with Uylenburgh family over Titus's inheritance from Saskia, lasts until Titus marries into his mother's family in 1668.
1644	37 or 38	First publication of a eulogistic poem on an art work by Rembrandt, by Joost van den Vondel.
1648	41 or 42	Publication of a play by Jan Six, *Medea*, with frontispiece etched by Rembrandt. Rembrandt praised in the text of a play adapted from the Spanish by the Amsterdam councilman Gerrit Schaep Pietersz. and the poet Jan Zoet. Mentioned with respect in a Dordrecht play on the treaty of Münster by his former pupil Samuel van Hoogstraten.
1649	43	September–October: Geertge Dircx sues Rembrandt successfully for breach of promise. Hendrickje, Rembrandt's new love, testifies on his behalf.
1650	44	In the course of the summer Rembrandt and Geertge's brother Pieter have Geertge committed to a house of correction in Gouda.
1652–68	46–62	Borrows from Peter to pay Paul, in loan arrangements with numerous parties, complicated by art deals, personal and political relations.
1653–54	46–47	Quarrels with neighbor, the Portuguese Jew Daniel Pinto.
1654	47–48	In June and July Hendrickje is reprimanded by the church council for living in sin with Rembrandt.
1654	48	30 October: baptism of Cornelia, daughter of Rembrandt and Hendrickje.
1654–	48–	Beginning of long-term relationship with Sicilian patron, Don Antonio Ruffo, marked by irritation and acrimony.
1655	48	15 April: publication of Menasseh ben Israel's book *Piedra gloriosa*; the etchings made for it by Rembrandt were replaced by engravings by another artist.
1655–65	49–59	Intermingling of finances of Rembrandt and Titus, complicated by the tutelage over Titus by the Orphans Court during Rembrandt's bankruptcy, ending only when Titus was granted legal majority.
1655	49	In December, Rembrandt holds a week-long sale of his possessions, in a fruitless attempt to avert financial disaster.
1656	49	14 July: the day before his fiftieth birthday, Rembrandt applies for *cessio bonorum*, a form of bankruptcy that is claimed by the debtor rather than the creditors.
1656–60	50–54	From 15 July 1656 to 15 December 1660, the courts process Rembrandt's bankruptcy, involving the forced sale of his house, household goods and art collections.
1658	51	1 February: Rembrandt's house sold by the courts.
	52	20 December: collection of prints and drawings auctioned.
1660	54	18 December: transfer of house to new owners; Rembrandt moves to the Rozengracht.
1660	53 or 54	Publication of volume of poetry, *Hollantsche Parnas*, with poetic tribute to Rembrandt by five different authors. Publication in Flanders notes Rembrandt painting in the collection of the archduke Leopold Wilhelm. An English tractate on etching gives Rembrandt's recipe for etching ground.
1661	55	Painting of Batavian revolt for town hall placed, then removed and presumably returned.
1662	55 or 56	Publication of praise of Rembrandt's etchings in England, and of paintings by him in two Dutch books.
1663	57	24 July: burial of Hendrickje Stoffels.
1666	59 or 60	224 etchings by Rembrandt recorded in collection of French abbé Michel de Marolles, who praises the artist in a poem.
1667	60 or 61	In volume of poetry by Jeremias de Decker, *Lof der geldsucht*, poems by de Decker and two others in praise of Rembrandt.
1667	61	29 December: visited by Grand Duke Cosimo III de' Medici.
1668	61	28 February: marriage of Titus and Magdalena van Loo, niece of Saskia's sister Hiskia.
1668	62	7 September: burial of Titus.
1669	62	22 March: baptism of Rembrandt's granddaughter Titia.
1669	63	8 October: Rembrandt buried in the Westerkerk, Amsterdam.

These remarks were published in 1641, twenty years after the events described, by the well-informed Jan Jansz. Orlers (1570–1646), publisher, historian and Calvinist city father of Leiden, in the first biographical sketch of Rembrandt.[11] They may sound like a conventional beginning to an artist's biography, but they tell us some important things about Rembrandt. The young Rembrandt had a career track laid out for him. Had he followed it, he would have become a town official of Leiden. A function of that kind did not stand in the way of a successful career as an artist. Many Dutch artists did work of other kinds as well, to supplement their uncertain incomes from art. Public service, as we know from the case of Isaac Claesz. van Swanenburg and some thirty other artists, could be an immensely valuable aid to an artist.[12] Rembrandt, however, rejected that possibility decisively. Unwilling to give in to his parents or compromise with them, he threw out the door his valuable schooling in one of the best secondary schools in the country along with the opportunity of a college education and all the advantages this promised for later life.[13]

With this radical step, Rembrandt took charge of his own life in greater measure than would have been the case had he completed his studies and entered a profession. He forfeited the support that would have been available to him from institutions such as Leiden University and the town government. Had he lived in a more meritocratic society, in which individual talent was the foremost factor for personal success, this would have been no problem for the likes of a genius like Rembrandt. Rembrandt's world was however more of an oligarchy than a meritocracy. The chances in life of even the most gifted individuals were dependent in large measure on adequate patronage. Rembrandt tended to forget this truth from time to time or prefer to ignore it. For this he paid a heavy price.

Rembrandt's parents were the miller Harmen Gerritsz. van Rijn (ca. 1567/68–1630) and the baker's daughter Neeltgen Willemsdr. van Zuytbrouck (ca. 1568–1640). He was the ninth of ten children, three of whom died in infancy. While his elder brothers entered the family trades, Rembrandt was given an education that would have prepared him for a profession, a career in government or the ministry. Around the age of fifteen, however, as we have seen, Rembrandt abandoned his studies and got his parents to apprentice him to an artist. Their choice of Jacob Isaacsz. van Swanenburg, the son of the late art ruler of Leiden, Isaac Claesz. van Swanenburg, may have been a desperate attempt by Rembrandt's parents to guide him in that direction.

Following a basic apprenticeship of several years in Leiden, Rembrandt entered the Amsterdam studio of Pieter Lastman (1583–1633) for advanced training, probably in 1625. In this he followed in the footsteps of his talented townsman Jan Lievens (1607–74), who studied under Lastman from 1617 to 1621. When he returned to Leiden, Rembrandt kept in close contact with Lievens, so close that many paintings and prints

of theirs from the late 1620s and early 1630s have been attributed, from their time to ours, now to one of them then to the other. As a pair, they came to the attention of the poet and polymath Constantijn Huygens (1596–1687). Secretary to Frederik Hendrik (1584–1647), stadholder and prince of Orange, Huygens was in a position to boost the careers of the two, and he did so lavishly for several years. Between 1627 and 1633, Rembrandt received commissions for at least fourteen paintings from the court at The Hague, paid for at a rate he could not have dreamed of in Leiden. In this period he also took on his first apprentices, one of whom, Gerard Dou, became one of the leading artists of Leiden. By 1631, when he was twenty-five, Rembrandt had earned so much money that he was able to lend a thousand guilders – more than twice an average income for a Dutch burgher – to the Amsterdam art dealer Hendrick Uylenburgh (1587–1661).

In 1633, Rembrandt's relationship with Constantijn Huygens turned sour (see p. 158); no new commissions came from the court, except for two (well-paid) paintings in 1646. By 1633 Rembrandt had moved to Amsterdam, where he lived in the house of Hendrick Uylenburgh. By all appearances, Rembrandt became the artistic head of a flourishing studio at the center of an overheated art scene in a boom town. After presenting his calling card as a portraitist with the smashing *Anatomy lesson of Dr. Nicolaes Tulp*, he had a steady stream of lucrative portrait commissions of Amsterdamers of all faiths and factions, while he also found time for a prodigious production of etchings and several history paintings a year as well.

In 1633, Rembrandt became engaged to Uylenburgh's cousin Saskia, the daughter of a deceased burgomaster of Leeuwarden and the last man to see William the Silent, Frederik Hendrik's father, alive before his assassination. In 1636 the couple left Uylenburgh's house for rented quarters; in 1639 Rembrandt bought a large, expensive house on the Sint Antoniesbreestraat, in a fashionable new part of town. The departure from Uylenburgh was marked by a sharp downturn in Rembrandt's production. After 1636 Rembrandt never received portrait commissions on the scale of the Uylenburgh period.

Rembrandt and Saskia had three children who died in infancy before in 1641 she gave birth to Titus. A few months later she died. She left her entire estate to Titus, under the guardianship of Rembrandt. The Uylenburgh family monitored Rembrandt's financial doings from then on, but despite this Rembrandt lost most of Titus's inheritance.

The city of Amsterdam, where he lived for the rest of his life, was a fickle working environment for Rembrandt. He received his share of commissions, topped by the *Night watch*, but after 1642 they came in only fitfully. A number were rejected by patrons, not on account of style or quality but, insofar as we know the reasons, because of being poor likenesses or technically imperfect. Possibly because he sued a powerful Amsterdam politician over one of these

11 Orlers 1641, p. 375. Doc. 1641/8. Reproduced in van Straten 2005, p. 352.
12 In Schwartz 1986, p. 48, I published a listing of nineteen artist-officeholders. Since then my list has more than doubled. See http://www.garyschwartz arthistorian.nl/?page_id=87.
13 Rembrandt's registration in the Leiden academy, which brought certain advantages in terms of taxation and civic responsibilities, does not mean that he attended university. It was customary for all pupils in the highest class of the Leiden Latin school to be inscribed in the *album studiosorum*, where we find his name. Frijhoff 1995, p. 125.

cases, Rembrandt never painted a sitting or former burgomaster of the city.

After Saskia's death, Rembrandt had an affair with his servant, Geertge Dircx. When he tried to leave her for a newcomer in the household, Hendrickje Stoffels, she sued him. This brought out an ugly side of Rembrandt's character. His vindictiveness toward Geertge led to her incarceration and to secondary conflicts between Rembrandt and Geertge's friends and her brother. Hendrickje remained with Rembrandt for the rest of her life, although he never married her, resulting in her exclusion from Holy Communion in the Reformed Church.

From 1650 on, Rembrandt's finances went from bad to worse. In a nightmarish decade, marked by an endless sequence of broken promises, evasive tactics and lawsuits, he lost his belongings, his house and the art collection that was so dear to him. He moved to a poorer neighborhood and stopped making etchings and even drawings. Valuable commissions continued to come in, but the once overfull studio in which Rembrandt trained apprentices and gave expensive art lessons to amateurs became a lonely place. The most prestigious of his commissions, a large painting for the new town hall, was taken down and returned to the artist, unpaid, after hanging for less than a year. To protect him from his creditors in the period following his voluntary bankruptcy, which was under the courts from 1656 to 1660, Rembrandt went into the service of a firm run by Hendrickje and Titus. His last years were embittered by their deaths, Hendrickje in 1663 and Titus, after marrying and fathering a posthumous daughter, in 1668. Rembrandt followed them to the grave in 1669.

In his years of adversity, Rembrandt enjoyed the patronage of the Amsterdam patrician Jan Six, though this relationship too went on the rocks when

Rembrandt needed help the most. The friend of Rembrandt's final years was the poet Jeremias de Decker, the central figure in a circle of meditative Calvinists. He and his friends extolled Rembrandt and his works in a chorus of praise that had begun long before, in Rembrandt's youth, both at home and, mainly through his etchings, abroad. A German Catholic churchman and chronicler wrote of Rembrandt about 1664 that he was "the miracle of our age," a judgment that was then and has remained far more prevalent than negative criticisms of Rembrandt's work. In the course of time, his life as well became a salutary legend, a model tale of the artist in conscientious conflict with a society that failed to appreciate him.

Art and faith

Not long before Rembrandt's birth, the seemingly everlasting link between art and religion was shattered. But not that between image and believers, which took on new forms. Art was now expected to deliver uplifting messages without benefit of clergy. Rembrandt provided these, to the lasting satisfaction of Christians and Jews.

When Rembrandt's grandparents were born in the 1530s, the art world of Leiden was by and large an adjunct to church life. Workshops of stained-glass artists, weavers of textiles and tapestries, sculptors in wood and stone, gold- and silversmiths, cabinetmakers and of course painters found the largest market for their skills in the church and its donors. Art itself was sacred, finding its meaning in Catholic dogma, ritual and spirituality. Artists were hired explicators of these values.

59
Pieter Serwouters (1586–1657)
Grace before the meal
Inscribed *P. Serwouters sculptor*,
with poem
Undated. Ca. 1625
Engraving, 36.8 x 48.4 cm.
Hollstein 19
Copenhagen, Statens Museum
for Kunst

14 Bangs 1997, pp. 15–17, 192–96.

60
Pieter Neefs the Younger
(1620–after 1675)
Interior of Antwerp Cathedral
Panel, 71.5 x 105 cm.
Salzburg, Residenzgalerie
(on loan from the Schönborn-
Buchheim collection)

Before Rembrandt's parents were born about 1568,
that thousand-year-old system had been dismantled in
a day. On 26 August 1566, in the wake of similar events
all over the Netherlands, there was an outbreak of icon-
oclasm in Leiden that led to the removal of most eccle-
siastical furnishings.[14] The impulse behind this was
the Protestant Reformation, with its antagonism to any-
thing that smacked of idolatry. Artists were confronted
with an unparalleled situation. The highly demanding
craft they were practicing lost its main *raison d'être*
from one moment to the next. Although some of the
old decorations and furnishings remained in the church-
es and although Protestant churches also needed skilled
carpentry and adornment, the self-evident union of art
and cult was broken.

Fortunately, it turned out that many of the same
donors who until then had been buying religious art for
the church were also lovers of art for its own qualities.
Paintings and carvings that they would have donated to
the church now entered their homes. For those who
remained Catholic, part of the house would sometimes
become a chapel, with a set of the same appurtenances
that otherwise were put in a church. Protestants bought

works of art not as cult objects but for their technical
skill, the stories they depicted, pious or not, their
decorativeness, the prestige they conveyed (fig. 59).

And so, when Rembrandt was born some forty years
later, the relation of art to religion would have been
unrecognizable to his grandparents. As far as we know,
not a single painting by Rembrandt was painted for a
church or placed in one in his lifetime.

Yet, the weakening of the bond between art and reli-
gion did not sever the more general tie between image
and faith. The edifying function of art did not disap-
pear. For a century following the adoption of the
Reformed faith, the most highly valued subject in art
was the "history," the representation of narrative. An
important reason for this is that the story told, more
often than not, was from the Bible. In a counter-move-
ment to the elimination of priestly power, the authority
of the Bible, in the countries of the Reformation, was
raised to new heights. Whereas the Catholic church
had always interposed itself and its liturgy between the
believer and the Bible, to the point of hindering the
publication of the Bible in vernacular languages,
Protestants were put in possession of complete new

61
Pieter Saenredam (1597–1665)
Interior of Bavokerk, Haarlem
Unsigned, undated.
Ca. 1630
Panel, 82.9 x 110.5 cm.
Philadelphia, Philadelphia
Museum of Art (John
G. Johnson Collection)

Bible translations. Every household contained its own source of Christian truth, in a family Bible. Prints and paintings of Bible stories and saints belonged in the houses of most Dutchmen.

Metaphysical meanings spilled over into other kinds of art as well. Scenes from everyday life were imbued with moral warnings, still lifes contained reminders that life on earth is short and eternity forever, portrait sitters were sometimes depicted as biblical personalities or endowed with moral attributes. Various Protestant denominations and some individual ministers had their own attitudes in this matter, ranging from total rejection of religious art as "ogen-dienst" (eye-dolatry; the Remonstrant Joannes Geesteranus, though his stance was not typical for Remonstrants in general) to the fargoing accommodation of the Lutherans.

Some non-churchmen as well were intensely concerned with the visual and literary arts as aids to living the good life. In their search for non-confessional paths to salvation, the Haarlem engraver and philosopher Dirck Volckertsz. Coornhert and his Amsterdam followers Roemer Visscher and Hendrick Dircksz. Spiegel made intensive use of visual imagery in the form of

emblems and prints. Spiegel's motto – Follow nature alone! – reverberates in the philosophy of art credited to Rembrandt.[15] Spiegel was referring not only to visual impressions of the natural world. By nature he also meant human nature and the power of reason. This attitude toward life is recognizable in Rembrandt's art as surely as is his debt to Caravaggesque realism.

Churches and philosophers aside, the city streets and countryside of Holland often buzzed with rumors of divine visions and wonders. Rembrandt's angels, which we shall look at below, were regular visitors to his neighbors. From moral philosophy to angels in the streets, from Catholics to Mennonites to Calvinists to Jews, all was grist for Rembrandt's artistic-religious mill.

15 Knuvelder 2003, vol. 2, p. 151.
See the website of Digitale
Bibliotheek Nederlandse
Letterkunde, www.dbnl.nl.

3

Family, loved ones, households

62
< Rembrandt
Detail of *Titus reading aloud*
(fig. 89)
Vienna, Kunsthistorisches
Museum

63
Rembrandt
Old man: "Rembrandt's father"
Unsigned. Inscribed probably
not by Rembrandt,
HARMAN. GERRITS.
Vanden Rhijn. Undated.
Ca. 1630
Red and black chalk,
18.9 x 24 cm.
Benesch 56 recto
Oxford, Ashmolean Museum

The vanishing van Rijns and ascendant Uylenburghs

WHILE HOPEFUL cataloguers were piling portrait upon portrait of Rembrandt's own family on slim or absent evidence, they ignored the many well-documented portraits he painted of Saskia's family. Exit the van Rijns, enter the Uylenburghs.

Like other Rembrandt conundrums, the mysteries surrounding Rembrandt's depictions of his family are not nineteenth-century inventions. They go back to the artist's own time. A drawing of an old man in the Ashmolean Museum in Oxford bears the seventeenth-century inscription *HARMAN. GERRITS. Vanden*

Rhijn, a form of Rembrandt's father's name. As early as 1644 a Leiden inventory mentions a "head of an old man, being the portrait of Master Rembrandt's father." (The painting was owned by Sijbolt Symonsz. van Caerdecamp, presumably a relative of the Jan Caerdecamp who held a mortgage on the van Rijn family windmill.) Coming from a source that close to the lifetime of Harmen Gerritsz., who died in 1630, this would seem to be firm evidence that a painted portrait of Rembrandt's father existed.

The problems begin. The 1644 document does not say that the painting of Master Rembrandt's father was painted by Master Rembrandt. Of the old man in the drawing there is no known painting by Rembrandt.[1] Neither the document nor the drawing, then, leads us to a painting by Rembrandt of his father. The worst

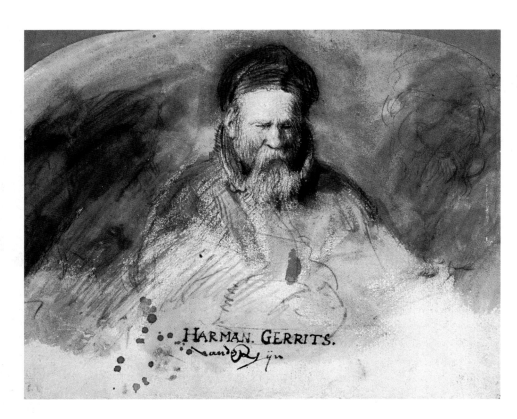

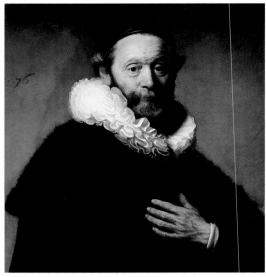

64
Rembrandt, Detail of *Johannes Wtenbogaert*
(1557–1646), Remonstrant preacher
Inscribed *Rembrandt f. 1633 AET 76*
Canvas, 130 x 101 cm. Bredius 173
Amsterdam, Rijksmuseum

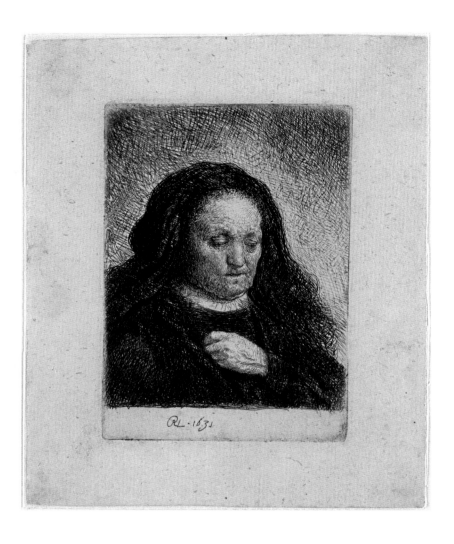

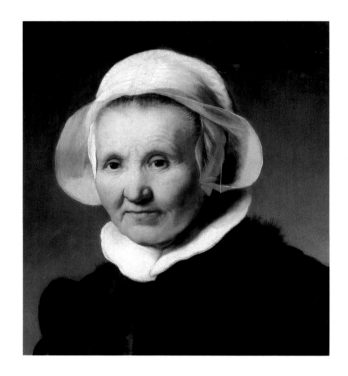

1 See however Schwartz 1985,
pp. 64–65. For a more generous
view of the question of Rembrandt's
mother and father in his art, see
Vogelaar 2005, which appeared
following the completion of this
chapter.

problem of all is the apparent age of the man in the
drawing. Harmen Gerritsz. was born around 1568 and
was not much older than sixty when he died. For com-
parison, let us look at the earliest Rembrandt portrait in
which the age of the sitter is inscribed, that of Johannes
Wtenbogaert (1557–1646). Could the man on the left
be sixteen years *younger* than the man on the right?

The same unlikelihood meets us when we try to iden-
tify Rembrandt's mother. An entry in the 1679 death
inventory of the Amsterdam print dealer Clement de
Jonghe identifies a copper plate in his possession as
"Rembrandts moeder" (Bartsch 349; the plate survives
and is owned by The Millennium Edition). Can the
woman in the print have been as young as sixty-three
years old, the age of Rembrandt's mother in 1631? For
comparison, look at the earliest portrait of a woman
by Rembrandt with the age of the sitter, from the fol-
lowing year. Is it conceivable that the woman on the left
is a few years *younger* than the one on the right? To me
she looks a generation older.

To heighten the power of this question, let us look at
a somewhat earlier painting of the same woman we see
in the etching of 1631. Note that the question avoids the
problem of whether people in the seventeenth century
aged more quickly than we do. These are comparisons
between two images by the same artist in the same
years (fig. 67).

We could look for more fitting candidates in
Rembrandt's sitters for the father and mother, but
without new documentary evidence – identifying the
Caerdecamp father, for example – this would be noth-
ing more than a guessing game. The paintings that come
into consideration are of a variety known as "tronies,"
faces or what might be called non-portraits: heads and
half-lengths that seem to have been made after studio
models rather than paying sitters. Rembrandt has not
left us the kind of family portrait produced by some
other artists of his time, showing the artist among his
kin. Knowing him, however, even a painting of that kind
would probably only have created more problems than
it solved.

The search for Rembrandt's relatives in his art may
have started on a small scale in the seventeenth century.
In the nineteenth century it began to take on obsessive
form. This was undoubtedly fed by the existence of
so many self-portraits and depictions of the women
in Rembrandt's life, who began to be identified in the
nineteenth century. Sentimentality aside, therefore, the
artist's kin was linked to Rembrandt's artistic image
to a greater degree than usual. And then there *was* senti-
mentality – the imagined scene of a doting parent or
fond sibling sacrificing time to help out a young artist
who in his turn shows his love for his family members
by portraying them in art. To viewers inclined that way,

67
Rembrandt
Old woman praying:
"Rembrandt's mother"
Unsigned, undated.
Ca. 1629
Copper, 15.5 x 13 cm.
Bredius 63
Salzburg, Residenzgalerie

68
Simon Luttichuys (1610–61)
Still life with a skull
Unsigned, undated.
Ca. 1635–40
Panel, 47 x 36 cm.
Gdańsk, National Museum
in Gdańsk

A wildcard in the discussion
on Rembrandt's parents. Three
very similar paintings attributed
to the British-Dutch painter
Simon Luttichuys show a
number of etchings and
paintings of old people by or
after Rembrandt and especially
Jan Lievens. Two facing
paintings resemble the old
man and old woman called
Rembrandt's father and mother.
However, in the iconography
of Luttichuys's paintings, with
their emphasis on mortality,
the images by the Leiden artists
seem merely to refer to old age
as such, not to specific
individuals.

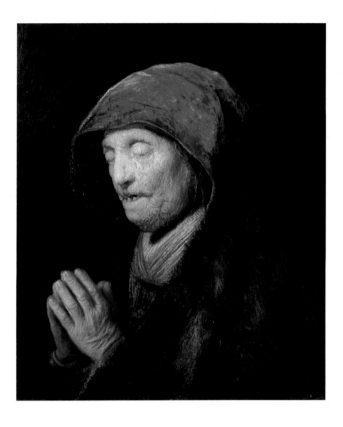

lack of documentation is no problem. The works of art
provide all the documentation needed. Never mind,
either, that the candidate models for Rembrandt's
father and mother recur in non-portraits by other
Leiden artists. Would Rembrandt's old parents perform
the same kind of time-consuming service for Jan
Lievens and Gerard Dou that they did for their son?
Or are these old people paid models after all?

A high point – no, a volcanic eruption – of family
portraits occurred between 1904 and 1908. In 1904
the German art historian Adolf Rosenberg wrote
a volume on Rembrandt's paintings for a new series
of popular though serious art books, *Klassiker der
Kunst*. In the index, he identified three paintings as
portraits of Rembrandt's father, six as the artist's

mother, two as his brother Adriaen and three as
an unnamed sister. In 1908 his colleague Wilhelm
Valentiner brought out a revised and greatly expanded
edition of the book, with almost triple that number of
relatives. Now there were twelve fathers, six mothers,
five Adriaens, five portraits of Adriaen's wife Elisabeth
van Leeuwen and twelve sisters. In 1921, in a supple-
mentary volume, Valentiner added three fathers, five
mothers, one brother and one sister – fifty identifi-
cations, some with question marks, to be sure, for most
of which there is simply no documentary evidence.

Rather than rejecting these commercially tinted
fantasies outright, which moreover identified obviously
different individuals as one and the same person, the
field hedged and compromised. In 1935, Abraham

69–70
*Klassiker der Kunst, Rembrandt:
des Meisters Gemälde*, 3rd ed.,
1908, pp. 599–601

Bredius brought Valentiner's total of family portraits down to thirty-five, and Kurt Bauch in 1966 to twenty, including several brothers and sisters. In Horst Gerson's catalogue of 1968 the identifications of the brother and sister were abandoned and the mothers and fathers are pushed down to below ten. This has been the prevailing situation since 1968 with regard to Rembrandt's blood relatives. At this point I would go a step further and say simply this: there is solid documentary evidence that a portrait of Rembrandt's father existed, probably painted by Rembrandt, but no existing work to which the reference can be linked. For the existence of portraits of Rembrandt's mother the evidence is less solid. The identification of the old woman in some prints and paintings of 1628–31 as Rembrandt's mother, even if it dates back to 1679, must be rejected on the grounds of the discrepancy between her apparent age and that of the historical Neeltgen Willemsdr. For depictions of brothers and sisters there is no contemporaneous evidence at all.

While this was going on, the awareness began gradually to dawn that while Rembrandt may have depicted his own relatives more rarely than we once liked to think, he devoted more attention than has been realized to Saskia's family. We have a positive identification of a drawing by Rembrandt of Saskia's sister Titia.

Rembrandt painted Saskia's older cousin Aeltje Pietersdr. Uylenburgh and her husband, the Reformed minister Jan Cornelisz. Sylvius. He also portrayed Sylvius in two etchings, while an inscription on the back of a third print identifies the sitter as Sylvius's son Petrus, also a clergyman. A family document from the 1630s records a copy of a portrait *à la Turque* by Rembrandt of the wife of Saskia's cousin Hendrick Uylenburgh, Maria van Eyck. An old inscription on the back of a man's portrait, probably painted by Rembrandt, identifies the sitter as Antonie Coopal, the brother of Rembrandt's brother-in-law François Coopal, Titia's husband.[2]

These manifold portrayals of members of the Uylenburgh family, the members of which were sometimes called van Uylenburgh, have their equivalent in other forms of documentation as well. The witnesses at Rembrandt's and Saskia's marriage and the godparents of their children were not van Rijns but Uylenburghs. From even before his marriage, Rembrandt's business life, his social life and his artistic interests were far more intertwined with Saskia's family than with his own. With only one or two extensions into the 1640s, the bond did not outlive Saskia herself. Nor did Rembrandt devote attention of this kind to the family of his other women. There is no sign that he ever painted relatives of Geertge or Hendrickje.

71
Rembrandt
Young woman: "Rembrandt's sister"
Inscribed *RHL van Rijn 1632*
Panel, 59 x 44 cm.
Bredius 89
Whereabouts unknown

72
Rembrandt
The man with the golden helmet: "Rembrandt's brother Adriaen"
Unsigned, undated.
Ca. 1650
Canvas, 67 x 50 cm.
Bredius 128
Berlin, Staatliche Museen, Gemäldegalerie

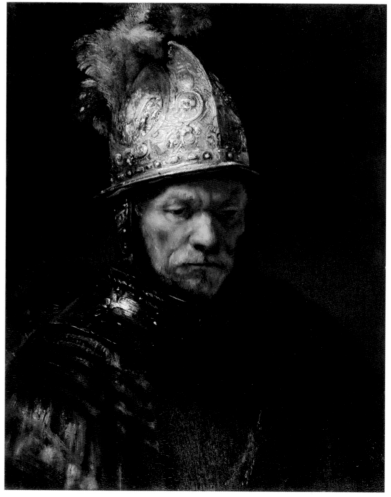

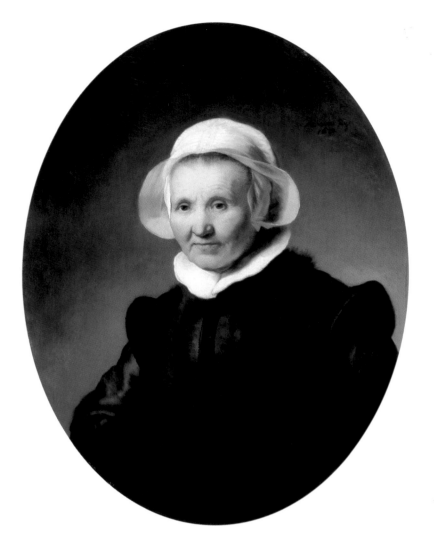

73
Rembrandt
*Sixty-two-year-old woman
in a white cap, identified as
Aeltje Pietersdr. Uylenburgh
(1570/71–1644), wife of Jan
Cornelisz. Sylvius*
Inscribed *RHL van Ryn 1632 /
ae/62*
Panel, 75 x 55.5 cm.
Bredius 333
The Hague, Mauritshuis (on
loan from a private collector)

74
Rembrandt
*Jan Cornelisz. Sylvius
(1564–1638), Reformed preacher*
Inscribed *Rembrandt f 1633*
Etching, 16.6 x 14.1 cm.
Bartsch 266 ii(2)
Haarlem, Teylers Museum

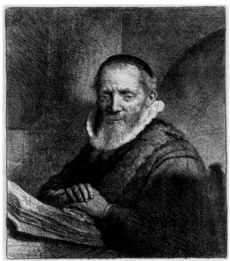

75
Rembrandt
*Jan Cornelisz. Sylvius
(1564–1638), Amsterdam
Reformed preacher*
Inscribed *Rembrandt 1646*
Etching, drypoint and burin,
27.8 x 18.8 cm.
Bartsch 280 ii(2)
Haarlem, Teylers Museum

76
Rembrandt
*Titia van Uylenburch (1605–41),
the sister of Rembrandt's wife
Saskia*
Unsigned. Inscribed by
Rembrandt *Tijtsija van
Ulenburch 1639*
Brown ink and wash,
17.8 x 14.6 cm.
Benesch 441
Stockholm, Nationalmuseum

2 See Broos 2005, which appeared
after this text was written.

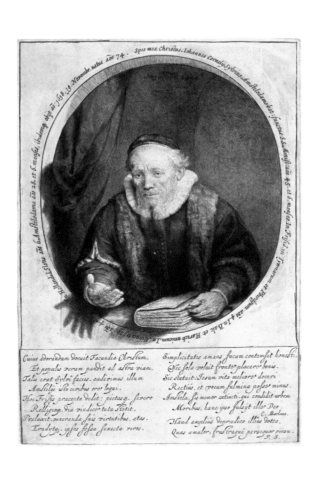

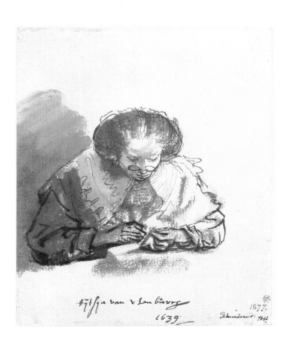

Saskia

For nearly ten years, Saskia Uylenburgh shared Rembrandt's life. They were the most exhilarating years of his life, but they were also full of heartbreak, as the couple lost three babies before the age of two months. After delivering a fourth child, Titus, Saskia herself died. During their years together, the Saskia look seems omnipresent in Rembrandt's depictions of women.

Although he did not sign the famous silverpoint drawing in Berlin – Rembrandt's *Mona Lisa* – and although he did not name the "huisvrou" either, no one doubts that this precious sheet is a portrait of Saskia Uylenburgh by Rembrandt.

This was drawn after my wife,
when she was 21 years old, the third
day when we were engaged
8 June
1633

The interpretation of the dates and terms in this seemingly straightforward inscription is one of those problems that turn Rembrandt studies into a battleground royale. The date does not jibe with the official records of Rembrandt's marriage nor the bride's age with Saskia's, and all attempts at reconciliation have been rebuffed by the field.

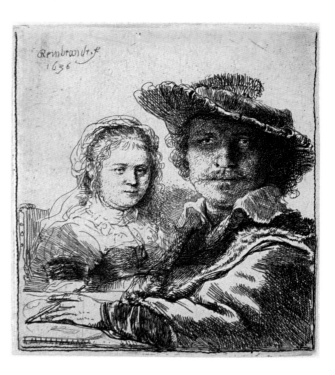

77
Rembrandt
Self-portrait with Saskia
Inscribed *Rembrandt f. 1636*
Etching, 10.4 x 9.5 cm.
Bartsch 19 ii(3)
Haarlem, Teylers Museum

78
Rembrandt
Portrait of Saskia in a straw hat
Unsigned. Inscribed *dit is naer mijn huisvrou geconterfeyt, do sy 21 jaer oud was, den derden dach als wij getroudt waeren den 8 Junijus 1633.*
Silverpoint, on vellum, 18.5 x 10.7 cm.
Benesch 427
Berlin, Staatliche Museen, Kupferstichkabinett

79
> Rembrandt
Rembrandt and Saskia as the prodigal son in the tavern
Unsigned, undated. Ca. 1635
Canvas, 161 x 131 cm.
Bredius 30
Dresden, Gemäldegalerie Alte Meister

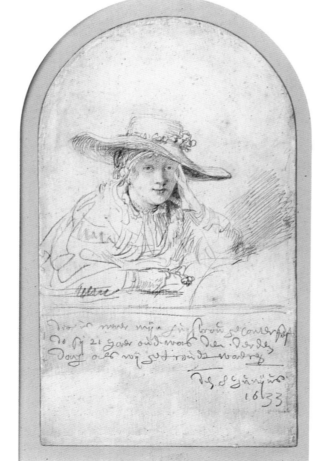

3 That is an Old Style date, in the Julian calendar. Rembrandt was married in Friesland, where the Gregorian calendar was not adopted until 1700.
4 Zumthor 1962, pp. 97–98: "The Church desired that baptism should be carried out as soon as possible after birth, and among the lower classes this was, in fact, the rule; but the upper classes preferred to wait until the mother was able to leave the house." Who knows whether Sjukje Wieckesdr. Aessinga, Saskia's mother, had to keep to her bed for two months after giving birth to her eighth and last child?

The inscription seems to have been added at least a year after the drawing was made. The artist calls the woman his "housewife," which implies the married state; Saskia did not become Rembrandt's housewife until 22 June 1634.[3] What happened on the 5th or 6th of June 1633, the date implied by the inscription, was not the marriage but the engagement of the two. As others have pointed out, the Dutch word "getroudt" could refer to the engaged as well as the married state. The state of the vellum, which is somewhat darker under the inscription than under the drawing, could mean that an older inscription was rubbed out and replaced by the artist with this one, which says "This is my wife before she became my wife, when we had just become engaged."

The next problem concerns Saskia's age. Because she was baptized on 2 August 1612, it is assumed that she would not have turned 21 until 2 August 1633, too late to be called 21 years old on 8 June 1633. There is however a way of rescuing the letter of the inscription rather than considering it an error on Rembrandt's part, as do all other interpretations. That is, to hypothesize that Saskia was born two months before she was baptized, before 8 June 1612. This in itself was not all that unusual in the seventeenth century.[4]

As I read it, the inscription tells us more about Saskia's birthdate than that. Why, when jotting down this inscription at least a year after the portrait, would Rembrandt have made such a point of specifying that it was made on the third day that they were *getroudt*? Why should he even remember this so exactly? My theory is that he remembered and recorded it because 8 June 1633 *was* Saskia's twenty-first birthday. That would provide the inscription, which is otherwise a bit strange, with a real reason for being. Having become engaged on 5 or 6 June 1633, Rembrandt and Saskia

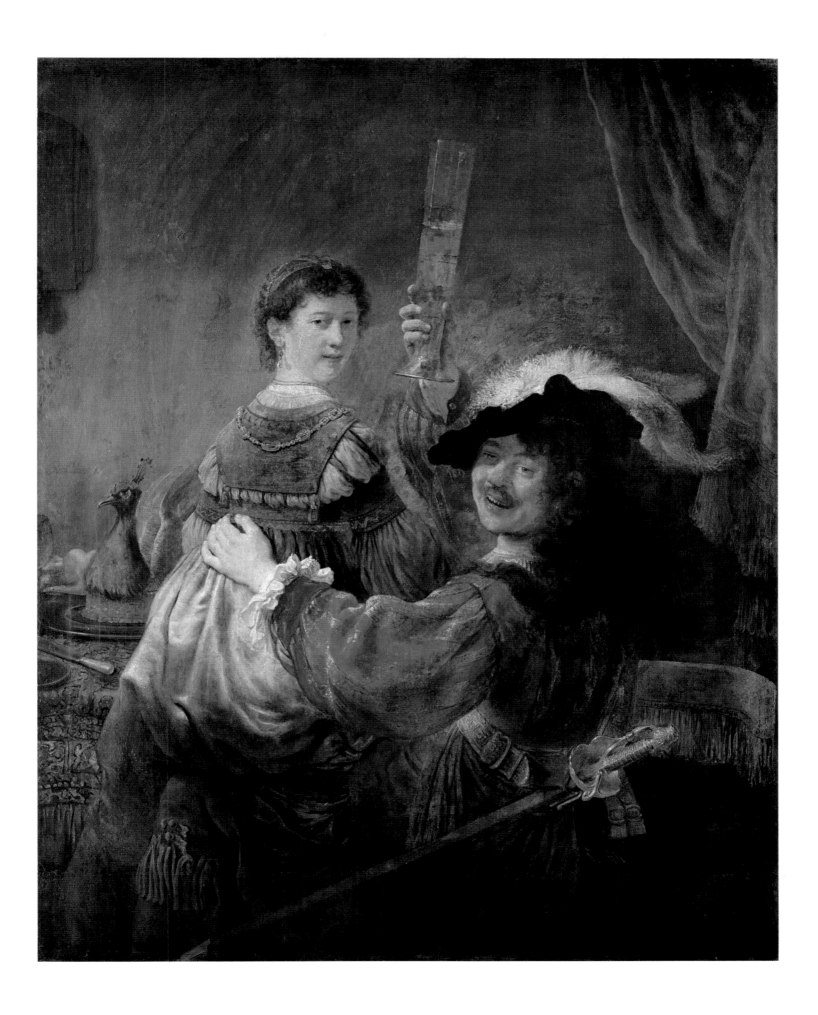

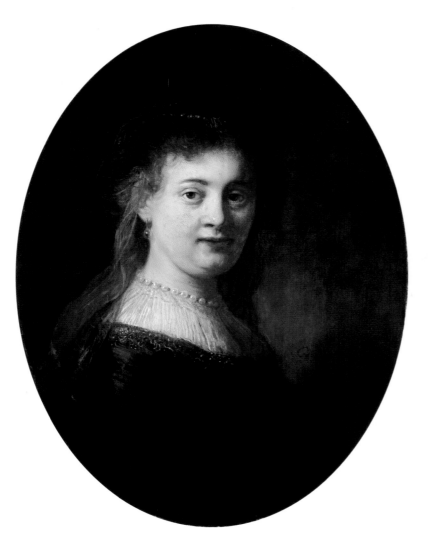

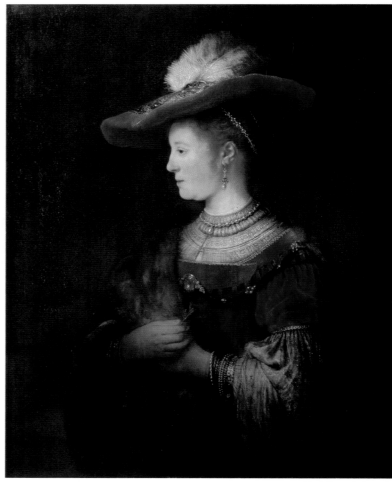

80
Rembrandt
The artist's wife,
Saskia Uylenburgh
Inscribed *Rembrandt ft. 1633*
Panel, 66.5 x 49.5 cm.
Bredius 94
Amsterdam, Rijksmuseum

81
Rembrandt
The artist's wife,
Saskia Uylenburgh
Unsigned, undated. Ca. 1635
Panel, 99.5 x 78.5 cm.
Bredius 101
Kassel, Staatliche Museen
Kassel, Gemäldegalerie Alte
Meister

<hr>

5 For the use of *zijn*, being, in the
sense of *worden*, becoming, see the
Woordenboek der Nederlandse taal,
vol. 28, col. 798, under Zijn (I),
(C,I, 92, *b*, which admittedly is
limited to the imperfect.
Rembrandt's usage would then have
been incorrect). In all fairness,
it must be said that when I launched
my reading of the inscription in
Het Financieele Dagblad on
9 November 2002, p. 24, no one
at all agreed with me.

enjoyed another special day two or three days later,
when Saskia turned twenty-one. He marked this by
drawing her portrait on vellum in the unusual and
glamorous technique of silverpoint. This is the kind
of thing that people remember forever. The only
adjustment it requires is to read the Dutch word "was"
in the sense of "to become": "This is my wife when
she turned twenty-one on the third day after our
engagement."[5]

In the section on Rembrandt's family (where we did
not discuss the artist's women and children), it was
remarked that Rembrandt did not leave us with a por-
trait of himself in the midst of his kin. There are also
no portraits of himself with Geertge, Hendrickje
or Titus. However, there are two images, a painting
and an etching (figs. 77 and 79), that show Rembrandt
with Saskia. The etching is dated 1636 in the plate and
the painting is assigned to the same period. Although
the two works are catalogued as self-portraits, they are
not simply that. In the print we see the artist, a chalk-
holder in his hand, presumably staring into the mirror
while making the print before us. Seated behind him,
Saskia seems to embody the proverbial good woman
behind her good man. In the painting, the two of them
enact the roles of a sinful woman consorting with a
sinful man, probably in allusion to the biblical parable

of the prodigal son in the tavern. In both, the figures
wear a mixture of historical and contemporary cos-
tume. An X-ray of the painting shows a second, bare-
breasted woman playing a lute, who was painted over,
possibly by a later hand than Rembrandt's. These com-
plications detract from whatever portrait-like qualities
one would be inclined to seek in depictions of the artist
and his wife.

That proviso does not seem to apply with the same
strength to Rembrandt's images of Saskia between 1633
and 1636. At least, one would like to believe that Saskia
was as happy as the woman in these images of delight.
They show a beautiful, self-assured young woman in
a variety of informal and formal guises. She may wear
a straw hat or a sprig of herbs, a circlet or complete
bouquet of flowers; she may have pearls in her hair
or sport an oversized feather hat. She may be dressed
in a fetching nightrobe, in tasteful *tenue de ville* or in
outrageously show-off furs and brocades. She might
be decked out in the height of 1630s fashion, in time-
less shifts or hundred-year-old masquerade garb.
Sometimes she is indistinguishable in demeanor from
portraits of paying customers; sometimes she poses
as the Roman nature goddess Flora; and once appears
in the guise of a learned woman, seated at a reading
desk. All of them seem to burst with energy and sup-
pressed humor.

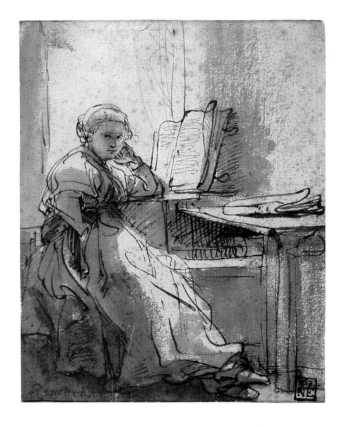

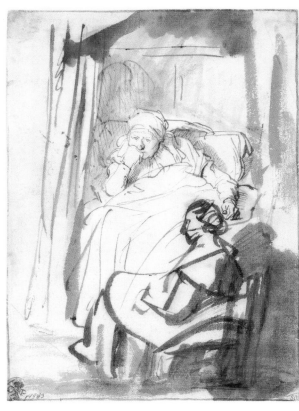

82
Rembrandt
*Saskia seated before a window,
looking up from a book*
Unsigned, undated. Ca. 1635
Brown ink and wash,
16.2 x 12.5 cm.
Benesch A9
Budapest, Szépmüvészeti
Múzeum

83
Rembrandt
Saskia lying in bed, and a nurse
Unsigned, undated. Ca. 1635
Brown and black ink and wash,
22.8 x 16.5 cm.
Benesch 405
Munich, Staatliche Graphische
Sammlung München

84
Rembrandt
Detail of *Portrait of Saskia
in a straw hat* (fig. 78)
Berlin, Staatliche Museen,
Kupferstichkabinett

85
Rembrandt
Detail of *Three studies of women*
(fig. 86; reproduced in reverse)
Haarlem, Teylers Museum

Still, even if Saskia Uylenburgh was Rembrandt's
muse and model for these works, this does not allow
us to interpret them as biographical documents. The
binding factor is too unstable. For one thing, the hard
core of Saskias is surrounded by a group of look-alikes,
some of whom were formerly thought to depict her.
In the second place, the role-playing and historic cos-
tuming of the Saskia of these years lead away from
the woman herself as a historical personality.

A second group of drawings, from about 1636, that
have often been called representations of Saskia show
a young woman with a child. In earlier literature the
toddlers in the drawings were identified as the children
of the couple. At a given moment, however, the realiza-
tion took hold that none of those poor children lived
beyond the age of two months. Since the children
cannot be hers, neither is it likely that she is the woman
in the drawings.

From the time of her first childbirth, a genre of its
own developed mainly in Rembrandt's drawings: a
weak, suffering woman in bed. In contrast to the draw-
ings with children, the age and chronology of these
sheets can be brought into line with Saskia's life. That
Saskia aged and declined after her first pregnancies and
childbirths can be seen well in a comparison of the 1633
vellum portrait with a similarly posed head of four
years later, in which her bright-eyed vitality and half-
smile have given way to a tired, inward-turned expres-
sion. In the reception of Rembrandt's art the sickly

86
Rembrandt
Three studies of women
Inscribed *Rembrandt*
Undated. Ca. 1637
Etching, 12.7 x 10.3 cm.
Bartsch 367 iii(3)
Haarlem, Teylers Museum

87
Rembrandt
Hendrickje bathing
Inscribed *Rembrandt f. 1655*
Panel, 61.8 x 47 cm.
Bredius 437
London, National Gallery

Saskia of the last seven years of her life is overshadowed by the girlish bride.

Saskia's appearances in the Rembrandt documents consist from 1635 on nearly only of records of baptisms, the burials of babies and last wills. On 17 November 1635, shortly before her first childbirth, she and Rembrandt drew up a joint will in which each bequeathed to the other their entire estate. Ten days before her death at the age of twenty-nine, on 5 June 1642, she wrote a new will, in which she left everything to her son, Titus, under Rembrandt's custody. Whatever her reasons, they were not hostile toward Rembrandt: the language and terms of the will express complete trust in him. It was fortunate for Titus that Saskia changed her will in this way. Although after Rembrandt's bankruptcy he received only a fraction of what Saskia was worth in 1642, had the will from 1635 been in force when she died he probably would have received only half of that.

The visage of his first wife appears not only in portraits, non-portraits and parables but also in a special kind of etching that is usually called a study sheet. Here she is a nearly disembodied presence, in the company of other people and scenes appropriated by the artist from life and combined in a strangely melancholy exercise in unfinishedness and indeterminacy.

Hendrickje

His fourteen years with Hendrickje Stoffels were the most tortured in Rembrandt's financial life, but she stood by him with all she had.

When Hendrickje Stoffels entered Rembrandt's household as a maid at the age of twenty-three and the forty-three-year-old artist fell in love with her, he was having an affair with another household servant, Geertge Dircx. Following a nasty conflict, in which Hendrickje testified on Rembrandt's behalf, Rembrandt had Geertge locked up in a penal institution. Although this does not sound like a promising beginning for a long-term relationship, that between Rembrandt and Hendrickje was. They went through other hard times together.

By the terms of Saskia's will, upon remarriage Rembrandt would have had to pay a quarter of what he was worth to Saskia's family and a quarter to his own family. Since his worth was tied up in bricks and mortar, art and rarities, this option was not viable and he never married Hendrickje. When she became pregnant, she was chastised by the church council for "living in sin [the Dutch word, *hoererije*, sounds worse] with Rembrandt the painter."

Like Saskia, Hendrickje became a recognizable though ambiguous personality in Rembrandt's art. The Hendrickje look is not that of the fresh young thing from the provinces that she was (she came from Bredevoort, in a part of Holland known as the Achterhoek, the back corner) but a warm and sensuous mature woman. As if entering into dialogue with the

88
Rembrandt
Hendrickje standing in a doorway
Unsigned, undated.
Ca. 1654
Canvas, 86 x 65 cm.
Bredius 116
Berlin, Staatliche Museen,
Gemäldegalerie

church council about Hendrickje's love life, Rembrandt painted his common-law wife in the guise of sexually compromised women: a woman in a doorway, posed like a Venetian courtesan; a Susanna-like bather in a garden; Bathsheba in unhappy meditation over the adultery she is being summoned to commit with her king (fig. 196). In that painting, Rembrandt bestows on Bathsheba the dignity of a tragic heroine, less sinner, as in the usual iconography, than sinned against.[6]

Hendrickje offered Rembrandt not only her lifelong love, her service as housekeeper, her body, as bedmate and as model, her reputation in the community and the motherhood of their daughter Cornelia. Following his bankruptcy, she also signed away all her belongings, her legal and financial responsibility to a firm whose sole purpose was to protect him against the claims of creditors. New claims could now devolve on her and Titus, her partner in the firm. Devotion on this scale was as rare and precious in mid-seventeenth-century Amsterdam as in any time or place. What a terrible loss it was to Rembrandt when this wonderful woman died, during an epidemic of the plague, in 1663, only thirty-seven years old. Rembrandt's life could never have been the same again.

6 Schwartz 1998.

Titus

Rembrandt's only son did not shine as an artist, but he seems like a nice boy and a nice young man. He helped his father in business, gave him a grandchild and died young.

When Titus was born, all his parents will have been thinking of is whether he would survive infancy. Of the three children born previously to Rembrandt and Saskia, one died at two months, the others at two weeks. This time the child lived. Alas, the mother did not. Whether or not as a direct result of pregnancy or delivery, Saskia died when Titus was nine months old. Whatever effect this may have had on his psyche, it did not stand in the way of a lifelong attachment to Rembrandt. Like Hendrickje, Titus stood by his father in the years of adversity, committing his property, at the age of nineteen, to the front firm that protected Rembrandt from his creditors.

As a character in the Rembrandt corpus, Titus played at least as intriguing a role as his mother Saskia and – for this was her part in his life – his stepmother Hendrickje. In the first place, by way of omission. Of the interest Rembrandt displayed in the 1630s in drawing other people's babies and children nothing seems to have remained when he had his own child. Only when he reached adolescence did Rembrandt paint his son. (That is, if the youngster we call Titus is indeed him, for which there is no proof. In this book I go along with that likely assumption.) His one etching of Titus looks so much like Rembrandt himself that Adam Bartsch included it among the self-portraits and dated it twenty-five years too early.

Although Titus was trained as an artist, presumably by Rembrandt, that is not the way his father depicted him. Rather, he shows him engaged in writing, reading and speaking. In a painting in Vienna, in which Titus is engrossed in a book he grasps in his two hands, his expression is so lively, his mouth open, with a bit of a smile on his face, that he seems to be reading aloud, a rare and intriguing subject. Before attaching too much anecdotal value to it, however, it is also well to recall that Rembrandt also painted Titus as a Franciscan friar (fig. 626), which cannot have face-value biographical significance.

Titus's work as an artist consists of three entries in Rembrandt's inventory – "Three small dogs, from life," "A painted book" and "A head of Mary" – none of them identified, and two sides of a single drawing, surprisingly amateurish for the son of such a father.

Titus's partnership with Hendrickje in the art trade consisted of more than a signature. He was also charged with the sale of Rembrandt's etchings. Arnold Houbraken reports this sneeringly. Rembrandt, he wrote, was a master in the mercenary skill of creating minute state changes in his etchings, in order to "peddle them" to fanatic collectors, "which he let his son Titus do, as if it were beneath him."[7] As much as one would like to hope that this was just a case of Houbraken being unnecessarily mean, the one documented occurrence of this activity confirms that Rembrandt was indeed not overly concerned with helping Titus maintain his dignity. The matter concerned was a print

89
Rembrandt
Titus reading aloud
Unsigned, undated.
Ca. 1656
Canvas, 70.5 x 64 cm.
Bredius 122
Vienna, Kunsthistorisches
Museum

90
Rembrandt
Titus at his desk
Inscribed *Rembrandt f. 1655*
Canvas, 77 x 63 cm.
Bredius 120
Rotterdam, Museum
Boijmans Van Beuningen

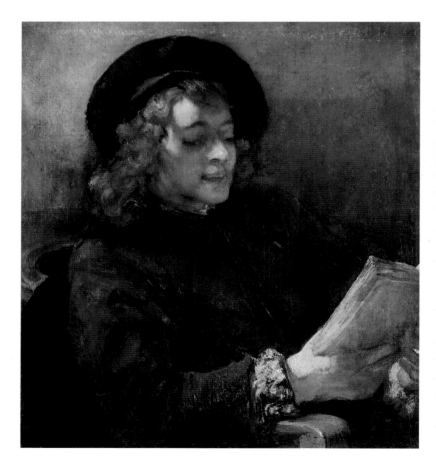

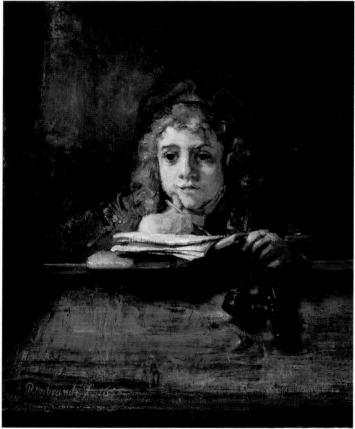

91
Titus van Rijn
*Meleager giving Atalanta the
head of the Caledonian boar*
Inscribed *titus v Ryn* (reverse).
Undated. Ca. 1660
Brown ink, 20 x 19.3 cm.
Sumowski 2209
Sale London (Sotheby's),
6 November 2001, lot 49

92
Titus van Rijn
Figure studies
Inscribed *titus v Ryn.*
Undated. Ca. 1660
Brown ink, 20 x 19.3 cm.
Sumowski 2209
Sale London (Sotheby's),
6 November 2001, lot 49

7 Houbraken 1718–21, vol. I, p. 271.
8 Dickey 2004, p. 160, in an excellent
discussion of the affair, pp. 159–62:
"Titus takes charge." The print is
Bartsch 264.
9 Watermark research on
impressions of states 1–3 indicates
that they were printed on paper
from about the time the plate was
made, 1665. The paper of the fifth
state is later. This fact, in combina-
tion with the long period of time
between commission and delivery,
suggests to me that these runs were
pulled before Rembrandt delivered
the plate to the publisher. See
[Hinterding] n.d., pp. 379–81. Rem-
brandt was accused in 1637 of the
same practice with regard to another
plate that he had sold for printing
and sale by a third party; the buyer
claimed that Rembrandt had printed
impressions to be sold by him before
delivering the plate. Doc. 1637/7.

became all the more desirable collector's items for not
having been printed in a book.[9]

Titus could have enjoyed a comfortable life. After the
settlement of Rembrandt's bankruptcy and his reaching
the age of legal majority, the courts paid him nearly
seven thousand guilders from Saskia's bequest. (In 1642
it was worth more than twenty thousand.) That was in
1665. In 1668 Titus married Magdalena van Loo, whose
uncle Gerrit was married to Saskia's sister Hiskia.
Since Hiskia was the Uylenburgh who kept the sharpest
eye on Rembrandt's money, this marriage put an end
to the old tensions caused by Rembrandt's inadequate
care for Titus's inheritance. And then, with Magdalena
expecting their first child, the poor boy died, two weeks
before his twenty-seventh birthday. Half a year after she
gave birth to Titus's posthumous daughter Titia (1669–
1715), Magdalena too died. This recapitulation a genera-
tion later of his loss of Saskia was spared Rembrandt.
He was buried two weeks before Magdalena. Hendrickje,
Titus, Rembrandt and Magdalena all lie beneath the
pavement of the Westerkerk.

Households

**Rembrandt was not a creator of coziness. His
favored location in the household is outside the front
door, with tense arrivals or departures taking place.
The babies in his drawings pull hair and throw
tantrums. The most relaxed members of his house-
hold in art are maids looking out the window.
According to early tradition, they too were given
a high charge by being placed in such a way that
passersby would mistake them for living girls.**

The household, in recent years, has become the
defining ambiance of the Dutch Golden Age. The pre-
ferred artist for our times is Vermeer, the preferred
image that of familiar domesticity. The enclosed spaces
of a calm, well-kept home, with its reassuring regularity
of tiles and tables, windows and doors, engross us.
The appurtenances of everyday Dutch life, the carpets,
candles, silverware, instruments for writing and making
music, brushes and brooms, food and drink, bring the
past closer to us. The genteel consumerism in these pic-
tures reflects an ideal that still lives in modern society.
That is even true of the moral meanings they sometimes
convey, which come close to what our politicians like
to call family values.

The Dutch household is a private realm into which
the outside world is admitted in the form of maps
on the wall, letters from afar, a view through an open
shutter of a street or courtyard. There is room to spare
for the universe itself, in the form of a pair of globes,
or for God, in religious prints and drawings or a church
tower in the distance. It has been called a microcosm,
but it is more like an inversion of the world, with the
smallest objects and most intimate values looming
largest and higher concepts and vaster realms reduced
to references. Phrases recently applied to Dutch

portrait commission from a Leiden publisher, a story,
writes Stephanie Dickey, that "is difficult to recount
without sentimentality."[8] For the frontispiece of a book
by the deceased physician Johannes Antonides van der
Linden, the publisher wanted an engraving rather than
an etching, in order to get more good prints from the
plate. Titus stuck his neck out, claiming that Rembrandt,
who never produced a pure engraving in his life, could
engrave with the best of them. He went away with an
order to produce a plate within two weeks. Three
months later, the portrait print had not yet been deliv-
ered, and the publisher had a notary record statements
concerning the commission. When Rembrandt finally
did come up with a plate, it was not only largely etched,
with some passages in engraving, but finished in dry-
point, the most delicate of the intaglio techniques and
entirely unfit for large print runs. The publisher never
used it, but Rembrandt did: during the three months
when the publisher was waiting for the print, he man-
aged to print normal runs of at least three states, which

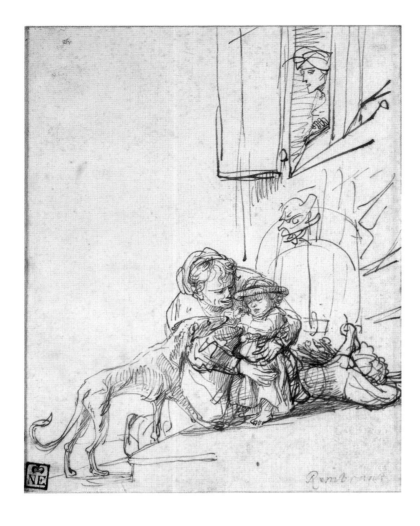

93
Rembrandt
*Woman holding a child
frightened by a dog, on the
doorstep of a house*
Unsigned, undated.
Ca. 1636
Brown ink, 18.4 x 14.6 cm.
Benesch 411
Budapest, Szépmüvészeti
Múzeum

94
Rembrandt
The naughty boy
Unsigned, undated.
Ca. 1635
Brown ink and wash, white
body color, 10.6 x 14.3 cm.
Benesch 401
Berlin, Staatliche Museen,
Kupferstichkabinett

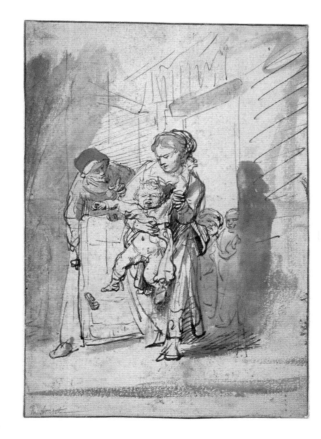

10 Perry Chapman, in Westermann
2001.
11 Houbraken 1718–21, vol. 1, p. 272.
12 Schama 1987, p. 570.
13 Schwartz 2001.

household representations are "Home and the display
of privacy" and "Home is where the heart is."[10]

That look, with its favoring of families and indi-
viduals above the community at large, did not come into
being until the second half of the seventeenth century.
It did not become a specialty in Dutch painting until
Rembrandt was fifty years old. At first glance, it seems
to have little affinity with him and his work. After all,
Rembrandt's guiding ideal lay in history painting, close
to the opposite of the household scene. In Rembrandt's
scale of values neither the household nor the individual
is sufficient unto itself. They are measured, far more
than in the work of artists like de Hooch or Vermeer,
against deeper verities than meet the eye. The classic
systems of Christian iconography, with their super-
natural assumptions, are still operative in his art.

Moreover, Rembrandt was no creator of coziness.
Rather than catering to your sense of ease, his art tends
to approach the viewer's discomfort level. For example,
there is no unfunctional food in Rembrandt's compo-
sitions. Unless there is a supper going on at Emmaus
or Abraham is entertaining the angels, Rembrandt
does not give anyone anything to eat. His spaces do not
further the Dutch ideal of *gezelligheid*, like those of Jan
Steen, places where you would like to hang out. We can
well believe Arnold Houbraken when he wrote that
Rembrandt "was not the man to spend a lot in the tav-
ern or in company, less still at home. He lived plainly
[*borgerlyk*] and when he was working he often took a
piece of cheese with bread or a herring for his meal."[11]

Simon Schama wrote insightfully of the habit
of household painters to locate their scenes near the
outside door. He sees in a series of paintings from the
1660s by Jacob Ochtervelt (1634–82) a "distinction
between home and world, between safety within and
unknowns without."[12] Rembrandt too gravitates toward
thresholds, but with a difference. He shows not the pro-
tected space inside the house but the more exposed area
outside. The front of the house or courtyard is often
peopled by nervous householders, clustered for safety
in doorways or leaning out of a shuttered window into
which they can duck back at a moment's notice.
Rembrandt's fascination with courtyards, I believe, was
one reason among others behind his choice for themes
such as the good Samaritan, the sacrifice of the parents
of Samson, the departure of the angel from the family
of Tobias, the expulsion of Hagar, the return of the
prodigal son, which take place outside the front door.

To Rembrandt, a household consisted more of people
than of spaces. In the latter 1630s, during the years
when Saskia was bearing and losing children,
Rembrandt drew a fair number of other people's chil-
dren, perhaps those of his Uylenburgh in-laws. He had
a preference for moments of intense contact between
babies and grown-ups. His babes in arms express
resistance by refusing food or aggression by pulling
hair. Rembrandt shows adults enjoying the once-in-
a-lifetime thrill when a child walks for the first time.
His toddlers shrink away from a scary dog into the
arms of a motherly protector or struggle helplessly

Gender statistics

The existence of these irresistible drawings has led people to think that Rembrandt had more interest in women and children than other Dutch artists. This is not the case, at least not in painting. For a large research project called 'Dutch culture in European context' I tabulated statistics on more than 3,500 paintings made between 1625 and 1675 by artists from all over Europe. 1,533 of them were by Dutch artists. Among other attributes, I and my associate Trudy van den Oosten counted the number of men, women and children in the paintings. The ratios are very heavily tilted toward the adult male. A comparison of these figures with the corresponding numbers for all history paintings and portraits by Rembrandt shows the results in the table.

The Dutch school, despite its reputation for special interest in women and children, turns out to be considerably more male-oriented than European art in general, and Rembrandt more male-oriented than the Dutch school as a whole. In history painting he includes more children than his contemporaries, but when it comes to portraiture he is an extreme exception. Rembrandt painted only a fraction of the number of child portraits than other painters of his time. It is a fascinating coincidence – or is it that? – that the other great favorite of Dutch seventeenth-century painting, Johannes Vermeer, also painted exceptionally few children.[13]

History painting	The number of women for every 100 men	The number of children for every 100 men
All European schools	26.5	7.3
Europe without the Dutch	29.0	7.7
All Dutch painters	21.8	7.7
Rembrandt	19.7	9.7

Portraiture	The number of women for every 100 men	The number of children for every 100 men
All European schools	29.5	18.4
Europe without the Dutch	33.8	24.5
All Dutch painters	27.3	15.5
Rembrandt	20.9	4.9

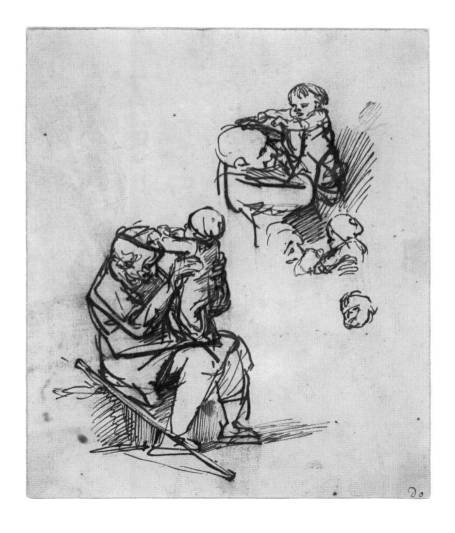

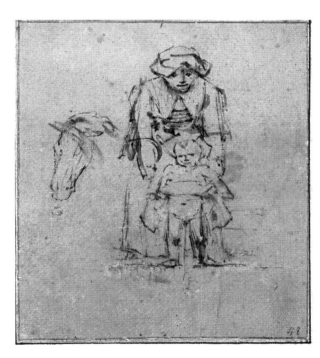

95
Rembrandt
Sheet with two studies of a child pulling off the cap of an old man
Unsigned, undated.
Ca. 1640
Brown ink, 18.9 x 15.8 cm.
Benesch 659
London, British Museum

96
Rembrandt
Woman with a child making water
Unsigned, undated.
Ca. 1657
Reed pen and brown ink, 13.5 x 12 cm.
Benesch 1140A
Amsterdam, Rijksmuseum

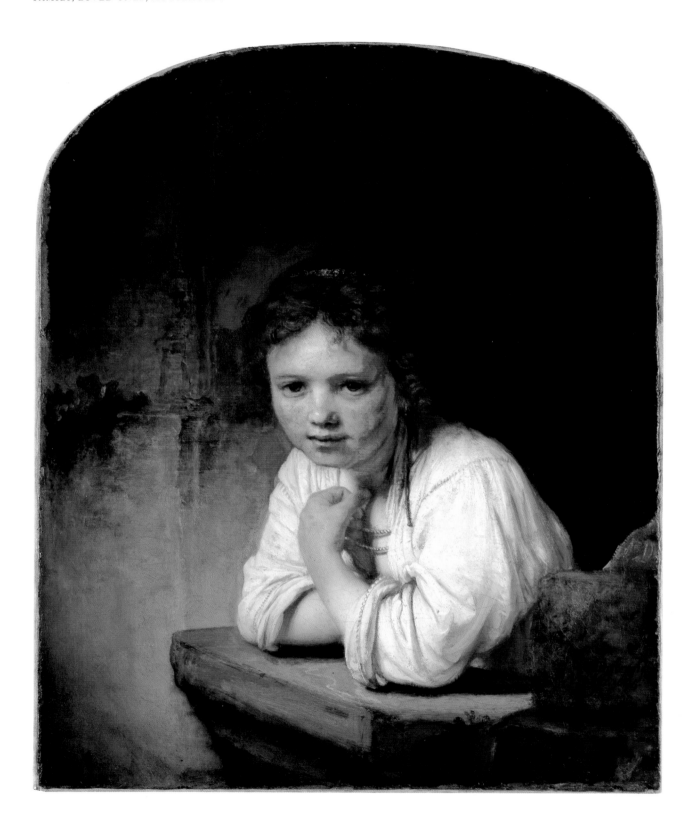

97
Rembrandt
Rembrandt's maid:
girl at a window
Inscribed *Rembrandt ft. 1645*
Canvas, 81.5 x 66 cm.
Bredius 368
London, Dulwich Picture
Gallery

14 Hofstede de Groot 1906a,
pp. 411–12, no. 350. Westermann
2001, pp. 70–73, credits Rembrandt
with introducing a novelty into
Dutch art by drawing his family.
15 Van Straten 2002, pp. 153–57,
appropriate ICONCLASS
categories from 42A 251 through
42A 51 1.

with her in the grip of a tantrum. Reminiscences of these drawings sometimes pop up in history subjects; his *Abduction of Ganymede* in Dresden reveals experience with children urinating while kicking their legs in the air.

In general, Rembrandt showed little inclination to bring out his household drawings in print. He seems in fact to have preserved most or all of them in a single album. In January 1680, in the estate inventory of the painter and merchant Jan van de Cappelle (1626–79), there is mention of a portfolio "containing 135 drawings, being the life of women with children by Rembrandt."[14]

That is more than the number of drawings of women with children known today. Otto Benesch's catalogue contains about 110.[15]

Reticence could not have been the reason why Rembrandt did not print etchings of his servants. He was willing to expose them to public glare in another, unorthodox way that moreover compromised his own privacy as well. One of his household paintings of a servant girl became one of Rembrandt's best-known creations in eighteenth-century France. Listen to the artist, art dealer, art critic, art historian, diplomat and spy who made it that, Roger de Piles (1635–1709):

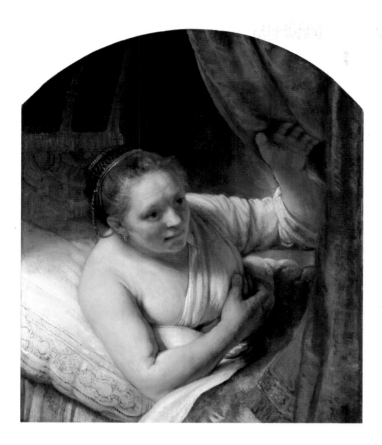

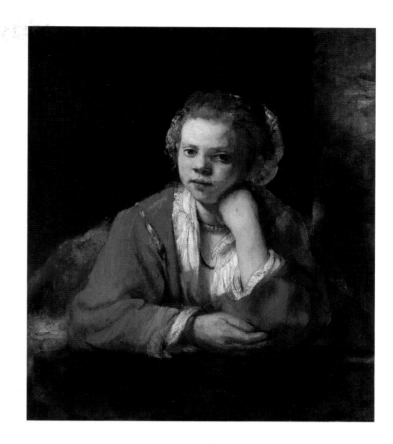

98
Rembrandt
Hendrickje in bed
Inscribed *Rembr ... , f 164..*
(ca. 1649)
Canvas, 80 x 66.5 cm.
Bredius 110
Edinburgh, National Gallery
of Scotland

99
Rembrandt
Young girl at a window
Inscribed *Rembrandt f. 1651*
Canvas, 78 x 63 cm.
Bredius 377
Stockholm, Nationalmuseum

100
Henk Snaterse
*A window of the Rembrandt
House, with Rembrandt's
painting of his maid (1645)*
1999
Photograph
Leiden, Primavera Press

16 Roscam Abbing 1999,
pp. 89–128: "Roger de Piles'
anekdote over Rembrandts
dienstmeisje (1708)."

Rembrandt, for example, amused himself one day by making a portrait of his servant to display in a window and fool passers-by. He succeeded; it was a few days before the deceit was detected. As one can imagine in the case of Rembrandt, it was neither beauty of drawing nor nobility of expression that produced this effect. Being in Holland I was curious to see this portrait. I found it to display such excellent brushwork and such great force that I bought it. Today it occupies an important place in my collection.

This story used to be dismissed as a conventional legend of praise, but a strong case has been made recently by Michiel Roscam Abbing for taking it more literally than that.[16] Roger de Piles really did own Rembrandt's painting of a servant girl, now in Dulwich Picture Gallery. When Roscam Abbing placed it in the window of the Rembrandt House, he came up with an image that despite certain incongruities could indeed have achieved the effect in the story. Another off-duty servant girl in Stockholm could have been put to work the same way.

Both paintings, in addition to several others such as *Hendrickje in bed* and *Hendrickje standing in a door-way* (fig. 88), show a different aspect of the household than the drawings of the 1630s. The children and grannies are gone. The members of the household Rembrandt now depicts are not mothers but pre-mothers, nubile young women with a tinge of sexual availability. What remains the same is the ambiguous relation between art and life. These women are identified as Hendrickje or as Rembrandt's maid, but is the artist saying anything about the models as actual persons? Or is he simply using them to create images that would be seen more as types – or in the case of Hendrickje in bed as a personage from a story – than as individuals? The latter is more likely. By depersonal-izing his models, Rembrandt makes them more access-ible to the customer of then and the viewer of now.

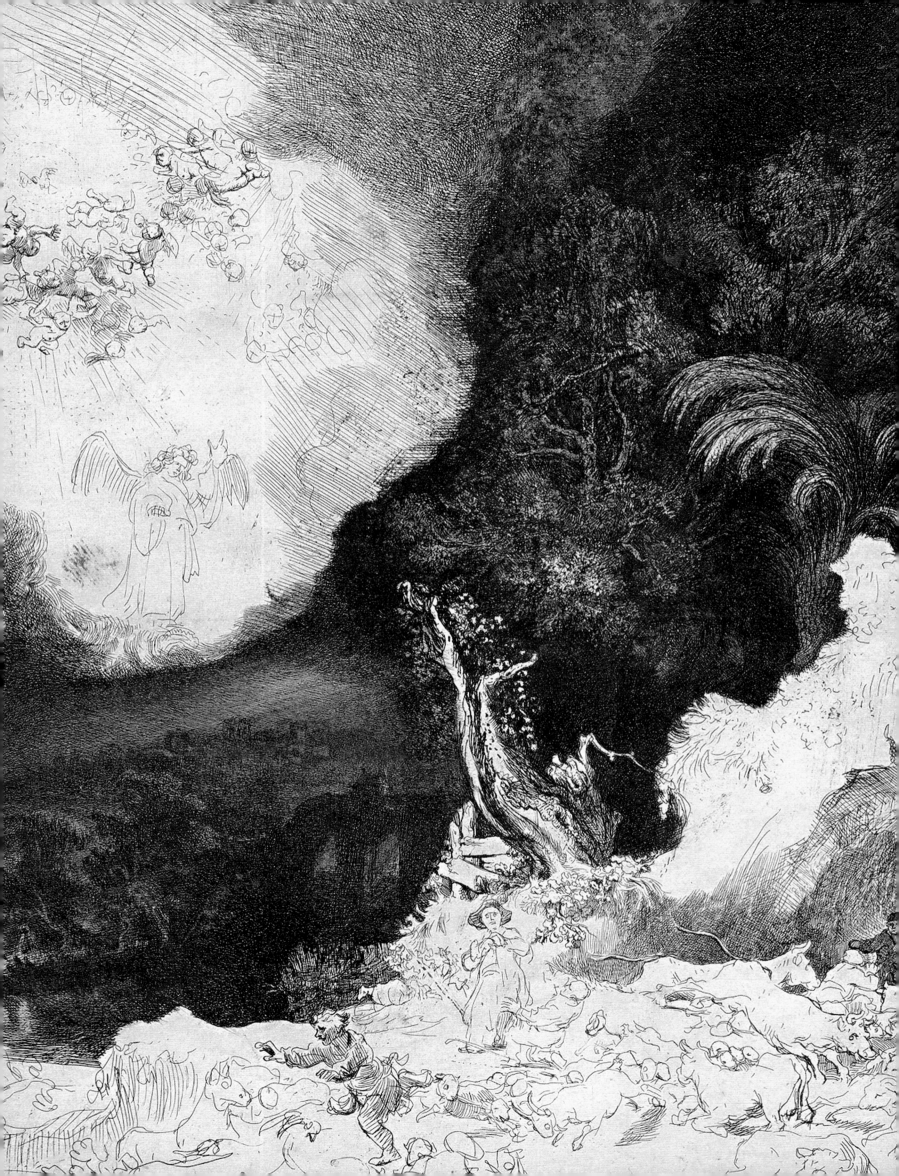

4

Craft

WHEN REMBRANDT made his great career move away from the classroom to the studio, he was about fifteen years old. That was late in life for a Dutch artist. In general, a boy being trained in a craft would enter the studio of his first master immediately out of or even while still in grade school, at the age of eight or nine. The companion in art of Rembrandt's youth, Jan Lievens, was eight years old when he began to study with Joris van Schooten. Rembrandt's first pupil, Gerard Dou, was contracted to the stained-glass painter Pieter Kouwenhorn when he was nine.

What this meant in terms of personal development differed from individual to individual, but I think it fair to assume that a boy who has a craft drilled into him at the age of eight or nine will practice it differently from one who begins his training as a developed adolescent. Rembrandt will have learned the basics of his craft more quickly than Lievens and Dou, and he will have been more critical in his attitude toward it.

He treated the crafts of drawing, etching and painting more as means to an end rather than as what he just happened to do.

Whether or not it was a function of his starting age, Rembrandt was not always as secure in his technique as many colleagues. A number of etchings, drawings and paintings suffer from avoidable technical deficiencies that he seems not to have taken very seriously. On the other side of the coin, Rembrandt was known as a technical innovator. To facilitate a certain aspect of etching that early on became part of his legend – the interruption of work on a plate to print intermediate states – he developed a varnish of his own. A simple recipe for the varnish was jotted down by Rembrandt on the back of an unusual drawing, executed entirely in wash, of the mid-1650s. A recipe attributed to him was published in 1660 in an English manual on the graphic arts as "The Ground of Rinebrant of Rine."

What if anything Rembrandt did to deserve it we do not know, but Arnold Houbraken, in reporting

Rembrandt's invention, says that he "never showed it to his pupils; that it is impossible to figure out how it is done; and that the find therefore … was buried with its inventor."[1] This report does not have the ring of truth, if only because the recipe was actually published during Rembrandt's lifetime. Moreover, it would have been in violation of guild regulations for a master to withhold craft techniques from his pupils. Had Rembrandt really done so, I do not think he would have attracted as many pupils as he did. What Houbraken's remark does tell us is that Rembrandt was thought of as a mystery artist; this part of his reputation has clung to him to our day.

The studio

Rembrandt's evocations of the artist in the studio show single figures alone with their thoughts or with a model. The reality was busier, more dynamic and more problematic.

The houses where Rembrandt lived were also the houses in which he worked. In one posthumous text he is said to have rented a large warehouse on the Bloemgracht where his pupils worked in partitioned spaces. While it is not impossible that this was so, we know that his own studio was in his house on the Sint Antoniesbreestraat. The overlap between the private and professional in Rembrandt's house is indicated in nearly symbolic form in a print known as *Het rolwagentje*, the walking learner. We see one of Rembrandt's little walkers from the "Life of women with children," with a woman of granny age, in a living room with a hearth. They seem to occupy a space directly behind the foreground, where two semi-nude boys – by all appearances studio models – are posing. The spatial relation between the two realms – art and life – is not spelled out clearly in the etching. On the contrary, it is a strangely dissociative image. The old woman and child are in an indoor room, but the boys, separated from them only by a low threshold, lean against an outdoor formation of some kind. Art introduces a nearly nightmarish strangeness into the house.

103
Rembrandt
*Two women teaching
a child to walk*
Unsigned, undated. Ca. 1632
Gallnut ink and wash,
16 x 14.4 cm.
Benesch 391 recto
Paris, Fondation Custodia
(Frits Lugt Collection)

1 Houbraken 1718–21, vol. 1, p. 271.

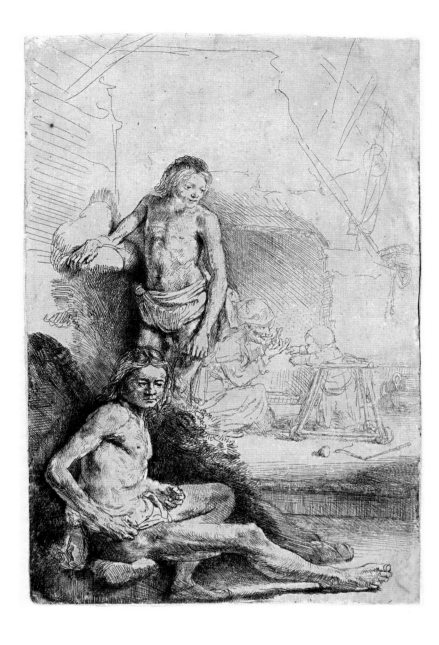

Compared with Houbraken's painting, the images of Rembrandt's studio, by him and his school, are staid and professional. Their relationship to Rembrandt's actual practice is questionable. In Leiden, where he may have shared working space with Jan Lievens and where he already took on his first pupils, his images of an artist in the studio show a single figure in rapt, lonely rapport with a panel on an easel in a bare room (fig. 106).

When he moved to Amsterdam, Rembrandt entered an art shop, that of Hendrick Uylenburgh, in which a multitude of commercial, craft and artistic activities were practiced. This scene never found its way into his art. The most crowded image of Rembrandt's studio that has come down to us was drawn about 1650 by a pupil (fig. 108). It shows the master giving instruction in drawing from the nude. On the shelf above the model are busts like those inventoried in the "small studio" – "The statue of the emperor Agrippa," "A Vitellius" and so forth.

Rembrandt's studio was less an ivory tower than an arena of interactions between him and his staff, his apprentices, associates and – even if they did not pose for him all that much – his family. The crossovers and overlaps we have seen between his subjects in art and his biography also characterize his living and working arrangements. His art is the product of a studio that belonged to more people than himself alone.[2]

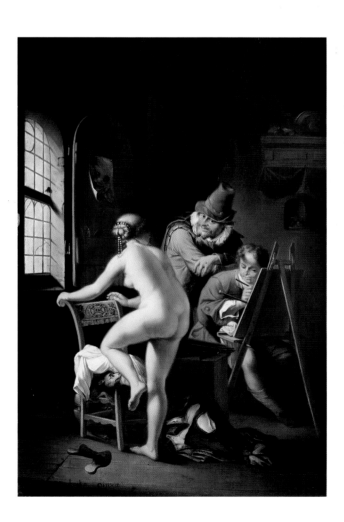

104
Rembrandt
Nude man seated and another standing, with a woman and a baby lightly etched in the background: "Het rolwagentje"
Unsigned, undated.
Ca. 1646
Etching, 19.4 x 12.8 cm.
Bartsch 194 i(3)
Haarlem, Teylers Museum

105
Arnold Houbraken (1660–1719)
The artist and his model
Inscribed *ANHoubraken.*
Undated. Ca. 1700
Panel, 28.5 x 19 cm.
Amsterdam, Rijksmuseum

2 Among the many writings on Rembrandt's studio, a special place is taken by Svetlana Alpers's book-length treatment of that environment, in Alpers 1988.

In Rembrandt's house on the Sint Antoniesbreestraat models and apprentices had to climb the stairs past the family living quarters and the grand "art room," where customers will have been received, to the "small studio," "large studio" and "studio storage space" on the upper floor. It was not a house where privacy was easy to protect. The story from which we learn (from Arnold Houbraken) about the loft on the Bloemgracht is not about working space only. It is about an incident concerning sex and discipline and group behavior arising from the practice of paying young women to remove their clothes for young men. This may have been more of an obsession of Houbraken's than Rembrandt's. Houbraken painted an outrightly spicy picture of a model being ogled by the friend of an artist. Given the close proximity of the master and his family, their servants, the studio staff, models and visitors, it is a credit to Rembrandt's capacities as both a *pater familias* and the head of a studio that only one of his many conflicts, the Geertge Dircx affair, concerned members of his household. Otherwise he never sued or was sued by a pupil or servant.

106
Rembrandt
Rembrandt as a young painter
in his studio
Unsigned, undated.
Ca. 1626
Panel, 25 x 32 cm.
Bredius 419
Boston, Museum of Fine Arts

107
Rembrandt
A young painter (Jan Lievens?)
in his studio
Unsigned, undated.
Ca. 1633–35
Brown ink, 20.5 x 17 cm.
Benesch 390
Los Angeles, J. Paul Getty Museum

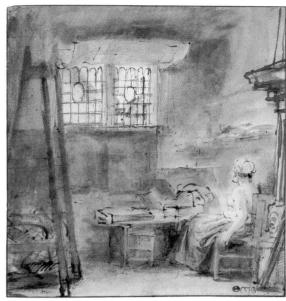

Drawings

The most complete catalogue of Rembrandt's drawings
ever published was brought out by Otto Benesch, with
the help of his wife Eva, in the 1950s and again, after
Benesch's death, in 1973. Benesch paid close attention
to the tools and pigments Rembrandt used. (He is less
complete on the paper and the condition of the sheets
in his catalogue.) In all, he specifies nearly fifty different
kinds of instruments and techniques. Some of these,
such as yellow water-color or red chalk solution, were
noted by Benesch only once or twice, and will not be
taken into consideration here. Another proviso attend-
ing the use of Benesch's catalogue is that many of his
attributions and datings are no longer accepted by spe-
cialists. Moreover, some of his technical descriptions
have been refined or corrected. However, the 1,550-odd
drawings he describes (this number includes the versos

of drawings, which he does not number separately)
form the best indication we have of the range of tech-
niques employed by Rembrandt and the volume of his
production over the years.

Before 1627 Benesch dates only four drawings, and
after 1662 a mere three. The latter circumstance calls
for comment. One might suspect that the drawings of
the 1660s have been lost, perhaps in one catastrophic
moment following the artist's death. There is however
evidence of another kind that suggests that around 1660
he may simply have given up the practice of drawing.
It was around this time that he also stopped making
etchings, a medium that is far better documented than
drawing. Why Rembrandt should have stopped creating
work on paper in the 1660s, a period when his activity
as a painter continued only slightly abated, is anyone's
guess. Whether or not it is indicative of a decline in
morale, it is disconcerting to find the artist abandoning

Graph 6
Rembrandt drawings in total
and by technique other than pen
and ink
(Source: Benesch 1973)

■ Total
■ Wash
■ Body color
■ Black chalk
■ Red chalk

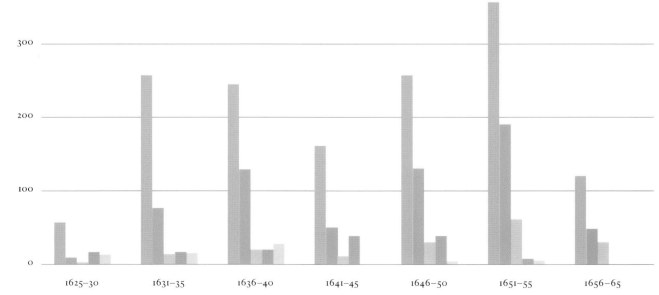

110
Rembrandt
Woman carrying a child
Unsigned, undated. Ca. 1636
Quill pen and brown ink,
10.3 x 8.6 cm.
Benesch 342
Amsterdam, Museum
Het Rembrandthuis

111
Enlarged detail of fig. 110.
All strokes could have been
made with the same quill.
The heavier lines are produced
by greater pressure. In a line
such as that beneath the nose
of the child, the typical effect
of dark edges produced by
a quill pen can be seen.

112
A quill

113
A reed pen

a means of expression he had used to such outstanding
effect for more than forty years.

Graph 6 shows the frequency of drawings in periods
of five years. The beige bar is the complete number of
drawings in the 1973 edition of Benesch's *Drawings of
Rembrandt*. More than ninety percent of these are in
pen and ink, so this category has not been graphed sep-
arately. The other bars give the distribution of the four
main materials used by Rembrandt beside brown ink.
These are wash, white body color, black and red chalk.

The rise and fall in the use of the wet techniques, ink,
wash and body color, follow in general the line of total
production, with peaks in the early 1630s and the early
1650s. There is a rise, however, in the percentage of
pen-and-ink drawings to which wash was applied. The
dry techniques, black and red chalk, show a different
curve. On a small scale, they were used by Rembrandt
with some regularity in his early years. Then, around
1640, he stopped using red chalk, and after the early
1650s black chalk.

The wet media are representative of Rembrandt's
drawings as a whole not only in frequency but also
in subject matter. For certain subjects he showed
marked preference for one or the other color of chalk.

For drawings of landscapes Rembrandt frequently used
black chalk but never red. For portraits and histories,
red had his preference. Drawings of faces and figures
are in both techniques.

Pen and ink

By far the largest number of Rembrandt's drawings
were executed in pen and ink. Both the pens and the
inks come in two main varieties.

The quill pen is a traditional writing or drawing
implement fashioned from the large, hollow outer wing
feathers of a goose, swan, raven or crow. The large,
primary flight feathers of the bird are plucked, scraped
and hardened by plunging into hot ashes or sand, prior
to being cut into a bifurcated pen nib. The quill was
valued for its versatility with regard to the width of the
point into which it could be cut, and the capacity of the
flexible tip to produce sweeping, calligraphic lines.[3]
The width of the line can be varied by the degree of
pressure on the pen. The quill pen produces a line that
may be dark along both edges and light in the center
as the ink runs out.

114
Enlarged detail of fig. 115.

The broader strokes of the reed
pen impose a limit on the
degree of fine detail that
a draftsman can employ.
The faces of mother and child
in this drawing are executed
with fewer strokes and broader
indications of feature and
expression.

115
Rembrandt
*Studies of a woman and
two children*
Unsigned, undated. Ca. 1640
Reed pen and brownish ink,
13.6 x 13.2 cm.
Benesch 300
Boston, Peck collection

The reed pen is cut from hollow-barreled grass,
including canes and bamboo. The fibrous structure
of the reed lends itself best to a blunt nib, which pro-
duced short, broad strokes that resemble brushstrokes
more than conventional pen lines. A reed pen can
create dense bands of ink when full, or mottled trails
when semi-dry.[4]

Rembrandt sometimes used both quill and reed in the
same drawing (fig. 116). In standard descriptions of the
technique of Rembrandt drawings, it is not specified
whether a quill or reed pen was used or both. In this
book, the type of pen is specified only when the muse-
um catalogue or a recent exhibition catalogue provides
that information or when the author has been able to
settle the issue to his own satisfaction.

116
Rembrandt or artist close to him
A cottage beneath trees
Unsigned, undated. Ca. 1640–45
Quill and reed pen and brown
ink, 18.3 x 32.6 cm.
Benesch 801
Dresden, Staatliche Kunstsamm-
lungen, Kupferstich-Kabinett

The background is drawn
largely in quill, the foreground
mainly in reed. The heavy
strokes at the top of the
farmhouse also seem to be
drawn with the reed pen.

3 Ackley 2003, p. 337. The section
on "Materials and techniques" from
which the quotes in the present
illustrated glossary are taken was
compiled by Deborah La Camera,
Rhona Macbeth and Kimberley
Nichols.
4 Ackley 2003, p. 337.

117
Rembrandt
The sleeping watchdog
Unsigned, undated.
Ca. 1637–40
Pen and brown ink, brush and
brown wash, 14.3 x 16.7 cm.
Benesch 455
Boston, Museum of Fine Arts
Some of the broader
strokes in this drawing are
beginning to darken and
deteriorate. This is due to the
presence of iron gall in the ink,
which behaves this way
especially when applied
broadly.[5]

118
Rembrandt
River with trees
Unsigned, undated.
Ca. 1654–56
Brush and brown wash,
13.6 x 18.7 cm.
Benesch 1351
Paris, Musée du Louvre,
Cabinet des Dessins

119
Rembrandt
Self-portrait: bust
Unsigned, undated. Ca. 1629
Pen and brown ink, brush and
black ink, 12.7 x 9.4 cm.
Benesch 54
Amsterdam, Rijksmuseum

Ink and wash

The great majority of Rembrandt's drawings look to
be in brown ink or wash. (Wash is usually diluted ink,
applied with the brush rather than the pen.) These
were however not necessarily executed with the same
materials. Rembrandt used inks of two main kinds.
One is called bistre, made from chimney root, some-
times with admixtures of pigments such as burnt
umber. Bistre came into use in the fourteenth or
fifteenth century. The other is a far older material,
known from Roman times on, iron gall ink. The iron
comes from the compound iron (II) sulfate, a chemical
used in metallurgy and the textile industry, while the
galls are "the bulbous growths formed on the leaves and
twigs of trees in response to attack by parasites. Galls
are collected from oak, oak-apple and pistachio trees."
(From a valuable Internet resource known as "The ink
corrosion website.")

Until the 1980s, art historians assumed that
Rembrandt's brown-ink drawings were mainly made
with bistre. In Otto Benesch's catalogue of
Rembrandt's drawings, nearly all the drawings in

brown ink are described as "pen and bistre." In the
early 1980s, however, scientists and art historians
at the Metropolitan Museum of Art discovered that
Rembrandt actually used bistre relatively rarely.
"Only one of the 22 drawings [by Rembrandt in the
Metropolitan Museum of Art], *Potiphar's wife Accusing
Joseph*, was executed entirely in this ink. In another
composition, *Cottage At Wood's Edge*, the presence
of this type ink was detected in a few wash passages.
Almost all the other ink sites were pure iron gall, or
iron ink containing elements suggesting the admixture
of pigments such as burnt umber."[6]

This discovery is of potentially great importance for
the conservation of Rembrandt's drawings, since iron
gall is an unstable substance that sometimes destroys
the paper with which it is bonded. The fact that the
discovery was made so late reflects the fact that there
is no characteristic visual difference between bistre and
brown iron-gall ink, at least until the iron gall begins
to decay. Various kinds of non-destructive techniques
that help in this determination have been developed,
but the results have never been systematically pub-
lished. In this book we therefore use the term "brown
ink" and "brown wash" without further distinction.
The term unfortunately covers not only different sub-
stances but also different shades of brown. Some of
Rembrandt's inks might be growing lighter as others
have grown darker, sometimes on the same sheet. The
more we learn about these materials, the more we real-
ize that Rembrandt's drawings may no longer look the
way they did when he finished them. At present we lack
the insight and the means to reconstruct their original
appearance.

In a few rare drawings, Rembrandt used the brush
alone.

Few of Rembrandt's pen drawings look today as
if they were drawn with black ink. Originally, this num-
ber may have been larger. The iron gall that he used for
these drawings may have turned brown in the course
of time. In a smaller number of drawings, another kind
of black ink was used, called Indian or Chinese, or just
black ink. This is composed of the soot created from
burning oils, resins, or resinous woods, or the charcoal
of many kinds of woods mixed with a gum or resin.
The mixture is hardened into a dry ink stick ready
to be watered down for use.[7]

In one early drawing (fig. 119) the wash consists
of two shades of black ink, achieved by different grades
of dilution. It is often difficult to determine whether
washes, which tend to be applied broadly, were added
by Rembrandt or a later hand. Rembrandt used black
ink in fewer than one in ten drawings. He used it
throughout his career, mainly for history subjects, land-
scapes and figure studies. In his copies after Indian
miniatures he used black ink far more intensively than
in other groups of works.

5 Ackley 2003, pp. 122–23.
6 Shelley 1982.
7 Ackley 2003, p. 337.

White watercolor or body color

Rembrandt occasionally enhanced the modeling of mass and volume by applying opaque white watercolor to create highlights on his drawings. However, he more often used the opaque white medium to correct or edit out lines that he wished to soften or suppress. The medium, based on a solution of lead white, often becomes more transparent with age, revealing the covered ink lines.[8] Conversely, white body color is sometimes oxidized, becoming dark. Rembrandt used white body color from the start of his career, in drawings of all subjects, though in increasing frequency as time went by. Toward the time that he stopped making drawings, he was using white lead more than half the time. When the white body color in fig. 120 was originally applied, it covered the lines beneath. However, with the passage of time, the lead white has grown transparent, so that we now see both the covered lines and those drawn over them. The feather in the man's cap was intended to be deleted, but has now reappeared. The legs of the man wielding the sledgehammer in fig. 121 are covered with white body color that has been oxidized and darkened. The paper was torn in two and then put together again, perhaps with a piece omitted on which the rump of the ox was drawn. The pen work in the two halves follows different modes of draftsmanship and tonality. The right half is drawn with finer lines and is more descriptive. The left half is drawn more broadly, with fewer details. This simple-looking object is in reality quite complex and difficult to understand, like many if not most of Rembrandt's drawings. The attribution of this drawing to Rembrandt is not accepted by all specialists.[9] Note the different color of the paper in the two drawings. Both sheets were soaked

120
Rembrandt
An Oriental standing, full-length
Unsigned, undated. Ca. 1639
Pen and brown iron-gall ink heightened with white on paper prepared with brown wash,
22.2 x 17.3 cm.
Benesch 207
London, British Museum

121
Rembrandt or artist close to him
Men slaughtering an ox
Unsigned, undated.
Ca. 1635–40
Pen and brown ink, white body color (oxidized), 11.7 x 15 cm.
Benesch A18
Munich, Staatliche Graphische Sammlung

8 Ackley 2003, p. 337.
9 Vignau-Wilberg 2001, no. 31, pp. 135–37.
10 Ackley 2003, p. 337.

122
Rembrandt
Man with arms extended
Unsigned, undated.
Ca. 1626–27
Black chalk, 25.4 x 19.1 cm.
Benesch 12
Dresden, Staatliche
Kunstsammlungen,
Kupferstich-Kabinett

123
Enlarged detail of fig. 122

by the artist in wash before he worked on them, in different colors. There is a wide range of colors in Rembrandt's washes and inks. It must be said, however, that the color of paper is seldom captured accurately in photography and printing.

In addition to these wet media, Rembrandt also employed, though on a smaller scale, dry drawing media as well.

Dry media

Black chalk is a composite of carboniferous shale and clay. Though its relatively friable nature lends itself well to broad effects, it is also capable, as in Rembrandt's drawings, of rendering more precise lines.[10] Rembrandt used black chalk mainly before 1650, for all subjects but with a certain preference for figures and landscapes.

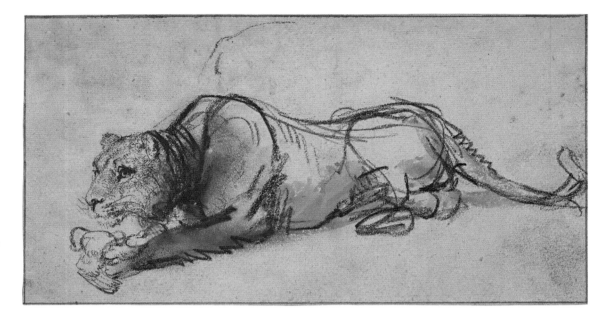

124
Rembrandt
A lioness devouring a bird
Unsigned, undated. Ca. 1638
Charcoal, with gray wash,
heightened with white, on paper
prepared with brown wash,
12.6 x 23.9 cm.
Benesch 775
London, British Museum

125
Enlarged detail of fig. 124

126
Rembrandt
*Two women teaching
a child to walk*
Unsigned, undated. Ca. 1635–37
Red chalk on rough gray paper,
10.3 x 12.8 cm.
Benesch 421
London, British Museum

Charcoal

Benesch names all drawings in dry black media black
chalk. Later researchers have however identified the
material in some of these drawings as charcoal, which
has a somewhat shiny finish. This is true in particular
of a group of drawings of lions, probably from the
late 1630s.

Red chalk gains its color from iron oxide or hematite.
The proportion of iron oxide to clay content determines
the specific hue of the chalk, ranging from a very pale
red to a burnt brownish orange.[11] Rembrandt used this
medium not infrequently in his early years, but discon-
tinued it except for retouching purposes after about

127
Detail of fig. 126. The texture
of the chalk line in this drawing
is broader and less finely
modulated than in the black
chalk and charcoal drawings
illustrated above.

128
Rogier van der Weyden studio
Detail of *St. Luke drawing
the Madonna*
Unsigned, undated. Ca. 1484
Panel, 138 x 110 cm.
Friedländer 106a
Munich, Alte Pinakothek

128
Rogier van der Weyden studio
Detail of *St. Luke drawing
the Madonna*
Unsigned, undated. Ca. 1484
Panel, 138 x 110 cm.
Friedländer 106a
Munich, Alte Pinakothek

129
Rembrandt
Sheet of studies with five heads
Unsigned, undated. Ca. 1633
Silverpoint on prepared vellum,
13.4 x 8 cm.
Benesch 341 recto
Rotterdam, Museum Boijmans
Van Beuningen

130
Enlarged detail of fig. 129.
The stroke has two aspects,
light and heavy. Rembrandt
could have used two different
instruments to achieve these
effects, but it would be nicer
to imagine him using a two-
sided silver rod like St. Luke's,
with a fine point on one end
and a finer one on the other.

1640. He used it for figure studies, scenes from daily
life and history compositions, notably in copies after
paintings by his master Pieter Lastman.

Silverpoint
Although Rembrandt made only a few drawings in met-
alpoint, they demand attention here exactly because
they were so exceptional not only in his work but in his
lifetime. The heyday of metalpoint drawing lay far in
the past, in the fifteenth and sixteenth centuries. Any
and all use of silverpoint in the seventeenth century
would make a viewer think of old craftsmanship and the
refined art of Albrecht Dürer and his contemporaries.

The instrument for drawing in silverpoint is a rod of
silver or silver-coated metal. An entire metal rod can be
used, or a small point attached to or stuck into a wood-
en shaft. Since regular paper will not register a visible
impression from such a point, the support has to be
prepared with a special receptive layer. This usually
consists of a mixture of organic and inorganic materi-
als: the finely ground bones of a barnyard fowl, eggshell
or shells mixed with gypsum and glue, diluted and
brushed on in layers. More often than paper, this
ground is applied to vellum, which is stiffer and less
likely to allow the ground to crack. The line left by a
silver stylus in the ground is gray at first but turns
browner as it tarnishes.

In his standard handbook on the art of drawing,
Joseph Meder writes glowingly of this technique.
"It always makes a festive impression. When St. Luke
drew the Madonna, he could only do it in silverpoint."[12]
Meder illustrates his remarks with a splendid detail
of a version in Munich of Rogier van der Weyden's
St. Luke drawing the Madonna, in which the artist-saint
indeed works in silverpoint, using a whole silver rod
with styluses on both ends.

131
Rembrandt
*The lamentation at the foot
of the Cross*
Unsigned, undated.
Ca. 1634–35
Pen and brown ink, brush
and brown wash, with red and
perhaps some black chalk,
reworked in oils *en grisaille*,
the sheet made up of cut
sections of paper,
21.6 x 25.4 cm.
Benesch 154
London, British Museum

132
Rembrandt
Cornelis Claesz. Anslo.
Inscribed *Rembrandt f. 1640*
Red chalk, heightened and
corrected with white oil color,
with some red wash on pale
yellowish-brown paper, the
outlines indented with a stylus
for transfer to a copper plate,
16.7 x 14.4 cm.
Benesch 758
London, British Museum

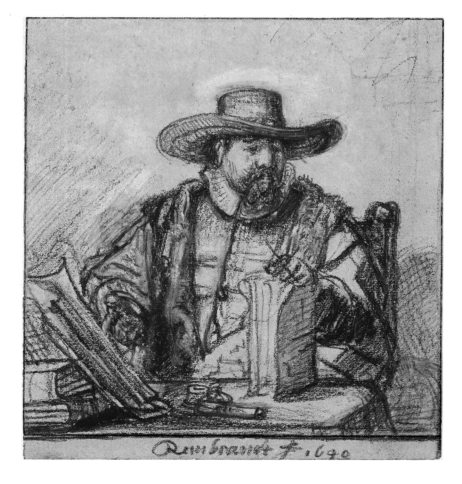

133
Rembrandt
Woman with child on her lap
Unsigned, undated. Ca. 1646
Pen and brown ink, brush and
brown wash, rubbed with the
artist's finger, 16.2 x 12.8 cm.
Benesch 382 recto
Paris, Fondation Custodia
(Frits Lugt Collection)

Rembrandt drew his own lady, as a young bride, in silverpoint, once in the famous drawing in Berlin (fig. 78) and again, in the same period, in the center of a sheet with five heads in Rotterdam (fig. 130). He used this intriguing compositional mode in etchings as well, from the beginning of the 1630s on. In the drawing in Rotterdam the ground, which posed considerable technical problems to the artist, seems to have become discolored unevenly.

Mixed media

The above drawings were chosen as representative examples of individual techniques, without others. However, such drawings are a minority in Rembrandt's work. The artist was anything but a purist when it came to technique. There are sheets that combine virtually all of the above techniques, sometimes even supplemented with oil, as if aspiring to the condition of painting. See fig. 131.

Mechanical treatments

In a fair number of drawings, Rembrandt applied techniques that did not involve bringing pigments or traces

of metal onto the support but affected it in mechanical ways that left a mark. Instruments that have been identified are knives, for scraping the surface of a sheet in order to create a white highlight; metalpoints for transferring a drawing onto an etching plate; and most surprisingly the artist's finger, to smudge ink or wash before drying.

The head of the woman in fig. 133 was initially further from the child. That first head was rubbed out by hand before the second, in darker ink, was drawn on top of it. Perhaps some day we will be able to extract Rembrandt's fingerprint or other biometric identifier from rubbings in drawings such as this. But then again, he touched with his fingers all the drawings he made or corrected or owned.

Techniques not used

Among the techniques available in his time that Rembrandt did not seem to have used except in an auxiliary fashion and rarely, are lead pencil, crayon, watercolor and white chalk. The latter especially is notable, since drawings in white chalk on blue paper were a popular medium for several pupils and other associates of Rembrandt. See fig. 173.

Graph 7
Etchings

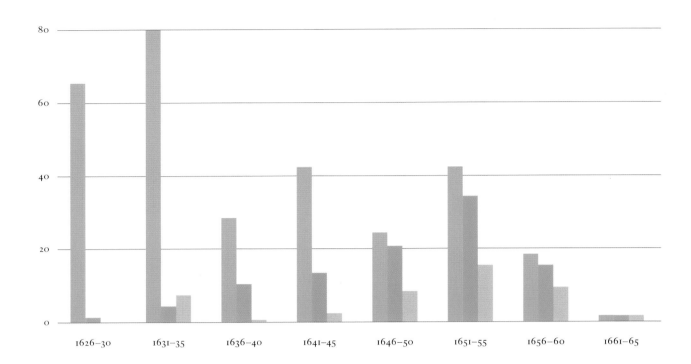

■ All etchings
■ With drypoint
■ With burin

Etchings

All the prints attributed to Rembrandt are intaglio prints printed from a metal plate. That is to say, an image was incised into a plate, ink was rubbed into the incised lines, and in a printing press the ink was transferred from the grooves in the plate – and sometimes from the surface between the grooves – onto the support. Here we will give a summary indication

of the main features and variants of this process as applied by Rembrandt.

Eighty-one of the copperplates from which Rembrandt etchings were printed have survived. All but three were in a single batch from Rembrandt's time until 1993, when they were dispersed by a London art dealer. Rembrandt used thin copperplates, varying in thickness from about three-quarters of a millimeter to a millimeter and a half. These were plates of the kind that

134
Rembrandt
Jacob caressing Benjamin
Inscribed *Rembrandt f.*
Undated. Ca. 1637
Etching, 11.8 x 9 cm.
Bartsch 33 i(2)
Boston, Museum of Fine Arts,
gift of Eijk and Rose-Marie
van Otterloo in honor of
Clifford S. Ackley

135
Rembrandt
The copper etching plate from
which the impression on the left
was printed.
11.8 x 9.1 x .078 cm.
Boston, Museum of Fine Arts

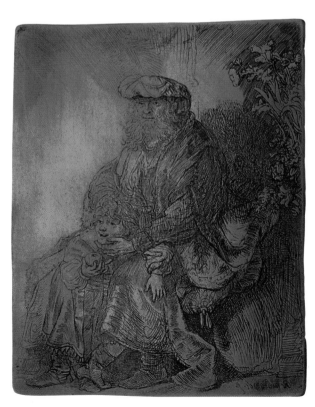

136
Rembrandt
Sheet of studies of men's heads
Inscribed *RHL* in reverse.
Undated. Ca. 1630
Etching, 9.6 x 12 cm.
Bartsch 366 ii(2)
Vienna, Albertina

137
Rembrandt
Old bearded man nearly in profile
to right: mouth half open
Unsigned, undated. Ca. 1630
Etching, 3.6 x 2.8 cm.
Bartsch 334 iii(3)
Amsterdam, Rijksmuseum

138
Rembrandt
Old man in fur coat and high cap
Unsigned, undated. Ca. 1630
Etching, 3.6 x 2.8 cm.
Bartsch 333 ii(7)
Haarlem, Teylers Museum

139
Rembrandt
Old man seen from behind, profile
to right: half-figure
Unsigned, undated. Ca. 1630
Etching, 7.2 x 4.2 cm.
Bartsch 143 iv(4)
Haarlem, Teylers Museum

140
Rembrandt
Man in a square cap, in profile
right
Unsigned, undated. Ca. 1630
Etching, 3.7 x 2.4 cm.
Bartsch 303 ii(2)
Amsterdam, Rijksmuseum

141
Rembrandt
Man crying out, three-quarters
left: bust
Unsigned, undated. Ca. 1630
Etching, 3.9 x 3.4 cm.
Bartsch 300 ii(5)
Amsterdam, Rijksmuseum

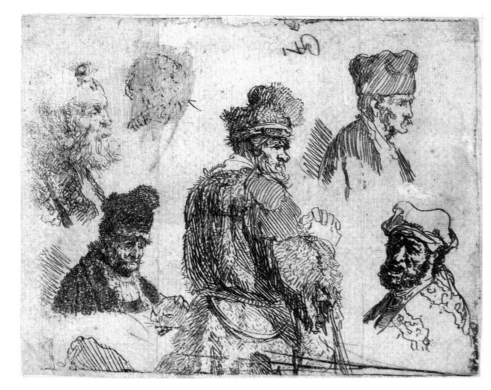

136

137

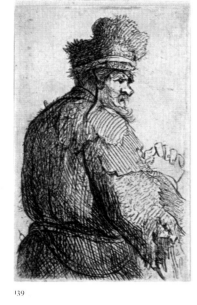

139

140

138

141

13 Hinterding 1993, p. 7.
14 Hinterding 1993–94, p. 288.

were also used by printers for book illustrations. One etching, *The return of the prodigal son* (fig. 32), was made on the back of a plate that had been used for a geometrical demonstration in a book published in Antwerp in 1598; it was brought to Amsterdam by a publisher about 1630 and used by Rembrandt in 1636.[13]

In working on a plate, Rembrandt would sometimes have to use the techniques of a metalsmith. The art historian who has conducted the most extensive research on the plates, Erik Hinterding, found hammer marks on the back of the plate of *Jacob caressing Benjamin*,

"mainly in the lower half, partly corresponding to a reworked area in front of the right feet" of the figures.[14] This implies that Rembrandt burnished out part of his original work and then used a hammer to even out the surface of the plate. This enabled him to re-etch and print the section he had rubbed out.

The hammer is not the only metalworker's tool Rembrandt used on his plates. From time to time he also used shears or a knife to cut a plate. In the array above is a plate that Rembrandt etched about 1630. The illustrated impression, in the Albertina in Vienna,

is the only complete one to survive. Probably not long after making and printing it, he cut it into pieces, five of which he subsequently printed as separate etchings. The individual heads each have their own title and Bartsch number. For each, the printing in the undivided plate is counted as the first state. (Not until 1969 did White and Boon demonstrate that the undivided plate had two states.)

Paper is more patient than metal. From around 1633, we have a sheet from Rembrandt's workshop in which the opposite intervention has taken place. Snippets of drawings of one or two figures have been pasted onto a new piece of paper, forming a study sheet of the kind that the etching plate Bartsch 366 was before it was cut up (fig. 136). Both objects provide a valuable insight into the instrumental way individual figures and their combination were regarded in the Rembrandt studio. The same drawing could be looked at separately or as part of a loose assemblage, as work material or as an object for sale.

"In printing, dampened paper is placed on the surface of the plate together with a felt blanket for padding and the resulting sandwich is passed through a roller-bed press." This is a strenuous action; a printer who wanted to get maximum results from the hard labor of pulling the press would put more than one plate at a time on the press. This was a matter of combining prints of various formats to fill the available surface as completely as possible. Rembrandt's small etchings of individual figures, such as those from the cut-up plates of heads, could be used to fill in unused corners and edges, earning him a few pence more out of a pull. Because the printer would lay one sheet of paper over all the plates on the table, and because recent research has made it possible to identify individual batches if not sheets of paper, some day we will be able to reconstruct Rembrandt's production as a publisher of his own etchings year by year.[15] The combination of plates on the press did not have to correspond to the chronology of the etchings. Rembrandt would sometimes reprint old plates in the same run as new ones.

The basic tool of the etcher is the etching needle. In the earliest complete manual on etching, by the French artist Abraham Bosse (1602–76), etching needles of various thickness are described and illustrated (figs. 144–46). In true etching, the artist does not draw directly on the copper plate. He leaves that part of the work to the operation of an acid. He covers the plate with an acid-resistant ground, made of ingredients such as wax, resin and asphalt. Rembrandt's ground – "The Ground of Rinebrant of Rine" – was reported by an English source of 1660 to have consisted of "half an ounce of Expoltum [asphaltum] burnt of Amber, one ounce of Virgins' wax, [and] half an ounce of Mastick," to be mashed, heated and mixed with water into a ball, then to be melted onto the (not too hot) plate.[16] A ground of this kind was known as a "soft ground," in contrast to the hard variety, which went

142
Rembrandt
Studies of nine figures (seven pieces of paper pasted onto an eighth to form a sheet of studies)
Unsigned, undated. Ca. 1633–34
Pen and brown ink,
17.8 x 18.4 cm.
Benesch 219
Berlin, Staatliche Museen,
Kupferstichkabinett

143
From the Dutch edition of Abraham Bosse's manual:
Tractaet in welke manieren men op root koper snijden ofte etzen zal … (Tractate on the ways of engraving or etching in copper),
Amsterdam (Jacob van Meurs) 1662. "The press from the side, in perspective." Collection of the author

15 Laurentius 1993, pp. 174–80.
16 Alexander Browne, *The whole art of drawing*, London 1660, p. 106. Quoted from Doc. 1660/29.

144–46
Three prints from the book by Bosse cited in fig. 143
Left: above, the fine etching needles; below, the broader ones, with a whetstone for keeping the needles sharp and a soft brush for rubbing dust and dirt from the plate.
Middle: the use of the broad point and of the wooden holder of the needle.
Right: the lines and effects of various thickness, shape, texture and density that can be etched by Bosse's etching techniques.

out of fashion during Rembrandt's lifetime. This international source in itself – and it does not stand alone – is enough to demonstrate that Rembrandt was famous for the recipe of his etching ground.

Into the ground the artist scratches the composition with the needle, exposing the copper plate where he has drawn. The plate is then either laid in an acid bath, or else held at an angle while acid is poured over it a number of times. Each etcher will experiment with the composition and strength of his acid and the manner of applying it. J.G. van Gelder surmised from the fine biting of his etchings that Rembrandt used a slow-working mordant rather than a harsh agent such as nitric acid.[17] Following this treatment, the ground is removed and the plate is ready for inking and printing.

The process is more complicated than it may sound. An artist drawing on a ground has to be able to see the traces of the needle. This demands the admixture to the functional acid-resistant ground of a white layer. Rembrandt is said by Alexander Browne to have used a two-layered ground: "lay your black ground very thin and the white ground upon it."[18]

That situation applies to work on a fresh plate. However, if the etcher wishes to check his progress and then continue, a different solution is required. Consider the state of affairs when Rembrandt printed the impression in fig. 147 of his *Angel appearing to the shepherds*. He had blocked in the entire composition and completed the background when he felt the need to see how the plate looked in printed form. To do this, he had to remove the ground, ink the plate, wipe off the ink

outside the grooves and pull an impression. When he had his proof and wished to continue work on the plate, he could not apply the same ground he used at first. That is because the black-and-white ground is opaque. If he put it back on the plate, he would not be able to see his work at all. To work on a partially etched plate requires a transparent ground that nonetheless registers the effect of new needle scratches. On the back of a landscape drawing in Paris (fig. 102), Rembrandt jotted down his recipe for a ground of this kind, called stopping-out varnish: "… to etch, white turpentine oil, add half as much turpentine, put together in a glass bottle, bottle in pure water, boil water for half an hour." Unfortunately, the inscription is incomplete as well as difficult to read and ambiguous. However, turpentine oil and turpentine are known as ingredients for stopping-out ground. For his completion of the brilliant *Angel appearing to the shepherds*, Rembrandt used a varnish of this kind in working on the last two states.

By the time he jotted down those lines about 1655, Rembrandt was actually not using stopping-out varnish any more. Indeed, he used no ground at all for later states of his plates. Instead, he drew directly into the plate with his etching needle, a technique known as drypoint. The artist scratches the outlines and modelling of his composition into the plate, raising a rough ridge of metal known as burr, which the artist can remove or leave. Graph 7 shows that after 1645 Rembrandt produced very few plates in pure etching.

17 White 1969, vol. 1, p. 13.
18 Cited from White 1969, vol. 1, p. 13.

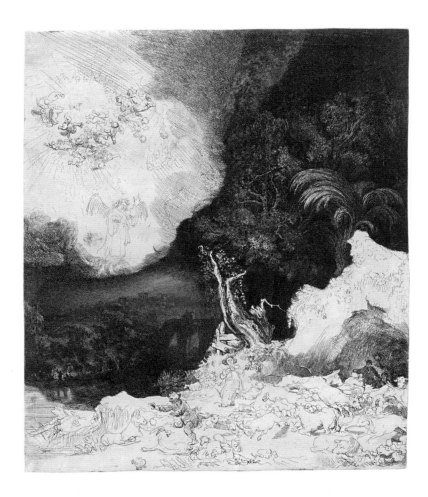

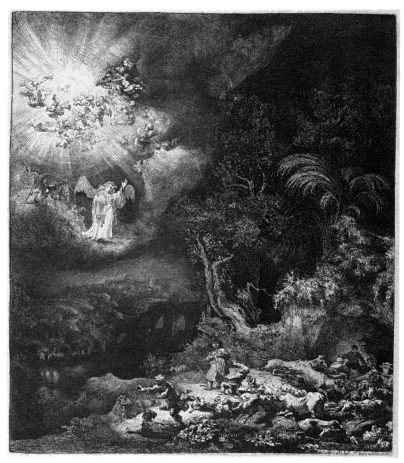

147–48
Rembrandt
*The angel appearing
to the shepherds*
Inscribed *Rembrandt f. 1634*
Etching, 26.2 x 21.8 cm.
Bartsch 44 i(3; fig. 147)
and iii(3; fig. 148)
London, British Museum
(fig. 147)
Haarlem, Teylers Museum
(fig. 148)

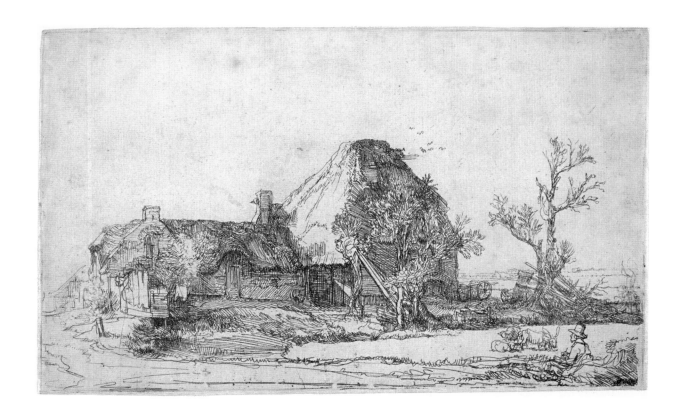

149
Rembrandt
*Cottage and farm buildings
with a man sketching*
Unsigned, undated. Ca. 1645
Etching, 12.9 x 20.9 cm.
Bartsch 219 i(1)
Haarlem, Teylers Museum

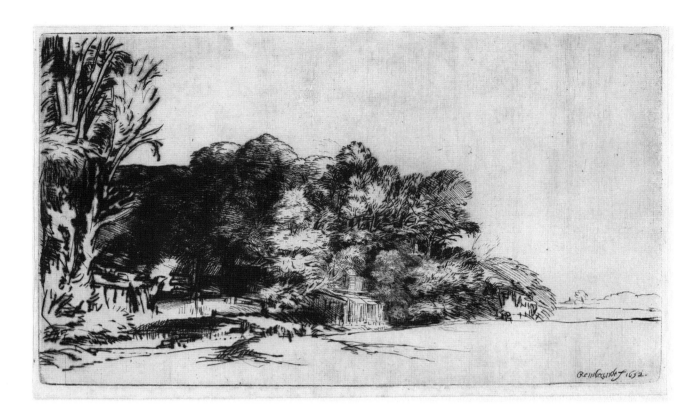

150
Rembrandt
Clump of trees with a vista
Inscribed *Rembrandt f. 1652*
Drypoint, 12.4 x 21.1 cm.
Bartsch 222 ii(2)
Haarlem, Teylers Museum

The effect of the two techniques – acid-bitten etching and mechanically incised drypoint lines – can be seen in these landscape prints of the same size, with similar subjects, figs. 149 and 150. The etching shows delicate, wavering, nearly tentative lines of roughly all the same width and intensity. The drypoint, in which most of the burr has been left standing, shows dramatic contrasts in all these properties. The lines are straighter, the transitions more angular. The overall contrast between the two prints is that between a rather dry, precisely observed farm portrait and a romantic evocation of bucolic picturesqueness. The etching provides a detailed

impression of the texture of the wood, brick and thatching of the farmhouse, specifics that you search for in vain in the drypoint.

This contrast should not be seen as difference in truth to life, with the etching as a documentary record. It has been observed of the etching that Rembrandt has performed a strange manipulation that undermines the veracity of the scene. The little structure on the left is an outdoor privy, which normally would be perched above water. The ground in front of the farmhouse has all the appearance of a shoreline. There is even a rowboat hidden in the reeds, with a stake in the ground

151
Rembrandt
Detail of *Cottage and farm
buildings with a man sketching*
(fig. 149)
Haarlem, Teylers Museum

152
Rembrandt
Detail of *Clump of trees
with a vista* (fig. 150)
Haarlem, Teylers Museum

153
From Abraham Bosse,
Tractaet ... (see fig. 143):
holding the burin

to which it could be moored. In other words, the area between the draftsman and the farm was a small body of water. After having etched it that way, however, Rembrandt added "ten inexpressive lines, while in the middle of the water (that now is supposed to be a meadow) he placed a group of small farm animals, consisting of a strange goat with curved horns and two sheep."[19]

These two prints illustrate opposite extremes of Rembrandt's two main techniques. In most cases, the effects of etched and incised lines approach each other more closely. It often takes a specialist with a magnifying glass to see the difference, and even then we are sometimes left in doubt. Christopher White has observed wisely that Rembrandt "aimed at a perfectly harmonious result which would not reveal the different tools employed. Everything was directed towards the end result, and the methods used had no *raison d'être* in themselves."[20]

Other tools that Rembrandt sometimes applied to his plates left even fewer distinctive marks. These were the engraving burin, the burnisher and the scraper. "The burin is a square shaft of steel with one end obliquely cut to a diamond-shaped tip and set into a wooden handle. Holding the burin in the palm of the hand, the engraver forces the sharp tool against the plate ... Rembrandt utilized engraving as a supplement

154
Rembrandt
St. Francis beneath a tree praying
Inscribed *Rembrandt f. 1657*
Drypoint and etching,
18 x 24.4 cm.
Bartsch 107 ii(2)
Haarlem, Teylers Museum

19 Voûte 1989, p. 28.
20 White 1969, vol. 1, p. 20.

on Japanese paper, which absorbs ink more liberally than European paper. Between them, these two moves allowed Rembrandt, from one and the same plate, to create prints with very different moods.

A final tactic that Rembrandt employed with a certain frequency was to print not on paper but on vellum. Impressions on vellum had a more velvety effect than those on paper; they also had the habit of shrinking after printing. Rembrandt used vellum not only for his more precious etchings, but also on occasion for his simplest ones. Fig. 157 is the same print, in the fourth state, as fig. 156. However, fig. 157, printed on vellum, shrunk so badly that Adam Bartsch himself, the great cataloguer of Rembrandt's etchings, thought that it was printed from a different plate and gave it a separate number, the ghostly, non-existent Bartsch number 301.

to etching rather than as an independent medium."[21] The burnisher was used to rub out incised lines in the plate, and the scraper to remove ridges that stood up from the surface, such as the burr of the burin or drypoint needle.

The two impressions of *St. Francis beneath a tree praying* here illustrated both show the same state of the same plate. The pronounced difference between them lies in two particulars alone: in printing fig. 154 Rembrandt cleaned the plate of ink outside the grooves before printing; in fig. 155 he left ink on the plate in certain key areas. This could be considered a form of modeling with sponge, rag and squeegee on the surface of a copper plate. Fig. 155 is moreover printed

21 Ackley 2003, p. 337.

158
Showcase in the Rembrandt
House with objects dug up
from the cess pit

In 1997, in the course of
reconstruction work on the
Rembrandt House, a cess pit
was excavated that dates from
the years of Rembrandt's
tenancy. Among the objects
found there are two pots that
bring us miraculously close
to Rembrandt the painter.
The relatively whole
earthenware pot in this
showcase in the museum
contains a mixture of chalk and
glue of the kind that Rembrandt
used for priming his canvases
and panels; the broken pot is
lined with dried lead white,
the bread-and-butter of the
artist's palette.

Graph 8
Panel and canvas as support
for Rembrandt paintings
(Source: Bredius-Gerson 1969)

22 Bomford et al. 1988. See also the
somewhat expanded version of part
of the introduction by Christopher
Brown in the *Grove dictionary of art*.
23 Van de Wetering 1997.
24 The paintings on copper are
Self-portrait, 1630 (Stockholm,
Nationalmuseum; Bredius 12)
Old woman, ca. 1630 (Salzburg,
Residenzgalerie; Bredius 63)
Laughing man in gorget, ca. 1628
(The Hague, Mauritshuis;
Bredius 134)
Night scene, 1628 (Tokyo, Bridgestone
Gallery; Bredius 533; doubted by
RRP).
Consider also *Man writing by candle-
light*, ca. 1629/30 (Minneapolis,
Dr. and Mrs. Alfred Bader;
Bredius 425; as "Circle of Rembrandt
Harmensz. van Rijn" in van de
Wetering and Schnackenburg 2001,
no. 59).
Those on paper, which perhaps should
not be called paintings at all, are

Paintings

Rembrandt's paintings are far more complex as physical
objects than his drawings and prints. Research into
them has proceeded far beyond the borders of art-
historical expertise, into areas of science, down to the
molecular level, that are mastered only by Ph.Ds in
physics and chemistry. As of yet, no synthetic study has
been published of the results of this research, or even
of more accessible investigative methods such as X-ray,
microscopic examination of pigments and the tree-ring
dating of wood panels. A one-chapter overview of
Rembrandt's painting materials and techniques cannot
therefore cover the ground as systematically as is poss-
ible for his work on paper. For an epochal exhibition
entitled *Art in the making: Rembrandt* in the National
Gallery, London, in 1988–89, the twenty paintings in
that collection were examined in the laboratory. Those
findings, made in a museum with extensive experience
in conservation science, still offer the largest body of
uniformly acquired scientific information concerning
Rembrandt paintings. This section is based mainly on
the catalogue of that show,[22] supplemented by Ernst
van de Wetering's outstanding book of 1997,
Rembrandt: the painter at work.[23]

Support and priming

Aside from four small early paintings on copper plates
and four on paper, Rembrandt painted exclusively
on two kinds of support, oak panels and canvases.[24]
The panels are mostly of Baltic oak and the canvases
of a standard variety manufactured in Holland for
general purposes, mainly ship's sails. At the start of his
career Rembrandt worked only on panel, at the end
only on canvas. The crossover point lay in the early
1640s. This was not untypical for the practice of other
painters of the time, such as Frans Hals. The main
external factor was size: the largest panel, *Man with
a bittern* of 1639, measures about 120 x 90 cm.[25] There
are about sixty larger paintings than this, all on canvas.
Rembrandt's formats, standing rectangles and ovals
and horizontal rectangles, are not exceptional.

In make and format the panels and canvases used
by Dutch painters are so similar that they are assumed
to have been bought across the counter rather than
prepared in the studio. The panels were sold in standard
sizes, with beveled edges. Canvases too, which come
in widths of one to three ells, were probably bought
by the piece.[26]

Raw wood and bare canvas are too uneven to be
painted on directly. They have to be covered first with
a ground that provides a level field, nonabsorbent and
capable of binding with oil paint. Craftsmen specialized
in priming canvases and panels were active in the
Netherlands in Rembrandt's time, but whether he made
use of their services is unclear. The National Gallery
panels are coated with "a fairly thin layer of chalk

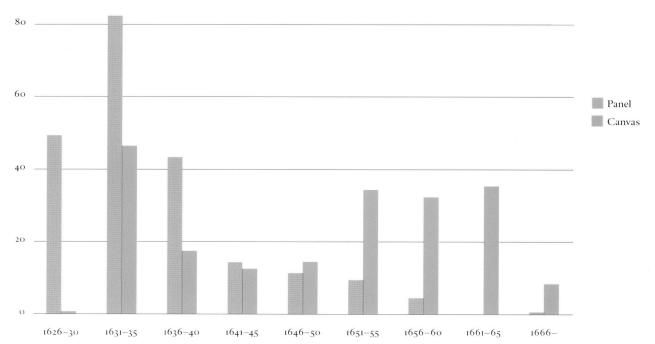

Christ at Emmaus, ca. 1628 (Paris,
Musée Jacquemart-André; Bredius
539)
Christ before Pilate and the people,
1634 (London, National Gallery;
Bredius 546)
Joseph relating his dreams, ca. 1635
(Amsterdam, Rijksmuseum;
Bredius 504)
and *The lamentation over Christ*,
ca. 1637/43 (London, National
Gallery; Bredius 565).
Consider as well *The rest on the flight
into Egypt*, ca. 1629/30 (The Hague,
Mauritshuis; Bredius 556; as "Circle
of Rembrandt" in van de Wetering
and Schnackenburg 2001, no. 65).
25 Karin Groen and Ella Hendriks,
"Frans Hals: a technical
examination," in Slive 1989,
pp. 109–27. Groen and Hendriks
(p. 109) report that about three-
quarters of Hals's paintings are on
canvas. In the case of Rembrandt,
the ratio is about fifty-fifty. Hals
would use canvas for any painting
larger than about 60 x 50 cm.
Rembrandt would stay with wood
for considerably larger paintings,
which can be taken as a systematic
preference on his part that lasted
until the 1640s.
26 Van de Wetering 1997,
pp. 108–09, 124.
27 Bomford et al. 1988, p. 30.
The discovery that all known Dutch
paintings of the seventeenth century
with a quartz ground emerged from
Rembrandt's studio was made by
Hermann Kühn in 1963. The
evidence was amplified by Karin
Groen, in "Grounds in Rembrandt's
workshop and in paintings by his
contemporaries," in van de Wetering
2005, pp. 318–34.
28 Van de Wetering 1997, p. 23.
29 Bomford et al. 1988, p. 32.
30 Freise 1911, pp. 20–21, nos. 32–34,
64 and (with six panels) 66.
Fascinatingly, one of the paintings in
dead color was a self-portrait.

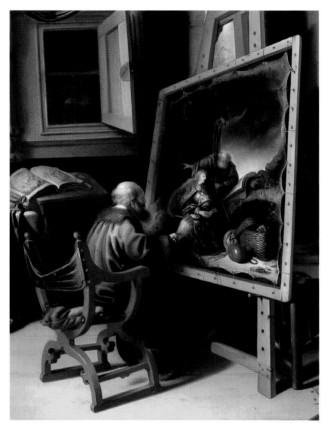

(calcium carbonate) bound in animal-skin glue, which tends just to fill the grain of the wood." The ground "is covered with a very thin imprimatura, generally of a warm yellowish brown." On the canvases two kinds of ground are encountered. Some have "a single layer of coarsely sieved quartz (silica sand) tinted with a little brown ochre and containing a low proportion of lead white, the mixture bound together in a drying oil." This ground is encountered only on canvases painted between 1642 and 1669 by Rembrandt or his studio. Beside his soft etching ground, the quartz ground on canvas can be considered a technical innovation by Rembrandt. The advantage of this medium, it is assumed, is that it is cheaper than the alternatives.[27] The other is a double ground of cheap earth pigments that fill in the weave of the canvas, with an upper layer of tinted lead white for the surface to which the paint would be applied. Of the thirteen canvases in the National Gallery examined for these features, four have a single-layer ground in white or beige, and nine a double-layer ground, the upper layers ranging from lead white to dark brown. Since Rembrandt "exploited the possibilities of tinted grounds to the full,"[28] he must have been attentive to their color, whether he bought pre-primed panels and canvases or did the job in his studio.

The paint layers

Seventeenth-century sources tend to describe the procedure of painting as a three-stage operation. The German artist Joachim von Sandrart (1609–88), who knew Rembrandt from a long stay in Amsterdam (1637–42), "is specific in describing three stages: first (he says) the artist should lay on the sketch, including 'all its appurtenances,' then 'examine it well and with dead colours (which one calls underpainting) correct the errors still to be found and finally, when it is thoroughly dry, with diligence paint it over and complete it."[29] None of the terms used for the preliminary stages – the laying-on sketch, dead color, underpainting – is unambiguous. Other contemporaneous sources use them in a different sense from Sandrart's or define the stages slightly differently.

Yet the evidence from X-ray and paint cross-sections seems to confirm that Rembrandt followed roughly this method. The main features of his paintings are under-painted in monochrome in all their details and are sometimes, as in Sandrart's second stage, corrected or worked up further in brown or gray. Fascinatingly, an inventory of Pieter Lastman's goods drawn up in 1632 includes references to no fewer than ten paintings in the dead-color stage. Apparently it was the practice of Rembrandt's master to finish his paintings up to this point and allow them indeed to dry thoroughly, before finishing them, presumably when they are ordered by a customer.[30]

In the final stage, the composition as laid down in monochrome would be covered in full color. (In passages where the tint of the underpainting or even the white of the ground provided the touch needed, this would be left uncovered.) The Rembrandt Research Project has developed the theory that the early Rembrandt always worked from back to front. That is to say, he painted the skies and landscapes of his

161
Rembrandt
Detail of *Portrait of an eighty-three-year-old woman, identified as Aechje Claesdr.*
Inscribed *Rembrandt. f|1634 | AE. SVE 83*
Panel, 68.5 x 53.5 cm.
Bredius 343
London, National Gallery

162
Rembrandt
Detail of *Portrait of an elderly man, perhaps the Amsterdam merchant and art collector Lodewijk van Ludick* (fig. 361)
The Hague, Koninklijk Kabinet van Schilderijen Mauritshuis

paintings first, reserving the areas where objects in the middle- and foreground were planned. "One hardly ever finds layers of paint abutting each other along a common boundary. The paint of one area nearly always slightly overlaps that of the other, showing that the overlapping part was the last one painted."[31] And that part, according to this theory, is always more to the foreground than the one it covers.

This procedure can only be carried out by grace of a complete underpainting. As he grew older, Rembrandt took more liberties in the course of his work on a painting, simplifying the underpainting and working up the surface in a less systematic way.

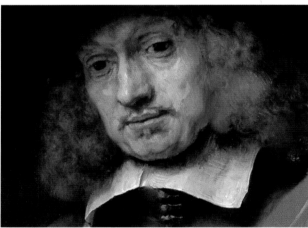

163–64
Rembrandt
Details of *Jan Six* (fig. 165)
Amsterdam, Six Collection

165
> Rembrandt
Jan Six (1618–1700), Amsterdam Reformed rentier, poet and future burgomaster
Unsigned, undated. Ca. 1654
Canvas, 112 x 102 cm.
Bredius 276
Amsterdam, Six Collection

31 Van de Wetering 1997, p. 33. The author's main source for this procedure in the literature of art is from Gerard de Lairesse's *Groot schilderboeck*. However, that authority recommends it only for paintings in which landscape is the predominant element. For paintings in which figures or other foreground features are the most important, he advises the artist to start with them and work toward the back. De Lairesse 1707, p. 12.

Whereas an early painting could not be left unfinished and still look like a complete composition, this became possible in later years. Several paintings from the 1650s and 60s are complete in their foremost passages and unfinished in secondary areas.

Rembrandt's application of paint also underwent a fundamental change in the 1640s, from a smooth to a rough style. The difference in the overall appearance of paintings answering to the purest forms of these descriptions can be great. However, a close look at the actual brushstrokes, as in the eyes of a portrait from 1634 and one from 1667, shows that the shift is limited in scope. The kind of details observed and the care with which the strokes are laid down are not diminished. The big difference is in the structure of the brushstrokes, which are unbroken in the early portrait and somewhat crumbly in the later one.

Associated with the smooth and rough modes were approaches we might call extensive and abbreviated. Both were available to Rembrandt throughout his career, sometimes occurring in a single work. A striking example in painting is the portrait of Jan Six from 1654, in which the sitter's face and collar are rendered in great detail, while his hand and glove are painted in a manner that looks slapdash up close but from a distance evokes the subject convincingly. The fact that the portrait as a whole stays together is due to a kind of sleight-of-hand; the artist plays with the willingness of the eye to be deceived.

To help the viewer's eye fool itself, Rembrandt employed a limited range of pigments in a variety of inventive ways. "Rembrandt's panel and canvas paintings are dominated by the most limited selection of pigments: the artificial colours lead white and bone black, as well as a generous selection of natural earth pigments, such as the ochres, siennas and umbers ... Much use is made too of lake pigments. These are a specific category of artificially prepared glazing pigments, for which the source of color is a natural dyestuff of plant or animal origin" Rembrandt's reds were red ochres and red lakes. For blues, he used natural azurite, which came from Central Europe, and smalt, a locally manufactured "potash glass coloured blue by the addition of cobalt oxide Yet this

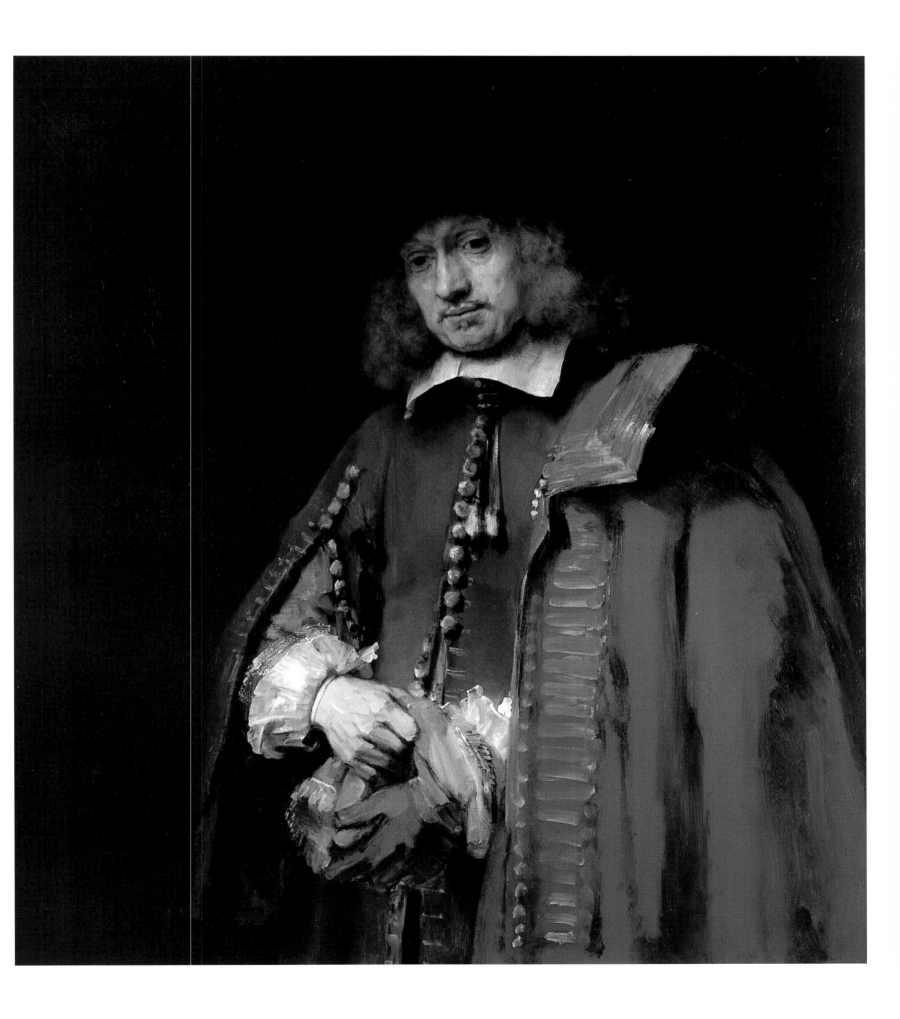

166
Cross-section of paint sample from the skirt
of Saskia in *Saskia as Flora* (fig. 556), magnified 175x
London, National Gallery

The lower two layers are the double ground: "coarse,
impure orange-red earth below," covered by lead
white with some charcoal black. The pigment layers above
are doubled because the artist changed the
subject of the painting in this passage.[32]

167
Cross-section of paint sample from the background
of the *Adoration of the shepherds*, magnified 240x
Inscribed *Rembrandt f. 1646*
Canvas, 65.5 x 55 cm.
Bredius 575
London, National Gallery

"The ground has been identified as a rough-textured
single layer of quartz (silica) combined with a quantity
of brown ochre bound in linseed oil."[33]

168
Cross-section of paint sample from the stirrup strap of
the horseman in the equestrian portrait of *Frederik Rihel*
(fig. 355), magnified 175x
London, National Gallery

"Brightest red impasto of stirrup strap, worked
in red ochre mixed with red lake pigment, over
darker underlayers."[34]

description of Rembrandt's palette, however accurate,
obscures the point of the painting method, in which
color and transparency are adjusted as continuously
varied combinations of relatively few pigments, and
further modified and adjusted as one layer of paint
is laid over another until the desired effect has been
reached."[35]

Modulating techniques of the kind referred to include
the composition and application of the binding medium

(mainly linseed oil), glazes (translucent paint) and
varnishes. There is lively discussion among specialists,
a discussion I am not qualified to join, concerning the
extent to which these materials and processes were
employed deliberately by Rembrandt to achieve certain
effects.

Beside pigments and their colors, oils, varnishes and
resins and their qualities, Rembrandt also worked with
surface structure. Here too, although there is a move-
ment from relatively flat surfaces in the early work
to highly structured ones later, Rembrandt used both
modes early and late. Two details from *Saskia as Flora*
in the National Gallery show a flat surface in her skin,
a low relief in her hair, including strokes with the butt
end of the brush, and in her sash a surface built of
mighty clods.

Rembrandt's highly conscious painting technique has
become the subject of a particular chic idea in recent
decades. It is often said that the surface of his paintings
and not the depicted depths form their real subject.
According to this idea, which is applied mainly to paint-
ings with heavy impasto, Rembrandt wished the viewer
to see his paintings not as representations but as "paint
itself."[36] I can find no justification for this notion either
in the paintings or in contemporaneous writing on art.
On the contrary, such passages took on their meaning
for Rembrandt and his contemporaries when seen from
a distance. Details that did not convey recognizable
form from close up but did so from further away are
cited as examples of particular mastery. The aim, in
Ernst van de Wetering's phrase, is "technique in the
service of illusion."[37]

169–70
Rembrandt
Two details of *Saskia as Flora*
(fig. 556)
Inscribed *Rem..a 1635*
Canvas, 123.5 x 97.5 cm.
Bredius 103
London, National Gallery

32 Bomford et al. 1988, p. 63.
33 Bomford et al. 1988, p. 92.
34 Bomford et al. 1988, p. 139.
35 Bomford et al. 1988, pp. 21, 23.
36 Alpers 1988, p. 14. Svetlana
Alpers works this idea particularly
heavily.
37 In Brown et al., pp. 12–39.

171
Raphael (1483–1520)
Detail of *The blinding of Elymas*
Unsigned, undated. Ca. 1516
Body color on paper,
304 x 405 cm.
Cartoon for tapestry woven
in Brussels
London, Victoria and Albert
Museum

172
Rembrandt
The blindness of Tobit
Inscribed *Rembrandt f 1651*
Etching, 16.1 x 12.9 cm.
Bartsch 42 i(2)
Haarlem, Teylers Museum

38 Slive 1953, pp. 129, 131, 219–21.
Roscam Abbing 1999, pp.89–128.
39 Acts 13:6–12. From the website
of the Victoria & Albert Museum:
http://www.vam.ac.uk/collections/
paintings/raphael/index.html
(9 July 2005). See there for a full
image of and information on the
Raphael cartoon.

Form

Rembrandt's less than consummate draftsmanship was one of the favorite targets of his early critics. He was not a bad draftsman, though. He only had other things on his mind.

In the chapter on the household, the reader might have noticed that Roger de Piles's compliment to *Rembrandt's maid: girl at a window*, a painting he bought himself, was rather left-handed. The painting achieved the greatest heights of illusionistic power, he wrote, but "As one can imagine in the case of Rembrandt, it was neither beauty of drawing nor nobility of expression that produced this effect." De Piles was the author of a famous grading system for artists, published in the same book, *Cours de peinture par principes*, as the remarks on *Rembrandt's maid*.[38] For "Dessein," the basis of form in art, de Piles gave Rembrandt six out of twenty points, the lowest score in this category. The highest grade, eighteen, was awarded to the artist whose work provided the measuring-stick for excellence in form, Raphael.

In fact, Rembrandt had no less admiration for Raphael than did de Piles. When we see the way in which he adapted the Italian master's work in his own, however, the difference in terms of form is apparent. In an etching of 1651 of blind old Tobit making his way to the door to greet his returning son, Rembrandt adapted the figure of a blind man by Raphael. "The Jewish sorcerer Elymas has just been struck blind by Paul because he tried to prevent Peter and Paul from converting the Roman proconsul Sergius Paulus to Christianity."[39] The detail is from a cartoon by Raphael for tapestries ordered by Pope Leo X for the Sistine Chapel in 1515, tapestries that were woven in Brussels first for the Pope and subsequently for other patrons who ordered sets for themselves. The cartoons were acquired by King Charles I in 1623; Rembrandt could have known the design from a set of tapestries or from an engraving by Agostino Veneziano.

The formal differences between Raphael's figure and Rembrandt's are characteristic. Raphael delineates the outlines of the blinded sorcerer in clear and fluid lines, taking care to show the forms of the body even in the heavy clothing, clothing that itself is arranged in elegant folds. These qualities are not altogether missing in Rembrandt, but he is willing to sacrifice them for other values. The sense of excitement and motion – call it (e)motion – are more important to Rembrandt than clarity of form. The barely defined clothing of the old man conceals his limbs. The outline of the figure is not complete; only in part is it presented as a major compositional element. In Raphael the modelling in dark and light hews to the drawing of the forms. Rembrandt, on the contrary, uses a variety of graphic conventions, such as cross-hatching and parallel strokes, that sometimes cut across the outlines of the subject.

which does not allow for finesse, careful definition or even correct drawing. Rembrandt also downplays the erotic element in his nudes, a quality that was highly appreciated by connoisseurs.

Lacking from the corpus of Rembrandt drawings are the kinds of studies associated with High Form in the art of Rembrandt's era: detailed studies of limbs, drapery, figures. If de Piles gave Rembrandt a six for *dessein*, Rembrandt would probably have understood why. Nonetheless, Roger de Piles was a fan of Rembrandt's. Not only did he buy a painting by the Dutch master but he also owned a large number of drawings by him.

Color

The color effects in Rembrandt's paintings, especially his flesh tones, derive less from the tone of his pigments than from the rich glow he was able to create with transparent pigments and glazes. His color range itself is surprisingly small.

Walk into the Dutch room in any large painting gallery with a color meter, point it at the pictures on the wall, and chances are that the warmest value will be registered by the Rembrandts. Of another suggested experiment, easier to carry out, Paul Taylor wrote: "If one asks a friend to stand next to a Rembrandt or a Hals, the colours of nature often seem faded and washed-out compared to the colours of art; and yet we do not, normally, notice the extent of the artifice when looking at a picture."[40]

And artifice it is. In general, Dutch painters were sparing in their use of reds, and to this rule Rembrandt was no exception. The rich tone of his paintings is achieved mainly with brown earth colors, applied in varied and ingenious ways. Conservation scientists and

173
Govert Flinck (1615–60)
Reclining nude
Inscribed *G. Flinck.*
Undated. Ca. 1650
Black chalk and white chalk
on blue paper, 24.9 x 41.2 cm.
Paris, Fondation Custodia
(Frits Lugt Collection)

The center of gravity in Rembrandt's Tobit lies within the figure, coexistent with the old man's feelings; in Raphael's Elymas it is more diffuse, shared with more formal values. Rembrandt's figure cannot be called inferior to Raphael's as an image of helpless blindness or even as a standing man, but it bypasses many of the concerns that Roger de Piles and many with him understand under *dessein, disegno,* form.

Some of Rembrandt's pupils felt this as a lack and went further than he did in approximating classical standards. Govert Flinck (1615–60) created figure studies and nudes in the academic tradition that provide instructive comparisons with Rembrandt. He preferred fine chalk and pen drawings on blue paper with highlights in white, a technique that Rembrandt avoided, probably studiously. The nudes that are still attributed to him – they have been removed in the dozens from his oeuvre and Flinck's as well – are often in reed pen,

174
Rembrandt
*Reclining nude, leaning
forward, asleep*
Unsigned, undated.
Ca. 1657
Brown ink and wash,
13.5 x 28.3 cm.
Benesch 1137
Amsterdam, Rijksmuseum

175
> Rembrandt
Titus
Inscribed *R*
Undated. Ca. 1657
Canvas, 69 x 57 cm.
Bredius 123
London, Wallace Collection

40 Taylor 1998, p. 171.

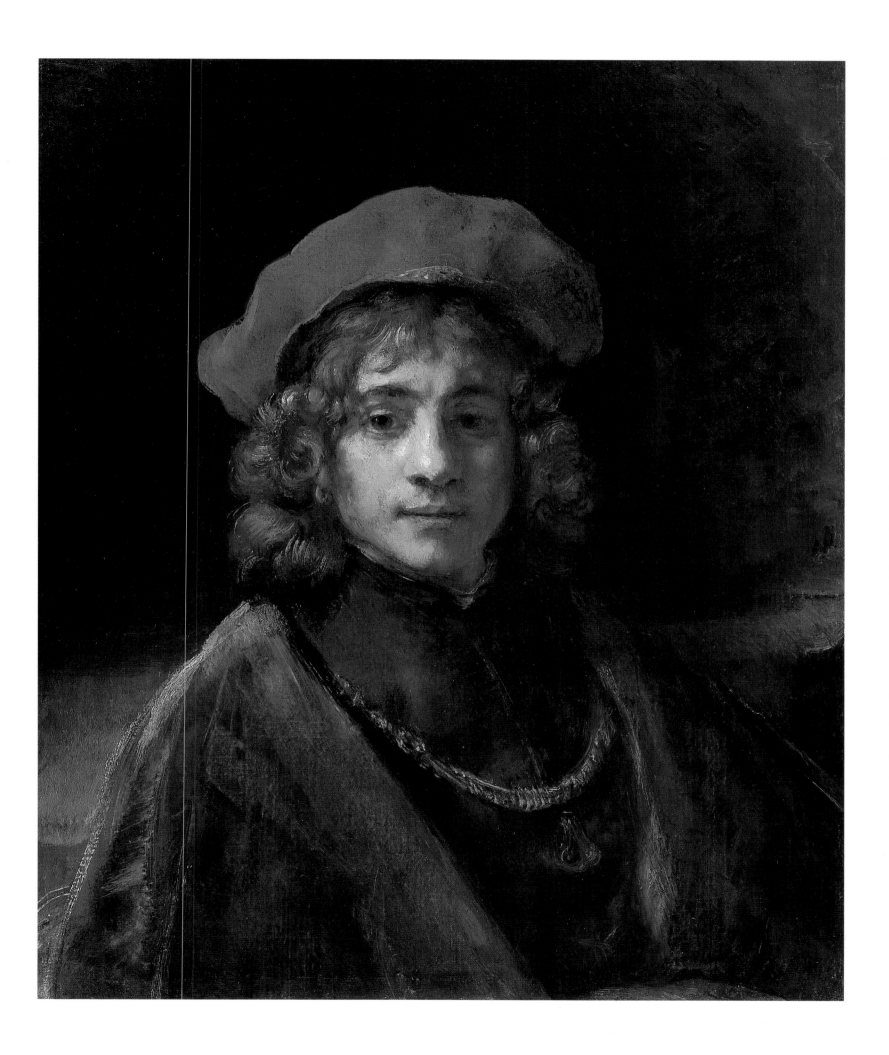

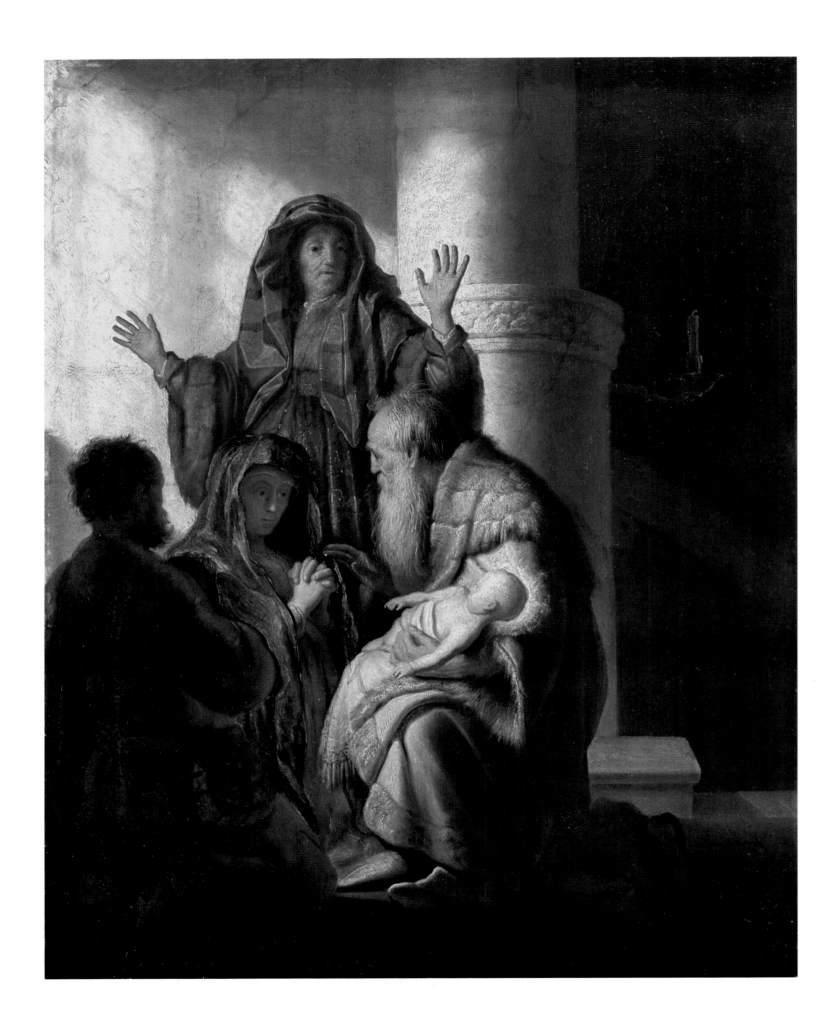

restorers who have studied Rembrandt's work closely insist on this point again and again: the look of his paintings comes about not mainly through the properties of his raw materials but the way he used them.

Taylor made his observation in an article on a revelatory discovery he made concerning the luminous tones of flesh and fabric in the work of Rembrandt and others. Researching the use of the term "glowing" (*gloeyend*) in art treatises, he found that it referred to a specific technique that according to Karel van Mander was practiced to great effect by Hendrick Goltzius (1558–1617) after being brought from Italy to the Netherlands in 1597 by an artist named Frans Badens (1571–1618). Badens was an artist's artist, an innovator held in high esteem by his peers but relegated to the dustbin of art history after his death.

The phenomenon he calls the glow, Taylor found, was achieved by "mixing red ochre, organic red or vermilion" into the second layer of a ground and using warm underpainting covered by reddish glazes. In an attempt to trace the technique back to Italy, Taylor came no closer than Correggio, Titian and Veronese, none of whom, however, "shaded their figures quite as warmly as Goltzius or Badens … At present, it would seem that the glow was one of those creative misunderstandings in the history of art; in their attempts to capture the warmth of the Italian style, Badens and Goltzius went too far, and so created a new manner."[41]

Rembrandt made thankful use of this manner. If he too associated it with sixteenth-century Italy, the coloring of his paintings can be brought into line with his manifold and ever-increasing appropriations of Italian sixteenth-century motifs in his subjects.

It would be a mistake however to isolate color as a quality on its own in Rembrandt's art. The search for glow forms part of an artistic ambition to achieve maximum lifelikeness and operates in tandem with shadow, modelling, perspective and expression. Significantly, none of Rembrandt's notes on drawings – a medium used by many artists as a color reminder – mentions color at all. Rembrandt's downplaying of local tone, the actual color of an object depicted, fits in with a distinction drawn by Roger de Piles between "couleur" and "coloris." The former refers to the colors of existing objects, the latter to the artist's pigments.[42] Of Rembrandt, de Piles writes that he was a master in juxtaposing "des couleurs amies," befriended colors, a method that places more value on *coloris* than *couleur*. In his grade scale of artists, de Piles measures *coloris* as one of the four chief values, giving Rembrandt a seventeen, equal to Rubens and second only to Titian and Giorgione. This too, like his six for *dessein*, Rembrandt would have understood.

41 Taylor 1998, p. 169.
42 Roscam Abbing 1999, p. 112.
43 Quoted from the quite good, little-known English translation, de Lairesse 1817, vol. 1, p. 163.
44 Janis Callen Bell, in *The dictionary of art*, vol. 6, p. 570.
45 Blankert 1997, no. 2.

176
Rembrandt
Simeon with the Christ child in the Temple
Inscribed *Rembrandt f..*
Undated. Ca. 1629
Panel, 55.5 x 44 cm.
Bredius 535
Hamburg, Hamburger Kunsthalle

Light

As limited as was the range of colors in which Rembrandt worked, so broad was his palette of light and dark, which covers the entire spectrum. Rembrandt does not draw surface compositions in light and dark; he molds them spatially. He was practically a sculptor in light and dark.

The fifth book of Gerard de Lairesse's *Groot schilderboeck* (1707) is devoted entirely to the subject of "lights and shades." It opens with the simple and forceful statement: "I judge this point to be one of the most important in the *art of painting*, for without a thorough knowledge of it it is impossible to make a good picture."[43] In twenty-five chapters, more than in any other of the thirteen books of his treatise, de Lairesse treats an immense variety of problems related to light in painting. Separate attention is devoted to "common" light and to the light, shadows and reflections of the sun (in different weathers and times of day), moon, stars, torch, lamp, candle and open fire.

All of these problems were dealt with by Rembrandt, who richly deserves his legendary reputation as an unsurpassed master of dark and light. Light was more important to him than color, if only for the reason that in the monochrome art of etching as well as in painting Rembrandt thinks in terms of light and dark. The light about which Gerard de Lairesse writes is light as we see it in the world. There are also forms of light that are entirely at the disposal of the artist. The distinction may not have been put into writing until the late eighteenth century, when Denis Diderot wrote that "chiaroscuro was … based on the imagination of the painter, while light and shadow depended on scientific principles."[44] Despite their late date, Diderot's remarks make sense for Rembrandt, whose mastery extends over all these forms and more.

In one of the early paintings that made the greatest impact on contemporaries, *Simeon with the Christ child in the Temple,* Rembrandt demonstrates an awareness of light not only in its natural and artistic dimensions but also as a supernatural and symbolic quality. The scene inside the Temple in Jerusalem has two sources of light. Daylight streams through a window outside the picture space on the left. The shadow of the window-bars on the wall has been called the earliest use of this motif in painting.[45] In the center of the painting is another, more subdued but more significant light source: the Christ child has a glowing halo. This light cannot but remind the viewer who knows the Bible story that Simeon called the Christ child "a light to lighten the Gentiles and the glory of thy people Israel." On the right is an extinguished candle – No Light, as it were – suggesting the burnt-out Old Covenant, replaced at this moment by the New.

In addition to depicting the action of various kinds of light on various surfaces, the composition has another feature relating to light. It silhouettes a dark foreground figure, seen from the back, against a lighter background.

177
Rembrandt
Officers and guardsmen of the
Amsterdam civic guard company
of Captain Frans Banning Cocq
(1605–55) and Lieutenant Willem
van Ruytenburgh (1600–52):
"The night watch"
Inscribed *Rembrandt f 1642*
Frans Banning Cocq, heer van
purmerlant en Ilpendam
Capiteijn
Willem van Ruijtenburch van
Vlaerding heer van Vlaerdingen'
leutenant
Jan Visscher Cornelisen'
vaendrich
Rombout Kemp' Sergeant
Reijnier Engelen' Sergeant
Barent Harmansen
Jan Adriaensen Keyser
Elbert Willemsen
Jan Clasen Leijdeckers
Ian Ockersen
Jan Pietersen bronchorst
Harman Iacobsen wormskerck
Jacob Dircksen de Roy
Jan vander heede
walich Schellingwou
Jan Brugman
Claes van Cruysbergen
Paulus Schoonhoven
Canvas, 363 x 437 cm. (strips
cut off the top, left and bottom)
Bredius 410
Amsterdam, Rijksmuseum
(on loan from the city of
Amsterdam)

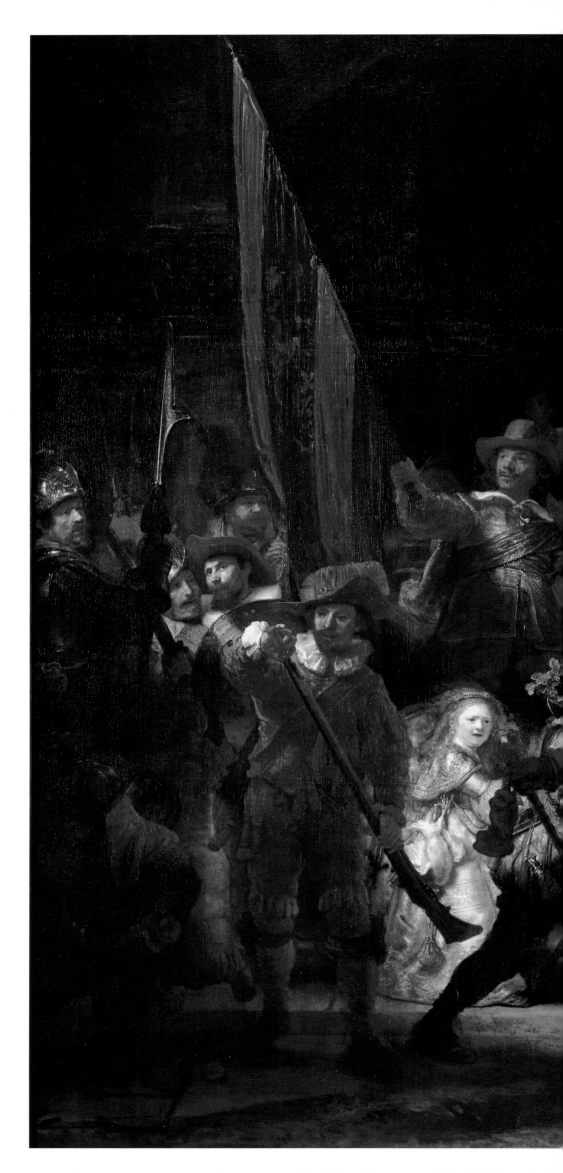

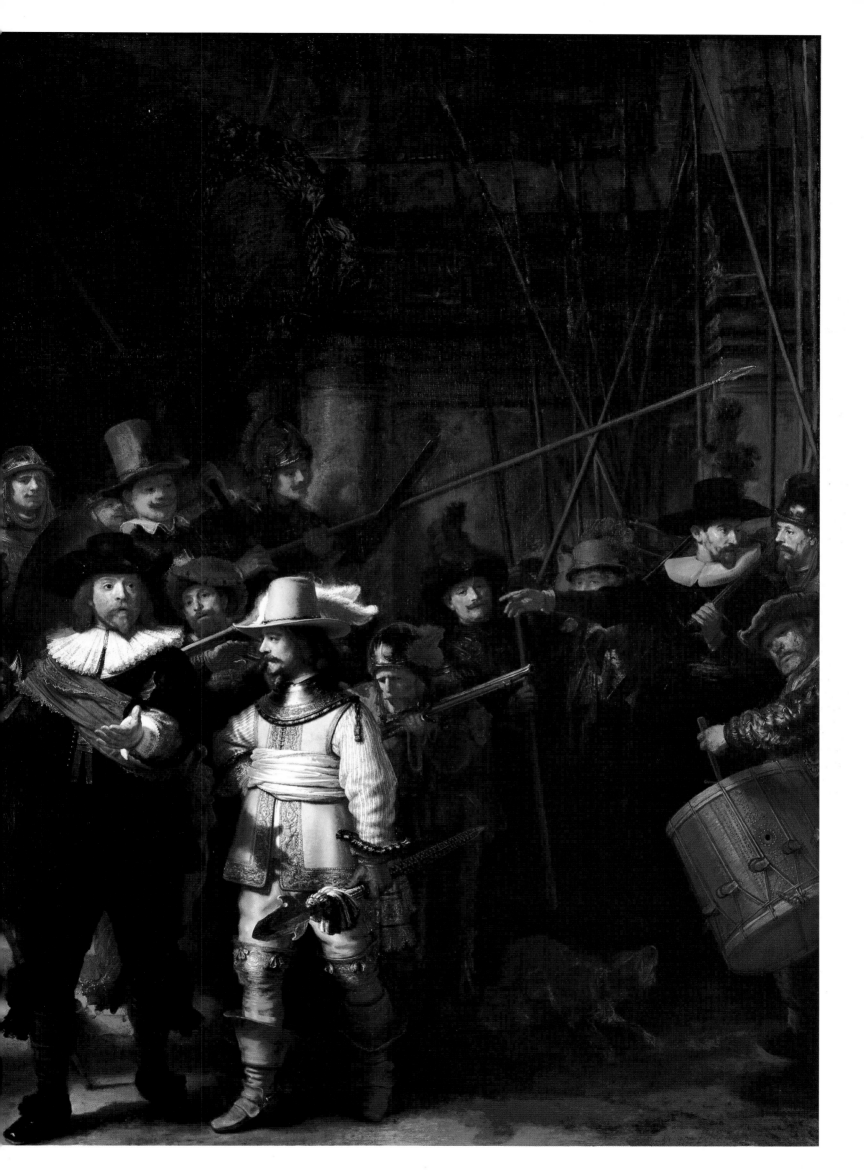

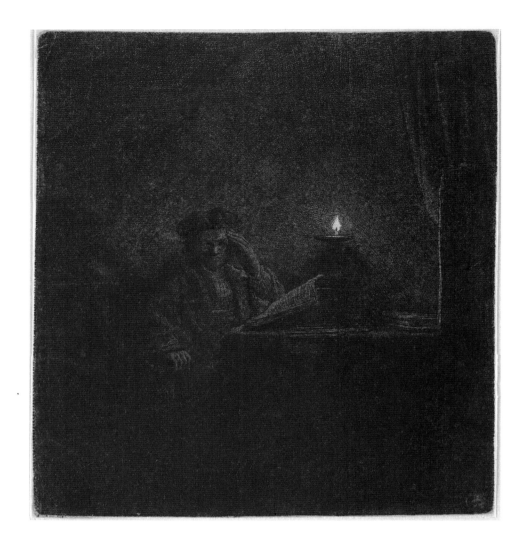

This play with darkness and light is an application of chiaroscuro as a device for composing in dark and light. This principle, turned into a trademark in early seventeenth-century Italy by Elsheimer and Caravaggio, was available to all seventeenth-century artists and was applied in one form or another by most. Rembrandt practiced a pronouncedly spatial variety of chiaroscuro. He uses it as an organizational device less on the picture plane than in the picture space.

The work that from the time of its creation was Rembrandt's most famous and most public painting, *The night watch*, was also known from its origins as a daring composition in dark and light. Here there seems to be a single, powerful shaft of light coming from behind us in the upper left. If it is sunlight, we must assume that it is shining over a building or through a window, since it falls directly only on the central group of figures, the captain and lieutenant, the girl and boy mascots. The rest of the figures are lit spottily, mainly in their faces; the left foreground is in shadow. The bright central light is offset by the gaping black hole inside the archway, where we would expect to see a view either into an interior or, if the edifice is a city gate, of the territory beyond. The absence of a view through the arch would be explained if it is a city gate whose further door is closed. If that is the case, then the time of day would indeed be night, and the light would have to be artificial. This possibility is usually denied vociferously, but perhaps it should be taken once more into consideration. The light and dark of *The night watch* distinguish it from other civic guard portraits at least as strikingly as the dynamism of the composition, which all commentators note. The light and dark in the painting were also the subject of discussion in its own time. Samuel van Hoogstraten closes his famous, very favorable judgment of the painting with the sigh, "Although I do wish he had lit it with more light."

Rembrandt's preoccupation with light and dark in the period of *The night watch* is illustrated dramatically in two etchings from that time. In these plates, rather than mixing light and dark, he minimizes first one, then the other. A scholar burns the midnight oil in a study lit by a single wick, producing barely enough light to make the subject visible. In *The descent from the Cross* the scene is blanched in brilliant light, a light that infuses nearly the complete subject without casting the shadows that help define volumes. The prints allow for only the dimmest definition of space and form, without the benefit of modeling in light and dark. Here too, Rembrandt makes use of the human inclination to fill in missing visual information in order to create a picture in one's own mind.

These examples are intended not to cover the field, but only to show the viewer that Rembrandt always thinks in light and dark. If there is any branch of art that he expanded more than another, it was the use of light and shadow.

178
Rembrandt
Student at a table by candlelight
Inscribed *Rembrandt.*
Undated. Ca. 1642
Etching, 14.7 x 13.3 cm.
Bartsch 148 i(1)
Haarlem, Teylers Museum

179
Rembrandt
The descent from the Cross
Inscribed *Rembrandt. f. 1642*
Etching, 14.9 x 11.6 cm.
Bartsch 82 i(1)
Haarlem, Teylers Museum

Observation

So compelling are Rembrandt's drawings that they all seem to be first-hand observations from nature. But we have no way of knowing if this was really so. What he saw in older art and in his mind's eye was just as real to him.

In 1977 the English sculptor Nigel Konstam published an article making a strong claim for the importance of direct observation to Rembrandt. "Rembrandt is at his best when he is able to observe directly from a stable studio situation, and as the visual stimulus receded from this optimum the quality declines …. He was a less sure draughtsman when drawing from his imagination."[46]

Konstam arrived at this conclusion on the basis of fascinating three-dimensional reconstructions of the positions of the figures in a number of drawings. Creating maquettes of a particular drawing, Konstam was able to show that the poses in one or more other drawings are in fact identical, but seen from another angle or through an angled mirror.[47]

A corollary to this argument is that Rembrandt drew by preference from living models, even for his history subjects. Konstam cites two drawings of a beheadal, which he argues was enacted – though not to the bitter end – by models in the studio. "Rembrandt's models

180
Rembrandt
A woman in Zeeland costume, from the back
Unsigned, undated. Ca. 1636
Pen and wash, 22 x 15 cm.
Benesch 315
Haarlem, Teylers Museum

181
Rembrandt
A woman in Zeeland costume, from the front
Unsigned, undated. Ca. 1636
Pen and wash, 13 x 7.8 cm.
Benesch 314
London, British Museum

46 Konstam 1977, p. 97.
47 Konstam's demonstrations have been dismissed or contested, I believe too easily. Royalton-Kisch 1992, no. 20, p. 70. One of Konstam's assumptions was that Rembrandt must have owned a large mirror in addition to the small one he used for his self-portraits. He was not aware that there is a strong indication in the documents that Rembrandt did indeed work with a large mirror. See Doc. 1658/13.

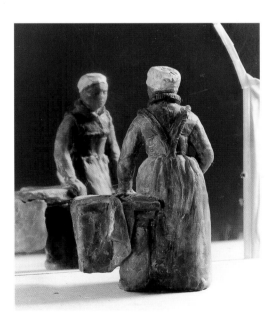

182
Nigel Konstam
Maquette with mirror based on two Rembrandt drawings of a woman in Zeeland costume
Ca. 1977
Plaster and mirror
Casole d'Elsa, collection of the artist

183
Rembrandt
The shell (Conus marmoreus)
Inscribed *Rembrandt f. 1650*
Etching, drypoint and burin,
9.7 x 13.2 cm.
Bartsch 159 ii(3)
Haarlem, Teylers Museum

184
Photograph of the marbled
cone snail *(Conus marmoreus)*

48 Despite this, Svetlana Alpers
writes of Konstam's ideas concern-
ing Rembrandt's studio, which
underlie her chapter "The theatrical
model" in Alpers 1988, that "no
theatrical conclusions were drawn"
by him. P. 134, note 24. Treatment
of this kind has turned Konstam into
a disappointed foe of all Rembrandt
experts.
See http://www.verrocchio.co.uk/.
49 Konstam 1977, p. 98.
50 De Winkel 2006, in press.
51 Roelof van Gelder and Jaap van
der Veen in van den Boogert 1999,
p. 53, citing Michael Latcham,
curator of musical instruments of
the Haags Gemeentemuseum, write:
"The harp is the musical instrument
that appears most often in paintings
and prints by Rembrandt … These
are often imaginary instruments,
unlike any known seventeenth-
century examples in terms of shape
and decoration."
52 Hinterding et al. 2000,
pp. 260–61.
53 Houbraken 1718–21, vol. 1, 1718,
p. 265.

seem to have been such remarkable actors," he writes.[48]
Konstam connects this phenomenon with the decline
in the production of drawings in Rembrandt's later
years. "This may well have been because of his bank-
ruptcy and the consequent loss of his mirrors and
theatrical wardrobe. But most important, in my view,
is the fact that he was no longer in a position to employ
models."[49]

At the other end of the spectrum is the equally strong
claim by Marieke de Winkel that Rembrandt did not at
all work by preference from living models in theatrical
costume. Approaching the question from the point
of view of costume history, she finds little evidence for
this and much for the use by Rembrandt of old prints
as a source for his historical compositions and portraits
in old-fashioned garb. According to her, Rembrandt
did not observe his dressed figures as much as concoct
them. "A painter could create garments from fantasy
with almost endless possibilities,"[50] she writes, and that
is what she says Rembrandt did.

Although de Winkel does not spell this out, her judg-
ment also contains the germ of a theory explaining why
Rembrandt made so few drawings in his latter years.
The reason would not be an inability to pay models,
but rather that his magnificent collection of graphic
art was sold in 1658. This idea is backed up by the pat-
tern of borrowings we detected above, in the section on
"Artistic tradition inherited" (pp. 24–39). Rembrandt's
increasing dependence in the 1640s and 50s on six-
teenth-century Italian sources was rudely interrupted
by the sale of his collection, a blow from which he never
recovered.

My own feeling is that it is more difficult than
Konstam thinks to distinguish eyewitness drawings
from those invented in the artist's mind's eye and less
certain than de Winkel thinks that Rembrandt depend-

ed more on old prints than on drawing from the model.
Both approaches open our eyes to certain aspects
of Rembrandt's practice, but both are too categorical
to do justice to the wide sweep of what "observation"
meant to Rembrandt. Rembrandt stood open to visual
and imaginary inspiration of all kinds. His figures and
compositions, in whatever medium, may be directly
observed, adapted from a model in older art or his own
store of drawings, invented from fantasy for the occa-
sion or combine elements from all of the above. Even
in his landscape drawings, where we might expect
to be able to see whether a particular sheet was drawn
on the spot or reconstructed in the studio, opinion on
the matter is often just that – opinion.

Concerning the quality of Rembrandt's observation
as such the same proviso is in order. Just as we are
allowing ourselves to be swept off our feet, which is all
too easy, by his acute eye for body language or human
psychology or natural form, along comes an expert
in musical instruments, arms or animals to tell us that
the master was not looking very carefully at all.[51]
One revelation of this kind concerns the famous *Shell*
of 1650. Rembrandt's version is too dark, it contains
hatching where the natural shell is sheer white and the
artist incorrectly drew a black contour along the white
areas of the shell.[52]

Arnold Houbraken makes an intriguing comment on
Rembrandt's powers of observation. Trying to explain
how the master depicted the emotions so well,
Houbraken wrote that he had the ability to form an
"amazingly accurate mental picture" of expressions.
"By capturing the emotions in the fleeting moment
when they display themselves, he is able to imprint
them and use them, a rare inborn quality." Call it
genius.[53]

Preparatory drawings

The relatively small number of surviving drawings accepted as authentic Rembrandts has led scholars to conclude that the master did not prepare his compositions on paper before taking his brush to hand. This notion is contradicted by the evidence, which strongly suggests that Rembrandt drew and kept many thousands of drawings.

Concerning Rembrandt's manner of composing his scenes there seems to be a shared opinion among specialists. He did not prepare them with preparatory drawings. He conceived his compositions in his mind and put them down on panel or canvas in the underpainting stage. "Rembrandt was probably not as prolific a draughtsman as has traditionally been assumed," wrote the leading specialist Peter Schatborn in *The dictionary of art*. "For instance, he seldom made preparatory studies for paintings and etchings. In the case of his prints, there are only four preliminary drawings that he indented for transfer on to the copperplate ..."

Let us examine one of those examples to see how rare it actually was. In 1634, Rembrandt painted a large, complex composition of *St. John the Baptist preaching*. The Precursor of Christ, having spent his entire life to date in the wilderness, enters the world to address the multitude. In the Gospel according to St. Luke (3:3–6),

he came into all the country about Jordan, preaching the baptism of repentance for the remission of sins; As it is written in the book of the words of Esaias the prophet, saying, The voice of one crying in the wilderness, Prepare ye the way of the Lord, make his paths straight. Every valley shall be filled, and every mountain and hill shall be brought low; and the crooked shall be made straight, and the rough ways shall be made smooth; And all flesh shall see the salvation of God.

The countryside and its properties are part of John's message and part of Rembrandt's scene – the Jordan valley is ready to be filled, the distant hilltop to be lowered.

Five preparatory drawings have been brought into connection with the painting. One is a quick composition sketch from a stage when the landscape was still flat and the placing of the figures quite different from the finished version (fig. 186). The other four are concerned with figures and their actions. A red chalk drawing of the Baptist shows him in two more upright poses than the forward-leaning figure in the painting, and more the man of the wilderness, used to living on locusts and honey. Two others mainly worry the motif of two men talking conspiratorially, with another, a bowing, servile man eliminated in the final version, listening to them eagerly. (The Hebrew inscription on the headcloth of the man to the left is not indicated on any of the drawings.) A sheet of "listening shots"

185
Rembrandt
St. John the Baptist preaching
Unsigned, undated. Ca. 1634
Canvas on panel, 62 x 80 cm.
Bredius 555
Berlin, Staatliche Museen
Gemäldegalerie

186
Rembrandt
St. John the Baptist preaching
Unsigned, undated. Ca. 1634
Pen and wash, 19.4 x 27.7 cm.
Benesch 139A
Private collection (1973)

187
Rembrandt
Detail of *St. John the Baptist
preaching* (fig. 185)
Berlin, Staatliche Museen,
Gemäldegalerie

188
Rembrandt
Two studies of St. John the Baptist
Unsigned, undated. Ca. 1634
Red chalk, 17.6 x 18.6 cm.
Benesch 142A
London, Courtauld Institute
of Art Gallery

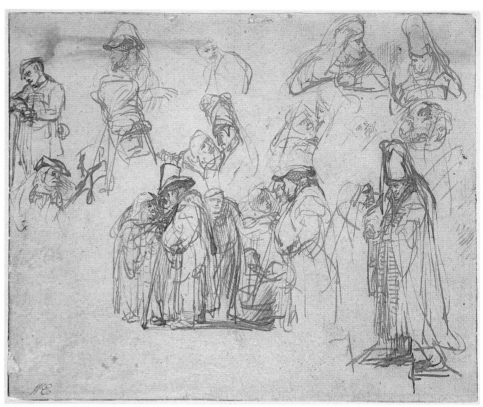

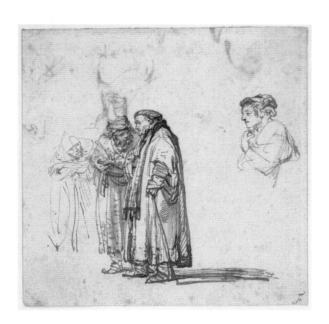

of a few of the figures was used partially in quite different ways in the painting, with clothing, positions and locations shifted.

St. John the Baptist preaching is Rembrandt's single most copious and varied composition. (See also the related *Hundred-guilder print* and its preparatory drawings, pp. 322–28.) The figures represent all mankind, the landscape the entire world. It stands to reason that the artist needed extensive preparations to characterize and place the figures and to fix the setting. They were all the more necessary since the composition – and the

canvas – was expanded to more than twice its original size in the course of work. Moreover, the X-rays show no further changes of the kind that were worked out in the drawings. The question regarding preparatory drawings that arises is: can Rembrandt have done with as few drawings as now survive? To ask the question, to my mind, is to answer it, in the negative.

As it happens, Arnold Houbraken, in a passage on this painting, alludes to Rembrandt's use of preparatory drawings. "Several of his pupils have declared to me that he sometimes drew a figure ten different ways before putting it to panel; also that he could spend a day or two arranging a turban to suit his taste."[54] In disagreement with Schatborn, I am inclined to accept that declaration at face value, with its corollary: to create his ninety-odd painted and eighty-some etched compositions (single-figure paintings and landscapes aside), Rembrandt will have made thousands of preparatory drawings, most of which have been lost. In addition to these preliminary and preparatory sheets, he also made many – the great majority of surviving sheets – that have no apparent connection with etchings or paintings. This amounts to thousands more. The documentary record too points in this direction. Rembrandt's inventory included twenty-three albums, one basket and one package of drawings by the master, plus "various packets of sketches, by Rembrandt as well as by others." Most of the albums are said to be "full of" drawings or sketches.

How full was full? Roelof van Gelder and Jaap van der Veen gathered evidence from other sources concerning the content of albums. They found

references in four collections to 318 albums of prints and drawings, with an average of 115 items per album. If that holds for the twenty-three albums, basket and package of Rembrandt's drawings as well, they would have contained 2875 sheets.[55] However, one may ask whether the average of 115 sheets per album is appropriate. The albums concerned were assembled by rich collectors, who stored their prints and drawings neatly in specially bound volumes. Rembrandt's holdings of his own drawings may well have been treated in quite a different way. The recurrent phrase "a book full of drawings by Rembrandt," may perhaps better be read as "a book crammed with drawings by Rembrandt." Concerning one of the albums we can be fairly sure of the minimum quantity. The book "with all Rembrandt's works" – not even "full of" Rembrandt's works – is taken to mean his complete production as an etcher. When the inventory was drawn up Rembrandt had made 270 etchings. The album is likely to have contained more prints, however, since he will have preserved some of the prints in more than one state.

The single piece of contemporaneous evidence concerning the number of sheets per album is noted on the reverse of a Rembrandt drawing in Munich: "640 schetse van Rembra/ leggen hier in" (640 sketches by Rembrandt are contained within). This is not much more than the largest number encountered by van Gelder and van der Veen: 541 sheets in a "large rectangular book" owned by Cornelis van Beyeren, the merchant father of the Rembrandt pupil Leendert van

Beijeren.[56] An average halfway between 115 and 640 – say 375 sheets per album, which also makes sense for the album with "all the works" – would yield more than nine thousand drawings in the sale. Numbers of this kind look absurd at first sight, but in fact nine thousand drawings, divided over the years from 1625 to 1656, amount to fewer than one drawing a day. The question is not whether Rembrandt could have made that many drawings – of course he could have made that many and more – but whether he chose to make them and chose to save them.

Consider too that those were the drawings Rembrandt *owned* in 1656. They do not include those that he sold or gave away in the preceding thirty years, or those he threw out. Since no more than about six or seven hundred drawings are currently accepted as original drawings by Rembrandt, we must face up to the likelihood that more than ninety percent of his drawings has been lost.[57] At that rate, all suppositions concerning what Rembrandt did *not* draw are off. The hypothesis I would advance here is that the extant (and presumed lost) drawings for *St. John the Baptist preaching* may represent the outer extreme of drawings per composition, but that in principle they were not an exception in Rembrandt's practice. Rembrandt was not a less but a far more prolific draftsman than we now know.

192–93
Rembrandt
Details of *St. John the Baptist preaching* (fig. 185)
Berlin, Staatliche Museen, Gemäldegalerie

194
Rembrandt
Listeners to the preaching of St. John the Baptist
Unsigned, undated. Ca. 1634
Pen, 19 x 12.5 cm.
Benesch 140
Berlin, Staatliche Museen, Kupferstichkabinett

55 In van den Boogert 1999, p. 25. On p. 58, however, the authors say that the albums contained only 1500 to 2000 drawings.
56 Wegner 1957, pp. 14–15, no. 23. The suggestions there that the figure may refer to the year 1640 or mean 64 rather than 640 attest to the same kind of incredulousness that marks most initial reactions to such large numbers. The existence of a documented album with 541 prints or drawings should help dispel this disbelief.
57 One of the albums was "A book, filled with drawings by Rembrandt, consisting of men and women in the nude." Benesch's catalogue contains only thirty-eight drawings that meet this description, of which all but a handful are now rejected. This too suggests a loss of ninety percent or more.

195
Rembrandt[58]
*The departure of Rebeccah
from her parents' home*
Unsigned. Inscribed on an
attached strip *dit behoorde
vervoucht te weesen met veel
gebueren die deesen hoge bruijt
sien vertrecken* ("This should
be joined with many neighbors
who [come to] see this high
[-born] bride take her leave").
Undated. Ca. 1637
Brown ink and wash,
18.5 x 30.6 cm.
Benesch 147
Stuttgart, Staatsgalerie,
Graphische Sammlung

58 The name "Rembrandt" in the
inscription is by a later hand, but the
rest of the text is in Rembrandt's
handwriting. The inscription, with
its critical comment on the composi-
tion, makes the drawing seem like
an assignment to an advanced pupil,
on which the master wrote his
reaction. Rembrandt's authorship
of the drawing has indeed been
questioned by Cornelis Hofstede
de Groot, Arthur Hind and more
recently Martin Royalton-Kisch,
who suggests that it is the work of
Gerbrand van den Eeckhout. Otto
Benesch was insistent that it is by
Rembrandt: "The mastery of form,
space relations and foreshortenings,
together with the expressive vigour
of the composition, do not allow
an attribution of this outstanding
drawing to a pupil." I am inclined to
side with the skeptics, but I discuss
the sheet here as a work by the mas-
ter in the sense that it was made
under his supervision. Benesch's
observation that "this drawing was
of great influence upon the School of
Rembrandt" is an indication that it
was the subject of intensive peda-
gogical discussion in the workshop.
59 Miedema 1973, vol. 1, p. 134, from
Chapter 5, "On the composition and
invention of histories," paragraphs
25–26.
60 Miedema 1973, vol. 1, p. 137, with
some small departures from his
translation into modern Dutch.

Storytelling

**Karel van Mander distinguished between lush and
lean forms of history painting. Rembrandt practiced
both. In both modes he respected in principle the
codes and conventions governing this highest form
of art, but in practice often pushed beyond them into
the realm of near-unintelligibility.**

Storytelling in art, says van Mander, comes in two
varieties: crowded and lonely, copious and spare. In a
delightful passage from his treatise on the art of paint-
ing, he first piles up details that "clever minds bring to
bear (when appropriate) in building copiousness into
a history: horses, dogs and other tame animals as well
as beasts and birds of the forests; … fresh youths and
beautiful maidens, old men, matrons, children of all
kinds … as well as landscape and architecture, also
jewelry, rigging and ornaments …"[59] Van Mander cites
two authorities for the excellence of this practice: Leon
Battista Alberti in the fifteenth century in Italy and the
German Gualtherus Rivius in the sixteenth.

Rembrandt had one of those clever minds, as we
have seen in his *St. John the Baptist preaching*. When
he worked in the copious mode, too much was never
enough. A drawing in Stuttgart of an obscure story
from Genesis 24 could have been made with that
passage from van Mander lying open on the table.
Rebeccah is leaving the house of her parents with her
nurse and her damsels to marry Isaac, the son of

Abraham, in the land of Canaan. She is preceded into
the distance by Abraham's servant, in a caravan that
includes not only the camels mentioned in the Bible
but also – if the eye does not deceive – an elephant that
is not.

An inscription in Rembrandt's handwriting indicates
that this nonetheless left him with a feeling of empti-
ness. "This should be joined with many neighbors who
[come to] see this high[-born] bride take her leave."
No neighbors are mentioned in the Bible, but that was
not the point. Using his knowledge of the world and
consulting his imagination, he was embellishing the
text to make it truer to life.

Although he practiced it himself and devotes far more
space to it in his treatise than to the lean mode, van
Mander took an officially dim view of embellishment.
"Good masters in their main works often avoid excess
or Copia, taking pleasure in sparseness with few
[details]. These [artists] … do not fashion themselves
after barristers and attornies who use many words in
their pleas; rather, they imitate great monarchs, kings
and mighty potentates who without talking much com-
municate their wishes in a few spoken or written words.
Such reticence adds much more honor to their reputa-
tions than immoderate blabber and chatter."[60]

Rembrandt worked in the spare as well as the lush
mode, and here he went even further. It sounds good
to say that he eliminated all inessential details to get
to the heart of the matter, but in many of his spare

196
Rembrandt
*Bathsheba with King
David's letter*
Inscribed *Rembrandt ft. 1654*
Canvas, 142 x 142 cm.
Bredius 521
Paris, Musée du Louvre

197
Rembrandt
Detail of *"The Leiden history
painting"* (fig. 249)
Leiden, Stedelijk Museum
De Lakenhal

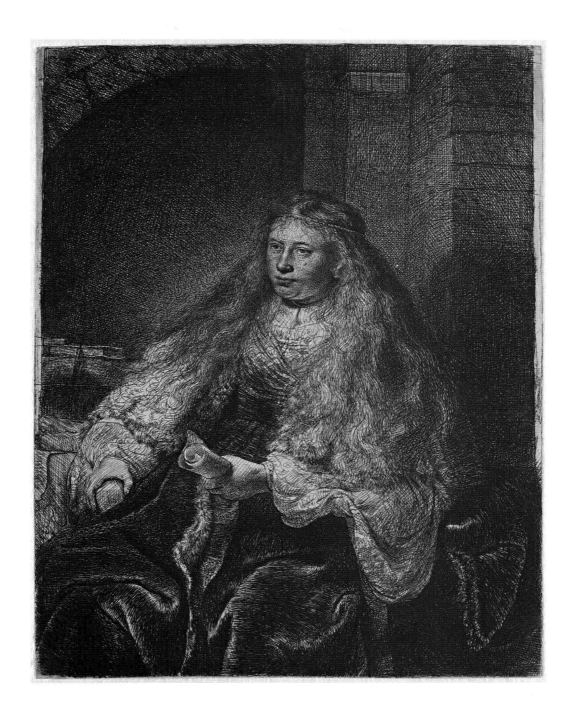

198
Rembrandt
Seated woman holding a letter:
"The great Jewish bride"
Inscribed *RHL 1635*
Etching, some drypoint
and burin, 21.9 x 16.8 cm.
Bartsch 340 v(5)
Haarlem, Teylers Museum

histories he eliminated essential details as well. Some-times one hardly notices this. His painting of a nude woman being groomed in a garden, holding a letter in her hand, can hardly be anyone other than Bathsheba pondering her summons to go to King David. That Rembrandt has left King David out of the scene, whose salacious gaze is an indispensable part of the story, does not make the painting incomprehensible. However, there are a good many superspare Rembrandt histories that *are* incomprehensible. In fact, a number of paintings, etchings and drawings actually contain the same basic elements: a woman being groomed and holding a letter in her hand. But these women are clothed and the scenes take place indoors, so they cannot well be Bathshebas. Instead, they are interpreted as Judith or Esther or a Jewish bride, although no conclusive identifications have yet been found.

It also sounds good to say that Rembrandt increasingly eliminated inessentials from his art as he grew older and wiser. But he started this practice when he was still young and green. In the 1620s he painted an Andromeda without the Perseus who always comes to rescue her; in the 1630s he created a Danaë, if that is who she is, without the rain of golden coins that is the defining feature of her iconography. In the same period, he left us in doubt as to whether certain paintings of Saskia are intended to be Floras or pagan brides, whether a woman with a bowl of poison is Sophompanea or Artemisia. In the 1640s we have a David and Jonathan that has some features of a David and Absalom or a David and Mephiboseth.[61] The 1650s brought us the etching called *A woman with an arrow* – or is it a bed-curtain or perhaps a stage curtain? And then there is the perennial puzzle from the 1660s, *The Jewish bride*.

61 Schwartz 1985a.

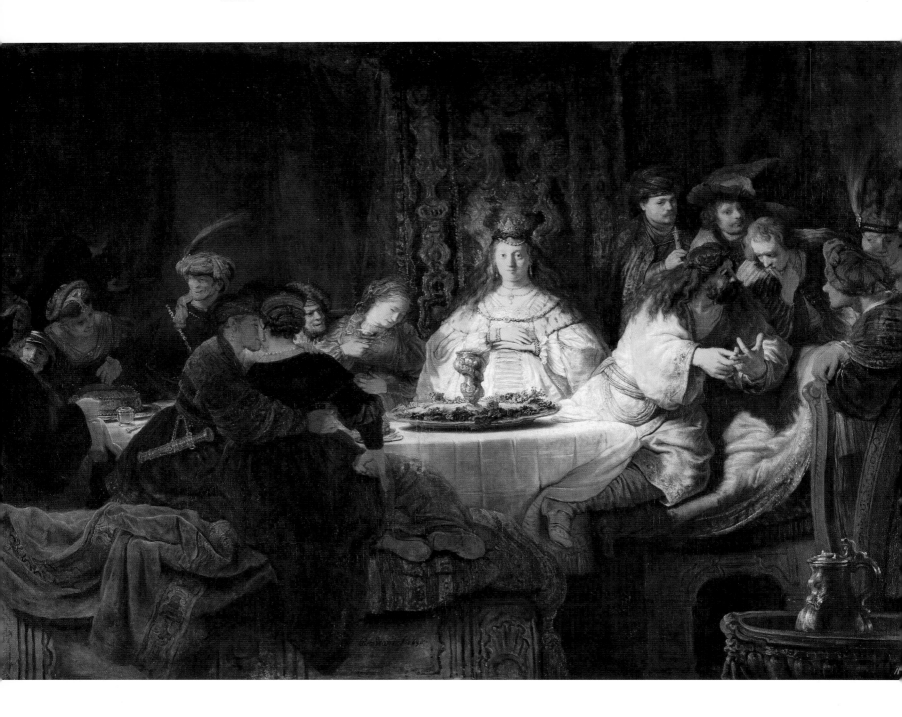

62 In Schwartz 1985, pp. 35–39,
I adopted the identification launched
by M.L. Wurfbain in 1968,
*Palamedes before Agamemnon:
a historical analogy to the trial of
Johan van Oldenbarnevelt.* I also
accepted the related assumptions
that the painting is a pendant to the
Martyrdom of St. Stephen in Lyon
and that these are the "two hand-
some, large pieces by Rembrandt"
in a 1663 auction associated with
the sale of the library of Petrus
Scriverius, which, S.A.C. Dudok van
Heel argued, came from the estate of
Scriverius. While I am still inclined
to believe this, no one else since 1985
has defended this complex of
theories. Therefore I withdraw
them – for the time being.
63 See the excellent discussion of this
point in Blankert 1997, pp. 41–49.

Rembrandt was simply not always out to provide the
viewer with cut-and-dried iconographies.

It is fascinating that the iconography of a copious
composition can be as impenetrable as that of a sparse
one. Rembrandt's first known exercise in ambitious
history painting has proved so impervious to inter-
pretation that it is now known by the defeatist title
"*The Leiden history painting*" (fig. 249).[62] The painting
is full of portentous details that do not correspond
sufficiently to any known iconography – some eighteen
have been proposed – to satisfy the field. Identifying
the subject of Rembrandt's First History Painting is the
equivalent in Rembrandt studies to proving Fermat's
Last Theorem. One interesting corollary of this prob-
lem is that it shows how completely we – and we
assume Rembrandt as well – are bound by the conven-
tional expectation that the painting depicts an existing

subject, whether or not it was ever before represented
in art. By the laws of the physical universe, there
is no obstacle to painting a work such as this that has
no narrative meaning. However, so impossible is this
considered under the laws of society and art that the
very issue is seldom raised.[63]

"*The Leiden history painting*" raises another problem
that is more disturbing. The expressions of the figures,
especially the two young men on their knees in the
right foreground, are quite pronounced (fig. 197). But
what are they expressive of? Various proposals for the
subject matter point in completely different directions,
from hearing their death sentence to being rewarded
by the ruler. Unless one knows the story, it seems, body
language and facial expression in themselves are not
always enough to convey an intended meaning.

199
Rembrandt
*Samson posing the riddle
to the wedding guests*
Unsigned, undated. Ca. 1638
Canvas, 126.5 x 175.5 cm.
Bredius 507
Dresden, Gemäldegalerie
Alte Meister

Most of the stories in Rembrandt's history scenes are from the Bible, and students of his work are inclined to regard them as visual renditions of Scripture. Selections from the Bible have long been published as "Rembrandt Bibles," illustrated with his depictions of biblical scenes. A major exhibition of Rembrandt's drawings and etchings from the Bible had the title *Rembrandt legt die Bibel aus*, Rembrandt explains the Bible.[64]

This view of Rembrandt's biblical representations is certainly not incorrect. One could even say with forgivable exaggeration that the first Rembrandt Bible dates from 1646, when the Amsterdam publisher P.I. Paets brought out *Bijbels tresoor* (Treasure of the Bible), including six woodcuts (out of a total of 750) copied from Rembrandt etchings by Christoffel van Sichem II (1577–1658) or III (1618–59). Although he drew freely on older series of Bible prints, Rembrandt himself resisted making series of this kind. In a sense, he served as a funnel, deriving inspiration from captioned print series to create non-serial, uncaptioned narrative representations of his own, which in their turn were used for later captioned series.[65]

The text was however only one of the givens in Rembrandt's mind when he sat down to depict a story. He also worked with non-biblical literary sources; models in older art, whether or not of the same scene he was depicting; antiquarian research; knowledge of folkways; attributes from his collection; enactments or maquettes in the studio; and his own imagination.

This quality was not lost on Rembrandt's contemporaries. In 1642 Rembrandt was praised for just this way of doing things in a festive address to the painters of Leiden by one of their number, Philips Angel (1616–82/85). Of another obscure scene from the Old Testament, Samson posing the riddle to the wedding guests, Angel wrote: "I once saw a depiction by Rembrant of the Wedding of Samson, of which we read in Judges, chapter 14, verse 10. You can see in it how that keen intelligence, by thinking hard about the actual way the guests sit (or in this case recline) at table – since the ancients used small beds on which to lie, not sitting at table the way we do today, but lying on their elbows the way the Turks still do in that part of the world – showed it very nicely."[66] There follows a further appreciation of other details, none of them derived from Scripture, ending, "these fruits of natural representation, true to the subject, come into being by reading the story well and analyzing it in deep and wide reflections."[67]

In addition to reflecting deeply and widely, Rembrandt also did a certain amount of looking. He must have seen the painting thought to be by the Utrecht painter Jacob Gerritsz. van Hasselt, an oriental rendition of a Dutch wedding. That Leonardo da Vinci's *Last supper* was on Rembrandt's mind when

200
Jacob Gerritsz. van Hasselt
(ca. 1598–ca. 1674)
*The wedding dinner of Grietje
Hermans van Hasselt and Jochum
Berntsen van Haecken*
Inscribed *J. Hasselt fe 1636*
Canvas, 102.1 x 135.5 cm.
Utrecht, Centraal Museum

64 Tümpel 1970.
65 Christian Tümpel, in various publications since the 1960s, has stressed the importance to Rembrandt of sixteenth-century prints. See also the work of his student Peter van der Coelen in Tümpel 1991, pp. 168–93: "Thesauri en trezoren: boeken en bundels met oudtestamentische prenten."
66 Angel 1642, p. 47.
67 Angel 1642, p. 48.

he painted his table company is evident – less so whether placing Samson's Philistine bride in the Christ slot has a deliberate meaning or is intended to be passed over politely. This is a juncture where respect for the text and antiquarian research meet artistic freedom.

What was Rembrandt after with his choice of narrative subjects, with all their embellishments, eliminations and extractions? As for the choice of biblical subjects, nearly all his themes came from established tradition and were painted by Pieter Lastman before Rembrandt. Josua Bruyn sought a general explanation in Rembrandt's "deeply personal view of the Bible."[68] Occasionally it can be demonstrated that a theme was chosen for its relevance to the life or interest of another person. In 1660 Rembrandt painted *Haman and Ahasuerus at the feast of Esther*, which in a poem of 1662 was said to belong to the Amsterdam regent Jan Jacobsz. Hinlopen. We know that in 1659 the play *Hester, or the salvation of the Jews*, was produced on the Amsterdam stage and that the play was dedicated to Hinlopen's wife Leonora Huydecoper. The understated passions of the figures in Rembrandt's painting have been brought into connection with the new, restrained acting style propagated by the author of the play, Joannes Serwouters. This information amounts to a strong indication that Rembrandt's thematic and

stylistic choices could be interpersonal rather than purely personal. My own inclination is to assume that this was more common than we know.[69]

Albert Blankert has posited the existence of another kind of extraction in Rembrandt's practice of narrative painting, an extraction in time and mood rather than space. "From a long story the moment is chosen when a sudden, complete reversal of the mood of the figures takes place." This tactic is described and given a name in contemporaneous literary theory. Joost van den Vondel, the foremost poet and playwright of Amsterdam in Rembrandt's time, recommends it to his colleagues as an application of the Aristotelian principle of *peripeteia*, the sudden reversal of circumstances, which he translates as *staetveranderinge,* and which was paired with recognition of the change on the part of the hero, *agnitio*. "Even though there is no written proof," writes Blankert, "I am convinced that the concept of *staetveranderinge* held as much importance to Rembrandt as it did to Vondel."[70]

This illuminating insight works in union with another constant feature of Rembrandt's narrative art, the preference for interaction between two protagonists, sometimes accompanied by a third, passive character. Indeed, so many of Rembrandt's drawings consist of nothing more than highly focused contact between two human – or superhuman – beings that one wonders whether the actions themselves were often no more than a pretext for him to get at the underlying interactions (fig. 633). Even in a large-scale panorama like *St. John the Baptist preaching*, Rembrandt breaks the audience down into groups of two or three, talking to each other about what is happening (fig. 190).

The various strategies and habits discussed here do not amount to a system. They are an attempt to identify some of Rembrandt's storytelling propensities. As we have seen, not all of them are straightforward or explainable. Rembrandt was not always out to make things clear to the viewer.

The *non finito* look

Rembrandt was able to project what looked like completely detailed representations with mixed and sometimes minimal means. Regularly, however, he stopped short of that point, leaving the viewer with a work of art that is not a convincing image of reality. In doing so, he goes beyond the ideal of illusion as the ultimate aim of art.

Rembrandt was a master of selective finish. In the painted portrait of Jan Six, we saw how he succeeded in combining a highly detailed portrayal of a face with a demonstratively abbreviated rendition of a coat into a single, unified image (figs. 163–65). A few years before, he had achieved the same effect in the *Hundred-guilder print* (fig. 574). It contains great variations not only in light and dark but also in finish and resolution, as in the man left whose hat is worked

201
Rembrandt
Detail of the *Hundred-guilder print* (fig. 574)

68 Bruyn 1958.
69 Schwartz 1985, pp. 272–73.
70 Blankert 1982, pp. 34–35.

202
Rembrandt
The artist drawing from the model
Unsigned, undated. Ca. 1639
Etching, drypoint and burin,
23.2 x 18.4 cm.
Bartsch 192 ii(2)
Haarlem, Teylers Museum

203
Rembrandt
Copper plate of *An artist
drawing from the model*
Unsigned, undated. Ca. 1639
Etching, drypoint and burin,
23.2 x 18.4 cm.
Bartsch 192
Amsterdam, Museum
het Rembrandthuis

204
Pieter Feddes van Harlingen
(1586–1623)
Pygmalion
Inscribed *P.F.Har.in.et.fe Ao.15* |
VOLGHT.NIET.Pygmalion …
[six lines] *LIEFT.ELCK.ANDER.*
Dated 1615
Van der Kellen 21

71 Nowell-Usticke 1967, nos. B192
and B259.

out in great detail and whose upper body is barely
drawn at all, with no damage to the power of illusionary
conviction.

There are limits, however, beyond which no artist, not
even a Rembrandt, can go without causing confusion.
About 1639 Rembrandt made an etching based loosely
on a print of 1615 by the forgotten Frisian artist Pieter
Feddes van Harlingen (1586–1623). Feddes's print
shows the Greek sculptor Pygmalion, who fell in love
with one of his own statues. The caption warns the
viewer not to imitate Pygmalion by falling in love with
your own work, but rather to love one another. The
"work" in Rembrandt's print is that of a draftsman.
If he is referring to Feddes's *Pygmalion* in more ways
than just the pose of the model, then his print warns
the etcher not to love his own work more than other
people. Rembrandt did not make this clear, however;
nor did he make clear what his intention was in leaving
the plate in such unfinished form.

One could regard this as a passing, mysterious inci-
dent were it not that in the same period Rembrandt
published other prints that also leave most of the sur-
face blank except for a few indicatory outlines. The
prints of the old men (figs. 206–07) are quite rare, but
the *Artist drawing from the model* is characterized in a
standard catalogue as "fairly common."[71] Of both, how-
ever, Rembrandt printed and sold editions in this form.
This is a significant fact. It may be assumed that

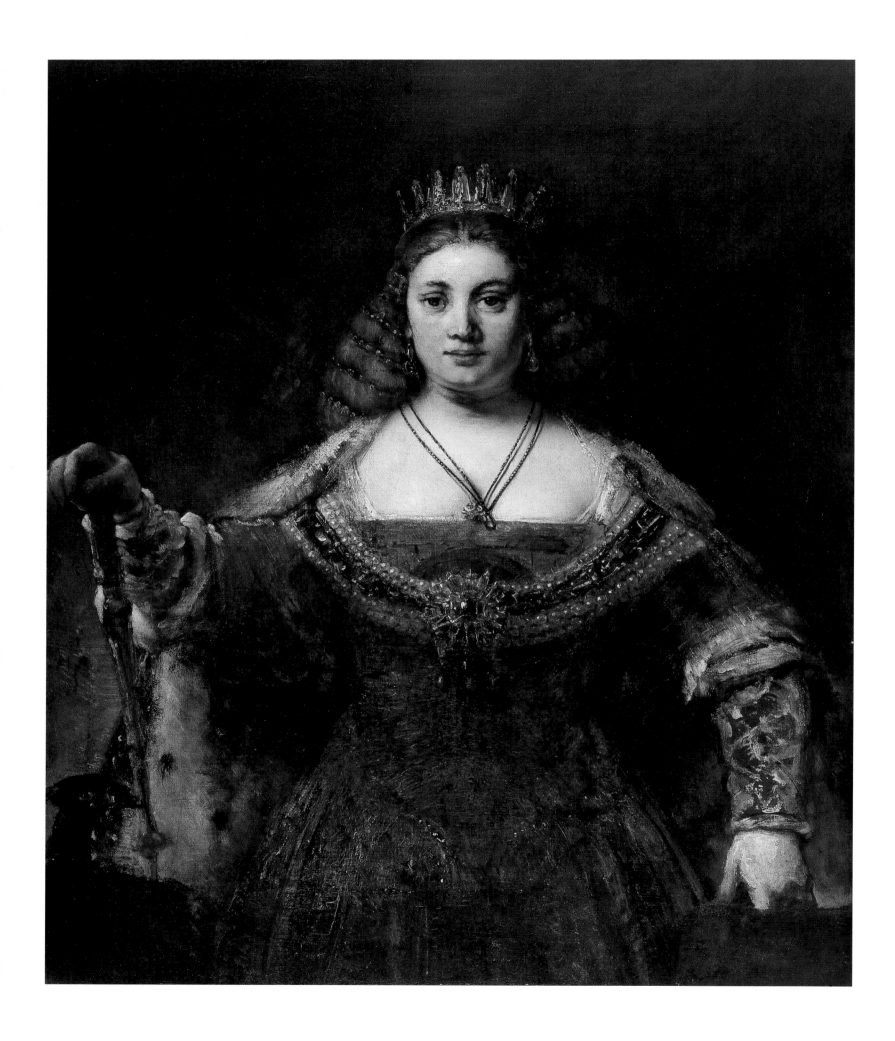

Rembrandt printed such impressions of many of his etchings while working, but that he threw them away when he had used them to move on to the next stage. Of these plates, he created an edition, turning them into a "state." In other words, he assigned artistic and commercial value to these images as they appear, in all their apparent incompleteness. For this reason, we must regard them as full-fledged creations by Rembrandt and not simply as unfinished works.[72] They have a status that later, with regard especially to the work of Michelangelo and Titian, came to be honored with the term *non finito*, (deliberately) unfinished. Unless Rembrandt thought of these prints in such terms, he would not have printed and sold impressions.

The category of the *non finito* is not a normal part of the Dutch discourse on art. Van Mander does not assign positive value to unfinished works of art. The point at which it entered the discussion is in fact nowhere else than in the Rembrandt sources and documents. The objects in question were not etchings but paintings. The completion of unfinished paintings became an issue in Rembrandt's negotiations with his financiers around 1650[73] and again in 1665, when a creditor complained "Let Rembrandt finish the Juno."[74] If the picture referred to is the only surviving painting by Rembrandt of the queen of the gods, then it is not impossible that Rembrandt never finished it at all. Nonetheless, the creditor did accept it, as it is mentioned in the inventory of his estate in 1678.

That was a legal document; the claimant's sigh was not heard outside the notary's office. Unfinishedness entered the Dutch literature on art in the famous quote attributed to Rembrandt by Houbraken: "a piece is finished when the master has achieved his aim in it." Although Houbraken reports it with annoyance, and although Rembrandt does not say what his aim was – indeed, he is implying that he does not have to – this one-liner is a veritable declaration of artistic independence. It also qualifies and moves beyond sheer illusion as the aim of art.

205
Rembrandt
Juno
Unsigned, undated. Ca. 1658
Canvas, 127 x 106 cm.
Bredius 639
Los Angeles, UCLA
Hammer Museum

206
Rembrandt
*Old man shading his eyes
with his hand*
Unsigned, undated. Ca. 1639
Etching and drypoint,
13.8 x 11.5 cm.
Bartsch 259 i(1)
Haarlem, Teylers Museum

207
Rembrandt
*Old man in meditation,
leaning on a book*
Unsigned, undated. Ca. 1645
Etching, 13.3 x 10.8 cm.
Bartsch 147 ii(2)
Haarlem, Teylers Museum

72 For another view, see Hinterding et al. 2000, no. 36, pp. 174–79.
73 Strauss and van der Meulen 1979, pp. 610–11, with regard to the verso of drawing Benesch 1169.
74 Doc. 1665/17.

5

Earning and spending

The market

THE ARENAS in which Rembrandt did best were the court of Frederik Hendrik, the Amsterdam upper class and serious collectors of prints throughout Europe. In these he did brilliantly.

Rembrandt was born in the early days of what has been called "the first modern economy," that of the Dutch Republic. It was marked by the establishment of solid, government-backed financial institutions, a flourishing market in stocks, commodities and derivatives, and global reach. These factors drew capital and goods to the Netherlands, especially to Amsterdam, from all over the world.

The market in art was part of what Jonathan Israel has called the "rich trade," in contrast to the bulk trade. It benefited from the networks and infrastructure that serviced larger areas of the economy. Piggybacking on the economic might of the Republic, Dutch artists attained a dominant position on the European art market.

Graph 9
The share in numbers of artists of the various European schools, by birth year of artists from 1601 to 1670
(Source: ULAN)

Southern Netherlands
Germany
Spain
France
Great Britain
Italy
Northern Netherlands
Other

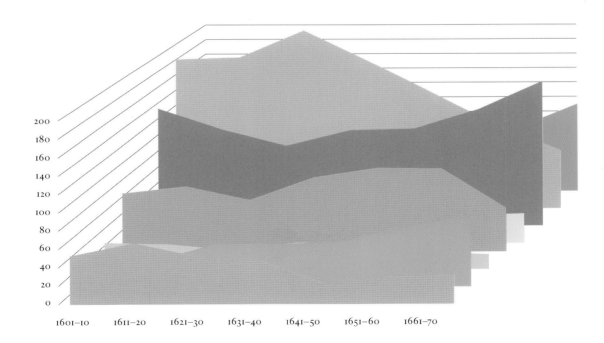

A quantitative landscape of the European art world, based on the Union List of Artist Names of the Getty Research Institute, shows Rembrandt to have belonged to the largest cohort of the seventeenth century: Dutch artists born between 1600 and 1620. They swarmed over Europe and exported their work to all corners of the globe. The sheer size of this magnificent generation of artists became a problem after 1640 when the market began to shrink.

In itself, the Dutch market for paintings cannot be called particularly modern. For one thing, it involved more old-fashioned patronage than many other markets. Think only of the portrait, which was nearly always made for a patron. Paradoxically, the art market in the southern Netherlands, which lagged far behind the north economically, was more modern than in the north. Antwerp inherited a long tradition of organized art financing and marketing that it continued to exploit in the seventeenth century. Rubens ran a larger studio, with more specialization, than anything we know

in the north. Flemish artists continued, after the large-scale emigration of so many artists, to feed a mass market that Protestant Holland could not service, Catholic devotional imagery for the Iberian peninsula and the New World. Dutch artists who wished to work this field could only do so by moving to the Spanish Netherlands.

Rembrandt's share of the Dutch market in art was divided between various niches. The table below shows which sales channels of the paintings trade he employed.

Table 2 Forms of sale for paintings in the Dutch seventeenth century

	Channel	General features	Rembrandt
ORDERS	Court patronage	Desirable, paid well, hard to get, high prestige, required broker.	Enjoyed more than his share of patronage from Frederik Hendrik, which made him a rich man by the age of twenty-five. After 1633 he received only two new commissions, in 1646, the best-paid sales of his entire career. Paintings and in some instances etchings by Rembrandt were also owned during his lifetime by courts in England, France, Germany, the Habsburg Empire and Italy.
	Government patronage	Idem.	Received only one direct commission from a government – the city of Amsterdam – in 1660. However, the painting for the new town hall was sent back after a year, unpaid.
	Church/corporate patronage	Within reach, via contacts, on limited scale, paid well.	No known church patronage; painted four group portraits for Amsterdam corporate bodies.
	Private orders	Demanding, fickle market, paid well, occasionally came with retainer.	Working without a retainer, Rembrandt succeeded in drawing a steady stream of private commissions, mainly portraits, with a spectacular high point in the early 1630s.
RETAIL	Studio sales	Strangely rare in the documents, while you would assume this was very common. Artists did sell each other's works.	None recorded, although the likelihood seems great that Rembrandt paintings owned by portrait sitters were bought from the artist and that he sold other paintings as well directly. When Cosimo de' Medici tried to buy a painting from Rembrandt directly in 1668, he was told that none was available.
WHOLESALE & MIDDLEMEN	High-class or gentleman dealer	Major vehicle for small group.	In this category fall Hendrick and Gerrit Uylenburgh, Johannes de Renialme, Lodewijk van Ludick and a few others. Extent of dealings difficult to determine.

	Channel	General features	Rembrandt
	Trade dealer, colleague	Kept the pot boiling.	Except for period with Hendrick Uylenburgh, never worked with a regular dealer. No stock of Rembrandt paintings present in inventories of colleagues.
	Agent abroad	Additional sales, extra costs and risks.	Sales to Don Antonio Ruffo in Sicily were brokered by agents; perhaps initiated by them.
	Licensed galleries	Prestigious locations, few and far between.	No known representation of Rembrandt in galleries.
	Related branches (e.g. frameshops)	Additional income, or more likely barter goods.	Incidental portraits of framemaker, goldsmith and other craftsmen may indicate barter.
	Unrelated branches (e.g. taverns)	Idem.	No such sales recorded.
CONSIGNMENT	Guild sales	Too low-powered to be lucrative.	No record of Rembrandt paintings in guild sales, but then again the guild records are lost.
AUCTION	Licensed auctions	Assured low-income sale, hard to arrange.	Rembrandt paintings appear incidentally in other people's auctions.
	Unlicensed auctions	A next-to-last resort, risky and subversive.	Week-long sale held by Rembrandt in December 1655; unlikely to have included paintings by himself.
	Forced auctions	Not exactly "market," but it happened to many an artist; low prices, everything goes.	As a result of his application for *cessio bonorum*, all of Rembrandt's goods were sold in 1656 and 1658. 1656 sale included more than sixty paintings by him and eight touched up by him. The results could not have been very high.
RAFFLES	Raffles, lotteries	Attractive channel for artist-entrepreneurs, good prices, but looked down on and not easy to organize.	No record of sales of this kind.
OPEN-AIR SALES	Licensed markets	Traditional, reliable, but limited in time.	None recorded.
	Unlicensed peddling	Low-risk way of getting quick cash on small scale.	None recorded.
	Second-hand trade	A last resort.	None recorded.
BARTER	Barter	Attractive, dependent on chance.	Rembrandt did not, like Vermeer, trade paintings for bread. No stock encountered in non-branch outlets.
MOVING ABROAD	(Temporary) expatriation	The grass *is* greener, but risk is higher.	If he ever considered it, Rembrandt never acted on a desire to work abroad.

Table 3 The market for etchings, in this more abbreviated chart.

	Channel	General features	Rembrandt
ORDERS	Court patronage	Incidental, initiative often proceeds from artist or intermediary.	No etchings known to have been made for court.
	Government patronage	Usually connected to special events.	*The concord of the state* might have come into being as an aborted commission from the city of Amsterdam for an etching.
	Private patronage	Largely limited to portraiture, well paid.	About twenty men's portraits, of which several might however have been presents from the artist or otherwise not made on commission.
	Commercial orders	Printer-publishers drove the market.	Provided illustrations for a few books, otherwise allowed work to be published by others only by way of rare exception.
RETAIL	Direct sales of individual impressions to small collectors	Probably a major part of the market, although poorly documented.	Presumably the rule, though no specific transactions are recorded.
	Direct or brokered sales of numerous etchings to major collectors	Important international market segment.	Rembrandt was represented in his lifetime with large holdings of more than one hundred prints in several important collections, though the channel by which they were purchased is undocumented.
WHOLESALE	Printsellers and publishers	In this branch of trade, alongside books and maps, prints by artists were also printed and offered, more in one shop than in another.	Incidental contacts during period of print production; afterward the plates come into the hands of printer-publishers.
	Rights	Sale of etching plate, with right to print and market impressions.	One recorded instance, in which Rembrandt was accused by buyer of printing a stock for himself.

The market for drawings seems to have been more informal than the above and far more dependent on personal contacts. Like other artists, Rembrandt gave drawings away as gifts, drew them in friendship albums and used them in teaching. Early collectors who owned batches of Rembrandt drawings seem to have acquired them directly or indirectly from the insolvency sale of 1658.

In all, Rembrandt worked particular segments of the upper end of the European art market of his time, from a base in the richest city of Europe, where most trade in his art took place. The main segment in which he did not play a role was church patronage. There is also no documentation concerning Rembrandt in Scandinavia, but this is more likely due to a gap in the records than anything else. Within a few years after his death important paintings by him had reached Stockholm.

Art as a profession and a livelihood

As a member of the Amsterdam guild of St. Luke, Rembrandt was bound by certain non-competition stipulations. In his early years in the city, this will not have bothered him. In his good years, Rembrandt's high-priced sales and purchases had a buoyant effect on the art market. When the tide turned, his insolvency depressed it.

On the scale between two Platonic ideas of a commercial environment, one in which all is permitted unless explicitly forbidden and one in which all is forbidden unless it is explicitly allowed, Rembrandt's environment was very close to the latter. He lived in a class society, in which the margins for individual freedom were narrowly defined and enforced. In the case of an Amsterdam artist like Rembrandt, the enforcing agency was the guild of St. Luke. No artist living in Amsterdam could sell paintings at markets, auctions, lotteries or guild venues in the city unless he was a guild member.

The records of the Amsterdam guild of St. Luke were unfortunately thrown out after the disbandment of the guilds at the end of the eighteenth century; we do not have a list of Rembrandt's co-members. Comparison with a city of 42,000 inhabitants like Haarlem, where 92 painters were registered in the guild in 1635, work out for Amsterdam, with its 116,000 souls, to over 250.[1] Even if this figure is on the high side, art was assuredly a trade of considerable importance. It is also plain that the guild will have had a hard time keeping its membership in line.

A token of the extent to which the guild attempted to control the lives of its members – literally a token – is a small medallion preserved in the Rembrandt House. The inscription on the recto reads: *Rembrant Hermans S.* – standing for *schilder*, painter, the branch of the guild in which Rembrandt was registered; on the verso is the date *1634* and an escutcheon with three blank shields, the arms of the Amsterdam guild of St. Luke.[2] This is the token issued by the guild to Rembrandt

when he became a member. It would be kept in guild headquarters with those of the other members, to be delivered by hand when another member from the same trade died. Members were required to pay their respects to the dead and leave the token behind at his or her house, upon penalty of a three-stuiver fine.

This kind of micromanagement did not extend to all areas of the lives of guild members. But the guild did try to control their professional and commercial behavior as much as it could. Its main concern was to maintain a high price level for the goods and services of its members; this entailed putting a limit on the mutual competition between them. These corporatistic aims collide with the ambitions and sometimes dire needs of individual members. In Haarlem the guild was involved in an ongoing struggle against a commercially inclined faction of the membership that wanted to hold more frequent auctions than were permitted by regulation and to maintain larger studios. In Amsterdam internal conflicts about such issues were milder, due to a laxer attitude of the guild.[3]

When it came to maintaining a high price level, Rembrandt, in good times, must have been the star member of the guild. During his lifetime, Amsterdam inventories list the amounts involved in the appraisal, sale or commission of thirty paintings by him. The average value is 270 guilders, the median 90 guilders. Comparative figures are hard to come by; the best set of numbers I know was compiled by Marion Goossens in the Haarlem archives of the value of paintings by Cornelis Cornelisz. van Haarlem (1562–1638). The average appraisal of forty paintings by him in seventeenth-century estate inventories was 47.65 guilders, the median 31.10 guilders.[4]

Those figures do not take account of the value of Rembrandt's commissions from Frederik Hendrik. The nine paintings of which we know the sales price – six hundred guilders for seven paintings and 1200 for another two – raise the roof on Rembrandt's prices. Combining all the available prices for forty-seven paintings recorded in his lifetime, we find an average of

209–10
Recto and verso of Rembrandt's membership medallion in the Amsterdam guild of St. Luke, 1634, enlarged
Brass, 2.8 cm. in diameter
Amsterdam, Museum het Rembrandthuis

1 Goossens 2001, p. 38.
Between 1625 and 1635 Montias found 82 registrations in Amsterdam of marriages in which the groom has his occupation as painter.
2 Doc. 1634/10.
3 Van Eeghen 1969b, p. 70. That article reports other indications of the inability of the guild to impose its will on members and non-members alike.
4 Goossens 2001, p. 282. This picture is confirmed by Montias 2004–05, which appeared following the completion of this chapter.

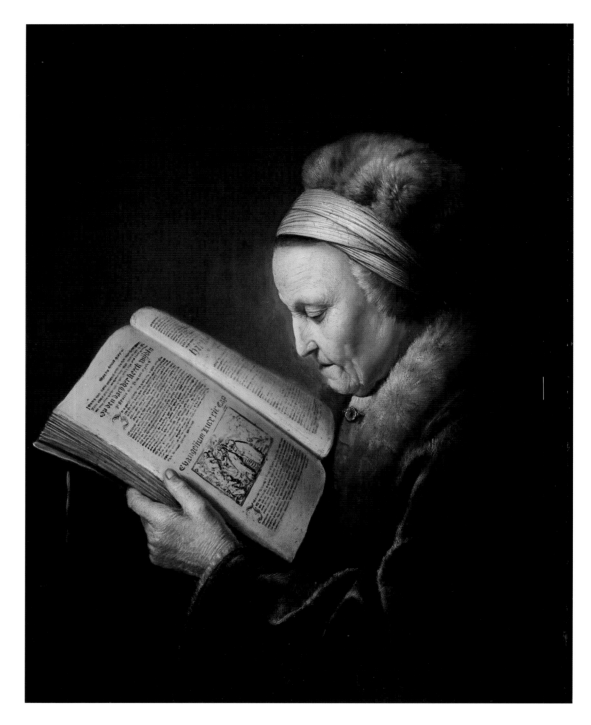

211
Gerard Dou (1613–75)
Old woman reading a lectionary:
"Rembrandt's mother"
Unsigned, undated. Ca. 1630
Panel, 71 x 55.5 cm.
Sumowski 245
Amsterdam, Rijksmuseum

337 guilders and a median of 110. In an economy where the income of a skilled craftsman or a schoolteacher or a minister was about five hundred guilders, these are extraordinary figures. At a conservative estimate, Rembrandt's income over the forty-five years of his active career averaged about two thousand guilders.

But the average was not equally distributed. We arrived at it by adding up and dividing the prices of paintings Rembrandt sold via normal channels. But there were also unsold ones – sixty in all – that went under the hammer at the forced sale of his goods between 1656 and 1658. No specification is known, but we do know the maximum, and it was disastrously low. The various sales in the insolvency included 363 lots, including beside Rembrandt's sixty paintings and his massive collection of prints and drawings

another sixty paintings by other named masters and ten anonymous ones. The total hammer price was about five thousand guilders, less than one-third the value of the forty-seven Rembrandt paintings whose prices we know. This result was not just a disaster for Rembrandt; it must have contributed significantly to the weakening of the market for art of all kinds in Amsterdam.

A few documents record the sales price of etchings. Disregarding those in frames, which cost more, the unit price ranges from one to eight stuivers. (There were twenty stuivers to the guilder.) The reverse of an impression in the Lugt collection of *An old man shading his eyes* (Bartsch 259) bears the inscription "9 stuivers." Against the background of such a low price level, it is all the more striking that Rembrandt's print of about 1650,

Christ among the sick, came early on to be called the *Hundred-guilder print*, a price that was said, in a letter of 1654, to have been paid for it more than once by then.[5]

Rembrandt did not keep all his etching plates himself. The plate for the etched portrait of Jan Six (1647) is owned by the heirs of the sitter, suggesting that the portrait was a commission for which the sitter paid and that included ownership of the plate. What such a commission was worth is indicated in a document of 1655, in which Rembrandt's creditor Otto van Kattenburgh offers four hundred guilders for an etched portrait of himself "from life, of the same quality as the portrait of Mr. Jan Six."[6] If we take that to be the rate for Rembrandt's most ambitious etched portraits, with correspondingly less charged for simpler etchings, then he may have earned even more from his twenty etched portraits than, on the average, from his painted portraits. (Counting the *Night watch* as sixteen portraits for one hundred guilders apiece, the way it was described by the sitters, and splitting up a double portrait of a man and wife the same way, then Rembrandt's portraits of twenty-eight sitters for which we have a price averaged 119 guilders apiece.)

Selling his own art was not the only way in which Rembrandt earned money. On the back of a drawing of about 1637 – a copy after a painting by his master Pieter Lastman – Rembrandt jotted down a note about selling paintings by his apprentices Ferdinand Bol (1616–80) and Leendert van Beijeren (1619/20–49; fig. 219).[7] Whether this was a lifelong practice is a moot point. In the period after he parted ways with Hendrick Uylenburgh he may have had the ambition to set up an art factory like Uylenburgh's. In the same period,

he bought and sold an expensive painting by Rubens, sold one of his etching plates to a colleague, did a fair amount of buying at auction and identified himself in two depositions as a merchant.[8] This too must have been the period about which Joachim von Sandrart, who lived in Amsterdam from 1637 to 1642, later reported with jealousy that Rembrandt had countless pupils whose tuition fees of one hundred guilders were good for two to two and a half thousand guilders a year – "cash," says Sandrart – above and beyond what he earned from the sale of work.[9]

The name Rembrandt van Rijn has yet to be found in documents pertaining to the better investments that were to be had in his mercantile environment. No shares in the Dutch East India Company, no municipal bonds added to his wealth. In one major document he does claim to have made investments and to have lost on them. On 14 July 1656, in his application for voluntary bankruptcy to the High Court of Holland, he cites "losses suffered in trade as well as damages and losses at sea."[10] It is unlikely that a petitioner for protection against creditors who were hounding him would lie about such circumstances. Indeed, the 1650s were a rough time for the Dutch economy and for the art trade in particular. However, as we shall see in the following chapter, from the time he eased up on his mortgage payments in the 1640s, Rembrandt's finances were an accident waiting to happen.

When the accident came, it hit hard. Rembrandt was not its only victim. For half a century, the art market in the Netherlands had known little but constant growth, in numbers of artists active, turnover in the branch, market size and share at home and abroad. Around mid-century, with the First English War of 1651–54 as a catalyst, the trend was reversed. Someone living at that time might well have assumed – indeed, it may have looked like the smart assumption – that the art market was in a temporary dip. It was not. Around mid-century, the market for the work of living Dutch artists went into a decline from which it would never recover. A school that in the second quarter of the seventeenth century, along with the Flemings, supplied a full third of the painters working in Europe, headed into a disastrous downspin. By the end of the century it will have shrunk to the negligible position it has occupied ever since. A trend break of this kind cannot be predicted or even recognized when it happens. Because Rembrandt was in such an exposed position when the break occurred, he was hit harder than most. The fortunes of an artist who earned more in his lifetime than all but a handful of seventeenth-century colleagues went down in flames.

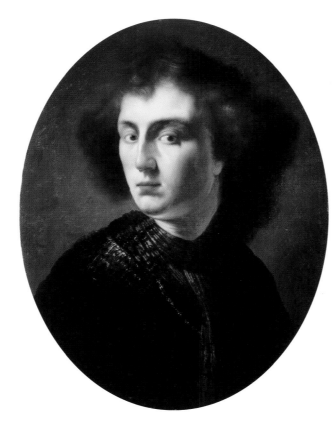

5 Luijten 2000, pp. 46–47.
6 Doc. 1655/8.
7 Peter Schatborn, in Bevers et al. 1991, no. 11, pp. 51–53.
8 Schwartz 1985, pp. 193–94. Docs. 1634/7, 1642/8.
9 Sandrart 1994, vol. 1, p. 326. Hofstede de Groot 1906a, no. 329, p. 394.
10 Doc. 1656/10.

212
Isaac de Jouderville (1613–1645/47)
Bust of a young man
Inscribed *Jouderville*. Undated. Ca. 1631
Panel, 48 x 37 cm.
Sumowski 940
Dublin, National Gallery of Ireland

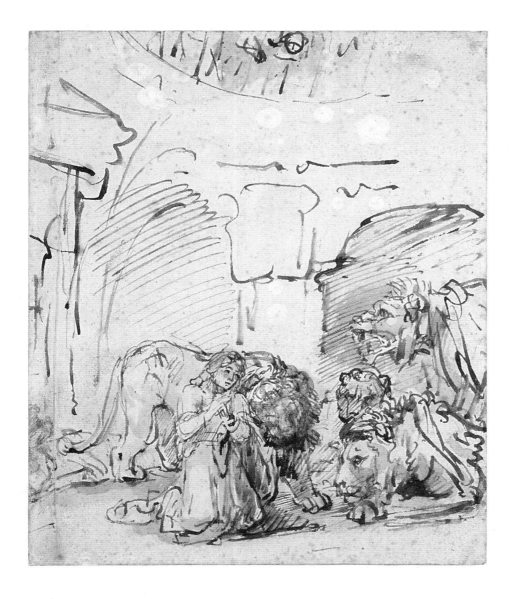

Pupils and assistants

Throughout his life, Rembrandt worked intensively with younger artists, whether or not they were paying pupils or full members of his workshop. They were a source of income for him in his lifetime and after his death a source of confusion to connoisseurs. Rembrandt's various manners, from the painstakingly detailed work of the Leiden period to the freer brushwork of later years, inspired followers who were not necessarily pupils.

According to Jan Jansz. Orlers, the author of the first piece of biographical writing on Rembrandt, Gerard (also called Gerrit) Dou (1613–75) entered Rembrandt's workshop as a pupil on 14 February 1628. Although he was only fifteen years old at the time, Dou already had an impressive period of training, apprenticeship and even professional activity behind him. Dou was the son of a glass painter; his brother Jan also practiced that craft. Gerard's first master, to whom he was sent at the age of nine to learn drawing, was the engraver Bartholomeus Dolendo (ca. 1570–1626), his second, when he was ten-and-a-half, the glass painter Pieter Kouwenhorn (1599–1654). At the age of thirteen he entered his father's workshop as a well-prepared journeyman, registered in the guild. After two years, Orlers reports, perhaps because "he was reckless in climbing up to the stained-glass windows," his father regretfully grounded him and sent him to "the talented and widely known Master Rembrant ... to learn the [safer] art of painting."[11] At twenty-two, Rembrandt was barely older than Gerard.

Dou's early years were typical for one kind of Rembrandt pupil. That is, the dyed-in-the-wool profes-

213
Rembrandt
Daniel in the lions' den
Unsigned, undated. Ca. 1650
Reed pen and brown ink, brown wash, some white body color, partly oxidized, 22.2 x 18.5 cm.
Benesch 887
Amsterdam, Rijksmuseum

214
Rembrandt pupil, perhaps Constantijn à Renesse, corrected by Rembrandt
Reclining lion
Unsigned, undated. Ca. 1650
Pen and brown ink,
12.2 x 15.8 cm.
Benesch 1370
London, British Museum

11 Doc. 1641/9.

215
Constantijn à Renesse
(1626–80)
Daniel in the lions' den
Inscribed *CARenesse inventor
et fecit 1652*
Pen and ink, 20.6 x 32 cm.
Sumowski 2145
Rotterdam, Museum Boijmans
Van Beuningen

216
Constantijn à Renesse
Inscription on the verso of
Daniel in lions' den (fig. 215):
*CARenesse
eerste tijckening getoont Bij
Rembramt in Jaer 1649 den
1 october
het waert voor de tweede mael dat
ick bij Rembrant geweest ben*
Rotterdam, Museum Boijmans
Van Beuningen

sional who lived and breathed art and nothing but art.
The kind of instruction Dou underwent has been
compared by Ernst van de Wetering with the training
of animals: through endless repetition and correction
at a young age, the apprentice learns craft procedures
and basic drawing and painting skills, techniques and
tricks that become second nature. By the time Dou
came to Rembrandt, he was ripe for perfecting his art
at an advanced level.

From a series of documents in the Leiden archives
concerning another pupil, Isaac de Jouderville (1613–
1645/47), we know what Rembrandt charged his pupils.
On 1 May 1630 he signed a receipt for fifty guilders for
half a year of instruction in the art of painting to the
recently orphaned boy. The two young Leideners,
both entrusted to Rembrandt's care at a young age,
had careers of very different kinds. Dou went on to
become the founder of the Leiden school of *Feinmaler*,
creators of easel paintings of miniaturistic refinement
and a certain wit. Jouderville moved to Amsterdam
around the same time as Rembrandt and disappeared
into a limbo from which he was not rescued until the end
of the nineteenth century, when the single painting bear-
ing his signature was found. Their early work has certain
features in common. The motifs are closely observed
and described in minute, even painful detail. There is a
certain dryness and sharpness in the definition of form.
They paint smallish figures on panel, as Rembrandt did.

They also share in common, as do many of the later
pupils, a disputed relationship to Rembrandt and to

each other. At a succession of moments in Rembrandt's
career, artistic interrelationships of such intensity came
into being that later connoisseurs and even contempo-
raries have been unable to disentangle the hands of the
several participants. One such moment were the years
around 1630. A fair number of well-wrought paintings
by accomplished artists continue to bounce back and
forth between Rembrandt, Jan Lievens, Gerard Dou,
Isaac de Jouderville and occasional others. It is a moot
point whether de Jouderville truly belongs on this list.
He was elevated to it by the Rembrandt Research
Project, to the incomprehension of most and the fury
of some.[12]

Dou and Jouderville were two kinds of Rembrandt
pupil: the professional who made it and the one who
didn't. A third type is the serious amateur. In his
Teutsche Academie der Bau-, Bild- und Mahlerey-Künste
(1685), Joachim von Sandrart says that Rembrandt gave
lessons to "countless children from good families,
each of whom paid him a hundred guilders a year."[13]
(Note that the amount is the same he charged his
apprentices.) This kind of pupil is exemplified by
Constantijn à Renesse (also called Constantijn
Daniel van Renesse; 1626–80), the son of a minister,
theologian, chaplain in the States Army and house
chaplain to the stadholder of Friesland. Renesse himself
was later to become town secretary of Eindhoven.[14]
On the back of a drawing by him of Daniel in the lions'
den, he wrote:

12 Bruyn et al. 1982–, vol. 2 (1986),
pp. 78–88. Among the radical
skeptics concerning this theory are
Seymour Slive and Walter Liedtke.
The sculptor Nigel Konstam felt
obliged to set up a Movement to save
Rembrandt from the Experts.
Anyone who could not tell the
difference between a Rembrandt
and a Jouderville, he said, should
not pretend to be a connoisseur.
13 Sandrart 1994, vol. 1, p. 216;
Hofstede de Groot 1906a, p. 394,
no. 329. Sandrart 1994, vol. 1, p. 326.
14 Vermeeren 1978, pp. 3–4, 13.

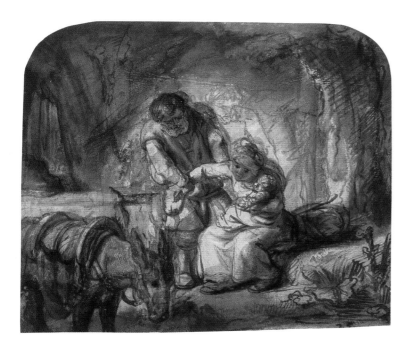

217
Rembrandt pupil
Rest on the flight into Egypt
Unsigned, undated. Ca. 1650
Red chalk, brown ink and wash,
white body color, 19.5 x 22.3 cm.
Dresden, Staatliche Kunst-
sammlungen, Kupferstich-
Kabinett

218
Inscription on the verso of the
Rest on the flight into Egypt
(fig. 217): *beeter waert dat
(om de veranderin)
den eesel van achteren was dan
dat al de hoofden iui[j]st wt het
stuck sien dat ook omtrent de
boom wat meerder groente was ...
1 josep ho[o]ft alte swaer en te
onbesuijst
2 maria most het kindeken wat
meerder vieren
 want een teeder kint magh sulck
duwen niet ver[dra ...]
Josep alte kort en dick | syn hooft
wast hem wt de [borst] sy hebben
alle beide alte groote koppen.*
Dresden, Staatliche Kunst-
sammlungen, Kupferstich-
Kabinett

15 Vermeeren 1978, pp. 7–8.
Schatborn and Ornstein-van
Slooten 1984–85, p. 79, no. 65.
Sumowski 1979–92, vol. 4 (1985),
pp. 4818–19, no. 2145. Giltaij 1988,
pp. 242–43, no. 130. All have differ-
ent theories about the discrepancy
of the dates, none of them very
satisfying.
16 Van Hoogstraten 1678, p. 192.
Schatborn and Ornstein-van
Slooten 1984–85, p. 10.

CARenesse
The first drawing shown at Rembramt's in the year
1649 on 1 October
It was the second time that I was with Rembrant.
That inscription is a rare piece of first-hand evidence
concerning a Rembrandt lesson. (The evidence would
have been neater if the front of the drawing were not
inscribed *CARenesse inventor et fecit 1652.*)[15] Renesse
was twenty-three years old in 1649. In coming to
Rembrandt after the age of apprenticeship, he must
have been motivated by sheer interest in Rembrandt
as a teacher. What the inscription seems to say is that
Renesse came for his first lesson sometime before
1 October 1649 and returned on that date with a draw-
ing that he submitted to the master. Renesse's drawing
of Daniel, whether it was the first one or whether it
was made three years later, shows enough resemblance
to a sheet by Rembrandt from the same period to
convince us that Renesse knew it (fig. 213). Perhaps
Rembrandt lent it to him with the assignment to create
his own variation.

Rembrandt's teaching method involved classic exer-
cises such as copying from prints, drawing from the
model and accompanying the master on walks in the
country. All were heavily dependent on drawing.
In addition to the twenty-five albums and boxes of
Rembrandt's own drawings, another pedagogical tool
was the pupil drawing corrected by the master. This
practice is recommended emphatically by Samuel van
Hoogstraten, especially with regard to improving com-
position.[16] A drawing of a lion in the British Museum
is an example (fig. 214). The heavy lines in reed pen are
taken to be Rembrandt's way of showing a somewhat
timid pupil where he should give it all he's got.

The kind of advice Rembrandt gave to his pupils is put
into words in an inscription on the back of a drawing
from the same mid-century years.

It would be better (to make [these] changes:) to see
the ass from behind rather than that all the heads just
peep from the painting. Also, that there were more
foliage around the tree.

1 Joseph's head is too heavy and too boldly [drawn].
2 Mary should hold the child a little more loosely,
because a tender child cannot endure to be clasped
[so firmly].

Joseph is too short and too fat. His head is growing
[straight] from the chest. They both have heads that
are too large.[17]

The advice is about heightening the visual interest
of a composition, enriching the details, thinking hard
about action, drawing, verisimilitude. It deals with the
behavior and appearance of the figures, their limbs and
stances, the logic of their poses. The sense of touch,
feelings of effort, weight, resistance, and vulnerability
are evoked in the contact between Joseph and Mary,
Mary and the Christ child. If the pupil's stroke in the
drawing of the lion was too heavy, here the master finds
Joseph's head laid in too heavily. Most of the advice
is however not about technical devices; it goes into
the depiction as if it were a real event, the figures real
people.

After these concrete remarks, the situation declines
quickly into uncertainty. Whose drawing is on the
recto? The Dresden print room, which owns the sheet,
called it a Ferdinand Bol in the nineteenth century,
a Samuel van Hoogstraten in the twentieth and a Barent
Fabritius in the twenty-first.[18]

Whose handwriting is on the reverse? It has been
suggested that the upper two blocks were written by
Rembrandt. To my eye, comparing the writing in
Rembrandt's letters to Constantijn Huygens, this is
unconvincing. It is simpler to assume that a pupil wrote
the notes on the basis of the master's spoken remarks.

219
Rembrandt
Inscription on the verso of
Susanna surprised by the elders,
after Pieter Lastman (fig. 457):
verkoft syn vaendrager sijn[t] 15 -
en floora verhandelt - 6 -
fardijnandus van sijn werck
verhandelt
aen ander werck van sijn voor
neemen
den Abraeham een florae
Leenderts floorae is verhandelt
tegen 5.-.
Undated. Ca. 1637
Red and black chalk,
23.5 x 36.4 cm.
Benesch 448 verso
Berlin, Staatliche Museen,
Kupferstichkabinett

17 Broos 1981–82, p. 258, with a
somewhat different transcription
and translation than there, provided
by Marten Jan Bok.
18 Looking at it in juxtaposition
to *Daniel in the lions' den* and
considering his penchant for writing
on the backs of his drawings, I find
myself wondering why Constantijn
à Renesse should not be considered
as author of the Dresden drawing.
Werner Sumowski does not include
this sheet in his ten volumes on the
drawings of the Rembrandt school.
19 Not only has no handwriting
expert given an opinion on this, no
paleographer has ever transcribed
the fascinating note. The most
recent catalogue of the Dresden
drawings by Rembrandt and his
school quotes the version in a note
in a book on van Hoogstraten by an
American art historian. The authors
did not notice that she was quoting
from a review by a Dutch art
historian who not only never saw
the original but complained with
annoyance that the "Staatliche
Kunstsammlungen, Dresden, . . . was
unable, or unwilling, to send me a
photograph." Dittrich and Ketelsen
2004, pp. 80–81, 207, no. 14. Brusati
1995, p. 275, note 40. Broos 1981–82,
p. 258, note 64.
20 Ben Broos, "Fame shared is fame
doubled," in Blankert et al. 1983,
pp. 35–58. A harder core would
consist of no more than five names,
for only one of which, Isaac de
Jouderville, are there legal docu-
ments proving his relationship to
Rembrandt. For Gerard Dou and
Constantijn à Renesse see above;
Samuel van Hoogstraten calls
Rembrandt his master in his book of
1678; and Leendert van Beijeren is
called a "disciple" of Rembrandt in
an auction record of 1637. Evidence
concerning the other fifteen or fifty
is second-hand or consists of sheer
conjecture.

Cornelis Hofstede de Groot gave the inscription as well as the drawing on the recto to Samuel van Hoogstraten; the new attribution to Fabritius was unattended by any comment on this matter.[19]

I dwell on these details to stress the uncertainties involved in discussing Rembrandt's tutelage in any detail. This extends to, or rather begins with, the very size and composition of his school. In 1983, Ben Broos drew up a list of fifty-five artists identified in the literature as Rembrandt pupils. He points out that more than half of these ties are undocumented and proposes a hard core of eighteen or twenty.[20] A critical student of the phenomenon, Walter Liedtke, argues that even if twenty young artists studied with Rembrandt, few stayed with him to produce Rembrandt-like works in his workshop. He criticizes the Rembrandt Research Project sharply for its too unquestioning assignment of rejected Rembrandts to the Rembrandt workshop. If Rembrandt did have a workshop, he asks, why did its members not contribute to large commissions such as the *Night watch*, which the Rembrandt Research Project considers to be entirely by the hand of the master?[21]

Liedtke and others have also pointed out another contradictory feature of the *Corpus of Rembrandt paintings*: "There is also general agreement . . . that the RRP has been 'highly selective regarding Rembrandt's oeuvre but willing to make all kinds of concessions and speculations about the work of his pupils, such as Drost, Jouderville and especially [Carel] Fabritius."[22]

In attempting to purify the Rembrandt corpus, the RRP has muddied our image of everyone around him. Liedtke's implicit claim is that the thousands of paintings that resemble Rembrandt but are not good enough to be autograph works were produced outside his workshop.

Another student of the question, Claus Grimm, proposes a very different solution to this conundrum. He sees no reason to doubt that Rembrandt conformed to the general pattern of successful artists of his time in maintaining a workshop and putting pupils to work for him.

No differently from other craftsmen, painters and sculptors brought in commissions, organized production, signed works and took payment from the buyer. [They practiced a mode of] division of labor [that] encompassed the preparation of painting materials, supports and grounds but also the assembling and arranging of models for motifs and doing the actual painting.[23]

In this situation, according to Grimm, it is senseless to limit the notion of an authentic Rembrandt to a drawing or painting that was executed entirely by the hand of the master. Even if different hands are not visible on the surface of a painting, they are likely to have worked on lower layers. Work of this kind also contributes to the quality of the finished work.

These are good questions, and until they are answered we would do well to reserve judgment on the larger issues involved.[24] My own inclination is to agree with Grimm, but I find it extraordinary that in the early twenty-first century it is still possible for Rembrandt specialists to hold such radically different views on such a basic subject.

A related question is the extent to which Rembrandt dealt in the work of pupils. On the back of a drawing of *Susanna surprised by the elders* in Berlin, Rembrandt jotted down the following note:

… his ensign sold, being 15 -
a flora sold - 6 -

Fardynandus of his work sold
other work of his design
the Abraham a Flora

Leenderts Flora sold for 5 - -

This seems to say in so many (fairly incoherent) words that Rembrandt traded in the paintings of his pupils for prices far below the rate for his own work. The names are assumed to refer to Ferdinand Bol and Leendert van Beyeren. The latter is particularly intriguing. He is the second-best documented Rembrandt pupil after Isaac de Jouderville, and not a single painting or drawing by him is known. Is it possible that Rembrandt put his signature on the work of his better pupils? Respected specialists hold diametrically opposed views on these matters.

220
Carel Fabritius (1622–54)
The raising of Lazarus
Inscribed *CAR. FABR..*
Undated. Ca. 1642
Canvas, 210.5 x 140 cm.
Sumowski 601
Warsaw, National Museum
in Warsaw

21 Liedtke 2004, pp. 48–49. In other
respects, the ideas of the Rembrandt
Research Project are closer to
Liedtke's than the latter lets on.
For example, both assume that
Hendrick Uylenburgh rather than
Rembrandt was the main force
behind the dynamic production of
portraits and heads coming out of
the house on the Sint Antoniesbree-
straat in the early 1630s. Ernst van
de Wetering, "Problems of appren-
ticeship and studio collaboration,"
in Bruyn et al. 1982–, vol. 2 (1986),
pp. 45–90.
22 Liedtke 2004, p. 61, quoting
Grasman 1997, p. 157.
23 From a manuscript kindly shown
to me by the author.
24 Ernst van de Wetering and Jaap
van der Veen of the Rembrandt
Research Project argue that since
discussions of authenticity took
place in the seventeenth century,
their own search for the master's
unique hand is not anachronistic.
To my mind this distorts the relation
between the interests of seven-
teenth-century collectors and
twenty-first-century art historians.
It also ignores the astronomical
growth in the market of the gap
between a real Rembrandt and
an "attributed" one.

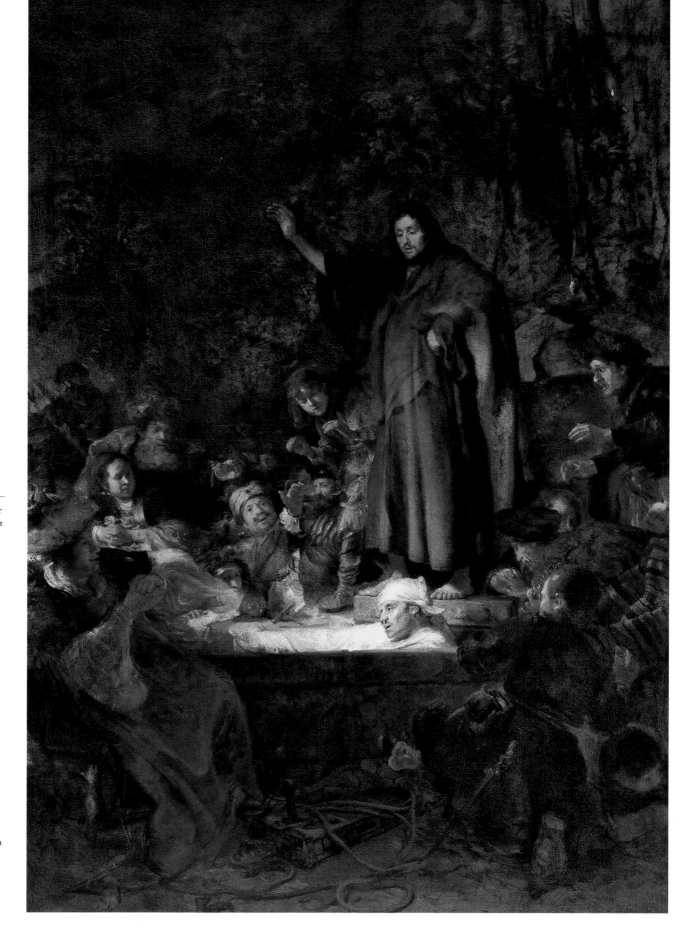

Retreating, then, to safer ground, we know that
Rembrandt gave instruction to and deeply influenced
a number of important younger artists. On the order
of Gerard Dou in terms of artistic and financial success
in Holland were Govert Flinck (1615–60; however,
Flinck may not have been an actual pupil of Rembrandt),
Ferdinand Bol (1616–80), Gerbrand van den Eeckhout
(1621–74), and Arent de Gelder (1645–1727). Unlike
Dou, who developed a famous specialty in allegorical
genre paintings, these masters followed Rembrandt in
sticking to the traditional mix of history painting and
portraiture. Nicolaes Maes (1634–93) went in for genre
and portraiture. More international careers were pur-
sued by Samuel van Hoogstraten (1627–78) and the por-
traitist Gottfried Kneller (1646–1723). The Rembrandt
disciple whose work is taken most seriously by present-
day art historians is Carel Fabritius (1622–54), whose
early death in a famed gunpowder explosion in Delft
cost the world a life that could have changed the face
of Dutch painting in the second half of the seventeenth
century. (Of these nine artists, four were from
Dordrecht, an interesting connection that keeps pop-
ping up in Rembrandt's life.)

Van Hoogstraten, a writer as well as a painter, was
one of the most inventive artists of his time and one of
the most reflective. His book on the art of painting is
divided into nine "learning shops," named for the nine
muses. Although the book is not as systematic as he
wished it to appear, the author is praised in the caption
to his self-portrait for an "art based on pure reason."
Van Hoogstraten's perspective boxes, contraptions
that achieve a higher degree of illusion than a flat pic-
ture, can be seen as a continuation and expansion of
Rembrandt's attack on the third dimension. (I do not

221
Rembrandt
The raising of Lazarus
Inscribed *RHL van Ryn f..*
Undated. Ca. 1632
Etching and burin,
36.6 x 25.8 cm.
Bartsch 73 x(10)
Haarlem, Teylers Museum

think that Rembrandt ever gave him the idea that art
was a function of pure reason.)

Beyond his documented pupils, Rembrandt had
fargoing impact on his surroundings. His fame is illus-
trated nicely in an anecdote told by Arnold Houbraken
concerning the painter Jan de Baen (1633–1702). At the
age of eighteen, his apprenticeship behind him, "he had
to adopt a manner of painting that was worthy of being
followed. The brushwork of Ant. van Dyk stood in high
respect and that of Rembrant also had many support-
ers." De Baen opted for the style of van Dyck "as being
more sustainable."[25]

Since van Dyck had been dead for nearly a decade by
then, it follows that de Baen's choice did not necessarily
involve apprenticeship. There were other artists, such as
Jacob de Wet of Haarlem (ca. 1610–75), who worked in
their own version of the Rembrandt manner without
paying the master one hundred guilders a year for the
privilege. Their efforts, perhaps mixed in with the work
of bona fide pupils, fill many a box of mounted photos
in the Netherlands Institute for Art History under the
depressing label Anonymous Rembrandt School. Many
of these works were formerly attributed to the master
himself, sometimes as famous masterpieces. *The man
with the golden helmet* in Berlin is one (fig. 72). The
most famous name in Dutch art flows over into a sea
of anonymity.

222
Arent de Gelder (1645–1727)
*Art collector (self-portrait?)
with Rembrandt's "Hundred-
guilder print"*
Inscribed *... de Gelder f..*
Undated. Ca. 1710
Canvas, 79 x 64 cm.
St. Petersburg, State Hermitage
Museum

25 Houbraken 1718–21, vol. 2 (1719),
p. 305.

Buying and paying for a house and its contents

Aside from his art, relics of Rembrandt's stay on earth are few. The house in Leiden where he was born was demolished in the 1930s to make way for a printing plant. One surviving location makes up for much of the loss: the splendid house on the Sint Antoniesbreestraat in Amsterdam, built in the year of his birth, where he lived for twenty years. Although the outside has changed and the interior is one hundred percent reconstruction, it remains a thrill to walk through the master's very house. The basis for the furnishing of the Rembrandt House Museum of today is the inventory of the artist's goods in 1656, which proceeds from room to room.

Rembrandt arrived twice in Amsterdam. In the 1620s he went there as a fledgling artist to study under Pieter Lastman and in the 1630s, after building the basis for a promising career in Leiden and The Hague, he returned as an associate of the art dealer Hendrick Uylenburgh.[26] Both times he came to the same street, Sint Antoniesbreestraat (St. Anthony's Broadway). This was no coincidence. That street was Amsterdam's answer to thoroughfares like the via Margutta in Rome, a place to which artists and art dealers gravitated.

Sint Antoniesbreestraat starts at the Sint Antoniesmarkt (now the Nieuwmarkt, New Market), on which the Sint Antonieswaag stood, a former city gate converted in 1617 into a weighing hall after a new city wall was built on an outside perimeter a kilometer further east. On the upper floor of the weighing hall, which was city property, were the premises of several guilds, among them the guild of St. Luke. (See below, pp. 164–69.) The street runs in a straight line toward the northeast for half a kilometer, then takes a dog's-leg turn further east just before the Sint Antoniessluis, a lock in the Verwersgracht. After another straight stretch of about six hundred meters the street ended at the Sint Antoniespoort, a gate that offered access to the outer borough known as the Plantage, to the road to Diemen and points east. (In later centuries the Sint Antoniesbreestraat, which became the heart of the Jewish quarter of Amsterdam, was renamed the Jodenbreestraat.)

These were Rembrandt's stamping grounds in Amsterdam for thirty years. Pieter Lastman lived in the first stretch of the Sint Antoniesbreestraat and Hendrick Uylenburgh in the second, just beyond the lock. On this short thoroughfare and its cross streets the Amsterdam archivist Bas Dudok van Heel has counted seventeen properties in which twenty-six renowned artists lived.[27] It did not lie, like the via Margutta, in an overcrowded old neighborhood where artists could get cheap lodgings. Quite the contrary, it was a wide new street, with large, comfortable houses, on land that was newly incorporated within the city walls. The very fact that so many artists could afford to live there tells us how prosperous the Amsterdam community of artists was.

223
Balthasar Florisz. van Berckenrode (1591–1645)
Detail from *Map of Amsterdam*: the new quarter east of the Old Side
The entire map is provided with numerous inscriptions, including dedicatory poem by Petrus Scriverius. Dated 1625
One of nine engraved plates, measuring in total 140 x 160 cm.
Amsterdam, Gemeentearchief

26 The years in which this took place are a matter of debate. Schwartz 1985, pp. 21, 132, dates the apprenticeship with Lastman to 1622–23 and the residency with Uylenburgh to 1631. Since then Ben Broos has argued persuasively that the stay in Lastman's studio did not take place until 1625–26, while Bas Dudok van Heel dates the definitive move to Amsterdam to 1633. Broos 2000 and Dudok van Heel in Brown et al. 1991, p. 54.
27 Dudok van Heel in Brown et al. 1991, pp. 58–59.

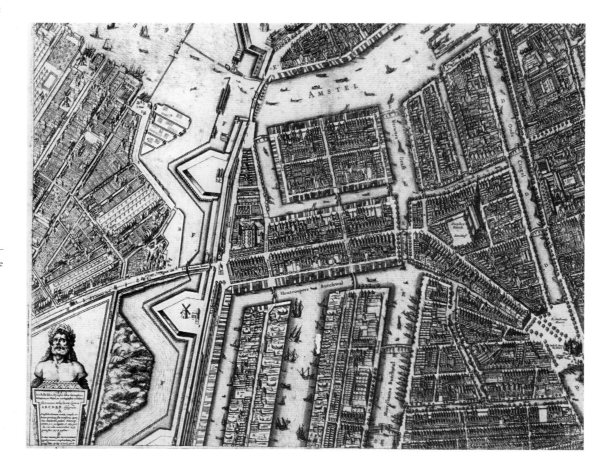

224
Detail from *Map of Amsterdam* (fig. 223):
the future Rembrandt House
Amsterdam, Gemeentearchief

Originally the future Rembrandt and
Uylenburgh houses, built together, had
similar step-gabled façades.

225
Henk Zantkuijl
*Reconstruction of Rembrandt House,
1627–60*
Ca. 1997
Amsterdam, Museum het Rembrandthuis

The façade of the Rembrandt House
was modernized in 1627 by Jacob
van Campen.

226
Johan Martinus Anthon Rieke (1851–99)
View of the Rembrandt House
Inscribed *A Rieke | 1868*
Aquarel, 34.6 x 19 cm.
Amsterdam, Museum het Rembrandthuis

In 1660 the Rembrandt House, looking
completely different from its former twin,
was split in two, with separate doors to
each half.

227
The Rembrandt House today
Jodenbreestraat 4–6, Amsterdam

In 1908 the second door was closed
and the reunified interior transformed
by K.P.C. de Bazel into an homage to
Rembrandt. In 1999 the de Bazel interior
was removed and a full restoration
undertaken to the plans of Henk
Zantkuijl.

It was here, in 1639, after having lived first in Hendrick Uylenburgh's house, then successively in two rented dwellings nearby, that Rembrandt and Saskia bought a grand house and established themselves as lord and lady of their own domain. The house was not just a home. It was also the location of Rembrandt's busy studio, the showroom for his art and, in the years when Rembrandt still entertained notions of being a merchant, the headquarters of Rembrandt, Inc. In this, Rembrandt and Saskia were no exceptions. Every house of any size had its commercial spaces. Private areas moreover spilled over readily into the street. The concept of personal privacy was as yet underdeveloped in the era in which they lived. Telling details in this regard are that Dutch houses of the seventeenth century had no fixed bedrooms and no toilets. Beds could be installed anywhere; and why waste good space on a toilet when a chamber pot or an outhouse will do?

Rembrandt and the house on the Breestraat seem to have been destined for each other. Construction was begun in 1606, the year of the artist's birth. The builders were two brothers from Antwerp, Hans and Cornelis van der Voort, who belonged to the circle of Pieter Lastman. The house was one of a pair. Next to it, on the corner facing the lock, was an identical house that was later to belong to Hendrick Uylenburgh, the house where Rembrandt came to live and work in the 1630s. Between 1606 and 1625, when Uylenburgh moved in,

this was the home and studio of Cornelis van der Voort (1576–1624), who was an important portrait painter. In their original form, both houses had step gables in brick and stone, of a form that could be found anywhere in northern Europe, from France to Pomerania.

The Rembrandt House was sold in 1608 to another wealthy immigrant from Antwerp, Pieter Belten. His daughter Magdalena and son Pieter, who both married in 1627, had the house renovated on that occasion. By all appearances, the architect who did the job was Jacob van Campen, who had just built a new house for Pieter's new father-in-law, Balthasar Coymans, yet another, even richer Antwerper in Amsterdam. The house was enlarged with an extra floor and the façade modernized with a classicizing pediment, the earliest known example in the city.[28]

In 1628 Rembrandt made his initial entry into the papers of this Antwerp-Amsterdam clan. On 15 June of that year, another new son-in-law of Balthasar Coymans, Joan Huydecoper, noted in his cashbook, "Two paintings purchased. One of Venus, a copy after rubbens 25 guilders. The other a head by warmbrant 29 guilders." In the same ink, Huydecoper crossed out *warm* and added *rem* above the line (fig. 228).[29]

This is the very earliest record of the purchase of a painting by Rembrandt. How did Rembrandt – apparently at second hand, since Huydecoper did not know his name – come to the attention of this important Amsterdamer and future burgomaster? Could

28 See the entry on Jodenbreestraat
4 on the website "Monumenten en
archeologie in Amsterdam":
http://www.bmz.amsterdam.nl/
adam/nl/huizen/jodenbr4.html.
29 Schwartz 1985, pp. 135, 138.

228
*Entry in cashbook of Joan
Huydecoper for 15 June 1628*
Utrecht, Utrechts Archief

it have come via the Belten connection? There is an interesting indication that it may have. While Pieter Belten was marrying into the Coymans family, his sister Magdalena married a Thijsz. From this family – needless to say a family of wealthy immigrants from Antwerp – Rembrandt was to buy the house on the Breestraat. In the year of her marriage to Anthonie Thijsz., 1627, the groom's uncle of the same name – also known as Antonius Thysius (1591–1648) – became professor of theology and Hebrew at Leiden University. It was around this time that Rembrandt, in Leiden, began to place Hebrew inscriptions on his paintings; what likelier advisor would he have turned to than the best local expert? It is therefore not impossible or even unlikely that Rembrandt's connection with the family to which he sold his first painting in Amsterdam and from which he later bought his mansion came into being during a Hebrew lesson in Leiden. As we shall see later, Rembrandt had an excellent knowledge of Hebrew letters and texts, a knowledge he began to acquire in Leiden.

The low-cost tie between Rembrandt and Rubens in Huydecoper's cashbook has a parallel in the more expensive realm of real estate. The Thijsz. family, it has been noticed by the Amsterdam archivist Isabella van Eeghen, not only sold Rembrandt his house; the uncle of the seller, the Antwerp merchant Hans Thijsz., is the man who sold Rubens the ground on which the Rubens House came into being. The comparison is telling. Rubens bought a vast tract of land in the best part of Antwerp for the relatively small sum of 8,960 guilders plus "a painting by his own hand as large or small as he, Rubens, considers appropriate, but one for which he would expect to be honored, and moreover teach and instruct the art of painting to a son of the aforementioned Hans Thijs at no further cost …"[30] We hear nothing more about Rubens's debt to Hans Thijsz., so we may assume it was paid in time. We also hear nothing more about a Rubens apprenticeship of any of Thijsz.'s four sons; the chances are that it never happened. As for the painting, despite all the leeway given

to him, Rubens took his sweet time in fulfilling the obligation. After the death of Hans Thijsz. a few months after selling Rubens his land, the heirs twice sent him reminders. Michael Montias, who located the record of the eventual delivery, counted the time it took Rubens to deliver: nine years and three days. The painting he sent, Montias concludes from what it cost to ship and frame, could not have been very large.[31]

The deal with Rembrandt was not accompanied by such honorific flourishes. And Rembrandt was not as keen a businessman as Rubens. He will not have known, when he entered negotiations with Hans's nephew Christoffel Thijsz., that Thijsz. and Belten had put the house on the Breestraat up for auction in 1636 and that it had failed to meet its reserve of twelve thousand guilders. Here it was three years later, and they got thirteen thousand for it from Rembrandt. At the time, the artist and his wife, with a net worth later estimated at over forty thousand guilders, could well afford it.

In a sales contract for the house, dated 5 January 1639, Christoffel Thijsz. offered Rembrandt extended payment terms: 1,200 guilders upon taking title on 1 May, another 1,200 on 1 November 1639 and 850 guilders on 1 May 1640. Within a year one-quarter of the purchase sum will thus have been paid. The remaining three-quarters, 9,750 guilders, was to be paid off in five or six years as Rembrandt pleased. As he pleased, but with interest of five percent – on the high side, but not excessive – on the unpaid balance.

What next happened, or failed to happen, remains a mystery. In the ten-and-a-half years following 1 May 1640 Rembrandt paid only 2,750 guilders of the 9,750 guilders of his debt. Instead of 817.50 guilders per half year, which would have gotten him in the clear within six years, he paid an average of only 230. And on 1 November 1649 he stopped paying interest as well.

In a note on the back of a drawing made around the time of his insolvency, Rembrandt outlines his tactics for a meeting with Christoffel Thijsz. (fig. 230). Let us take it as evidence for Rembrandt's style of doing

30 Van Eeghen 1977, p. 61. See also Montias 2002, chapter 16: "Art collectors and painters I: Rubens's promise to Hans Thijsz.," pp. 153–63.
31 Montias 2002, p. 158.

229
Rembrandt
A child being taught to walk
Unsigned, undated. Ca. 1660
Brown ink, 9.3 x 17.4 cm.
Benesch 1169
London, British Museum

business. By this time, we learn from the inscription, the problem had gone to a committee of arbitration – *goede mannen* (good men) in Dutch. Normally, parties who agree to arbitration commit in advance to abide by the decision of the arbiters. Apparently, however, the arbiters had come up with a decision with which Rembrandt could not live, since he now wished to float the proposal that he and Thijsz. withdraw the case from arbitration and seek another formula. That formula would have started with the completion for and

delivery to Thijsz. of one of two Rembrandt paintings in which the creditor had previously expressed interest. Insofar as this resembles the Rubens sale – including art works in the price of a piece of real estate – the difference is painful. Rubens paid Hans Thijsz. his money and kept his heirs waiting for the art. Rembrandt failed to pay Christoffel Thijsz. his money and tried to slip in art after the fact, art that could not have been worth more than about ten percent of his debt, at a moment when the situation could no longer be saved.

230
Rembrandt
Inscription on reverse of *Child being taught to walk*
dit voor af te vragen | [vr]agen oft weij t an de Heeren | goede mannen willen laten verblijven
2
dan Tijscen te vragen oft hij niet een |[van] beijden d schilderien gelieft opgemaeckt te hebben| geen van beijden begerende.
(Before beginning to raise this question, to ask if we want to let it [the issue] remain with the arbitrators / 2 / then to ask Thijsz. if he would not like one of the two paintings finished. If he doesn't want either …)
Before July 1656
Benesch 1169 verso
London, British Museum

231
The hearth in the salon of the
Rembrandt House

The early seventeenth-century
hearth was purchased in the
1990s. The herms at the corners
match those on the façade and
those that can be seen on
a hearth in the same location
in a drawing of Saskia in bed
(fig. 232). The bed presently in
the Rembrandt House is on
loan from the Rijksmuseum.

Rembrandt's insolvency generated a slew of docu-
ments for which the historian must be grateful in a sad
way. The longest and most detailed of these is one of
the most important documents in the history of seven-
teenth-century art, the "inventory of the paintings as
well as furniture and household goods found in the
estate of Rembrandt van Rijn, living on the Breestraat
near the Sint Antoniessluis." The official responsible
for drafting this document on 25 and 26 July 1656 was
Frans Bruijningh, the secretary of the Insolvency Office
of Amsterdam, the poetically named Chamber of
Desolate Estates (*Desolate Boedelskamer*). The high
quality of the information in the listing seems to indi-
cate that Rembrandt walked with Bruijningh from
room to room in the house, dictating the specifics
of each item, 363 in all. Let us follow them.

In 't voorhuys (in the entrance hall): twelve paintings
by Rembrandt, four each by Adriaen Brouwer and Jan
Lievens, one by Hercules Seghers and one "finished"
(who started it?) by Rembrandt's neighbor on the
Breestraat, Hendrick Anthonisz. These were easy
pieces. Aside from a *Nativity* by Jan Lievens, there were

no history paintings here, only landscapes, genre paint-
ings and heads, a saint and some animals. Three paint-
ings "retouched" by Rembrandt hung here, as well as
three animal paintings by him – hares, a pig and a lion
fight – that have disappeared from art history. A few
plaster heads and figures and six chairs round out the
furnishings, aside from the mysterious item "een
poviese schoen," which no one has ever deciphered.
(Or might it just be "Een perzische schoen" – a Persian
shoe?) To my eye, the contents of this room look like
trade, relatively inexpensive stuff that might be sold
to passersby.

In de sijdelcaemer (in the anteroom): forty-two paintings
of a somewhat heavier caliber. In addition to ten land-
scapes and seascapes by Rembrandt, Jan Porcellis (the
brother-in-law of Hendrick Anthonisz. – was it Porcellis
who started the painting in the entrance hall that was
finished by Hendrick?) and Simon de Vlieger, ten heads
by Rembrandt, Jan Pynas, Lucas van Valckenborch and
others and a scattering of scenes from everyday life,
mostly by Rembrandt, there were also seven history
paintings, including a large *Descent from the Cross* by

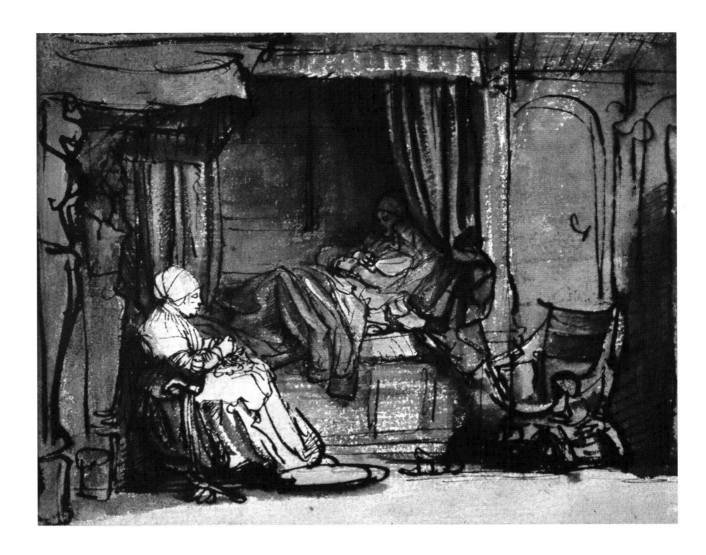

232
Rembrandt
*Woman in bed, with attendant,
presumably the ailing Saskia*
Unsigned, undated. Ca. 1640
Pen and wash, 14.3 x 17.6 cm.
Benesch 426
Paris, Fondation Custodia
(Frits Lugt Collection)

233
First page of Frans Bruijningh's
inventory of Rembrandt's
possessions
Amsterdam, Gemeentearchief

Rembrandt, in a handsome golden frame. The list otherwise mentions no frames around paintings. In this room the paintings must have covered the walls completely.

In de caemer agter de sijdelcaemer (the room behind the antechamber). The room was hung with eighteen paintings and two drawings, including three histories by Rembrandt (and two copies after him), an Aertgen van Leyden and a Jan van Eyck. The rest were down-market copies and works of less expensive genres. The "oak press" must have been a linen press. Four chairs stood in the room.

In de agtercaemer offte sael (in the back room or salon). The present look of the room comes closer to the impression given in the inventory than any other of the rooms with paintings, with about the same number hung, in the low twenties. One misses one of the little set pieces in Rembrandt's furnishing – two paintings of an ox, one by Lastman and one by Rembrandt. With histories by Rembrandt alongside others by Italian artists and one early Netherlander, this must have been the most dignified show room. Whether it is right to call it part of Rembrandt's "collection" any more than the assortment in the front hall I would dispute. One of the star items is described as "A large painting of the Samaritan woman by Giorgione, half of which belongs

234
Spiltrap (spiral staircase)
in the Rembrandt House

235
Re-creation by the Rembrandt
House of the "art room"

236
Anonymous Roman sculptor,
Bust of the emperor Galba
Unsigned, undated. Ca. 69 AD
Marble, 38 cm. in height
Stockholm, Nationalmuseum

Believed to have been bought
by Queen Christina from
Rembrandt's collection.

237
Rembrandt
Bust of the emperor Galba
Unsigned. Inscribed *ALBA*.
Undated. Ca. 1640
Pen, 14.2 x 9 cm.
Benesch 770
Berlin, Staatliche Museen,
Kupferstichkabinett

Roman emperors (except for Claudius, who is just called "a Roman emperor") and marble or plaster busts of Heraclitus, Socrates, Homer, Aristotle, Brutus, Empress Faustina and "a brown ancient head." Another obligatory item for a display of this kind tops the list: Frans Bruijningh calls it "twee aerdtclooten," two globes of the earth, although they were more likely to have been one terrestrial and one celestial globe. The use of two globes for the study of heaven and earth and their relation was a favorite pastime for seventeenth-century amateurs. Sculptures of "ancient love" and "two completely naked figures" added spice to the collection.

Beside carved and modeled sculptures, Rembrandt also had casts – "eight large pieces of plaster, cast from life," one of a moor, two others of Prince Maurits, including a death mask. The art room was also a private armory, with examples of helmets, one of them Japanese, shields, one of which was said to have been made by the Antwerp artist Quentin Matsijs, who started out in life as a smith, a bow, whips, armor.

Animal, vegetable and mineral rarities were present as well as basketry from the Indies and China, a hammock and a few doodads in porcelain and stone and glass.

And then come the treasure chests. "A chest with medals," which are not identified, but of which we can form an idea through drawings of medals by Rembrandt and medallic motifs in compositions. The ownership (presumed) of even a single medal by Pisanello, which Rembrandt used for his *Three Crosses* of 1653, is indication enough that the collection was a serious one.

The true wonders of the art room and of Rembrandt's collection as a whole were his holdings in prints and drawings. The twenty-five books and albums of drawings by Rembrandt, the content of which we estimated above at nine thousand sheets (see p. 106), were preserved here. The number of prints by him and others has been estimated at more than four thousand sheets and the drawings by other masters at more than

238
Rembrandt
Detail from *Christ crucified between the two thieves: "The three crosses"* (fig. 598)
Haarlem, Teylers Museum

239
Antonio Pisanello
(ca. 1395–ca. 1455)
Reverse of *Medallion for Gianfrancesco Gonzaga (1395–1444)*
Inscribed *Opvs Pisani pictoris.*
Undated. Ca. 1444
Bronze, 9.4 cm. in diameter
Utrecht, Koninklijk Penningkabinet

to Pieter la Tombe." Trade, I would say. This room contained a bed; the Rembrandt House has provided one that resembles a bed in a drawing from the first period in the house on the Breestraat. The "diaper chest" makes this room the nursery as well as the master bedroom, the linen press a working space for the housemaids, and the oak table and six chairs a dining or living room. Comparison with present-day room functions fails.

Up the narrow spiral stairway in the middle of the house that connects all the floors, going to the room above the *sael*, we arrive in the real collection:

Op de kunstcaemer (in the art room). The striking thing about Rembrandt's "art room" is that none of its 150 items, by far the most in any of the rooms, is a painting! What was meant by "art" were Rembrandt's fabulous collection of prints and drawings and the sculptures, rarities and curiosities with which the room was filled. There was a series of perfectly named

240
Rembrandt
Inscription on reverse of
Old man in a long cloak
Unsigned, undated.
Before July 1656
Inscribed with fragmentary list,
apparently of prints.
… *ter verkracht van guido*
[e]remijt elshamer
ordel migel Angylo
… *u elegant paleijs*
[m]aria van gwydo
… *ius Christus [?] ant taf* …
… *stuck*
[j]osef en marija
munneken van mutsi
ander munneken
[g]roetenes Barotius
… *[?] munick Coerats*
… *'t [?] o [?] ver sidts op*
de schoot
[ma]ria met d'enghel
[m]aria Madaleen
[m]unnick door baroeseus
ovael Maria
Lange maria
van d luit over d [?]
j not [?]
Pen and ink, 15 x 9.4 cm.
Benesch A96a
London, Courtauld Institute
of Art Gallery

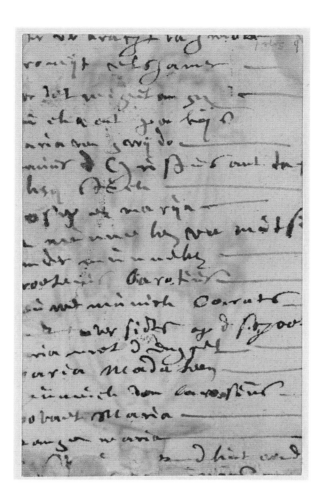

fifteen hundred.[32] Many of the great names in European art are dropped in the inventory, with only occasional indications of the nature of the material. There are statues by Heemskerck, erotica by Raphael, Turkish buildings and folkways by Melchior Lorch. The special features, the masters represented with "all their works," "the best of" or a "very precious" book are, beside Rembrandt, Andrea Mantegna, Raphael, Maarten van Heemskerck and Titian.

In our analysis of the formal sources of Rembrandt's art, where these same masters are prominent, we observed a heavy emphasis on the Italian sixteenth century. Rembrandt's prints and drawings show the same bias. There are thirty-six mentions of masters active before 1600 and only eighteen afterwards; twenty-three mentions of Italian artists as against fourteen northern Netherlanders, fourteen southern Netherlanders and seven French and German masters. One omission makes me suspect that even this large list may not be complete: where is Jacques Callot (1592/93–1635), from whom Rembrandt borrowed his beggars so gratefully?

An additional listing of a few of the items from the collection of works on paper has been overlooked in the literature since the 1950s.[33] On the back of a drawing from around the time of the auction of Rembrandt's prints and drawings in 1658, the master himself listed twenty of his prints, providing more complete information on some than we find in Bruijningh's rather global inventory. For one thing, it provides us with

another name not mentioned by Bruijningh: a *Monk* by Girolamo Muziano (1532–92), yet another sixteenth-century Italian, even if the print concerned, one from a series of anchorite saints, was engraved for Muziano by the North Holland engraver Cornelis Cort (d. 1578).[34] Of exceptional interest is the listing of two prints by Federico Barocci, an *Annunciation* and a *Monk*. (Nearly all the subjects on this list are religious; four are monks and one a hermit.) Barocci etched only four plates in all. At least one of them, a *Virgin and Child in the clouds*, served Rembrandt as a model for a print (figs. 43–44). Thanks to Rembrandt's listing of two other prints by the much-admired Italian artist, we can hypothesize that he owned at least three of Barocci's four etchings. This may serve as an indication of his seriousness as a collector of graphic art. It also brings home the extent of the loss to Rembrandt as an artist when his collection was sold and dispersed.[35]

Rembrandt might have derived a measure of solace from this disaster had the collection been honored at its full value by the market and had he been able to pay his creditors with the returns on the sale. This was however not to be. Goods whose value was estimated by experts to be worth 17,400 guilders fetched less than 4,500 guilders.[36] This was insulting as well as injurious to one of the most knowledgeable art collectors of his time.

One section of Rembrandt's collection that must have been largely removed and sold before the inventory – I am thinking of the long sale in December 1655 – was his books. Only five titles are specified in the inventory – Jan Six, *Medea*, for which Rembrandt supplied the title print; "All Jerusalem" by Jacques Callot (not his beggars; in fact the book must have been the second edition [1620] of *Tratatto delle piante et immagini dei sacri edifizi di terra santa* by Bernardino Amico da Gallipoli, for which Callot made reduced etched copies of Antonio Tempesta's illustrations for the first edition [1609]); Albrecht Dürer's treatise on proportion (probably the Dutch edition of 1622); an edition of Flavius Josephus's history of the Jewish wars against Rome, with prints by Tobias Stimmer; and "an old Bible." In addition there was a German book with war illustrations and another German book with woodcuts; and a further "fifteen books in various formats."[37]

The notion that these were the only books Rembrandt owned is to my mind completely out of the question. More than any artist of his age, Rembrandt lived among poets and playwrights. (See below, pp. 214–22.) He was praised by Philips Angel for his erudition, specifically for his close reading. All his life he was engaged passionately with the narrative and historical aspects of his craft. No attribute occurs more commonly in his portraits than the book. (See p. 294.) No genre subject attracts him more than the reader. (See pp. 290–93.) His years in the Latin School and his early contacts with Leiden humanists and with Constantijn Huygens must have brought with them a respect for the book and, for a man with Rembrandt's collecting instincts, a desire to own them. His training with Pieter Lastman

32 Van Gelder and van der Veen in van den Boogert 1999, p. 58.
33 Published and discussed in Münz 1952 and in both editions of Benesch's catalogue, under no. A96a, but thereafter ignored.
34 Sellink 1994, pp. 176–78.
35 For an appreciation of the value of the collection to Rembrandt, see Ben Broos, "Rembrandt and his picturesque universe: the artist's collection as a source of inspiration," in van den Boogert 1999, pp. 91–139.
36 Van Gelder and van der Veen in van den Boogert 1999, pp. 54–56.
37 Golahny 2003, pp. 77–78. Golahny performs a fascinating analysis of the meaning to Rembrandt of these books and a few others that he must have known or owned.

241
Rembrandt
Two Moors
Inscribed (questionably)
Rembrandt f. 1661.
More likely before 1656
Canvas, 78 x 64.5 cm.
Bredius 310
The Hague, Koninklijk Kabinet
van Schilderijen Mauritshuis

38 Golahny 2003, p. 209, takes
the opposite view, claiming that
Rembrandt's "passion was for the
visual, rather than the literary arts."
To a painter of biblical and
mythological histories and a
participant in the lively interchange
between painters and poets,
a categorical distinction of that kind
would have made no sense.
Her following statement is more
apposite: "Artists who ... amassed
sizeable libraries often were art
collectors; they were generally better
off financially ... than the average
artist." This is the group to which
Rembrandt belonged. Van Gelder,
van der Veen and Broos also
acquiesce in the idea that Rembrandt
owned no more than twenty-two
books. I cannot imagine why.

could only have intensified this. Lastman's inventory included "about 150 books." Would his pupil have owned fewer? In my picture of Rembrandt, this is inconceivable.[38] I count Rembrandt's library among the missing items in the inventory.

Let us move on to *'t Voorvertreck voor de kunstcaemer* (the anteroom to the art gallery), with only one last look back at an item in the art room: a small board for the game of tables, the predecessor to backgammon. Whatever other games Rembrandt played were in his art.

"Three framed prints" are an exception in the anteroom. No other prints and only two drawings were framed. All others were kept, as they should be, in closed albums or other containers. Three paintings by Titus were accompanied by various paintings painted over by Rembrandt or copied after him. Here too were subjects by Rembrandt that have since disappeared: a nude model and a horse.

Op de cleyne schildercaemer (the small painting room or studio, probably in the attic) we find five partitions, apparently storage space for art-room objects of the second order: more than a hundred old weapons and musical instruments, western and oriental, seventeen casts of human limbs, statues and busts of emperors and other ancients as well as "two modeled portraits of Barthold Beham and his wife" and two small paintings by Rembrandt.

In de groote schildercaemer – the large painting room or studio, the largest room in the house, covering its entire width – there were more western and oriental weapons, including the casque of a giant, a cast of a Michelangelo Baby Jesus and "Two moors in one painting by Rembrant," taken to be the painting now in the Mauritshuis. This particular image is a wonderful personal instance of contact with another continent,

242
Rembrandt
Self-portrait in studio attire
Unsigned, undated. Ca. 1655
Brown ink, 20.3 x 13.4 cm.
Benesch 1171
Amsterdam, Museum het
Rembrandthuis

The authorship of this drawing,
which has long been thought
of as an iconic self-portrait,
has recently been questioned.
It must be admitted that once
doubt is expressed, the drawing
stops looking as strong as it
always had.

243
Reconstruction of the courtyard
of the Rembrandt House
between 1640 and 1660, with
"schilderloos," the painter's
shed. From the page on Joden-
breestraat 4 of the website
"Monumenten en Archeologie
in Amsterdam":
http://www.bmz.amsterdam.nl/
adam/nl/huizen/jodenbr4.html

a hankering that expresses itself otherwise more in
objects and motifs than in living individuals. At the
same time however it shows a certain impersonality.
The mutual relation between the figures is puzzling,
neither has eye contact with the viewer, the costume
seems more like a half-hearted and, in the left figure,
half-complete invention than proper dress. The paint-
ing is signed and dated 1661, but the authenticity of the
inscription has been doubted. I illustrate it here for
these reasons, because it corresponds to the entry on
the only painting in the large studio on the Breestraat
and because it embodies the kind of problem encoun-
tered so often in Rembrandt studies: powerfully sug-
gestive connections of which the pieces stubbornly
refuse to fall neatly into place.

It was in this room that Rembrandt's main workshop
must have been located, where his painting, etching and

– although this may have spilled over into the attic – his
teaching took place, where his life in art fulfilled itself
for twenty years.

Op de schilderloos (in the painter's shed) were two lion
skins and colored skirts along with a large painting
of Diana and a painting by Rembrandt of a bittern.
This has been interpreted to be an outdoor lean-to in
the courtyard, heightened in 1640 to accommodate the
Night watch, which was too large to have been painted
indoors. The large painting of Diana may have been
a similarly outsize commission, further undocumented.

Whoever slept in the bed *Op 't cleyne kantoor* (in the
small office), perhaps Titus, shared the space only with
"ten pieces of painting by Rembrant, both small and
large." *In de kleyne keucken* (in the small kitchen)
and *In de gangh* (in the corridor) were a few items

Table 4
Works of art in 1656 inventory
of Rembrandt's goods

	Netherlands before 1600	Italian before 1600	Netherlands after 1600	Rembrandt	Touched up by Rembrandt	After Rembrandt	Anon.
Paintings	7	9	44	50	9	3	9
Drawings			3 albums	25+ albums etc.			13
Prints	15 albums	20 albums	13 albums	1 album			

of house ware. The inventory ends with a modest laundry list.

A space not mentioned in the inventory is the large downstairs kitchen, which must have had a bed for the housekeeper. There were two other rooms in the basement that could be entered from the street; these were rented out to third parties.

A table and a list should help to form a better picture of the totality of Rembrandt's holdings in 1656 than the above, fragmentary room-by-room impression (see Table 4).

Thirty of the forty-four paintings by contemporaries were by four artists – Adriaen Brouwer, Jan Lievens, Jan Porcellis and Hercules Seghers – in whose work Rembrandt seemed to have dealt. The sixty-two paintings by, touched up by and after Rembrandt were also for sale. Two of the Italian paintings were half-owned by the dealer Pieter de la Tombe. There is little reason to believe that the twenty-three other paintings in the inventory, nine of which were anonymous, were not also meant for the trade. What I understand under Rembrandt's collection proper, as opposed to stock for sale, was the work on paper and the curiosities:

 150+ weapons
 100+ curiosities, rarities and naturalia
 70 sculptures and casts, of which 39 were ancient or after ancient models
 22 books
 22 musical instruments

The inventory, aside from the chairs and linen presses, was impossibly meager for a household like his:

 30 chairs
 5 tables
 2 beds
 2 tablecloths
 2 cushions
 2 pillows
 2 blankets
 2 linen presses
 50 miscellaneous household items and pieces of clothing

Notable omissions: aside from three men's shirts and some collars and cuffs:

 No wardrobe items.
 None of the old clothing Rembrandt is said to have bought at flea markets.
 No tools and materials for painting or etching.
 No copper plates of completed etchings.
 No stock of printed etchings by Rembrandt, only the one album of "all Rembrandt's works," which one assumes were not intended for sale.
 No library.

With regard to the value of the inventory for negative conclusions – that is, as proof that Rembrandt did not own any particular item because it is not on the inventory – we can be short: it has none whatsoever. Thera

Wijsenbeek-Olthuis, in her extensive study of Delft inventories in the eighteenth century, says the following: "The most incomplete inventories are those drawn up for bankruptcies, the so-called *desolate boedels*. In these cases the parties concerned had something to gain by withholding information; the amount of goods that could be concealed was limited only by the quality of the control This entire class [of inventories] must be regarded as unreliable for research into possessions."[39] In the case of Rembrandt's large inventory, Frans Bruijningh took a mere two days to draw it up, with Rembrandt at his side, and performed no additional control to verify that nothing was being concealed.

The first intensive study of the inventory, by Rob Scheller in 1969, saw in it evidence of the late Renaissance encyclopedic collection of a gentleman of leisure.[40] This view was challenged in 1999 by Roelof van Gelder and Jaap van der Veen.[41] Comparing Rembrandt's holdings with those of gentleman Amsterdam collectors of the time, they find it lacking exactly in the encyclopedic organization that characterize such repositories. They also miss the library that is invariably present in such collections. Rembrandt's house, they furthermore point out, does not figure on the list of mandatory visits for foreign connoisseurs. Most heavily, they bring in the evidence of Rembrandt's conduct. With his nonconformist and sometimes reprehensible behavior he removed himself deliberately from the social class of the proper gentleman virtuoso.

To my mind, van Gelder and van der Veen overstate this part of their otherwise impressive case. Rembrandt may have fallen short in certain respects as a gentleman collector, but he cultivated so many practices associated with this way of life that it cannot be denied to him categorically. A man who lived in a gentleman's house, was married to the daughter of the burgomaster of an important city, owned one of the most distinguished collections of prints and drawings in the city, amplified with an impressive collection of weapons and exotic rarities, a man who associated – as those authors themselves demonstrate – with a wide circle of like-minded collectors, can only be removed from the status of virtuoso collector if another slot were available one notch lower. None is. In the end he failed as a gentleman collector, since his collection had to be sold, and in the interim as well he fell short of the ideal. For one thing, the man could not have had much leisure. Nor was he the type to belong to the kind of mutual admiration societies that marked so many cultural circles in the Dutch Republic. That he did not live up to the ideal of the gentleman virtuoso in all respects does not however mean that he did not honor it in his way.

Since I moreover refuse to believe, as do van Gelder and van der Veen, that Rembrandt did not own more than the twenty-two books in the inventory, I take off my hat, in leaving the Rembrandt house in 1656, to Rembrandt the artist but also to Rembrandt the distinguished lover and collector of art and curiosities.

39 Wijsenbeek-Olthuis 1987, p. 98. Indeed, the author does not include insolvency inventories in her statistical sample.
40 Scheller 1969.
41 In van den Boogert 1999, esp. pp. 67–68, 81–89. Ben Broos, on p. 139 of that excellent publication, agrees with this view.

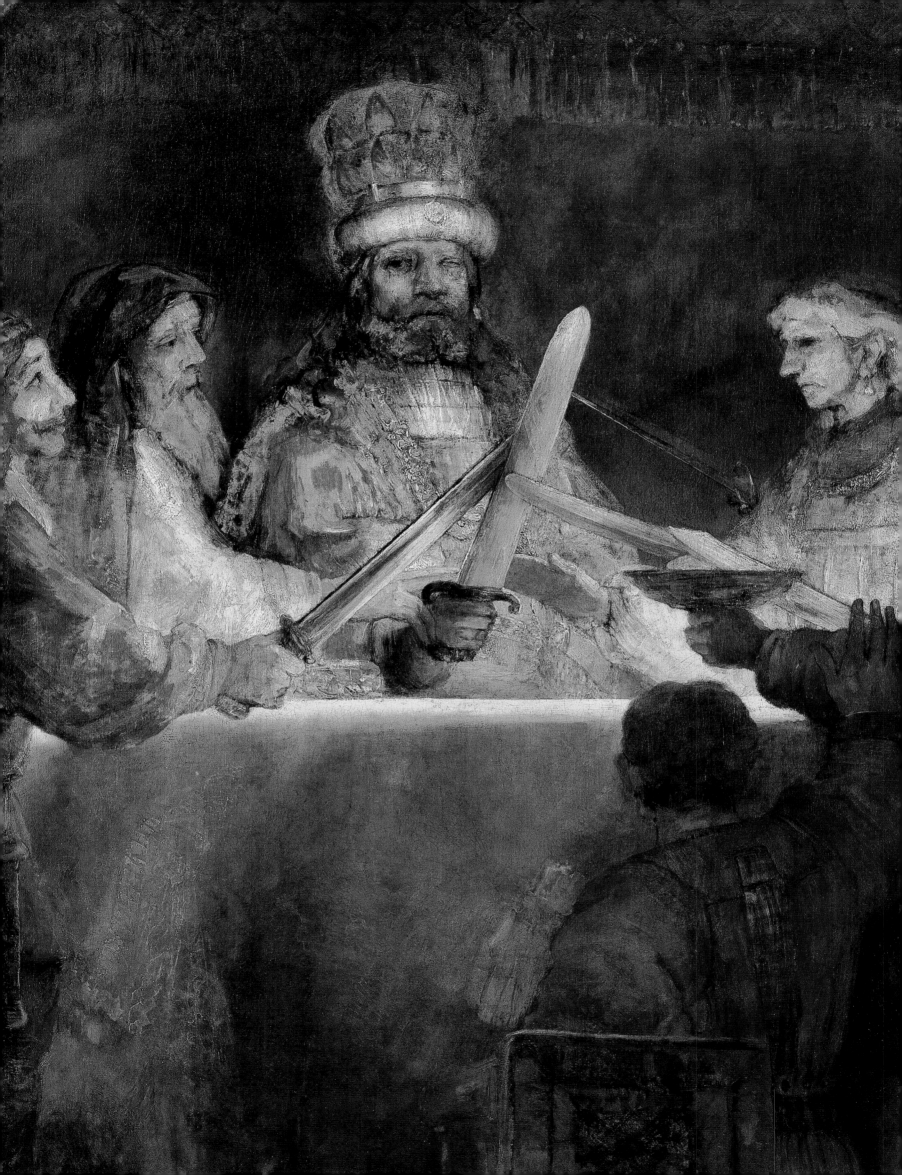

6

Patrons

244
Rembrandt
Detail of *The oath of Claudius Civilis* (fig. 308)
Stockholm, Nationalmuseum

Leiden patrons

THE FIRST RECORDED LEIDEN OWNER of a painting by Rembrandt was a distinguished scholar and writer. Theodorus Schrevelius was headmaster of the Latin school of Haarlem before he was dismissed on account of his Remonstrant leanings. He then came to Leiden, where he took up the same position in the school where Rembrandt had studied. He was enthusiastic about Rembrandt's talent and was not shy about praising him to others. Other evidence shows that Rembrandt's first circle of admirers were Leiden Remonstrants.

The first surviving words written about Rembrandt's art were in Latin. They occur in the notes of the Utrecht attorney and antiquarian scholar Aernout van Buchell (Buchelius; 1565–1641). In May 1628 he was in Leiden, where he paid a visit to his colleague in learning Theodorus Schrevelius (1572–1649), on which he made some notes. One of them reads: "Also, a lot is expected of a miller's son from Leiden, but that is premature." I interpret this to mean that Schrevelius showed Buchelius a work by Rembrandt, praising its quality in terms that Buchelius found exaggerated. He made comments of the kind on other painters as well. Esaias van de Velde, also represented in Schrevelius's collection, he calls an "elegant but lightweight painter."[1]

Recently a document turned up in the Haarlem archives, the city where Schrevelius came from and where his family lived, that may well refer to the Rembrandt painting that was the object of such a mixed reception in 1628. In October 1652, when the estate of Schrevelius and his wife was drawn up, the share of their daughter Bregitta included "A small panel in an ebony frame being a fat face (*een dick tronie*) by Rembrant of Leyden, famous painter."[2] Assuming that this painting was owned by Schrevelius in 1628 and that he showed it to Buchelius in May of that year, let us call

it, with all due reservation, the first documented Rembrandt, and Schrevelius the earliest documented owner of a painting by Rembrandt. Despite the inconclusive nature of the evidence, the note from 1628 alone demands that we look more closely at Theodorus Schrevelius than has been done until now in the literature on Rembrandt.

Schrevelius was a Haarlemer. After studying in Leiden with a grant from the town of Haarlem, in 1597 he began teaching at the prestigious Latin school in his home town, of which he later became headmaster. He filled that position until 1620, when he ran into trouble of a religious-political nature that led to his dismissal. It happened like this.

The revolt of the Netherlands against Spain, as everyone knows, was accompanied by the rejection of mandatory state Catholicism. William of Orange, the leader of the revolt, and many others with him, would have liked to admit Protestantism into the country while tolerating Catholic worship as well, in a system they called religious peace. However, he found it impossible to hold the allegiance of the mighty provinces of Holland and Zeeland, which were uncompromisingly anti-Catholic, without coming out more decisively than that for Protestantism.

The Protestant denomination with the clearest dogmatic code and the most viable ecclesiastical structure were the Calvinists, who became the religious branch of the revolt. They acquired the status not of state church – William was able to draw the line there – but of the "public church" of the Republic. In that function, the Calvinist church was expected to operate the way official churches did in other European countries, helping to "forge a communal identity and strengthen internal cohesion. A shared religion was supposed to weld rulers and subjects together under the Divine Protection that depended on an orderly religious life regulated by true doctrine, a well-ordered church organization, decent public worship and pious public conduct."[3]

1 Doc. 1628/1. The dating of the event given there is 10 January 1628. However, the evidence for a visit on that date, first posited by Werner Weisbach in 1926, seems to be lacking. We know from another entry in Buchelius's notes that he was in Leiden in May 1628, which following van Gelder 1953, p. 6, I take to be the time of the visit to Schrevelius as well. Hoogewerff and van Regteren Altena 1928, p. 63: "In Majo 1628 apud Overbekium Leidae vidimus …"
2 Found by Pieter Biesboer and placed on the Getty Provenance Index under document N-1939, number 3.
3 Spaans 2002, p. 75. Available on Internet (15 August 2005) at the exemplary website of Jo Spaans and Peter van Rooden.

245
Jan van de Velde (1593–1641)
after Frans Hals (1582/83–1666)
Petrus Scriverius (1576–1660),
historian and humanist of
Haarlem and Leiden
Inscribed *Harlemi, Fr. Hals*
pinxit. I.v.Velde sculpsit,
Aetatis 50. A° 1626. Legend
around frame: *Petrus Scriverius |*
Legendo et scribendo, eight-line
Latin poem
Engraving, 27 x 15.5 cm.
Haarlem, Teylers Museum

The painting after which the
print was made survives.
It was acquired, together with
the pendant portrait of
Scriverius's wife Anna van der
Aar, by the Metropolitan
Museum of Art in 1929.

246
Jacob Matham (1571–1631)
after Frans Hals
Theodorus Schrevelius (1572–
1649), Remonstrant sympathizer,
writer and headmaster
Inscribed *Fr. Hals pinxit |*
MDCXVIII | Theodorus
Schrevelius gymnasiarcha
Harlemensis | [Greek motto] *|*
in image: *AET 42*
Engraving, 26.1 x 25.9 cm.
Hollstein 114
Amsterdam, Rijksmuseum

The painting after which the
print was made survives.
It was acquired by the Frans
Hals Museum in 2003.[4]

True doctrine, in Calvinism, implied proper acknowledgment of divine grace. What this constituted to Calvinists was a doctrine that many others consider extreme. In opposition to the Catholics, who believed that human beings can earn grace through good works during their lives on earth, Calvin taught that man has nothing whatsoever to do with his salvation. Faith and grace are free gifts of God, unaffected by anything a person does in life. Since God is all-knowing, He knew even before the creation of the world which individual humans he was going to send to heaven and which to hell. This doctrine, called predestination, rigorously excludes the possibility that a person can earn grace through his or her own merits. The very thought is an affront to the Lord.

In 1603 a professor was appointed at the University of Leiden who wished to temper this discouraging doctrine a wee bit. Jacobus Arminius (1559/60–1609) did not doubt that humans were predestined to heaven or hell, but he introduced an element into predestination that according to his critics, to whom no bit could be wee enough to be admissible, compromised God's sovereignty. Arminius said that people could choose whether or not to accept divine grace, but that their choice, and therefore their fate, was foreknown by God since before the creation.

In quick stages, all hell broke loose. Following the death of Arminius in 1609 a movement known as Arminianism or Remonstrantism came into being that attempted to gain acceptance for his doctrines within the Reformed church. They were opposed bitterly by the Counter-Remonstrants, led by Arminius's former teacher Franciscus Gomarus (1563–1641; his allies were also called Gomarists). Because the controversy raged within the public church, it formed a threat to the stability of the country, forcing the government to step in. Johan van Oldenbarnevelt (1547–1619), the main representative of the States of Holland and the closest approximation to a prime minister, was inclined to look for a compromise and held out hope to the Remonstrants. The stadholder however, Prince Maurits of Orange (1567–1625), did not want to risk any change in the religious status quo and in 1618 he came out for the Counter-Remonstrants, with force of arms behind him. After a trial that has been called a judicial murder, Oldenbarnevelt was beheaded. The Remonstrant leaders were imprisoned or driven out of the country as the prince marched from town to town replacing the Arminian councilmen with loyalists. A synod of the Reformed church was convened in Dordrecht, where the principles of Calvinism were reaffirmed in terms that left not the least bit of room for doubt or equivocation. From a hopeful caucus within the Reformed church, Remonstrantism became a separate denomination, forever afterward mistrusted by orthodox Calvinists as a kind of crypto-Catholicism. However, Arminianism as a religious ideal and as a divisive element in the polity lived on.

247
Rembrandt
*Jan Cornelisz. Sylvius
(1564–1638), Amsterdam
Reformed preacher*
Inscribed *Rembrandt 1646,*
legend around frame, fourteen-
line Latin poem by Caspar
Barlaeus, two-line Latin poem
by Petrus Scriverius
Etching, drypoint and burin,
27.8 x 18.8 cm.
Bartsch 280 ii(2)
Haarlem, Teylers Museum

4 For a study of the relationship
between the painting and two
engravings after it, see Bijl 2005.
5 Spaans 1989, p. 158. Brandt 1704,
vol. 4, pp. 193–95.
6 Rembrandt's cousin Cornelia
Cornelisdr. van Zuytbroeck, in
marrying a man named Dominicus
Jansz. van der Pluym, became
the sister-in-law of Hendrik
Swaerdecroon. We know that this
relation was not trivial, because
sons of both couples – Bernardus
Swaerdecroon (ca. 1617–1654), the
son of Hendrik and Machtelt Jans
van der Pluym, and Karel van der
Pluym (1625–72), the son of Cornelia
and Dominicus Jansz. van der Pluym
– later became painters, and possibly
pupils of Rembrandt. The pupilship
of van der Pluym is convincingly
presumed from his style and
subjects, that of Swaerdecroon
deduced speculatively from the
family tie only. See de Baar 1992,
pp. 19–20.
7 Scriverius 1738, p. 52. Scriverius's
Remonstrant sympathies are cited in
Brandt 1704, vol. 3, pp. 606–07.
On 9 January 1633 the sheriff of
Leiden, Willem de Bont, found
Scriverius at a forbidden meeting
of Remonstrants.
8 The resemblance was first
remarked on by Slive 1970–74,
vol. 1, pp. 121–23.

Now back to Theodorus Schrevelius. Although he was a member in good standing of the Reformed church, he was suspected of harboring Remonstrant sympathies. Beside being headmaster of the school, Schrevelius also sat on the town council. When Prince Maurits marched into Haarlem on 25 October 1618, Schrevelius was one of those removed from office. The next blow came when the Counter-Remonstrants embarked on a purge of the schools. The synod sent instructions to all towns in the country, instructing them to require teachers in public schools to sign a dec- laration of orthodoxy. In 1620 the paper was laid before Schrevelius. He declined to sign, saying that a humble admission of ignorance concerning the mysteries of predestination was preferable to a presumptuous asser- tion of knowledge. That was all the orthodox party had to hear. Schrevelius was dismissed. He left Haarlem for Leiden, where in 1624 he became headmaster of the Latin school where Rembrandt had studied.[5]

Did Schrevelius's low-grade Remonstrantism have anything to do with his ownership of a painting by Rembrandt? Not in terms of subject matter perhaps, but with regard to networking there are strong indica- tions that it did. In 1624 Rembrandt became related, through the marriage of his cousin Cornelia, to a man who had lost his rectorate of the Leiden Latin school for exactly the same reason as Schrevelius lost his in Haarlem, Hendrik Swaerdecroon (ca. 1594–after 1651).[6]

Schrevelius did not let Buchelius leave his house empty-handed. He gave him an impression of a recent print by the Haarlem artist Jan van de Velde the Younger (1593–1641). It was a reproduction of a painted portrait by Frans Hals (1582/83–1666) of the humanist Petrus Scriverius (1576–1660). The gesture was significant. Scriverius was considered by the Remonstrants to be a defender of their side. If he had had a teaching job or public position of any kind, like Schrevelius he would certainly have been fired from it. But he prided himself on his independence and his ability to live on his money and his wife's. Like Schrevelius, Scriverius was a Haarlemer who ended up in Leiden. The two men, whose lives were linked so closely, both had themselves painted by Hals early in his career, and both had the painted portraits engraved, with the addition of Latin inscriptions. In a poem on another portrait of Scriverius, Schrevelius describes his friend as a lover of art as well as learning.[7] Indeed, Scriverius had constant contact with artists and print publishers, and his friend- ship album was adorned with drawings by important artists from Haarlem and Leiden. There is uncertainty concerning the ownership of thirty paintings that were added to the auction of his library after his death – some of them belonged to his deceased son – but it is highly likely that some came from his collection.

Nearly twenty years later, the name of Petrus Scriverius turns up in the Rembrandt records. The scholar contributed a two-line Latin verse to a posthumous portrait by Rembrandt of a (Counter- Remonstrant) Amsterdam minister, Jan Cornelisz. Sylvius. It is preceded by a fourteen-line poem by another Remonstrant humanist from Leiden, Caspar Barlaeus (1584–1648). The sitter is not just any Rembrandt patron. Jan Cornelisz. Sylvius was the cousin and guardian of Rembrandt's late wife Saskia. The willingness of Barlaeus and Scriverius to lend their names to a tribute to Rembrandt's deceased relative, who stood in the opposing religious camp to theirs, is a sign of trust in the artist as well. (It also shows that the religious divisions did not go to great extremes. Remonstrants and Counter-Remonstrants could talk to each other and belong to the same social and profes- sional circles.) Rembrandt returned the compliment by adopting the formal arrangement of Jan van de Velde's portrait of Scriverius: an oval frame through which the sitter emerges, with Latin inscriptions on the rim and beneath, very different from any other portrait print by Rembrandt.[8]

Given his proven ties to Schrevelius and Swaerdecroon, there is every reason to believe that Rembrandt's acquaintanceship with Scriverius and Barlaeus did not come into being in Amsterdam, but that it dates from the 1620s, from Remonstrant circles in Leiden. This is important in judging the meaning of another document pertaining to Rembrandt. The list of paintings attached to the catalogue of Scriverius's library includes "two handsome, large pieces by Rembrandt." If these were paintings made in Leiden and if they were a pair, we know of only one candidate:

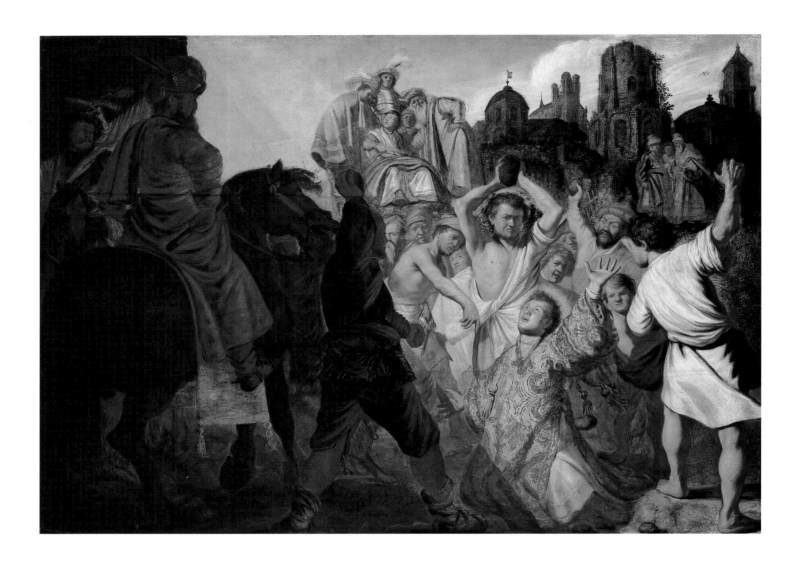

248
Rembrandt
The martyrdom of St. Stephen
Inscribed *Rf. 1625*
Panel, 89.5 x 123.5 cm.
Bredius 531A
Lyon, Musée des Beaux-Arts

the pendants formed by the *Martyrdom of St. Stephen*, dated 1625, and the *"Leiden history painting"* of 1626. In 1984, I embraced the theory that these paintings were commissioned by Scriverius and that they refer to the execution of Johan van Oldenbarnevelt.[9] This hypothesis, first launched by Maarten Wurfbain in 1968, has been vociferously combated by others, and must be considered speculative.[10] There are other, indeed better suggestions for the subject of the Leiden history painting – the Oath of the Horatii, for one – but none of them fits as well into a framework encompassing the other circumstances surrounding the painting.

Compared to this distinguished array of intellectuals, the other Leideners with documented connections to Rembrandt are simple burghers. Only a handful of civil servants and notaries, including some Mennonites as well as Remonstrants, are recorded as owners of work by him. Barely ten paintings by her most famous son occur in Leiden inventories during Rembrandt's life. Three drawings changed hands in 1645 for two guilders and eighteen stuivers, a painting was appraised in 1653 for six guilders. He never received a public commission in Leiden. Clearly, his native town did not have what it took to keep him there.

9 Schwartz 1985, pp. 35–39.
10 Ben Broos goes a step further, claiming that these paintings and other works of 1625 and 1626 were painted by Rembrandt in Amsterdam, under the tutelage of Pieter Lastman, and not in Leiden at all. Broos 2000.

Patrons in The Hague

From a base in humanist circles in Leiden, Rembrandt and his friend Jan Lievens were discovered by the great man of court patronage, the poet and polymath Constantijn Huygens. For six years he and Frederik Hendrik lavished commissions on them. Rembrandt emulated the great hero of courtly art, Peter Paul Rubens of Antwerp, in his work and his appearance. He embraced as his own the rhetoricians' ideal of moving the viewer, a quality for which he became famous. The court commissions came to an end after 1633, around the time that Huygens reacted badly to a Rembrandt portrait of a friend.

The first extended text written about Rembrandt was also in Latin. It was penned in an autobiographical essay by Constantijn Huygens (1596–1687). The writer was a man of quite different standing from Arnoldus Buchelius. Huygens too was a learned participant in the European network of scholars known as the Republic of Letters. He corresponded with philosophers, mathematicians, theologians and classical scholars in their own fields. But he was much more. He was one of the greatest poets of his time, in Dutch, Latin and French,

249
Rembrandt
"The Leiden history painting"
Inscribed *RH. 1626*
Panel, 90 x 121 cm.
Bredius 460
Leiden, Stedelijk Museum
De Lakenhal (on loan from the
Netherlands Institute for
Cultural Heritage)

11 Jorissen 1873, p. 16. The first
motto is from Aristotle, the
second from Cicero.

an accomplished musician and amateur of the arts.
Those were his avocations. All of these gifts, as well
as his personal gentility and social grace, he brought
to his calling as servant of the house of Orange.
His official title was not very impressive. He was secret-
ary to Stadholder Frederik Hendrik, prince of Orange
(1584–1647), the younger half-brother of Maurits.
Huygens was not even the senior secretary. Like the
overachiever that he was, he made up for this with extra
efforts on all fronts. On the job he ran circles around
his colleagues, producing an endless stream of commu-
niqués and directives, letters of recommendation and
of solicitation. He worked his network pitilessly, in full
awareness that asking for favors is just as binding as
granting them. Placing himself above his own function,
he wrote a manual on the art of good secretaryship,
under the mottos: "le bien est en l'ordre" and "Tous
abus provient [*sic*] de la perturbation des rangs et
d'ordre."[11] In a portrait painted by Thomas de Keyser
during Huygens's second or third year on the job
(fig. 250), he shows himself creating order, sending off
a dispatch from a desk at which the two globes remind
him of his place on earth and under the heavens.
In "La secrétairie," written in the same period as de
Keyser's portrait, Huygens distinguishes in a tree-

structured table between two main classes of dispatch,
five subclasses, twenty sub-subclasses, etc. His letters
to Rembrandt have been lost, but they fell under two
categories. The "deliberative missives" by which he
placed orders for paintings were "commissions and
orders," those in which he reminded the artist that
he was years late in delivering "exhortations."

One area in which Huygens outshone the rest of the
court, a field in which he had direct and exclusive access
to the prince and princess, Amalia van Solms (1602–75),
was the arts. With his taste, knowledge and contacts,
Huygens was in an unrivaled position to manage the
design of the prince's palaces, mediate in the patronage
of poets and advise in the purchase of art.

Like every head of court in a patronage society,
Frederik Hendrik surrounded himself with satellite
courts for buffering and support. Some of these satel-
lite courts were even more art-loving than that of the
stadholder. Elizabeth Stuart, the wife of Frederik
Hendrik's nephew Frederick V of the Palatinate, and
Johan Maurits van Nassau-Siegen, Frederik Hendrik's
cousin, were more interested personally in art than
was the stadholder. However, Frederik Hendrik, prob-
ably thanks to Huygens's love of order, was a reliable
and consistent patron. Although he has been accused

12 Van der Ploeg and Vermeeren 1997, pp. 55–57. I am at a loss to understand why they write: "The overwhelming predominance of Southern Netherlandish masters is one of the most remarkable aspects of the Stadholder's collection." Of the twenty-six painters in the inventory of 1632 represented by more than one painting, only ten were born in the southern Netherlands, five of whom lived elsewhere, three in the northern Netherlands. The other sixteen were born and lived in the northern provinces. In numbers of paintings, the relation is even more favorable to painters from the northern Netherlands.

13 This is not certain. In the inventory of the goods of Amalia van Solms of 1654–68, mention is made of a profile portrait of Frederik Hendrik by Rembrandt. There it is paired with a profile portrait of Amalia van Solms by Hanneman. Drossaers and Lunsingh Scheurleer 1974–76, vol. 1, p. 283, no. 1209. For the amazingly complex circumstances surrounding these portraits and their documentation, see van der Ploeg and Vermeeren 1997, pp. 134–41.

of neglecting the artists of his own land in favor of Flemings, he actually favored Dutch painters above those of other schools. Once he began patronizing an artist, moreover, he tended to continue doing so.[12]

Because painters, with some famous exceptions, were considered craftsmen on the level of carpenters or masons, it was not normal for a prince to deal with them directly. A notch higher on the social scale were poets and writers. The more sophisticated among them would speak French, the language of the court, they would dress like gentlemen and know how to comport themselves in the presence of nobility. A prince could hold an intelligent conversation with a poet about his or her art needs. At the same time, a native-born poet would also speak Dutch and know how to behave with commoners. Those who were connoisseurs of the manual arts were in an excellent position to act as brokers for the ruler.

There were artists in Holland who by playing this system were able to work for all the courts and for several foreign ones as well. The great examples are Michiel van Mierevelt (1567–1641) and Gerard van Honthorst (1592–1656). One advantage they had is that they were hired to paint portraits of the royals, giving them quality time with princes and princesses and a chance to charm them. Rembrandt never got that far. He did paint a portrait of Amalia van Solms, but symptomatically it seems to have been made to match an existing portrait by Honthorst of Frederik Hendrik.[13]

The pairing with Honthorst was a one-time incident of unknown import. Another pairing was far more profound. Huygens writes about Rembrandt as half of a twin-like couple of smart, talented young painters

from Leiden whose protector he wanted to be. The other was Jan Lievens (1607–74), fellow pupil with Rembrandt of Pieter Lastman and close buddy when they were in their early twenties. This is when Huygens discovered them and went overboard about both of them, perhaps even with a slight preference for Lievens. There is no mystery about how he might have been introduced to them. In 1627 and 1628 he was in very close contact with Caspar Barlaeus in Leiden, for one thing. Rembrandt's teacher Jacob van Swanenburg had already delivered work to the court. There are more than enough candidates for the role of the mediator who brought Huygens to what sounds like a studio shared by Rembrandt and Lievens.

In the longest piece of writing about Rembrandt from the artist's lifetime (not published until 1897), Huygens strikes a very different tone than the grudgingly relayed "premature" praise in Buchelius's notes (not published until 1888). Both make a point of saying he was a miller's son; for Huygens, who adds that Lievens's father was an embroiderer, it was reason for amazement that such miracles of talent and ability could come from such lowly backgrounds. "The miller's son" was present from the start as a foundation stone for the Rembrandt Story. The miracle continued as Lievens and Rembrandt trained under inferior teachers, whom they quickly put to shame. Huygens was not impressed by their physical appearance. They looked more like boys than young men, he says at the beginning of his essay, but at the end he complained that they resemble old men for the way in which they shun the innocent pleasures of youth. He also says that they work too hard.

252
Gerard van Honthorst
(1592–1656)
*Stadholder Frederik Hendrik
(1584–1647), prince of Orange*
Inscribed [*Signed*] *1631*
Canvas, 77 x 61 cm.
The Hague, The House of
Orange-Nassau Historic
Collections Trust

253
Rembrandt
*Amalia van Solms (1602–75), wife
of Stadholder Frederik Hendrik*
Unsigned, undated.
Ca. 1632
Canvas, 68.5 x 55.5 cm.
Bredius 99
Paris, Musée Jacquemart-André

254
Rembrandt
Detail of *Judas returning the
thirty pieces of silver* (fig. 255)
Mulgrave Castle, private
collection

"Rembrandt," writes Huygens, "surpasses Lievens in the faculty of penetrating to the heart of his subject matter and bringing out its essence, and his works come across more vividly. Lievens, in turn, surpasses him in the proud self-assurance that radiates from his compositions and their powerful forms ... Rembrandt, ... obsessed by the effort to translate into paint what he sees in his mind's eye, prefers smaller formats, in which he nonetheless achieves effects you will not find in the largest paintings by others." There then follows the most famous passage in the Rembrandt documents.

The painting of the repentant Judas returning to the high priest the pieces of silver, the price of our innocent Lord, illustrates the point I wish to make concerning all his works. It can withstand comparison with anything ever made in Italy, or for that matter with everything beautiful and admirable that has been preserved since the earliest antiquity. That single gesture of the desperate Judas – that single gesture, I say, of a raging, whining Judas grovelling for mercy he no longer hopes for or dares to show the smallest sign of expecting, his frightful visage, hair torn out of his head, his rent garment, his arms twisted, the hands clenched bloodlessly tight, fallen to his knees in a heedless outburst – that body, wholly contorted in pathetic despair, I place against all the tasteful art of all time past, and recommend to the attention of all the ignoramuses – I have disputed them elsewhere – who hold that our age is incapable of doing or saying anything better than what has already been said or the ancients have achieved. I tell you that no one, not Protogenes, not Apelles and not Parrhasios, ever conceived, or for that matter could

conceive if he came back to life, that which (and I say this in dumb amazement) a youth, a born and bred Dutchman, a miller, a smooth-faced boy, has done: joining in the figure of one man so many divers particulars and expressing so many universals. Truly, my friend Rembrandt, all honor to you. To have brought Ilium – even all of Asia Minor – to Italy was a lesser feat than for a Dutchman – and one who had hardly ever left his home town – to have captured for the Netherlands the trophy of artistic excellence from Greece and Italy.

14 Roodenburg 2004. The subject
was introduced into the Rembrandt
literature by Eddy de Jongh.

255
Rembrandt
*Judas returning the thirty
pieces of silver*
Inscribed *RHL 1629*
Panel, 76 x 101 cm.
Bredius 539A
Mulgrave Castle,
private collection

This passage is full of rhetorical oppositions, all that many branches on a tree structure in Huygens's mind: modern times against antiquity, Rome against Greece, the Netherlands against Italy, extreme emotion against "tastefulness," particulars joined with universals, Leiden in relation to the rest of the Netherlands. It follows on other remarks pitting commoners against bluebloods, comparing and contrasting Rembrandt with Lievens, expressing the wish that Rembrandt and Lievens would emulate Peter Paul Rubens. As far as Huygens was concerned, it was clear where Rembrandt's branch on the tree of art was.

Huygens's emphasis on body language, gesture and facial expression in his discussion of Rembrandt's *Judas*, in their relation to the figure's emotional and spiritual condition, is of great importance for understanding his judgment of the painting and his expectations of its author. The portrait of Huygens by Thomas de Keyser recently adorned the jacket of a book entitled *The eloquence of the body: perspectives on gesture in the Dutch Republic.*[14] The author, Herman Roodenburg, shows how acutely aware Huygens was of these issues in his own life as well as in art. As a commoner living among aristocrats, Huygens was faced with the need, in Roodenburg's phrase, to "incarnate civility," to act with perfect poise, to be aware of himself and his appearance without displaying self-consciousness. Huygens's writings, in keeping with the tradition of civility manuals like Baldassare Castiglione's *Il cortegiano* (The courtier, 1528), were full of advice on how to stand, sit and walk, what cast of the face and body were appropriate for which occasion, what to wear when, and countless other details of proper deportment. The great aim was to display easy grace as if to the manner born, a quality Castiglione called *sprezzatura*. Underlying this ideal was a belief in the congruence of outer and inner qualities. Elegant behavior bespeaks moral propriety, even an intimation of divine grace. One wonders whether the resemblance in pose and composition between Thomas de Keyser's portrait of Huygens and the image of Minerva painted by Rembrandt for the court is entirely coincidental (figs. 250–51).

The pursuit of *sprezzatura* brings with it an awareness of its opposite, or opposites. Boorishness of course is to be avoided at all costs. But so is the uncontrolled display

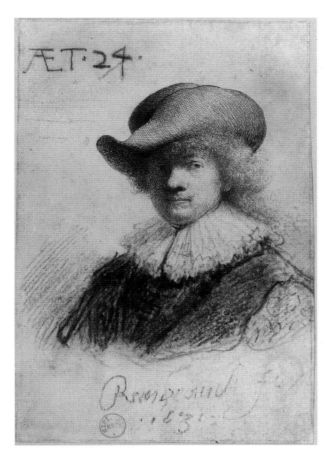

256
Rembrandt
Self-portrait leaning forward
Unsigned, undated. Ca. 1628
Etching, 6.1 x 4.8 cm.
Bartsch 5 iii(3)
Haarlem, Teylers Museum

257
Rembrandt
Self-portrait in soft hat
Inscribed *AET. 24.*
Rembrand 1631.
Etching (Bartsch 7 iv/10),
corrected in black chalk,
14.8 x 13 cm.
Benesch 57aNB
Paris, Bibliothèque Nationale

258
Rembrandt
Self-portrait in a soft hat and embroidered cloak
Inscribed *RHL 1631 |*
Rembrandt f..
Etching, 14.8 x 13 cm.
Bartsch 7 ii(11)
London, British Museum

15 Drossaers and Lunsingh
Scheurleer 1974–76, vol. i, pp./
nos. 185/94 (*Annunciation*, now in
Dublin), 191/208 (*Alexander crown-
ing Roxanne*, Schloss Mosigkau),
191/218 (*Cloelia*, destroyed in the
Second World War), 192/230
(*Flora and Zephyr*, Schloss Wörlitz),
203/516 (*Artemisia*, Palais Sanssouci),
207/620 (*Mars and Venus*,
Hermitage, "trophy art" taken from
Germany after the Second World
War).
16 Schwartz 1985, pp. 106, 368.
17 The classic reconstruction of the
relation between Rembrandt and
Rubens is to be found in Schama
1999.

of passion. A gentleman does not lose his cool. Huygens's fascinated dense description of Judas's "gesture," its related emotions and spiritual condition, shows how he looked at and interpreted figures – and living persons – in the throes of passion. The kinds of remarks he entrusted to paper were first, I am sure, the subject of conversation between him and Rembrandt. I have no doubt that they influenced Rembrandt's approach to portraiture and history painting from that time on. I even dare to suggest that the contact with Huygens was responsible for the makeover in Rembrandt's self-presentation that took place in his Hague period. The unkempt, hunched-up Rembrandt of a self-portrait from the time Rembrandt met Huygens, bare-headed and frizzy-haired, squinting suspiciously into the mirror, gave way to an upright, self-assured young man about town, in a cocked hat and flat lace collar of the latest fashion. That is an image of his protégé that Huygens could show with pride. The new Rembrandt was partly his creation.

Aside from general advice on the eloquence of the body, Huygens had a living model to hold up to Rembrandt. The prince of European painters was a fellow Netherlander, Peter Paul Rubens (1577–1640). Although Rubens wrote to a friend when taking a commoner for his second wife, rather than making the court marriage everyone was pushing on him, that he did so because this (sixteen-year-old) daughter of a merchant "would not blush to see me take my brushes in hand," the man represented the pinnacle of European gentility. He was the confidant of kings

– quite literally: Philip IV of Spain appointed him secretary to his privy council. Moreover, Rubens had already brought back the glories of Greece, Rome and Italy to the Netherlands. Unfortunately for Frederik Hendrik and Huygens, it was the southern Netherlands to which he brought these glories. For the palaces of The Hague they were able to buy a few treasures – five subjects from classical antiquity and one *Annun- ciation*.[15] The reason they were unable to place direct commissions with Rubens was not so much that he was a southern Netherlander and therefore the subject of the enemy Spanish king, but that he actually engaged not only in diplomatic but even in espionage missions for Spain. The last of his visits to the north took place in December 1631, when he was sent packing almost as soon as he arrived.[16]

Rembrandt shows no signs of shyness or embarrass- ment about accepting the challenge to model himself on Rubens.[17] Taking a print of 1630 by Paulus Pontius after a self-portrait by Rubens, he created, with consid- erable pains, a portrait of himself that resembles it quite closely. On an impression of the print in the British Museum, he even sketched in a frame like the one around Rubens. By the time he was finished decking himself out, in the tenth state of the eleven through which he worked the print, he rather overdid the flair side of *sprezzatura* at the cost of the attendant natural- ness (fig. 260).

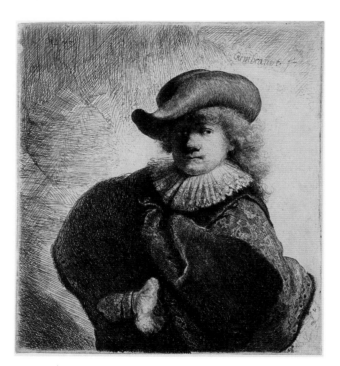

The makeover was not only a question of looks. In the course of work on the *Self-portrait in a soft hat*, Rembrandt changed his signature, taking on the name by which he was known from then on. Before 1633 he tended to use the monogram *RHL*. This stood for the Latinism Rembrandus Hermanni Leidensis (Rembrandt Harmensz. of Leiden), which would have pleased the classical scholars Schrevelius and Scriverius. After 1633 he never used that form again, signing himself only Rembrandt, in the fashion of sixteenth-century greats like Lucas and Leonardo. Rembrandt seems even to have played with the idea of upping his age. In the impression in the British Museum (fig. 258) and another doctored one in the Bibliothèque Nationale (fig. 257), Rembrandt plays not only with his appearance and signature but also his age, first making himself twenty-seven years old and then covering it with twenty-four.[18]

It was not only in his personal looks that Rembrandt accepted the challenge of the Rubens model. The most important direct orders to Rembrandt from the court, for five paintings of the Passion of Christ, began with a *Raising of the Cross* and *Descent from the Cross*, finished in 1633, that are plainly modelled on Rubens's famous versions of those subjects in Antwerp. Given the relations between a princely court and a painter, this could not have been a move on the part of the artist. We must assume that Rembrandt was hired to create small versions of the Rubens altarpieces for the prince's painting gallery in Noordeinde Palace. In keeping with his admiration for Rembrandt's ability to achieve "effects you will not find in the largest paintings by others," Huygens asked Rembrandt to produce paintings less than one-twenty-fifth the size of the Rubenses. (Aside from Rembrandt's powers as a downsizer, the difference in viewing distance between a Cathedral altarpiece and a gallery painting would have minimized the disparity to the spectator.) There is evidence from a number of drawings related to the *Raising of the Cross* that the commission dated from the earliest period of Rembrandt's acquaintance with Huygens, about 1628.[19] It must also have been agreed upon between Huygens and Rembrandt that the artist would insert himself into the composition as one of the followers of Christ who eased the body to the ground. (This image of Rembrandt for the prince was not a self-portrait; about 1630, the prince bought a Rembrandt self-portrait to be presented, via Sir Robert Kerr, to King Charles I of England. The Dutch court was taking Rembrandt seriously as a personality as well as an artist.)

When the paintings were delivered in 1633, a new commission followed, for three more paintings of scenes from the Passion of Christ, *The entombment, The resurrection* and *The ascension.* In a letter to Huygens of January 1639, Rembrandt makes a point of saying that "His Highness commissioned me to make" them.

The first to be delivered, early in 1636, was *The ascension,* the last in iconographic order. If in the *Raising* and *Descent* Rembrandt had vied with Rubens, in the *Ascension* he moved back in time to the artist who enjoyed one of the few greater reputations than Rubens's own, the Venetian master Titian. In a composition based on one of Titian's most famous works, the *Assumption of the Virgin* in the Church of the Frari in Venice, Rembrandt created an image of earth, sky and heaven, with mortals taking leave of a divine creature being raised by angels to the Godhead itself.

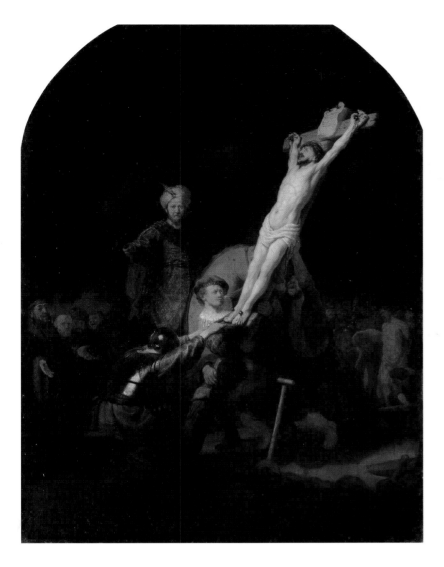

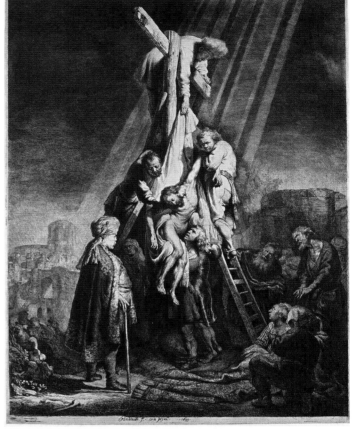

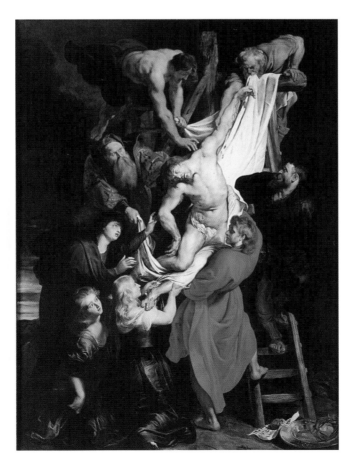

261
Rembrandt
The raising of the Cross
Unsigned, undated.
Ca. 1636
Canvas, 96 x 72 cm.
Bredius 548
Munich, Alte Pinakothek

262
Rembrandt
Detail of *The descent from the
Cross* (fig. 266)
Munich, Alte Pinakothek

263
Rembrandt
The descent from the Cross
Inscribed *Rembrandt.
f. cum pryvlo. 1633*
Etching and burin,
53 x 41 cm.
Bartsch 81(II) ii(5)
Haarlem, Teylers Museum

264
Peter Paul Rubens
The descent from the Cross
Unsigned, undated. Ca. 1612
Panel, 420 x 360 cm.
Antwerp, Cathedral

265
Rembrandt
The descent from the Cross
(see fig. 266)
Munich, Alte Pinakothek

In the same scale as fig. 264

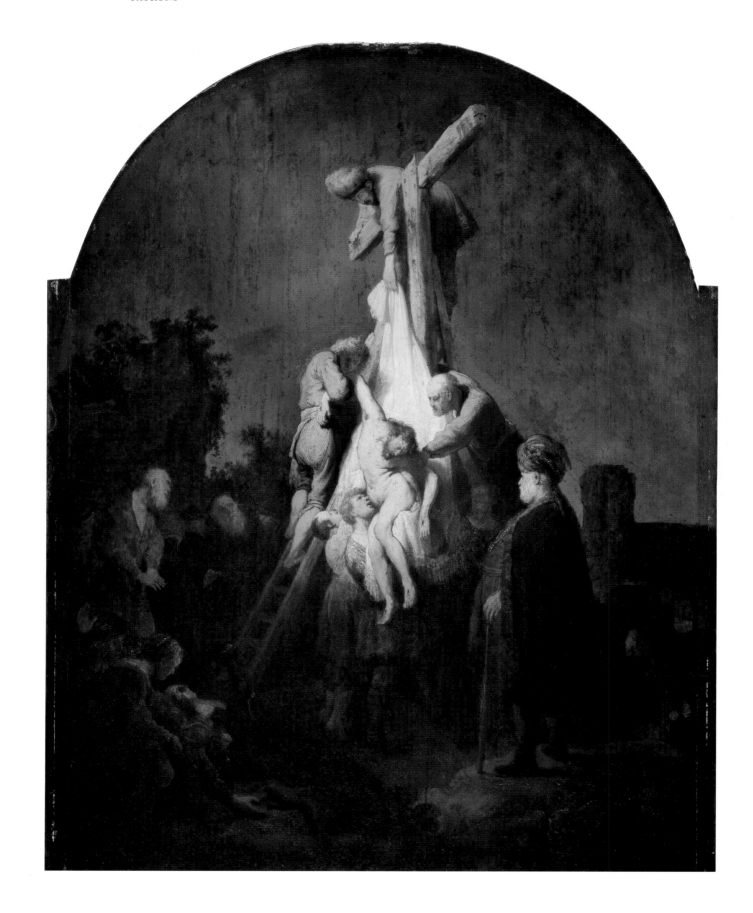

266
Rembrandt
The descent from the Cross
Unsigned, undated.
Ca. 1633
Canvas, 89.5 x 65 cm.
Bredius 550
Munich, Alte Pinakothek

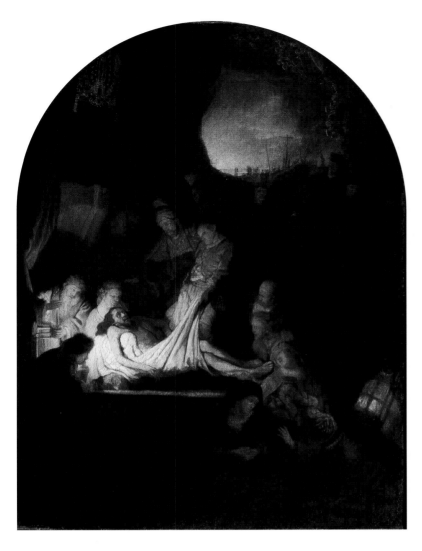

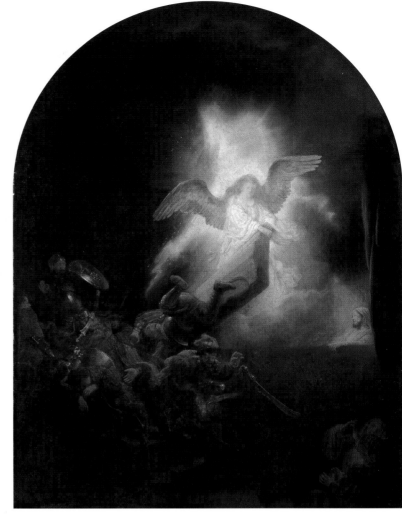

267
Rembrandt
The entombment of Christ
Unsigned, undated.
Ca. 1639
Canvas, 92.5 x 70 cm.
Bredius 560
Munich,
Alte Pinakothek

268
Rembrandt
The resurrection of Christ
Unsigned, undated.
Ca. 1639
Canvas, 92 x 67 cm.
Bredius 561
Munich,
Alte Pinakothek

20 Huygens 2003b. Disappointingly, Huygens's journal of the trip says very little about art.
21 Huygens 2003a, vol. 1, p. 107. This quote is from Huygens's Latin autobiography of 1677–79.
22 Weststeijn 2005.

Venice was an important city in Huygens's life. As a twenty-three-year old, from 25 April to 7 August 1620, he served on a diplomatic mission there, under his patron at court, François van Aerssen (1572–1641). Van Aerssen was an aristocrat from Brabant, where Huygens's father was also born. He enjoyed full command of the kind of *savoir-faire* that Huygens so admired. As a protégé himself of Prince Maurits, following the execution of Oldenbarnevelt van Aerssen became the equivalent of foreign secretary of the United Provinces. The trip to Venice, toward the end of the Twelve Year Truce between the Netherlands and Spain, was an attempt on the part of a new republic to arrive at an understanding with an older one on relations with Spain when the truce expired.[20] While the heavyweights were negotiating, Huygens, as he later wrote, "let nothing escape the scrutiny of my hungry eyes. There I studied music avidly, painting and poetry, the churches, squares and statues"[21]

The reception of the *Ascension* was not enthusiastic and did not lead to new commissions from The Hague. In a letter of February or March 1636, following delivery and Rembrandt's receipt of a reaction from Huygens, the artist wrote, "I agree that I should come soon to see how the picture matches with the rest."

Huygens had apparently let him know that he or the prince felt the new canvas did not quite match the rest.

We hear nothing more until three years later, when on 12 January 1639, a week after buying his house on the Sint Antoniesbreestraat, Rembrandt wrote to Huygens to announce the completion of the final two pieces from the commission of 1633. The language Rembrandt uses to describe the representations is very much like his notes on drawings. He does not call them merely the entombment and the resurrection. No, one is "where Christ's dead body is being laid in the tomb and the other where Christ arises from the dead to the great consternation of the guards." The reason they took so long, Rembrandt wrote, is that "in these two pictures the greatest and the most natural (e)motion has been expressed."

This phrase – *die meeste ende die naetuereelse beweechgelickheyt* – has been studied and worried over more than any quotation in the history of Dutch art. The word *beweechgelickheyt* has been variously interpreted to refer to physical movement or the power to move the viewer's emotions. Recently, it has been interpreted more subtly and completely in relation to the teachings of rhetoric or oratory.[22]

The classical manuals on this essential skill, taught in all Latin schools in the early modern period, were

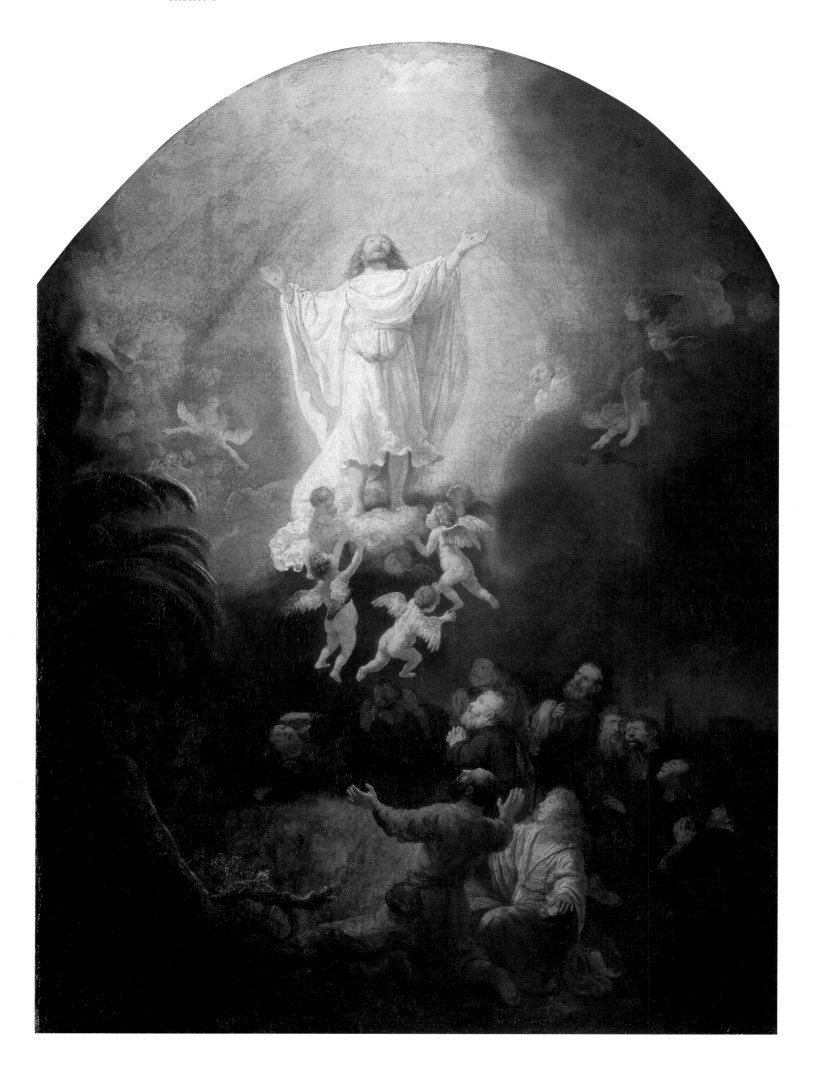

There is also every reason to believe that this high aim of art – the power to evoke an emotional scene so forcefully that the viewer thinks he is present at the event depicted – was the subject of discussion between Huygens and Rembrandt, and that this is what Rembrandt was talking about in his letter.

The concept has far-reaching implications for Rembrandt's art, personality and place in art history. "Quintilian formulates the rhetorical conviction that the orator who wants to move his public should first be moved himself. Rembrandt must have taken this to heart."[24] His inclusion of an image of himself in the *Descent from the Cross* can be seen as an extension of this principle. That is, if you wish to make the spectator think he is actually present at the event depicted, then the artist should do so as well, and show it. His self-portraits as well, I would argue, are exercises in empathy with others as much as presentations of the personal individuality of Rembrandt van Rijn (see p. 9).

"There are also three aims which the orator must always have in view; he must instruct, move and charm his hearers."[25] Of the three elements of Quintilian's famous exhortation, Rembrandt cannot be said to have taken instruction and charm very seriously. All the more did he bind himself, as Huygens realized when writing about the *Judas*, to the central tenet – *movere*. Rembrandt's pupil Samuel van Hoogstraten (1627–78), in a major book on painting published in the year of his death, seizes on this feature in a passage where he reduced a number of great artists to what he considered their essential characteristic. Rembrandt's greatest excellence was in the "lijdingen des gemoeds," the passions. Half a century earlier, this was the way Huygens too saw his protégé. (See above, p. 149 and below, pp. 273–83.)

This reading of the line in Rembrandt's letter by no means excludes the more literal meaning of the word *beweechgelickheyt,* motion. As Weststeijn has further pointed out, the quality of *enargeia* was very much linked to physical motion. The highest aim of the painter as of the poet was to capture the moment, to evoke instantaneity, actuality, the turning point.[26] The surest way of doing so was to convince the viewer that he is witnessing change itself, which always implies motion. In his characterization of the paintings in his letter, Rembrandt uses verbs rather than nouns to describe the subject.

For Rembrandt's capacities as a portraitist, Huygens had a distinctly lower regard. In fact, an incident concerning a portrait seems to have led to a cooling between the two and a cessation of new commissions. The sitter was a man particularly close to Huygens, the artist Jacob de Gheyn (1596–1641), a childhood friend with whom Huygens traveled to England in 1618 on an art pilgrimage. Rembrandt's portrait of de Gheyn did not stand alone, however. The sitter for a pendant was even closer to Constantijn. It was his own brother, Maurits Huygens (1595–1642). In 1632, the two men performed a rare sentimental gesture. They both had

269
Rembrandt
The ascension of Christ
Inscribed *Rembrandt f. 1636*
Canvas, 92.5 x 68.5 cm.
Bredius 557
Munich, Alte Pinakothek

270
Titian
The assumption of the Virgin
Unsigned, undated. Ca. 1516
Canvas, 690 x 360 cm.
Venice, Santa Maria Gloriosa dei Frari

In actual size, forty times larger than fig. 269.

the writings of Cicero and Quintilian. The terms they established for speaking were easy to apply to the visual arts. At times they did so themselves, as when they advise the orator "to conjure up a very vivid image." Quintilian writes: "From such impressions arises that *enargeia* which Cicero calls *illumination* and *actuality,* which makes us seem not so much to narrate as to exhibit the actual scene, while our emotions will be no less actively stirred than if we were present at the actual occurrence."[23]

As Thijs Weststeijn argues, there is every reason to think that the concept of *beweechgelickheyt* to which Rembrandt was referring was equivalent to Quintilian's *enargeia*. The word was used in just that sense in the 1630s by the great Dutch-English authority on classical art, Franciscus Junius (1589–1677). In the Dutch edition (1642) of a book on the art of the ancients that was first published in English (1637), he uses the word "beweghelick," in a passage on a very moving account of the sacrifice of Isaac, for "patheticall," full of pathos.

23 Quintilian, *Institutio oratoria* 6, 2, 32. Quoted from Bill Thayer's Internet edition of *Institutio oratoria* as published in the Loeb Classical Library, 1920–22, in the translation of H.E. Butler.
24 Weststeijn 2005, p. 113.
25 Quintilian, *Institutio oratoria*, 3, 5, 2. Weststeijn 2005, p. 112. Quoted from Bill Thayer's Internet edition of Quintilian.
26 Weststeijn 2005, p. 117, citing Blankert 1976. Instead of the Greek term *peripeteia*, Weststeijn comes up with the English version of the word, peripety.

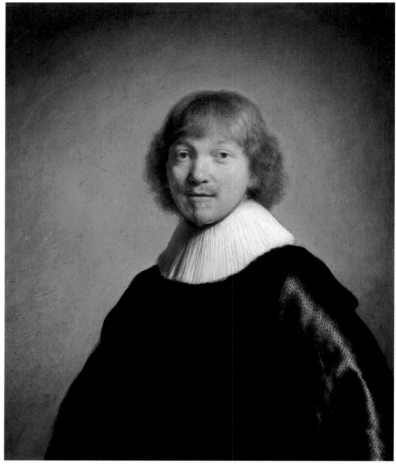

27 Schwartz 1985, pp. 95–97. The poems were first translated from the Latin by Loekie Schwartz for the Dutch edition of that book. Other commentators on the poems see them as conventional compliments to the sitter rather than insults to the painter. For this interpretation I can find no justification.

28 Huygens 2003a, vol. 1, p. 79; vol. 2, pp. 62–71.

their portraits painted by Rembrandt in two panels of the same smallish size. Apparently they agreed that each would keep his own portrait and that the first to die would leave it to the other. The portraits were reunited in 1641 after the death of de Gheyn, who was outlived by his friend for only half a year.

Was Constantijn pleased that Rembrandt painted these touching portraits of his brother and their friend? He was not. He was piqued, and he took it out on Rembrandt. In February 1633, Constantijn wrote eight sharp Latin verses on Rembrandt's portrait of de Gheyn, giving them the title "Squibs on a likeness of Jacob de Gheyn that bears absolutely no resemblance to its model."[27] In 1644 he published seven of them, omitting the one mentioning Rembrandt's name, perhaps to avoid adding injury to insult. In his voluminous published writings, Rembrandt is never named.

As difficult as it may have been for a manual artisan to become a gentleman, it was considered imperative for a gentleman to master the basics of drawing and painting. Huygens did that and more. As he confided to his children in later life, he looked down on those who are ignorant of painting, "the full sister of poetry, which to put it sweetly and simply can be called the art of seeing. Those who are not familiar with it I truly consider deficient human beings My worthy father must have experienced this, since he was a layman in the area. He wished us to be accepted and treated as equals in high places and among experts." Taking lessons from Hendrik Hondius, Huygens boasts that "I did not do badly; people even thought that if my father or fate had allowed me to continue instead of pursuing higher education I would have achieved a certain repute among artists of the middling sort."[28]

271
Rembrandt
*Maurits Huygens (1595–1642),
secretary of the Council of State*
Inscribed *RHL van Rijn 1632*
Panel, 31 x 24.5 cm.
Bredius 161
Hamburg, Hamburger
Kunsthalle

272
Rembrandt
*Jacob de Gheyn (1596–1641),
artist in The Hague and Utrecht*
Inscribed *RHL van Rijn 1632*
Panel, 29.5 x 24.5 cm.
Bredius 162
London, Dulwich Picture
Gallery

273
Rembrandt or artist close
to him
*Portrait of Rembrandt with gorget
and helmet*
Inscribed *Rembrandt f. 1634*
Panel, 80.5 x 64 cm.
Bredius 22
Kassel, Staatliche Museen
Kassel, Gemäldegalerie Alte
Meister

Rembrandt's authorship of this
painting has been doubted by
Horst Gerson, Claus Grimm
and the RRP. Van de Wetering
2005, pp. 216–17. All agree
however that it emerged from
his workshop.

Huygens's attachment to the visual arts was a life-long passion. To other courtiers the importance of art was a derivative value, mainly derivative of warfare. Castiglione considered "the art of painting useful in many ways, and especially in warfare, in drawing towns, sites, rivers, bridges, citadels, fortresses, and the like."[29] Indeed, on the scale of values at a court like that of Frederik Hendrik, commander-in-chief of the States army in wartime, the art of painting came nowhere near the art of war. One of the greatest commissions ever given to an artist by the stadholder's court was granted to Jacques de Gheyn II (1565–1629), the father of Jacob, for a drill manual for the States army. The portraitists of The Hague made some of their best money from painting military men in armor, portraits for which there was often multiple demand. Rembrandt never got in on this trade. However, he responded to the environment in his own way. During the years when he

was painting for the court and visiting The Hague with some regularity, he created a number of paintings and etchings of himself in armor or with a sword. If this was an attempt to fit in with his surroundings, it cannot have been very successful. It is hard to imagine the military entourage of the stadholder, the he-man crew with which he spent half his time, thinking highly of self-portraits as a warrior by a man who never bore arms. A portrait of Rembrandt of this kind in Kassel has a particularly ill-adapted look. If Rembrandt was taking *sprezzatura* lessons in The Hague, he was flouting them here by hunching over, head in neck, with a worried expression on his face. In comparing it to the more assured attitude of the painting of about 1629 newly re-attributed to Rembrandt, we see him entering The Hague ready to conquer the place and leaving it somewhat battered by the experience.

29 Roodenburg 2004, pp. 57, 60–65.

Great Amsterdam and Rembrandt's small part of it

Amsterdam was a boom town when Rembrandt moved there. The oligarchy of old Amsterdam families that controlled its politics was the most powerful force in the country, alongside the stadholder. Rembrandt found more support from the merchant and professional class than from the regents. He was at home in the rich new neighborhood for which he painted his group portraits. Toward mid-century a number of crises created extreme tensions between Amsterdam and The Hague, the effects of which added to the causes that brought about his financial downfall and move to a poorer part of town.

It is hardly an exaggeration to call seventeenth-century Holland the city-state of Amsterdam. From the late sixteenth to the mid-eighteenth century, Amsterdam's "reign, like those of Venice and Antwerp before her, was the reign of a city – the last in which a veritable empire of trade and credit could be held by a city in her own right, unsustained by the forces of a modern unified state."[30] As unlikely as it may seem, this newcomer among the cities of Europe, in a shallow recess of the Zuider Zee, governed by *nouveau riche* families unrelated to the rulers of the rest of Europe, was the foremost economic power in the world.

The growth of the Amsterdam population followed the growth of the city's wealth. In 1600 it housed about 60,000 inhabitants, and in 1630 about 115,000.

274
Joan Blaeu
Map of Amsterdam,
from *Tooneel der steden*,
Amsterdam 1649
Colored engraving,
41.6 x 53.3 cm.
Brussels, Bibliothèque royale
de Belgique

Most maps of Amsterdam present an overly neat impression of the city, as if the famous *gracht-engordel*, the canal belt, were a complete and sufficient delineation of the basic form of the city. In fact the belt came into being in fits and starts, it lined up poorly with the adjoining Jordaan, and it was abandoned by the city fathers in unfinished form. The map published by Joan Blaeu in 1649, an update of a map first drawn in the 1630s, shows the messier reality. The dotted line shows the planned continuation of the new city wall, intended to complete a rough two-thirds circle to the eastern harbor. (Maps of Amsterdam are traditionally oriented with north on the bottom, east on the left and so forth.) The city wall was therefore composed of sections from two different plans, with a provisional connecting wall where the Leidsegracht now lies.

Before the enlargement of Dam Square in front of the new town hall, which had not taken place in 1647 (see figs. 304–305), the largest square in the city was that around the Sint Antonieswaag, in Rembrandt country.

30 Barbour 1963, p. 13.

275
The Kloveniersburgwal looking from the Doelenstraat to the Nieuwmarkt, January 2005. The tower of the Zuiderkerk rises in the distance, as above all of Rembrandt country.

The greatest single decade of growth was that in which Rembrandt moved to Amsterdam. Between 1630 and 1640 the population rose by about 20,000, to some 135,000. To house the burgeoning population, large extensions were laid out in 1585 and 1593 (the foremost residential street in these plans was the Sint Antonies-breestraat) and in the decades after 1615 the territory within the walls was more than doubled with the building of the famous canals, the Herengracht, Keizers-gracht and Prinsengracht.

The Amsterdam that imposed its will on the rest of the Netherlands and dominated world trade was not the Amsterdam of all its hundred thousand dwellers. There was a city within the city, a closed group of families who controlled Amsterdam's wealth and its government. In the seventeenth and eighteenth centuries, Amsterdam history was written around these clans of regents, as they were called. They were the men – the time when women could hold public office was still centuries away – who ran the great trading companies. Of the foremost of these families, the Bickers, it was said that like Spain and Portugal dividing the Atlantic basin between them at the treaty of Tordesillas (1494), the Bickers could divide the entire world at the breakfast table, with one son taking control of the Baltic grain trade, another the Mediterranean trade in luxury goods, a third the spice imports from Asia and a fourth the colonial goods going to and coming back from the New World.

Beneath the regents in standing but more important for entrepreneurship and culture in the city was the merchant, professional and manufacturing class. The more successful among them could be as wealthy as regents and live in the same parts of town. However, they remained dependent for their trade patents, custom and appointments on the good graces of regents.

Shopkeepers, innkeepers, artisans, craftsmen, skilled laborers and civil servants provided the services and everyday goods for the thriving city. Because their presence was required in proximity to the wealthier classes, space was reserved for housing them on the connecting streets between the grand canals. At the same level

in terms of earnings, but with a separate status of their own were army and navy officers and men of the cloth.

The class beneath them was partly integrated into city life as servants, porters, soldiers, sailors and unskilled laborers. Intermeshing with this group was an underclass that was cut off from the power network above. These were traveling folk, beggars (although the activity was forbidden), petty criminals and the underclass known as *het grauw*, the rabble. They were shunted off to spandrel spaces like the Jordaan or elbowed out of town, to illegal squatters' colonies from which they could be evicted and their houses leveled at the whim of the sheriff.

Crossing through all these classes except that of the regents were dividing lines between old Amsterdamers and newcomers. Because all parts of society tended to organize themselves into clan structures, just as the regents did, non-Amsterdamers had a harder time in the city than natives. Marrying into an Amsterdam family would help things along, of course. Easy earnings of any kind would first be divided up among the established families in that branch, including their in-laws; outsiders had to compete for the harder kind. Still, they came to the city in droves.

Rembrandt's place in this social structure was complex. The son of a manufacturer, he was an artisan who had aspirations to join the merchant class and who derived a certain amount of patronage from the regents. His first wife was a daughter of the regent class, though not of Amsterdam, and his second, common-law wife a servant girl. More conventionally classed individuals would be uncertain where to place him, and he did not make it any easier on them. He could have done so by striking a certain pose and sticking to it, or joining a coterie and identifying himself by its codes, but he did not do either. As we shall see, this cost Rembrandt dear in terms of patronage.

If Rembrandt had a base of protection within Amsterdam, it was his neighborhood. Amsterdam was divided into twenty precincts (*wijken*), and Rembrandt country was located nearly entirely in only one of them. It was a part of town, as we have seen, where many

artists and art dealers lived. So many of the recently arrived Jewish community lived there that Rembrandt's street, in the decades after his death, was to change its name to the Jodenbreestraat. The regents of this precinct, and the civic guard company it delivered, were known to be more liberal and more inclined to Remonstrantism, than in the city as a whole.

All of Rembrandt's temporary and permanent dwellings from 1622 to 1658 were located within a few hundred meters of each other, in the shadow of the Zuiderkerk. Here were the homes of his teacher Pieter Lastman, his associate and in-law Hendrick Uylenburgh and his own rented dwellings as well as the house he bought on the Sint Antoniesbreestraat. Even the municipal bodies for which he painted his four group portraits were located in the same streets. At the corner of today's Kloveniersburgwal and Doelenstraat, standing beside the building for which the *Night watch* was painted, one sees the drapers' hall in the narrow Staalstraat to the right, and at the end of the wide and glamorous Kloveniersburgwal the Waag, home of the surgeons' guild, for which the anatomy lessons of Nicolaes Tulp and Joan Deyman were painted (fig. 275). Rembrandt's wealthiest patrons lived on this canal, Jan Six and the Trip brothers. The churches in which Saskia and three of her and Rembrandt's children were buried were the Zuiderkerk and the Oude Kerk, a few streets west of the Waag.

There was only one other building in the city for which Rembrandt delivered an official commission, and that was the new town hall, a short distance away. The result was magnificent and the upshot disastrous, as we

shall see. With all due respect for unknown losses, it is symbolic of Rembrandt's relationship to the political powers of Amsterdam that he never depicted the glorious new Eighth Wonder of the World (pp. 178–83) that the township built for itself in the 1650s nor its venerable medieval predecessor, but that he did draw the gutted ruins of the latter after the fire of 1652. Rembrandt's relationship with official Amsterdam was not an easy one. The drawing of the burnt-down town hall is the only drawing of a location that is identified in the artist's handwriting (fig. 276). Rembrandt was apparently impressed by the historical significance of the accident, by the loss of this tie to the past.

Of the streets around his house, only three drawings in black chalk are preserved. The one made closest to Rembrandt's front door shows the entrance to the lock on the Verwersgracht, the Sint Antoniessluis (fig. 277). Boudewijn Bakker has remarked about these sheets, "What is remarkable is that Rembrandt left no picture of the fine, impressive new buildings on Jodenbreestraat, but chose instead to portray the somewhat chaotic activity of the waterfront on the islands near his home."[31] Although in the course of the thirty years he lived around that lock Rembrandt must have drawn many more views that are now lost, it is a fact that none of the surviving drawings of the inner city shows new buildings, while there are a fair number depicting older ones.

In the preceding chapter, it was noted that Rembrandt received no new commissions from the court after 1633. A contributing factor may have been his move to

276
Rembrandt
The ruins of the old town hall in Amsterdam after the fire
Inscribed *vand waech afte sien stats huis van Amsteldam doent afgebrandt was den 9 Julij 1652. Rembrandt.* (Seen from the weighing hall, the town hall of Amsterdam after it was destroyed by fire, 9 July 1652. Rembrandt)
Brown ink and wash, touches in red chalk by later hand, 15 x 20.1 cm.
Benesch 1278
Amsterdam, Museum het Rembrandthuis

31 Bakker et al. 1998, p.150.

277
Rembrandt
*The entrance to the lock at
St. Antoniessluis seen from
Uilenburg*
Unsigned, undated.
Ca. 1651
Black chalk, 9.4 x 15.6 cm.
Benesch 1257
Berlin, Staatliche Museen,
Kupferstichkabinett

Amsterdam. Relations between the court at The Hague and the council chambers of Amsterdam are a tale of two cities that gave rise to constant and sometimes dramatic tensions throughout the course of the Republic.

Yet, after his move Rembrandt did receive one more commission. In 1646 he delivered two paintings in the same format as the five paintings of the Passion of Christ.[32] These two also showed scenes from the life of the Savior, but as an infant. The *Adoration of the shepherds* is one, now in the Alte Pinakothek in Munich with the five Passion paintings; the other is a lost *Circumcision*. For these paintings, Rembrandt was paid the princely sum of 2,400 guilders. However, shortly thereafter a series of major crises took place that drove a wedge between Orange and the oligarchs. As negotiations on a peace treaty between the United Provinces and Spain were moving toward closure in Munster and Osnabrück, with Amsterdam pushing for peace and the court obstructing the peace process, Frederik Hendrik reinvigorated the war by undertaking in the summer of 1646 an unsuccessful, last-ditch attempt to capture Antwerp, with the aid of Saskia's relative Antonie Coopal. Then the prince died in 1647 and was succeeded by his rather undiplomatic twenty-year-old son Willem II. In 1650, following on what Willem saw as a provocation by Amsterdam, the young prince attempted to take the city and failed. He did however manage to unseat the uncrowned king of Amsterdam, Andries Bicker. A few months afterward, Willem died. Amsterdam refused to recognize his posthumous son as his successor or to appoint anyone else to the office of stadholder. The Republic entered its First Stadholderless Period, which lasted for the rest of Rembrandt's life.

The House of Orange did not have that much artistic patronage to dispense following the death of Frederik Hendrik. But it went out with a glorious swan song. Starting in 1647, Amalia van Solms gave commissions to a large number of painters from Holland and Brabant for the Oranjezaal, a ballroom decorated with huge paintings glorifying Frederik Hendrik. It was the showplace of her country house, Huis ten Bosch. Rembrandt was not one of the recipients of a commission. But then again, neither was any other Amsterdam painter. Politics and patronage were getting tougher than they had ever been. And Rembrandt was pretty much the odd man out.

When Rembrandt's financial collapse had played out its course, the house on the Breestraat had to be sold. It fetched 1,800 guilders less than what he and Saskia paid for it twenty years earlier. Sometime between May 1658 and December 1660 he and Hendrickje and Titus moved from the Oudezijds, the old side of town, to the Nieuwe. The Rozengracht, where he rented a house, was a big step down from the Sint Antoniesbreestraat. A few Rembrandt drawings of this part of Amsterdam have survived, but none dates from after his move.[33] By then he had stopped making drawings and etchings nearly completely. The choice of the new neighborhood was not arbitrary. Other artists and dealers too were moving west, to cheaper locations. Yet it was here, in a building that in the 1980s housed a discount odds-and-ends shop called the Star Bazaar, that Rembrandt received the only visits to his studio recorded in the archives. On 29 December 1667, he received Cosimo de' Medici, the grand duke of Tuscany, to whom he was only able to show unfinished work. On 2 October 1669, the Amsterdam amateur scholar Pieter van Brederode made notes and drawings in his notebook on a few "antiquities and rarities collected over a period of time by Rembrant van Rym."[34] Two days later – not forgotten, but not appreciated at his full worth, either – our hero died.

32 For a theory as to why he received the commission, see Schwartz 1985, pp. 236–40.
33 Bakker et al. 1998, pp. 171–76.
34 Doc. 1669/3.

The New Market

Rembrandt lived for the good part of his life in the eastern part of Amsterdam, the Old Side, at the center of which stands St. Anthony's weighing hall on New Market Square. For the quarters of the surgeons' guild, on the upper story of the building, Rembrandt painted two majestic commissions: the anatomy lessons of Drs. Nicolaes Tulp and Joan Deyman. The events they depict and the paintings themselves are fraught with deep meaning.

The nerve center of Rembrandt's part of town was the Sint Antonieswaag, the St. Anthony weighing station.[35] Dating from 1488, the massive pile was built as Amsterdam's gate to the east. In the early seventeenth century, when a new, larger city wall was built and the old one demolished, it was left high and dry. In 1617/18 it was given a set of new functions. The ground floor was turned into a weighing station and the upper floors were converted into offices for four guilds, those of St. Barbara (brickmasons), St. Eloy (metalsmiths), St. Luke (painters) and Sts. Cosmas and Damian

(surgeons). (Only the main trade, craft or profession of each guild is mentioned. They all combined a confusing potpourri of livelihoods.)

The earliest record linking Rembrandt to the guild of St. Luke dates from 1634, when his membership medal was struck. Two years earlier he completed a major commission for the surgeons' guild, the brilliant *Anatomy lesson of Dr. Nicolaes Tulp* (fig. 281). With three earlier group portraits of Amsterdam surgeons, it was a public painting that could be seen by visitors. Disappointingly, there are no documents pertaining to the commission or, during Rembrandt's lifetime, the reception of the *Tulp*. Two main circumstances, aside from our conviction that the guild must have been thrilled with this masterpiece, indicate that it was well received: the great stream of portrait commissions of Amsterdamers that followed and the fact that two decades later Rembrandt was brought back to paint another anatomy lesson, given by Joan Deyman.

In a famous passage of his *Schilder-boeck*, Karel van Mander compared picture-making to cooking. In his advice to young painters, he writes with a culinary pun: "Steal arms, legs, bodies, hands, feet. Here it is not forbidden. He who wants [to succeed] will have to act the part of Rapiamus ["Let us steal," treated as a proper name, as if a character in a play]. Well-cooked rapes [turnips] make good porridge."[36]

The *Anatomy lesson of Dr. Nicolaes Tulp* provides a good example of how this recommended robbery might work. Various sources for different parts of the composition have been identified. From a painting by Rubens of 1612, *The tribute money*, a composition that was reproduced in a print and was therefore widely known, Rembrandt borrowed the general setup: a distinguished man on the right, speaking to a group of men who are listening to him raptly (fig. 282). The scallop shell, a symbol of baptism and rebirth in Christ, was lifted by Rembrandt and moved from the left to the right, where it frames the head of the surgeon suggestively. That juxtaposition in turn resembles another painting by Rubens of the same period as the *Tribute money*, of a group of befriended scholars in the circle of the philosopher Justus Lipsius, a circle to which Rubens belonged.[37]

278
The Sint Antonieswaag
on the Nieuwmarkt,
Amsterdam
December 2005

279–80
The entrances to the
quarters of the guilds
of St. Luke and of the
surgeons, inscribed
THEATRUM ANATOMICUM

35 For a summary Internet dossier on the building, see http://www.bmz.amsterdam.nl/ adam/nl/groot/waag.html.
36 Van Mander 1604, fol. 5r.
37 Warnke 1993.

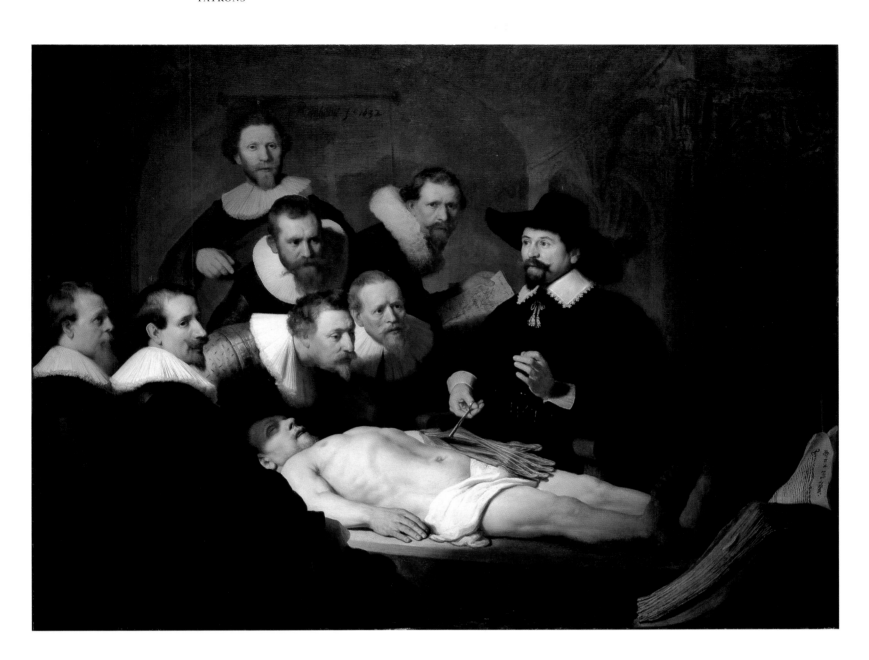

281
Rembrandt
*The anatomy lesson of
Dr. Nicolaes Tulp (1593–1674),
Amsterdam Reformed
prelector in anatomy and
future burgomaster*
Inscribed *Rembrant f: 1632*
Canvas, 169.5 x 216.5 cm.
Bredius 403
The Hague, Koninklijk Kabinet
van Schilderijen Mauritshuis

282
Claes Jansz. Visscher
(1586–1652) after Pieter Paul
Rubens (1577–1640)
The tribute money
Inscribed *CJVisscher Excudit |
P.P.Rubens Inventor |* [Caption in
Latin and Dutch].
Undated. Ca. 1612
Engraving, 40.2 x 50.3 cm.
Haarlem, Teylers Museum

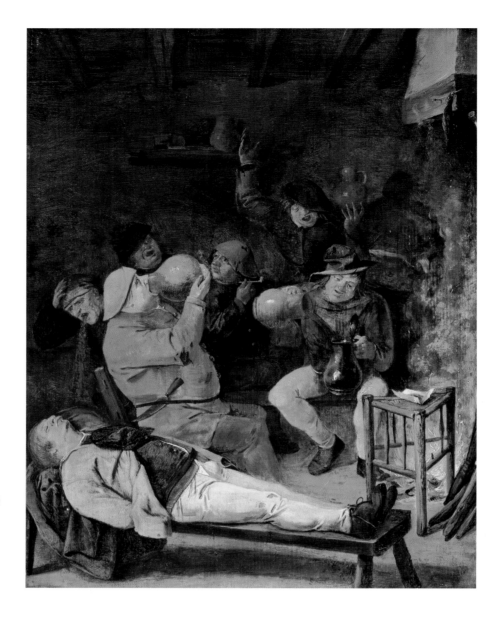

283
Adriaen Brouwer (1605/06–38)
Drunken peasant in a tavern
Unsigned, undated.
Ca. 1624
Panel, 34.8 x 26 cm.
Rotterdam, Museum
Boijmans Van Beuningen

38 Volkenandt 2004.
39 Middelkoop et al. 1998,
pp. 39–50.
40 The thought arises that the hand
might have been changed by another
artist. However, the fact that some
parts of the body overlap the hand
prove that it must have been made
before the painting was completed
and that the change was in all
likelihood made by Rembrandt.

The cadaver (of the thief Adriaen Adriaensz. of Leiden, also known as Aris 't Kint) is laid out at the same angle and on the same kind of wooden slab as a drunken peasant in a painting by Adriaen Brouwer, an artist represented in Rembrandt's inventory of 1656 with seven or eight paintings – for the trade, as I believe. The existence of three well-established sources from three paintings of such different character – a New Testament history painting, a lowlife tavern scene and a Flemish portrait of a group of friends is a warning, I believe, not to attach too much thematic significance to any specific borrowing.

The interpretation of Rembrandt's *Anatomy lesson of Dr. Nicolaes Tulp* is a sub-field of its own in Rembrandt studies. In 2004 the Swiss art historian Claus Volkenandt wrote a book of more than four hundred pages on the painting, its interpreters and its possible meanings.[38] His book shows how difficult it is to do justice at one and the same time to the many sides of this complex work. It is a document of the history of Amsterdam, of medicine, of the guild system, of the treatment of criminals, of education. It is an exercise in appropriation, in the emulation of Rubens by Rembrandt, in the

body language and symbolism of the portrait, the conventions of Dutch group portraiture, the reshuffling of genres and other simple as well as sophisticated artistic strategies. For the museum visitor and the aesthete, it is an existence in what Volkenandt calls the "vivid present time," where we encounter it face to face. The *Anatomy lesson of Dr. Nicolaes Tulp* is also an object lesson in restoration. An exhibition on the painting held in the Mauritshuis in 1998 on the occasion of a major restoration revealed that the painting had been restored twenty-one times before.[39]

The most spectacular discovery of that campaign was made not during direct examination of the painting itself but in re-examining old technical documents. Looking closely at old X-rays of the *Tulp*, the Mauritshuis conservation department found a fascinating anomaly. It had often been remarked that the hand of the cadaver looked a bit well-manicured for an executed low-life criminal. Well, the X-ray revealed that under the hand lies a stump. Although none of his previous sentences included the chopping off of a hand, by the time he was executed Aris 't Kint had lost his right hand. Extraordinarily, no earlier researcher noticed

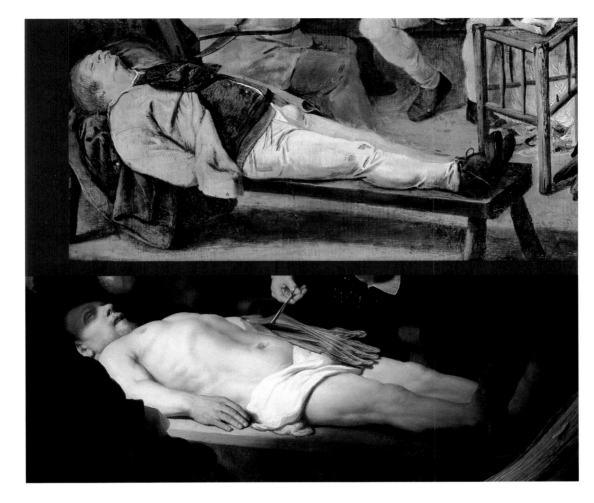

284
Adriaen Brouwer
Detail of *Drunken peasant
in a tavern* (fig. 283)
Rotterdam, Museum Boijmans
Van Beuningen

285
Rembrandt
Detail of *The anatomy lesson
of Dr. Nicolaes Tulp* (fig. 281)
The Hague, Koninklijk Kabinet
van Schilderijen Mauritshuis

this, or commented on the fact that the right arm of the corpse is one hand shorter than it should be. (An art historian can never be humble enough about his powers of observation.) Equally extraordinary is that even in a painting devoted to the study of human anatomy, Rembrandt should have painted a non-existing hand over the stump, creating an incorrectly proportioned arm, and that the patrons, the surgeons' guild itself, should have approved, perhaps requested, this cosmetic deformation.[40]

Cosmetics were apparently not an issue a quarter-century later, when Rembrandt came back to the surgeons' guild for a return performance (fig. 288). The lecturer now was Dr. Joan Deyman. In three days starting on

29 January 1656, he demonstrated the anatomy of the body on the unfortunate Jores Fonteijn van Diest, hung on the 28th. The lectures were a public spectacle for which admission was charged, in this case raising 187 guilders and six stuivers for the guild. The body parts that Rembrandt exposed in this painting, the abdominal cavity and the brain, do not seem as if they would be less troubling to a visitor than a neat stump.

The visual association of this cadaver, for a sophisticated viewer, would be not with a drunken barfly but none other than the dead Christ. Andrea Mantegna's famous image of the 1470s, revived by Orazio Borgianni about 1615, instantly comes to the mind of anyone who – as we may assume Rembrandt did – knew of those paintings or any of their numerous spinoffs.

286
X-ray of detail of *The anatomy
lesson of Dr. Nicolaes Tulp*
(fig. 281)
The Hague, Koninklijk Kabinet
van Schilderijen Mauritshuis

287
Rembrandt
Detail of *The anatomy lesson
of Dr. Nicolaes Tulp* (fig. 281)
The Hague, Koninklijk Kabinet
van Schilderijen Mauritshuis

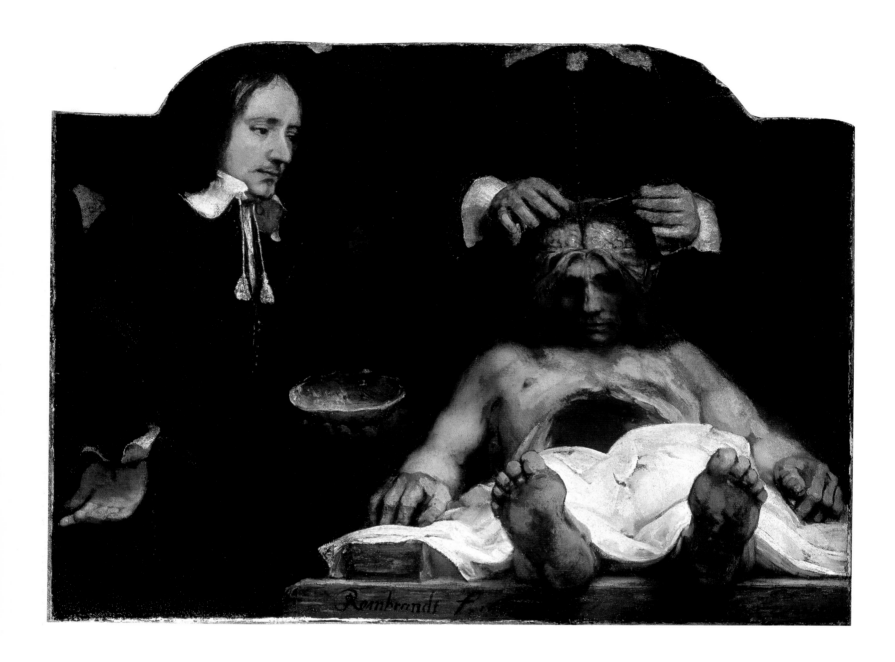

288
Rembrandt
*The anatomy lesson of Dr. Joan
Deyman (1620–66), Amsterdam
prelector in anatomy*
Inscribed *Rembrandt f. 1656*
Canvas (fragment),
100 x 134 cm.
Bredius 414
Amsterdam, Amsterdams
Historisch Museum

289
Rembrandt
Study for *The anatomy lesson
of Dr. Joan Deyman*
Unsigned, undated. Ca. 1656
Brown ink, 11 x 13.3 cm.
Benesch 1175
Amsterdam, Amsterdams
Historisch Museum

One characteristic shared by the three compositions is their violation of perspective. In an accurate view of a body taken from as close as these images, the feet would be much larger and the head smaller than they are shown by Mantegna, Borgianni or Rembrandt.

Public anatomies were far from an everyday or universally accepted part of Dutch life. They were conducted only on the bodies of executed criminals, provided by the town government. This was a way of allaying the uneasiness surrounding dissection, which after all was a violation of the body and for all one knew a threat to the soul. Anatomists in their turn took pains to avoid challenging Christian doctrine. Their dissections, they insisted, were not a challenge to what Tulp, in a student oration at Leiden University, called "the sympathy between body and soul," but quite the opposite.[41] A lovely example of the reasoning was put into verse by Joost van den Vondel in 1633, in a poem on a Dutch translation by Vobiscus Fortunatus Plempius of an anatomical treatise by Bartholomeus Cabrious. The verse combines religious with humanistic themes: the anatomy is regarded as a proof of intelligent design in creation, while mankind is enjoined to introspection. The ultimate aim of the study of the human body, Vondel concludes, is to understand God.

On the dissection of the human body, translated into Dutch by V.F. Plemp

"Know thyself" were words engraved
Above a Delphic architrave
As enlightenment divine
From the mistress of that shrine.
Today the same is taught to us
By doctors like wise Cabrious …
He who seeks to comprehend
From beginning unto end
What our human skins encase,
What keeps all our parts in place,
How the wisdom of the Lord obtains
Throughout our nerves, throughout our veins,
How artists are all put to shame
By the artful human frame
Should his book help such a one succeed
To know himself and then proceed
To knowledge of God's nature too,
Then Plemp will feel he's had his due.

"Artists" may all be "put to shame by the artful human frame" but what a frightening distinction even to be a contender, to be compared at all with the Creator and Creation. Here too lies a source of uneasiness, articulated regularly in Greek philosophy and Christian dogma, about the false pretences, the moral dangers and the idolatrous inclinations of art. Rembrandt and Tulp both had to watch their step in Calvinist Amsterdam. Both did, and were never accused of heterodoxy.

The meanings, references and associations we have encountered in this brief look at Rembrandt's two anatomies are enough to show how many-sided a painting can be and how impossible to interpret unequivoc-

ally. This is especially true of paintings that do not fit into an established iconographic mode. It is exciting to think of Rembrandt's anatomies enriching the lives not only of the surgeons, but also of the masons, painters and metalsmiths who visited their colleagues in another guild, and of the tourists to whom the anatomy theater was shown. Enriching their lives – and their thoughts about death.

290
Andrea Mantegna (1431–1506)
*The lamentation over
the dead Christ*
Unsigned, undated.
Ca. 1470–80
Tempera on canvas,
80 x 68 cm.
Milan, Pinacoteca di Brera

291
Orazio Borgianni (1578–1616)
*The lamentation over
the dead Christ*
Unsigned, undated.
Ca. 1615
Canvas, 55 x 77 cm.
Rome, Galleria Spada

292
Rembrandt
Detail of *The anatomy lesson
of Dr. Joan Deyman* (fig. 288)
Amsterdam, Amsterdams
Historisch Museum

41 "Diss. de animi et corporis sympathia," known only from later references. I.C.E. Wesdorp, "Dr Nicolaes Tulp als medicus," in Beijer et al. 1991, p. 19.

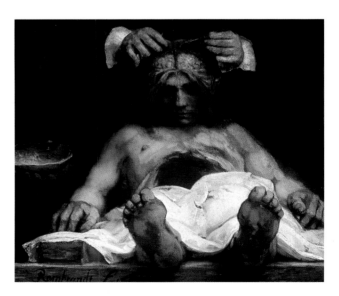

The Kloveniersdoelen

At the other end of the Kloveniersburgwal from the Waag stood the proud Kloveniersdoelen, the headquarters, practice range and meeting hall of the musketeers' civic guard. For the prestigious new "great hall," Rembrandt and five other painters were commissioned to paint group portraits of the six companies of guardsmen. The result was the iconic masterpiece known as the *Night watch*.

The most public of Rembrandt's public paintings hung a few hundred meters from the Nieuwmarkt. It was made for the new wing of another revamped structure left over from the same former city wall from which the Sint Antonieswaag had been carved. This survivor of medieval Amsterdam was not a gate but a bastion, a tower called Svych Wtrecht (Utrecht Hold Your Peace), built in 1481–82.[42] In 1522 it became part of a complex that included the headquarters of the musketeers' civic guard and a shooting range. The musket (*kolver*) was one of the three weapons that gave its name to a branch of the Amsterdam civic guard, along with the handbow and the crossbow. Each had grounds for practice, offices for meetings and halls for gatherings. These ensembles were called *doelens* (targets, a short designation for a practice range).[43]

In the 1630s the governors of the musketeers' *doelen* (Kloveniersdoelen) had a new building erected beside Svych Wtrecht.[44] On the main level, one story above the ground floor, they put in a hall for banquets and ceremonies. From the start the "great hall" was one of the premier locations in the city, where visiting dignitaries would be received and official dinners were held. Until the building of the town hall twenty years later, with its far more imposing Burgerzaal, Citizens' Hall, the great hall of the Kloveniersdoelen must have been the single most prestigious and busily frequented public room in Amsterdam.

In honor of the occasion and of themselves, the governors ordered a new set of group portraits of the six companies of musketeers. All of the city's *doelens* had group portraits of some of its companies, but never before had a suite of this kind been ordered. About 120 of the two hundred musketeers paid to be included in the portraits. The captains of the six companies por-

293
The Doelen Hotel, incorporating elements from the Kloveniersdoelen

294
Rembrandt
Svych Wtrecht Tower and the Kloveniersdoelen
Unsigned, undated.
Ca. 1654
Reed pen and brown ink,
16.4 x 23.5 cm.
Benesch 1334
Amsterdam, Rijksmuseum

42 Wijnman 1974, p. 143.
43 For a fuller treatment of the themes in this chapter, see Haverkamp Begemann 1982, Schwartz 1985, pp. 209–13, Tümpel 1988 and Schwartz 2002.
44 There is disagreement among specialists about the date of construction, with opinion varying from 1627–28 (Dudok van Heel, cited from ms. by Haverkamp Begemann 1982, p. 52, note 6; Bakker 1998, p. 177), 1631–36 (Haverkamp Begemann, ibid.), to 1640 (Wijnman 1974, p. 143).

295
Jorien Doorn, Computer
drawing of the great hall of
the Kloveniersdoelen as it is
thought to have looked about
1645

Group portraits, from left to
right
Joachim von Sandrart
*Officers and guardsmen of the
Amsterdam civic guard company
of Captain Cornelis Bicker*
Govert Flinck
*The governors of the Klovenier-
sdoelen*
Govert Flinck
*Officers and guardsmen of the
Amsterdam civic guard company
of Captain Albert Bas*
Rembrandt
*Officers and guardsmen of the
Amsterdam civic guard company
of Captain Frans Banning Cocq*
Nicolaes Eliasz. Pickenoy
*Officers and guardsmen of the
Amsterdam civic guard company
of Captain Cornelis van
Vlooswyck*
Jacob Backer
*Officers and guardsmen of the
Amsterdam civic guard company
of Captain Cornelis de Graeff*
Bartholomeus van der Helst
*Officers and guardsmen of the
Amsterdam civic guard company
of Captain Roelof Bicker*

All of the paintings are in the
Rijksmuseum, on loan from the
city of Amsterdam

45 Kok 1967.

trayed in the Kloveniersdoelen were junior members
of the Amsterdam oligarchy. When they were painted,
most had been aldermen, but none had yet been
a burgomaster (lord mayor), the highest office in the
city. Captaincy of a civic guard company was one
of the stepping stones on the way to high office, and
four of the six captains were on the way to that high
dignity. Cornelis de Graeff, the head of his clan,
became burgomaster in 1643, his brothers-in-law
Cornelis Bicker in 1646 and Frans Banning Cocq
in 1650, and his ally Albert Bas in 1647.

The great hall of the Kloveniersdoelen, then, was
a gallery of the coming men of Amsterdam. Fittingly,
they were painted by leading artists of the city. The
commissions went to six different artists, who despite
their different backgrounds were all related in one way
or another to Rembrandt's in-law and former partner
Hendrick Uylenburgh. He had brought Rembrandt
from Leiden, Jacob Backer (1608–51) from Harlingen
and Govert Flinck (1615–60) from Cleves to
Amsterdam and had employed them there. He lived
next door to Nicolaes Eliasz. Pickenoy (1588–1650/56),
who was the master of Bartholomeus van der Helst
(1613–70). It is not unlikely that the governors of the
Kloveniersdoelen, rather than conducting a search of
their own for the right artists for this major campaign,
used Uylenburgh to broker the commissions.

Although no contract for the commission has come
down to us, two precious documents concerning the
price paid for the *Night watch* were drafted in 1659.
One of the guardsmen said that "he was painted and
portrayed by Rembrandt van Rhijn, painter, with other
persons of their company and corporalship, sixteen
of them, in a painting now standing in the great hall
of the Kloveniersdoelen and that each of them, as far
as he the witness remembers, paid for being painted

the sum of one hundred guilders on average, one paying
more and the other less, depending on their place in it."
The other witness said that "the painting cost the sum
of sixteen hundred guilders." One hundred guilders
accords with Rembrandt's normal fee for a half-length
portrait. The extra work that went into the *Night watch*
must have been charged to the artist's pride and desire
to stand out from the rest. Whether the captain and
lieutenant paid an additional sum we do not know.

The year before Rembrandt received the commission
for the *Night watch*, the most important event in the
history of the Kloveniers took place. On 1 September
1638 Maria de' Medici (1573–1642), the queen mother
of France, was received in Amsterdam with the greatest
public ceremony the city had ever seen. Needless to say,
the civic guard was heavily involved. The day before the
entry, "there was a mighty to-do among the captains
concerning who was to be first or last to march out or
back. Ditto concerning where everyone was to stand,
and where and when to march."[45] Lots were drawn, and
the lead position inside the city gates went to the com-
pany depicted in the *Night watch*, the men of the second
precinct.

The reception of the queen mother by the civic guard
is commemorated directly in one of the other groups
in the great hall. In Joachim von Sandrart's portrait
of the company of Cornelis Bicker, the men are seated
solemnly around a bust of Maria de' Medici (fig. 296).
There may also have been another portrait of the queen
in the hall. An authoritative guidebook to Amsterdam
published in 1663 says this in so many words, although
the painting itself is unknown.

Although the *Night watch* has no overt references
to Maria de' Medici, the sheer glamour of the painting,
suggestive of a special occasion and not the regular
duties of the troop, could not but call to mind her

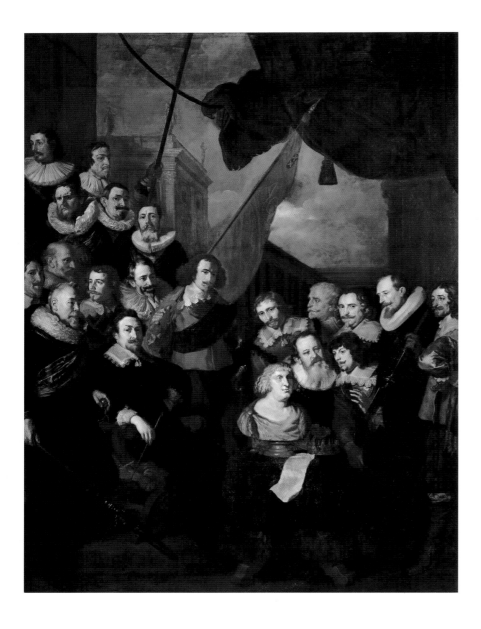

296
Joachim von Sandrart
*Officers and guardsmen of the
Amsterdam musketeers' company
of Captain Cornelis Bicker
and Lieutenant Frederick van
Banchem*
Unsigned. [Formerly inscribed
with a poem by Vondel.]
Undated. Ca. 1640
Canvas, 343 x 258 cm.
Amsterdam, Rijksmuseum
(on loan from the city of
Amsterdam)

46 The frequently repeated opinion
that paintings, unlike prints, do not
refer to specific events is not shared
by me. In referring to a certain event,
a painting – or a print, for that
matter – need not be an eyewitness
report.

glorious entry. The painting evokes a moment, and
what other moment in the history of the company
could have been intended?[46] The comparison of
Sandrart's painting of the company of Cornelis Bicker
and Rembrandt's of the men under Frans Banning
Cocq is a study in contrasts. The German artist shows
his guardsmen in complete immobility, their thoughts
and inward-looking gazes focused on their liege lady,
present in cold, colorless marble. His is a contemplative
painting, as against Rembrandt's *Night watch*, prover-
bial from the start for its action. Sandrart's captain
is seated, Rembrandt's leading a march. Weapons,
in Cornelis Bicker's company, are borne symbolically
by a few men. Banning Cocq's guardsmen all brandish
their weapons demonstratively.

The musket or arquebus, the chief weapon of the
company, is featured in the middle ground of the *Night
watch* with a succession of the stages in the firing of
the weapon. The guardsman in red to the left, a man
in the prime of life, is loading the weapon through the

muzzle; the small figure behind the captain, seemingly
a child, is firing it; and the older man behind the lieu-
tenant is blowing the unexploded powder off the pan.
This mini-composition is crossed by another. The boy
firing the musket, dressed in historical costume, is
accompanied by two mysterious girls dressed in gold
and blue. From the waist of one of the girls hangs a
chicken by its claws, an emblem of the Kloveniers,
whose name was sometimes interpreted to mean claws.
Another child holding a powder horn seems to be run-
ning from the scene. The latter two seem to be part of
the support force that would accompany the guardsmen
on a campaign or in practice sessions. However, the
relation in the *Night watch* between the eighteen officers
and guardsmen and sixteen auxiliary figures has never
been satisfactorily explained.

Behind the musketeers, in front of the strangely dark
arch, is the standard-bearer carrying the colors of the
troop. Because of his vulnerability in the field, he has
an armed escort of his own, with shields (purple in the
drawing). On the right are the pikemen, the secondary
weapon of the Kloveniers. Individual members of the
company bear an assortment of other arms and military
attributes, coded in fig. 299. The scene is set in front
of what looks like a closed city gate, in an architectural
order, the Tuscan, that was not found in the city walls of
Rembrandt's Amsterdam but that was certainly appro-
priate as a reference to a visit by the daughter
of a grand duke of Tuscany. (The building in the back-
ground of Sandrart's painting seems to be the Palais
du Luxembourg in Paris, the palace of Maria de'
Medici, to which she would never return.)

Fig. 299 shows an unfortunate feature of the *Night
watch*: it is cut down on three sides. The loss on the left,
where two figures and an important indication of the
spatial setting are lacking, is the most serious. *The night
watch* has been affected not only by curtailment, per-
formed when it was moved from the Kloveniersdoelen
to the town hall in 1715, but also by surface damage
inflicted by time and the hand of man. Until it was
moved into a proper museum in 1815, the *Night watch*
always hung in spaces that were used for all kinds of
other purposes. It looked down on hundreds of meet-
ings of military men and politicians, receptions, auc-
tions and other events of the kind that take place in
catering halls and government offices. In this situation,
it is no surprise that it was damaged. Restorers have
counted sixty-three different tears and holes in the
canvas. One wonders whether Rembrandt would have
put his name to the canvas we see today.

From the moment it was hung in the Kloveniers-
doelen, the *Night watch* was a famous painting. Its crit-
ical fortunes have been somewhat varied, but on the
whole quite favorable. Remarkably, the most frequently
heard judgments, both positive and critical, found
expression in the very first recorded reaction to the
Night watch. It is a brilliant passage in Samuel van
Hoogstraten's treatise on painting, published in 1678.
What makes the passage all the more important
is that van Hoogstraten was a pupil of Rembrandt's

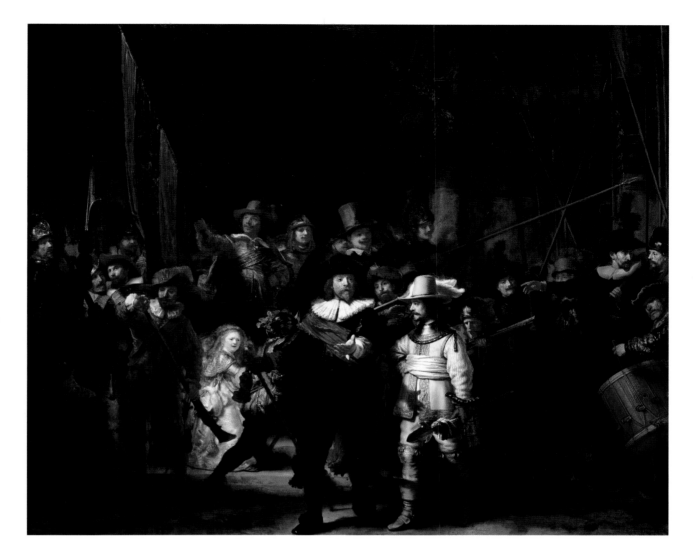

297
Rembrandt
Officers and guardsmen of the
Amsterdam civic guard company
of Captain Frans Banning Cocq
(1605–55) and Lieutenant
Willem van Ruytenburgh
(1600–52): "The night watch"
Inscribed *Rembrandt f 1642 /*
Frans Banning Cocq, heer van
purmerlant en Ilpendam
[and fifteen other names]
Canvas (cut down),
363 x 437 cm.
Bredius 410
Amsterdam, Rijksmuseum
(on loan from the city of
Amsterdam)
See also fig. 177

at the very time that the *Night watch* was painted and
delivered. What he writes about the painting sounds
like the kind of thing that would have been said about
it when it was first hung.

His book is called *Inleyding tot de Hooge Schoole der*
Schilderkonst (Introduction to the Academy of
Painting). In it van Hoogstraten praises the *Night watch*
as a prime example of a painting that successfully com-
bines observation from nature with pure artistic inven-
tion. The individual motifs in a painting, he wrote, are
"imitations" of real things. But combining them into a
composition is an intellectual achievement that exists
only in the artist's mind.

It is not enough that a painter place his figures in rows
one beside the other. You see far too much of that
here in Holland in the *doelens* of the civic guard. True
masters manage to give unity to the entire work....
Rembrandt achieved this in his painting in the *doelen*
in Amsterdam extremely well. According to some too
well, by making more of the big picture in his ima-
gination than of the individual portraits that were
ordered from him. However, I feel that this same
work, open to criticism though it may be, will surpass
all its competitors. It is so picturesque in conception,
so graceful in the placing of the figures and so power-
ful that beside it, in the judgment of some, all the

other paintings [in the Kloveniersdoelen] look like
playing cards. Although I do wish that he had lit it
with more light.

This passage contains the germ of one of the most
persistent myths in the history of art: that the sitters to
the *Night watch* rejected the painting. Van Hoogstraten
implies that there was a certain measure of discontent
concerning the individual portraits. Although there
is no written evidence that the sitters complained, as
some other sitters did complain to Rembrandt about
their portraits, there does seem to have been a certain
amount of grumbling. Van Hoogstraten's remarks also
contain a fascinating echo of another criticism leveled
against Rembrandt, that he followed nature alone.
In the dichotomy between imitation – following nature
– and invention, Rembrandt is blamed by his pupil for
an excess of the latter!

Van Hoogstraten's prediction that the *Night watch*
would surpass all its competitors in the eyes of later
judges has held true in general. But the other group por-
traits from the Kloveniersdoelen are not its competition
any longer. Since the nineteenth century the *Night*
watch has been one of the ultimate icons of world art,
above all competition. This status was confirmed
resoundingly when in 1885 the *Night watch* was moved
to the new Rijksmuseum building. The architect Pierre

298
Jan Martszen de Jonge
(ca. 1609–after 1647)
Maria de' Medici riding past a
theater arch at the Varkenssluis
on the Oude Zijds Voorburgwal,
the route flanked by civic guards-
men with muskets and pikes
Inscribed *J.M. de Jonge 1638*
Brown ink, 28 x 38.8 cm.
Amsterdam, Rijksmuseum

See Snoep 1975, pp. 50–54

The visit to Amsterdam on 1–5 September 1638 of the queen mother of France, Maria de' Medici, was seized upon by the city to demonstrate its own high status while displaying hers. The event followed on and was compared to the magnificent ceremonial entry into Antwerp of His Royal Highness Ferdinand of Austria on 15 May 1635, to the design of Peter Paul Rubens. That *Pompa introitus* (grand entry) was published in a lavish folio that was circulated all over Europe. Amsterdam pulled out all the stops, putting to work its own humanists, artists and poets, architects, town officials and civic guard to create, within a mere two weeks, a spectacle worthy of a queen. As in Antwerp, a grand publication, *Medicea hospes*, was brought out in Latin, but also in Dutch and French editions.

Among the decorations were two arches on the streets between the lodgings of the queen mother in the Admiralty of Holland and the town hall on the Dam. The passage of the royal coach before the arch on the Varkenssluis, the lock on the Oude Zijds Voorburgwal near the Dam, was drawn by Jan Martszen de Jonge for an engraving in *Medicea hospes*. The route is flanked by guardsmen with muskets and pikes.

The constellation of elements in this drawing – the bridge and its railing, the arch, the civic guard and its weapons – resembles the *Night watch* so closely that coincidence can be ruled out. The commission for the *Night watch* was in fact given in the very months when the illustrations for *Medicea hospes* were being drawn and engraved. There is therefore every reason to believe that a reference to the entry of Maria de' Medici was part of that commission.

Cuypers conceived of the national museum as an encapsulation of all Dutch history and art. The central object in his vision was none other than the *Night watch*. He created a space for it where the painting took on a nearly sacral character, like the altar in a Gothic church (fig. 649).

At the moment of writing, the *Night watch* is in a temporary gallery while the Rijksmuseum is being renovated. The space is smaller than the hall Cuypers built for it, and it can be seen from close by, to great advantage. However, it is fitting that the Rijksmuseum has promised that in the New Rijksmuseum, due to open in 2009, Rembrandt's masterpiece will be restored to its pontifical position.

If Rembrandt was sensitive to such issues, he went out of his way not to show it. When in the 1650s he drew Svych Wtrecht and the Kloveniersdoelen, he distorted them nearly beyond recognition, downplaying the new, classicizing features, such as the great hall, and robbing the tower of its crowning feature, a high pointed roof.[47] In his mind's eye, the environment for which his most famous painting was made barely existed.

47 Bakker et al. 1998, p. 181.

299
Jorien Doorn, Computer drawing
of the *Night watch*, with the
members of the company coded
by weapon

☐ Guardsmen
▨ Additional figures
☐ Baton
▨ Partisan
▨ Halberd
☐ Two-hand sword
▨ Sword
☐ Pike
▨ Lance
▨ Musket
☐ Musket rest
▨ Pistol
▨ Powder horn and
 powder cartridges
▨ Rondache
☐ Breastplate, leg armor
☐ Gorget
▨ Helmet

The two officers, three sub-officers and thirteen guardsmen of the
Amsterdam civic guard company from the second precinct that
Rembrandt painted for the great hall of the Kloveniersdoelen,
together with sixteen auxiliary figures who did not pay to be included
in the painting. Only a few of the known sitters can be identified with
figures in the painting.

1. Frans Banning Cocq (1605–1655), lord of Purmerland and
Ilpendam, captain. Son of a wealthy druggist, son-in-law of a far
wealthier city father of Amsterdam from whom he acquired his title.
Followed a career in town government, eventually becoming burgo-
master in 1650 for the first of four terms.
2. Willem van Ruytenburgh (1600–1652), lord of Vlaardingen, lieu-
tenant. Son of a merchant in spices who bought an aristocratic title
that he passed to his son. Followed a lesser career in Amsterdam
politics.
3. Jan Cornelisz. Visscher (1610–1650), standard-bearer. Used the
inheritance from his family fortune to collect art and books; practiced
music.
4. Reijer Engelen (1588–1651), sergeant, cloth merchant.
5. Rombout Kemp (1597–1654), sergeant. Successful cloth merchant,
deacon of the Reformed Church, governor of one of the city poor-
houses.
6. Musketeer
7. Helmeted man with sword
8. Herman Wormskerck, with shield and sword. Wormskerck was
a wealthy cloth merchant.
9. Musketeer with furket and slow-match
10. Musketeer loading his weapon
11. Boy wearing a gunner's priming horn and an oversize helmet
12. Girl in gold and blue
13. Girl in gold and blue
14. Shooting youth
15. Head of a man

16. Head of a man
17. Head of a man
18. Helmeted man with shield and sword
19. Head of a man
20. Pikeman
21. Head of a man
22. Helmeted man supporting a musket being fired
23. Pikeman (Wallich Stellingwou?)
24. Man blowing the pan clean of powder residue
25. Pikeman (Jacob de Roy?)
26. Head of a pikeman
27. Musketeer
28. Head of a man
29. Pikeman
30. Drummer (probably Jacob Jorisz.)
31. Head of a man
32. Bareheaded musketeer (in section removed ca. 1715)
33. Man with a hat (in section removed ca. 1715)
34. Child (in section removed ca. 1715)

Beside Engelen, Kemp and Wormskerck, four other guardsmen in the
Night watch were also cloth merchants. Others dealt in hemp, wine,
spices and other trades. Jan Keijser, a wine dealer, later became the
tavernkeeper of the Handbowmen *doelen.*

300
The Staalhof in the Staalstraat.
The building belonged to
the drapers' guild, which
commissioned Rembrandt's
group portrait of the guild
syndics

48 Wagenaar 1760–, vol. 2, p. 42.
49 Schwartz 1985, pp. 335–37.
50 Gerson 1968, p. 128.
51 Van Thiel et al. 1976, p. 11.

The Staalhof

Rembrandt's final group portrait depicts the sampling officials of the Amsterdam drapers' guild. The tension in the poses and gazes of the sitters, for which no explanation is offered by the painting or the known circumstances of the commission, opens the *Syndics* to a multitude of responses.

A stone's throw from the Kloveniersdoelen lay the third and last Amsterdam public building for which Rembrandt delivered a group portrait. It was a less accessible location than the other two, the body he painted less involved with the public than the surgeons or the musketeers, and the commission more hedged about with conditions. In 1763, the Amsterdam historian Jan Wagenaar described the institution for which Rembrandt's painting was made and the tradition of portraiture into which it was expected to fit:
 Downstairs in the Staalhof ... is a large room where the cloth is sampled or leaded [with a seal], and

a courtyard where it is first hung up for inspection; a room where the five cloth wardens, also called syndics [*staalmeesters*; sample masters], appear in turn, one at a time, three times a week, ... to judge the materials and put their seal on the blue and black cloths that are the only kind brought to the Staalhof. In this room hang six paintings of syndics from the sixteenth and seventeenth centuries. The oldest is marked with the year 1559. In each of these paintings are portrayed five wardens seated and the Staalhof steward, standing."[48]
Rembrandt's painting does not show the men doing that part of their job. The object in hand is not a bolt of cloth but a book, seemingly the one in which they recorded their judgments.

Rembrandt did not accommodate himself to this hundred-year-old tradition with perfect grace. The X-rays show that he first painted the foremost figure standing up straight, as in a preparatory drawing in Rotterdam (fig. 302). In the finished painting the man is bent into a position that with a little good will can be called half-seated. The man has been identified as Volckert Jansz. (1605/10–1681), a Mennonite draper with a large collection of art and curiosities.[49]

As in his other group portraits, Rembrandt looked for a way of enlivening the composition, of transforming a mere set of likenesses into a captured moment in the life of the sitters. The built-in drama of an anatomical demonstration or a military manoeuvre did not come with the territory of a committee meeting. The pose of Volckert Jansz., who is in the act of sitting down or rising, is one feature that gives the *Syndics* a momentary quality. Another is the direction of the rather intense gazes of the figures, four of whom look directly at the viewer with what some interpreters see as a challenging or challenged look. F. Schmidt-Degener (1881–1941), director of the Rijksmuseum from 1921 on as well as a poet and evocative essayist, saw in the painting a moment when the authority of the panel had been challenged from the floor at a public meeting. Aside from the fact that the syndics never had to justify their doings to the public, it is inconceivable that a body of this kind would have accepted a painting that portrayed them defending their probity. However, Schmidt-Degener was right, I believe, to insist on the instantaneity of the scene.[50]

This quality was not apparent to all viewers. When the city of Amsterdam, which still owns the *Syndics*, offered it for sale to the national art gallery in the first years of the nineteenth century, the offer was rejected because "inspector [Cornelis Sebille] Roos judged the painting too big and too dull, showing nothing but 'five gentlemen all in black, not doing a blessed thing but sitting to have their portrait painted.'"[51]

Between the insensitivity of Roos and the hypersensitivity of Schmidt-Degener lies a range of responses as wide as human nature itself. Once more, Rembrandt has deftly hit an ace into the court of the observer.

301
Rembrandt
*The five sampling officials
of the drapers' guild and
the guild steward: "The syndics"*
Inscribed *Rembrandt f. 1662*
Canvas, 191 x 279 cm.
Bredius 415
Amsterdam, Rijksmuseum

302
Rembrandt
The standing syndic
Unsigned, undated. Ca. 1662
Brown ink and wash, white
body color, 22.5 x 17.5 cm.
Benesch 1180
Rotterdam, Museum Boijmans
Van Beuningen

The town hall

In the early 1660s Rembrandt had an opportunity to re-establish his standing following his humiliating insolvency. A monumental painting by him of a stirring moment in the history of Holland was hung in the new town hall of Amsterdam. Sadly, however, his *Oath of Claudius Civilis and the Batavians in the sacred grove* hung only for a short time before it was removed. The reason, it is here suggested, had more to do with economizing and patronage than with taste or style.

The ultimate public space in Amsterdam was the new town hall. Plans for the replacement of its outgrown predecessor, the offices of which spread out over the neighborhood, were in the air for a long time. The approaching Peace of Munster (1648), which ended the Eighty Years War and from which Amsterdam expected renewed prosperity, gave the final impetus for action. The town government decided to put aside all pretence at modesty and go for a building that could seriously be called the eighth wonder of the world. In the process they demolished a considerable chunk of the historical center.

A greater and more concrete distinction than the label "wonder of the world" is that the new town hall was dedicated to all the citizens of Amsterdam and was open to any and all. The great central space, the Burgerzaal or Citizens' Hall, gave the people of Amsterdam an environment in which they could enjoy an uplifting sense of their own power. The architect, Jacob van Campen (1596–1657), endowed the building with a grandiosity bordering on the mystic. The dimensions of the Burgerzaal – 120 feet long, sixty wide and ninety high – are suggestive of Pythagorean number worship. In the contemporaneous Oranjezaal, a project in which van Campen was heavily involved, the paintings memorializing Stadholder Frederik Hendrik include an image of the town hall of Amsterdam as an emblem of the heavenly Jerusalem.[53]

The building is alive with allusions to sources of authority and legitimacy for Amsterdam and the Dutch Republic. The architectural vocabulary is classical, the Burgerzaal reminiscent of a Roman basilica. The iconography of the paintings and sculptures is taken from classical mythology and history, the Jewish Bible (the Christian Bible seems to have been avoided, probably to forestall an uproar from Calvinist preachers), modern allegory and – this is where Rembrandt comes in – the story of the Batavians.

The Batavians were one of the tribes that inhabited the low countries in the centuries when they formed part of the Roman Empire. In his book *Germania* (chapter 29), the Roman historian Tacitus calls them the bravest of the nations of the Rhineland. The Romans extended privileges to the Batavians in order to be able to draw on their fighting power in time of war, "as one uses a depot of arms and armor." In Book Four of the *Histories*, Tacitus says that the Romans

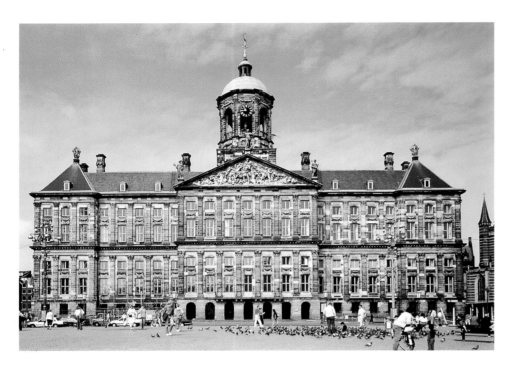

303
Royal palace on the Dam in Amsterdam, built ca. 1647–54 as the town hall

304–305
The Dam in 1625 and 1657 respectively. Details from the map of Amsterdam by Balthasar Florisz., in two successive editions.[52]

52 From Fremantle 1959, figs. 6–7.
53 Eymert-Jan Goossens, in Huisken et al. 1995, p.215.
54 In the translation of Kenneth Wellesley on the website of Our Civilisation.
55 Van der Coelen 2004.

abused the Batavians by unjustly executing one of their leaders, Julius Paullus, and taking off another, Claudius Civilis, in chains to Rome. Civilis, Tacitus writes, "was unusually intelligent for a native, and passed himself off as a second Sertorius or Hannibal, whose facial disfigurement he shared" – that is to say, the loss of one eye. He feigned friendship with Emperor Vespasian in order to regain his freedom. When he returned to his tribal grounds in the marshes of the Betuwe, he organized the revolt he had long been planning. The pretext was the rapacious way the Romans conducted conscription into the army. "The levy was by its nature a heavy burden, but it was rendered still more oppressive by the greed and profligacy of the recruiting sergeants, who called up the old and unfit in order to exact a bribe for their release, while young, good-looking lads – for children are normally quite tall among the Batavians – were dragged off to gratify their lust."[54]

At first the revolt was a stunning success; the Batavians drove the Romans out of their lands. Inevitably, the Romans regained the upper hand. In doing so, however, they paid the rebels the compliment of negotiating a peace with them and restoring their former privileges rather than annihilating them. Although this story of arrogance and deceit does not supply a clear model for good behavior and success on either side, to the Dutch in the mid-seventeenth century it resonated with echoes of the revolt against Spain and the negotiations that in 1648 brought full recognition by their former master of their independence.

The appeals to ancient authority in the town hall seem to follow a certain order. The Burgerzaal, dominated by Atlas, confronts the Maid of Amsterdam with earth and heaven. Her hall is girded about with circles of Batavian, Roman and Jewish forebears, kept to a measure out of each other's territory. The Batavians were given a splendid place, in the gallery circumscribing the Burgerzaal and its courtyards. On 28 November 1659, Rembrandt's former pupil Govert Flinck, risen to higher favor in the oligarchy than his master ever achieved, was commissioned to paint twelve immense canvases, five and a half by more than five meters each, rounded on top, of which eight were subjects from the Batavian revolt. Flinck took his inspiration from a series of thirty-six etchings by Antonio Tempesta in collaboration with Otto van Veen, published in 1612 in a book by van Veen on the Batavians and Romans.[55] The series was made all the more famous by the purchase in 1613 by the states general of a suite of twelve paintings by van Veen of the revolt, now in the Rijksmuseum. The artist was showing the stuff that made him a worthy teacher of the learned painter *par excellence*, Rubens.

Flinck had hardly begun his mammoth commission, which was to be delivered at a rate of two paintings a year, when on 2 February 1660 he died unexpectedly. With what they may have thought of as greater circumspection, the burgomasters now split the job between a team of painters, Rembrandt, Jan Lievens and Jacob Jordaens. In fact, from this point on the entire project came apart at the seams and was never completed. The misfortune that now befell Rembrandt – first delivering a conspicuous painting, then seeing it taken off the wall – was merely the first in a series of half-baked measures on the part of the town council with regard to the monumental paintings in the gallery.

The scene that Rembrandt painted was the beginning of the Batavian uprising. Once more, Tacitus:

306
Daniël Stalpaert
Groundplan of the first floor of the town hall, from a publication of 1650 describing the building under construction

307
Royal palace on the Dam, the Burgerzaal

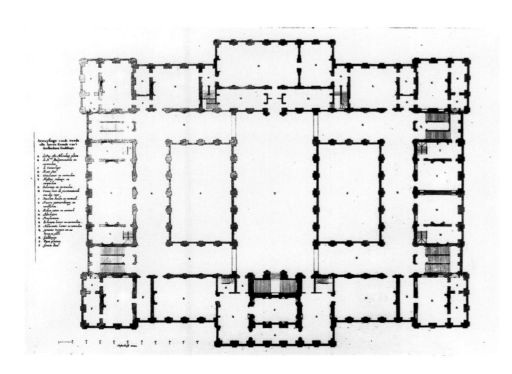

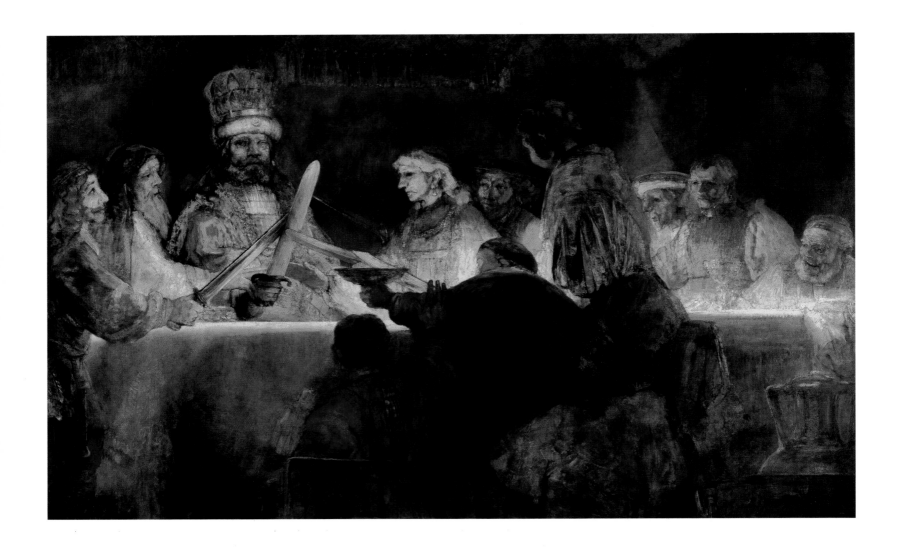

308
Rembrandt
*The oath of Claudius Civilis and
the Batavians in the sacred grove*
Unsigned, undated. Ca. 1661
Canvas (fragment, originally
nearly 550 x 550 cm., arched
above), 196 x 309 cm.
Bredius 482
Stockholm, Nationalmuseum

309–10
Rembrandt
*The oath of Claudius Civilis and
the Batavians in the sacred grove*
Unsigned, undated. After
25 October 1661, the date of the
funeral announcement on the
back of which the drawing was
made
Brown ink and wash, some
white body color, 19.6 x 18 cm.
Benesch 1058 recto and verso
Munich, Staatliche Graphische
Sammlung München

311
Antonio Tempesta (1555–1630)
and Otto van Veen (1556–1629)
*The oath of Claudius Civilis and
the Batavians in the sacred grove*
Unsigned, undated. Ca. 1611
Published in Otto van Veen,
Batavorum cum Romanis bellum,
Antwerp 1612
Etching, ca. 14.5 x 21 cm.
The Hague, Koninklijke
Bibliotheek

312
Simon Frisius (d. 1629)
Feast of a Germanic tribe
Unsigned, undated. Ca. 1616
Published in Philippus
Cluverius, *De Germania
antiqua*, Leiden 1616
Engraving, 25.5 x 31.7 cm.
Collection of the author

Civilis invited the nobles and the most enterprising
commoners to a sacred grove, ostensibly for a ban-
quet. When he saw that darkness and merriment had
inflamed their hearts, he addressed them. Starting
with a reference to the glory and renown of their
nation, he went on to catalogue the wrongs, the
depredations and all the other woes of slavery....
Civilis was listened to with whole-hearted approval.
He exacted from all his hearers an oath of loyalty
marked by barbarous ritual....

In the iconographic tradition of the Batavians, the artist
had one main choice: whether to show them looking
more like Romans or more like barbarians. Van Veen
and Tempesta, followed by Govert Flinck, tended
toward the former. The costumes and behavior of the
figures may be more Burgundian than Roman, but they
are far more civilized than the competing image of the
Batavian as a naked savage projected by the antiquarian
scholar Philippus Cluverius and the artists who illus-
trated his book of 1616, *De Germania antiqua*.

Rembrandt takes a position halfway between those
two looks. His figures are clothed, but not in a fashion
that anyone would think of as Roman. Instead of the
two-plumed cap with which Civilis is adorned by van
Veen, Rembrandt's hero wears a tower of a round, pat-
terned hat. While van Veen's Batavians take the oath
with a handshake, Rembrandt's cross raised swords.
(Weirdly, there is one sword more in the painting – the
one touching the front of the leader's blade – than
Batavians to hold them.)

By 21 July 1662, the day Melchior Fokkens signed the
dedication of a book on Amsterdam saying that
Rembrandt's *Oath* hung in the south gallery of the town
hall, over a statue of the goddess Diana, the painting
must have been delivered and mounted.[56] In August
1662 the painting was still there, when Rembrandt
brought in "the quarter share of his profits accruing
from the piece for City Hall and his prospective earn-
ings from it" in a loan agreement with the art dealer
Lodewijk van Ludick.[57] The other artists of the second
commission, Lievens and Jordaens, were paid 1,200
guilders for paintings in the gallery (Flinck was to get
only one thousand apiece); Rembrandt must have anti-
cipated the same.

56 Van de Waal 1952, vol. 1, p. 225.
See van de Waal's admirable chapter,
"De decoratie van het Amster-
damsche stadhuis (1655–1697),"
vol. 1, pp. 215–28 and notes in vol. 2.
57 Doc. 1662/6.

313
Govert Flinck (1615–60) and
Jurriaen (Jürgen) Ovens
(1623–78)
The conspiracy of Claudius Civilis
Unsigned, undated. Ca. 1662
Canvas, 546 x 538 cm.
Sumowski 641
Amsterdam, Stichting
Koninklijk Paleis

314
Photograph of gallery in the
royal palace, the former town
hall of Amsterdam. *Claudius
Civilis* hung in the lunette
adjoining the one in this view
at a right angle.

58 Franken 2005, p. 76.
59 Van Eeghen 1969c, p. 149.
60 Westermann 2000, p. 298.

By 24 September 1662, however, when the archbishop and elector of Cologne was received in the town hall, Rembrandt's painting was gone, replaced by a painting begun by Govert Flinck and finished by his German pupil Jürgen (or Jurriaen, as he was called in Holland) Ovens.[58] In 1734 the fragment that we know, lacking foreground and background, space on the right and on the left, surfaced at an Amsterdam auction and was bought for Stockholm.

Because no record of payment for the *Claudius Civilis* has survived, it has been assumed that Rembrandt received nothing for his rejected work but the canvas, paid for by the city, on which it was painted. However, one register in which payment to Rembrandt could have been recorded is missing from the Amsterdam archives; he may have been reimbursed for his work.[59]

In the lack of real information, we can only guess what went wrong. There are issues of payment, of politics and – the most commonly accepted theory – propriety. "Rembrandt's rough style and unpolished conception of the Batavians and their 'barbaric ritual' conflicted with the contemporary heroization of Civilis and his companions," writes a recent authority.[60] However, there is reason to doubt this. In the known instances when artists were taken off the job by the authorities in seventeenth-century Holland, it was always a matter of money, time or patronage, never style. Another artist who shared Rembrandt's fate was none other than the architect of the town hall itself,

Jacob van Campen. For whatever reason the final stages of the construction of the town hall were taken out of his hands – he was not even present at the dedication – it cannot have been his style. Van Campen's heroic classicism was the very trademark of the new Amsterdam. Had van Campen enjoyed continued support from the right people in the town government, he would not have fallen out of favor. The same, I believe, goes for Rembrandt.

A theory that makes minimal assumptions about motives might sound like this: Jan Lievens, in his *Brinio raised on the shield,* and Jacob Jordaens, who painted *The defeat of the Romans* and *The truce between Claudius Civilis and the Roman general Cerialis,* chose for a more Roman variant of the Batavian than Rembrandt. When all four paintings were in place, the discrepancy was evident. The responsible committee was bothered by this. With three "Roman" paintings against one "semi-barbarian," it was far cheaper to replace the Rembrandt than the other three, no matter which look the city fathers may have preferred. Moreover, there was Flinck's unfinished canvas of exactly that subject, in "Roman" style, in the closet. Jurriaen Ovens, who assumed direction of Flinck's studio after his master's death, was ready to finish the job for forty-eight guilders, and that clinched it. They were willing to accept the circumstance that the Flinck–Ovens version, which concentrates on the darkness and merriment of the text, was less dignified than the Rembrandt, in

which the solemn oath is the central motif. End theory.

While the world would be a better place had Rembrandt painted twelve monumental canvases as gripping as *Claudius Civilis* for the town hall, the actual turn of events has certain advantages. The remaining section of the painting is more visible in the Nationalmuseum in Stockholm than is the Flinck–Ovens in the spot where Rembrandt's painting once hung. The Nationalmuseum is open six days a week throughout the year, while the former town hall of Amsterdam, once famous for its openness, is now a royal palace that can be visited only in the summer. Moreover, the Flinck–Ovens hangs in a high, dark corner, while *Claudius Civilis* can be admired in good light at eye level. Even the mutilation of the painting has its benefits. Rather than being kept at a distance by a stepped dais, we are nearly face to face with the one-eyed rebel, standing at the table in the sacred grove where his people join him in a solemn oath of life and death, freedom and subjection. *Claudius Civilis* has functioned better as a public painting in Stockholm than its replacement or the other pieces in the series in Amsterdam.

The Trip House

The erection of the new town hall marked the late validation in Amsterdam of classicism as the proper architectural vocabulary for power politics. Within a few years, it was also adopted for power economics. On 24 May 1660 the seven-year-old Louis Trip picked up an engraved silver trowel and laid the first stone of the largest and grandest private dwelling in the city. Actually, it was two private dwellings masquerading as one, one for Louis' father Hendrick and the other for his uncle Louis. Each of them could well afford a house this big for themselves, but that was prohibited by the city code, which established a fairly narrow maximum width for houses. In their desire to give expression to their fabled wealth, the brothers attached one big façade to their adjoining houses, which had no interior connection.

The founders of the Trip dynasty, Jacob and Elias Trip, started life as shippers on the Maas and Waal rivers from Dinant, where their father was born, to Liège, the birthplace of their grandfather, to their own home town of Zaltbommel and on to Dordrecht, where they established themselves as regents in the 1590s. Elias moved to Amsterdam in the 1610s, where he was later joined by Jacob's sons Hendrick and Louis. In a few brief decades of mining, manufacturing, arms dealing and trading on a grand international scale, the family built one of the great fortunes of the age.[61] Among their main enterprises was iron mining in Sweden, where they held very profitable monopolies, leaving the Swedish state in their debt until the nineteenth century. Because they were not around in Amsterdam in 1578 when political power was divvied up between the established families, the Trips were long unable to land a seat on the town council. They made up for the lack in other ways, such as building the Trip House and furnishing it with paintings of their Swedish lands and portraits of themselves.

315
The house of the Trip family on the Kloveniersburgwal in Amsterdam, built by the architect Justus Vingboons (1621–98)

61 The Trips are the subject of one of the best studies ever written of a seventeenth-century grand merchant family, by Peter Klein. Klein 1965.

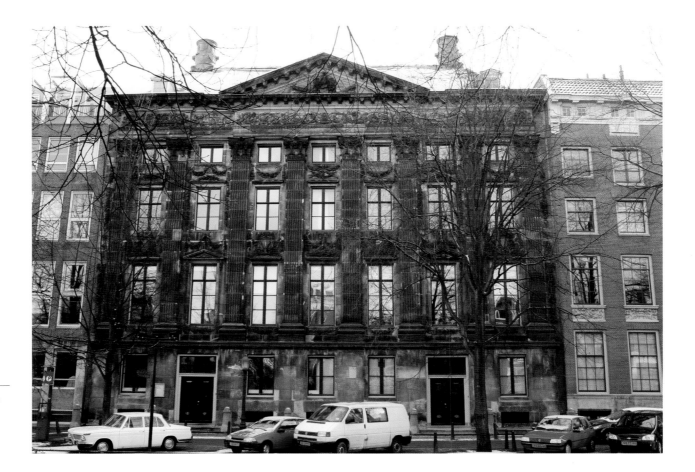

The patriarch and matriarch of a mighty clan are clearly our superiors. Jacob's cane resembles the staff of a military commander. To the visitor to the Trip House this would make sense. The pediment crowning the façade frames sculptured cannon pointing up and down the Kloveniersburgwal; the chimneys have the form of heavy-duty mortars. The martial associations of the house are tempered by the fruits and palms of peace carved on the front, the benefits for which one fights.

The frontal pose of Marguerite de Geer gives her too a commanding presence, going beyond the usual role of "wife of …" in pendant portraits of husband and wife. In terms of family history, this is quite appropriate. The marriage was part of a long-term and not always peaceful strategic alliance between the Trips and the de Geers, whose stamping grounds lay in Liège and the adjoining lands of La Hesbaye. The brothers Elias and Jacob married the half-sisters Marie and Marguerite de Geer, with whose father Louys and brother Lodewijk they conducted some of their major enterprises. Jacob and Marguerite's son Hendrick also married a de Geer. During the sometimes bitter conflicts between the two families, Marguerite will have played an important role.

The couple is old not only in years but also in garb. Marguerite wears clothing that was fashionable when she was in the prime of life, thirty years earlier; Jacob is given a *tabbaard* (see below, p. 187), a warm tunic associated with sedentary and spiritual professions. Rembrandt gave the couple a helping hand, lifting them over the threshold of life to the kind of immortality that an artist can bestow.

Rulers and leaders

Rembrandt did not paint portraits of kings and rulers. This was due more to bad breaks at the court in The Hague and among the Amsterdam oligarchy than to a choice of his own. Nonetheless, he was not out of favor in high places. Self-portraits by him hung in the royal and imperial palaces of Britain, France and the Holy Roman Empire and in the art-loving Medici court in Florence.

Rembrandt's repertoire as a portraitist is noticeably different from that of his peers in the Netherlands and Europe. The monarchs of Europe were painted by Rubens, van Dyck and Velázquez, the stadholder's court by van Mierevelt, Honthorst and van Dyck. Rembrandt's somewhat timid portrait of Amalia van Solms does not put him in this category (fig. 253). There is a reference in the inventories of the House of Orange to "a painting of his highness Prince Frederick Hendrick of praiseworthy memory, in profile, made by Rembrandt," but this is probably an erroneous reference to a portrait by Honthorst.[64]

Not even in Amsterdam, where Rembrandt was the prince of painters for nearly forty years, did he paint portraits of the ruling elite. The most powerful figures in the city were the burgomasters and ex-burgomasters.

316
Rembrandt
Jacob Trip (1575–1661), Dordrecht manufacturer and merchant
Inscribed *Rembr …*.
Undated. Ca. 1661
Canvas, 130.5 x 97 cm.
Bredius 314
London, National Gallery

62 Only one earlier trip by Rembrandt to Dordrecht has left a trace, in the form of a landscape drawing of about 1641, Benesch 802.
63 It has been suggested, on insufficient grounds, that Rembrandt's portrait of Jacob Trip is posthumous.
64 Drossaers and Lunsingh Scheurleer 1974–76, vol. 1, p. 283, no. 1209 and note.

Although the paintings are undocumented before the eighteenth century, it is assumed that Rembrandt's magisterial portraits of the brothers' parents, Jacob Trip and Marguerite de Geer, were made for the Trip House. Once again, as in the case of the town hall, Rembrandt was preceded to this rich source of patronage by a pupil – not one but two. Ferdinand Bol and Nicolaes Maes both came from Dordrecht, where they were favored by the Trips. Since Jacob and Marguerite lived in Dordrecht, Rembrandt presumably had to travel there to paint them.[62]

Rembrandt endows the aged couple – even Jacob, who died around the time the portrait was painted[63] – with striking forcefulness. In contrast to the old people who were the subject of Rembrandt non-portraits of the 1650s, Trip and de Geer are not wrapped up in their own thoughts, staring philosophically into the middle distance. These two engage the viewer forthrightly, establishing a contact of equals. Equals? Not really.

317
Rembrandt
Marguerite de Geer (1583–1672),
wife of Jacob Trip
Unsigned, undated. Ca. 1661
Canvas, 130.5 x 97.5 cm.
Bredius 394
London, National Gallery

65 Schwartz 1985, pp. 346–50.
66 Reformed: Johannes Cornelisz.
Sylvius, Petrus Sylvius, Johannes
Elison and Eleazar Swalmius.
Remonstrant: Johannes Wtenbogaert.
Mennonite: Cornelis Claesz. Anslo.

Rembrandt did paint a number of portraits of men who were later to become burgomasters – Jan Six, for example, who did not attain that office until 1691, thirty-seven years after Rembrandt painted him – but never a sitting or former holder of the highest office in the city.

In part, this was a matter of choice. Nothing prevented artists from producing paintings and prints of the great men and women of their own time as of the past, people who never sat for them. It was not a widespread practice in Rembrandt's time, however, and we can well imagine that he would consider it beneath his pride and harmful to his status to produce and market uncommissioned portraits of this kind. There is no reason to believe that Rembrandt turned down portrait commissions from on high. He accepted commissions of other kinds from the court and the township of Amsterdam, and painted portraits all his life.

A more important part of the reason was surely involuntary. After Constantijn Huygens wrote his nasty little squibs about what he considered Rembrandt's failed portrait of Jacob de Gheyn, he can hardly be expected to have supported a commission to Rembrandt to paint anyone else at court, least of all the stadholder. In Amsterdam, Rembrandt ran up against another, far more serious issue of the same kind. In the period when he was painting the *Night watch*, with its portrait of Frans Banning Cocq, he also painted Cocq's brother-in-law Andries de Graeff (fig. 327). Whether or not because he was disappointed by the likeness, de Graeff refused to take possession of the finished portrait. Rembrandt sued him, and a commission of arbitration found in his favor. De Graeff had to accept the painting and to pay Rembrandt five hundred guilders for it. But he did not have to refrain from badmouthing Rembrandt to his confrères. Whether or not on this account, after 1642 Rembrandt never again painted a portrait of anyone with political power in Amsterdam.

In fact, the greats of the earth showed more interest in Rembrandt than vice versa. Charles I of Great Britain, Louis XIV of France, Emperor Karl VI of the Holy Roman Empire and the Medici grand dukes of Tuscany may have had to do without Rembrandt portraits of themselves, but all of them (and not the House of Orange) owned self-portraits by the artist.[65] The display in the palaces of Europe of these works, several of which were soon and widely reproduced in prints, assured Rembrandt of a lasting association with royalty. However much his reputation may have suffered in other respects, Rembrandt retained a royal imprimatur that helped him through some bumpy centuries to come.

Men of the cloth

Between 1633 and 1646 Rembrandt drew, painted and etched at least four ministers of the Reformed, one of the Remonstrant and one of the Mennonite faiths.[66] The mutual conflicts between these groups did not stand in the way of a working relationship with the artist, from the side of the sitters or of Rembrandt. Among these sitters are Calvinist relatives of the artist's wife Saskia and Mennonite relations of her cousin Hendrick Uylenburgh. Catholic clerics at home and abroad collected and praised his work. Rembrandt's self-chosen image as St. Paul was understood by the clergy of his age.

In the Catholic countries of the *ancien régime* the clergy may have formed the first estate, with far-going political rights and influence, but in the Netherlands of Rembrandt's time men of the cloth had no such luck. Something like division of church and state was practiced, with civic leaders seeing to it that the Calvinist church never exercised secular authority. Nor did an individual churchman ever achieve anything resembling the power of Cardinal Richelieu in France.

318
Rembrandt
*Johannes Wtenbogaert
(1557–1644), Remonstrant
preacher*
Inscribed *Rembrandt f. 1633*
AET 76
Canvas, 130 x 101 cm.
Bredius 173
Amsterdam, Rijksmuseum

67 Joke Spaans, "Religious policies
in the seventeenth-century Dutch
Republic," in: Ronnie Po-chia Hsia
and Henk van Nierop (eds.),
*Calvinism and religious toleration in
the Dutch Golden Age,* Cambridge
(Cambridge University Press) 2002,
pp. 72–86. Also Spaans's website.
68 Schwartz 1985, p. 149, based on
translation from Latin into Dutch
by Loekie Schwartz.
69 Dickey 2004, pp. 35–42.
70 Doc. 1633/2.

"In all different religious groups in the Republic," writes Joke Spaans, "among Jews, Catholics, and Lutherans, as among Mennonites and Reformed, the clergy wielded spiritual authority only. All Churches had lay boards of elders, procurators or wardens, recruited from the local social elite, who were responsible for the election of clergy, church finance, and keeping the peace within the community."[67] The government entity to which the church boards answered was the municipality, with the situation differing from city to city. There was no hierarchy of Calvinist clergy, no head of the church or central consistory. To fully exercise his spiritual authority, a clergyman had to have gifts of his own. Rembrandt portrayed or had other ties to gifted men of that kind.

In Leiden and The Hague, there are no traces of close contact between Rembrandt and the clergy of any denomination. In Amsterdam, however, he had significant contact with leaders of all the churches mentioned by Spaans except for the Catholics. Rembrandt showed sympathetic interest in their faith in other ways (see pp. 350–52).

The first clergyman painted and etched by Rembrandt was the most important churchman

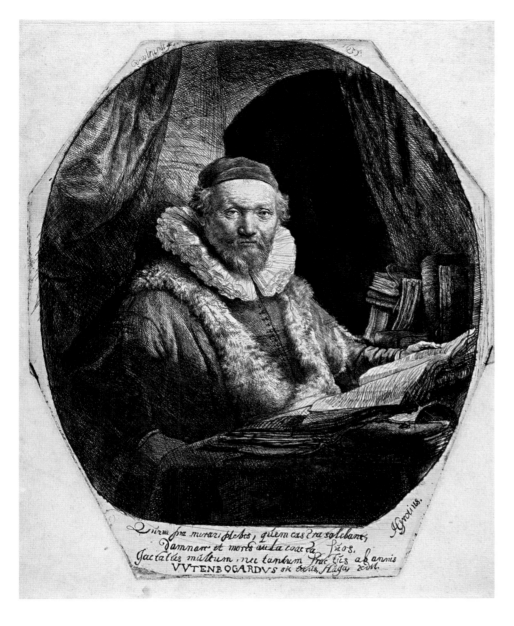

319
Rembrandt
*Johannes Wtenbogaert (1557–
1644), Remonstrant preacher*
Inscribed *Rembrandt ft 1635* and
Latin quatrain, translated as:
*The pious in the land and the
army spoke well of this man,|
But what he preached was
damned by the assembled clergy.|
The years imposed heavy tribula-
tions on him without breaking
him.| Behold, The Hague, your
Wtenbogaert comes home.*
H. Grotius[68]
Etching, 25 x 18.7 cm.
Bartsch 279 iv(6)
Haarlem, Teylers Museum

August 1618 he felt so threatened that he went into hiding. On 24 May 1619, a week after the beheadal of Oldenbarnevelt, Wtenbogaert was banished and his possessions seized. Not until the political climate shifted enough to make the Netherlands safe for Arminians, under Stadholder Frederik Hendrik, did he dare to return to the Netherlands, in 1626 to Rotterdam and in 1629 to his home in The Hague.

Four years later, on a visit to Amsterdam, Wtenbogaert noted in his diary, "13 April 1633. Painted by Rembrandt for Abraham Anthonisz."[70] The man who commissioned the painting was a militant Remonstrant who earlier had gotten into trouble with the authorities for having a bust of Oldenbarnevelt mounted on the front of his house. In those nervous times, when one wrong step or abuse of confidence could cost a person dearly, the fact that Abraham Anthonisz. chose Rembrandt to paint his hero is a sign of trust that I feel is related to the artist's connection with prominent Remonstrants in Leiden. The other artist who painted Wtenbogaert in the 1630s, Jacob Adriaensz. Backer (1608–51), was a Mennonite and therefore a political ally of the Remonstrants.

Rembrandt gives the grand old man of liberal Calvinism a rich assortment of distinguishing attributes: the hand on the heart, expressive of devotion and steadfastness, the skullcap and the long, fur-lined gown, called a *tabbaard*, items of clothing associated with clerics.[71] The hat on the table may be an indication that the preacher was on a visit and not in his own home. (It is best not to take such theories too seriously; it is too easy to find counter-examples.) The most important of the attributes is however the book. It is not a printed book, but a folio volume with writing, presumably that of Wtenbogaert, who was famed for his way with language.

Rembrandt's painted portrait of Wtenbogaert, a private commission, was joined two years later by a far more public portrait in print. Now he sits (as I assume the seventy-six-year-old did at his session of April 1633) in what looks like his own study, at a table piled with books, dressed in the same garments as in the painting. The etching is provided with a four-line Latin quatrain by one of Wtenbogaert's comrades in the Remonstrant cause, Hugo Grotius (1583–1645). As the political leader of Remonstrantism, Grotius was considered a greater danger than Wtenbogaert; he was never allowed to return to the Netherlands. Nonetheless, he left a mark on his century with his writings on religious tolerance and international law. That etching joins three of the greatest Dutchmen who ever lived.

If Rembrandt came to Amsterdam with introductions to prominent Remonstrants, once there he locked into orthodox Calvinist and Mennonite circles at a high level as well. These churches were less controversial in the early seventeenth century than the Remonstrants, but in the sixteenth they underwent bloody repression and massive exile. The Calvinists and Mennonites had their own martyrs, their own tales of religious persecution far more terrible than those of the Remonstrants.

– indeed, the most important individual, alongside Amalia van Solms – he ever portrayed.[69] Johannes Wtenbogaert (also written Uyttenbogaert; 1557–1644) was the man who, after the death of Jacobus Arminius, embodied the "lenient" movement, the *rekkelijken*, within Dutch Calvinism. In 1610 he penned the Remonstrance itself, the appeal to the states of Holland to reconsider, in a synod, certain strict points of dogma in the state-sanctioned catechism and confession. The move had disastrous results. A synod came, not on the terms of the Remonstrance but on those of a Counter-Remonstrance submitted in 1611 by the orthodox opponents of Arminius. It was convened in Dordrecht in November 1618 and when it handed down its judgment in May 1619 it not only confirmed the catechism and confession but added to them five statements that spelled out the Counter-Remonstrant position in unequivocal language. Any minister who refused to swear to these points of faith was not only removed from office but expelled from the country.

Even before things got that far, Wtenbogaert's life was wrecked. When Oldenbarnevelt was arrested in

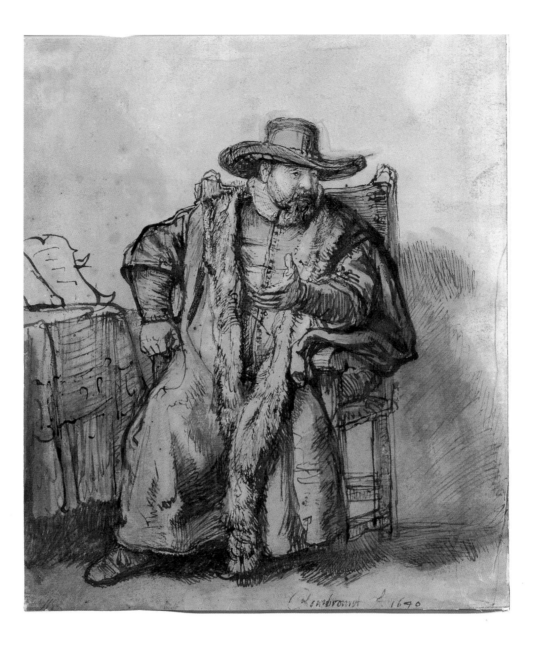

320
Rembrandt
*Cornelis Claesz. Anslo
(1592–1646), Amsterdam cloth
merchant and Mennonite
preacher*
Inscribed *Rembrandt f. 1640*
Red chalk, brown and black ink
and wash, 24.6 x 20.1 cm.
Benesch 759
Paris, Musée du Louvre,
Cabinet des Dessins

72 Only the posthumous portrait has
poems inscribed in the plate. For the
complete texts, based on translations
from the Latin by Loekie Schwartz,
see Schwartz 1985, p. 185. Of the
earlier one there are impressions
with handwritten eulogies; see
Dickey 2004, p. 240.
73 Dickey 2004, pp. 33–35, 63–65.
Dickey disagrees with my earlier
suggestion, Schwartz 1985, p. 235,
that the timing of the second
portrait print points to personal
interests on Rembrandt's part.
74 De Hoop Scheffer 1974.
75 Although that relationship did
not come into being until 1645,
Swalmius and his relatives were on
the scene in personal and profes-
sional ways for years before. Family
documents of 1655, 1657 and 1672
suggest that Rembrandt also painted
portraits of Swalmius's wife Eva
Ruardus and their daughter Helena.
Van der Veen 1997. Montias 2002,
pp. 169–70, rightly takes me to task
for not having mentioned Swalmius
in Schwartz 1985.

Although the notion of "tolerance" has been overplayed
as a unique virtue of the Dutch, it remains something
of a wonder that churches and believers who had been
killing each other so recently in religious wars and
pogroms were able to live together in peace in the
United Provinces.

Rembrandt's depictions of both Calvinist and
Mennonite churchmen seem to have come about via the
Uylenburgh connection. Saskia's father Rombout (also
called Rombertus) Uylenburgh had three brothers,
Pieter, Hendrick and Gerrit. Pieter's daughter Aeltje
was married to the orthodox Calvinist minister Jan
(also called Johannes) Cornelisz. Sylvius. (See above,
pp. 47–51.) After serving in various churches in
Friesland and Holland, he was called to Amsterdam,
where he spent the last twenty-eight years of his life,
ending up at the Grote or Oude Kerk, one of the major
parishes in the country. He maintained his position
throughout the near civil war during and after the
Twelve Years Truce, years in which not only
Remonstrant but also several Counter-Remonstrant

ministers were removed from their posts. This is
testimony enough to Sylvius's balance. It also lends
credence to the praise on Rembrandt's print, which
might otherwise sound like empty rhetoric.[72] When
Rembrandt married Saskia in 1634, he therefore
became a fairly close relative of one of the most impor-
tant preachers in the city. It was Sylvius who gave away
the bride at the marriage of Rembrandt and Saskia.

Even before the marriage, though, in 1633, the year
of his engagement to Saskia, Rembrandt brought out
an etched portrait of Sylvius (fig. 74). In 1646, eight years
after the death of the sitter, he made another one
(fig. 75).[73] What is more, two of the other three Calvinist
predikanten portrayed by Rembrandt were relatives of
Sylvius – and therefore, at a distance, of Rembrandt.
An impression of an etching dated 1637 (Bartsch 268),
showing a young man in a flat cap at a desk with books,
is inscribed "Petrus Silvius," identifying him as the then
twenty-seven-year-old son of Johannes Cornelisz.,
born in 1610 and deceased in 1653.[74] The same date is
inscribed on a copy of a lost portrait by Rembrandt of

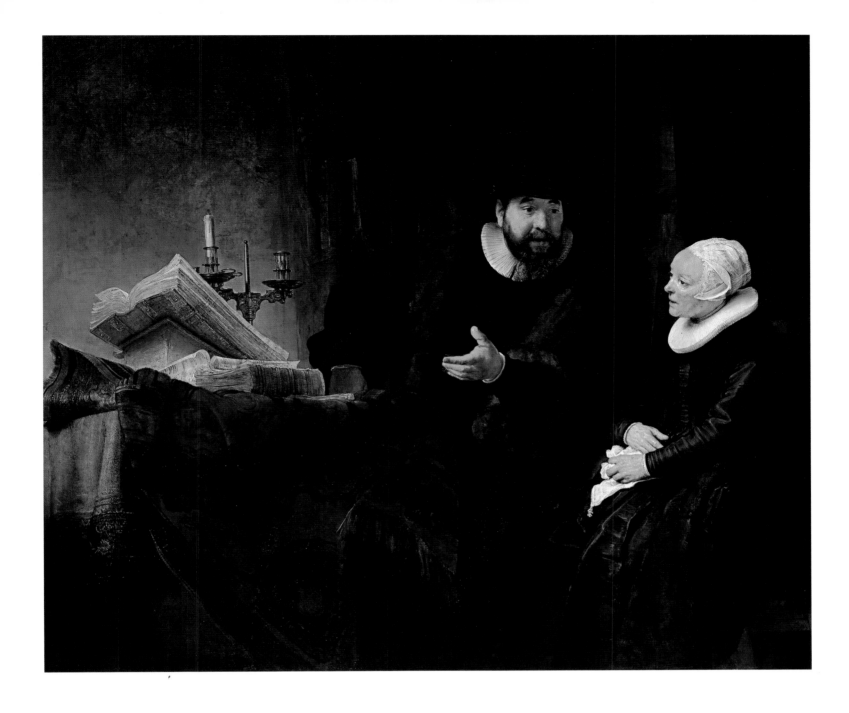

321
Rembrandt
*Cornelis Claesz. Anslo
(1592–1646), Amsterdam
Mennonite preacher and cloth
merchant, in conversation with his
wife Aeltje Gerritsdr. Schouten
(1598–1657)*
Inscribed *Rembrandt f. 1641*
Canvas, 172 x 209 cm.
Bredius 409
Berlin, Staatliche Museen,
Gemäldegalerie

76 "Ay, Rembrant, maal *Cornelis*
stem.
Het zichtbre deel is 't minst van hem:
't Onzichtbre kent men slechts door
d'ooren.
Wie *Anslo* zien wil, moet hem
hooren."
Vondel 1927–40, vol. 4, *1640–1645*,
p. 209. On Internet on the DBNL
site.
77 This aspect of the issue was
analyzed in a highly influential essay
by Jan Emmens (Emmens 1965).

the orthodox Calvinist Eleazar Swalmius (1582–1652),
whose daughter Catharina was the sister-in-law of
Petrus Sylvius.[75] Only with Johannes Elison, Calvinist
preacher of Norwich, and his wife Maria Bockenolle,
did Rembrandt have no family ties, as far as we know.

Disconcertingly, Rembrandt's posthumous portrait
of Johannes Cornelisz. Sylvius is the more lively of the
two. In 1633, Rembrandt gave his wife's distinguished
cousin by marriage a nearly disconsolate downward
gaze. His hands are folded over a handkerchief resting
on an open book. He is not even a reader, let alone
a speaker. The memorial image of 1646 shows a vital
old man reaching out of the picture space, his fingers
holding the place in three or four passages of the book
from which he is speaking.

The same conceit of the speaking portrait sitter had
earlier been employed by Rembrandt in his most
grandiose image of a divine minister. In his painting
of Cornelis Claesz. Anslo and his wife Aeltje Gerritsdr.
Schouten, Rembrandt takes on the famous challenge
of evoking the spoken word in paint. Of the painting

(or the etched single portrait of Anslo that attended this
commission, or a preparatory drawing for the painting
or etching), Joost van den Vondel wrote these often-
quoted lines, here translated as literally as possible:
Ay, Rembrandt, paint Cornelis's voice
The visible part is the least of him.
The invisible one can know only through the ears
He who wants to see Anslo has to hear him.[76]
The quatrain sets up an opposition between sight and
sound, between the outer, insignificant appearance of
the sitter and his invisible but more profound voice.[77]
That tension is certainly present in the painting, but
it would be a mistake to assume that Rembrandt was
thinking only in those terms.

As in the *Anatomy lesson of Dr. Nicolaes Tulp* and the
Night watch, Rembrandt takes on more than just the
sense of hearing. He seems to want to break completely
out of the box, to offer his sitters not only a voice but
also a third dimension through which to enter our
world and the possibility of movement in the congealed
fixedness of a painting. The voice, moreover, is not

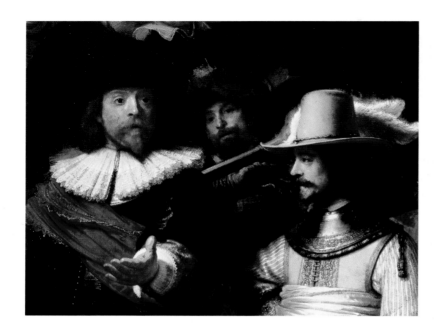

merely a sound, but also what it is saying, the heartfelt message that a professor, a leader of men, a preacher lives to convey. An inscription in the family album of Frans Banning Cocq, the caption to a drawn copy of the *Night watch*, puts words into the captain's mouth, like Vondel's poem on Anslo: "the young lord of Purmerland ... commanding his lieutenant ... to order his militia company to march."

In the *Night watch* and the Anslo–Schouten double portrait, painted in the same years, the relationship between the speaker and listener is given form in similar ways, with nearly the same angles and distances between the heads, direction and nature of the gazes, gesture of the hand. With their rapt attention, the listening figures – Lieutenant van Ruytenburgh in the *Night watch* and Aeltje Schouten in the double portrait, like the auditors in the *Tulp* – provide the medium through which we "hear" the voices of the commander and the preacher. The effect is directly related to a suggestion of movement and an illusion of space, a dissolution of the tissue of the picture plane, as the painted figures move into our world.

It was remarked above that Saskia's father had three brothers, Pieter, Hendrick and Gerrit. (Hendrick died before 1598.) Pieter's daughter Aeltje was married to the Calvinist Sylvius. Gerrit was a Mennonite, a follower of the Frisian Reformer Menno Simons (1496–1561). The Mennonites were a conservative branch of the Anabaptists, a radical sect with a subversive reputation

that, it must be said, it had earned. On this account, the Mennonites too were persecuted, and many of them fled to Poland. Gerrit's sons Hendrick and Rombout were brought up in Kraków. There they learned arts and crafts that they practiced at the court of the Polish king. In the 1620s, perhaps in the train of a Polish royal visit to the Netherlands, Hendrick moved to Amsterdam. Within a few years, he met Rembrandt, whose commissions from Mennonites such as Cornelis Claesz. Anslo are assumed to have come via Uylenburgh.

So thick was Rembrandt with the Amsterdam Mennonites that he went into Italian art history as one of them. On the basis of information provided by the Danish Rembrandt student Bernhardt Keil (1624–87), Filippo Baldinucci (1625–96) wrote in 1686 of Rembrandt in a book on the art of etching that Rembrandt "professed the religion of the Mennists, which while being false in itself, was also contrary to that of Calvin."[78] A distinguished Jewish rabbi Rembrandt met in the 1650s, Menasse ben Israel, was formerly believed to be the subject of an etched portrait of 1636. This has now been shown to be unlikely. (See below, p. 302.)

A small stream of documents from the last decade of his life shows that Rembrandt attracted the attention of Catholic as well as Reformed clergymen in his own country and abroad. Paintings by him were owned by preachers from Leiden, the Lutheran Rudolphus Hegerus (a head), and Delft, Gerrit van Heusden (a painting of St. Paul!), and by the Utrecht canon Nicolaes Meyer (portrait of an old man). His etchings were collected and praised by the French abbé Michel de Marolles. About 1664 the German Benedictine Gabriel Bucelinus called him "the wonder of our age," singling him out as the greatest living artist of his time. A Catholic choir deacon from Eindhoven, Joannes Crisostomus de Backer, owned seventy-three etchings by Rembrandt upon his death in The Hague in 1662.

The big question in all of this is whether the mutual regard for Rembrandt and the clergy of his time had religious or denominational significance. Expectations in this regard are watered down, it must be said, by the prevalence of patronage, business and family ties in the commissions. This in itself makes it less likely that doctrinal issues played a role. None of the attempts to pin down Mennonite, Remonstrant, Catholic or Jewish meanings in his portraits, in relation to commissions from believers in those faiths, has been generally accepted by the field. For myself, I am sure that when Rembrandt, a giant of Christian art, spent time with a man like Wtenbogaert or Sylvius, he did not talk about the weather.

One conclusion we can draw with certainty is that the high regard for Rembrandt in confessional circles was an essential part of his St. Paul-like destiny to become all things to all men.

Patricians

The regent class of the Republic, the men who called the shots in the cities, let Rembrandt down. He did not court them and they did not seek him out for patronage. This cost Rembrandt dearly in terms of protection and income; it cost them in terms of immortality. Today the best-known Amsterdam regent of the seventeenth century is Jan Six, only because Rembrandt painted and etched his portrait. When those works were made the man had not even served the lowliest office in city government.

On the first day of February every year, a solemn assembly took place in the town hall of Amsterdam. The four burgomasters met with all former burgomasters, the incumbent and former aldermen to choose three new burgomasters for the coming year. One of the sitting burgomasters stayed on as presiding burgomaster, the highest office in the city. This exercise in oligarchic co-optation, crowned by the installation of the new team on Candlemas Day, 2 February, was the closest thing to an election in Amsterdam between 1578 and 1795.

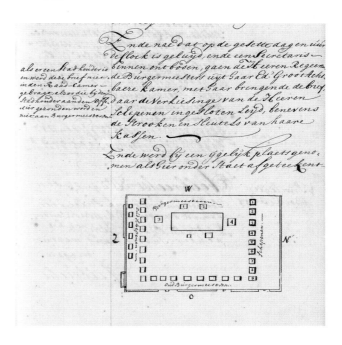

As closed as it was, this system concealed a still more hidden mechanism. Power in Amsterdam was divided between a small number of clans who monopolized the most influential positions in the town government, its banks and trading companies. The dominant force, throughout Rembrandt's years in the city, was the Bicker–de Graeff faction. This was led by Andries Bicker (1586–1652) until 1650, when he was deposed following Stadholder Willem II's aborted attack on Amsterdam. His position was taken over by Cornelis de Graeff (1599–1664). The Bickers, although they belonged to the Reformed church, had the reputation of being Arminians, the de Graeffs of being non-churchgoing libertines. Whoever wanted to make it big

78 Hofstede de Groot 1906a, doc. 360, p. 421.

Dirck Bleeker	Joachim von Sandrart	Jurriaen Ovens	Jacob van Campen	Jan Lievens	Rembrandt van Rijn	Govert Flinck
Cornelis Claesz. Moyaert		P.C. Hooft	Joost van den Vondel	Caspar Barlaeus	Jan Vos	Bartholomeus van der Helst
Jan Gerritsz. van Bronchorst	Petrus Scriverius	Alderman Roelof Bicker (brother-in-law)	Burgomaster Andries de Graeff (brother)	Burgomaster Cornelis Bicker (brother-in-law)	Constantijn Huygens	Pieter Saenredam
Daniel Stalpaert	Samuel Coster	Burgomaster Andries Bicker (brother of brothers-in-law)	Cornelis de Graeff, chief burgomaster of Amsterdam	Burgomaster Joan Huydecoper (distant cousin)	Tesselschade Roemers Visscher	Ferdinand Bol
Jacob van der Ulft	Jacob Lescaille		Burgomaster Frans Banning Cocq (brother-in-law)		Geeraerd Brandt	Cornelis van der Voort
Jan Jansz. van Bronchorst	Reinier Anslo	Jan Zoet	Jacob Westerbaen	Thomas Asselijn	Tobias van Domselaer	Jacob Backer
Cornelis Brizé	Elias Noski	Artus Quellinus	Gerard van Honthorst	Willem Strijcker	Nicolaes de Helt Stockade	Nicolaes Eliasz. Pickenoy

 Primary patron Poet client-brokers Artist client-brokers
 Power client-patrons (family) Poet clients Artist clients

Table 5
Chart of patronage relationships in Amsterdam in the years after 1650

The diagram indicates some of the patronage relationships between the chief burgomaster of Amsterdam, the family members he maintained in positions of power and the poets and artists they patronized. Rembrandt occupied a modest position as one of many recipients of occasional commissions.

327
Rembrandt
Andries de Graeff (1611–79), Amsterdam libertine patrician, future burgomaster
Inscribed *Rembrandt f. 1639*
Canvas, 200 x 125 cm.
Bredius 216
Kassel, Staatliche Museen Kassel, Gemäldegalerie Alte Meister

79 Dudok van Heel, in Middelkoop 2002, pp. 54–57.

in Amsterdam had to be on the right side of the family faction.

Rembrandt was not. As well as he was able to negotiate difficult religious terrain with clergyman patrons, he seems not to have been able to get on with people in power. Above I referred to Rembrandt's dispute with Andries de Graeff over delivery of an ordered portrait. Rembrandt won the case, but it was a Pyrrhic victory. For an artist to stand up to a proud patrician was apparently all it took to keep Rembrandt out of the running for future commissions from the clan. The painting concerned has been identified convincingly as a richly dressed man standing in the doorway of a palatial house, one glove lying mysteriously on the ground, pointing outward. Other members of the family also had themselves painted in full-length, life-size portraits in the same period. The portraits were apparently intended for an ancestors gallery in Ilpenstein Manor.[79]

Whether or not as a result of the de Graeff affair, it is a fact, as far as we know, that Rembrandt never painted any of the burgomasters or former burgomasters who sat in on those conclaves. He was able to borrow money at a bad moment from Cornelis Witsen, but there is no indication that this was a sign of favor. Witsen got his money back on preferential terms.

Future burgomasters counted only if they were obvious contenders for that post. That was true of a number of the patricians who were painted by Rembrandt, such as Andries de Graeff and Frans Banning Cocq. But neither of them, nor Joan Huydecoper, the first recorded buyer of a painting by Rembrandt and a powerful man in Amsterdam, continued to patronize him after they assumed high office. It is nearly pathetic that the one patrician who did the most for Rembrandt, Jan Six, is so often identified in captions to Rembrandt's portraits of him in drawing, etching and painting as Burgomaster Six. He did not attain that dignity until twenty-two years after the death of the artist. Six's closest tie to the office during the years when he supported Rembrandt was through his surgeon father-in-law, Nicolaes Tulp (see above, pp. 164–69), who was appointed burgomaster for the first of four terms in 1654. In 1655 Six married Tulp's daughter Margaretha. His own first, modest official appointment followed in 1656, as commissioner of marriages. A colleague of his in that post, Frederick Alewijn, owned a painting and three etchings by Rembrandt when he died. This is as likely to be an emanation of Six's enthusiasm as anything else. The closer one gets to the connections between Rembrandt's patrons, the smaller his world gets.

328
Rembrandt
*Jan Six (1618–1700), Amsterdam
Reformed rentier, poet and future
burgomaster*
Inscribed *Rembrandt f. 1647*
Etching, drypoint and burin,
24.4 x 19.1 cm.
Bartsch 285 iv(4)
Haarlem, Teylers Museum

80 Van de Waal 1952, vol. 1,
pp. 233, 237.
81 Van Maarseveen 1998.
82 Van Maarseveen 1998, p. 9.

In all, the regent class and Rembrandt did not match up. More paintings and etchings by him are recorded in the palaces of kings and emperors than of burgomasters or aldermen of his own country. The burgomaster of Leiden wrote a capsule biography of him, that of Arnhem noted his existence in his notebook, two Utrecht patricians owned paintings by him, an Amsterdam councilman praised him in the text of a play that he translated from the Spanish. Among the possible reasons for this failed relationship, the one that is most favored is that Rembrandt's art did not match the taste of the regents. Henri van de Waal wrote of the deep "opposition between Rembrandt's feeling for beauty and that of the surrounding society. . . . How poor were the chances of reconciling the Renaissance cult of the hero with [Rembrandt's] credo as an artist." Writing of the removal of the *Claudius Civilis*, he wrote that it was simply impossible for the burgomasters to

accept it.[80] As we see in the case of the de Graeff conflict twenty-three years before, concerning a painting that answers to all the demands of heroic portraiture, it did not take a divergent sense of beauty to disturb the relations between Rembrandt and the regents. Moreover, no reconciliation seems to have been necessary between the feeling for beauty of Rembrandt and the clergy of his time. If they continued to praise and patronize the artist, why should the regents not have done so? The main reason, I believe, lies in Rembrandt's contentiousness, which got him into trouble with people like Andries de Graeff.

Be that as it may, it was not the regent class of the Republic that launched Rembrandt's career. The only town patrician whose interest in him matched that of Constantijn Huygens was Jan Six. But that was more in his capacity as a writer than a regent.

Military men

In the course of the twentieth century, Dutch history, which used to be centered on the Revolt against Spain, metamorphosed into a demilitarized glorification of the Golden Age. In the study of Rembrandt, this led to a more civilian interpretation of the *Night watch* than previously. It also complicates the task of understanding why Rembrandt painted and etched himself in arms in so many self-portraits of the years around 1630. The meaning of this fascinating phenomenon still evades us.

In 1998 celebrations were held all over Europe to commemorate the 350th anniversary of the Treaty of Münster, ending the Eighty Years War between the Netherlands and Spain and the Thirty Years War that raged within Germany. The challenge of mounting exhibitions in the Netherlands on the end of the Revolt sent art historians off on a search for war-related art. One such exhibition was held in the Prinsenhof Museum in Delft, under the title *Images of a war.*[81] What the organizers found as they went about their work was rather astonishing. On the one hand an

unexpected wealth of material: coins and medals, maps and prints, drawings and paintings. On the other hand, in trying to research the significance of these images, they came across a scholarly vacuum or even what pop psychology calls "denial." The Delft catalogue quotes a statement by the great Dutch historian Johan Huizinga to the effect that the painting of warfare by its nature contained "less beauty and less truth than a Dutch painter deserved."[82] This attitude, which did not originate or end with Huizinga, has been responsible for the marginalization of war-related art in Holland.

Within Rembrandt studies it is too easily forgotten that the master's premier painting, the *Night watch*, was a military portrait. The guardsmen in the painting may have been burghers of Amsterdam, but they were also under oath to serve the state in the field. In The Hague as well, Rembrandt's one known portrait of a burgher showed the man, a wine merchant, in his military function.

Otherwise, it must be admitted that Rembrandt did not seek out commissions from or depict on his own initiative the great officers of the States army in The Hague or the sea heroes of Amsterdam and Rotterdam, as did so many of his colleagues and pupils. Nor did he depict battle scenes, even as the subject of Biblical or

329
Rembrandt
Joris de Caullery (ca. 1600–61), Hague wine merchant and civic guardsman
Unsigned, undated. Ca. 1632
Canvas, 101 x 82.5 cm.
Bredius 170
San Francisco, Fine Arts Museums of San Francisco, Roscoe and Margaret Oakes Collection

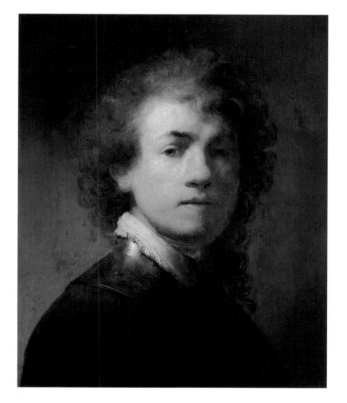

330
Rembrandt
Self-portrait with gorget
Inscribed *RHL f.*
Undated. Ca. 1629
Panel, 38.2 x 31 cm.
Not in Bredius
Nürnberg, Germanisches Nationalmuseum

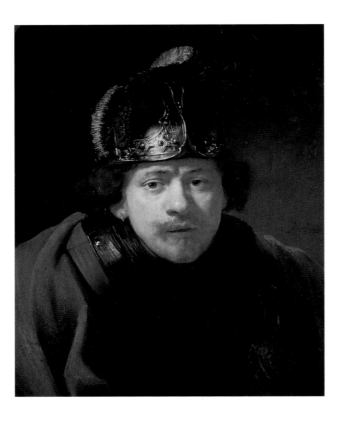

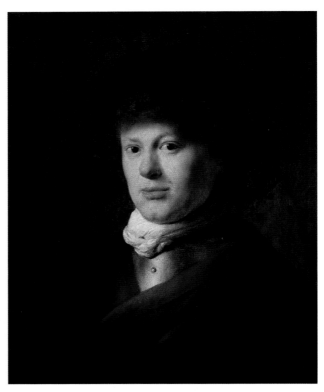

331
Rembrandt or artist close
to him
Detail of *Portrait of Rembrandt
with gorget and helmet*
(fig. 273)
Kassel, Staatliche Museen
Kassel, Gemäldegalerie Alte
Meister

332
Jan Lievens (1607–74)
Rembrandt van Rijn with gorget
Unsigned, undated. Ca. 1629
Panel, 57 x 44 cm.
Amsterdam, Rijksmuseum (on
loan from Els Cevat, Guernsey)

ancient stories. Remarkably, the soldierly figure that
recurs most frequently in Rembrandt's work is
Rembrandt himself, who as far as we know never bore
arms. Even more remarkably, Rembrandt in armor is
found not only in his own pictures of himself but in a
portrait of Rembrandt by Jan Lievens.

In the years around 1630, the years when he was in
and out of The Hague, where the headquarters of the
States army was located, Rembrandt created a good
number of painted and etched self-portraits with
swords, gorgets and helmets. These are troublesome
images that do not lend themselves to ready explana-
tion. Mere identification of the artist with army officers
he saw at court does not cover the case. In some
Rembrandt bears standard weapons that any guards-
man might own, but in others he is decked out with
exotic or antique arms or garb. One etching, formerly
known as *Self-portrait with raised saber*, has now been
renamed *"Self-portrait" as an Oriental potentate with a
kris*.[83] Compared with the former name, this entails a
factual correction (kris for saber), an expression of
doubt on the nature of the representation ("self-
portrait" for self-portrait) and a wildly speculative leap
into the unknown (Oriental potentate). This case is typ-
ical of the fortunes of an entire range of paintings and
etchings in the mutually contradictory writings of
dozens of art historians.

In volume 4 of the *Corpus of Rembrandt paintings*,
these images are no longer called self-portraits. That
term is reserved for more conventionally portraitlike
pictures. This is sensible in itself, but it does not tell
us why Rembrandt and others cast him in military

guise in this period. The literary historian Harry
Berger, Jr. has worried the question vigorously, along
with other questions pertaining to the guises of
Rembrandt and his sitters, in an extraordinary book
entitled *Fictions of the pose: Rembrandt against the Italian
Renaissance*. Diving deeply into the impenetrable thick-
et of Rembrandt scholarship, Berger pits one opinion
against a second and a third, revealing in the process
the inadequacy of existing interpretative strategies.
("Strategy" is however an unmerited compliment for
the mixture of approaches that art historians tend to
use. "Preconceived notions" and "opportunistic tactics"
are more like it.) Berger's solution is an honest non-
solution. His words concerning another of Rembrandt's
fictional poses, that of the Venetian patriarch, are
appropriate here as well: "It is the work of those devices
to disrupt the stability of the image."[84]

The instability is not only in the images. It is also in
their makers and in us. Faced with another Rembrandt
quandary, we ourselves turn out to be part of the prob-
lem. If any support is forthcoming from Rembrandt
himself, it may be in the form of the only true self-por-
trait in which he took on the guise of another. Thirty
years later there came into being the *Self-portrait as
St. Paul* that is the guiding image of this book. Around
1630 Rembrandt took the sword of the saint in hand,
but not yet the book.

83 White and Buvelot 1999, p. 156,
no. 41.
84 Berger 2000, p. 495.

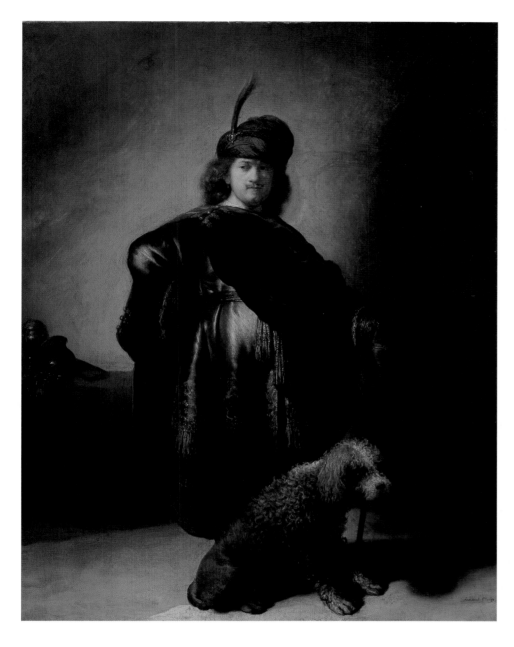

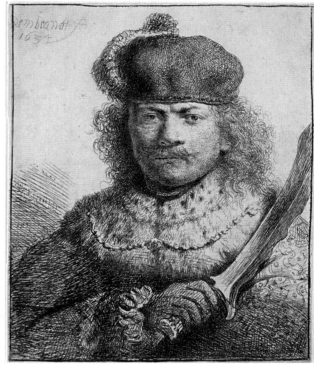

333
Rembrandt
Self-portrait with poodle
Unsigned, undated. Ca. 1631
Panel, 81 x 54 cm.
Bredius 16
Paris, Musée du Petit Palais,
Musée des Beaux-Arts de la
Ville de Paris

334
Rembrandt
Self-portrait with raised kris
Inscribed *Rembrandt f. 1634*
Etching, with some burin,
12.4 x 10.8 cm.
Bartsch 18 ii(2)
Haarlem, Teylers Museum

85 Van Eeghen 1969d, pp. 202–03.
Dickey 2004, pp. 48–53.
86 Schama 1987.

Merchants, manufacturers, tradesmen and professionals

Rembrandt was born into the upper middle class of Holland and lived his life within its wide confines. The members of this class were his most reliable patrons as portrait sitters and buyers of his work. At every phase of his career he created images of himself that match, in mode and allure, portraits of his merchant sitters, even the mightiest of them. The portraits do not show the business activities or commercial interests of the sitters. They project a complimentary image comparable to the literary picture of the Wise Merchant, the term applied by Caspar Barlaeus to the burghers of Amsterdam.

Cornelis Claesz. Anslo was a man of the cloth in more ways than one. He was a clergyman in the sense that he preached to his congregation of Waterland Mennonites. That was however not a paying occupation among the Mennonites, who chose their preachers for their spiritual, oratorical and pastoral gifts from among lay members of the community. One had to have a handsome income to accept the honor. Anslo derived his from the family business, the trade in cloth. Anslo took the combination of functions so seriously that he sacrificed a small fortune – sixty thousand guilders lost by his son Gerbrant in Danzig in a deal that went bad – to maintain his self-respect as a preacher. In words put into his mouth by his great-grandson, "No! I will not have it (although I am not obliged to pay) that my teaching be turned fruitless against me or that it lose its strength."[85]

Anslo's behavior is illustrative of what Simon Schama called the embarrassment of riches in the Dutch Republic.[86] The preacher in Anslo was fearful of being contaminated with the ill repute that a merchant was always risking. The very word merchant – *koopman* – has overtones and undertones. Pillars of society, to be sure, creators of the age of mercantilism and the welfare for which it stands. The inaugural lecture of the new institution for higher learning in

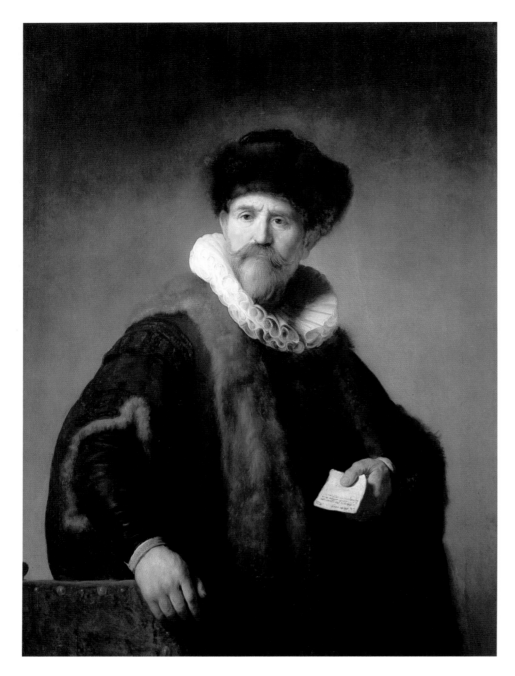

Amsterdam, delivered in 1632 by Caspar Barlaeus, was called "Mercator sapiens," the wise merchant. To be a burgher-oligarch or merchant-adventurer was the condition to which every red-blooded middle-class Dutchman aspired. The merchant was a shining example even for those above him. By the middle of the seventeenth century complaints were being voiced that the regents who governed the cities "were no longer merchants nor actively engaged in overseas trade, 'but derived their income from houses, lands, and money at interest.' In other words, the merchants had become *rentiers*."[87] The merchant was the hero who brought in wealth with hands-on business activities; the *rentier* has something of the parasite about him.

The *koopman* is however also the man who commodifies everything he touches. The merchant is associated with mercenariness; since at least 1669 the Dutch word *marchanderen* has meant shameless bargaining.[88] Dutch merchants did not all have a good name. Stadholder Frederik Hendrik was filled with hatred for the "boorish" Amsterdam merchants who not only traded with the enemy, but sold shiploads of gunpowder to the Spanish while conflict was raging.[89] They were hard at work gaining the reputation for soulless greed that Anslo was paying good money to avoid.

Be that as it may, there was no way for an artist in the Dutch Republic to avoid doing business with merchants and the rest of the upper middle class of which they were the chief representatives. No matter what the specialty of an artist, the main interest for his or her kind of product came from this part of society. Among the individuals documented as owners of work by Rembrandt in his lifetime, the largest single group, about thirty-five, were merchants, while fifteen were tradesmen and about twenty professionals, notaries, advocates or physicians. Government and court officials, in the same earning category, account for another twenty owners of works by the artist.[90]

If Barlaeus came from Leiden to credit the merchants of Amsterdam with wisdom, Rembrandt arrived at the same time to give them good looks. Rembrandt endowed them and their wives with a guise far removed from the crassness of which they were often accused, even, elevating them above their actual occupations. This begins with Rembrandt's first Amsterdam portrait. Knowing as we do that Nicolaes Ruts was in the Russia trade, it is often said that the fur of his cloak is a reference to his livelihood. However, the garment is the same kind of *tabbaard* worn by Rembrandt's clergymen. The only seeming reference to Ruts's profession in the portrait is the note in his hand, a discreet and general attribute that can just as well be given to a diplomat or statesman as a merchant or tradesman.[91] Not the mercantile side of Ruts's existence is the underlying subject of this portrait, but his contained yet vital demeanor. The bearing of the sitter in portraits such as this, it has been argued, expresses a form of Christian stoicism. These thriving Dutchmen are in and of the world, but they do not surrender to its temptations or succumb to

335
Rembrandt
*Nicolaes Ruts (1586–1649),
Amsterdam merchant in the
Russian trade, born Mennonite
and converted to Calvinism*
Inscribed *RHL (unclear) 1631*
Panel, 115 x 85.5 cm.
Bredius 145
New York, The Frick Collection

336
Rembrandt
Self-portrait
Inscribed *Rembrandt.f 1634*
Panel, 70.8 x 55.2 cm.
Not in Bredius
Las Vegas, The Wynn
Collection

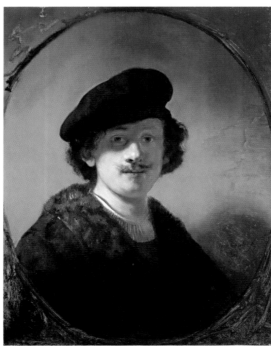

337
Rembrandt
Detail of *Amalia van Solms*
(fig. 253)
Paris, Musée Jacquemart-André

338
Rembrandt
Detail of *Oopjen Coppit*
(fig. 340)
Paris, Rothschild collection

87 Boxer 1965, p. 31.
88 *Van Dale groot woordenboek van de Nederlandse taal*, 14th edition, 2005. In French the word *marchander* had that meaning since 1502.
89 Wagenaar 1760–, vol. 1, pp. 535–39.
90 This count accepts at face value any and all attributions of a work to Rembrandt in a document. Needless to say, some of these attributions – we do not know which – will have been inaccurate. My assumption is that the general picture of the early ownership of Rembrandts remains valid.
91 The most explicit reference to money in a Rembrandt portrait is the moneybag in the portrait of Jean Pellicorne and his son in the Wallace Collection. The attribute is however put into the hands of the son, becoming less a symbol of profit than of the family fortune. Still, this is a great exception in Rembrandt's portraiture, if the painting is indeed by Rembrandt, as the Rembrandt Research Project doubts.
92 Adams 1997.
93 Groeneweg 1995, p. 236, who draws the comparison between the two paintings. She writes that Oopjen Coppit's lace collar was of an even newer make than that of Amalia.
94 Van Hoogstraten 1678, p. 45.
95 Van Deursen, in Brown et al. 1991, vol. 1, pp. 41–49, writes of "Rembrandt and his age: the life of an Amsterdam burgher." His view of Rembrandt's life and problems is considerably more anodyne than mine.
96 Schwartz 1985, pp. 193–94.
97 Doc. 1667/1. Sluijter 2001, pp. 116–27.

passion and emotion. Their steadfastness arms them against the uncertainty of fortune, their faith in Christ assures them of a righteous death.[92]

What was good enough for the sitters was good enough for the artist. In a number of self-portraits of the early Amsterdam period Rembrandt poses and dresses himself in the same dignified, somewhat distanced air. Like most of his sitters, he shows no attributes of his occupation.

Not only were Rembrandt's merchants distinguished, they were also fashionable. Frederik Hendrik might have called the Amsterdamers boors, but Rembrandt knew better. Fresh from The Hague, where he painted no less a personage than Amalia van Solms, Rembrandt found young matrons who were as up to date as the princess. One of the above details, both of which show women wearing the same new style of starched white lace, with a diamond brooch hanging from a pearl choker and a rosette on a high-waisted sash over a black dress, is the princess of Orange and the other a *haute bourgeoise* of Amsterdam. Rembrandt cannot be credited with having brought this style from The Hague to Amsterdam. The sitters did it themselves, following advice that was put into words later in the century in a civility handbook: "To find out how to dress, … one should 'return to the source of fashion – the court.'"[93]

Artists did the same. Like his Flemish contemporary Anthony van Dyck (1599–1641) and Dutch colleagues like Thomas de Keyser (1596–1667), among many others, Rembrandt mined the repertoire of aristocratic Italian portraiture of the sixteenth century for his bourgeois sitters. In keeping with the ideals he found there, Rembrandt lent his sitters a flattering air of dignity and a non-pretty handsomeness. It is often said that Rembrandt was unsparing in his depiction of his sitters, valuing truth above discretion. "Warts and all" is the code name for this approach to portraiture. While Rembrandt may have allowed a wart or two into his non-portraits or in the famous nudes-with-garter-marks, in his commissioned portraits he took the oppo-

site tack and showed himself to be not above the usual kind of flattery. The advice offered by Samuel van Hoogstraten to the portrait painter he might have heard from his master: "few will be offended by a bit of enhancement – especially not the ladies."[94] Indeed, if we are to believe Rembrandt, none of his sitters had a wart at all; few even had bags under the eyes, let alone a visible disfigurement.

The upper middle class is the class into which Rembrandt was born and in whose wide confines he lived his life. That was not a source of embarrassment, and in most respects Rembrandt behaved like a typical member of his class.[95] In two documents he identified himself as a *koopman* (see above, p. 123). In that capacity, he was not as conscience-ridden as Anslo. Far from going out of his way to avoid damage to his reputation, he trod a none too fine line at the edge of business and financial respectability.[96]

Networking was a way of life in Rembrandt's Europe, and membership in the Dutch upper middle class brought opportunities that no one could afford not to pursue. The documentation of Rembrandt's paintings includes a good many owners from the artist's social environment. The pattern was established in Leiden, where works by Rembrandt were owned by a physician, a notary and a merchant. The merchant of the group has recently been singled out as a distinguished case study in the history of collecting. Hendrick Bugge van Ring (d. 1669), from a family of Delft brewers, became a Leiden brewer in 1638 when he married Aeltgen Hendricxdr. van Swieten of Rembrandt's home town.[97] This brought him quite close to the van Rijn family business. Their mill, which in 1638 was still being run by Rembrandt's brother Adriaen, processed malt for the brewers of Leiden. Bugge was quite a wealthy man, with impressive holdings in real estate and personal belongings, among them an art collection. He and his wife were Catholics; their house included a private chapel in the attic, fitted out for celebrations of the Mass by visiting priests. The inventory of his goods, drawn up in 1667 preceding his second marriage after

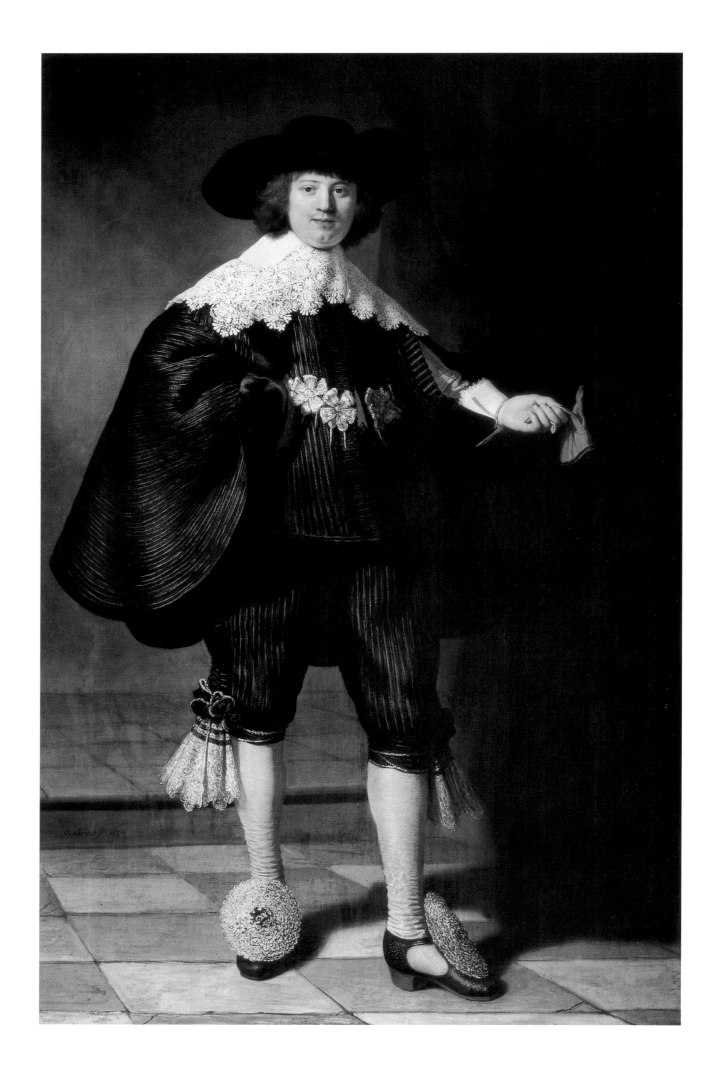

339
Rembrandt
Marten Soolmans (1613–41)
Inscribed *Rembrandt f. 1634*
Canvas, 210 x 134.5 cm.
Bredius 199
Paris, Rothschild collection

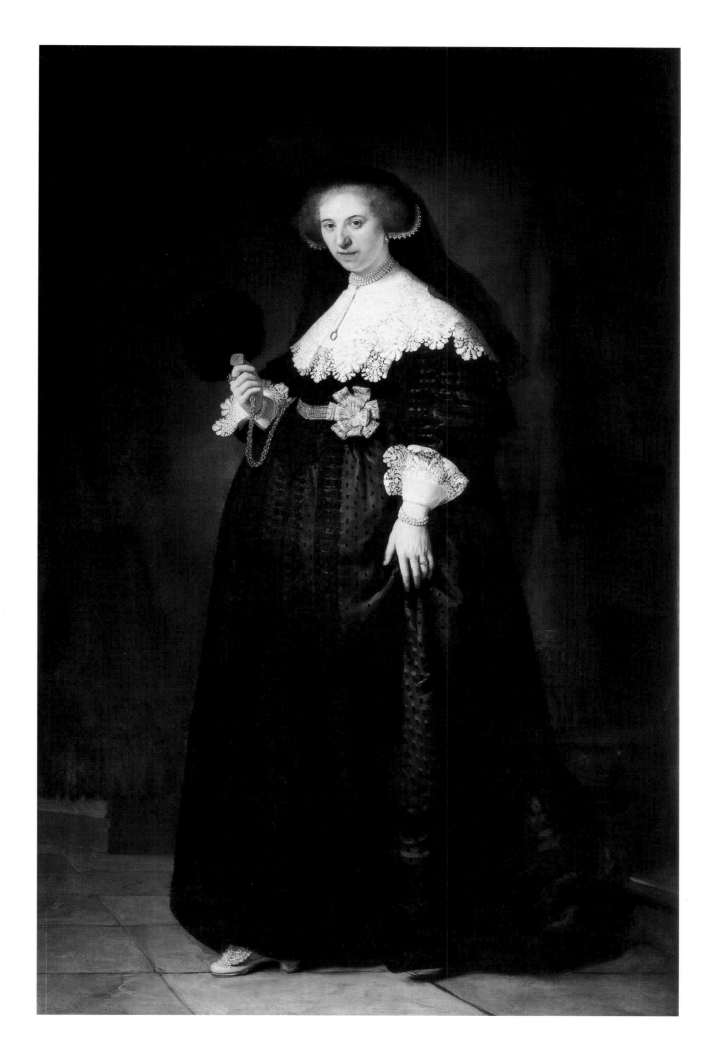

340
Rembrandt
Oopjen Coppit (1611–89),
wife of Marten Soolmans
Unsigned, undated. Ca. 1634
Canvas, 209.5 x 134 cm.
Bredius 342
Paris, Rothschild collection

the death of Aeltgen in 1666, lists no fewer than 237 paintings, including "nineteen religious paintings [in the chapel] that apparently had a devotional function."[98] No such dignified function was reserved for Bugge's single "piece by Rembrant, being a doctor with his books," which hung in a summer house outside Leiden.

Bugge's background in Delft is not uninteresting for the reconstruction of the artist's impact on his contemporaries. More collectors in Delft than anywhere else in the Netherlands outside Amsterdam and Leiden are recorded as owners of work by Rembrandt. Aside from a few merchants, there were also a Delft tax collector, preacher and artist, serious art collectors all. Financial interests of the van Rijns in Delft may have had something to do with this. In 1640 the estate of Rembrandt's mother included the income from a loan to a certain "Van der Burch, brewer of 'The Bell' in Delft."[99] The uncovering of such connections reinforces the notion that the Dutch art market was less anonymous and impersonal than it is often considered.[100]

Another example of mixed family and professional ties among Rembrandt's Amsterdam patrons came to light recently. In 1659 "Adriaen Banck, approximately 46 years old, merchant in this city, declared … that in the year 1647 he the attestant bought from Rembrandt van

Rijn … a painting of Susanna, for which he the attestant paid him the sum of five hundred guilders …" This document has been known since 1885.[101] In 2002 Michael Montias published information revealing that in 1645 Adriaen Banck's sister-in-law became related by marriage to the Sylvius family, who were very close to Rembrandt and Saskia (see above, p. 50). Moreover, Banck's line of trade was canvas.[102] Perhaps he was Rembrandt's supplier. It becomes hard to escape the impression that the contacts that led to Banck's purchase from Rembrandt of a *Susanna* were rather personal.

These observations go to show not only that Rembrandt's world was smaller than one might think, but also that he was by no means repudiated by the society of his time. The documentary references to merchants, manufacturers, tradesmen and professionals as Rembrandt owners do not decline in the artist's later years, when according to popular legend and even to many art historians society was turning its back to him. A brief review of Rembrandt's portraits of members of his own class shows that this notion is without substance.

The life-size, full-length standing portraits of Marten Soolmans and Oopjen Coppit and the double portraits

341
Rembrandt
Jan Rijcksen (1560/61–1637), Amsterdam Catholic shipbuilder, and his wife Griet Jans (ca. 1560–after 1653)
Inscribed *Rembrandt f. 1633*
Canvas, 111 x 166 cm.
Bredius 408
The Royal Collection,
Her Majesty Queen Elizabeth II

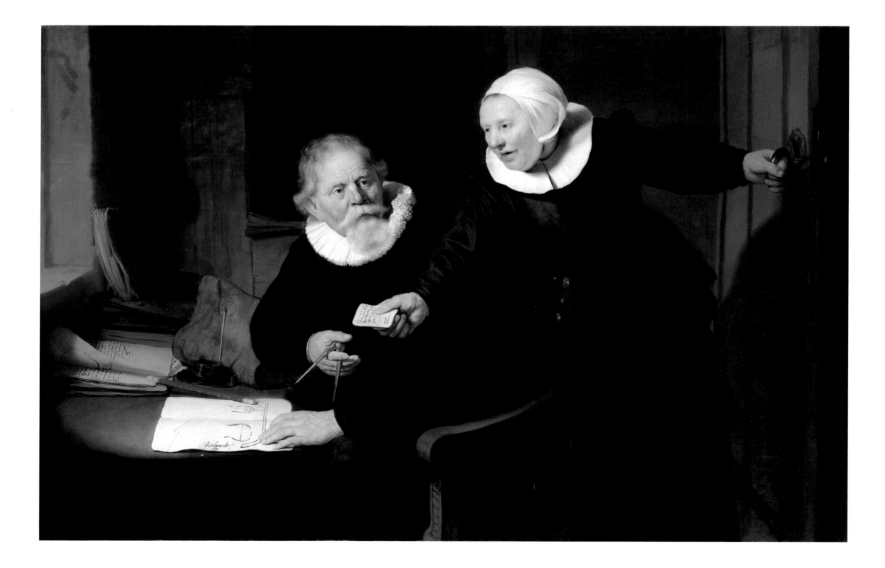

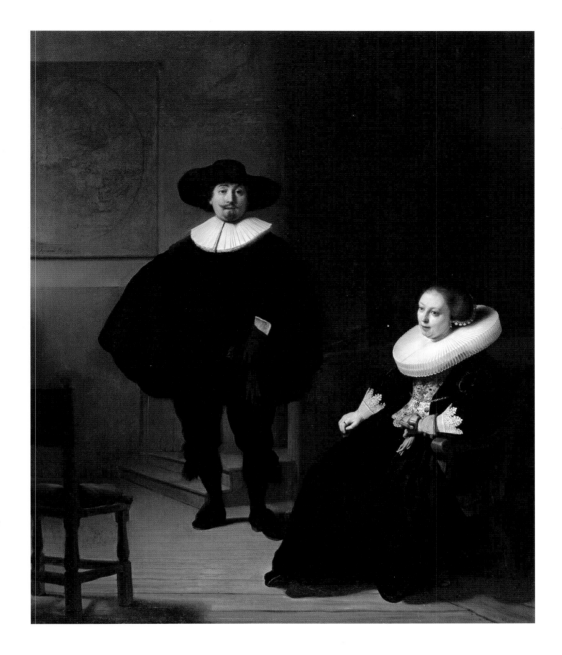

342
Rembrandt
*Jan Pietersz. Bruyningh
(1599–1646), Amsterdam
Mennonite cloth merchant and
art collector, and his wife
Hillegont Pietersdr. Moutmaker
(1599–1640)*
Inscribed *Rembrandt f. 1633*
Canvas, 131 x 107 cm.
Bredius 405
Property of Isabella Stewart
Gardner Museum, Boston
(stolen in 1990)

98 Sluijter 2001, p. 119.
99 Doc. 1640/9. The archive of the
van der Burch family from 1520 to
1873 is deposited in the Regionaal
Historisch Centrum Delft under
no. 466. See http://thema.delft.nl/
archief/inventaris/pdf/0466.pdf,
for promising leads to tracing
the Delft end of this loan.
100 In a fascinating book on today's
market for contemporary art, Olav
Velthuis found a strikingly similar
pattern of "familial or friendly
ties [An] anonymous customer
who enters a gallery and wants
to buy a work of art on the spot
– the type of transaction assumed in
economic theory – is the exception
rather than the rule." Velthuis 2005,
p. 76.
101 Doc. 1659/17.
102 Montias 2002, pp. 166–67.
103 Doc. 1659/18.

of Jan Rijcksen and Griet Jans and of Jan Pietersz. Bruyningh and Hillegont Pietersdr. Moutmaker are exceptionally large and elaborate for Rembrandt. The prices and terms are unknown, but from other documents we know how much they will have cost. The two standing portraits fall into the category of the portrait of Andries de Graeff, for which Rembrandt charged five hundred guilders. This was about as much as a skilled worker or a minister in the Reformed church earned in a year. Marten and Oopjen not only ordered two paintings of this format, they also bought other work by Rembrandt, including a *Holy Family*. Since the *Holy Family* in Munich is dated the same year as the portraits, 1634, it seems likely that this was the painting they owned. All three paintings breathe an air of luxury and copiousness in scale and in detailing. This certainly accords with the way Marten and Oopjen present themselves in dress and environment. The marble floor on which they stand, as familiar as it seems, was in fact not very common in Dutch interiors. It is the only floor of the kind in a Rembrandt portrait; otherwise, if a floor is

visible at all, it is made, more accurately, of wooden planks.

In a document of 1659 regarding a double portrait of his wife and himself, Abraham Wilmerdonx, a director of the Dutch West India Company, attested that around 1642 he paid Rembrandt five hundred guilders for the portrait and sixty for the canvas and frame.[103] This will have been the cost of the Rijcksen and Bruyningh portraits; Anslo and his wife, which is more than twice the size of those paintings and richer in detail, will have cost more.

Most of Rembrandt's portraits are smaller, simpler and cheaper. Good examples of his normal run of work are the three pairs of portraits here illustrated, made between 1634 and 1641 (figs. 343–48). There is no documentation concerning the price for portraits of this size; the only appraisal during the artist's lifetime of an identified work concerns the larger painting of Johannes Wtenbogaert, of 1633. In 1664, after the death of the man who commissioned it, a "portrait of Uijtenbogaert" hanging in the "best

343
Rembrandt
Dirck Jansz. Pesser (1587–1651),
Rotterdam Remonstrant brewer
Inscribed *Rembrandt ft 1634*
Panel, 67 x 52 cm.
Bredius 194
Los Angeles, Los Angeles
County Museum of Art,
Frances and Armand Hammer
Purchase Fund

344
Rembrandt
Haesje Jacobsdr. van Cleyburg
(1583–1641), wife of Dirck Jansz.
Pesser
Inscribed *Rembrandt f. 163*[4]
Panel, 68 x 53 cm.
Bredius 354
Amsterdam, Rijksmuseum

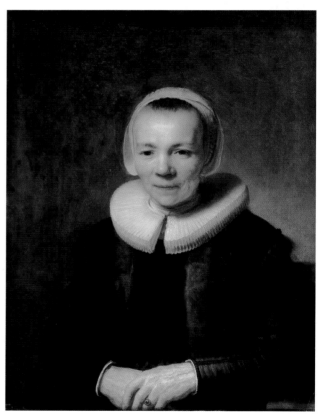

345
Rembrandt
Herman Doomer (1595–1650),
Amsterdam frame maker
Inscribed *Rembrandt f. 1640*
Panel, 74 x 53 cm.
Bredius 217
New York, Metropolitan
Museum of Art

346
Rembrandt
Baertjen Martens (1596–1678),
wife of Herman Doomer
Inscribed *Rembrandt f .*
Undated. Ca. 1640
Panel, 76 x 56 cm.
Bredius 357
St. Petersburg, State Hermitage
Museum

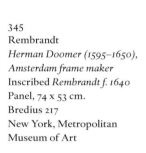

104 Bruyn et al. 1982–, vol. 2 (1986),
pp. 558–570, nos. A102–03.
105 An armorial stamp on the back
of the woman's portrait belongs to
the husband of Dirck Pesser's grand-
daughter, and Pesser's age in 1634
was forty-seven, corresponding
with the age inscribed on the man's

room" of his house and assumed to be the painting
now in the Rijksmuseum, was appraised at forty
guilders.

The six smaller portraits illustrated here exemplify
a number of complex issues in Rembrandt studies.
To begin with, the six paintings are in six different
collections and in six different states of preservation,

color and brightness. As a result, paintings that were
made to be displayed together, showing a husband left
(heraldic right or dexter) and wife right (heraldic left,
sinister), are seen that way only at special exhibitions.
And even when seen or reproduced next to each other,
they no longer match the way they should. The variant
care and conservation practiced by different owners can

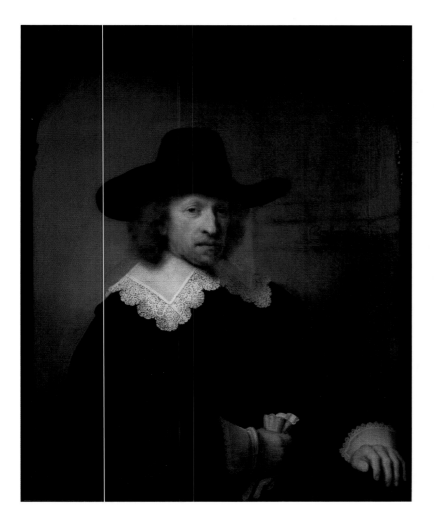

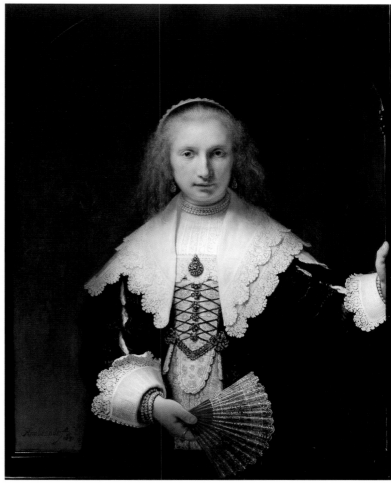

347
Rembrandt
*Nicolaes van Bambeeck
(1596–1661), Amsterdam
Reformed merchant*
Inscribed *Rembrandt f. 1641.
AE[tatis] 44*
Canvas, 105.5 x 84 cm.
Bredius 218
Brussels, Musées Royaux
des Beaux-Arts de Belgique

348
Rembrandt
*Agatha Bas (1611–58), wife of
Nicolaes van Bambeeck*
Inscribed *Rembrandt f. 1641.
AE[tatis] 29*
Canvas, 104.5 x 85 cm.
Bredius 360
The Royal Collection, Her
Majesty Queen Elizabeth II

portrait. However, I must say that
an undisputed drawing of Pesser
illustrated in Bruyn et al. 1982–,
vol. 2 (1986), p. 563, looks nothing
like the sitter for the painting.
106 Dudok van Heel 1986.

rob paintings of their visual togetherness. In general, one can hold the art trade responsible for splitting up pendant pairs. Private owners almost always keep them together.

The formats of the three pairs of portraits range from head-and-shoulders to head, shoulder and hands to half-length plus. The choice between these formats would have been made by the sitter, presumably based on a price quotation by the artist. One would assume that there would also be a difference in price between a portrait with only face, hat and collar and one with a fancy fan and elaborate cuffs, like those of Agatha Bas.

The head-and-shoulders pendants in figs. 343–44, dated 1634, were painted on wooden panels, presumably ovals, that at some point were transformed to a twelve-sided panel and then, through the addition of sixteen small blocks of wood, to rectangles. The early nineteenth century, and once again the art trade, is given the blame for this dangerous and disfiguring operation.[104] On a somewhat thin basis of evidence, the sitters have been identified as a staunchly Remonstrant Rotterdam couple, Dirck Jansz. Pesser and Haesje Jacobsdr. van Cleyburg.[105] This fits into Rembrandt's biography well enough and even into his family history. His Remonstrant kinsman Hendrik Swaerdecroon became rector of the Latin school in Rotterdam in 1634, which would make for a neat if unprovable tie-in.

The heads-and-hands couple (figs. 345–46) are likely to have been professional relations of Rembrandt. Herman Doomer, an immigrant from Germany, was a frame maker who might have been Rembrandt's supplier. His son, the artist Lambert Doomer (1624–1700), stood in a definite but indeterminate relation to Rembrandt. Herman and his wife Baertjen Martens were terribly proud of their portraits by the great master. In Baertjen's will of 1662, she left the originals to Lambert on condition "that he provide each of his brothers and sisters with a copy, at his own expense," and that upon their deaths the copies be returned in order to be presented to the grandchildren. The family lived so intensely with these images of their forebears that Lambert actually made one pair of the copies not as paintings but as reliefs or sculptures, which unfortunately have been lost.[106]

In the case of Nicolaes van Bambeeck too a personal relationship with Rembrandt is more likely than not. This wealthy merchant came from Leiden; by 1631 he had moved to Amsterdam and was living in the Sint Antoniesbreestraat. Van Bambeeck was moreover an investor in the business of Hendrick Uylenburgh, multiplying the odds in favor of a close acquaintance with Rembrandt. The identification of the sitters dates from 1958, when Isabella van Eeghen found that the inscribed ages of the sitters matched those of Nicolaes and Agatha and that her features match those of a girl

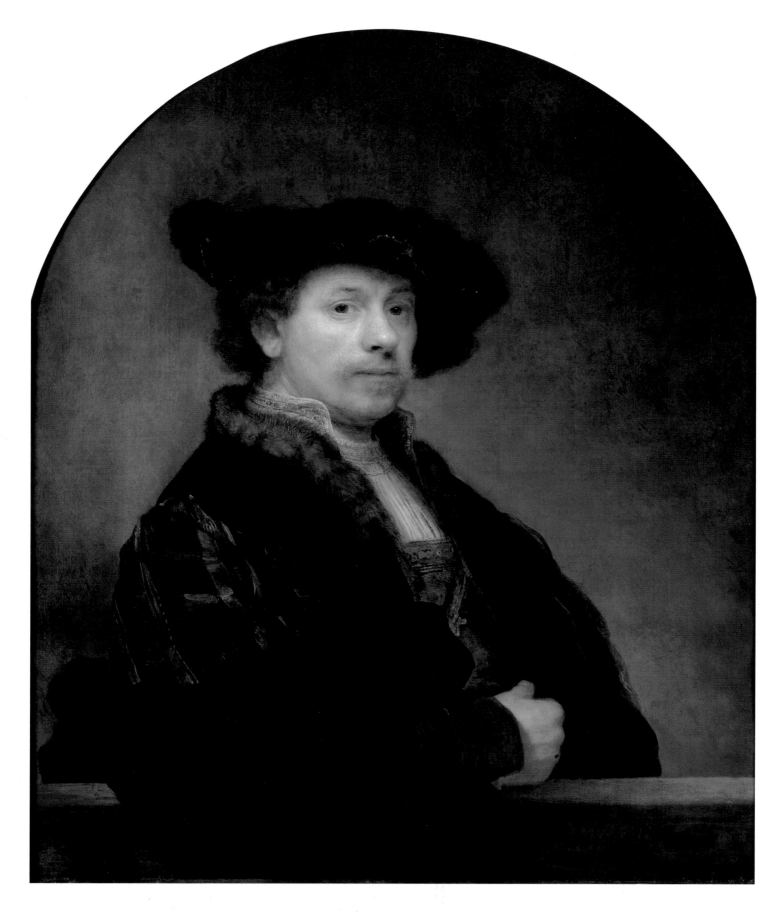

349
Rembrandt, *Self-portrait*
Inscribed *Rembrandt f. 1640*
Canvas, 102 x 80 cm.
Bredius 34
London, National Gallery

350
Rembrandt
Nicolaes Bruyningh
(1629/30–1680)
Inscribed *Rembrandt f. 1652*
Canvas, 107.5 x 91.5 cm.
Bredius 268
Kassel, Staatliche Museen
Kassel, Gemäldegalerie Alte
Meister

351
Rembrandt
Catharina Hooghsaet (1607–85),
Amsterdam Mennonite
Inscribed *Catrina Hoog/Saet.*
Out 50/Jaer Rembrandt f. 1657
Canvas, 126 x 98 cm.
Bredius 391
Collection Penrhyn Castle

352
Ferdinand Bol (1616–80)
Portrait of a man in a fur-lined
velvet cloak and a beret
Unsigned, undated. Ca. 1645
Canvas, 87.5 x 72.5 cm.
Blankert 143, Sumowski 1
Munich, Alte Pinakothek

107 Van Eeghen 1958.

on an earlier portrait of the Bas family.[107] The canvases
of the two paintings may have been trimmed at the top.
This pair of paintings has considerably more allure than
the other two. The figures hold onto the architecture
of their arched frames, enhancing the illusion of real
presence. Rembrandt lends Nicolaes a courtly pose he
himself had assumed a year before, in his most assertive
self-portrait, coming at us with a thrust of what
Joaneath Spicer brilliantly called the Renaissance
elbow. This was one of Rembrandt's more catching and
influential examples. It was quickly adapted by follow-
ers like Ferdinand Bol for portraits that in turn were
copied and revised. (The example in Munich is a bit less
elbowy than Rembrandt's.)

While his portrait commissions from the regent class,
as we have seen, evaporated into thin air after 1640,
this was not the case with merchants, manufacturers,
tradesmen and professionals. The rate at which
Rembrandt painted and etched portraits of people
in this category never deviated much after 1636. The
surviving examples average out to two or three a year
for the years after 1636, when he left the art dealer
Hendrick Uylenburgh. The frequently repeated notions
that Rembrandt abandoned portraiture in favor of his-
tory painting, or that he fell out of favor as a portraitist
later in life, are in no way supported by the facts.
When he stopped making etchings after 1660, he made

353
Rembrandt
Self-portrait drawing at a window
Inscribed *Rembrandt f. 1648*
Etching, drypoint and burin,
16 x 13 cm.
Bartsch 22 v(5)
Haarlem, Teylers Museum

354
Rembrandt
*Arnout Tholinx, inspector of
medical colleges, Amsterdam
(1609–79)*
Unsigned, undated. Ca. 1656
Etching, drypoint and burin,
19.8 x 14.9 cm.
Bartsch 284 ii/2
Haarlem, Teylers Museum

The sitter was also depicted by
Rembrandt in a simple head-
and-shoulders portrait now in
the Musée Jacquemart-André,
Paris.

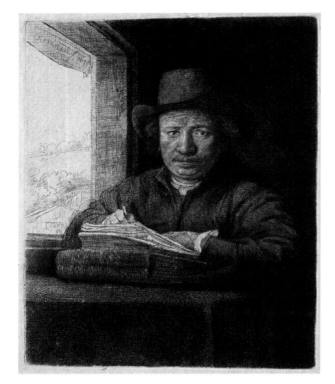 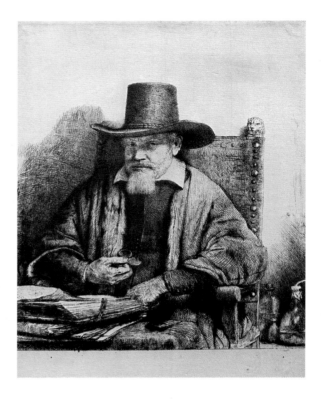

355
Rembrandt
*Frederik Rihel (1621–1681),
Amsterdam Lutheran merchant,
on horseback*
Inscribed faintly *R … brandt
1663* (?)
Canvas, 294.5 x 241 cm.
Bredius 255
London, National Gallery

up the difference with an increase in the number of
painted portraits. The years from 1632 to 1636, when
Rembrandt was churning out portraits at a higher rate,
are exceptional in his career. These were the years
Rembrandt spent with Uylenburgh, and there is every
reason to believe that he was the one responsible for
the short-lived burst of portrait commissions.

Rembrandt's sitters of the 1640s and 50s included
a number of *rentiers* like Jan Six and Nicolaes
Bruyningh. Their financial lives help to understand why
the burghers preferred to be ruled by merchants who
lived from their income rather than the heirs of large
fortunes. Both Six and Bruyningh indulged themselves
with high living and art collecting, leaving their heirs
with mountains of possessions and considerable debt.
Floris Soop, a former manufacturer turned *rentier*, had
himself painted by Rembrandt in his capacity as ensign
of his civic-guard company. He left his heirs with a
problem of another kind, but equally annoying. If he
wrote a last will, he did not tell anyone where it was;
a group of mutually suspicious potential inheritors
spent months turning his house upside down, sealing
the rooms as they came and went. Since no testament
was found, everything went to his closest kin, his blind,
eighty-year-old half-brother Petrus Scriverius.[108]

The men who came to Rembrandt for portraits of
themselves and sometimes their wives as well were
physicians like Ephraim Bueno and Arnout Tholinx,
city officials like Thomas and Pieter Haringh (and
Tholinx once more, a physician in city service, like his
father-in-law Nicolaes Tulp), art dealers like Lodewijk
van Ludick and Otto van Cattenburgh, industrialists
like the Trips, craftsmen like Jan Lutma and Lieven
Willemsz. van Coppenol. Every portrait of them has

its near or rough equivalent in a portrait of the artist.
Rembrandt was part of their world; he modeled himself
on them and them on himself.

All but one of them, at least. The single most exception-
al portrait Rembrandt ever painted, in terms of the nor-
mal practice of portraiture in the Dutch seventeenth
century, is in a mode Rembrandt could not possibly
have emulated. It is a life-size equestrian portrait in
the National Gallery, London, one of only two known
Dutch paintings of the kind. The other is a ten-year
older painting of Diederik Tulp, the son of the surgeon,
still owned by the sitter's descendants, the Six family.
The horse and rider in both paintings are executing
a levade, described by Walter Liedtke as a

> seemingly effortless but exceedingly difficult move-
> ment … The horse bends his haunches deeply, …
> the body is held at no more than a 45-degree angle, …
> The forelegs are tucked in close to the body, …
> The head is held straight and close to the body.
> The rider's pose is similarly frontal, erect, and
> motionless. The movement, or rather position (since
> there is nothing transitory about it) is held for as long
> as the strength and skill of the horse allow (usually
> about five seconds).[109]

Paintings of this type – like the statues and tapestries
which also had equestrian portraits as their subject –
would normally have depicted only royalty or high
nobility. The great prototype was Titian's portrait of
Charles V on horseback in the Prado, which inspired
Velázquez, Rubens and van Dyck in paintings of
Spanish and English kings. The ability to perform
a levade not only displayed mastery over the horse,
it was also symbolic of the ability to rule. The closest
antecedent to Rembrandt's painting is in fact the lost

108 Van Eeghen 1971, p. 179.
109 Liedtke 1989, pp. 19–20.

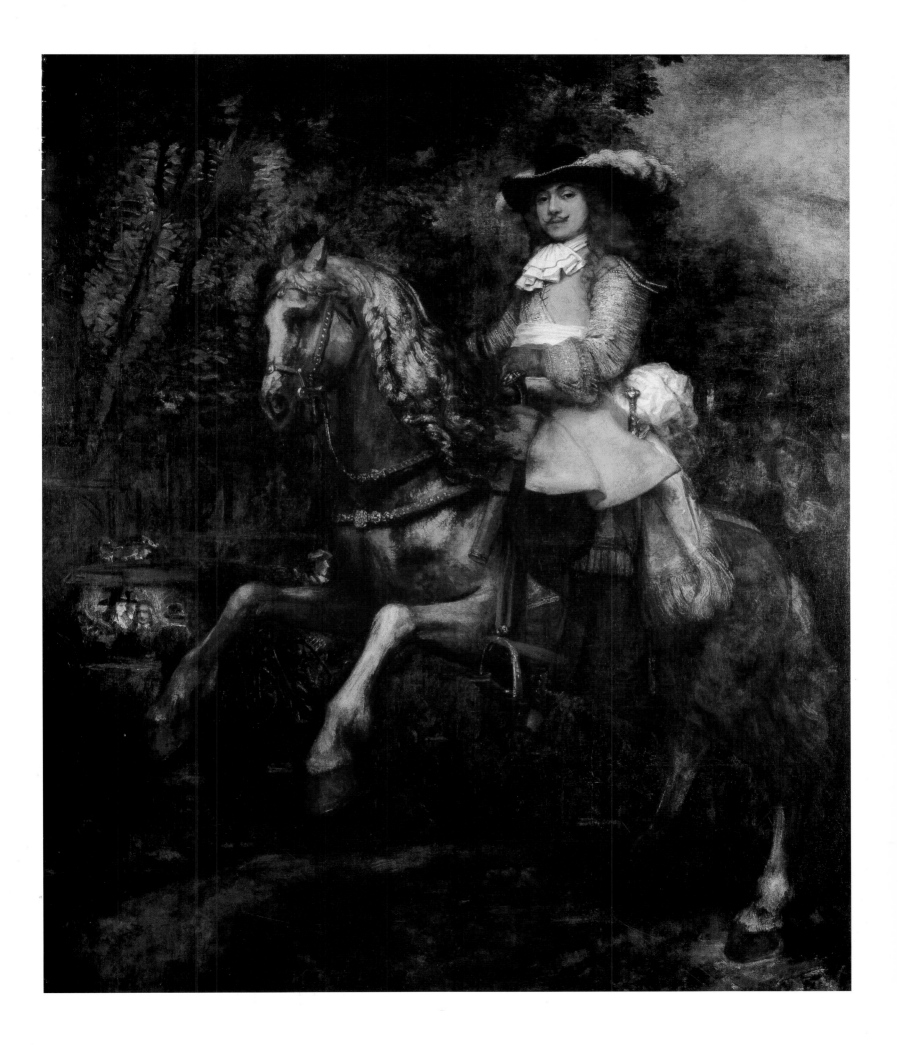

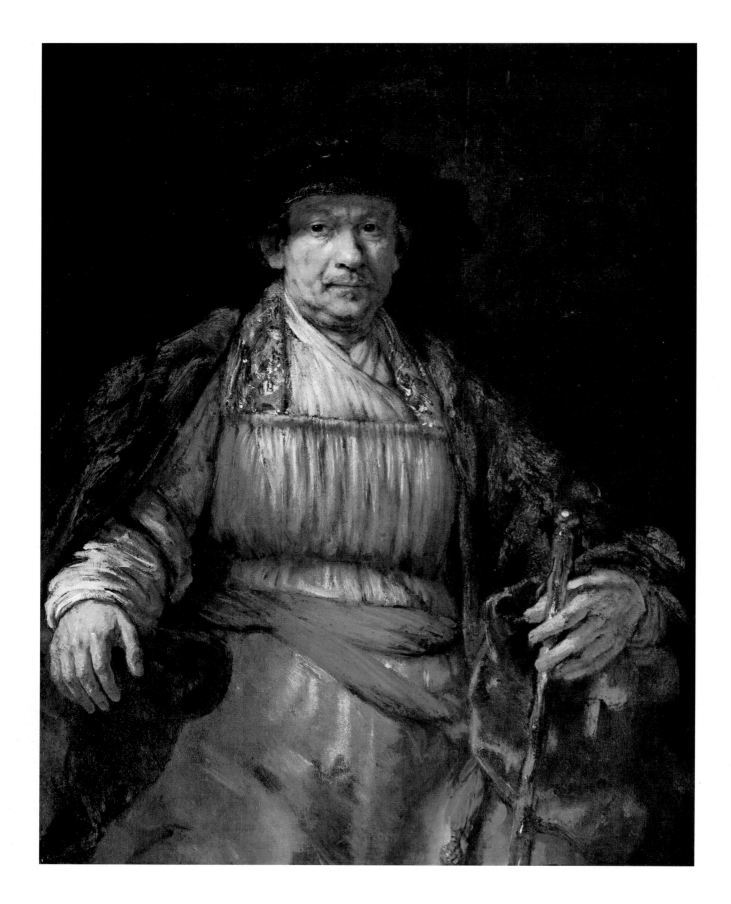

356
Rembrandt
Self-portrait
Inscribed *Rembrandt f. 1658*
Canvas, 131 x 102 cm.
Bredius 50
New York, The Frick Collection

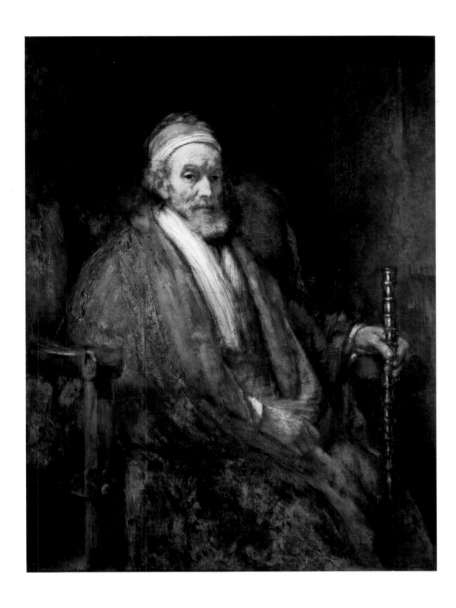

357
Rembrandt
*Jacob Trip (1575–1661),
Dordrecht and Amsterdam
Reformed manufacturer and
merchant*
Inscribed *Rembr*
Undated. Ca. 1661
Canvas, 130.5 x 97 cm.
Bredius 314
London, National Gallery

110 Snoep 1975, pp. 86–90.
111 Van Eeghen 1958. MacLaren
and Brown 1991, vol. 1, pp. 358–62,
no. 6300. Why anyone should enter-
tain doubt on the matter is beyond
me. Nonetheless, this identification
is often followed by a question mark,
while so many other, weaker
propositions in the Rembrandt
literature pass without comment.

Equestrian portrait of Philip IV that Rubens painted in 1628 in Madrid. Titian's *Charles V* and several of its descendants refer to specific events at which the ruler displayed notable leadership.

Rembrandt's painting is one of the few in his oeuvre that indeed refers to an event in his own time. The rider in his painting is heading a procession of horsemen and carriages that has been identified as the entry into Amsterdam on 15 June 1660 of high representatives of the houses of Orange and Stuart. Mary Stuart, the sister of Charles II of England and the widow of Stadholder Willem II, came to the city with her son, the future Stadholder-King William III. The event was part of a new understanding between the city of Amsterdam and the House of Orange, after decades of bad blood. It was also important for the relations between Amsterdam and England, on the eve of the restoration of the monarchy. England had lost its king, Charles I, in 1649, and the Republic its stadholder, Willem II, in 1650; their offices were done away with. In England the reversal was at hand, in the Netherlands it was des-tined to take place in 1672.[110]

At the head of the third group of riders in the wel-coming party was a man identified in the sources as the otherwise unknown "Hendrik Riel." Isabella van Eeghen argued with complete persuasiveness that this was a slip of the pen for Frederik Riel or Rihel, a man whose estate included "Het conterfijtsel van de overleden te paert door Rembrandt" (The portrait of the deceased on horseback by Rembrandt) as well as pieces of costume and riding equipment that occur in the painting. He also owned horses of his own.[111]

Rihel was a native of Strasbourg who came to Amsterdam as a boy to work in the famous Bartolotti banking house. By the time he was thirty he had advanced to a responsible post in the firm. When Guillelmo Bartolotti died in 1658, Rihel took over the reins on behalf of the widow and her three minor sons. One major client was the House of Orange, to whom Bartolotti extended credit. By then Rihel was also doing business as a principal, in a partnership called Bartolotti and Rihel. It is no wonder that the thirty-eight-year-old magnate took part in the welcoming ceremonies for Mary Stuart and young Willem of Orange in 1660, nor that he should want to commemo-rate the occasion in a portrait. Still, it was a daring iconographic endeavor in which he and Rembrandt collaborated. No commoner anywhere else in Europe would have had the temerity to have himself painted in a mode otherwise reserved for the prince. And Rihel was not even a regent.

By then, in more than one self-portrait, Rembrandt was engaged in the thematic upgrading of his own image. The most notable example is the majestic self-portrait of 1658 in the Frick Collection, where he adopts the Grand Merchant Look in even grander form than he bestowed three years later on Jacob Trip. Alongside the grandiose Rembrandt of the Frick self-portrait, the artist was also showing himself in more down-to-earth roles, as in his studio smock (Paris), and more spiritual roles, as St. Paul (Amsterdam). In these miserable years, as his possessions were being sold by the courts for a pittance, he cannot have intended to say in the Frick painting that he was a great man of affairs. Another underlying thought is more fitting: if he was implying that he stood in relation to the other Dutch painters of his time as did Jacob Trip to the other merchants, he was saying no more than what we think.

The early 1660s saw the creation of a pair of portraits in which the couple, unusually, are both given attrib-utes. The man holds a loupe, a kind of magnifying glass used among other purposes for examining precious stones or counting the threads of textile. Because the portraits date from the same years as *The syndics of the drapers' guild*, a tie-in is hypothesized. It would be as nice to speculate that the loupe was used to inspect plants and flowers like the one held by the woman, and that the two are botanists. Whatever their occupation, they certainly seem to be wealthy, judging by their clothing and jewelry. Fascinatingly, the same couple was painted ten years earlier, more conventionally,

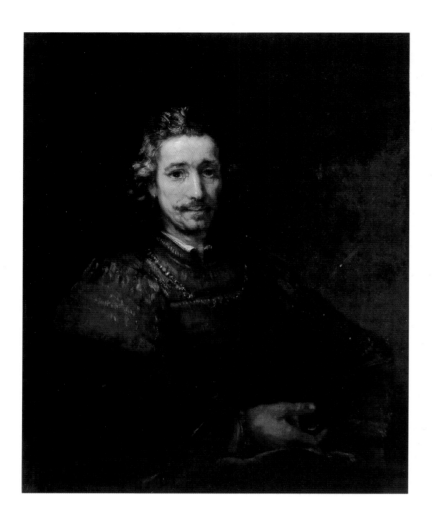

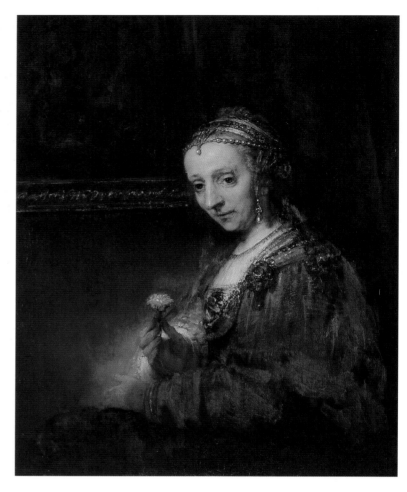

358
Rembrandt
Man with a magnifying glass
Unsigned, undated. Ca. 1662
Canvas, 91.4 x 74.3 cm.
Bredius 326
New York, Metropolitan
Museum of Art

359
Rembrandt
Woman with a carnation
Unsigned, undated. Ca. 1662
Canvas, 92.1 x 74.6 cm.
Bredius 401
New York, Metropolitan
Museum of Art

112 Van der Ploeg 1999, p. 7.

by Jan Victors (1619–76), who is assumed to have studied under Rembrandt in the late 1630s. Once more, Rembrandt seems to have picked up patrons who had prior contact with one of his former pupils – Flinck for the town hall, Bol for the Trips and now Victors for these unknown sitters.

The grand look was not the only option for a portrait of a merchant. A case has been made for the identification of the elderly man in a portrait in the Mauritshuis as Lodewijk van Ludick, a somewhat shadowy non-artist in the Amsterdam art world (fig. 361). Van Ludick was an associate, perhaps even a friend of Rembrandt's from 1653 on. They did deals in art, in real estate, in cash, in credit. Although van Ludick backed Rembrandt financially in the 1650s, his own situation deteriorated so badly that in 1662 he had to sell his art collection. One of his problems was a loan of a thousand guilders that Rembrandt took from Jan Six. Van Ludick signed as guarantor, and when Rembrandt failed to pay he was left holding the bag. By 1666 he was living on Rembrandt's inexpensive street, the Rozengracht. The two old men had a lot to reminisce about. As Miss van Eeghen pointed out, they were born and died within a few months of each other.

When the portrait of van Ludick was bought by the Mauritshuis, the museum repeated the usual wisdom on the subject: "In the process of painting this likeness,

Rembrandt seems to have deliberately broken with the conventions of portraiture. No efforts were made to show the old man as more handsome or dignified than he actually is."[112] Without knowing what the sitter looked like, that judgment cannot be substantiated. Van Ludick may have been a stroke victim whose one-sided paralysis was artfully camouflaged by the painter. To my eye the portrait is pleasantly informal, not un-dignified.

Rembrandt's way with portraiture was not a break with convention at all. Like all Dutch portraitists of his generation, he worked with formulas developed in the fifteenth and sixteenth centuries in the Netherlands and Italy. What distinguished Rembrandt's portraits, as we saw in the previous chapter, was his impatience with the limitations of portraiture. He lets his sitters violate fictional picture space, he endows them with suggested powers of locomotion and sometimes – more in the case of preachers than of merchants – of speech. But these were easel paintings, after all, and their limitations are real, not arbitrary. The net effect of Rembrandt's games with the genre was a certain outright or suppressed vitality in his sitters. This was dependent for its results on the existence of conventions and the viewer's acquaintance with them. In group portraits and double portraits Rembrandt was able to generate more visible action, but some of his individual portraits and

pendants also squirm under the constraints of their genre.

One quality that is often assigned to Rembrandt's portraits is, I must admit, imperceptible to me. His portraits are said to be more "psychological" than those of his contemporaries. What this might mean I frankly do not understand. The word psychology and its attendant beliefs about the mind and the nature of man did not exist in Rembrandt's time. The closest equivalents would have been the study of character and of physiognomy. Neither field stressed personal individuality; they treated persons as representatives of types.

If a portraitist in the seventeenth century wished to depict something other than the outward appearance, behavior or attributes of a sitter, he would have to begin by characterizing the person in terms of his or her temperament, the melancholic, choleric, phlegmatic or sanguine. Characterological depictions of that kind are not rare in art; even Rembrandt employed them in his history paintings (see below, The Senses and the Passions, pp. 273–83). In portraiture, however, such characterizations would quickly resemble caricatures. Moreover, they would detract from the stoic imperturbability that Rembrandt's portrait sitters *do* emanate.

Even the less marked properties that fall under the heading of physiognomy, the correspondence between bodily features and character, are not apparent in Rembrandt's portraits.

In reviewing a dynamic career like Rembrandt's, we would expect to encounter a certain measure of conflict. This indeed emerges from the documents, but in more than what one would call "a certain measure." No fewer than thirty documents come out of conflicts between Rembrandt and Amsterdam merchants. The largest number concerns panic loans that the artist took out in the 1650s, borrowing from Peter to pay Paul, with Christoffel Thijsz. in the role of Paul and with lots of Peters. However, Rembrandt also quibbled in court with merchants, as he did with regents, about other matters: the quality of portraits, accusations of sharp business practices, leaving someone else responsible for tax payments he incurred, fights with the neighbor.

One feature of Rembrandt's patronage that may indicate a form of exclusion is that few of his known sitters belonged to old Amsterdam merchant families. They came from Leiden and from Dordrecht, from Germany and the southern Netherlands; the most ostentatious of them came from Strasbourg. The most important Amsterdamer he ever painted was Andries de Graeff, a commission that as we know ended up in legal arbitration. This may have put the de Graeff–Bicker clan off Rembrandt.

Nonetheless, Rembrandt's relations with the merchant and professional class, as a portraitist and history painter, were the chief mainstay of his career. He did them right and they paid him well.

360
Rembrandt
Self-portrait
Unsigned, undated. Ca. 1669
Canvas, 59 x 51 cm.
Bredius 62
The Hague, Koninklijk Kabinet van Schilderijen Mauritshuis

361
Rembrandt
Portrait of an elderly man, perhaps the Amsterdam merchant and art collector Lodewijk van Ludick (1607–69)
Inscribed *Rembrandt f. 1667*
Canvas, 81 x 67 cm.
Bredius 323A
The Hague, Koninklijk Kabinet van Schilderijen Mauritshuis

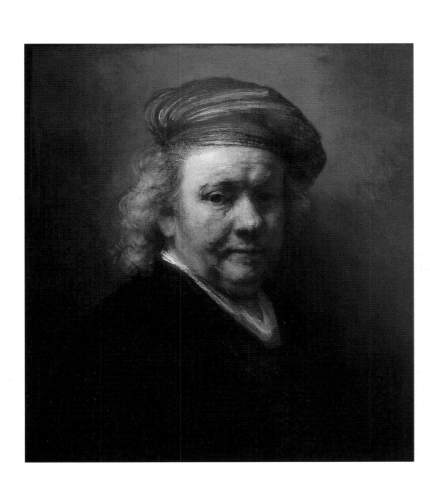

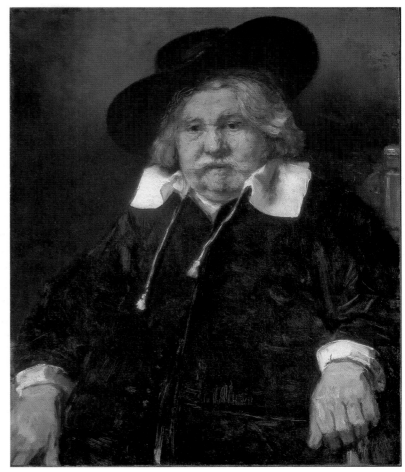

Scholars and poets

Rembrandt was praised and discussed by more poets and playwrights than any other Dutch artist of his day. His relationship with them was far better than with patrons from politics or trade. With his atmospheric evocations of mood and narrative, Rembrandt fit magnificently into the ideal of painting as the sister art of poetry, *ut pictura poesis*. In self-portraits of mid-career he identifies himself with the Italian poet and courtier Ludovico Ariosto. The artist's closest personal friend of whom we know was the Christian poet Jeremias de Decker. A crown on Rembrandt's artistry is formed by a three-painting suite for the Sicilian collector Antonio Ruffo; the hero of the suite is Homer. With Homer Rembrandt shared a controversial reputation for following nature beyond the limits of discretion.

If the pot in Rembrandt's studio was kept boiling by merchants, the stew in the pot was cooked by poets and scholars. During Rembrandt's lifetime, these were the people who wrote about him, in a few rare cases even expressing ideas about his art. Before the artist was twenty-five years old, the courtier-poet Constantijn Huygens committed to paper a long appreciation of Rembrandt's power to capture emotion (p. 149). Later in life, Rembrandt attracted the attention of the humble Christian poet Jeremias de Decker, who praised in Rembrandt the ability to bring the words of the Bible to life (p. 333). These were not conventional compliments. They were qualities that the artist was to culti-

vate all his life and for which he remained famous ever after. I for one am convinced that the ideas about Rembrandt's art in the writings of Huygens and de Decker were the subject of long conversations between them and him, and that they are likely to have influenced Rembrandt's artistic choices.

Constantijn Huygens and Jeremias de Decker were the only two people to write that Rembrandt was their friend. In the case of Huygens this may have cooled (although Rembrandt wrote in his letter to Huygens of 27 January 1639 of "your lordship's good favor and affection" and of his own "service and friendship"), but de Decker remained Rembrandt's friend for life.[113] It says even more that none of Rembrandt's many contacts with writers and poets ever ended in the courts, like so many of those with merchants.

Discourse on the arts in the Dutch seventeenth century took its starting point from classical antiquity and from the doctrine of the "Affinitie between the arts."[114] The classic formula for this proposition was the phrase from Horace's *Ars poetica*: "ut pictura poesis" – as is painting, so is poetry. (Also understood vice versa.) That premise lay at the basis of one of the most influential books ever published on ancient art, *The painting of the ancients*, by the Dutch-British philologist Franciscus Junius the Younger (1589–1677). After publishing his book in Latin in 1637 and English in 1638, he brought out a Dutch edition in 1641, the purpose of which "was to bring to Dutch art the benefits of the experience of classical art."[115]

That translation was part of a wave of publications of classical texts in Dutch, texts that indeed are sometimes found in the libraries of artists.[116] This development not only broadened the audience for classical literature but also laid a claim for the dignity of the Dutch language. In 1616 Petrus Scriverius edited a volume of Dutch poems by the Leiden professor of classical studies Daniel Heinsius, announcing the arrival of the vernacular in high Dutch literature. "Neerlandsche Poësy, niet minder als de Griecken,/ En 't oude Romen was; roert nu vry uwe wiecken."[117] Dutch poetry, not inferior to that of Greece or ancient Rome, spread wide your wings.

On the Amsterdam scene, the cooptation of classical antiquity for contemporaneous Dutch purposes went even further. The Amsterdam city fathers, like those of other proud cities of Europe, compared themselves to Roman consuls and their city to Rome in the motto SPQA, adapted from SPQR, The Senate and Populace of Rome. The style of the town hall was classical, the citizens' hall like a Roman basilica. Even for anti-classicists, the ancients remained the act to beat. In Rembrandt's heyday in Amsterdam the head of the theater, the poet Jan Vos (ca. 1610–1667), boasted that he knew no Greek or Latin. He was praised as a "Hollander of Amsterdam, poet in the vernacular, ... a native talent, unversed in Latin learning and Greek; on the contrary, instructed by Nature alone."

After knowledge of Greek and Latin ceased to be the birthright of every educated Dutchman, a movement

362
Reinier Persijn (1615–68) after Joachim von Sandrart (1606–88) after Titian (ca. 1488–1576)
Portrait formerly believed to depict the poet and courtier Ludovico Ariosto (1474–1533)
Inscribed *Reg*[nerus]. *Persinius sculps*[it]. With two quatrains on Ariosto and the portrait by Caspar Barlaeus, a dedication to Johann Maximilian Zum Jungen, a Frankfurt patron of Sandrart and the information that the painting by Titian was in the collection of Alphonso Lopez. Ca. 1640
Engraving, 26.1 x 19.7 cm.
Hollstein 35
Amsterdam, Rijksmuseum

363
Rembrandt
*Self-portrait leaning on
a stone sill*
Inscribed *Rembrandt f 1639*
Etching, 20.5 x 16.4 cm.
Bartsch 21 i(2)
Melbourne, National Gallery
of Victoria

113 Doc. 1639/4.
114 Junius 1991, vol. 1, pp. 49–50, 365.
115 Junius 1991, vol. 1, p. xl. Cited from "the introduction by one of the learned nephews of Junius, Jan de Brune de Jonge."
116 Schwartz and Bok 1989, pp. 181–88: "A humanist in the vernacular."
117 Dan: Heinsii Nederduytsche poemata, by een vergadert en uytgegeven door P.S., Amsterdam (Willem Janssen) 1616. Complete facsimile on Internet site of Leiden University.

might not mean that much. However, in 1640 we know it to have been in Amsterdam, in the collection of a converted Portuguese Jew named Alphonso Lopez (1572–1649). Lopez, the owner of Rembrandt's painting of *Balaam and the ass*, worked for Cardinal Richelieu and the French crown as an agent in arms, ships, jewelry and art. In 1628 and again in 1636–41 he was in the Dutch Republic. At the Lucas van Uffelen auction, he bought the Raphael portrait of Baldassare Castiglione that was sketched by Rembrandt (fig. 38). The under-bidder was the artist and writer on art Joachim von Sandrart. Born in Frankfurt of Calvinist refugee parents from Hainaut in the southern Netherlands, Sandrart spent the years 1625 and 1637–45 in the north-ern Netherlands, operating at Rembrandt's level in terms of patronage. In 1640, in fact, both Rembrandt and Sandrart were at work on commissions for civic-guard portraits for the Kloveniersdoelen. (See fig. 296.)

So that when Sandrart drew the Titian portrait of Ariosto for reproduction and Rembrandt produced a self-portrait in the same format with a similar conceit, this cannot have gone unnoticed in the small, overheat-ed Amsterdam art world. And it would not have escaped attention that the poet behind whose balustrade he took his place was a hero of vernacular (Italian) poetry in the classical mold. The inscription under Sandrart's print identifies Ariosto in the first place as the author of *Orlando furioso* (1516), an epic that Italianizes Virgil. Where Virgil began his poem on Aeneas with the words "Arma virumque cano" (Of arms and the man I sing), Ariosto needed more elbow room for Orlando: "Le donne, i cavallier, l'arme, gli amori,/ le cortesie, l'audaci imprese io canto" (Of loves and ladies, knights and arms, I sing, / Of courtesies, and many a daring feat; translation of William Stewart Rose, 1823). Ariosto's place in Italian letters, we could say, is equivalent to that assigned by Huygens to Rembrandt in relation to Dutch art. Both were artists of modern times who vied, in their own language, with the ancients.

Rembrandt's association with a poet in this self-por-trait did not come out of the blue. The Leiden human-ists with whom he was in contact were minor poets, Huygens in The Hague major. No sooner had Rembrandt arrived in Amsterdam than he made the acquaintance of playwrights and poets in his new home town. Two of the surgeons in the *Anatomy lesson of Dr. Nicolaes Tulp* (1632) wrote and published in their spare time (p. 255); one of them helped set up a new (short-lived) music theater under the direction of the poet-playwright Jan Harmensz. Krul, whose portrait was painted by Rembrandt in 1633. With the town theater as well, supervised by the municipality for the benefit of charity homes, Rembrandt had extensive ties. Of the men who served on the theater board, six praised Rembrandt in print or owned work by him. Rembrandt made at least one etching for the printed version of a play, perhaps more.

came into being, in emulation of developments in France, to apply classical criteria to vernacular art and literature as well. The adherents of those standards organized in a group called Nil Volentibus Arduum (Nothing is difficult to those who try).

Where did Rembrandt stand in this system of values? On the one hand he was praised seriously by Huygens as superior to Protogenes, Apelles and Parrhasios and by de Decker as "the Apelles of our age." Needless to say, neither poet had ever seen a work by an ancient Greek painter. The comparison was based on words alone. In the eyes of Nil Volentibus Arduum, however, he was no better than Jan Vos – "instructed by Nature alone" – a scorner of beauty and the eternal verities of art, "the first heretic of painting."

In one self-portrait, Rembrandt takes on a guise that his contemporaries would have associated with a poet (fig. 363). In his etched self-portrait of 1639, in which he once again points the Renaissance elbow at us, Rembrandt emulates a pose bestowed by Titian on a sitter thought at the time to be the Ferrara court poet Ludovico Ariosto (fig. 362). Without further knowledge concerning the Titian, the resemblance

364
Rembrandt
*Jan Harmensz. Krul
(1601/02–1646), Amsterdam
Catholic poet*
Inscribed *Rembrandt f. 1633*
Canvas, 128.5 x 100.5 cm.
Bredius 171
Kassel, Staatliche Museen
Kassel, Gemäldegalerie Alte
Meister

118 *Verscheyde Nederduytsche
gedichten*, p. (*)2 recto.

Together with his pupil Govert Flinck, Rembrandt rode high on an outburst of companionship between the poets and painters of Amsterdam in the 1650s. The movement was well under way by 1651, when a collection of poetry appeared under the title *Verscheyde Nederduytsche gedichten* (Various Dutch poems). The collection is dedicated to the artist Gerard Pietersz. van Zijl, who is addressed by the poet editor with the words "Poetry, which has so much in common with your art of painting that the one sometimes paints in words while the other speaks in paint, gives me the opportunity to offer you poems for paintings and words for pigments."[118] The volume is shot through with the rhetoric of the affinity of the arts.

A continuation volume published in 1653 was dedicated by the publisher, on 30 July of that year, to Jan Six. Such a dedication suggests that Six supported the publication financially, manifesting himself as a Maecenas, a patron of the arts. However, Six is not mentioned in connection with the main event in the

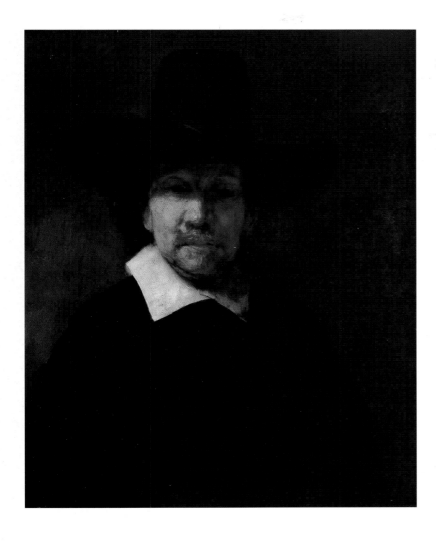

365
Rembrandt
*Jeremias de Decker (1609–66),
Amsterdam Reformed poet*
Inscribed *Rembrandt f. 1660*
or *1666*
Panel, 71 x 56 cm.
Bredius 320
St. Petersburg, State Hermitage
Museum

119 Postma and Blok 1991, with wel-
come correction to misunderstand-
ing in Schwartz 1985, pp. 262–63.
The authors deny that the
Vereeniging van Apelles en Apollo
was an organ, claiming it was only
a one-time extension, with poets,
of a St. Luke's Day celebration.
120 Schwartz 1995.
121 Doc. 1634/6.
122 The form of the last letter itself
is ambiguous; in terms of style and
the personal history of the two men
the painting could have been made
in either year. In 1660 Hendrick
Waterloos published a poem in
Hollantsche Parnas on a Rembrandt
portrait of de Decker. Although the
poem speaks not of a finished paint-
ing but of Rembrandt's intention to
paint a portrait, I consider the poem
evidence that the portrait is from
that year rather than 1666.

arts that year. On 20 October 1653, the saint's day
of St. Luke, the patron of painters, the poets and
painters of Amsterdam joined to celebrate the Union
of Apelles (the hero of painting) and Apollo (the god
of poets). At the head of the table was the poet Joost
van den Vondel.[119] If an institutional bond was intended,
it did not hold; on 21 October 1654, in what could have
been the second celebration of the Union, a Brother-
hood of Painting and Sculpture was founded instead,
under the patronage of Joan Huydecoper. If the poets
were insulted, they did not show it; the founding of the
Brotherhood, which also went nowhere, was the subject
of even more poems than the Union. In the longest of
them, by Jan Vos, the first of the Amsterdam painters
in the roll call of immortality is Rembrandt.

In 1660 Rembrandt was once again the foremost
painter to be praised by the poets of Amsterdam in
a 600-page collection of poems entitled *Hollantsche
Parnas* (Dutch Parnassus). The publisher, Jacob
Lescaille, dedicated the book on 29 April 1660
to Joan Huydecoper, who was presiding burgomaster
that year. The dedicatory verses written to Huydecoper
as the patron of the Brotherhood of Painting are includ-
ed in *Hollantsche Parnas*. The dedication begins, "The
ancient writer Simonides once said, *Poetry is a speaking
painting, and painting a silent poetry.* This truth is plain
for all to see." Of living artists, Rembrandt and his work
receive most attention, in poems by Jeremias de Decker,
his friend Hendrick Waterloos, one I. Boogaard and

– in poems on the portraits of Jan Six and his mother,
which however do not mention Rembrandt as the artist
– Joost van den Vondel. The publisher himself wrote a
glowing poem on Rembrandt's etched portrait of Jan
Six, "commissioner of maritime affairs," a position he
only acquired the year before. How unfortunate for
Rembrandt that his friend was so low down on the
totem pole. Huydecoper had far more patronage to dis-
pense, but although he had bought a Rembrandt paint-
ing as early as 1628 (see above, p. 132), he showed no
favor to Rembrandt when he came to power.

The constellation of poets, painters and politicians
was typical not only for Amsterdam but for artistic
patronage in early modern Europe in general. The array
of the three groups was always in place, but it would
come alive mainly when government bodies had major
artistic patronage to bestow, as in splendid ceremonies
or the decoration of an important public building.
Projects of both kinds were happening in Amsterdam
in mid-century, bringing with them a round of musical
chairs for prestigious and well-paid commissions.[120]
Although Rembrandt did not play that game well with
the politicians, when it came to the poets he did not
have to play at all. The affinity of his art with theirs
was unfeigned and recognized by both. It says a lot
that several of Rembrandt's pupils were also poets.
Gerbrand van den Eeckhout was an occasional poet,
but Samuel van Hoogstraten and Heyman Dullaert
were full participants in Dutch literary as well as artistic
life. Rembrandt himself left us only one couplet. In June
1634 he inscribed the friendship album of Burchard
Grossmann with the lines *Een vroom gemoet | Acht eer
voor goet* (A pious soul values honor above posses-
sions).[121] Whatever literary gifts Rembrandt possessed,
which are not apparent in his letters, went into the
orations that were so admired by Michael Willmann.
(See above, pp. 18–19.)

The poets who are mentioned most often in writings on
Rembrandt are Constantijn Huygens and Jan Six. But
neither of them did for Rembrandt what Jeremias de
Decker did: writing and publishing a good, serious
poem on a work of art by Rembrandt (see below,
p. 333). De Decker's poem on *Christ appearing to Mary
Magdalene* was published first in *Hollantsche Parnas* and
was reprinted in a posthumous collection of 1667,
which also contains three poems on a portrait of de
Decker painted by Rembrandt in 1660 or 1666, the year
of the poet's death.[122] One is by his brother David de
Decker and one by the Amsterdam town treasurer Jan
van Petersom. The third is a tender poem of thanks by
Jeremias de Decker himself. It counts thirty verses,
beginning with a few lines celebrating Apelles as the
only artist allowed to paint Alexander the Great and
then thanking "the Apelles of our day" for painting
his portrait …

… not to earn the right to charge a fee.
But straight from the heart,
From noble attraction to the goddesses of poetry,
Inspired by love of art.

366
Rembrandt
Homer reciting verses
Inscribed *Rembrandt aen Joanus
Sicx. 1652*
Reed pen and brown ink,
15.5 x 18 cm.
Benesch 913
Amsterdam, Six Collection

123 Held 1969, p. 19.
124 Vondel 1927–40, vol. 7, 1932,
p. 60.
125 Jan Vos wrote two entries in
Six's album, one being a poem of
thanks to the patron for his appoint-
ment as head of the theater in 1647.
The poem was printed in 1651 in
Verscheyde Nederduytsche gedichten.
Möller 1984, pp. 81–83.
126 For a book-length reconstruc-
tion of the commissions and the
circumstances surrounding them,
see Giltaij 1999. A later contribu-
tion, in which additional documents
are printed and some of Giltaij's
judgments corrected, is found
in Rutgers 2003.

Who was this man? Jeremias de Decker was born
in 1609 in Dordrecht, but moved to Amsterdam as
a child, where his father Abraham, a religious refugee
from Antwerp, ran a grocery store. He was close to
Rembrandt by 1638, and remained so until his death
in Amsterdam in December 1666. De Decker was
a melancholy bachelor who found his calling, when
he was not tending his father's shop or the old man
himself, with whom he lived, in poems of resignation
and bitterness. His masterpiece was *Goede Vrydag ofte
Het lijden onses Heeren Jesu Christi* (Good Friday, or the
Passion of our Lord Jesus Christ; first published in
1651). De Decker admits of himself "full of fun I'm
not ... I'd rather see you learn than laugh." He associat-
ed himself gladly with his Old Testament namesake,
whose *Lamentations* he put into psalm form. Both
Rembrandt and de Decker devoted a large part of their
lives to the artistic interpretation of the Bible. It is a pity
that when de Decker's *Goede Vrydag* was reprinted
in 1654 and 1656 with illustrations, the publisher, Jacob
Colom, used not a new suite by Rembrandt but a fifty-
year-old Passion series by Karel van Mander as
engraved by Jacques de Gheyn.

Rembrandt was quite amenable to the game of mutual
admiration between poets and painters. If his poet
friends cited Apelles as the generic great painter,
Rembrandt enlisted Homer for the same rank in poetry.
In 1652, in an album in which Jan Six collected drawings
and inscriptions from befriended artists and writers,
Rembrandt drew Homer reciting his verses to a rapt
audience.

In the age of Rembrandt and Six, love for Homer
was not the harmless commonplace it is today. Strange
as it may sound to us, Homer was a controversial author
who had to be defended against charges of vulgarity.
Julius Caesar Scaliger (1484–1558), a distinguished
Italian humanist who spent his latter years in France,
attacked Homer as "a liar, an ape of nature ..."[123] In
1646, Joost van den Vondel introduced his Dutch trans-
lation of the works of Virgil with a lengthy summary of
the polemic between champions of Homer and Virgil.
"If Envy criticized Virgil, it criticized Homer with more
reason ... Virgil never transgressed against propriety,
Homer often," he wrote.[124] In the context of the times,
this made Homer and Rembrandt partners in crime
against good taste. As far as the Maronists were con-
cerned, the party of the refined Virgilius Maro, Homer
was a kind of Greek Jan Vos.

As a member of the theater board that took on and
maintained Jan Vos as director, Six could not have
objected to the reference.[125] Six also knew that
Rembrandt based the composition in his album on the
famous fresco of Parnassus by Raphael in the Stanza
della Segnatura, the mother lode of classicism. Insofar
as Homer stood for truth to life in art versus Virgil,
poet of the ideal rather than the real, Rembrandt posits
truth to life as the central value in art. Without making
too much of it, it is intriguing to recall that in 1640
Rembrandt associated himself with Virgil, through
his posed emulation of the reborn Virgil, Ludovico
Ariosto. Intentional or not, the move corresponds with
the change in Rembrandt's poet friendships from
Huygens, a Virgil-lover, to Jan Six and the Homeric
Jan Vos.

The relationship between patrons and poets found
extraordinary expression in one of Rembrandt's most
remarkable series of commissions. In 1652 and 1659
Rembrandt received orders from abroad for three large,
expensive paintings. The patron was a Sicilian noble-
man named Don Antonio Ruffo (1610/11–1678) of
Messina.[126] What prompted Don Antonio in the first
place to place a commission with Rembrandt we do
not know. The man being a major collector, owning
364 paintings upon his death by Italian, French,
Spanish, Flemish and Dutch masters, the fact of the
commission is not that unusual. The terms are not
known, but judging from later documents and the
paintings themselves, the artist was given a great deal
of freedom in his choice. The first order seems to have
been for a life-size half-length. If the subject were
specified at all, it would have been "a philosopher."
It was in any case a philosopher Rembrandt chose,

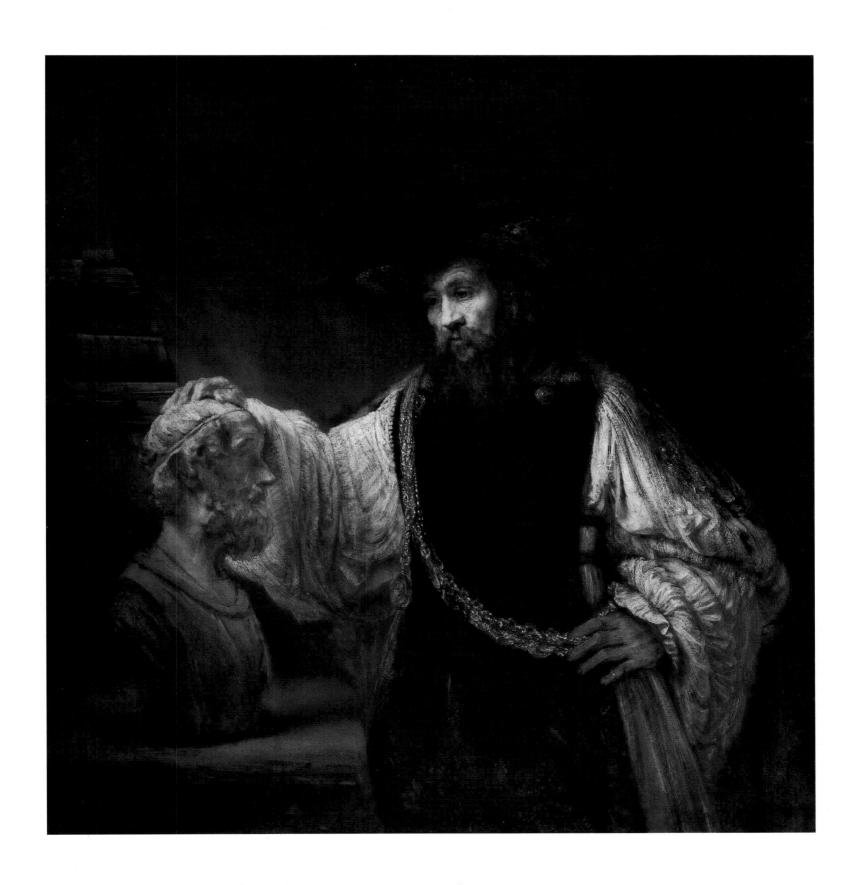

367
Rembrandt
*Aristotle contemplating a bust
of Homer*
Inscribed *Rembrandt f. 1653*
Canvas, 143.5 x 136.5 cm.
Bredius 478
New York, Metropolitan
Museum of Art

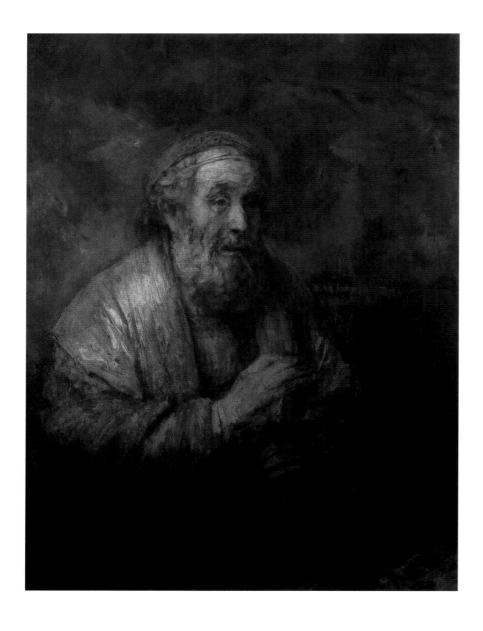

Aristotle, whose identity was not immediately apparent to the patron. Even less plain in Sicily was the identity of the second personality in the painting – Homer, not in living life but in the form of a marble bust on which Aristotle lays a loving hand. (Rembrandt's inventory included a bust of Homer as well as one of Aristotle.) A third figure from ancient Greece in the painting is alluded to in even more obscure form. Hanging on the philosopher's chain is a medallion with a helmeted head that Rembrandt seems to have taken for Aristotle's pupil Alexander the Great. This point is speculative.

Aristotle, the author of a timeless treatise on poetry, indeed had a special admiration for Homer, as did Alexander, of whom Plutarch writes, "He was naturally a great lover of all kinds of learning and reading; and Onesicritus informs us that he constantly laid Homer's Iliads, according to the copy corrected by Aristotle, called the casket copy, with his dagger under his pillow."[127] A link between the three is therefore not far-fetched.

Ruffo was so pleased with his *Aristotle* that several years later he asked Rembrandt for another two half-lengths. The witty choice of subject fell on a painting of the two minor actors in the first commission, Alexander and Homer. There is a raft of documents concerning the shipment and payment of this order, the technical quality of the *Alexander* and the dimensions of the *Homer*. There are entries in the Ruffo ledgers, and correspondence between Ruffo and other artists concerning his Rembrandts. It is the only set of documents of its kind concerning a Rembrandt commission, and it tells us a lot about the mechanics of long-distance patronage. There were middlemen involved, brokers, shippers and agents of the kind we never learn about

368
Rembrandt
Homer reciting
Inscribed ... andt f. 1663
Canvas, fragment,
108 x 82.5 cm.
Bredius 483
The Hague, Koninklijk Kabinet
van Schilderijen Mauritshuis

369
Rembrandt
Homer reciting to a scribe
Unsigned, undated. Ca. 1660
Pen and brown ink, brush and
brown ink, white heightening,
14.5 x 16.7 cm.
Benesch 1066
Stockholm, Nationalmuseum

127 Held 1969, p. 19. Passage
from Plutarch in the translation
supervised by John Dryden (1683),
accessed on http://classics.mit.edu/
Plutarch/alexandr.html.

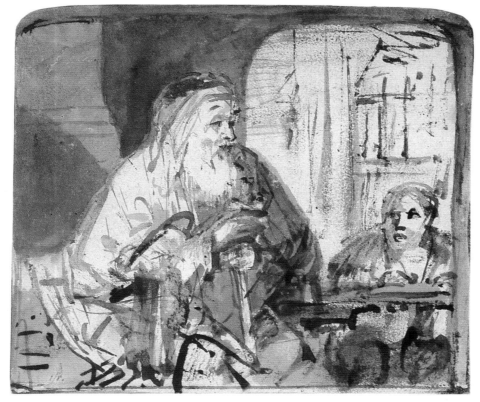

370
Rembrandt
Aristotle contemplating a bust of Homer
Inscribed *Rembrandt f. 1653*
Canvas, 143.5 x 136.5 cm.
Bredius 478
New York, Metropolitan Museum of Art

371
Johann Konrad Schnell the Elder (1646–1704) or the Younger (1675–1726)
Print after a self-portrait of Johann Ulrich Mayr (1630–1704) painted in 1648
Etching, 22.6 x 17 cm.
Private collection

128 It must however be said that Ruffo did more with the paintings than hang them in Rembrandt's sequence. He also ordered other half-figures from Italian painters, at a far cheaper rate, to go with them.
129 Discussion on this point is insufficient. The figures suggest a loss of sixty centimeters in the height and eighteen in the width, but an autoradiographic examination of the canvas in 1982 showed cusping on the right and left edges of the painting as well as the top. This implies that no part of the painted surface can have been removed on these sides. Ainsworth et al. 1982, pp. 51–56.
130 "… un Alessandro magno, che stà à sedere al suo spadone, lancia à lato" (an Alexander the Great, who is seated on his long sword, a lance at the side; what can "seated on his long sword" mean?) Rutgers 2003, p. 13. For the arguments for but mainly against the possibility that Ruffo's *Alexander* was one of the paintings of men in armor in Glasgow and Oeiras, Portugal, see Giltaij 1999, pp. 55–66.
131 Tacke 1995, pp. 172–73, no. 80. For a fascinating discussion of the role of Mayr in the genesis of the *Man with a gold helmet* of about 1650, see Nystad 1999.
132 And with the future, in *Picture this*, a remarkable novel by Joseph Heller in which Alexander, still alive in ancient Greece, comes into being as a painting in Rembrandt's studio and to rest in the Metropolitan Museum of Art. The mode has been known since classical antiquity as a dialogue of the dead.

in art writings. Praise and criticism from other artists were elicited by Ruffo. There were complaints from the patron to the artist about the physical stability and optical impression of a painting (*Alexander*) patched together from several pieces of canvas, and a translation of the artist's rather belittling riposte ("Credo che sono poco Amatori a Messina" – I believe that connoisseurs are few and far between in Messina). There are also details concerning the subject, dimensions, format, price, placing and framing of the three paintings.

In a note added to an invoice of 31 July 1661, one middleman wrote somewhat obscurely to another that "the painter Rembrandt reminded me that *Homer* still has to be painted, which he will do for five hundred guilders, in such a way that he would provide it with an arch above the canvas, while it would fit well with the other one to place *Alexander* in the middle; if this is what they wish, let me know." From inventories of the Ruffo collection down to 1689, we know that this plan was carried out, although Rembrandt received only three hundred guilders for the *Homer* and we hear nothing more about the arches. The sequence in which the Rembrandts are listed is always the same: Aristotle, Alexander and Homer. They had the same size, which was referred to by Rembrandt in an autograph note in these words: "If each piece is 6 palms wide and 8 high the formats will be good." In Sicilian *palmi*, where the sizing apparently took place, this converts to 206 x 155 cm. (Yet, a drawing in Stockholm that is taken to be a sketch by Rembrandt for the *Homer* has a horizontal format; fig. 369.) The carved and gilded frames too were identical.

Had the three paintings been preserved in the form in which Rembrandt created them, in the constellation agreed upon by him and Ruffo, we would have been able to enjoy a rare ensemble of a Rembrandt philo-

sopher, patron of the arts and poet from classical antiquity.[128] Sadly, however, the later fortunes of the paintings are a disaster. They may still have been in Messina in 1783, when the city was hit by an earthquake that did not spare the Ruffo palace. Whatever the reason, *Homer* survives only as a damaged fragment; *Aristotle* now measures 143.5 x 136.5 cm., cut down on at least two sides;[129] and the *Alexander* has been lost completely. Ruffo's painting showed a seated figure, which rules out the two main candidates.[130]

The most likely indication of what the painting looked like is to be found in a self-portrait of 1648 by the German Rembrandt pupil Johann Ulrich Mayr, engraved in the year of his death, 1704 (fig. 371).

The assumption behind this is that Rembrandt had been working in the 1640s on a painting of Alexander the Great not as a warrior but as a learned ruler. Mayr adapted Rembrandt's invention for a self-portrait as the young Alexander. When Ruffo placed his second commission, Rembrandt returned to the motif, giving Alexander a long sword and a lance. Interesting to note is that in 1650 Mayr anticipated another element of the *Aristotle* in a self-portrait with his hand on an ancient bust (fig. 373).[131]

Aristotle, *Alexander* and *Homer* have more features in common than have been named so far. They are complex paintings in which the main figure is accompanied by a significant other – Aristotle has Homer, Alexander a bust of Pallas Athena, Homer his disciples. The paintings of the philosopher and poet, perhaps that of the prince as well, attempt to transcend the purely visual mode of a painting. Homer is speaking, reciting verses to a disciple who is writing them down, Aristotle is engaged in a dialogue with the past.[132] Going further than in the *Night watch* and the portrait of Anslo and

372
Ferdinand Bol (1616–80)
A scholar at his desk
Inscribed *fBol feci(t) /1652*
Canvas, 127 x 135 cm.
Blankert 70, Sumowski 127
London, National Gallery

Rembrandt's former pupil
Ferdinand Bol too, in 1652,
painted a thinking man wearing
a medallion of an ancient
emperor.

373
Johann Ulrich Mayr
(1630–1704)
*Self-portrait with his hand on
an ancient bust*
Inscribed on the back *Jo[] Mair
fecit | Wahr ich 20 Jahr alt. | 1650*
Canvas, 107 x 88.5 cm.
Sumowski 1476
Nürnberg, Germanisches
Nationalmuseum

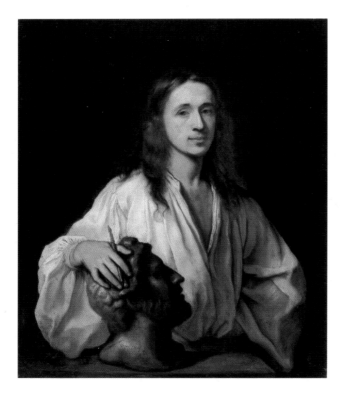

cannot be better illustrated than in the responses in
Messina to the *Aristotle*. The painting was entered in
the Ruffo records as "Aristotle or perhaps Albertus
Magnus," and when Guercino was asked to paint a
companion piece for the *Aristotle*, he wrote to Ruffo
that in his opinion the subject of the Rembrandt was
a physiognomist, a student of the form and bumps
on the human head in connection with character. And
in 1999 Simon Schama embraced a new, as yet unpub-
lished theory by Paul Crenshaw that Aristotle is not
Aristotle at all, but Apelles.[133]

It is dispiriting for the historian that even the best-
documented commissions ever given to Rembrandt,
beside the Passion and Nativity paintings for Frederik
Hendrik, are so poorly understood. Documents are not
everything. For the time being, the main lesson learned
from the Ruffo commission and its aftermath is that
the relations between Rembrandt, his sources, works,
pupils, followers, patrons, viewers and past and present
students are too complex and too insufficiently docu-
mented to be grasped.

his wife, in which Rembrandt froze speech, in this
three-piece suite he goes after the depiction of thought
processes, reflection and poetic creation. Such an enter-
prise depends, however, on the insight of the viewer.
We must recognize the subject and be able to fill in the
thoughts of the figures. The extreme unlikelihood that
communication along these lines can really succeed

133 Schama 1999, pp. 582–94 and
notes. Schama's reconstruction
of the commission is wonderfully
evocative, down to the sweat on
the brows of the porters.

Artists and collectors

Whether or not Rembrandt the artist thought of himself as just one of the boys, his images of the studio and the craft all feature himself, never anyone else. Especially in etching, he created memorable portraits of art collectors, sometimes in lieu of paying cash debts. His images of himself and his collectors flow into each other. This is especially true of portraits in which art takes on a spiritual dimension.

Rembrandt spent his working life in one of the largest communities of artists the world has ever seen. (See above, p. 117.) A count in the files of the Netherlands Institute for Art History turned up no fewer than six hundred painters active in the Northern Netherlands between 1640 and 1660. Rembrandt did not avoid their company. In Amsterdam, he chose to live in neighborhoods with lots of artists. Although not all were full-time professionals, Rembrandt would have had a hard time going to the corner baker and back without bumping into a colleague. His relations with them seem to have been affable enough. Of the twenty-five conflicts traceable in the documents, only one concerns a fellow artist. In 1637 he was accused by the Portuguese Jewish artist Samuel d'Orta of improper behavior in a trade transaction.[134]

On and off through the years, Rembrandt drew, etched and painted a small number of images of artists at work. The largest single group, in all three media,

is of himself. Nor did he paint or etch many portraits of colleagues. The only other artist he seems to have portrayed is the landscape painter Jan Asselijn (d. 1652), who is dressed for a social visit rather than for work and is provided not with brushes but with books. Curiously, Rembrandt's major non-portrait etching of an artist in the studio (figs. 202–03) was left incomplete.

374
Rembrandt
Self-portrait drawing at a window
Inscribed *Rembrandt. f 1648*
Etching, drypoint and burin,
16 x 13 cm.
Bartsch 22 v(5)
Haarlem, Teylers Museum

375
Rembrandt
Abraham Francen (b. 1613), Amsterdam apothecary and art collector
Unsigned, undated. Ca. 1657
Etching, drypoint and burin,
15.8 x 20.8 cm.
Bartsch 273 ii(10)
Haarlem, Teylers Museum

134 Doc. 1637/7.

376
Rembrandt
Joannes Wtenbogaert (1604–84),
Amsterdam Remonstrant tax
collector: "The goldweigher"
Inscribed *Rembrandt f. 1639*
Etching and drypoint,
25 x 20.4 cm.
Bartsch 281 iii(3)
Haarlem, Teylers Museum

377
Rembrandt
Johannes Lutma (1584–1669),
Amsterdam goldsmith
Inscribed *Rembrandt f. 1656*
Etching and drypoint,
19.6 x 15 cm.
Bartsch 276 i(3)
Haarlem, Teylers Museum

378
> Rembrandt
Self-portrait
Inscribed *Rem ... f 1660*
Canvas, 111 x 85 cm.
Bredius 53
Paris, Musée du Louvre

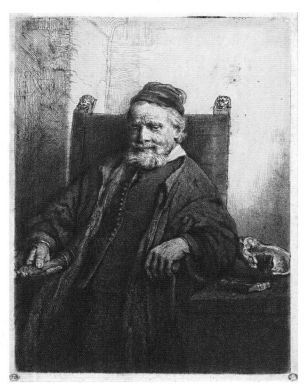

Two etchings of the mid-1650s show sculptors. The
1656 portrait of the gold- and silversmith Johannes
Lutma (1584–1669) with a small crafted object in his
hand and a bowl on the table behind him was preceded
in 1655 by a diminutive etching of a sculptor at work.
One wonders whether the honor paid to Rembrandt
at the Brotherhood of Painting and Sculpture in 1654
affected this unique choice of motifs.

Considerations of favor and commerce did play a role
in Rembrandt's portraits of art collectors and dealers,
who were often creditors as well. Joannes Wtenbogaert
was portrayed by Rembrandt in the year when he
helped the artist collect quick payment from the stad-
holder, Jan Six at the start of a period when the patri-
cian commissioned and bought works from the artist
as well as lending him money. Abraham Francen and
his brother Daniel were involved in financial trans-
actions with Rembrandt when the etched portrait
of Abraham was made in the difficult mid-1650s
(fig. 375).[135] Rembrandt's choice not only of portrait
sitters but also, as we shall see, of landscape motifs
was bound up with his financial problems.

135 Dickey 2004, pp. 142–49.

379
Rembrandt
Self-portrait
Unsigned, undated.
Ca. 1660
Canvas, 114 x 94 cm.
Bredius 52
London, Kenwood House

The portrait of Abraham Francen is one of the most flattering images of a collector imaginable (fig. 375). The modest interior, bare but for a table and several works of art, fits the description of Francen vouchsafed to us by the French art dealer and cataloguer Edmé-François Gersaint (1694–1750) in his posthumous catalogue – the first – of Rembrandt's etchings (1751). "This art lover had an extreme passion for prints, and since his means did not permit him to satisfy himself readily, he would often skimp on food and drink in order to acquire pieces that pleased him when the opportunity arose."[136] Francen's passion, in Rembrandt's portrait, extended to painting and sculpture as well as graphic art. Call him a poor – well, modest – man's version of Joannes Wtenbogaert and Jan Six. Francen is the only collector who is caught by Rembrandt in the very act of art delectation. Placed beside Rembrandt's most recent – and final – self-portrait etching, of 1648, both showing men seated at a desk beside a window – one can imagine that Francen is admiring a sheet on which Rembrandt was working.

The animating conceit of those etchings derives from the stunning etched portrait of Jan Six (fig. 328). That print was not only a pioneering technical achievement, in which drypoint and burin were added to etching to produce a new range of blacks; and not only a model image of the cultivated gentleman. It also plays with light pouring through a window, facilitating and symbolizing the intellectual concentration of a writer-reader (Six), an artist (Rembrandt) and a connoisseur (Francen). The light from outside turns the intellectual and artistic inspiration of the sitters into a kind of spirituality. This is underlined in the Six and Francen portraits by the presence on the wall of paintings of the Passion of Christ. It is no wonder that the etching of Jan Six became a veritable template, for centuries to come, for portraits of sitters who felt themselves inspired by literature or art. Rembrandt himself was called upon, in partial payment for the purchase of a house, to produce, at a value of four hundred guilders, "a portrait of Otto van Kattenburch, which the aforementioned van Rijn will etch after life, of the quality of the portrait of Mr. Six."[137] The portrait was never executed, probably because the sale of the house fell through.

Rembrandt's ultimate contribution to the image of the artist at work is formed by two large paintings of 1660 showing himself with his palette, maulstick and brushes in hand. (Or is that a mirror rather than a palette in the Kenwood House painting?) He is dressed warmly in comfortable-looking clothes and a fur-lined cloak, with a simple white cap on his head. These close-ups of the solitary artist have loomed large in the later iconography of the artist, more than any of the other self-portraits. The painting in Paris shows Rembrandt at work on a large panel, of a kind that few painters other than him were still using. In the self-portrait in Kenwood House, the arcs on the wall compete for our attention with the image of the man so successfully that writings on the painting almost always devote more

attention to those few simple lines than to the highly wrought self-portrait. In keeping with that tradition, here I would like to point out that such forms are not unique to the Kenwood self-portrait. Arcs appear in the background of Rembrandt paintings, drawings and etchings from the 1620s on. The earliest is in *Judas returning the thirty pieces of silver* (fig. 254), where a curve springs from the top of the head of one of the Pharisees in about the same spot as in the Kenwood House self-portrait. Two other images of this kind are closer in time to the Kenwood painting. In the etched portrait of Lieven Willemsz. van Coppenol and his grandson of ca. 1658 (fig. 493), the boy's head covers part of a black arc in the early states, to be replaced in the fourth state by a triptych of the *Crucifixion* like that in the portrait of Abraham Francen. In some unexplained way, the arc was interchangeable with a Crucifixion. In *An old man as St. Paul* of 1659, two roundels are set into the wall behind the man, one empty, the other with a relief of the *Sacrifice of Isaac,* also a reference to the sacrifice of Christ. On the basis of these comparisons, it might be more fitting to look for a spiritual interpretation of the forms rather than one in art theory, as is usually done. In calling attention to these predecessors, I also wish to suggest that in the Kenwood House self-portrait, as in so many others, Rembrandt does not remove himself from the run of mankind. His images of himself and the artist that he was show him as a representative of the same humanity that he saw in his portrait sitters and studio models.

136 "Ce Curieux avoit une extrême passion pour les Estampes; & comme ses facultés ne lui permettoient pas de se satisfaire avec facilité, il s'épargnoit souvent le boire & le manger, pour pouvoir acquérir dans l'occasion, les Morceaux qui lui faisoient plaisir." Gersaint 1751, p. 199.
137 Doc. 1655/8 of 25 December 1655.

7

Landscape

Graph 10
Number by date of landscape
paintings, etchings and
drawings

REMBRANDT'S DEPICTIONS of the world around him are not universal in scope. He shows no interest in plants and little in clouds. His trees are generic – not identifiable oaks or beeches, just trees. His landscapes and even his city views are nearly unpopulated – no folklore for him. The season is almost always summer, but his vision of landscape cannot be called seasonal. He does not avoid convention, does not hesitate to adopt older formulas, and he flirts with clichés.

Considering the avidity with which the young Rembrandt attacked so many specialties and the tenacity with which he held on to favorite themes throughout life, his approach to landscape was late and brief. The chronology of his landscapes – etchings, drawings and (very few) paintings combined – shows a pattern unique in his career. More than two-thirds of Rembrandt's known depictions of landscape – all of them etchings and drawings, to the total exclusion of paintings – were made in only seven years, between 1649 and 1655.

Yet when those seven years were over, Rembrandt had created not just one of the most highly prized bodies of work in his oeuvre. He had also created

a look, a vision of the Dutch landscape that imprinted itself on the imagination of centuries to come. The Rembrandtesque, often equated with picturesque decay, dilapidated farmhouses and ruins, is a triumphant application of the advice of Karel van Mander, who advised the young artist-in-training to roof his bucolic buildings "not with bright red tiles, but rather with clods of earth, thatch and straw, patches and holes; plaster them crookedly and cover them with moss …" Despite this, most of Rembrandt's country (and town) views show perfectly well-maintained buildings. What Rembrandt's landscapes suggest is not so much age as timelessness. By and large they lack indication of season, actuality, anecdote or reference to history. While quite a few of their locations have been determined thanks to dedicated and clever research in the 20th century, few of Rembrandt's landscapes are captioned or would have been identifiable by sight even to contemporaries. In a way, this makes them more available to viewers of later centuries, who are hardly at a disadvantage to the artist's own generation in appreciating them.

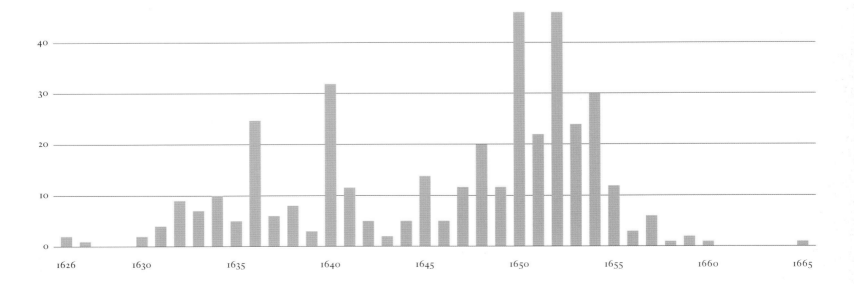

Rembrandt dips his toes in the water

Looking at the early work in search of a budding interest in landscape, we find something close to the opposite, an avoidance, aversion, perhaps even fear of this very popular genre. The outdoor history subjects Rembrandt depicted in Leiden could have been placed in landscapes. Rembrandt chose instead to forefront them on a narrow stage set off by a plant or two in front and a tree or tower or cloud behind. There was hardly any air in the compositions, let alone open space. Not until the early 1630s, in a number of etchings and history paintings, did he take a step back, reduce the figures in size and give them identifiable surroundings. Once he took this step, he took it decidedly. The first etchings and paintings concerned contain a full complement of landscape elements. The etched *Angel appearing to the shepherds* (figs. 147–48) and two painted mythologies take place on richly wooded riverbanks. All three are scenes of divine intervention on earth. In the etching an angel of the Lord appears in the sky; in one of the paintings the god Zeus abducts Princess Europa and in the other the goddess Diana turns the unfortunate hunter Actaeon into a stag who is then devoured by his own dogs.

The settings for the three compositions are quite similar. A shoreline curves from the right foreground into the left middle ground. Above it is an opening into a background that is blocked at the back, in the etching by a town on a hill, in one painting by a harbor, in the other by a low cliff. The largest elements in the compositions are massive, looming trees. The compositional scheme derives from formulas that had been worked out by Flemish artists in the preceding decades. It was employed in a contemporaneous painting by Rembrandt's older contemporary Alexander Keirincx, who was born in Antwerp in 1600, moved in 1628 to Utrecht and is recorded in Amsterdam in the mid-1630s. The painting is thought to be a collaboration between Keirincx and the Utrecht painter Cornelis van Poelenburgh (1594–1667), to whom the figures are attributed. Their bathing nymphs, painted around the same time as Rembrandt's, indicate yet another strong connection in these years between Rembrandt and the Utrecht school.[1]

Rembrandt paid close attention to all parts of his scenes, but in the two paintings he seems to have been particularly fascinated by the water, elaborating on the surface ripples, reflections and refraction. In the raised arms of one of Diana's nymphs, we even get a sense of the cool temperature of the stream into which she is stepping.

Between those two mythologies, Rembrandt painted his only sea picture, *Christ in the storm on the sea of*

381
Rembrandt
The abduction of Europa
Inscribed *RHL van Rijn 1632*
Panel, 61 x 77.5 cm.
Bredius 353
Los Angeles, J. Paul Getty
Museum

1 Koester 2000, p. 151, no. KMS1863
and p. 336, pl. 79.

382
Rembrandt
*The goddess Diana bathing, with
Actaeon turned into a stag and
Callisto's pregnancy discovered*
Inscribed *Rembrandt fe. 1634*
Canvas, 73.5 x 93.5 cm.
Bredius 472
Isselburg, Museum Wasserburg
Anholt, Fürstlich Salm-
Salm'schen Verwaltung

383
Alexander Keirincx (1600–52),
the figures probably painted
by Cornelis van Poelenburgh
(1594–1667)
*A woody landscape with nymphs
bathing in a pool*
Ca. 1634
Panel, 40 x 61 cm.
Monogrammed *AK*
Copenhagen, Statens Museum
for Kunst

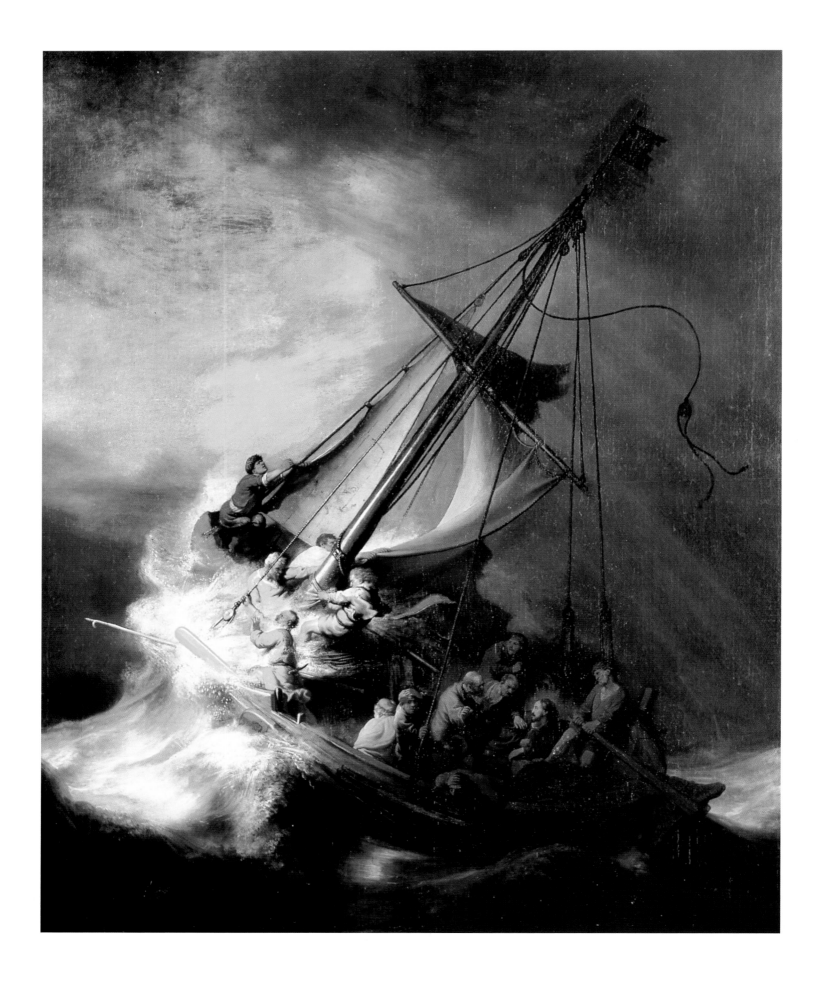

384
Rembrandt
*Christ in the storm on the sea
of Galilee ("St. Peter's boat")*
Signed *Rembrandt f. 1633*
Canvas, 160 x 127 cm.
Bredius 547
Property of the Isabella Stewart
Gardner Museum in Boston,
but missing since it was stolen
from there in 1990

385
Rembrandt
The ship of fortune
Signed and dated *Rembrandt.
f. 1633*
Etching, 11.3 x 18.4 cm.
Bartsch 111 ii(2)
Haarlem, Teylers Museum

386
Rembrandt
Two sailing-boats at anchor
Unsigned, undated. Ca. 1636
Black chalk, 14.5 x 16.2 cm.
Benesch 468
Vienna, Albertina

Galilee. In the same year, 1633, he etched a unique alle-
gory of seafare for a book published in 1634 under the
title *Der zee-vaert lof* (In praise of seagoing), by Elias
Herckmans.

In the upper left, the text tells us, the doors of the
Temple of Janus are being closed after the Roman fleet

won the Battle of Actium in 31 BC. In front of the
statue of the two-faced god Janus, Marc Anthony, still
wearing the laurel wreath of his victories in Egypt,
is going down in defeat as his mount collapses under
him. In despair, he watches the gigantesque Lady
Fortune turning her naked back on him and sailing out
of the harbor. (Her craft is a single-masted *boeier* – the
classic Dutch fishing boat – much like the one in which
St. Peter is struggling for his life.) The self-assured
god of the sea, Neptune, is at the rudder. The print
had particular resonance for current events. In 1631
a change of fortune at sea had major consequences for
the revolt against Spain. Archduchess Isabella of the
Spanish Netherlands sent a powerful fleet of flat-
bottomed boats like the *boeier* to drive a wedge
between the rebelling provinces of Holland and
Zeeland. Despite its superior power, the fleet was
routed when the fog came in. The event was commem-
orated in allegorical poems and medals.[2]

These representations – to which we can add a lonely
drawing of two *boeiers* from the same period – fore-
shadow a later Rembrandt who never came into being,
a maker of rather precious mythologies, peopled
forests, marines and allegories. Instead, a few years
later, another approach to landscape manifested itself,
more tentatively than in the forceful works above, but
more prophetically for Rembrandt's later development.

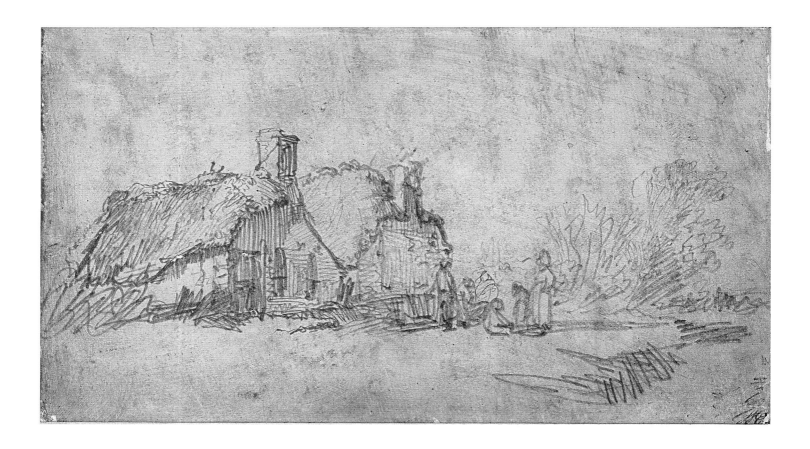

387
Rembrandt
*Landscape with two thatched
cottages*
Unsigned, undated. Ca. 1636
Silverpoint on prepared vellum,
10.8 x 19.2 cm.
Benesch 466 recto
Berlin, Staatliche Museen,
Kupferstichkabinett

388
Rembrandt
*Landscape with a man standing
beside a road*
Unsigned, undated. Ca. 1636
Silverpoint on prepared vellum,
10.8 x 19.2 cm.
Benesch 466 verso
Berlin, Staatliche Museen,
Kupferstichkabinett

2 De Groot and Vorstman 1980,
no. 63.

A start on dry land

The two sides of a drawing in Berlin present a touching
contradiction. The subjects are unpretentious land-
scapes, the mode that of the quick sketch made on the
spot. On the recto, we see two cottages with thatched
roofs, on a road with a group of figures. The reverse
shows a man – is it an artist with drawing materials? –
observing a broad panorama with a town on the distant
horizon left and right, and a farmhouse among trees
in the center. The technique, by contrast, is the most
costly and demanding of all dry media. The material
is vellum, the flawless skin of a sheep or goat, limed,

shaven and dried in a delicate process, and the tech-
nique silverpoint, requiring the vellum to be coated
to receive the (indelible) strokes of the metal point.
Rembrandt used it very rarely for drawings. The most
famous example is Rembrandt's tender portrait of
Saskia in Berlin (fig. 78). In the 1650s he drew another
modest landscape subject on this costly support.

Rembrandt's silverpoint drawing of the cottages
is characteristic in subject and style of a small group
of drawings in pen, black chalk and wash dated to the
1630s. They are classified as landscapes, but the sub-
jects are kept so close to the foreground that cottage
studies is a better name for them. This motif has

389
Claes Jansz. Visscher II
(1586–1652)
Two farmhouses
Inscribed *te bussum*
(in Bussum).
Unsigned, undated. Ca. 1610–20
Pen and ink over a black chalk
underdrawing, 14.3 x 18.8 cm.
Paris, Fondation Custodia
(Frits Lugt Collection)

390
Rembrandt
Two thatched cottages
Unsigned, undated. Ca. 1633
Pen and bistre, some white body
color, 13.7 x 20 cm.
Not in Benesch
Los Angeles, J. Paul Getty
Museum

235

a venerable history in the Netherlands. Rembrandt was falling back on models from the earlier seventeenth century in Holland and the sixteenth in Flanders.

A drawing from the 1610s by Claes Jansz. Visscher II (1586–1652; fig. 389) shows cottages of the same kind, with more visual information than Rembrandt provides about the road and the foliage, with more careful perspective and placing in space.[3]

Bible stories in space

For the remainder of the 1630s, landscape was to remain in the background of Rembrandt's paintings. Not in the background of portraits – Rembrandt never adopted this formula, which was quite popular in his time – but only behind biblical scenes. The landscape backgrounds in these paintings – views through on the left, punctuated by impressive though ill-defined buildings – succeed in varying measure in avoiding the feel of a

backdrop rather than real space. With the *Landscape with the good Samaritan* in the Czartoryski Museum in Kraków, dated 1638, a breakthrough is achieved (fig. 394). Here for the first time the figures of a Biblical story are truly immersed in the world. It was around this time that Rembrandt painted his first independent landscapes, of which *The stone bridge* in the Rijksmuseum, with similarly dramatic lighting as the *Good Samaritan* in Kraków, is a stunningly accomplished example, if that word can be used for one of the high points of Dutch landscape painting.

Brilliant sunlight breaks through dark clouds to light up the trees and cottages in the middle of the picture. The light falls as well, in minute, exquisite detail, on the barely visible upper surface of the stone bridge that gives the painting its name. This subtle touch makes one think of the penetrating sound of an oboe in a composition for dark strings and brass. The rest of Rembrandt's scene takes place in the shadows of the clouds. A lot is going on in the painting. On the left

391
Rembrandt
St. John the Baptist preaching
Unsigned, undated. Ca. 1634
Canvas laid down on panel,
62 x 80 cm., enlarged from
38 x 52 cm.
Bredius 555
Berlin, Staatliche Museen,
Gemäldegalerie

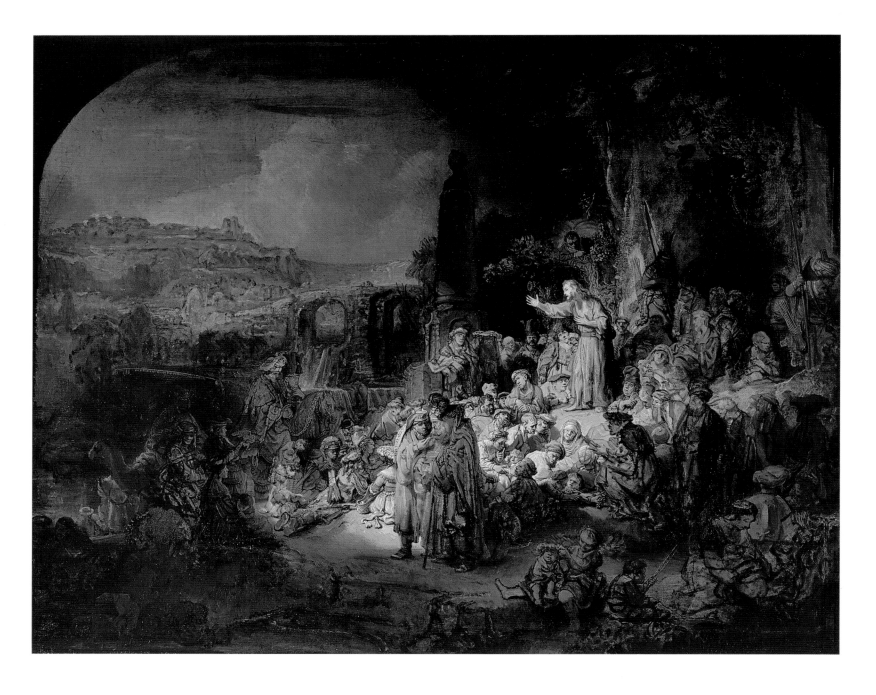

392
Rembrandt
The stone bridge
Unsigned, undated. Ca. 1638
Panel, 29.5 x 42.5 cm.
Bredius 440
Amsterdam, Rijksmuseum

Continuous modulation comes into being when an artist constantly changes the mix-
ture of pigments on his brush (or stick), substitutes one brush for another, or shifts
the direction or modifies the pressure of his brushstroke. Those acts in the execution
of a painting – thousands in a panel such as this – are guided by a clear vision of the
intended effect, sure knowledge of what is needed to achieve it and above all by
intense concentration. The artist must have prepared the composition in advance,
whether in drawings or in his mind's eye, and must be aware of the shape, size and
make of all the objects in the picture. To the extent that the subject is taken from life,
the observation of nature must be accurate, its translation into paint convincing.
The proper relation must be respected between foreground and background in terms
of the size, the tone and the resolution of the elements depicted. Necessary circum-
stances for working this way, aside from mastery of all the parts of art, good light
and good eyesight, are excellent materials and paints. The result, as in *The stone
bridge*, is a painting that trembles with life, in which the energy and focus bestowed
on his work by the artist are there to be unpacked by the viewer who delves into the
picture. A telling application of continuous modulation is the horizon. It is formed
by living and dead trees of various kinds at various distances from the picture plane,
illuminated variously, interrupted at two spots by the roofs of the farm and the church
tower. Not a single stretch of this long passage is mechanical or routine. It is unpre-
dictable, irregular without being jagged, not pleasing in itself but contributing greatly
to the balance and lifelikeness of the scene.

3 Schneider 1990a, p. 74.

a coach stands before an inn, the passengers seated and waiting to depart; lone figures approach the bridge from either side. On the far shore of the river is a farm, with the farmer out front, walking behind his horse; his cattle are grazing in the meadow on the right. In the foreground two men punt their way in a rowboat through the water; behind them, a second boat is framed satisfyingly by the bridge.

The sky, the foliage, the water, the land are all painted with nearly miniaturistic precision, in a mode that to my eye is typical of Rembrandt the painter at his best, whether in portraits, landscapes or history paintings. For want of a better term, it may be called continuous modulation. Any spot on the painting, down to the smallest spot the eye can see, is different from the surrounding spots. (See p. 237.)

An important problem in Rembrandt connoisseurship is that not all the paintings given to the master display such denseness and intensity. Sometimes the difference lies in condition. A painting whose surface has been damaged can lose exactly those subtle qualities that constitute the superb quality of *The stone bridge*. In other cases, the suspicion exists that Rembrandt started but did not finish a particular work. Two other possibilities are that the painting in question is not by the master at all but by a pupil or imitator. And finally, the most difficult consideration of all – that Rembrandt himself did not always do his best. If one accepts that premise, then it becomes extremely – perhaps impossibly – difficult to distinguish between an uneven or indifferent Rembrandt and a non-Rembrandt.

393
Rembrandt
The risen Christ appearing to Mary Magdalene
Inscribed *Rembrandt f. 1638*
Panel, 61 x 49.5 cm.
Bredius 559
The Royal Collection, Her Majesty Queen Elizabeth II

See also p. 333

394
Rembrandt
Landscape with the good Samaritan
Inscribed *Rembrandt f. 1638*
Panel, 46.5 x 66 cm.
Bredius 442
Kraków, Princes Czartoryski Foundation at the National Museum

395
Rembrandt and/or an artist
close to him, perhaps
Ferdinand Bol (1616–80)
River valley with ruins
Inscribed *Rembrandt f.*
Undated. Ca. 1637–40
Panel, 67 x 87.5 cm.
Bredius 454
Kassel, Staatliche Museen
Kassel, Gemäldegalerie Alte
Meister

Rembrandt and no longer Rembrandt

To illustrate how sharply recent connoisseurs have distinguished between Rembrandt and non-Rembrandt, it is enough to look at a painting in Kassel that was unquestioningly attributed to the master until in 1989 and 1990 the Rembrandt Research Project and Cynthia Schneider respectively asserted that the painted surface as we see it is not the work of the master.[4]

Fig. 395 displays a combination of motifs that we recognize from works we have seen, in a mode that closely resembles them. The panel on which it is painted has been determined to come from the same tree from which the wood for two other paintings, *Man in Polish costume* (dated 1637) and *The concord of the state* (ca. 1642; fig. 17), was cut. The signature is also of the same form as that on *The concord of the state*. Yet, if one compares it to *The stone bridge*, one can only agree with the RRP that "the painting is today marked by a rather undifferentiated application of paint, with scant suggestive power." Large parts of the painting indeed lack the quality that I have called continuous modulation.

The RRP pointed out for the first time that the X-rays of the painting reveal "substantial variations from the picture visible today." This much is indisputable. The problem is how to reconcile the changes and the disappointing quality of the painting with its

equally unquestionable relation to Rembrandt. In this regard, the RRP and Cynthia Schneider, in her book *Rembrandt's landscapes*, arrive at two opposite conclusions. The RRP says that the painting was conceivably begun by Rembrandt in the late 1630s, but that nearly all of the original version was overpainted in the 1650s by Ferdinand Bol. Cynthia Schneider turns the order of paint application around. She thinks the underlying version was made by a pupil or follower of Rembrandt about 1636–42 and that parts of it are a "reworking [by Rembrandt] of his pupil's rather vacuous landscape." Schneider quotes with approval the opinion of the journalist Richard Tüngel that "Rembrandt's overpainting was removed by a Kassel conservator, leaving a painting that best belongs in the depot." She explains the signature (in the authenticity of which the RRP places "little trust") by stating that "it would have been consistent with workshop practice for Rembrandt to claim a picture produced in his studio as his own."

Neither of these contradictory explanations, I must say, is very satisfying. Again, we must confess that we do not have sufficient information to arrive at a judgment that will command a solid consensus. Once more, in the case of a painting that the eminent specialist Horst Gerson characterized in 1968 as a "powerful picture," we must face up to the fact that in the connoisseurship of Rembrandt's paintings we are skating on thin ice. With these provisos, here is my own

4 Bruyn et al. 1982– , vol. 3,
pp. 514–20, no. B12; Schneider
1990b, pp. 206–11, no. R5.

396
Rembrandt
Landscape with a castle
Unsigned, undated. Ca. 1640
Panel, 44.5 x 70 cm.
Bredius 450
Paris, Musée du Louvre

397
Rembrandt
Town on a hill in stormy weather
Inscribed *Rembrandt f.*
Undated. Ca. 1638
Panel, 52 x 72 cm.
Bredius 441
Braunschweig, Herzog Anton
Ulrich-Museum

398
Rembrandt
Winter landscape
Inscribed *Rembrandt f. 1646*
Panel, 17 x 23 cm.
Bredius 452
Kassel, Staatliche Museen
Kassel, Gemäldegalerie Alte
Meister

399
Esaias van de Velde (1587–1630)
Winter landscape
Inscribed *E.V.VELDE 1629*
Panel, 11.2 x 15 cm.
Keyes 72
Property of the Wallraf-
Richartz-Museum in Cologne.
Stolen from the museum in
July 2004

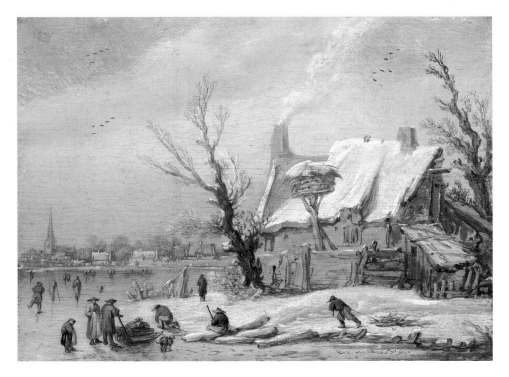

opinion about the painting in Kassel. Considering that the panel emerged from Rembrandt's studio in the years when Ferdinand Bol (1616–80) was active there, and that it indeed shows considerable similarity to his own later works, why not assume that the entire painting is by him? That it was Bol who painted it under Rembrandt's supervision in the late 1630s, perhaps after a design by Rembrandt. He took it back to Dordrecht, where he returned to it in later years.

A smattering of landscape paintings

We have passed the first spike in the chronological graph of Rembrandt's landscapes (p. 229). It consists, for the year 1636, mainly of cottage drawings. It would nearly be matched in 1638 by paintings, but since these have been ejected from the Rembrandt corpus, we are left with a phantom spike. In view of Rembrandt's unquestioned authorship in the late 1630s of a number of outstanding landscape paintings, and the probability that others emerged from his workshop, the thought arises that in these years Rembrandt planned to set up a serious line in landscape paintings, some to be painted entirely by him, others to be manufactured by his assistants and pupils under his supervision. If this were the case, then the project was aborted. Following 1640, only three landscape paintings are given to the master, one of which is disputed. Each of them is anomalous in its own way.

The diminutive *Winter landscape* in Kassel (fig. 398) is Rembrandt's only winter scene, his only outspokenly seasonal painting and his smallest landscape. In motif and mode, it leans heavily on very similar works of twenty and thirty years earlier by Esaias van de Velde.

The rest on the flight into Egypt in Dublin (fig. 400) is Rembrandt's only night scene. It is an adaptation of a famous painting by Adam Elsheimer (fig. 401) that

400
Rembrandt
The rest on the flight into Egypt
Inscribed *Rembrandt f. 1647*
Panel, 34 x 48 cm.
Bredius 576
Dublin, National Gallery
of Ireland

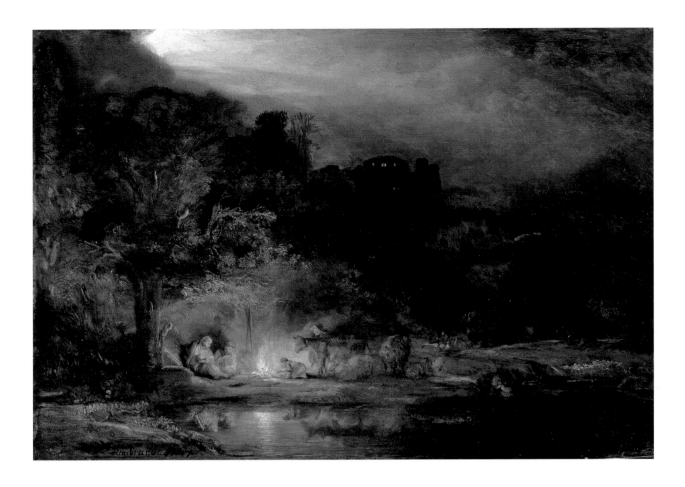

401
Adam Elsheimer (1578–1610)
The rest on the flight into Egypt
Inscribed on the back *Adam
Elsheimer fecit Romae 1609*
Copper, 31 x 41 cm.
Andrews 26
Munich, Alte Pinakothek

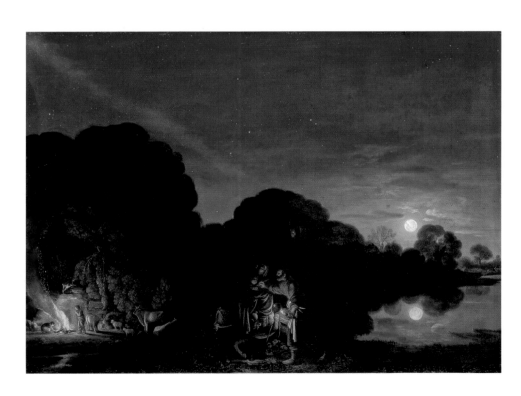

circulated in the Netherlands during Rembrandt's youth, and that was reproduced in an engraving by the Utrecht artist Hendrick Goudt in 1613. A painted copy was owned by the Delft collector Herman de Neyt when he died in 1642.

The mill (fig. 402), if it was painted by Rembrandt, would be his only landscape on canvas rather than panel. The three paintings have been called evocations of small humans in a dark and cold world, but an opposite reading – that they show defenseless people unafraid for their safety – seems to me closer to the truth. The villagers in the *Winter landscape* and the Holy family at its fire are ensconced cozily in little worlds of their own. *The mill* goes further: it can be read as an icon of Dutch self-confidence at the end of the Eighty Years War. The windmill stands on a fortification bulwark, in an exposed position. At various times during the war, windmills in spots like that – including those belonging to Rembrandt's father – had to be dismantled for safety. The fisherman in the water, the washerwoman and promenaders on the shore are outside the city wall as the sun sets, the hour when during the war the gates in the wall would be closed for the night. They are not protected because they do not have to be. For this reason it is tempting to date the painting, which on stylistic grounds has been variously assigned to the mid-1640s and mid-1650s, in or shortly after the year 1648, when the Netherlands signed a peace treaty with Spain. It can be read as a painted paean to the blessings of peace and security, like the poems that everyone in the country wrote in 1648. Those blessings were of short duration. Only three years later a sea war with England was to break out that had a devastating effect on the Dutch economy and on Rembrandt's personal fortunes.

In its combination of motifs, *The mill* corresponds to the left side of a two-sheet drawing in black chalk of a much less dramatic cast (fig. 403). Nor are the name and story of the windmill very romantic.

The idiosyncratically constructed windmill in the drawing and in an etching of 1641 entitled *The windmill* (fig. 404) are the same one – De Kleine Stinkmolen (The Little Stink Mill) on the bulwark known as De Passeerder, north of the present Leidseplein, on the west side of the city. On the east side, looking out over the IJ, Rembrandt also drew the Blauwhoofd bulwark with its windmill (fig. 405). These compositions look so right, so typical of Rembrandt that it comes as a shock to realize that he hardly drew or etched windmills at all. Cottages outnumber windmills as a motif by a good five or ten to one.

Lost landscapes

Whatever the date or authorship of *The mill* in the National Gallery of Art, after 1648 Rembrandt's activity as a painter of landscape was at an end, at least as far as existing works are concerned. The story of Rembrandt's landscape paintings is however not complete without reference to the twelve landscape paintings, one of them uncompleted and another painted over by the master, listed in the inventory of Rembrandt's goods at the time of his bankruptcy in 1656.[5] Most are called simply "lantschap" or "lantschappie," but several are specified further: "een achter huijs" (a house behind another), "een berch achtich lantschappie" (a mountainous landscape), "eenige huysen" (some houses), "een avont stont" (an evening), "een maneschijntie" (a moonlit scene). These are as many landscape paintings as have been attributed – and subsequently de-attributed – to Rembrandt in modern catalogues of his work.

Moreover, these are not the only references in inventories from Rembrandt's lifetime to landscape paintings by him. At least one had been sold before 1656 and cannot be identical with one of the twelve entries in Rembrandt's inventory. In 1644 "a landscape by Rembrandt" was sold from the collection of the Delft tax collector Boudewijn de Man, one of the most important art collectors in the city, for the strikingly high amount of 166 guilders. More typical was the appraisal after Rembrandt's death of a "castle by

402
Rembrandt or an artist close to him
The mill
Unsigned, undated. Ca. 1648
Canvas, 87.5 x 105.5 cm.
Not in Bredius
Washington, National Gallery of Art

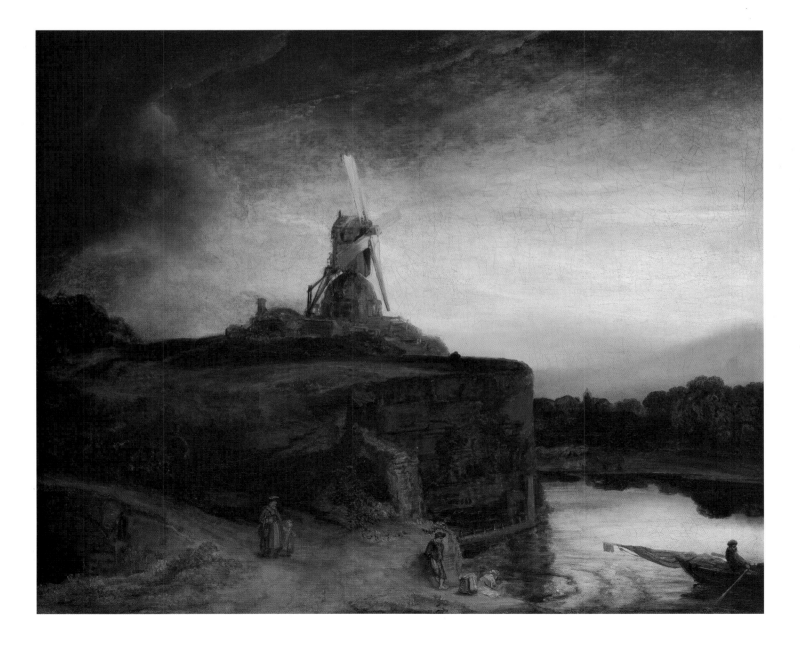

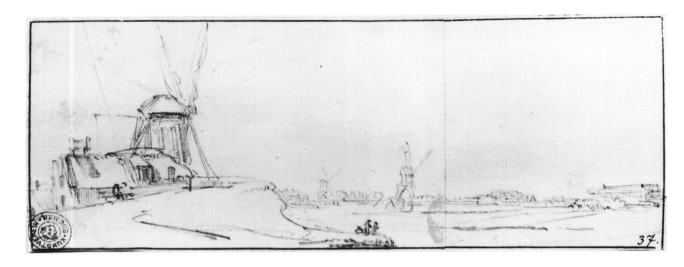

403
Rembrandt
De Kleine Stinkmolen
on the bulwark De Passeerder
of Amsterdam
Unsigned, undated. Ca. 1640–41
Black chalk, on two sheets of
paper, 8.5 x 23.1 cm.
Benesch 810
Property of the Kunsthalle
Bremen, but missing from the
museum since it was looted
during the Second World War

Rembrandt" in the collection of the widow of the Delft alderman Johan van der Chijs at ten guilders. In 1673 the Amsterdam cloth merchant Abraham de Potter owned "a painting, being a mountainous landscape, with several figures made by Rembrandt."[6] De Potter had close personal ties to the distinguished Rembrandt pupil Carel Fabritius.[7] The latter two paintings may have come from Rembrandt's bankruptcy sale, but that from Boudewijn de Man's estate must be added to the twelve that Rembrandt still owned in 1656. This number must be on the low side, unless we accept the very unlikely assumption that Rembrandt sold only one of thirteen landscapes that he painted.

Clearly, there is a major discrepancy in the numbers of Rembrandt landscape paintings documented in the artist's lifetime and those recognized today. Thirteen works are documented, five are extant. As upsetting as it is, the ratio is sadly typical for the survival rate of Old Master paintings as a whole. It corresponds nearly exactly to the figure for another body of work associated with well-documented Rembrandt paintings. The engraver Jan Gillisz. van Vliet (1600/10–1668), with whom Rembrandt worked closely in the early 1630s, produced eighteen prints after compositions by living artists of his time, probably all paintings. Of the originals, only eight are known today. In this case, as in that

404
Rembrandt
The windmill
Inscribed *Rembrandt f 1641*
Etching, 14.5 x 20.8 cm.
Bartsch 233 i(1)
Haarlem, Teylers Museum

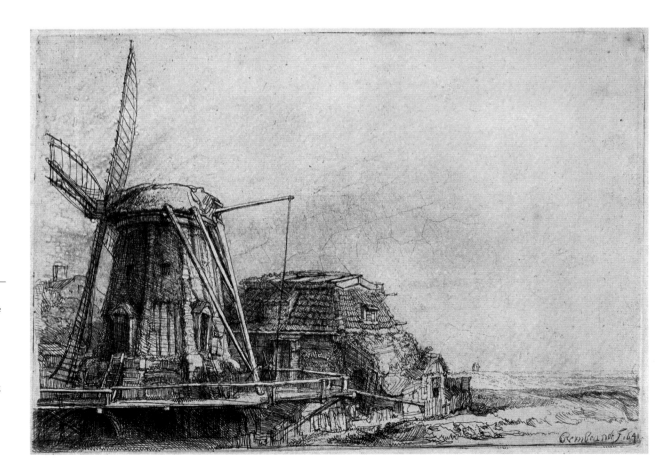

5 Doc. 1656/12. Schwartz 1985,
pp. 288–91, where the entries in the
inventory are arranged by category.
6 "Een schilderij sijnde een
berghachtigh landtschap, daerin
eenige personagien van Rynbrant
gemaeckt." Hofstede de Groot
1906a, p. 390, no. 325. The wording
leaves it unclear whether only the
figures or – more probably – the
entire painting was by Rembrandt.
7 Brown 1981, see references in
index, p. 168.

244

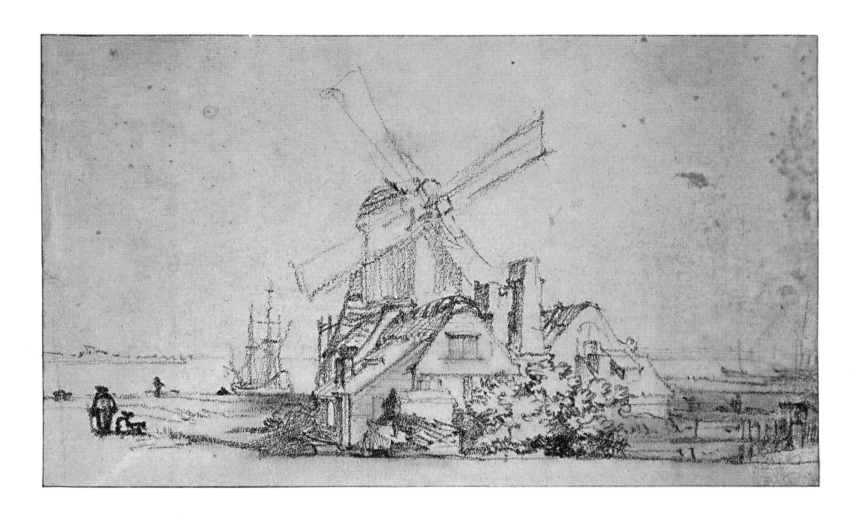

405
Rembrandt
*The windmill on the Blauwhoofd
bulwark in Amsterdam*
Unsigned, undated. Dated
variously ca. 1640 and ca. 1652
Oiled charcoal on brown tinted
paper, 16.6 x 27.5 cm.
Benesch 813
Rotterdam, Museum Boijmans
Van Beuningen

8 Schwartz 1996.
9 Benesch 785–88.

of Rembrandt's landscape paintings, the rate of survival
is about forty percent.[8]

How and where did Rembrandt make his landscape drawings?

In leaving the subject of Rembrandt's landscape paint-
ings for that of his drawings and etchings of the 1640s,
we are not leaving uncertainty behind us. The series
begins with a mysterious group of four drawings, two
of which bear Rembrandt's signature and date – 1640 –,
of places in London he probably never visited.[9] Why
Rembrandt should have drawn and signed these sheets
– or whether he did; some authorities question their
authenticity – is a mystery. This is a disconcerting
beginning to a discussion of more than 250 drawings
and etchings that lay a heavy claim to veracity. Nearly
all of them project an image of immediacy; in modern
scholarship they are examined very closely for their eye-
witness value. A case like the London drawings starts
us off on the wrong foot. Nonetheless, contemplating
many of these prints and drawings, it is nearly imposs-
ible to withhold one's belief that they are based on first-
hand observation. The 1656 inventory of Rembrandt's
goods puts it in so many words, describing "an art book
full of landscapes drawn from life by Rembrandt."

There is a recent tendency in Rembrandt studies to
force this issue. Scholars apply close reading techniques

and enhanced common sense in order to distinguish
between drawings made on the spot, copies of such and
compilations of on-the-spot motifs; entries in sketch-
books and loose drawings; inventions, adaptations of
work by other artists and visual reports; preparatory
drawings for etchings or paintings and independent
pieces; landscapes for the artist's own pleasure and
work for the market. Various criteria are related ad hoc
to these distinctions: materials, techniques and dimen-
sions; viewing point and perspective; the presence or
absence of particular landmarks; intangible qualities
of directness and remoteness; assumptions about the
artist's temperament. Sometimes this approach leads
to concrete and defensible conclusions. A minute
comparison of two drawings of a city gate in Rhenen
allowed Boudewijn Bakker to show that one of them
contained misunderstandings of the situation that
would not have been made by a draftsman working
on location, while the other was sensitive to the actual
disposition of the architectural elements (fig. 429).
However, for every success of this kind there are many
more instances in which close reading only ends up
in debatable speculations. In general, the available
evidence does not allow for conclusive solutions to such
questions. In the following remarks, I will be conserva-
tive in judging the function of specific drawings or the
exact degree of their verisimilitude.

A rule of thumb of which I remind myself from time to time is that the first aim of an artist like Rembrandt is to make a picture that can stand on its own, not to produce eyewitness testimony to be judged against facts on the ground. This applies to preparatory documents as well, such as landscape drawings. It does not mean that verisimilitude never matters. Whether it does or not depends on the market for which the work is intended. If buyers are going to judge a work of art against outside standards, the way they might judge a map or a botanical print, then the artist will take account of these. In Rembrandt's time one such demand was for historical accuracy; writers on art make fun of artists who use contemporary attributes for biblical subjects. Complaints about topographical fidelity are unknown to me. One telling indication that accuracy of this kind was not expected is that Rembrandt's landscape etchings all depict their motif in reverse. See below, p. 252.

such vagueness was unnecessary, and he set out to identify whatever locations he could. In a book he called Walks with Rembrandt – *Wandelingen met Rembrant in en om Amsterdam* in Dutch (1915) and *Mit Rembrandt in Amsterdam* in German (1920) – he succeeded in transforming a large number of generic landscapes into what he thought of as portraits of places.

Rembrandt the landscape draftsman was a more systematic worker than one would have thought, a professional who used his time quite economically. The views of particular locations tend to be bundled in the same period. Since few of Rembrandt's landscape drawings are dated, we are dependent on surmise in this respect, but right now that's the best we have. In each of the closest sectors – from 0–3 kilometers, 4–6, 7–9 and 10–12 kilometers – Rembrandt made about twenty drawings. In areas further afield but still on the map, fewer sheets have come down to us.

The chronology of his landscapes suggests that Rembrandt went out on no more working walks than required. He need not have left his house more than twenty times in the years 1649–54 to have created the seventy or so drawings of identified locations in the vicinity of Amsterdam from that period now given to him. The thirty drawings of spots in Amsterdam itself are concentrated in only seven of the thirty-eight

406
Jan Jansz. Dou (1615–82) and Steven van Broeckhuysen
Detail of map of the Rijnland
Extensively inscribed, dated 1647
Engraving in several plates
Haarlem, Teylers Museum

The dating and authorship of the landscape drawings attributed to Rembrandt do not pose any less of a problem than for the paintings. In one area, however, real progress has been made beyond clashing opinions. That is, in the identification of depicted places. Until the early twentieth century, these images bore titles such as *Cottages on a road* or *A windmill on a bulwark*. In 1915, the Dutch art historian Frits Lugt decided that

Detail of map by Dou and van
Broeckhuysen, from Schneider
1990, showing spots along the
Amstel River where Rembrandt
made drawings or etchings

years that he lived there. (From the Leiden period, no
representations of landscape are known.) There were
campaigns in 1640–41, 1646, 1649, 1651–52 and 1654.
This extreme focus, compared with the far more
diffuse chronological distribution of the other major
genres in his work, has implications for the role of
landscape art in Rembrandt's work. In particular, it
forms a challenge to the theory, which we will discuss
below, that Rembrandt created his landscapes out of
a deep personal need.

Rembrandt's working walks

Thanks to the efforts of Frits Lugt and his followers,
we can follow Rembrandt's footsteps on the ground.
In 1998, Boudewijn Bakker of the Amsterdam muni-
cipal archives, with his associates Erik Schmitz and
Jan Peeters, systematized and enriched our knowledge
of Rembrandt's topography in an outstanding book-
catalogue with the title *Landscapes of Rembrandt:
his favourite walks*. In a section called "Six walks to share
with Rembrandt," they lay out the following routes.
Behind each route I have filled in the number of
Rembrandt etchings and drawings included in that
section.

> Walks I and II: Through the inner-city streets [twelve
> drawings] and along the city wall [ten drawings,
> one etching]
> Walk III: From Amsterdam over the Diemer Dike
> to the village of Diemen [twenty-two drawings,
> two etchings]
> Walk IV: From Amsterdam to Ouderkerk along the
> river Amstel [thirty-three drawings, four etchings]
> Walk V: From Amsterdam along the Overtoomse-
> vaart to the villages of Amstelveen and Sloten
> [twenty-seven drawings, five etchings]
> Walk VI: From Amsterdam over the Spaarndammer
> Dike towards Bloemendaal in the dunes [five draw-
> ings, three etchings].

The furthest points on the country walks – Diemen,
Ouderkerk aan de Amstel, Amstelveen, Sloten,
Bloemendaal (or at least the neighboring Haarlem) –
were connected by passenger barge to Amsterdam,
so that Rembrandt only had to walk in one direction.
(Interestingly, nearly all the views were drawn with
Amsterdam behind the draftsman's back.)

In five of the six walks, there is a similar ratio
between the drawings and the etchings: from five to ten
drawings for each etching. This raises the suspicion that
a disproportionately large number of drawings on the
route of Walk VI have been lost. Certain imbalances
in the choice of motifs raise the same uneasiness.
On Walk IV, along the Amstel, there are hardly any
drawings from the picturesque stretch closest to home.
The gaps further along the route are fewer: Rembrandt
hit all the famous views along the way.

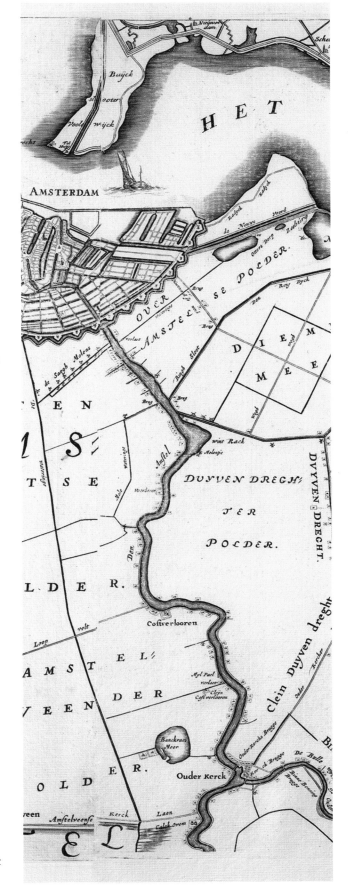

The Amstel then and now

The closest spot on the Amstel from Rembrandt's house was where the Blue Bridge (Blauwbrug) now crosses the river. In the artist's time, there was a bridge at the same location, from which he drew a panorama (fig. 408); adjoining the bridge on the far shore was a bulwark, where he drew another like it (fig. 410). Here they are compared with photographic montages showing the same locations today.

The view from the bridge is executed in pen-and-brown-ink and brush-and-brown-wash on parchment. With its rounded upper arch, a somewhat theatrical form that Rembrandt employed in several paintings as well, the drawing has the look of a presentation piece, the kind of sheet that might be framed and hung on the wall.

The angle of sight in figs. 408 and 410 is far wider than the rules of responsible draftsmanship (or photography) prescribe, but if an artist is out to get a broad stretch of nearby territory onto paper, this is the usual way to do it. The palisades that nearly join in midstream were part of the city's defenses. The gap between them would be closed at night. They are long gone. So is the row of piles along the shore that also formed part of the defensive structure known as the Amstel Barrier.

Compared with the present-day situation, only one element is still in place, the bridge (now a drawbridge) on the left of the lower drawing, leading to the canal that after Rembrandt's time was named the Nieuwe Herengracht. All the other features of the riverbank and construction on its edge have undergone total transformation. The marina for pleasure craft on the left of the upper drawing, the windmills, the irregular riverbank, all are gone. The somewhat industrial atmosphere of this end of the Inner Amstel has been replaced by a completely urban environment. Nonetheless, the location is still recognizable, and the Blue Bridge is still a spot from which visitors make views.

408
Rembrandt
The Amstel from the Blauwbrug
Unsigned, undated.
Ca. 1649–50
Pen and black and brown ink,
brush and black and brown
wash on prepared vellum,
13.2 x 23.1 cm.
Benesch 844
Amsterdam, Rijksmuseum

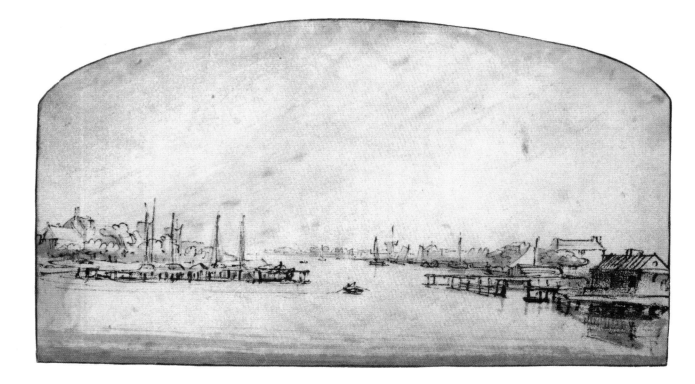

409
Photograph of the location in
fig. 408, 2004

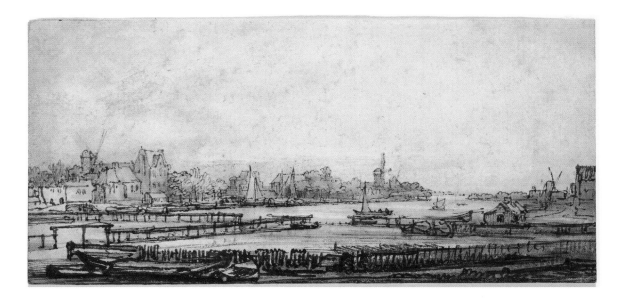

Not a cloud in the sky

The juxtaposition of Rembrandt's drawings with new photographs teaches us an important thing that has nothing to do with topography but a lot with landscape: Rembrandt almost never draws clouds. He hardly etches them either. Only in three of his 24 landscape etchings do clouds appear at all. In his paintings, on the other hand, clouds play a major role. Strangely, while writers on Rembrandt like to expand on his dramatic use of clouds in paintings like *Christ in the storm on the sea of Galilee,* they remain silent on the cloudlessness of the great majority of his landscape drawings and etchings. As it happens, we have an authoritative interpretation of cloudlessness in landscape, by none other than Karel van Mander. Addressing his fellow artists of the Netherlands at the turn of the seventeenth century, van Mander wrote in his didactic poem on the art of painting:

"More than one foreign nation accuses us of never painting good weather, but always [depicting] stormy skies full of clouds ... So let us, to avoid that disapproval, divest our skies of clouds and sometimes show them completely clear."[10] Rembrandt a sunny-sky artist? Rembrandt an artist who took preventive measures to avoid criticism from outsiders? This image of the artist takes a little getting used to, but in his landscapes on paper, there it is: when it came to working outdoors, Rembrandt was a fair-weather man. In his drawings and etchings, there are hardly any trees bent in the wind or figures fighting the elements. The reflections on the water are untroubled, with only mild ripples. In only one etching, *The three trees,* is there a hint of rain. In keeping with this, Rembrandt was not an outdoorsman of all seasons. With few exceptions, it is always summer in Rembrandt's landscapes, generally a sunny summer. When there are trees in his drawings, they usually have a full head of leaves.

10 *Den grondt der edel vry schilder-const,* fol. 35v, chap. 8, par. 15–16, in Miedema 1973, vol. 1, pp. 208–09; vol. 2, pp. 545–46.

412
Rembrandt
The former copper mill on the Weesperzijde
Unsigned, undated.
Ca. 1654–55
Reed pen and wash in bistre,
11 x 24.2 cm.
Benesch 1356
Vienna, Albertina

413
Rembrandt
View across the Amstel to the Bergenvaarderskamer
Unsigned, undated. Dated variously early 1640s or mid-1650s
Pen and brown ink,
10.9 x 17.7 cm.
Benesch 798
Wrocław, Ossolineum

414
Rembrandt
De Omval (The Tumbledown)
Inscribed *Rembrant 1645*
Etching and drypoint,
18.7 x 22.7 cm.
Bartsch 209 ii(2)
Haarlem, Teylers Museum

steep gables, the right one higher than the rest. Two pen drawings of this location (figs. 412–13) add up when laid side to side to a panorama of the Outer Amstel, with a windmill at a former copper plant on the left and the Bergen-goers Chamber on the right.

The discovery that the two sheets belong together was not made until 1998, by Boudewijn Bakker. He does not claim that they were intended to be viewed together, calling it probably unintentional that they add up to a panorama of this spot on the Amstel. Yet, one is brought up short by the fact that in the standard catalogue of Rembrandt's drawings, by Otto Benesch, the right sheet is dated ca. 1640–41 and that on the left ca. 1654–55. Perhaps paper research can determine whether or not these datings should be joined. If that is the case, the later date would be the more likely one to prevail, since it fits well into a group of similar sheets.

The sublime and the ridiculous at De Omval

The first bend of the Amstel outside Amsterdam presented Rembrandt with a constellation of features – an inn, a number of windmills, farmhouses and factories on the river and a small island, a canal cutting off from the Amstel into the new polder of Watergraafsmeer, picturesque vegetation – that captivated him. The name of this spot contributed to its magic. It is called De Omval, The Tumbledown, an old name even in Rembrandt's time. It was a favorite destination for holidaymakers and it had a reputation as a lovers' lane as well. Rembrandt's first depiction of the place, one of his best-known etchings, assured the Omval of lasting fame.

Two drawings of the guild hall of the Bergen merchants and their dates

Continuing along the Amstel on Walk IV, the only identified subjects in the three kilometers between the Blue Bridge and the Tumbledown (De Omval) is an inn on the west shore known as the Bergen-goers Chamber (Bergenvaarderskamer). The name refers to the shippers who traded with Bergen in Norway and who established their guild headquarters here in the sixteenth century. The buildings are recognizable from the juxtaposition on a riverbank of four adjoining houses with

415
Rembrandt
The Omval seen from the Amsteldijk
Unsigned, undated. Ca. 1653
Pen in brown, brush in brown and gray, on gray-brown paper, 10.8 x 19.7 cm.
Benesch 1321 recto
Formerly Chatsworth, collection of the Duke of Devonshire. Present whereabouts unknown

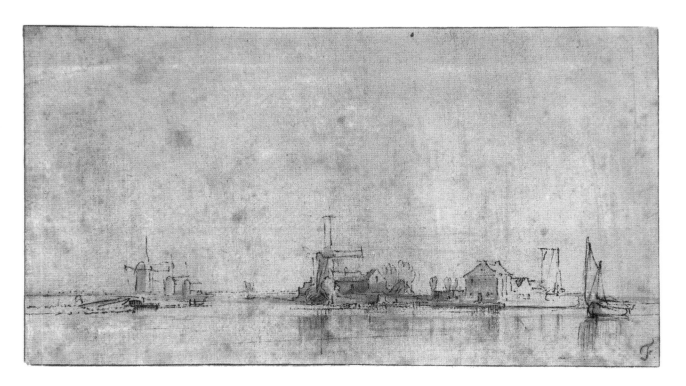

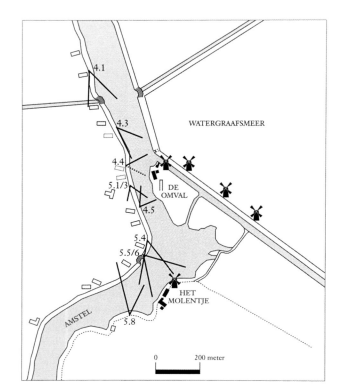

416
Erik Schmitz
Reconstruction of the area
around the Omval about 1650,
with indications of the viewing
points of the drawings and
etchings Rembrandt is known
to have made there[11]

417
Rembrandt
Detail of *De Omval* (fig. 414),
reproduced in mirror image
Haarlem, Teylers Museum

11 Bakker et al. 1998, p. 266.

available for re-reversing the image, but Rembrandt never used these. As a result, his topographical and presumably all his other subjects are mirrored right to left.

The viewing point for the etching is at number 4.4 of Erik Schmitz's drawing. Rembrandt stood on the west shore of the Amstel, looking straight at the mouth of a major crossroads in the Holland system of water routes. It was here, in the canal between the Watergraafsmeer and the Omval, that the water route between Amsterdam and the industry towns of Muiden and Weesp joined the Amstel. The dotted right line in the angle of point 4.4 stands for the willow blocking the edge of the view. A reversed reproduction of the etching shows the situation more clearly (fig. 417). The view across the stream must have been based on an earlier drawing like that from the Chatsworth collection. As the many angles in Schmitz's map show, Rembrandt came back several times to this spot, a mere forty-five-minute walk from his house.

Rembrandt's take on the Omval looks unassuming, but it is phenomenally rich. Upstaging the Watergraafsmeer Ring on the opposite shore is a fascinating old willow in the throes of death and revivification. Enclosed within the hollow of the trunk, barely visible at first sight, is a young woman, leaning with her back against the tree, while a young man raises a wreath to place on her head. Between these emblems of industry and pastoral love is a man looking out over the water, while a small pleasure craft floats by. The etching is an elegant summary of various functions of the Amstel: a lovers' lane, a waterside path for constitutionals and promenades, a river for recreational boating, a conduit for industrial traffic, an inn for Amsterdamers and, indicated by the windmills, the mouth of a major polder project that turned a lake into a large new development for country houses and factories. The post in the foreground signifies that the path along the Amstel, which served as a towpath for barges plying the river to Ouderkerk and from there to Utrecht, was also a thoroughfare for coaches.

The arrangement of these elements seems to embody a certain message. The willow tree, with its living and dead trunks, can be interpreted as a symbol of the cycle of birth and death in nature and in human life. The love of the pair in the shadows embodies the physical passion that drives the cycle. Rembrandt bounds the rest of human activity, manifestations of what people do during their time on earth, by this tree of life and death. Although there are no explicit references to an afterlife or to Christian belief, the hint of metaphysical meaning in the scene brings to mind thoughts of God as the creator of the world and of the eternity that waits beyond death.

The motif of the dead tree with living shoots, as it occurs in the etchings of the Omval and *St. Jerome* (fig. 418), was undoubtedly prepared by Rembrandt in drawings such as a sheet in Turin (fig. 419). Yet I must confess to a measure of doubt concerning the authorship of this particular drawing.

Thanks to the precision of Erik Schmitz of the Amsterdam Municipal Archive, Rembrandt's position on the ground when making this etching can be determined with great exactitude.

Or at least as much exactitude as Rembrandt and Time allow. Rembrandt's share in creating difficulties begins with directionality. In the normal method of making an etching – copying a preparatory drawing onto a plate and printing the plate – the direction of the subject is reversed. There were various techniques

418
Rembrandt
St. Jerome beside a pollard willow
Inscribed (in the second state)
Rembrandt f. 1648
Etching and drypoint,
18 x 13.3 cm.
Bartsch 103 ii(3)
Haarlem, Teylers Museum

419
Rembrandt or artist close to him
Study of the trunk of a pollard willow
Unsigned, undated. Ca. 1645–48
Pen and bistre, 16.8 x 14.2 cm.
Benesch 852a
Turin, Library

A similar tree of life and death appears in an etching of three years later, which although it is a religious image counts as a landscape as well. In *St. Jerome beside a pollard willow,* the tree provides shade for the bespectacled scholar-saint, with his skull and his lion. In this case, the American art historian Susan Donahue Kuretsky has shown how the emphatic juxtaposition of St. Jerome with a tree fits into a specific system of Christian meanings, the doctrine of redemption through faith.[12] The very name of the saint in Latin, Hieronymus, was said to mean Holy Tree. Whether it is legitimate to apply equally heavygoing associations to an image without overt Christian references is a moot point. In the case of *De Omval* I am inclined to do so.

If the tree in *De Omval* generated thoughts of death and resurrection in Rembrandt and his audience, the locale in which the scene is placed assuredly reminded them of more frivolous subjects. Another American art historian, Rodney Nevitt, has demonstrated that in songbooks and popular poetry of Rembrandt's time the Omval and the Diemermeer (Diemen Lake) "had not merely recreational, but specifically amorous associations."[13] The title print of *Amsteldams Minne-Beekje* (Amsterdam's Love Stream, first published in Amsterdam in 1637) combines many of the features of Rembrandt's etching: a couple in pastoral guise, a view of an inn and windmill across a river in a specifically Amsterdam location. One of the later printings came out in 1645, the year of Rembrandt's *Omval*. The deepest reflections in *Amsteldams Minne-Beekje* express such thoughts as these, in a lyric first included in the 1645 edition:

> Thus I turn along the Amstel streams
> Towards the Diemermeer,
> Where once I much enjoyed
> The dear light
> Of your countenance.
> Green alder trees
> Where once my love appeared;
> To the pleasure of my field-goddess,
> Where the Diemer-streams
> No longer flow, but a rivulet
> Of tears, in witness to my love.[14]

420
Title print of *Het eerste deel van 't Amsteldams Minne-Beekje ...,* Amsterdam 1637

12 Kuretsky 1974.
13 Nevitt 1997, p. 173.
14 Nevitt 1997, p. 177.

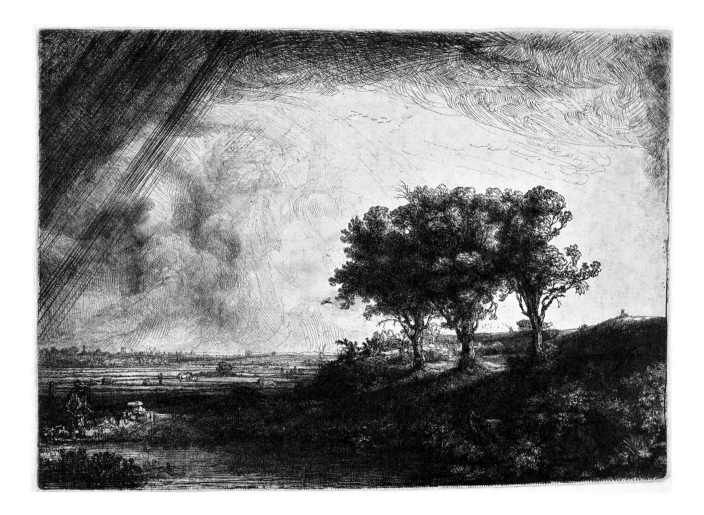

421
Rembrandt
The three trees
Inscribed *Rembrandt f. 1643*
Etching with drypoint and
burin, 21.3 x 27.9 cm.
Bartsch 212 i(1)
Haarlem, Teylers Museum

Whatever else, then, the first viewers of Rembrandt's etching might have thought of when first seeing the print, it was unavoidable that they also be reminded that the place was a byword for outdoors lovemaking.

Of course, viewers have to find the couple before thinking those thoughts. At first sight, you do not see them, hidden as they are in the foliage. I am convinced that all but a few viewers have to have this detail pointed out to them, either by a gleeful collector or by a dutiful art historian, before they notice them.

The same applies to the lovers in *The three trees,* who "are not merely inconspicuous, but are hidden" in the dark enclosure to the right.[15] Because they cannot be seen in a normal reproduction, I have outlined their form in a detail.

On the opposite side of the scene is another couple, who although they are not in an embrace contribute to the erotic overtones of the scene. He is a fisherman with his line in the water, she seated beside him on the bank with a basket. Nevitt compares this constellation with a number of captioned prints in which couples are shown in the vicinity of fishermen. The captions invariably play on the suggestive connotation of fishing as seduction and intercourse. In one print of this kind, a seemingly innocent riverside scene by Jan van de Velde, the accompanying verse reads:

422
Rembrandt (retouched)
Detail of *The three trees*
(fig. 421), with lovers in the
shadows darkened
Haarlem, Teylers Museum

In silence is it best to fish with rod and line;
The fish is surprised, deceived by the hook.
So is it with love; sooner than one might guess,
The skirt is in the net, caught by the angling of the trousers.[16]

15 Nevitt 1997, pp. 168–69.
16 Nevitt 1997, p. 167.

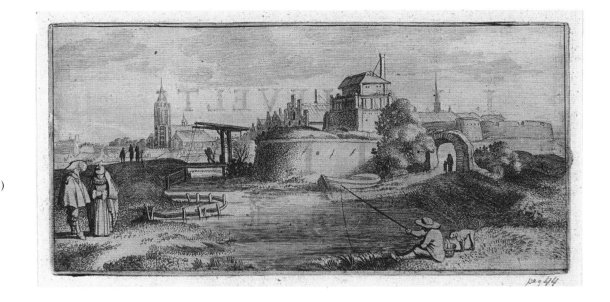

The engraver of this print was the Haarlem artist Jan van de Velde II (1593–1641), whose work Rembrandt respected, as we have seen above in the case of *The good Samaritan* (figs. 12–13). What's more, he also knew the poet of the lines it illustrates. The rhyme and print were published in 1627 in an elegantly produced songbook entitled *Amsterdamsche Pegasvs.* One of the poet-editors of the volume, whose name appears above this page, was Jacob Jansz. Colevelt. Poetry was a hobby of Colevelt's. His profession was surgery, and in this capacity he was portrayed in 1632 by Rembrandt as the leftmost, somewhat bleak auditor of the *Anatomy lesson of Dr. Nicolaes Tulp.*[17]

The down-to-earthness of this motif puts pressure on more solemn theories concerning *The three trees.* To one scholar "the three sturdy trees … seem reminis-cent of the three crosses at the crucifixion of Christ as darkness fell (compare the *Three crosses*)."[18] Since *De Omval* seems to combine pastoral love with a meta-physical message, this is not impossible. However, the combination of a couple making out in the shrubs with the *Crucifixion* exceeds my own conception of the limits of Rembrandtesque iconography.

Outdoors printmaking?

That lovemaking sometimes takes place out of doors is beyond doubt. Concerning printmaking in Rembrandt's time dispute is possible. Of complex compositions like *De Omval* and *The three trees*, no one would imagine that the artist etched them on the spot.

17 Heckscher 1958, pp. 188–91.
18 Hinterding et al. 2000, p. 207, no. 48.

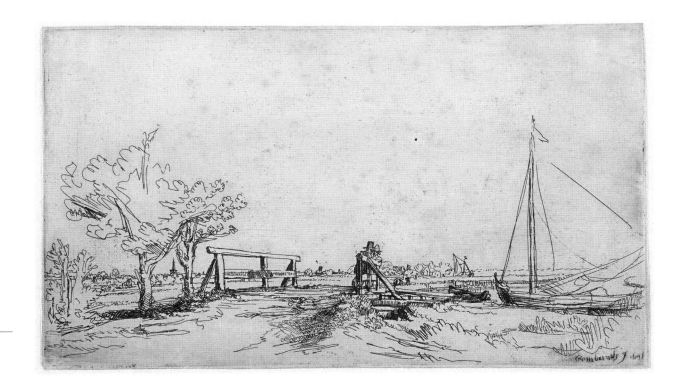

However, Rembrandt's etchings include simpler landscapes, and concerning at least one of these, it was said early on that it was etched directly on the plate out of doors. The print is dated in the same year as *De Omval*, 1645, a very good year for the landscape etchings. Since 1731, it has been known as *Six's bridge*, although the country estate depicted is more likely to have been Klein Kostverloren on the Amstel, which in 1645 belonged to Albert Coenraetsz. Burgh (1593–1647), to whom we shall return below. The spot is further along the Amstel on the road to Ouderkerk, which can be seen on the horizon to the left. It was about an hour and a half by foot from Rembrandt's house.

In 1751, the posthumous catalogue of Rembrandt's etchings by the Paris art dealer and auctioneer Edmé-François Gersaint (1694–1750) included in the entry on *Six's bridge* the toss-away remark that Rembrandt "avait toujours des planches toutes prêtes au vernis" (always had plates prepared with varnish – prepared, that is, for drawing onto the etching ground).[19] It accompanied a little illustrative story concerning the print itself, namely that Rembrandt made it on a bet that he could produce the etching before a servant returned from buying a pot of mustard in a nearby village. He took the bet, wrote Gersaint, because he knew how slow Dutch servants could be: "quand ils répondent 'anstons', que veut dire toute à l'heure, employent au moins une demie-heure sans paroître" (when they say "aanstonds," meaning right away, they disappear for at least half an hour – in other words, the story is not so much about Rembrandt's speed as about his cleverness).

The question of whether or not Rembrandt actually made some of his landscape etchings out of doors has been hotly disputed since. The Gersaint party is still quite outspoken. "Most of Rembrandt's informal etched landscapes," Martin Royalton-Kisch writes, "belong to the majority category of his etched work as a whole in having been executed straight on to the plate, without any preparation in drawings."[20] Landscape prints made in this way, he surmises, are more likely to have been made on site than from mem-

ory in the studio. He adduces the detailed quality of certain etchings as evidence that they were etched in front of the subject, while admitting that "no written seventeenth-century text confirms that artists took etching plates out of doors."

Boudewijn Bakker takes a different tack. He observes that of Rembrandt's twenty-six landscape etchings, five combine motifs from different locations and another five are based on fantasy. These can only have been made in the studio. Of the remaining sixteen plates, Bakker writes of five that "drawings have been preserved which were used in the preparatory process."[21] (Royalton Kisch only includes two drawings in this category.) If one then subtracts the complex compositions that Royalton-Kisch too agrees could not have been made spontaneously, this leaves only a handful of prints as candidates for plein-air etchings. The absence of obvious preparatory drawings for these plates, however, cannot be construed as evidence that Rembrandt must have worked directly on the plate. As we have seen, we must assume a fairly large percentage of loss in his drawings. All things considered, it seems to have been more the rule than the exception that Rembrandt created his etchings in the studio. There is indeed a good reason why *Six's bridge* should be such an exception. It was made on a private estate, where the artist could concentrate without being jostled and disturbed by kibitzers. Most of the identifiable sites etched by Rembrandt were on busy intercity routes.

The drawings

In following these arguments about Rembrandt's etchings, it is no wonder that we have not looked at many drawings. It is a peculiar fact that the order in which Rembrandt produced his evocations of landscape proceeds by and large from paintings to etchings to drawings. The bulk of Rembrandt's landscape drawings were made at a time when he had stopped painting landscapes and after most of his etchings had been made.

Graph 11
Number of paintings, etchings and drawings in Rembrandt's landscapes, by decade

19 Hinterding et al. 2000, p. 209, no. 49.
20 Hinterding et al. 2000, p. 75.
21 Bakker et al. 1998, p. 30.

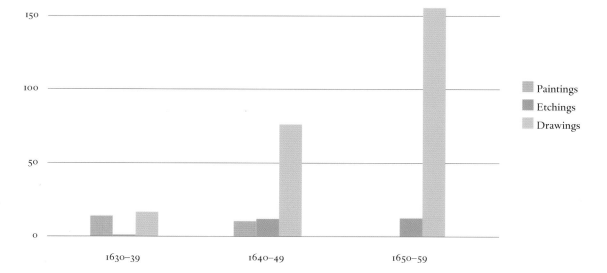

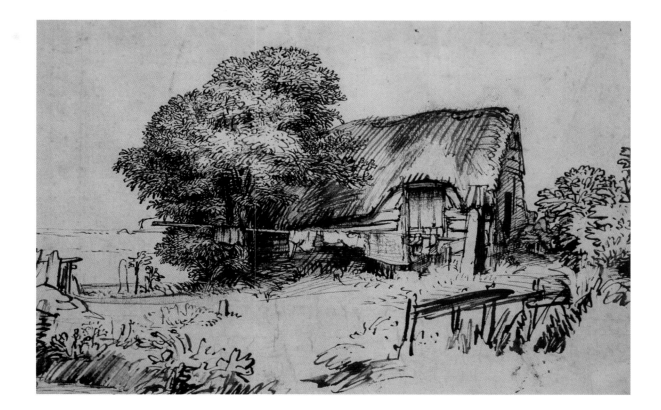

425
Rembrandt
Thatched cottage with tree
Unsigned, undated. Ca. 1650
Reed-pen and brown ink, in
parts rubbed with the finger,
17.5 x 26.7 cm.
Benesch 1282
Chatsworth, Devonshire
Collection

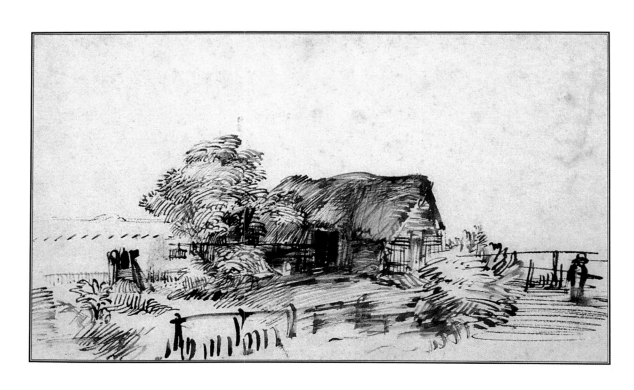

426
Artist close to Rembrandt,
perhaps Willem Drost
(1633–59)
Thatched cottage with tree
Unsigned, undated. Ca. 1650
Reed-pen and brown ink,
15.5 x 26.1 cm.
Benesch 1283 (as Rembrandt)
Wrocław, Ossolineum

Whereas one might expect Rembrandt the landscapist to have started off by producing a store of drawings to mine in years to come for paintings and etchings, he did something like the opposite. (That is, if the existing sheets survived in equal measure in all periods.) His production of landscape drawings grew as the paintings diminished, and the etchings first grew and then fell off.

This process could not yet be predicted in 1640, when Graph 11 shows the second spike in the frequency of

landscape in Rembrandt's production. As Bakker has observed, there was something in the air that year. I quote his list of Amsterdam artists who for the first time in the 1640s began to draw out of doors.

Not until the 1640s did outdoor drawing in this Amsterdam circle receive a new unexpected boost with the appearance not only of Rembrandt but also a group of talented draughtsmen and etchers such as Anthonie Waterloo, Jan Abrahamsz Beerstraten, Simon de Vlieger and – of the younger generation –

Reinier Nooms alias Zeeman and Rembrandt's young friend, Roelant Roghman. It wasn't long before these names were joined by a large group of landscape artists who had been pupils of Rembrandt or were strongly influenced by his artistic style: Ferdinand Bol and Govert Flinck, Gerbrand van den Eeckhout, the Koninck brothers, Lambert Doomer, Abraham Furnerius and Johannes Leupenis, Jan Lievens, and many more.[22]

Landscape drawing seems to have become an important part of Rembrandt's teaching, perhaps even of professional socializing. A surprising number of his drawings have such close equivalents in the work of pupils or colleagues that we assume them to have been made at the same time. Rembrandt's walks were not all solitary. Even some of his most private-looking drawings were made in the company of another draftsman.

A drawing of a modest cottage in Chatsworth (fig. 425) has a near twin in a sheet in Wrocław (fig. 426) that was drawn a few feet behind and to the right of where Rembrandt was sitting. The latter is executed with so much less finesse and with so many fewer varieties of stroke and effects that it is attributed to a pupil, perhaps Willem Drost. As likely as it seems that the drawings were made at the same sitting, this is not necessarily the case. One little difference in the motif is found in the wash hung out to dry. There is more of it in Rembrandt's drawing than in the pupil's. The comparison of these two drawings is indicative of the direction in which the connoisseurship of Rembrandt's drawings is moving. Until the 1980s both drawings

were given to Rembrandt. The re-attribution of the drawing in Wrocław to Willem Drost was proposed by Werner Sumowski, who has spent half a lifetime working on the paintings and drawings of Rembrandt's pupils and collaborators. Once the differences in exactitude and sensitivity have been pointed out, the sheet in the Polish collection indeed looks less good than when it is viewed less critically. The problem is then to decide to what extent differences such as these oblige or permit the connoisseur to remove a drawing from Rembrandt's oeuvre.

Landscape and love life

Whatever professional reasons Rembrandt may have had for practicing landscape, no matter how fond he was of the genre, a number of personal motives make themselves felt in his choice of subjects and the intensity of his involvement with landscape. These have to do with the women in his life and with his ties to certain Amsterdam patricians.

The most tenuous of these ties concern Saskia and her Frisian background. Certain cottage types in Rembrandt drawings of the 1630s, it has been suggested rather diffidently, could point to a trip by Rembrandt to that province. The drawings on vellum from the mid-1630s (figs. 387–88) fall in this category.

Concerning the second known woman in Rembrandt's life, Geertge Dircx, we have a more concrete indication. A small drawing in the Ashmolean

427
Rembrandt
The church of Ransdorp in Waterland
Unsigned, undated. Here dated to spring or summer 1650
Pen and Indian ink,
13.1 x 8.9 cm.
Benesch 1310
Oxford, Ashmolean Museum

428
Photograph of the church of Ransdorp, somewhat repaired since the seventeenth century, December 2005

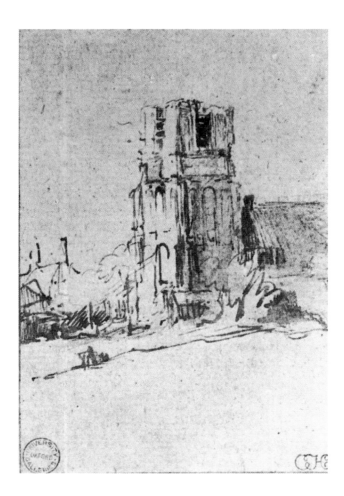

22 Bakker et al. 1998, p. 22.

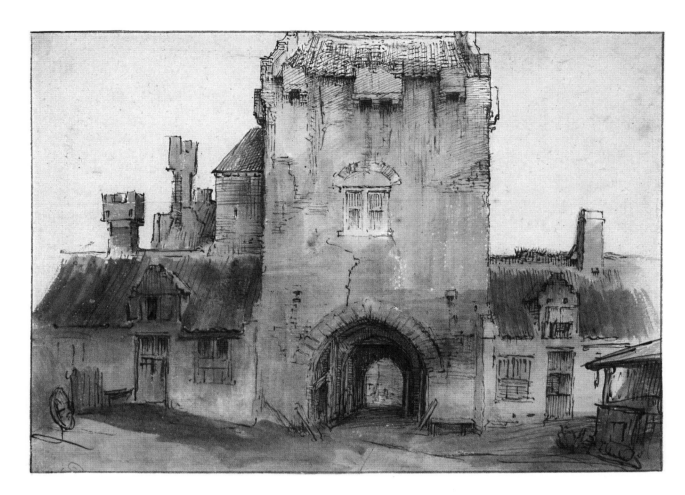

429
Rembrandt
The Westpoort at Rhenen
Unsigned, undated. Late 1640s
Pen and brown ink and wash
with touches of white,
16.8 x 22.6 cm.
Benesch 826
Haarlem, Teylers Museum

Museum in Oxford shows the unmistakable contours of a church north of the IJ River across from Amsterdam (fig. 427). It is one of only two drawings Rembrandt is known to have made in this part of Holland. While he ventured east, west and south from his dwelling, he showed no interest in the area to the north. Except for this drawing and one of the same area, of the same date, from across the River IJ.

The village of Ransdorp, or Rarep as it is called by the locals, occurs in the Rembrandt documents in a distinctly unhappy context.

On 28 April 1650, Giertje dircx, widow of the sailor Abram Claesz, residing on Rapenburgh [Island in Amsterdam], above the [sign of the] Swarte Bottje [The Black Bone], and about to move to Rarep, appeared and declared most vehemently that she appoints and authorizes – as she does herewith – her brother, Pieter Dircx and her cousin by marriage, Pieter Jacobs, jointly to take charge of, prosecute and further her cause, rights, and just claims against and toward anyone . . .[23]

Anyone . . . The person against whom Geertge had "just claims" was Rembrandt. On 23 October 1649 the courts in Amsterdam had ordered him to pay her two hundred guilders a year for the rest of her life, for breach of promise.[24] In empowering her brother to look after her interests, Geertge was attempting to protect her interests in case Rembrandt failed to comply with the court order. There was much worse to come for her. Between April and July 1650, Rembrandt and Pieter Dircx, the

brother Geertge trusted, collected testimony about her behavior from her neighbors and in July had her committed to a penal institution in Gouda, where she remained until 1655.[25]

These facts seem to have bearing on Rembrandt's drawing of the church town of Ransdorp. Otto Benesch dates the drawing on stylistic grounds ca. 1652–53. In terms of Rembrandt's biography, this is two years too late. Rembrandt's visit or visits to Ransdorp will have taken place between April and July 1650.

The Geertge Dircx affair had another, far more significant meaning for Rembrandt's landscape drawings. The year 1649, a nightmare year for Rembrandt and Geertge, filled with conflict and court cases, is the only year from the beginning of his career in 1625 until his death in 1669 when not a single painting, drawing or etching is dated. However, as Graph 10 shows, it marks the beginning of Rembrandt's most intensive activity as a landscape draftsman. If the beginning of Rembrandt's activities as a landscape draftsman in 1640 were part of a general trend, the intensification of this branch of his art may well have been due to a need to get out of Amsterdam in order to clear his mind.

The only known drawings by Rembrandt further than one day's journey from Amsterdam, aside from one view possibly made in Dordrecht and a cottage drawing in Hilversum,[26] also seem to have their basis in the artist's love life. Around 1647 and again in 1652 are a scattering of drawings made in Amersfoort, Utrecht and Rhenen and a disputed depiction of a spot

23 Doc. 1650/3.
24 Doc. 1649/9.
25 Docs. 1656/4–5.
26 A drawing clearly showing the tower of the Grote Kerk in Dordrecht, datable about 1641, is Benesch 802. The location is inscribed on a copy after the drawing by Lambert Doomer (Fondation Custodia). See van Berge 1997, pp. 82–84 no. 34.

in Arnhem. All these places lie on the way from Amsterdam to the family home of Rembrandt's third woman, Hendrickje Stoffels, in Bredevoort. To judge by the dates assigned to the drawings, in 1647 he would have taken the route via Amersfoort and in 1652 via Utrecht, passing both times through Rhenen.

These thoughts might seem to be excessively romantic, even anachronistic. Actually, they pertain to one of the few areas of Dutch life that was associated at the time itself with personal feelings. Faced with reverses in love (or money matters, an increasing problem for Rembrandt in 1649), a Dutchman of the day would be urged by his friends to seek powerful diversion in recreational activities. They could be sought in theatergoing or telling jokes, but walks in the country too were recommended constantly in poetry as a remedy for cares and woes. For an approaching bout of melancholy, which Rembrandt had every reason to fear in 1649, everyone would have advised him to leave the city. That he took paper, pen and ink with him – well, what artist would not?

430
Rembrandt
Detail of *Joannes Wtenbogaert*
(fig. 376)
Haarlem, Teylers Museum

Country houses and Rembrandt's finances

Few of the identified locations in Rembrandt's etchings and drawings are occupied houses or estates. The first example associated with a name is the famous etching of 1645 known since the eighteenth century as *Six's bridge* (fig. 424). There is a good argument to be made for locating this site on an estate just north of Ouderkerk, the church tower of which appears on the left, framed between the two trees. In 1915, Frits Lugt suggested very speculatively that the bridge stood on an estate named Klein Kostverloren, that the owners of the property were the Burgh family and that the two men on the bridge are Albert Coenraetsz. Burgh (1593–1647) and his future (from 1650 on) relative by marriage Jan Six (1618–1700). Even though Jan Six never owned Klein Kostverloren, this theory establishes a link between him and the traditional name of the etching.

Lugt emphasized rightly that his idea is more than a little hypothetical. Nonetheless, it is worth adding that Rembrandt did have real ties to both these men. Among his many offices, Albert Coenraetsz. was a governor of the Kloveniersdoelen.[27] He was therefore one of the officials behind the commission to Rembrandt of the *Night watch*. And Jan Six was Rembrandt's friend, patron and creditor (see pp. 193–94).

Whatever the likelihood that the two figures in *Six's bridge* are Burgh and Six, two other landscape etchings by Rembrandt and a larger number of drawings from mid-century certainly are connected with significant figures in the artist's life. These men were Joannes Wtenbogaert and Christoffel Thijsz.

Wtenbogaert, the legendary "Goldweigher" of Rembrandt's allegorical portrait print of 1639 (fig. 430), was one of the most powerful money men in the Republic. In 1638 the States-General appointed him receiver-general of taxes in North Holland, a territory that included Amsterdam, the wealthiest city in Europe at the time. From then on the stadholder himself was dependent for about half his income on Wtenbogaert and his bureau. In a system that gave government functionaries lots of elbow room, this job offered great opportunity for self-enrichment. Wtenbogaert made judicious use of his chances. The arts benefited. Wtenbogaert's town and country houses, furnished with costly collections of paintings, prints and drawings, were gathering places of artists and poets. There was Herengracht 108, a stately townhouse, and then there was Kommerrust (Repose from Care) in the woody area near Naarden.

Rembrandt's relation with Joannes Wtenbogaert might have begun as early as 1626, when Wtenbogaert came to Leiden to study. He lived in rented rooms in the house of Rembrandt's relative Hendrick Swaerdecroon. In any case, the tie was close enough by 1639 for Rembrandt to have been able to call upon the (tax) collector for help in a very delicate matter: twisting the arm of Constantijn Huygens for payment for two expensive paintings. In the same year, Rembrandt created an etched portrait of Wtenbogaert that has

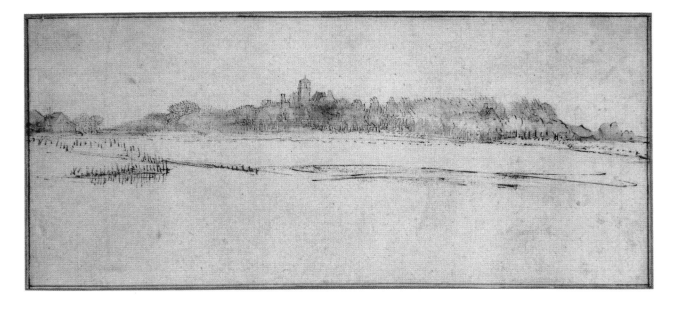

431
Rembrandt
*Landscape with trees, farm
buildings and a tower*
Unsigned, undated. Ca. 1650
Etching and drypoint,
12 x 31.9 cm.
Bartsch 223 iv(4)
Haarlem, Teylers Museum

432
Rembrandt
*The House with the Tower,
seen from across the Schinkel*
Unsigned, undated. Ca. 1650
Pen and brush in brown,
9.8 x 21.6 cm.
Benesch 1267
Los Angeles, J. Paul Getty
Museum

27 Elias 1903–05, vol. 1, pp. 327–31,
no. 106 (Albert Coenraetsz.) and
pp. 453–54, no. 158, his son
Coenraed Burgh.
28 Dickey 2004, pp. 70–75.
Dickey has added persuasive new
evidence for the identification of the
figure in the portrait etching as
Wtenbogaert, which is still not
absolutely clinched.
29 Dudok van Heel 1978, p. 164.

always been one of the great conversation pieces in
Rembrandt's work.[28] The fascination lies in the ambi-
guity of the image. The anecdotal portrait of a man
at his work is troubled by the rather emphatic but not
readily decipherable symbolic look of his dress, which
seems to date from the sixteenth century, and attrib-
utes, including the big scales and the painting of the
Brazen Serpent. The print has had a rocky reception
history. The sitter became a figure of fun for his sup-
posed avarice; some critics have even doubted whether
the plate was executed by Rembrandt at all.

Rembrandt also drew and etched one and perhaps
two country houses belonging to Wtenbogaert. In 1731,
the well-informed collector Valerius Röver noted of one
of his Rembrandt etchings that it depicted "the country
house of Uitenbogaert outside Naarden."[29] That would
be Kommerrust, the house to the east of the city, where
the collector held court to an entourage of artists and

poets. None of the landscape etchings has as yet been
identified as Kommerrust; indeed there is no likely can-
didate. Perhaps Röver was after all in error, confusing
the house near Naarden with another property belong-
ing to the tax collector, west of Amsterdam. This has
been identified with considerable certainty as the
House with the Tower, which occurs in one drawing
and three etchings of about 1650.

In the marvelously delicate drawing (fig. 432), we see
the small estate – "an unostentatious but thoughtfully
designed country house . . . built in the early seven-
teenth century . . . and a sizeable farmhouse" – from
across an old canal called the Schinkel, near the present
Overtoom. The most characteristic feature of the com-
plex is the tower that gave the estate its name. "This
tower," writes Boudewijn Bakker, "had rooms at the
upper level with windows on all sides and a domed roof
culminating in a spire."

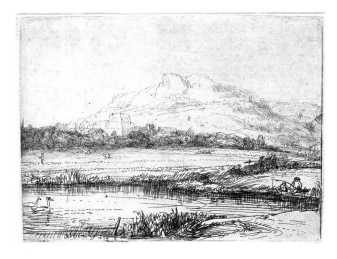

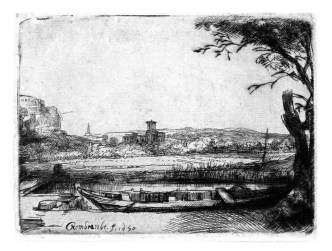

None of the three etchings into which Rembrandt incorporated the House with the Tower is as straightforward as the drawing. In an undated etching of around this time (fig. 431), the lightly-drawn house, placed in the right background, is set off by a more heavily modeled farmhouse that actually stood a few hundred yards from it. Most remarkably for an etching with some claim to topographical accuracy, however, the house in the *Landscape with trees, farm buildings and a tower* undergoes a remarkable transformation between the second and third states. The dome and spire that were still there in the first state, as in the drawing (though in slightly different form) are now

removed, leaving only a square tower. This is the same kind of manipulation Rembrandt performed in drawings of two towers in his neighborhood, Svygh Wtrecht (fig. 436) and the Montelbaanstoren (fig. 435). What did the man have against spires?

More remarkable yet are Rembrandt's references to The House with the Tower in two etchings dated 1650. In these plates, Wtenbogaert's estate is relocated from the flat outskirts of Amsterdam to river valleys of different kinds. In *Canal with a large boat* (fig. 434) the house, with semi-abbreviated dome and spire, is featured in the center of the composition, near a jagged cliff on the left. Between them the tower of a church

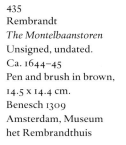

436
Rembrandt
The tower called Svych Wtrecht
Unsigned, undated.
Ca. 1654–55
Pen in brown, 16.6 x 23.5 cm.
Benesch 1334
Amsterdam, Rijksmuseum

437
Rembrandt
*Panorama near Bloemendaal
with Saxenburg House
("The goldweigher's field")*
Inscribed *Rembrandt 1651*
Etching and drypoint,
12 x 31.9 cm.
Bartsch 234 i(1)
Haarlem, Teylers Museum

breaks the distant, hilly horizon. The House with the Tower lies further back in the space of the *Landscape with an angler*, less prominent because, as in the second state of the *Landscape with trees* (fig. 431), the top of the tower is once again gone. Although the lay of the land is very different, with a mountain of some size looming over the house, the cliff – now seen to be a small outcrop – still rises from the ground in the same relation to the house as in the other print. In both the house lies behind a body of water in use by a fisherman in one scene, by an absent boatsman in the other.

Without pressing the point, we can remark that these three etchings resemble the etched portrait of Wtenbogaert in playing with the identity of the subject. In the portrait the identity of the sitter is altered, in the landscapes that of the house. Someday, it is to be hoped we will know more about what seems to be a little game Rembrandt and Wtenbogaert were playing with each other.

The second money man whose estate was drawn, etched and perhaps painted by Rembrandt in this period also seems to have lent bucolic hospitality to

Koninck. A few years later Rembrandt's pupil Gerbrand van den Eeckhout drew here.[30]

None of the others, however, had as fraught a relationship with Christoffel Thijsz. as did Rembrandt. On the back of a drawing from the 1650s, Rembrandt scratched some notes in preparation for a discussion about his creditor with a committee of arbitrators who were mediating between them (fig. 230). One of the issues to be discussed concerned two unfinished paintings that Rembrandt had offered to complete for Thijsz., apparently in part payment of his debt. The final line reads: "if he wants none of the two" – the end of the sentence is cut off.

Under such circumstances, it is hard to imagine that the print was not implicated in Rembrandt's financial relationship with Christoffel Thijsz. Exactly what role it played we do not know. However, it is striking that in the years when Rembrandt's finances entered their downward spiral he would have created flattering public images of the country homes of two men who were in a position to help him. They might not have been the only two. Around 1648 Rembrandt turned his artistic attention to another country house owned by a very wealthy and influential Amsterdam patrician, Gerrit Schaep (1598–1666). Schaep owned a property called Grote Boomgaard (The Large Orchard) on the Spaarndammerdijk, west of the city near the River IJ. In the same spirit as in the depictions of the House with the Tower and Saxenburg, Rembrandt put the Grote Boomgaard into the picture, hidden among the trees, without portraying it (fig. 439).[31] He also seems, believe it or not, to have left off the pointed top of the house.

In the year when the drawing is dated on stylistic grounds, Rembrandt enjoyed a public mark of favor

438
Rembrandt
*Panorama near Bloemendaal
with the skyline of Haarlem
and Saxenburg House*
Unsigned, undated. Ca. 1651
Pen and brown ink, brush and
brown wash, 8.9 x 15.2 cm.
Benesch 1259
Rotterdam, Museum Boijmans
Van Beuningen

artists. He was the man who, with a partner, held the mortgage on Rembrandt's house on the Sint Antoniesbreestraat, a mortgage Rembrandt never paid off. The debt was going to bring him down not too long after he made an etching in 1651 incorporating Christoffel Thijsz.'s (1603–80) country house Saxenburg, in Bloemendaal, with the city of Haarlem on the horizon to the left (fig. 437). A drawing of the same piece of country, from another angle, takes care to include the tower of Saxenburg on the extreme left (fig. 438). Rembrandt was not the only artist to depict this estate. In the same period, there are drawings of Saxenburg in its magnificent setting near the dunes by Ferdinand Bol and Philips Koninck and a painting previously given to Rembrandt and now assigned to

439
Rembrandt
*Farm buildings near a brook
and a high embankment*
Unsigned, undated. Ca. 1648
Pen and wash, 14.4 x 24.4 cm.
Benesch 832
London, British Museum

30 Bakker et al. 1998, pp. 374–79.
Hinterding et al. 2000, pp. 268–72.
31 The location was cleverly
identified by Erik Schmitz and
Jan Peeters in Bakker et al. 1998,
pp. 366–69.

440
Rembrandt
*The bend in the Amstel
at Kostverloren, with horseriders*
Unsigned, undated. Ca. 1651–52
Pen and brown ink, brush and
brown wash, white highlights,
on cartridge paper,
13.6 x 24.7 cm.
Benesch 1265
Chatsworth, The Duke of
Devonshire and the Trustees
of the Chatsworth Settlement

from the Schaep family. Gerard Schaep himself, the leader of the Calvinist faction in the town council and many-time burgomaster, was described by a colleague as "learned, but not quick-witted and the opposite of eloquent."[32] He had a nephew who was however quite articulate and who served as spokesman for his uncle. Gerrit Schaep, Pietersz., was moreover a scholar and something of a writer. In 1648, he adapted a Spanish farce for the stage in Amsterdam. *Zabynaja, or promiscuity disguised*, was translated into Dutch prose by Schaep and then put into rhyme by a professional writer named Jan Zoet. The play went into premiere on 2 March and was repeated on the 5th and the 9th to a rapidly shrinking audience, after which it was removed forever from the repertoire. From the published edition we know that Rembrandt's name, which could not have been in the (never identified) Spanish original, was inserted in the text as a symbol of excellence in art. A female character is said to have been such a brilliant embroiderer that "she eclipses the paintings of Rembrandt himself with her needle." This may not seem like much of a recommendation, but it established, at a low point in Rembrandt's career, that the Schaeps approved of him. Although further evidence will probably never be forthcoming, the constellation – a country-house drawing by Rembrandt coinciding with public approval from its owner – once more reminds us that Rembrandt's choice of landscape motifs was not necessarily dictated by mere picturesqueness.

Around the same mid-century years, Rembrandt showed marked interest in one other country estate, Kostverloren, a property on the Amstel River about which our information is sparse. "Tradition has it that the house was destroyed by fire in 1650. Perhaps it was

for this reason that … in 1651 Gerrit van der Nath sold it to his brother Dirk," wrote the Amsterdam archivist I.H. van Eeghen, who knew the documents better than anyone.[33] It is also in 1651 that three wide-format drawings by Rembrandt are dated on stylistic grounds.[34] Although the van der Nath brothers are not documented in connection of any kind with Rembrandt, we can be forgiven for wondering whether there was not after all a tie.

Is that all there is?

The word landscape as used in this book is a term from art writing, referring to representations in art of the natural world. In the case of Rembrandt, as of most artists, the notion of the natural world has to be stretched to apply to the world inhabited and adapted by man. The landscape artist takes a position in and vis-à-vis the world; that position necessarily shows in his art, even if it is not explicit.

The position taken by Rembrandt shows a spread of attitudes and meanings that was typical for a Dutch artist of his time. The landscape backgrounds to his history paintings and most of his landscape paintings give rather conventional visual expression to notions of "the woods," or "a riverbank" or "a river valley in the mountains." The compositional and formal vocabulary of these paintings is derived from other works of art. While they convey certain overtones and moods, it would seem too much to attribute symbolic meaning to them. The same basic ingredients served as settings for stories from the Old and New Testament, classical mythology and non-narrative paintings. Only *The mill*, with its dominant motif and powerful atmosphere,

32 "was wel gestudeert, maer niet
gauw van verstant en gants niet wel
bespraeckt." Elias 1903–05, vol. 1,
p. 356.
33 Van Eeghen 1969, unpaginated
but opposite fig. V.
34 The other drawings are Benesch
1268 and 1269. See Bakker et al.
1998, pp. 281–89.

seems to convey a message, interpreted here as a celebration of safety.

Not until the 1640s, well into his maturity, did Rembrandt begin to take the out-of-doors seriously as a subject in his art. He gave expression to this interest, first in paintings and etchings and then mainly in drawings. In this chapter we have traced this development and found it to be linked to professional, social, private and economic factors.

In our chapters on Rembrandt's depictions of people and stories we have found all these factors as well. But they have not always stood alone. In addition, we have found more personal expressions than are determined by pure market considerations and more spiritual ones than demanded by the subject in itself. How does Rembrandt's treatment of landscape look in this regard?

Most art historians consider landscape a quintessentially secular subject. They view non-narrative landscape painting without religious content as a new development in art, beginning in the early sixteenth century and maturing in the seventeenth. The Belgian economic historian Wilfried Brulez joins it to still life, portraiture and architectural painting in charting the triumph of secularism over religion in European art between 1400 and 1800.[35] At the beginning of that period, he writes, nearly all art had overtly religious content; at its end non-religious subjects were dominant. This trend went further in the northern and southern Netherlands than anywhere else in Europe.

This version of things has been challenged by two Dutch art historians. Josua Bruyn doubts whether landscape is really as secular as all that.[36] Where others see depictions of the natural world, Bruyn sees a moral landscape, in which mankind is faced with dire choices. He sees indications everywhere of a particular iconography of landscape that emerged in the sixteenth century: the road of life. In a painting such as Rembrandt's *Stone bridge*, Bruyn focuses on the human figures in relation to the landscape. Some are pilgrims who follow the straight and narrow path, while others have lost their way or have allowed themselves to be seduced by earthly delights.

In his book *Landscape and world view from van Eyck to Rembrandt*, Boudewijn Bakker goes further, arguing that landscape occupied a unique and uniquely religious place in Dutch art.[37] The outside world, he says, was not just a subject like any other for the Christian artist. It was a form of divine revelation, on a par with the Bible itself. "From Saint Augustine on, all medieval natural philosophers spoke of the Two Books: the visible book of Creation and the readable book of the Holy Scripture … Contemplation of the world and its message was the specific task of the student of the arts." According to Bakker, this view of Creation was unchanged in the Dutch seventeenth century. The very act of drawing or painting landscape was a religious deed. When landscape drawings are said to be made "naar het leven," from life, "this implied that the human artist was supposed to have no creative ambitions of his own, and that it is his difficult but noble task to study

the works of God, to recreate them in the most perfect and beautiful form, and present them to his public as a clear sign of God's power and goodness."[38]

Stated in such general terms as this, I cannot agree with Bruyn and Bakker. There are a few landscape elements in Rembrandt's work, such as the tree of St. Jerome, that clearly bear a religious meaning. The rest, whether they are cottage studies, backgrounds to history paintings, river views or panoramas of the city or countryside, show no "clear signs" either of the pilgrimage of life or of Nature as the First Book. Nor did Rembrandt create the kind of closely observed study of plants or insects that might be interpreted as inspections of divine order on a small scale. Not only did he not study clouds, he actually eliminated them from all but a few of his skies, thereby reducing both their truth to life and the attention they might otherwise have drawn to God's heaven. When Rembrandt does aim for that effect, as in his *Angel appearing to the shepherds* (figs. 147–48) or *The ascension* (fig. 269), he is perfectly capable of evoking God's power in nature. For that reason, a religious reading of an etching such as *The three trees* (fig. 421) should not be dismissed out of hand. When no such signs are evident, though, we should hesitate before reading them into his work. Even if there were no atheists in the seventeenth century, and even if people tended to allegorize everything in sight, it cannot be said that all landscape art bore an outright Christian message.

If there is a general tendency in Rembrandt's landscapes, I would seek it not in God's but in man's creation. Although there is little anecdote in his landscapes and not many figures, Rembrandt, like most of his contemporaries, gravitates toward motifs that show manmade environments: roads, tamed rivers, farms, city skylines, village streets. Somewhere in his landscapes there is always a country house or castle, a church or monument, a windmill or an obelisk. I would go so far as to say that if a Rembrandtlike landscape were to show up that lacks reference to human interference in the world, this in itself would be reason enough to question its attribution.

Man and his works may be everywhere in Rembrandt's landscapes, but in understated form. Buildings are covered by foliage; figures are inconspicuous and sometimes actually hidden. This speaks of a certain shyness, a disinclination to show themselves. Although some of the infrastructural features of the landscape were new in Rembrandt's time, he took the shine off them in his drawings and etchings. He also kept away from the more aggressive, straightedge projects of his time, such as the Haarlemertrekvaart. He aged some of the buildings in his landscapes by removing their later towers, sometimes playing with architectural features, adding or eliminating them from state to state in an etching or from drawing to drawing.

Is that all there is? I would say there is indeed something more to Rembrandt's landscapes than our presumption of what met his eye in the field or what he could sell to his customers. The meanings I detect that

35 Brulez 1986.
36 Bruyn 1987–88.
37 Bakker 2004.
38 Bakker 2004, pp. 393–94, 397.

441
Rembrandt or artist close
to him
Christ and the woman of Samaria
Inscribed *Rembrandt f. 1659*
Canvas, 60 x 75 cm.
Bredius 592A
St. Petersburg, Hermitage

go beyond representation and beyond professionalism are personal ones. Above I speculated that the origins of Rembrandt's landscape drawings were linked to tensions in his home life. Expanding on that thought, I would suggest that his manipulations of reality in landscape reflect a certain discomfort in the artist and represent an attempt to rectify it. They show him envisioning a lived-in world in which he could feel more at home than at home, a space without the rough edges and messiness of his family situation after the death of Saskia and neater than the environment he actually encountered on his walks. That he ended his quest at the time of his bankruptcy and move to a poorer part of town I take as an implicit acknowledgment of failure. Failure not in the quality of the drawings but in their capacity, combined with walks in the country, to effectuate the healing he needed. His comforting pictures of bends in the Amstel on dry summer days, with no clouds in the sky and no puddles on the ground, ceased to offer the solace Rembrandt was seeking. The visions Rembrandt brought back from his drawing campaigns of quiet country dwellings surrounded by protective trees did not materialize in his life.

Before Rembrandt began to etch and draw the outdoors, he painted it into the backgrounds of his history paintings. This went on into the 1640s and 50s, but it came to an end at the very time when he stopped drawing landscape. After two strangely stilted paintings, dated 1659, of *Christ and the woman of Samaria* (fig. 441), none of his histories, not even the *Oath of Claudius Civilis* (fig. 308), which took place in a forest, are situated in a natural setting. (One exceptional portrait, a huge equestrian portrait dated 1663, is placed out of doors; fig. 355). Because it is the only such work in Rembrandt's oeuvre, the presumption is strong that the format was ordered by the sitter.) To the extent that his jaunts in the country and evocations of landscape in his paintings came from interest in the outside world, that interest disappeared when Rembrandt reached his early fifties. For all we know, he never left Amsterdam at all for the last ten years of his life.

These were years of tragic personal loss, as in the 1650s Rembrandt lost his fortune, his financial independence, his art collection and his house. In the 1660s he suffered the deaths of Hendrickje, Titus and Titus's wife Magdalena. Rembrandt's world was collapsing in. While acknowledging that the proposition is unprovable, I would suggest that these events are reflected in the disappearance from his art of outdoor and even of indoor space. Toward the end, he could not even imagine what spaciousness was like.

442
Rembrandt
A two-humped camel
Inscribed *Drommedaris.*
Rembrandt fecit. 1633.
Amsterdam
Brown ink, some white body
color, 19.4 x 28.9 cm.
Benesch 453
Bremen, Kunsthalle, until the
end of the Second World War.
Missing since then[39]

39 Röver-Kann 2000, p. 174, no. A20.
Several authors have doubted
whether the drawing is by
Rembrandt. I do not, but I must
admit that my judgment is swayed
more by the inscription than by the
drawing. Discussion to be resumed
on the happy day when the drawing
returns to Bremen.

Animals

Rembrandt had the reputation of being an immoderate animal lover, and he made good on it in his art.

In no aspect of Rembrandt's art is the documentary evidence more at odds with received knowledge than in his portrayals of animals. In unequivocal terms, the inventory of 1656 lists five paintings of animals – hares, a pig, a lions' fight, two greyhounds and a horse – that cannot be identified with existing paintings. Two more, an ox and a bittern, may be the large, famous paintings of these subjects in Paris and in Dresden. There was also a Chinese basket "full of drawings by Rembrandt, consisting of animals, from life." The surviving examples are far too few to fill a basket. A kind of art that was obviously of some importance to the artist has been lost to us. By chance? Or perhaps because we fail to recognize Rembrandt's hand in his paintings of animals.

To judge by the species named in the inventory and those depicted in his drawings, Rembrandt preferred big animals to small ones. Nor was he particularly interested in zoology. He was not the artist to detail finely

443
Photograph of a two-humped
camel, taken from uncredited
source on Internet, 2005

444
Rembrandt
Sleeping puppy
Unsigned, undated. Ca. 1640
Etching, 6.4 x 10.5 cm.
Bartsch 158 iii(3)
Haarlem, Teylers Museum

the features that distinguish a black mallard from a gray one. As in his landscape drawings, where a tree is a tree is a tree, Rembrandt's ducks and birds, with few exceptions, are undistinguished from each other. His dogs are raceless mongrels. He had no apparent interest in insects or rodents.

Rembrandt had barely arrived in Amsterdam before he went into the streets with pen and paper to sketch a two-humped Bactrian camel, the first to be shipped to Amsterdam. It is the only animal he labeled by name – dromedary – and he got it wrong. Although he was not the only one to confuse the two, there was a clear pref-

erence in Rembrandt's time as well as ours to reserve the word dromedary for the single-humped variety. The anatomy is not right either; to my eye, the rump is longer than it should be and the neck too short.

A few years later a visiting elephant drew him outdoors, allowing him to improve the elephants in his compositions.[40] Lions too could count on Rembrandt's fascinated attention. They form the largest group in his studies of individual animals. Not that he was an indiscriminate feline man. When it came to smaller animals, Rembrandt definitely preferred dogs to cats.

445
Rembrandt
The hog
Inscribed *Rembrandt f 1643*
Etching, 14.5 x 18.4 cm.
Bartsch 157 i(2)
Haarlem, Teylers Museum

40 For the fascinating story of this elephant, Hansken, see Roscam Abbing 2006.

269

446
Rembrandt
The slaughtered ox
Inscribed *Rembrandt f. 1655*
Panel, 94 x 67 cm.
Bredius 457
Paris, Musée du Louvre

"From life" does not have to mean "alive." In the aviary department, for example, Rembrandt dabbled in the late 1630s with peacocks and a partridge, all of them dead. One peacock is stuffed as part of a fancy pastry, two others, freshly killed, are laid out on a sill to bleed and tenderize. A young girl leans on the far side of the sill, her eyes fixed on one of the birds. A newly bagged bittern is held up by a hunter. In making the dead animals the object of emphatic visual display, Rembrandt brings their deadness to the fore.

The one trade of which we have an annotated drawing by Rembrandt is that of the butcher (fig. 470). One of his most affecting paintings shows the carcass of an ox hung up to bleed. While showing the details of the rack on which the butchered animal is hung and the condition of the carcass, it is not a clinical picture. The head of the woman peering tentatively into the space where the animal hangs introduces an element of questioning into the scene, like the gaze of the little girl with the dead peacocks. What the question might be is open. The possibility that Rembrandt had moral qualms about killing animals for food cannot be dismissed out of hand. The principle of vegetarianism had been broached by Erasmus in the sixteenth century and it pops up sporadically in seventeenth-century religion as well as hygiene. (Erasmus apologized for eating meat, which he had to do for his health, he said. Descartes and Rubens said they avoided meat for the same reason.) The infrequency in Rembrandt's art of food and feasting suggests a certain abstemiousness in this regard. Indeed, Arnold Houbraken says of him in so many words that "he lived plainly [*borgerlyk*] and when he was at work often took a piece of cheese or bread or a pickled herring for his meal."[41]

More moving yet than the painting of the dead ox is the etching of an animal not yet dead, but trussed for slaughter. Behind the highly finished hog in the print of 1643, barely sketched, is an excited family of five, smiling as if in anticipation of the meat meal on its way to their table (fig. 445). That the meal is a placid, trusting, domesticated sow, showing us a belly with teats that fed her own litter, adds poignancy to the image.[42] Beside the paintings and drawings of animals alone, some with people as auxiliary figures, Rembrandt also inserted animals willingly into compositions and portraits. Some of his dogs, especially those performing indiscreet bodily functions, became instant staples of hostile criticism. One possibly non-existent animal became immortal in that way: Rembrandt's monkey.

> I just recalled an example of his stubbornness ... Rembrandt happened to be painting a large portrait of a man, wife and children. The piece was still in progress when a monkey he had died unexpectedly. Not having another canvas at hand, he painted the dead monkey in the painting I mentioned. The [sitters] did not like this at all, not wanting their portrait adorned with a disgusting dying monkey. But no: he loved the model of the dead monkey so much that he preferred to keep the unfinished painting rather than please them by painting it over. And that is what happened; so that the painting remained with him, later serving as a partition for his pupils.[43]

This unlikely story was repeated in another seven writings on Rembrandt between 1729 and 1852.[44] Aside from the putative point, it makes another one: Rembrandt had the reputation of being an immoderate animal lover.

He was not the only one. Although there is no corroboration for the dead monkey story, none is needed for the affection of one of Rembrandt's later portrait sitters for her parrot. The widowed Catharina Hooghsaet, in Rembrandt's portrait of her at the age of fifty, is in lively commune with her pet bird. Rembrandt's animals. A thankful subject for an as yet unwritten book.

447
Rembrandt
Detail of *Catharina Hooghsaet*
(fig. 351)
Collection Penrhyn Castle

41 Houbraken 1718–21, vol. I, p. 272.
42 For elements in the etching that several students consider incongruous, see Dickey 1986. Dickey includes it in her category of "divided images," etchings with a clear break in degree of finish between one part of the image and the rest.
43 Houbraken 1718–21, vol. I (1718), pp. 259 -60.
44 Scheller 1961.

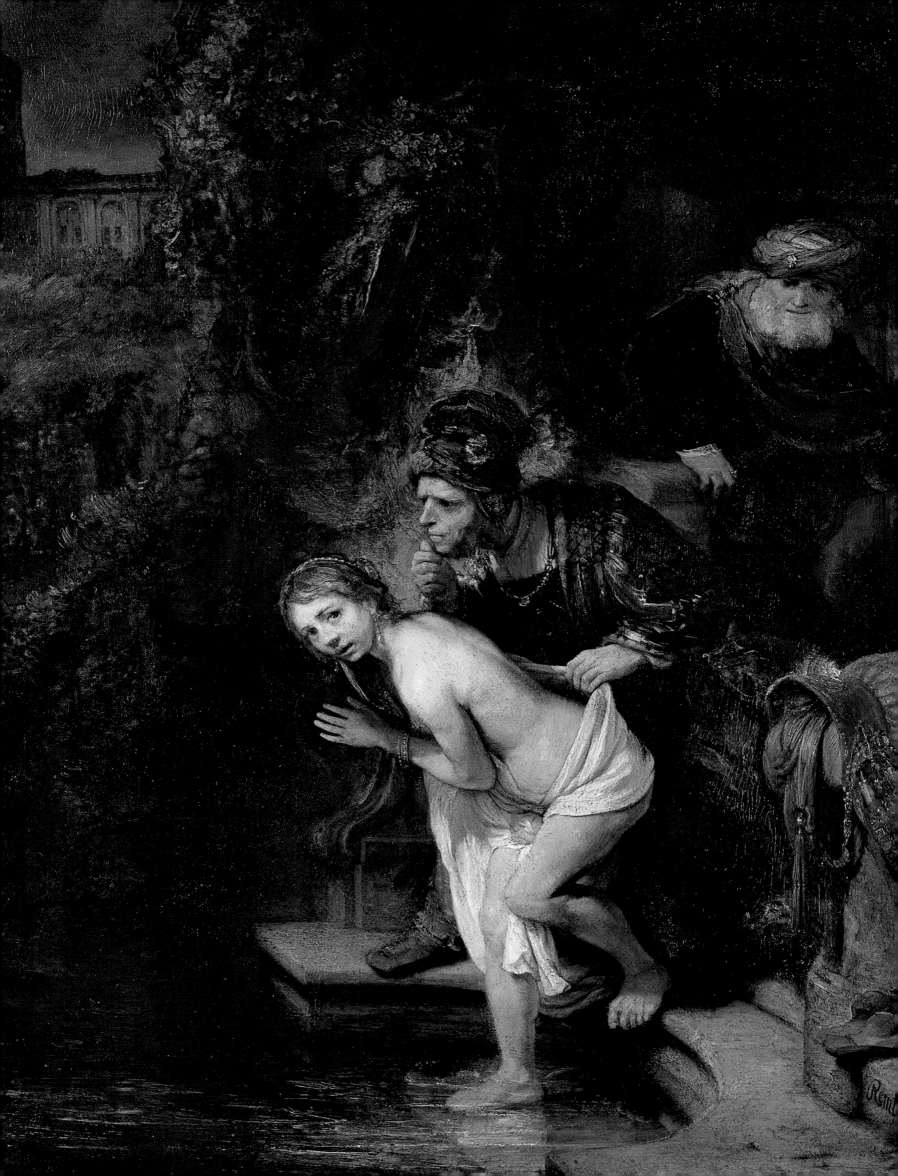

8

Humankind

448
Rembrandt
Detail of *Susanna surprised by the elders* (fig. 457)
Berlin, Staatliche Museen, Gemäldegalerie

The senses and the passions

ART CAN AROUSE the senses, touch the feelings and stir the passions. In exercising these formidable powers, the artist should respect certain limits of good taste and moral propriety. Rembrandt possessed unequaled skill in depicting the passions in original ways without breaking the code. Well, hardly ever.

Can you define Rembrandt in a single phrase? No present-day art lover would even want to try. But his contemporaries had no qualms about doing so. Samuel van Hoogstraten gladly reduced the greatest reputations in art to a word. "Who among the great Italian or Netherlandish masters … did not have something special of his own?" He answered his own question with a row of seventeen names, from Michelangelo to Goltzius, each provided with a single quality. Of "our Germans," van Hoogstraten writes, "Durer was fixated mainly on a certain fabric of garment, Lukas van Leyden on virtuousness, Rubens on rich compositions, Antony van Dyk on gracefulness, Rembrand on the passions of the soul (*de lydingen des gemoeds*) and Goltzius in imitating the hands of various great masters."[1]

Van Hoogstraten's pupil Houbraken expands on this in his life of Rembrandt. "Imagine having to depict, with fixed and recognizable features, joy, happiness, sadness, fright, wrath, amazement, etc., that is, the manifold passions of the soul." Rembrandt, he wrote, was praised for his ability to do so, but not in a way that can be taught. He possessed the "rare natural ability" to capture fleeting expressions of emotion and imprint them in his memory.[2]

Amidst all the shifting judgments about Rembrandt we have encountered, it is a pleasure to come across one that has been expressed repeatedly, nearly unchanged, from Rembrandt's time to ours. What is more, the special gift attributed to Rembrandt is not an arbitrary quality, but according to his contemporaries the highest aim of art. This can be shown from a contemporaneous

source that has not yet been discussed in connection with Rembrandt and the passions.

In the year 1650 a leading Amsterdam art collector, the merchant Marten Kretzer (1598–1670), brought the apothecary-poet Lambert van den Bosch (1620–98) to his house. Kretzer was a well-known personality on the Amsterdam art scene. Starting in 1644, he served several terms on the board of the Amsterdam town theater. Plays were dedicated to him, including two, one of them by van den Bosch, for which he provided the playwrights with their material. In the field of painting Kretzer was more than a well-meaning amateur. The guild of St. Luke, of which he was a member, called him in on occasion to perform appraisals of important painting collections. In 1654 Kretzer was one of the founders of the Brotherhood of Painting.

Van den Bosch's visit resulted in a 120-quatrain poem on some forty-two paintings in Kretzer's collection, among them a Rembrandt. They are described as Kretzer's cherished property, lamentably about to be dispersed.[3] Indeed, an advertisement in the *Amsterdamsche Courant* of 19 March 1650 tells us that

Marten Kretser of Amsterdam plans to sell by public auction to the highest bidder, on the coming 3 May and the following days, in the Heerenlogement, a remarkable group of excellent paintings and drawings by various Italian masters and others, the catalogue of which can be obtained in the shops of various booksellers three weeks in advance.[4]

Van den Bosch's poem, published under the title *Konst kabinet van Marten Kretzer*, must have served as publicity for the sale. It survives in only one copy; not a single copy of the catalogue is known.

In Rembrandt studies *The art cabinet of Marten Kretzer* is referred to only for these lines: "I shall not attempt, O Rembrant, to depict your fame with my pen. Everyone knows what honor you deserve, when I merely name your name."[5] The Rembrandt painting owned by Kretzer has never been identified. However, the poem has far more interesting things to say than

1 Van Hoogstraten 1678, p. 75.
2 Houbraken 1718–21, vol. 1, pp. 264–65.
3 For Kretzer and the poem, see a forthcoming article by the author. For the text of van den Bosch's poem, see the version transcribed by the author for the Digitale Bibliotheek voor de Nederlandse Letteren.
4 Dudok van Heel 1977, p. 107. Dudok van Heel's opinion that van den Bosch's poem is the catalogue referred to and therefore "the oldest preserved auction catalogue" cannot be correct. The *Konst kabinet van Marten Kretzer* does not answer to any of the major specifications of an auction catalogue. Moreover, the number of items sold in a multi-day auction of paintings and drawings must have exceeded by far the less than fifty objects in the *Konst kabinet*.
5 Ick sal niet poogen uwe roem
O Rembrant met mijn pen te malen,
Elck weet wat eer dat ghy kont halen
Wanneer ick slechts u name noem.
Doc. 1650/6.

that. In effect, it tells us what a collector in 1650 thought was important about the art of painting.

To begin with, painting evokes and stimulates the senses.[6] This is a subject with which van den Bosch had dealt before, and he had dealt with it in collaboration with Kretzer. In 1648 Kretzer gave van den Bosch a number of English plays from which to choose a model for a translation. The one he picked out was *Lingua: or the combat of the tongue, and the five senses for superiority* (1607) by the Cambridge wit Thomas Tomkis. Lingua, the tongue, is personified in the play by a woman who claims to be the ruler of the microcosmos, the human being. Her rivals are the five senses. When the case comes up to trial in the court of Common Sense, the combat is won by the senses, and within the senses by Sight. In *The art cabinet* as well, this hierarchy is evident. As if the *Konst kabinet* were written under the jurisdiction of Common Sense, van den Bosch consistently degrades speech and glorifies sight. Far from regretting the silence of painting, as Vondel did in his poem on Rembrandt's portrait of Anslo, he treats it as an added distinction. To create a comprehensive representation without speech, that was art! All the other senses are alluded to in the poem, but sight lords it over them.

Konst kabinet takes a step beyond *Lingua* in a direction not envisioned by Thomas Tomkis. It not only propagates the superiority of vision above the other senses and the tongue but also posits the supremacy of painting over all other sights. Van den Bosch phrases it quite straightforwardly, as if he were letting the reader in on his brief from the patron: "It is my duty to praise art far above everything that reaches the human eye, if that be honor enough."

Checking in with Rembrandt, we find that he showed a certain interest in the theme of the five senses. So did Jan Lievens, who often preceded Rembrandt in new directions during their years together in Leiden. Three panels of about 1624, the earliest paintings attributed to Rembrandt, are allegories in everyday form of the senses of sight, touch and hearing; smell and taste, if they were completed, have been lost. The sense of sight is represented by a spectacles seller, hearing by three singers, touch by a head operation. Rembrandt does not privilege sight above the other senses. Hearing is the most dignified of the three little scenes. He does however provide the lead singer with spectacles and, in the first use of his favorite attribute, a book. In this context, the book can be seen as a device for turning the word, which belongs to hearing, into a silent, printed form that must be seen with the eyes. Rembrandt's singers then reclaim it for the ear. From the start, Rembrandt introduced little complications of this kind into his iconographies.

Rembrandt did not return to the allegory of the senses as such, but certain motifs from his first known paintings recur in later work. In 1626 he painted another musical trio, this time consisting of a woman singing and leading an older man playing the viola da

449
Rembrandt
The music makers
Inscribed *RHL 1626*
Panel, 63 x 48 cm.
Bredius 632
Amsterdam, Rijksmuseum

450
Rembrandt
Music makers by candlelight, in allusion to the sense of hearing
Unsigned, undated. Ca. 1624
Panel, 32 x 25 cm.
Bredius 421
The Netherlands, W. Baron van Dedem collection

6 The order of subjects is my own interpretation and does not follow the sequence in the poem.

gamba and a younger one on the harp. The atmosphere of this scene is different. The presence of drink and the woman's luxurious dress introduce an element of potentially dangerous sensuality. The painting on the wall, Lot and his family leaving Sodom, shows what happens when the senses run riot.

Sight and touch are recombined in later decades in an interesting way. For depictions of the healing of the blindness of old Tobit, a powerful reference to the sense of sight, Rembrandt gives young Tobit the pose of the barber-surgeon from his early painting of the sense of touch. Rembrandt was not categorical in his treatment of the senses. This is also evident in his amplifications of the canonical five senses. The sense of humor soon entered his repertoire as well. The head of a laughing man was a motif that went out into the world under his name in prints of about 1630 by his associate Jan Gillisz. van Vliet.

Back to *Konst kabinet*. Having established that sight is the foremost sense and art the premier application of the sense of sight, van den Bosch goes on to examine and grade the uses of painting. Its ultimate achievement, he writes, is the ability to deceive the eye to such an extent that inanimate paint and canvas come to life. In van den Bosch's rhetoric this goes beyond mere seeming. He writes of "making life itself from canvas and wood and precious sludge." The artists in Kretzer's collection, he writes, are creators on the order of Prometheus, the maker of man in Greek mythology. Van den Bosch even expresses concern that the exercise of this gift by Dutch painters might constitute an offense as punishable as that of Prometheus (whose name means foresight). When Prometheus stole fire from Zeus and brought it to earth to animate man,

the gods had his liver eaten out of his body by an eagle, not once but day after day (fig. 55).

Granted the gift of divine creativity, what does an artist do with it? Well, he stimulates human passions. In this realm there is no standard set like the five senses. There is however a canonical highpoint. Those are the feelings that according to Aristotle define the highest form of art, tragedy. In Part Nine of the *Poetics*, he writes: "Tragedy is an imitation ... of events inspiring fear or pity. Such an effect is best produced when the events come on us by surprise." This is exactly the combination of values that Lambert van den Bosch finds in the greatest paintings in Kretzer's collection. Only paintings of tragic subjects can achieve true greatness, such as Titian's *Beheadal of St. John the Baptist* and Honthorst's *Death of Seneca*. Passion operates both within the painting and through it. The figures in the paintings are moved by fright and pity, but so is the viewer. Van den Bosch is surprised into thinking that he is witnessing the actual death of the two great martyrs. The resolution of these feelings, an Aristotelian catharsis, comes when the poet realizes that his eye has been deceived and he can take distance from the subject of the paintings. "What see I here? For pity, what a tragedy meets our eyes? Oh, 't is only art, I am deceived. O heaven how that rejoices me."

Not all artists possess the good judgment of a Titian. Some, van den Bosch says, abuse their gift and go too far. One of the Both brothers from Utrecht does this in painting a brothel scene that is so arousing that it "makes ... of every heart a whorehouse." In depicting sensual love, says van den Bosch, the painter does better to do so through allegory "which neither moves nor touches." Rembrandt gave this tack a try, in a painting of the mid-1630s of a chaste little Cupid. This was around the

454
Rembrandt
Cupid
Unsigned, undated. Ca. 1634
Canvas, 74.5 x 92 cm.
Bredius 470
Vienna, Museum Liechtenstein

455
Rembrandt
Joseph and Potiphar's wife
Inscribed *Rembrandt f. 1634*
Etching, 9 x 11.5 cm.
Bartsch 39 i(2)
Haarlem, Teylers Museum

7 Is it coincidence that both works came into being in the year of Rembrandt's marriage? Can they be a sign of discomfort with sex on the part of the twenty-eight-year-old bridegroom? Personally, I do not dare to advance that conclusion, but the psychohistorical study of Rembrandt might take account of this suggestive constellation.

time he etched an allegory of sailing (fig. 385). Rather than shooting his arrows to kindle unbearable desire in his victims, Cupid leaves his bow unstrung and blows bubbles to tell us that lust is but a passing thing. Messages of this kind, in full allegorical form, are so unusual for Rembrandt that Horst Gerson and other Rembrandt specialists, including myself, could not see his hand in the painting. The Rembrandt Research Project, judging it more on its painterly merits than on its mood, rightly put it back into the corpus. Yet, art "that neither moves nor touches" was not Rembrandt's cup of tea. He went higher up the scale in his play with the passions.

In the same period, perhaps the same year as the off-duty Cupid, Rembrandt created his most forthright image of sexual lust run wild. In a small etching, he evokes the famous scene from the story of Joseph when the good-looking young man is assaulted by the wife of his employer Potiphar, the captain of Pharaoh's guards. "She caught him by his cloak and said, 'Come to bed with me!' But he left his cloak in her hand and ran out of the house" (Genesis 39:12). Rembrandt goes above and beyond the call of duty in his depiction of the hot-blooded woman. He puts her naked pudenda into full frontal position, thrusting toward us as she pulls at Joseph.[7]

Sexual passion had been the theme of a number of Rembrandt's mythological paintings of the late 1620s and early 30s. Jupiter indulged his desires in animal form with the abduction of Europa and Ganymede (figs. 381, 609, 611), Pluto took off the screaming Proserpina. In 1634 Rembrandt turned to Biblical examples of blind lust, examples that lent themselves better to moral seriousness. If Potiphar's wife was the embodiment of uncontrollable, illicit female sexual desire, male desire was epitomized in the tale of Susanna. This subject too was picked up by Rembrandt in 1634. It was a more interesting theme from the Aristotelian point of view, since it combines the elements of surprise, fear and pity.

The story comes from an apocryphal thirteenth chapter of the semi-apocryphal Bible book Daniel.

It takes place in the exiled Jewish community of Babylon. Susanna was a married woman, as pious as she was beautiful. Two elders of the people, newly appointed as judges, were so inflamed by her beauty that they sneaked into the garden of her husband's house to have sex with her. They were sufficiently ashamed of themselves not to admit their lust until they ran into each other in the garden. When Susanna undressed to bathe, they made their move. She spurned them, even when they blackmailed her, preferring to

face false charges of adultery with a young man of their invention rather than to submit to their lecherous will. She was tried and sentenced to death, but Daniel rescued her by catching the elders out in contradictory statements. In a reversal like that of Mordechai and Haman in the Book of Esther, they were the ones to be executed.

Of the incidents in the chapter, the one that is depicted in art most often by far is the attack of the elders on the naked woman. In most cases the choice amounts to transparent exploitation of the Bible as an excuse for selling salacious imagery à la Both. That is not how it was handled by Rembrandt. His Susannas crouch in fear, covering their nakedness as well as they can with hands and arms.[8] From 1634 to 1647, Rembrandt worked on two paintings of the subject. The phases in this project are difficult to date. It all seems to have begun when, following the death of Pieter Lastman, Rembrandt made a number of red chalk drawings after paintings by his deceased and highly respected master. One of these was a *Susanna surprised by the elders*, dated 1614. In two paintings and several related drawings, Rembrandt created variations on Lastman's version of the subject: the surprised woman crouched beside a body of water in a palatial garden, approached from behind.

In a panel of 1636 Susanna covers her breasts and groin in a pose that has been compared to that of the classical Venus pudica, the modest Venus. In that version, in the Mauritshuis, the elders are barely visible.[9] Around the same time Rembrandt began work on a canvas, closer in format and scope to the Lastman, in which the elders and their passions are more prominent.[10] At first, as we know from X-rays and a student

8 In the Bredius catalogue of the
paintings of Rembrandt, no. 493
shows a naked Susanna as the victim
of attempted rape. That painting is
not accepted as a Rembrandt.
9 Broos 1993, pp. 262–68, no. 32.
See also Broos's entries in Blankert
1997, nos. 20, 77 and 80.

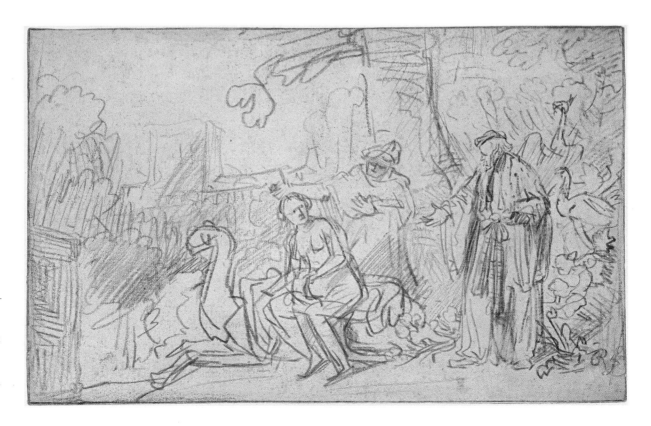

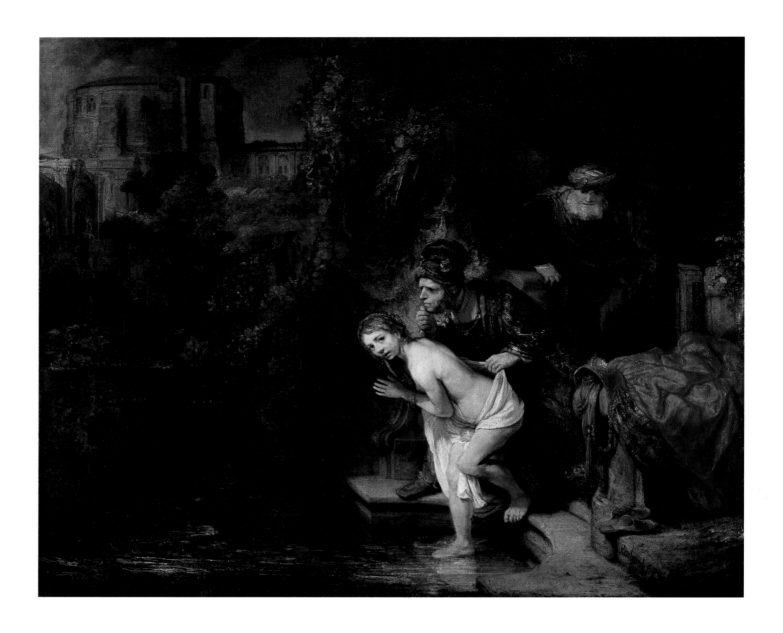

458
Rembrandt
Susanna surprised by the elders
Inscribed *Rembrandt f. 1647*
Panel, 76 x 91 cm.
Bredius 516
Berlin, Staatliche Museen,
Gemäldegalerie

459
Rembrandt
*Study for an elder approaching
Susanna*
Unsigned, undated. Ca. 1636–37
Gallnut ink, 17.3 x 13.5 cm.
Benesch 157
Melbourne, National Gallery
of Victoria

10 Jan Kelch, in Brown et al. 1991,
pp. 233–37, no. 37. It is worth noting
that the second version is also more
copious in its details of the garden
and Susanna's discarded clothing.
Rembrandt does not always elimi-
nate "inessential" details.
11 Sluijter 2000, p. 11.

drawing, he showed the foremost elder with his hand
on Susanna's breast. But he changed his mind about
this explicit act; a drawing in Melbourne shows the
offending hand pulled back toward the body of the
elder, undefined. When the painting was finally com-
pleted, in 1647, he holds only the sheet in which
Susanna is draped. His runaway passion is expressed
more in his intense gaze than anything else.

That gaze of desire is burnt into the paper of the
drawing, in corrosive gallnut ink, in even more intense
form than in the painting. Here Rembrandt depicts a
gaze in art; but in the poem by Lambert van den Bosch
it is the viewer's gaze that is the problem. That is also
the case in a remarkable poetic attack on the art of
painting by Dirk Rafaelsz. Camphuysen, himself a land-
scape painter, published in 1624: "Painting bred from
the dalliances of the fickle brain,/ Is an ever-flowing
fountain for the foolish desire of the eye."[11] Of course
painting does not emerge only from the brain of the
artist, but also from his vision. Passionate gazes flow
back and forth, in the subject, the artist, the owner,
the viewer.

460
Rembrandt
Detail of *Study for an elder approaching Susanna* (fig. 459)
Melbourne, National Gallery of Victoria

461
Rembrandt
Detail of *Susanna surprised by the elders* (fig. 458)
Berlin, Staatliche Museen, Gemäldegalerie

Before Cupid put aside his bow, it was the low passion of physical desire that most occupied Rembrandt. In the mid-1630s he turned to stories that illustrate the high passions of fear and pity. For example, the terror of King Belshazzar of Babylon. It happened in the middle of a feast served on the gold and silver vessels that his father Nebuchadnezzar had brought back as booty from the Temple in Jerusalem. "Suddenly the fingers of a human hand appeared and wrote on the plaster of the wall, near the lamp stand in the royal palace.

The king watched the hand as it wrote. His face turned pale and he was so frightened that his knees knocked together and his legs gave way" (Daniel 5:5–6).

Aristotelian surprise also overcame Abraham, when the angel of the Lord swooped down on him on Mount Moriah. He was about to perform an act that aroused the greatest pity imaginable, killing one's own child. The suddenness of divine intervention is symbolized in the painting by the knife with which he was going to do the deed: it is in mid-air, fallen from his grasp.

462
Rembrandt
Detail of *The feast of Belshazzar* (fig. 534)
London, National Gallery

463
Rembrandt
Detail of *The angel stopping Abraham from sacrificing Isaac* (fig. 613)
St. Petersburg, State Hermitage Museum

279

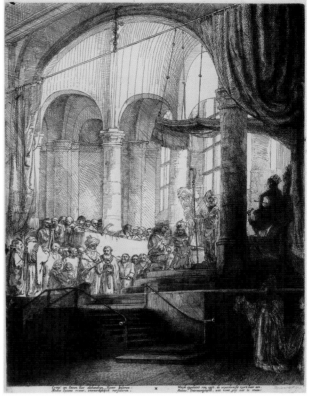

464
Rembrandt
*Christ and the woman taken
in adultery*
Inscribed *Rembrandt f. 1644*
Panel, 83.5 x 64.5 cm.
Bredius 566
London, National Gallery

The settings for the two depic-
tions of wronged women from
the 1640s are magnificent
temples, the Temple in Jeru-
salem and a Greek sanctuary.
The suggestion is conveyed that
society and the powers that be
are all turned against the victim.

465
Rembrandt
*Medea: or the marriage of Jason
and Creusa*
Inscribed *Rembrandt f. 1648
Creus' en Iason hier elckandren
Trouw beloven:
Medea Iasons vrouw,
onwaerdighlijck verschoven,
Werdt opgehitst van spijt,
de wraecksucht voert haer aen.
Helaes! Ontrouwigheydt,
wat komt ghij dier te staen!*
Etching with some drypoint,
24 x 17.6 cm. Bartsch 112 iii(5)
Haarlem, Teylers Museum

12 Schwartz 1998.

His face and eyes still express pity for his child and him-
self over the averted tragedy.

In his three last decades, Rembrandt returned again
and again to sexual passion. The tone of these scenes,
however, could not be more different than the mytholo-
gies and the cluster of 1634. Bypassing the Aristotelian
moment suprême, Rembrandt looked beyond it to the
longer-enduring consequences of infidelity, sexual abuse
and rape. The woman taken in adultery and forgiven by
Christ, Bathsheba, Medea and Lucretia each suffered in
her own way from the unbridled sexual drive.

Medea a wronged woman? That might come as
something of a surprise to those who know her reputa-
tion from Greek and Roman mythology and drama.
Wasn't she the sorceress who murdered her own child
to get even with her husband? Well, yes, but according
to the author whose play on Medea was illustrated
by Rembrandt, there were mitigating circumstances.
That was none other than Jan Six, who was not only
on the theater board but also the author of a play that
was staged there in 1648. The story: after helping Jason
capture the Golden Fleece and marrying him, Medea
was forced by circumstance to flee with him to the
court of King Creon of Corinth. When Creon's only
daughter Creüsa fell in love with Jason, the king
ordered him to marry her and Medea to depart and
leave her daughter behind. Medea's revenge is terrible.
After killing Creon and Creüsa with poisoned gloves,
she punishes Jason by throwing their daughter Eriope
to her death from a balcony; she then commits suicide.

Medea was ready-made as a negative example, and this
is the role in which she was cast again and again. That
is however not how Jan Six sees her. In the preface to
his *Medea*, he writes:

> The object of this play is rather to render hateful
> Jason's blatant infidelity. For even if Medea were
> guilty of other crimes (of which she deeply
> repented, ...), she did not deserve to be deserted by
> Jason, robbed of her child, and sent away. In all, she
> is sooner to be pitied when, as a result of the great
> injustice that has been committed against her, she is
> driven to such mad despair, so fiercely to revenge,
> that she even goes so far as to spare not even herself ...

This view of the subject informs Rembrandt's print
as well, which shows Medea hiding in the shadows at
the wedding of Creüsa and Jason. The inscription
below the print reads:

> Creus' and Iason here plight their troth to one
> another:
> Medea, Iason's wife, unworthily shunted off to the
> side,
> is infuriated by sorrow; she is driven by vengeance.
> Alas! Infidelity, how dearly are you paid!

The blame for what is to happen is laid squarely at the
feet of Creüsa and Jason, and our sympathy is enlisted
for the wronged wife, Medea.[12]

This maneuver by Six and Rembrandt has a striking
parallel in Rembrandt's treatment of Bathsheba in his
painting of 1654. That story is simpler (2 Samuel 11:
2–4):

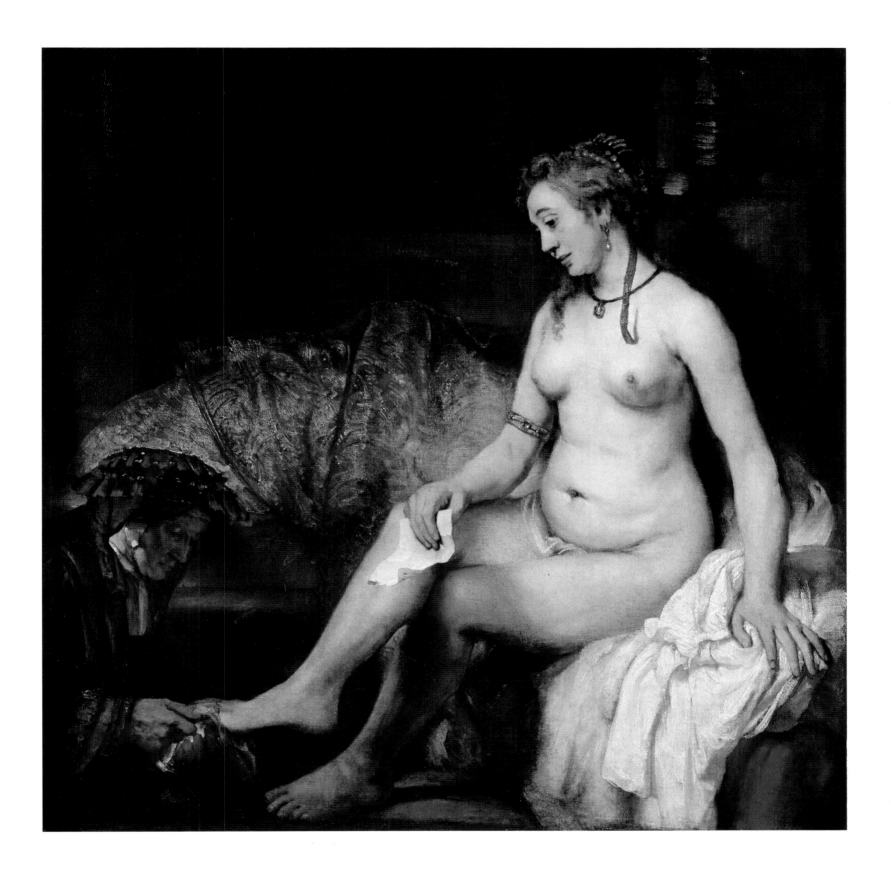

466
Rembrandt
Bathsheba with King David's letter
Inscribed *Rembrandt ft. 1654*
Canvas, 142 x 142 cm.
Bredius 521
Paris, Musée du Louvre

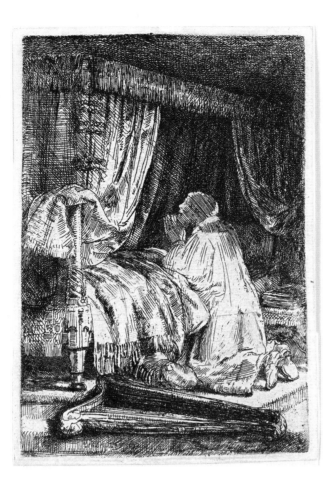

467
Rembrandt
David in prayer
Inscribed *Rembrandt f. 1652*
Etching and some drypoint,
14.3 x 9.3 cm.
Bartsch 41 ii(3)
Haarlem, Teylers Museum

468
Rembrandt or artist close to him
Joseph accused by Potiphar's wife
Inscribed *Rembrandt f. 165[5]*
Canvas, 106 x 98 cm.
Bredius 523
Washington, National Gallery
of Art

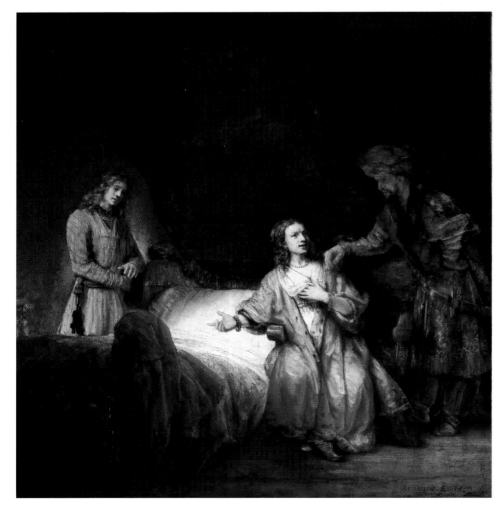

One evening David got up from his bed and walked around on the roof of the palace. From the roof he saw a woman bathing. The woman was very beautiful, and David sent someone to find out about her. The man said, "Isn't this Bathsheba, the daughter of Eliam and the wife of Uriah the Hittite?" Then David sent messengers to get her. She came to him, and he slept with her.

In Dutch art and literature of Rembrandt's time, Bathsheba was nothing but a name for a complaisant woman with an irresistible body. A quatrain by Reinier Anslo, published in 1651, puts into words her primary – in art, her exclusive – association in seventeenth-century Holland:

On David's sin, 2 Samuel 11
Oh man beloved of God, does fair white skin seduce you
Through thoughtless lust, to murder and foul adultery?
How low can virtue sink? Alas, what does love bring forth
But cares beyond all sense from care-denying senses.[13]

"Cares beyond sense." This could be the motto of Rembrandt's only etching of King David, dated 1652. David has laid down his harp, and prays, his head and hands in defeaturing shadow, kneeling at his bed, surely the bed in which he committed his sin.

But when Rembrandt painted Bathsheba two years later, it was her feelings, not David's, that he took as his subject. Rembrandt goes so far as to leave King David out of the painting altogether. It is not too much to say that Rembrandt's *Bathsheba* is to other depictions of the subject as Six's *Medea* is to its predecessors. Just as Six enlists our sympathy for a woman otherwise defined in terms of evil, Rembrandt does the same for a heroine reduced in other paintings to fleshly temptation. Like Six, Rembrandt took a heroine who was usually treated as a flat figure, standing for a purely negative quality, and reshaped her in a characteristic way of his own, rejecting the existing stereotype, and imbuing her with a richer array of feelings. Jan Six and Rembrandt practiced something like a seventeenth-century version of feminism.

Even the woman who twenty years earlier gave occasion to Rembrandt's most naked portrayal of sensuality, Potiphar's wife, returns now in more dignified guise. In two paintings of the subject, both dated 1655, Rembrandt shows her between Potiphar and Joseph. This scene does not occur in the Bible, and there is every reason to relate it instead to the telling of the story in Vondel's play *Joseph in Egypt*. The play was written in 1640, but in 1655 it was back on the Amsterdam stage, enjoying particular success with a woman in the role of Iempsar, the name Vondel gave to Potiphar's libidinous wife. In his paintings of the story, Rembrandt allows Iempsar to present herself in her own terms, as the indignant victim of unwanted advances, even if those terms are a lie.

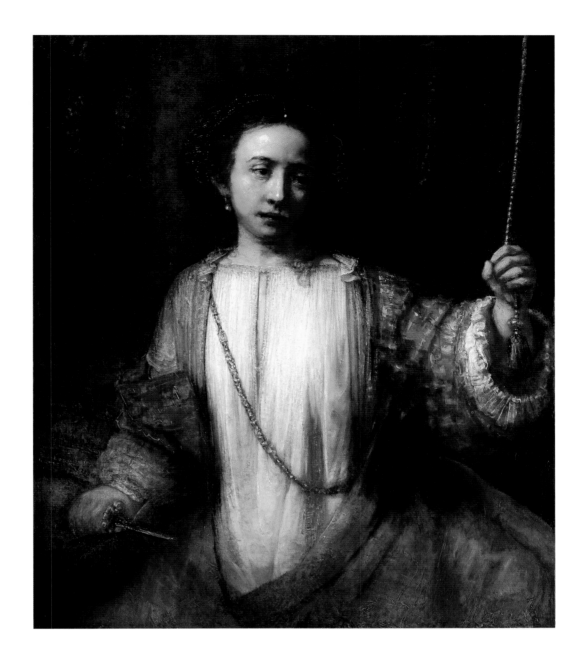

469
Rembrandt
The suicide of Lucretia
Inscribed *Rembrandt f. 1666*
Canvas, 111 x 95 cm.
Bredius 485
Minneapolis, Minneapolis
Institute of Arts

These are what we might call post-passion paintings, evocations not of raging sexuality itself, but of its tragic effects. The most moving of Rembrandt's paintings of this kind, of which he also painted two versions, one in 1664 and one in 1666, show the suicide of Lucretia. The main source for this story is in Livy's history of Rome, but it was cited commonly in the Christian literature of Rembrandt's time as well. The son of the tyrant of Rome, Sixtus Tarquinius, raped the beautiful Lucretia under threat of a fate worse than death. In addition to murdering her, Sixtus said that he would destroy her reputation forever by also killing a slave and placing him beside her dead body as proof that she had committed adultery. After giving him his way, she called her husband and father and stabbed herself to death before their eyes. The bloody knife became the emblem of revolt against the tyrant; in reaction to the rape of Lucretia, kingship was abolished and Republic established.

By now, Rembrandt had stopped trying to surprise or frighten the viewer. Again, he focused on the feelings of the woman and the woman only. One emotion has displaced the rest: pity.

Of course Rembrandt's work, as Houbraken wrote, contains evocations of other passions beside lust. The contrition of Judas, the indignation of old Tobit and of Samson, the rage of Saul and of Ahasuerus, the tenderness of the couple in *The Jewish bride*. Strange to say for an artist with Rembrandt's reputation, however, these subjects are relatively rare in his work. There is another range of passion that occupies him far more deeply. To Rembrandt, as to Lambert van den Bosch, high art was indissolubly tied up with profundity of subject. As we shall see, Rembrandt devoted his most concentrated powers to the one life and the one death that mattered more than any to a Christian, the life and death of the Savior and their attendant passions.

13 "*Op Davids Sonde*, 2 Sam. 11."
Verscheyde Nederduytsche gedichten,
Amsterdam 1651, p. 237.

Crafts and trades

Rembrandt avoided stereotypical depictions of the crafts, as he avoided all standard series. For an artist with more than average interest in the doings of humanity, he was strikingly uninterested in the specialty that later came to be called genre. The trade in which he showed the most spontaneous interest is butchery. In the greatest possible contrast to his *Slaughtered ox* of 1655, the same year he created an immortally tender image of the artist as a creator of love.

Beside those of the artist,[14] the manual skills for which Rembrandt showed the most interest are those of the surgeon and the butcher. Surgeons not only dissect corpses in the two paintings of anatomy lessons (figs. 281, 288); there is also a surgical touch in Rembrandt's several representations of the healing of the blindness of old Tobit, which is said to resemble present-day procedures for removing cataracts. The slaughter and dressing of dead pigs and cows, poultry and game birds are depicted in more than passing detail in drawings (fig. 121), etchings (fig. 445) and paintings (fig. 446). There is an unfortunate imbalance in the

study of these two subspecialties. Rembrandt has benefited lavishly from the attention of doctors, historians of medicine and students of the human body not only with regard to the cadavers in his anatomy lessons but also as diagnosticians of his models and himself. No butcher, however, has to my knowledge written about his dead animals. We are left to wonder whether Rembrandt thought of dissected human and animal bodies in similar terms.

He himself jotted a note on the work of hog butchers on a drawing in Frankfurt: "the hide covering it and further pulling the rest along," a note that a present-day butcher might be able to explain in relation to the drawing. *The slaughtered ox* of 1655 (fig. 446) provides majestic proof that Rembrandt's fascination with the subject was not a passing thing. Although the butchers who slaughtered and hung the animal are not in the picture, we are very aware that it is the result of human handiwork that we are seeing.

What *was* a passing thing was Rembrandt's interest in street occupations. In the mid-1630s he etched two street trades: the door-to-door peddling of rat poison and cooking small pancakes on an outdoor fire. While the "vleeshouwer" (butcher) and the "chirurgyn" (surgeon) made it into the top hundred trades in Jan

470
Rembrandt
Two butchers at work,
one cleaving the carcass of a pig,
the other carrying a pig
Inscribed *t vel daer aen ende*
voorts de rest bysleepende.
Unsigned, undated. Ca. 1635
Brown ink, 14.9 x 20 cm.
Benesch 400
Frankfurt, Städelsches
Kunstinstitut und Städtische
Galerie

and Caspar Luiken's *Spiegel van het menselyk bedryf* (Mirror of human activity), these two lowly occupations did not. Rembrandt's etchings do not simply present craftsmen at work. He places them in their social environment, showing how others react to them. The householder purchasing rat poison from the vendor and his little mate, who advertise the effectiveness of their product by displaying its victims, turns his head away from it all. The pancake woman, on the other hand, attracts a small crowd of happy customers. These etchings look like scenes from daily life, but they

are actually carefully contrived compositions, based on earlier examples by other artists, preceded by preparatory drawings and tied in with contemporaneous history paintings and landscapes.

A more classical representation of a trade that *is* among the top favorites in depictions of the crafts is *The goldsmith* of 1655. The group on which the artist is working is a personification of charity, a mother embracing and protecting her two children. Charity – *caritas* in Latin, *agape* in Greek, also meaning love – is one of the three theological virtues of which St. Paul said: "And now these three remain: faith, hope and love. But the greatest of these is love" (1 Corinthians 13:13). If I have not love, the apostle said, I have nothing.

Rembrandt's evocation of the virtue of virtues is twofold, perhaps three- or fourfold. The loving gesture of the mother for her children is echoed in the sculptor's embrace of his piece. And if we let ourselves be carried away to the extent of the great Rembrandt scholar Christopher White, we will expand the scope of love to include Rembrandt's love of art and White's love of Rembrandt: "Such is the tenderness of the scene that it might represent the artist as a widower creating the family he lacks, or possibly like Pygmalion falling in love with his own creation. The eloquent affection of the sculptor for his work may be taken as a visual symbol of the artist's deep attachment to his craft, and one cannot help personalizing such devotion."[15] In short steps we have come a long way from the butchers.

474
Rembrandt
The blind Belisarius receiving alms
Unsigned. Inscribed *erbarmt u over den armen bellisaro die nochtans wel was in groot aensien door syn manhaftyge daden en door de jaloesy is verblindt.* (Pity poor Belisarius, who yet was highly respected for his manly deeds and who was blinded by jealousy.)
Undated. Ca. 1660
Brown ink, some white body color, 16.7 x 12.1 cm.
Benesch 1053
Berlin, Staatliche Museen, Kupferstichkabinett

Belisarius (505–65) was a great Byzantine general. According to medieval legend, he was blinded by Emperor Justinian and condemned to beg passers-by for obols. If ever a beggar was deserving, it was he. Rembrandt drew and inscribed this raw drawing of Belisarius the beggar after his own fall from financial grace. The play *Bellisarius* by the Brussels publisher and playwright Claude de Grieck (1625–ca. 1670), translated from the French drama (1643) by Jean de Rotrou (1609–50), in itself translated from the Spanish (1632) of Antonio Mira de Amescua (1574–1644), was staged on the Amsterdam theater fourteen times between 1654 and 1662, including performances in 1659 and 1661.

Beggars

The beggar was not a motif like any other for Rembrandt. His beggars share vital features with his visions of St. Joseph, of Christ and of himself. This implies a more personal and respectful attitude toward the beggar than in earlier art or than in Dutch society.

In the years when the young Rembrandt will have been taking his first excursions from his home town of Leiden to the court city of The Hague, three hours away, a gang of peddlers was disturbing the peace between the two cities. Jan Jansz. van Leiden, a vagabond king who called himself Jan de Parijs – John of Paris – assembled a troupe of the unemployed with scary nicknames like John with the Long Hair and Susanne the Babylonian. Until they were captured, they pestered the neighborhood by breaking into farmhouses at mealtime and forcing the peasants to feed them and by dancing naked in public. When they were apprehended and tried in 1625, Jan Jansz. was banished for twenty-five years, indication enough of how seriously his offenses were taken by the community.[16]

Dutch society had a hard time dealing with "gypsies, lepers, beggars, vagabonds [and] landlopers," in the terms of a long-lived edict issued by Charles V in 1531, which placed these undesirables in the same category as "spies and thieves." Members of this underclass who were able to present themselves as innocent victims, representatives of the deserving poor, could expect sympathy and support for a period of time. However, as soon as they began to seem undeserving, or made the impression of malingering when they should be out looking for work, they would be turned out into the streets. "Studies of poor relief show highly-regulated urban communities, characterized by a concern with boundaries, social control and criteria for inclusion/exclusion. Any form of itinerancy tended to be treated

as vagrancy, usually punished by expulsion, so that vagrants were actually produced by the system."[17] Begging itself was often forbidden, placing beggars at the mercy of authorities who were sometimes "tolerant" and sometimes sticklers for law and order.

The image of the beggar in Netherlandish art was no better than in society as a whole. Hieronymus Bosch's beggars, copied and elaborated on throughout the sixteenth century, are often indistinguishable from his demons. Their stock in trade consists of repulsive wounds and pathetic ailments, which were sometimes

16 Van Deursen 1978, p. 76. The present chapter was published in different form in 2005 in a catalogue of Rembrandt's beggar etchings in a private American collection.
17 Kelly 2004. See also the excellent chapters on poverty and relief in de Nijs and Beukers 2002.

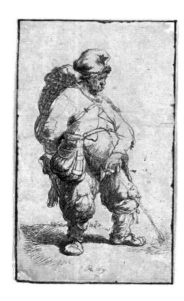

475
Rembrandt
A man making water
Inscribed *RHL 1631*
Etching, 8.2 x 4.8 cm.
Bartsch 190 i(1)
Haarlem, Teylers Museum

476
Rembrandt
A woman making water
Inscribed *RHL 1631*
Etching, 8.1 x 6.5 cm.
Bartsch 191 i(1)
Haarlem, Teylers Museum

477
Rembrandt
The flight into Egypt
Unsigned, undated. Ca. 1627
Etching, 14.6 x 12.2 cm.
Bartsch 54 i(6)
Haarlem, Teylers Museum

478
Rembrandt
Standing beggar leaning on a stick
Unsigned, undated. Ca. 1629
Black chalk, 29.2 x 17 cm.
Benesch 30 recto
Amsterdam, Rijksmuseum

479
Rembrandt
Beggar leaning on a stick
Unsigned, undated. Ca. 1630
Etching, 7.8 x 6.6 cm.
Bartsch 163 i(1)
Haarlem, Teylers Museum

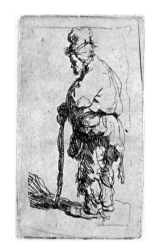

18 Silver 1996, p. 139, with reference to the research of Paul Vandenbroeck.
19 Van Vaeck 2001. Definition from *Webster's third new international dictionary*, 1961.
20 Singer 1906. This remark is to be found not in the book itself, but on a separate sheet that could only be acquired by mailing in a detachable form between pages 270 and 271.

feigned. "These social outsiders are defined as lazy rather than industrious, dirty rather than clean, and they are unproductive, parasitic and profligate in a society that esteems work, thrift and self-restraint. Small wonder that in representations by Bruegel and others, beggars are made to look as unattractive as possible."[18] In Rembrandt's youth, this tradition was lowered to new depths, but brilliantly, by Adriaen van de Venne (1589–1662), who made a specialty of beggars, peasants and cripples in desperate and often violent circumstances. Like the social class he took as his subject, the artistic genre practiced by van de Venne was considered the lowest of the low in the hierarchy of specialties in art. It corresponds to a kind of painting that Pliny the Elder (23–79 AD), in his writings on art, called rhyparography, the depiction of mean, unworthy or sordid subjects.[19]

It would not then have been out of line with the convictions of his society, with Netherlandish artistic tradition or classical art theory had Rembrandt depicted beggars as contemptible or loathsome creatures. Indeed, some of his work fits perfectly well into this picture. His etchings of street people relieving themselves in public can hardly be seen as other than derogatory or mocking. The revealingly frontal view of the woman in a matched pair of etchings from 1631 was found so offensive by Hans Wolfgang Singer in 1906 that he refused to believe it could have been made by a master he loved and respected. While accepting Rembrandt's authorship of *A man making water* in his complete edition of Rembrandt's etchings, he wrote of the companion *A woman making water*: "I recognize in this worth-

less sheet only an attempt by some talentless individual to outdo Rembrandt's etching B. 190 [of a man urinating] in a certain direction. Rembrandt indeed had a sense of humor, but nothing of the kind can be found in this print."[20]

The first homeless people in Rembrandt's oeuvre however could not be more different. They are none other than Mary, Jesus and Joseph, in *The flight into Egypt* of 1627. The figure of the trudging Joseph in particular corresponds to a type that Rembrandt was to depict in many variations in the years to come. He is a bearded man, no longer young but not visibly impaired. He has a high, soft cap on his head and wears a nondescript, somewhat ragged cloak and pants. Around his waist is a sash from which a knife hangs. He has shoes on.

The entry of this figure into Rembrandt's work in the guise of St. Joseph answers a question often asked of Rembrandt's beggars: are they despicable in the artist's eyes? Comparing the saintly Joseph with a beggar such as that etched by Rembrandt about 1630, we can only conclude that this is out of the question. An artist who looked down on a figure such as the *Beggar leaning on a stick* would not have given the same guise to a saint.

The depiction of Joseph as a landloper was not a one-time inspiration. *The flight into Egypt* and *The rest on the flight* were etched by Rembrandt more frequently than any other narrative, recurring in the 1630s and 1650s eight times in a variety of modes. And in each decade there were etchings of beggars or vagrants that come close to Rembrandt's Josephs.

480
Rembrandt
*The Holy Family crossing a brook
on the flight into Egypt*
Inscribed *Rembrandt f. 1654*
Etching, 9.3 x 14.4 cm.
Bartsch 55 i(1)
Haarlem, Teylers Museum

481
Rembrandt
Peasant family on the tramp
Unsigned, undated. Ca. 1652
Etching, 11.3 x 9.3 cm.
Bartsch 131 ii(2)
Haarlem, Teylers Museum

482
Rembrandt
The blindness of Tobit
Unsigned, undated. Ca. 1629
Etching, 7.9 x 6.3 cm.
Bartsch 153 ii(5)
Haarlem, Teylers Museum

One etching by Rembrandt of a biblical subject, the blind old Tobit, was not recognized as such by Adam Bartsch, the author of the standard catalogue of the master's etchings. Bartsch included it among the prints of beggars. This kind of crossover between street life and sacred history matches a pattern that we find elsewhere in Rembrandt's work, as when he paints images of Jesus in the guise of young Jewish men from his surroundings or when he incorporates entire populations of street people into a major composition such as the *Hundred-guilder print* (fig. 574).

A mixture of another kind brings the artist himself into his beggar imagery. The etching catalogued by Edmé Gersaint under number 168 was placed by him in the category "Gueux, ou Mandians," beggars. He called it a "beggar sitting on a mound" ("Autre Gueux, assis sur une motte de terre," the title that it

has kept since then). Early in the twentieth century, though, a close resemblance was noticed between the face of the beggar and that of Rembrandt in a self-portrait dated the same year, a plate known as *Self-portrait open-mouthed, as if shouting.*

When in 1631 Rembrandt painted *Christ on the Cross* he gave the dying Christ the same anguished features as in the two etchings. Just as the image of St. Joseph was therefore related to the figure of the beggar, so was Christ himself. If Rembrandt's beggars were examples of rhyparography, then, they were only one step removed from the opposite category – megalography, the painting of great things, of which the crucified Christ, in Rembrandt's age, was the greatest of all. The resemblance of *Christ on the Cross* to Rembrandt's Passion paintings for Stadholder Frederik Hendrik (figs. 261–62, 267–69) suggests that *Christ on the Cross* as well was intended for his eyes.

This constellation of images and of markets – from strangers on the street to the person of the artist, from social outcasts to God himself, from the pennies paid for small etchings of beggars to the veritable fortunes Rembrandt earned for paintings for the stadholder – shows how essential Rembrandt's etchings of beggars were in his formative years as an artist. The way he imagined the beggar is inextricable from the way he imagined himself, the way he imagined Christ, the way he conceived of imagery itself.

From the very beginning of Rembrandt studies, in the catalogues of his etchings from the mid-eighteenth century, it was realized that in his prints of beggars, Rembrandt owed a great debt to the French artist Jacques Callot (1592–1635). In 1622, Callot brought out a series of twenty-five small prints under the title *Les gueux*, The beggars. Rembrandt was not the only artist to be gripped by this publication, a breakthrough in the annals of rhyparography. Callot's beggars were not the abject creatures Rembrandt knew from Bruegel

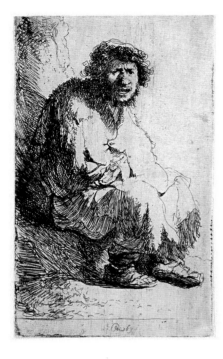

483
Rembrandt
Beggar seated on a bank
Inscribed *RHL 1630*
Etching, 11.6 x 7 cm.
Bartsch 174 i(1)
Haarlem, Teylers Museum

484
Rembrandt
Self-portrait open-mouthed,
as if shouting
Inscribed *RHL 1630*
Etching, 8.1 x 7.2 cm.
Bartsch 13 iii(3)
Haarlem, Teylers Museum

485
Rembrandt
Detail of *Christ on the Cross*
(fig. 594)
Le Mas d'Agenais, Collégiale
Saint Vincent

486
Jacques Callot (1592–1635)
Seated beggar eating
Unsigned, undated. From
the series *Les gueux* of 1622
Etching, 13.7 x 8.7 cm.
Lieure 502 i(2)
Formerly Novità Old Master
Prints

487
Rembrandt
Beggar warming his hands
at a chafing dish
Unsigned, undated. Ca. 1630
Etching, 7.7 x 4.6 cm.
Bartsch 173 ii(2)
Haarlem, Teylers Museum

and Adriaen van de Venne. They stood on their own two feet – well, sometimes it was one foot – and were provided with attributes that gave them a certain seriousness if not dignity. This attitude toward the beggar informs Rembrandt's images as well, which he began making a few years later.

Rembrandt never copied Callot literally. The example illustrated here is one of the closest matches between the two sets of prints. The general compositions and details give one the impression that Rembrandt might have had Callot's prints in front of him, but this need not necessarily have been the case. Callot is certainly an inspiration to Rembrandt, but Rembrandt's beggars and the etchings as such have a different look from Callot's. Part of the difference lies in the technique used by the two artists. To put it simply, Callot's etchings aspire to the condition of engraving, Rembrandt's to that of drawing.

Callot's beggars helped to humanize the image of the beggar in Dutch art. Indeed, they helped Rembrandt attain his not altogether deserved reputation for kindliness. Mean and sordid though they may have been in life and in art theory, in Rembrandt's etchings beggars are bestowed with sanctity and individuality.

488
Rembrandt
Two studies of a beggar woman
Unsigned, undated. Ca. 1632
Gallnut ink, 17.5 x 14 cm.
Benesch 197
Paris, Musée du Louvre

Readers and writers

In 1993 the Kunsthalle in Frankfurt organized the exhibition *Leselust: Niederländische Malerei von Rembrandt bis Vermeer* (Love for reading: Dutch painting from Rembrandt to Vermeer).[21] It was a wonderful demonstration of the intense fascination of Dutch artists with the written and printed word. Examples lay everywhere for the grasping. The main task of the organizers was not to search out hard-to-find items but to weed out the best among the countless examples in Dutch painting of books, letters, broadsheets, documents, writing instruments, printed matter and writing of every conceivable kind, readers and writers, professional and leisurely.

The environments in which reading and writing occur are as numerous as Dutch society itself. They serve in all functions, rich and poor, religious and secular, intellectual and erotic. They occur in all kinds of painting except perhaps landscape: genre scenes and portraiture, still-life and history painting.

Rembrandt is a gratifying example of this phenomenon. He was as infatuated with books and reading as any artist of the time. Among his readers are his wife Saskia (fig. 496), endowed with all the dignity of a scholar, and his son Titus (fig. 89), who seems to be reading aloud. In his self-portrait as the apostle Paul, which I interpret as a confessional statement, he clutches a book (figs. 1, 630). He never missed a chance to include a book in his portraits of scholars or preachers (figs. 319, 320, etc.).

He also liked the mechanics of writing. Twenty years before he drew, painted and twice etched the portrait of the writing master Lieven van Coppenol, he drew and painted scribes sharpening their quills. Several portraits of writers include inkpots.

History subjects that do not demand readers get them from Rembrandt anyway. Joseph's sister Dinah, in the foreground of the etching *Joseph telling his dreams*, looks up from her reading to listen to him. The Holy Family were all readers. Even the carpenter Joseph is deep in a book in an etching of about 1632 (fig. 497).

Rembrandt was drawn to the theme of people concentrating hard. One of his most intimate drawings of this kind shows a seated woman, apparently a household servant, with a small book. He shows her twice. In one sketch she leans forward eagerly, engrossed in her reading. In the other, she sits back in her chair,

489
Rembrandt
Man sharpening a quill
Inscribed *RHL van Rijn 1632*
Canvas, 105 x 83 cm.
Bredius 164
Kassel, Staatliche Museen
Kassel, Gemäldegalerie Alte
Meister

490
Rembrandt
*Scribe sharpening his quill
by candlelight*
Unsigned, undated. Ca. 1635
Brown ink and wash,
12.5 x 12.3 cm.
Benesch 263
Weimar, Stiftung Weimarer
Klassik und Kunstsammlungen

21 Schulze 1993.

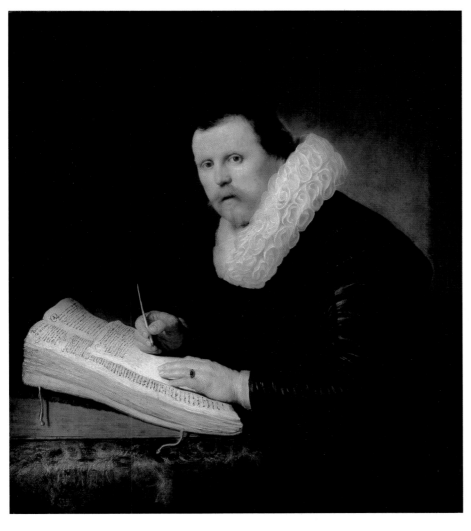

491
Rembrandt
*Young man at a desk, transcribing
a document*
Inscribed *RHL van Rijn 1632*
Canvas, 104 x 92 cm.
Bredius 146
St. Petersburg, State Hermitage
Museum

492
Rembrandt
*Studies for Joseph telling his
dreams: a woman reading and
an Oriental*
Unsigned, undated. Ca. 1638
Brown ink and wash, some white
body color, 13.9 x 12.5 cm.
Benesch 168
USA, private collection

493
Rembrandt
*Lieven Willemsz. van Coppenol
(1599–after 1677), Amsterdam
Mennonite calligrapher and
writing master*
Unsigned, undated. Ca. 1658
Etching, drypoint and burin,
25.8 x 19 cm.
Bartsch 282 iv(5)
Haarlem, Teylers Museum

494
Rembrandt
Detail of *Joseph telling his dreams*
(fig. 635)
Haarlem, Teylers Museum

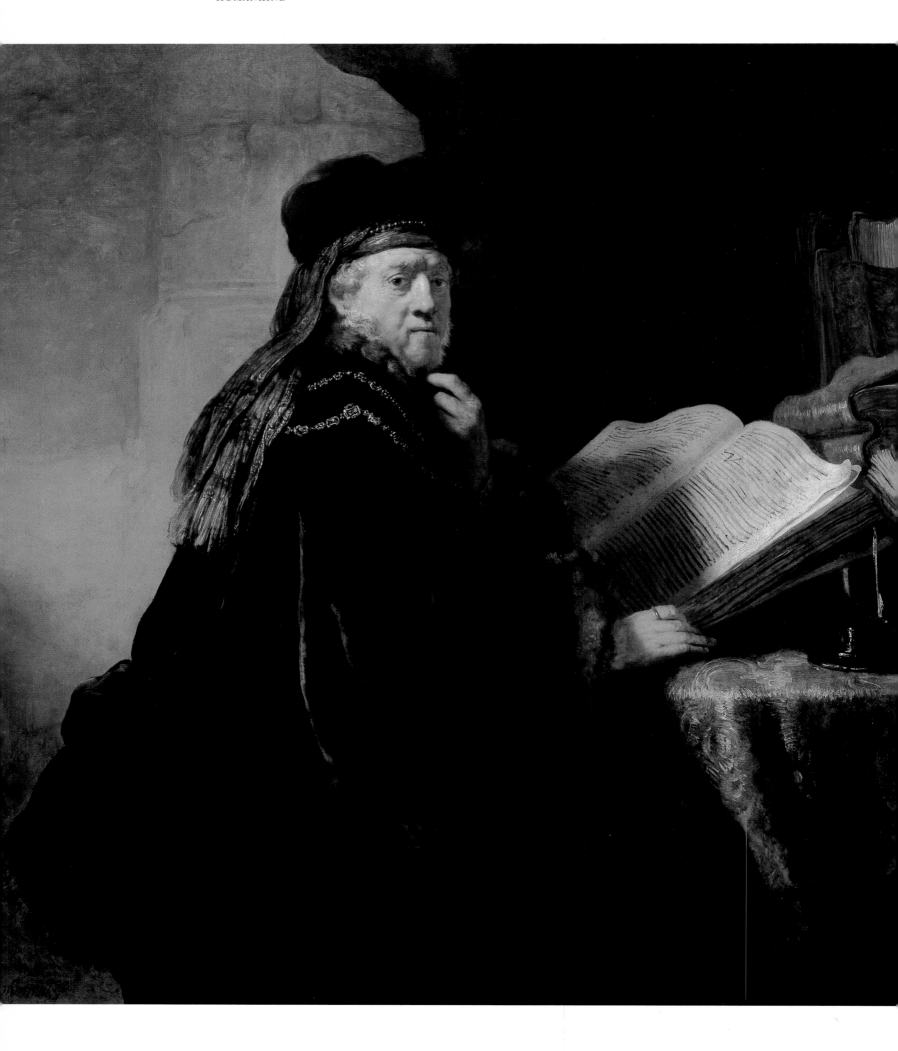

495
Rembrandt
Scholar in his studio
Inscribed *Rembrandt f. 1634*
Panel, 141 x 135 cm.
Bredius 432
Prague, National Gallery

496
Rembrandt
Saskia seated before a window,
looking up from a book
Unsigned, undated. Ca. 1635
Brown ink and wash,
16.2 x 12.5 cm.
Benesch A9
Budapest, Szépmüvészeti
Múzeum

the book beneath her bosom, perhaps exhausted by her reading to the point of falling asleep. See the following section, on sleepers.

On the following page is a selection from the books in Rembrandt's paintings, drawings and etchings, sorted by size. His books are not neat bibliophile items, like those of his colleague Pieter Claesz., for example, whose books look as if they are fresh from the binder. Rembrandt's books have been heavily used, without overdue consideration for their condition. The pages are often crinkled, the bindings curled at the edges. Sometimes the book blocks hang loose in the binding. In his earliest paintings, Rembrandt painted piles of highly detailed books; later he was more sparing, but books – generic books, without readable text or titles – remained his favorite attribute. This circumstance reinforces my conviction that Rembrandt was a dedicated reader and that he owned a considerable number of books. To give symbolic expression to that idea, the examples show twenty-two books, the number in Rembrandt's inventory. They are all different, and they amount to a small fraction of the books in his art.

497
Rembrandt
The Holy Family
Inscribed *RHL.* Undated. Ca. 1632
Etching, 9.6 x 7 cm.
Bartsch 62 i(1)
Haarlem, Teylers Museum

498
Rembrandt
Two studies of a young woman reading
Unsigned, undated. Ca. 1633
Brown ink, 17.3 x 15 cm.
Benesch 249
New York, Metropolitan Museum
of Art

Duodecimos

499 500 501 502

Octavos

503 504 505 506 507

Quartos

508 509 510 511 512

Folios

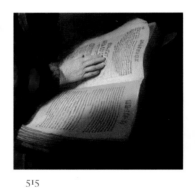

513 514 515 516

Unprinted folios

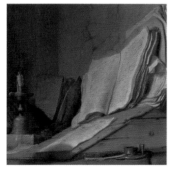

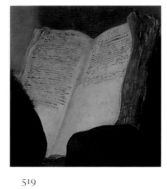

517 518 519 520

Sleepers

521
Rembrandt
*The Holy Family asleep,
with angels*
Unsigned, undated.
Ca. 1645
Brown ink, 17.5 x 21.3 cm.
Benesch 569
Cambridge, Fitzwilliam
Museum, University of
Cambridge

There is the self-indulgent sleep of the lazy and the wanton and the righteous sleep of the exhausted. Sleep is the vehicle of dreams and divine revelation. It incites tenderness and excites lust. It follows on sexual satiety, making strong men vulnerable. Sleep can be a symptom of weakness and approaching death. Rembrandt was a connoisseur of sleep. A few of his variations on the theme are illustrated on these pages.

522
Rembrandt
Jupiter and Antiope
Inscribed *Rembrandt f 1659*
Etching, drypoint and burin,
13.8 x 20.5 cm.
Bartsch 203 i(2)
Haarlem, Teylers Museum

523
Rembrandt
Old man asleep
Unsigned, undated.
Ca. 1629
Panel, 52 x 41 cm.
Bredius 428
Turin, Galleria Sabauda

524
Rembrandt
A girl sleeping
Unsigned, undated.
Ca. 1655
Brown wash, 24.5 x 20.3 cm.
Benesch 1103
London, British Museum

Foreign ways

Rembrandt's reputation as a conscientious and sympathetic observer of strange folkways dates back to his own lifetime. However, few of his existing works give substance to this important part of his image.

Although the age of exploration was at its tail end by the time Rembrandt was born, he will not have noticed the decline. The excitement of foreign voyages was kept alive by a constant stream of publications on discoveries past and present and by breaking news from sailors and soldiers, merchants and missionaries returning to Europe from all parts of the globe. During Rembrandt's lifetime, an average of one travel book a month was published in the Netherlands.[22]

The role of visual artists in this major enterprise was depressingly small. The few exceptions make one realize how poor the overall record is. In painting, only two of Rembrandt's contemporaries created more than an incidental new image of non-European parts. Albert Eckhout (ca. 1610–ca. 1665) and Frans Post (1612–80) painted immeasurably precious pictures of the Dutch colony in Brazil and its people. They did this on the initiative of the governor of the colony, Johan Maurits van Nassau-Siegen (1604–79). Thanks to his personal interest these artists and the natural historians Willem Piso (1611–78) and Georg Markgraf (1610–44) were brought to Brazil, where they produced pioneering verbal and visual descriptions of the flora and fauna, landscape, topography and a bit of the society of the New World. No other seventeenth-century official

of a Dutch trading company in North America, Africa, the Indies, Japan or the subpolar regions ever commissioned a campaign of this kind. Nor did any Dutch artist ever undertake a journey on his own to portray distant lands. It is sad to think what the world is missing because of this thematic inertia. The dominant role of Johan Maurits is a reminder of how important a patron can be as an agent of artistic innovation.

In printmaking, many more collections of images of distant lands were produced, although the tendency was to copy the illustrations, themselves second- or third-hand derivatives, published by older artists.

Rembrandt was typical in his casual interest in foreign cultures of his own time. He liked to collect weapons, musical instruments and curiosities from the Orient (see above, p. 141), but he did not devote serious attention to these items or the cultures from which they came.

When exotic characters showed up in the streets he was willing to grab a sheet of paper and draw a Moor or a Pole or a Turk, but his efforts of this kind cannot be called serious contributions to the study of foreign peoples. In general, his foreign-looking motifs are adaptations of conventional images of "the Turk." Although he did not clothe his sitters in foreign costume, as some portraitists did, he was not averse, at least in one self-portrait, to assuming Oriental airs himself (fig. 527). This kind of dressing up was common and was not taken very seriously. Of a painting by Jan Lievens of "a so-called Turkish potentate" in the collection of Frederik Hendrik, Constantijn Huygens wrote that it was "done from the head of some Dutchman," which could apply equally to most of Rembrandt's Turks and

525
Rembrandt
Russian courtiers
Unsigned.
Inscribed *in ongenaeden synden en werden niet geschooren* (those in disgrace are not shaved).
Undated. Ca. 1637
Brown ink and wash,
14.4 x 20.1 cm.
Benesch 145
New York, The Morgan Library

22 The invaluable *Short Title Catalogue Netherlands* (stcn.nl), which provides succinct descriptions of all books published in the Netherlands between 1580 and 1800, lists 860 titles on travel (*reisverhalen*) published between 1606 and 1669.
23 Royalton-Kisch 1992, p. 71. On 11 May 2006 Elmer Kolfin of the University of Amsterdam gave a talk in which he demonstrated the presence of one or more blacks in some thirty paintings, drawings and etchings by Rembrandt. Although most are background figures, Kolfin's exposé broke the field wide open.

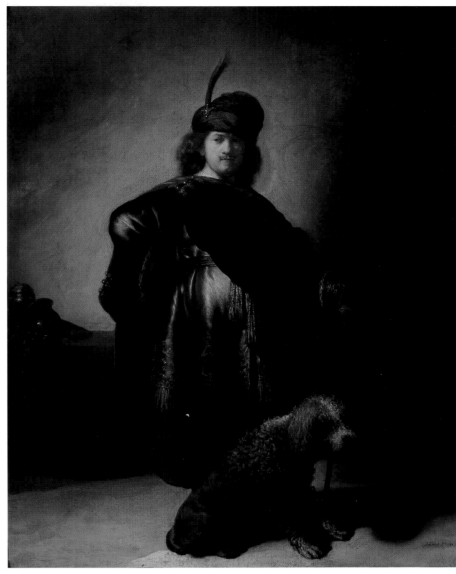

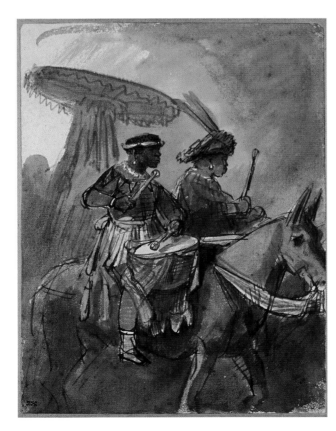

526
Rembrandt
An Oriental standing
Unsigned, undated. Ca. 1633
Brown ink and wash, corrected
and heightened, 22.1 x 16.9 cm.
Benesch 207
London, British Museum

527
Rembrandt
Self-portrait with poodle
Unsigned, undated. Ca. 1631
Panel, 81 x 54 cm.
Bredius 16
Paris, Musée du Petit Palais,
Musée des Beaux-Arts de la
Ville de Paris

528
Rembrandt
*Two Negro drummers mounted
on mules*
Unsigned, undated. Ca. 1637
Brown ink and wash, red chalk
and yellow watercolor, height-
ened with white, 22.9 x 17.1 cm.
Benesch 365
London, British Museum

Slavs and Persians. This did not prevent the exotic look
from becoming an important part of the Rembrandt
legend.

The hesitancy of experts to come up with positive
identifications of seemingly closely observed elements
in Rembrandt's work is a bad sign. A drawing in the
British Museum corresponds to a description of the
black African drummers in a pageant celebrating the
marriage in The Hague of Amalia van Solms's sister
in February 1638. However, the curator of drawings
in the British Museum finds the headdress of the sec-
ond figure more Hungarian than African and thinks
that the drawing is just as likely to have been made in
Amsterdam as The Hague.[23]

Equally shaky are the identifications of ethnicity and
costume in Rembrandt's blacks. Concerning his most
famous painting of black Africans, *Two moors* in the
Mauritshuis, it is not even certain whether the subject
is one man painted twice or two different figures
(see also fig. 241).

It is however too soon to give up altogether on
Rembrandt as an observer of foreign ways. A new inter-
pretation of a misunderstood drawing of four standing
men in the Morgan Library in New York shows that the

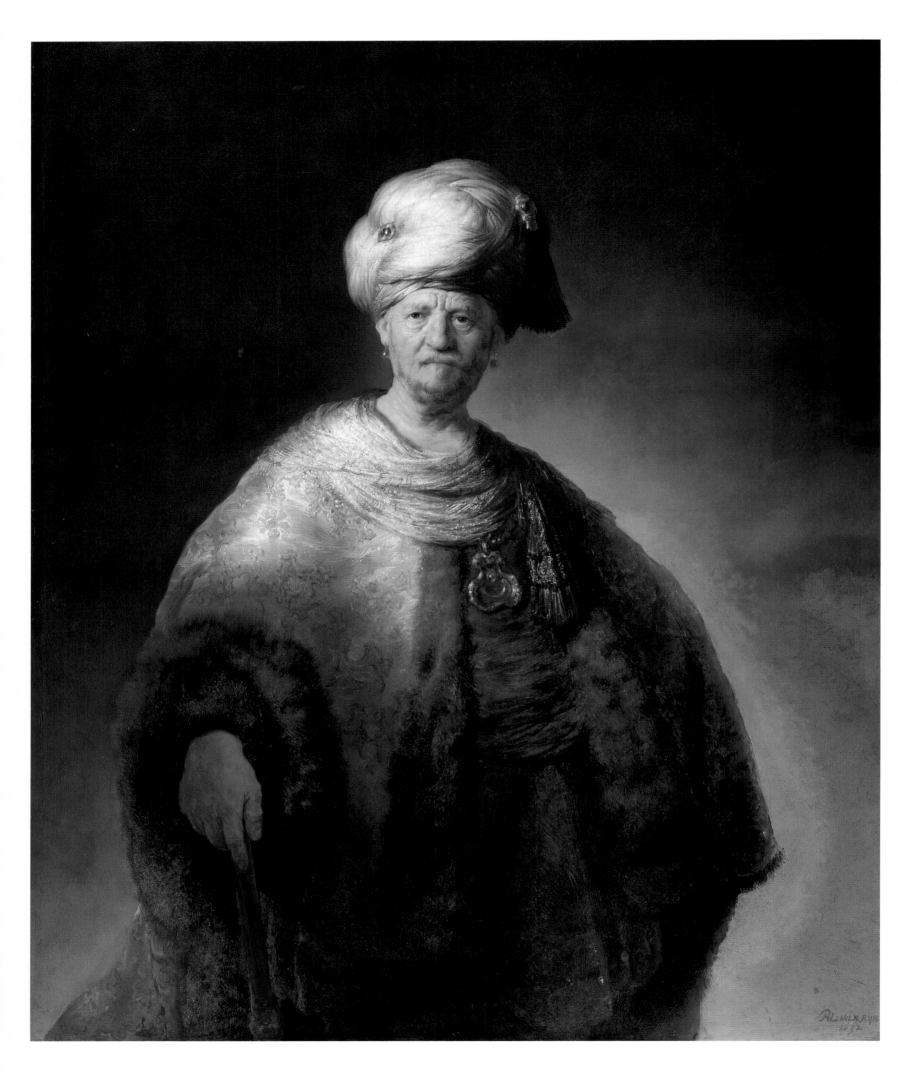

529
Rembrandt
Man in fanciful costume:
"The noble Slav"
Inscribed *RHL van Rijn 1632*
Canvas, 152.7 x 111.1 cm.
Bredius 169
New York, The Metropolitan
Museum of Art

530
Rembrandt
Two moors
Inscribed *Rembrandt f. 1661.*
Canvas, 78 x 64.5 cm.
Bredius 310
The Hague, Koninklijk Kabinet
van Schilderijen Mauritshuis

531
Rembrandt
The white Negress
Inscribed *RHL.* Undated.
Ca. 1630
Etching, 11.2 x 8.4 cm.
Bartsch 357 ii(2)
Haarlem, Teylers Museum

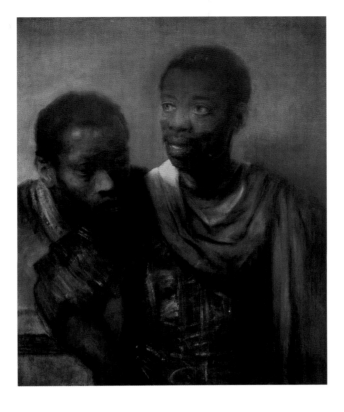

24 De Winkel 2006, forthcoming.
With kind thanks to the author for
showing me this part of the
manuscript before publication.
25 When I showed these remarks
and the Morgan drawing to the
Russian art historian Roman
Grigoryev, he denied emphatically
that the costume is Russian and
disputed de Winkel's interpretation.
In 1974 Ben Broos made a strong
case, based on Polish costume
history, for regarding the *Polish rider*
in the Frick Collection, New York,
as an accurate depiction of a Polish
knight.
26 Smith 1836, p. 105, no. 285.
Hofstede de Groot 1915, pp. 198–99,
no. 349.

limiting factor may be not Rembrandt's lack of interest but our own ignorance (fig. 525). Otto Benesch called the drawing a "Sheet of studies with two scenes from the Old Testament (each represented by two men)," referring to passages from the books of Numbers and Samuel. Then the historian of costume Marieke de Winkel came up with a fascinating discovery. On the basis of a publication of the 1990s on Russian costume, she identified the "gown with hanging sleeves (*ferez*) and the high fox fur hat called *šapka gorlatnaya*" worn by the second figure from the left as Russian garments that in the sixteenth and seventeenth centuries could only be worn by the boyars and princes who held the highest functions at the court of the tsar of Muscovy.[24]

Looking further into the situation depicted in the drawing, she noticed that the figures in the foreground have short hair and those in the background long, unkempt hair. This corresponded with "a contemporary usage current at the court of Moscow that those noblemen who were in disgrace (*opala*) with the tsar were removed from the *duma* and had to grow their hair long to distinguish them clearly from the other Russian nobles, who always shaved their heads." As it happens, Rembrandt jotted down a few words on the drawing, and they describe the very same practice: *in ongenaeden synden en werden niet geschooren* (those in disgrace are not shaved). Here, then, is a highly convincing reading of the drawing as a single scene, a reading that reveals Rembrandt to have been at least something of a student of foreign ways.[25] In these remarks, the study of living contemporaries is isolated from other kinds of interest in the unfamiliar. The distinction was not drawn sharply at the time. The Near East of biblical times was thought to survive in contemporaneous folkways and

– see the following section – in the habits of the Jews of Amsterdam. Rembrandt even conflated the eating and dressing customs of seventeenth-century Indians, which he copied from Mughal miniatures, with those of the Jewish patriarch Abraham (see p. 39). Accuracy in these matters was a highly regarded quality in art, a quality that Rembrandt was thought by his contemporaries to possess to a supreme degree (see p. 111), even if we do not see things that way.

The all-embracing framework of opinion and judgment for Rembrandt and his contemporaries, the touchstone for all knowledge and truth, remained the Christian faith. The time had yet to come when a Dutchman of any denomination could weigh the values of a non-Christian against his own with any chance of favoring the other faith.

Near yet not quite there: Rembrandt and the Jews

For the past two centuries, Rembrandt and the Jews have enjoyed a special relationship in Western culture, to great mutual benefit. However, a critical examination of the grounds for the notion that Rembrandt had more interest in or liking for the Jews of Amsterdam than other Dutch history painters is rather disenchanting. Despite this, the enchantment is not likely to disappear.

In the first catalogue of Rembrandt's paintings, by John Smith (1836), the painting later called "*The noble Slav*" (fig. 529) was called "A Jew rabbi" and in 1915 a "Turkish nobleman."[26] The model himself, like that

532
Rembrandt
Detail of *Hannah and Samuel
in the Temple*
Inscribed *Rembrandt f. 16[50]*
Canvas, 40.6 x 31.8 cm.
Bredius 577
Edinburgh, National Gallery
of Scotland

533
Rembrandt
Detail of *Moses with the tablets
of the law*
Inscribed *Rembrandt f. 1659*
Canvas, 167 x 132 cm.
Bredius 527
Berlin, Staatliche Museen,
Gemäldegalerie

534
Rembrandt
The feast of Belshazzar
Inscribed *Rembrandt fecit 163..*
Ca. 1635
Canvas, 167 x 209.5 cm.
Bredius 497
London, National Gallery

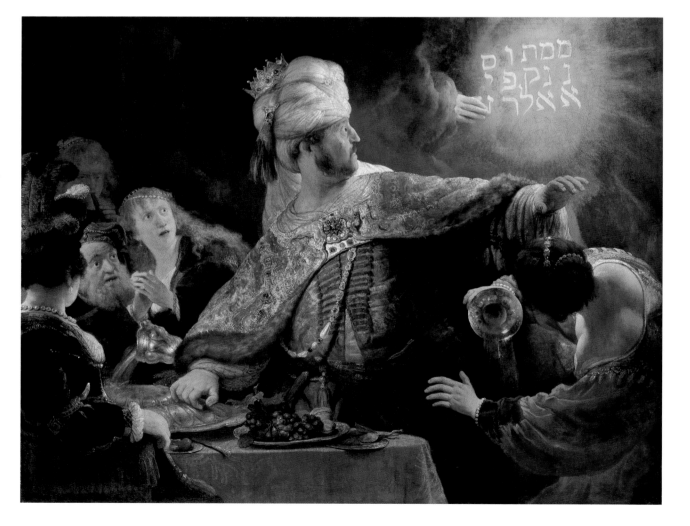

27 Liedtke et al. 1995, vol. 2,
pp. 42–45, no. 2.
28 Landsberger 1946, p. 36.
29 For Leiden, see above, pp. 131–32.
When Jacob de Gheyn needed
a Hebrew inscription for a painting
of King David, he turned to his
friend Constantijn Huygens,
who forwarded the request to
the minister of the Reformed
community in London, Cesare
Calandrini. See Worp 1911–17,
vol. 1, p. 16.
30 D'Os in de Bruyloft. Wijnman
1928.
31 This painting is presently consid-
ered the work of an assistant,
I believe on insufficient ground.
Even as a workshop product,
however, it is properly considered
Rembrandt's invention.
32 Alexander-Knotter 1999,
pp. 149–50. Sabar 1993 takes a more
positive view of the evidence.
33 Alexander-Knotter 1999,
pp. 144–47. Her contention that
the shape of Rembrandt's letters
is typical of Sephardic calligraphy
is interesting, but not backed up
by examples.

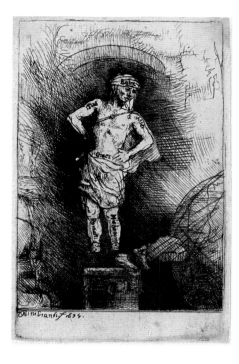

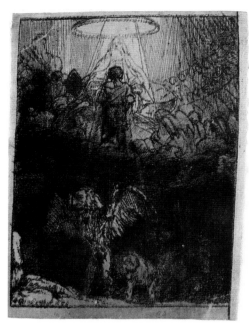

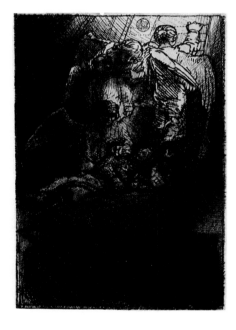

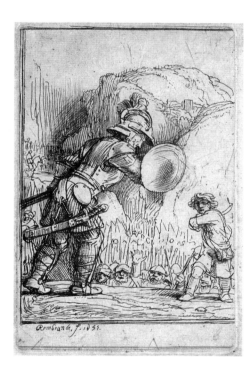

535–38
Rembrandt
*Illustrations for Piedra gloriosa
by Menasseh ben Israel:
The image seen by
Nebuchadnezzar
Jacob's ladder
Daniel's vision of the four beasts
David and Goliath*
Inscribed *Rembrandt f 1655.*
Etching, burin and drypoint,
various dimensions,
ca. 10 x 7,5 cm.
Bartsch 36, various states
Haarlem, Teylers Museum

for Lievens's "Turkish potentate" in the prince's collection, was most likely, as Constantijn Huygens wrote, to have been "some Dutchman."[27] The model for the "Noble Slav" bears a suspiciously close resemblance to non-portrait heads in etchings and paintings by Rembrandt and Jan Lievens. The quality of Jewishness, it seems, is not strained. It spilleth over from and into any number of other Central and Western European and Oriental identities. Unlike other exotic nationalities, however, Jewishness cleaves to Rembrandt.

The associations between Rembrandt, Jews and Jewishness are many. But whether or not they amount to a special relationship is a moot point. This was admitted by the German-Jewish art historian Franz Landsberger, in his sensitive and conscientious book *Rembrandt, the Jews and the Bible*, published in English

translation – and only in English translation, not in German – in 1946 in the United States, where he fled from the Nazis. Landsberger wrote disarmingly, "Everything we know of [Rembrandt . . .] suggests that he was a friend of the Jews; although this conclusion is based upon conjecture and not upon any available evidence."[28]

Let us present and cross-examine the evidence.

Rembrandt lived in the Jewish section of Amsterdam.
So did twenty or more other artists, who began moving there even before the Jews. Does this make them too friends of the Jews? Actually, Rembrandt's next-door neighbor was a Sephardi named Daniel Pinto. Rembrandt's relationship with him was so bad that a disagreement between them on problems of maintenance ended up in the courts.

Rembrandt had a marked interest in subjects from the Jewish Bible. True, but in this respect he was no different from his master Pieter Lastman and many other Dutch artists. There was nothing necessarily Jewish about this. The Old Testament was part of the canon of holy literature for Christians as well as Jews. Dutch Calvinists thought of themselves as the Israelites of latter days, persecuted by the great (Catholic) powers and rescued by the Lord.

Rembrandt was able to paint authentic Hebrew texts, with well-formed letters. There were Christian Hebraists around to whom he was more likely to turn for help in that regard than to Jews.[29] The former professor of Hebrew at Leiden University, who was moreover a printer and seller of Hebrew books, was the Amsterdam Mennonite Jan Theunisz. (1569–1637). This colorful character taught Hebrew at the Nederduytsche Academie, an Amsterdam center for education and entertainment, while running a tavern called – three hundred and fifty years before *Fiddler on the Roof* – The Ox at the Wedding.[30] In any case, Rembrandt did not take his Hebrew all that seriously in the end. In 1659, in *Moses with the tablets of the law*, he repeated, with some new errors, the constellation of letters he had used in 1650 for *Hannah and Samuel in the Temple*.[31] In this respect he was bettered by his colleagues Leonard Bramer (1596–1674) and Gabriël Metsu (1629–67), who both painted the complete Ten Commandments more correctly than he.[32]

An Aramaic inscription on a Rembrandt painting of the mid-1630s shows a specifically Jewish rather than a Christian Hebraist twist.[33] This is the famous writing on the wall – *Mene mene takel upharsiz* (should have been *upharsin*) – in Rembrandt's *Feast of Belshazzar* of the mid-1630s (fig. 534). Why could Belshazzar not read the writing on the wall? Only Jewish commentators considered the simple suggestion that it was written from above to below rather than right to left. This is the form shown by Rembrandt. True, but this knowledge does not necessarily mean that Rembrandt

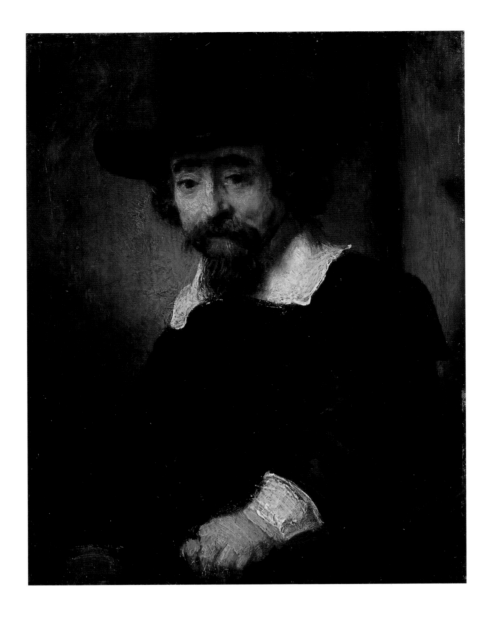

539
Rembrandt
*Ephraim Bueno (1599–1665),
Amsterdam Jewish physician*
Unsigned, undated.
Preparatory oil sketch
for an etching dated 1647.
Panel, 19 x 15 cm.
Bredius 252
Amsterdam, Rijksmuseum

34 Doc. 1637/7.
35 Gersaint 1751, p. 195, no. 249.
Dudok van Heel 1993, pp. 22–23.
36 For a review of the other evidence
in the question, see Dudok van Heel
1993. That author too rejects
resoundingly the identification of
the etching as Menasseh or as a Jew.
Doubt about the identification of the
sitter was first published in 1992 in a
letter to the editor of *Vrij Nederland*
by Adri Offenberg, former librarian
of the Bibliotheca Rosenthaliana.
37 Landsberger 1946, pp. 100–01.
Only three copies of the book with
Rembrandt's etchings are extant,
leading one to surmise that the
publisher never brought out an
edition with those prints.
38 Doc. 1654/4.

was a friend of the Jews. The only Jew with whom he had documented contact in the 1630s could have helped him with the inscription. This man, if he ever was Rembrandt's friend, did not remain so for long. He is the otherwise unknown "Portuguese painter" Samuel d'Orta. In December 1637 d'Orta accused Rembrandt of cheating him in a fascinating deal. D'Orta, who bears the name of a Jewish printer active in Italy and Portugal at the turn of the sixteenth century, bought from Rembrandt the etching plate of *The dismissal of Hagar*. Rembrandt had promised not to sell any of the "two or three" impressions he had printed for himself, but d'Orta apparently had evidence that he did.[34]

In 1636 Rembrandt etched the portrait of Menasseh ben Israel, one of the great scholars of Jewish Amsterdam. Did he? The earliest source for the identification of the sitter for the etching in question dates from 1751 and seems to be a misunderstanding.[35] The iconography of the portrait virtually rules out that the man is Menasseh. Rembrandt never failed to furnish the scholars or divine ministers he portrayed with one or more books as an attribute. To me it is inconceivable that he would not have given a book to a sitter who was not only a scholar and divine minister but also a publisher and printer![36]

In 1655 Rembrandt etched four illustrations for Menasseh's mystical book Piedra gloriosa. True, but Rembrandt's prints were quickly replaced by another set, journeyman revisions of Rembrandt's compositions, with a number of sensitive changes. Most particularly, the Godlike manifestation in Daniel's vision was removed, one assumes out of respect for the Second Commandment, leaving only an empty oval.[37] It is hard to imagine Rembrandt, or any artist for that matter, remaining friendly through exploitative treatment of this kind.

The Jewish physician Ephraim Bueno was etched by Rembrandt. Bueno was also etched, somewhat later, by Jan Lievens. Lievens's etching has the identifying inscription for which Rembrandt left space but did not fill in. It would seem that Bueno turned to Lievens for a substitute of Rembrandt's portrait. Does this make Lievens a friend of the Jews? More than Rembrandt, in any case.

Rembrandt painted as well as etched portraits of Jews. There is only one documented instance of this; the documentation consists of a notarized refusal by the patron Diego d'Andrada to accept the portrait by Rembrandt of a young girl, claiming that the portrait bore not even the remotest resemblance to the sitter.[38]

breath. What is left are later, questionable identifications based on the supposedly Jewish garb or Semitic features of non-portrait models in paintings attributed to Rembrandt. Are there more of these by Rembrandt than others? Does the ethnicity of a model make the artist a friend to their race? Does the de-attribution of a former Rembrandt *Jew* – as most have been de-attributed – detract from Rembrandt's presumed bond with Jewishness and add to the philosemitism of the other artist?

Rembrandt used Jews as models for depictions of Christ. Perhaps. But if he did, he was indeed only *using* them, as a tool to approximate the description of Christ in a famous historical fraud that was still believed in his time, the letter of Lentulus. This medieval pseudepigraph pretended to be a letter by Publius Lentulus, the governor of Judea before Pontius Pilate. It describes Christ thus:

> His hair is of the color of a ripe hazelnut, parted on top in the manner of the Nazirites, and falling straight to the ears but curving further, with blond highlights and fanning off his shoulders. He has a fair forehead and no wrinkles or marks on his face, his cheeks are tinged with pink. His nose and mouth are faultless. His beard is large and full but not long and parted in the middle … his eyes are changeable and bright.[39]

And so forth. This description is from Samuel van Hoogstraten, who quotes it approvingly even though he seems to know it is fictional. The strong resemblance of all of Rembrandt's heads of Christ to the image evoked in the Lentulus letter leaves little room for the supposition that Rembrandt was portraying his Jewish neighbors as they normally looked.

Rembrandt created respectful non-portraits of Jews. As we have seen in the case of the "*Noble Slav*", Jewishness in this regard is an elastic concept. Another case is the etching that was known as the *Little Jewish bride* until an attentive student realized that the wheel behind the woman identified her as St. Catherine. No document from Rembrandt's lifetime identifies a model as a Jew. Not even Rembrandt's detractors, like Andries Pels (1631–81), or detractors of Jews as models, mention Rembrandt and the Jews in one

39 Van Hoogstraten 1678, p. 105.

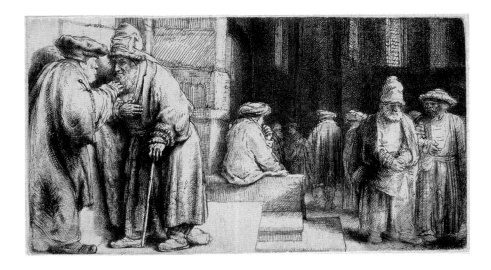

543
Rembrandt
Jews in the synagogue
Inscribed *Rembrandt f. 1648.*
Etching and drypoint,
7.1 x 12.9 cm.
Bartsch 126 ii(2)
Haarlem, Teylers Museum

A poem by Hendrick Waterloos on Rembrandt's *Hundred-guilder print* says that the Christ was etched "from life," but the attitude towards Jews in his other poems on the print is downright anti-Semitic. (See below, pp. 322–29.)

In 1648 Rembrandt etched a picture of Jews in the synagogue. The interior has none of the features that make a synagogue a synagogue, nor was there a synagogue anything like this large stone building anywhere in the Netherlands in 1648. If the figures are indeed Amsterdam Jews, they have been placed in a generic templelike space (compare the temple in *Medea* of the previous year) by an artist who either never saw the inside of a synagogue or did not pay attention if he did.

In an etching of about 1652, Rembrandt displays a knowledge of Jewish mysticism. The print depicts a practitioner

544
Rembrandt
Faust
Unsigned, undated. Ca. 1652
Etching, drypoint and burin,
21 x 16 cm.
Bartsch 270 ii(3)
Haarlem, Teylers Museum

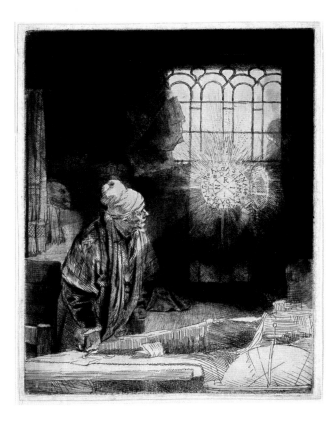

40 As Jewish as it might be, the prayer was well known to Christians and has a long history in Christian art and magic. Van de Waal 1974, pp. 133–39.
41 Perlove 1993.
42 For a seriously argued opposing view, see Zell 2002.
43 Gans 1971, pp. 80–81, illustrates the earliest set of engravings of Jewish ceremonies, from the 1682 edition of Johannes Leusden's book *Philologus hebraeo-mixtus.*
44 This development, which falls outside the scope of this book, is the subject of a 2006 exhibition in the Jewish Historical Museum in Amsterdam under the title *The "Jewish" Rembrandt.*

of the occult arts who invokes a celestial vision. The top letters, *ALGA*, are one of the anagrams for the prayer *Atah gibor le'olam Adonai*, Thou art powerful forever, Lord.[40] These are the first words of the second section of the Amidah, the Standing Prayer that occupies a central and especially numinous place in every synagogue service. More than that, in Jewish mysticism they refer to a specific aspect of the Godhead: Gevurah, Power, the fifth of the ten sephirot, the emanations of God in Kabbalah. This was long taken as a sign of genuine and sympathetic interest in Jewish lore by Rembrandt.

That was until the American art historian Shelley Perlove focused attention on a feature that other interpreters glided over too easily, namely that the central element of the vision is the title INRI, Jesus of Nazareth King of the Jews, the text put on the Cross itself by Pontius Pilate. If the visionary is a Jew, then, the climax of his mystic exercise, a divine revelation, is an affirmation of the truth of the Christian religion, the divinity of Christ and the duty of the Jews to worship him.[41] The message is uncompromisingly Christian and in no way friendly to Judaism. It fits perfectly into the antagonistic attitude toward Judaism that was still universal in seventeenth-century Christendom, except for the small group of Christians who befriended Jews in order to convert them, learn about Judaism from them or use them to bring about the Second Coming of Christ. The extent of the antagonism, even among Christian Hebraists, is perfectly symbolized in the fact that professors of Hebrew at the university of Leiden were also expected to fill a chair in the refutation of Judaism.

My own judgment, in the light of the above, is that Rembrandt's attitude toward Judaism was Christian through and through – that is, marked by fundamental rejection – and that he entertained no special relation with any of the Jews in his surroundings.[42] Compared with artists who demonstrably entertained ties with the Jewish community, like Romeyn de Hooghe (1645–1708), starting with his 1665 drawing of a circumcision in the home of a Sephardi family, or Emanuel de Witte (1617–92), with his paintings of the 1670s of the Portuguese synagogue, no earlier master, including Rembrandt, can be said to have taken contemporaneous Jews and Jewry seriously.[43] Landsberger's dictum will have to be reversed: nothing we know about Rembrandt suggests he was a friend of the Jews.

Documentation and proof positive, though, are not everything in life or even in history. In the course of the eighteenth century, Rembrandt began accumulating Jewish attributes and associations in such a large degree that the knot that ties them will never be undone. In the nineteenth century Jewish art lovers began to cultivate a special attachment to Rembrandt; art historians, Jewish and non-Jewish alike, called an increasing number of his models Jews and began assuming that the artist was sympathetic toward them. The effect was reinforced by the all too ready attribution to Rembrandt of heads with a Jewish look just because of that feature. Some of his Jewish ties had

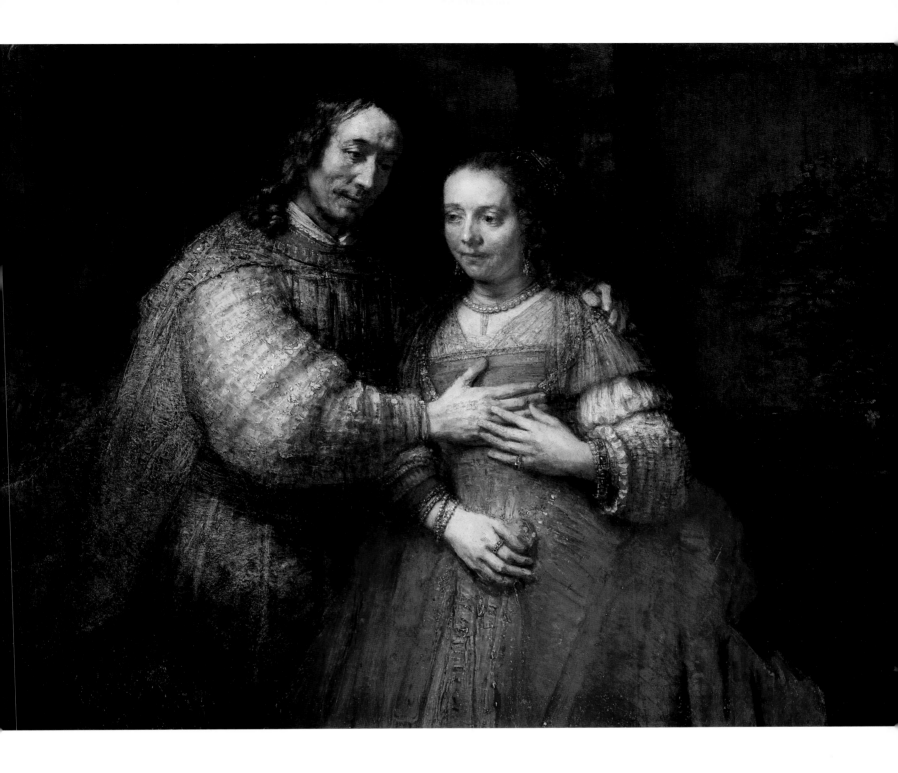

545
Rembrandt
A man embracing a woman:
"The Jewish bride"
Inscribed *Rembrandt f. 16 …*
Ca. 1663
Canvas, 121.5 x 166.5 cm.
Bredius 416
Amsterdam, Rijksmuseum

45 "eene voorstelling van de
Joodsche bruid, die door den Vader
versierd werd met een Halsketting";
Bergvelt et al. 2004, p. 170,
no. 146. If Adriaan van der Hoop
had not bequeathed his stunning
collection to the city of Amsterdam,
the Netherlands would not be the
first-rate center for old Dutch art
that it is today.
46 Quoted from the *Jewish Chronicle
of London*, 13 September 1935, on the
website jewishhistory.com.

nothing to do with the historical Rembrandt or
his art at all.[44]

The ultimate exemplar of the Jewish Rembrandt
is the attachment in 1833 to one of Rembrandt's
greatest masterworks of the title *The Jewish bride*.
The Amsterdam banker Adriaan van der Hoop bought
the painting in that year as a depiction of Jephta about
to sacrifice his daughter, but preferred to enter it in his
books as "a depiction of the Jewish bride being adorned
by her father with a necklace."[45] The father soon
became a bridegroom and the painting an immortal
icon of romantic love, with the Jewishness of the couple
adding depth to the sentiment.

From the Jewish side, the conviction is unshakeable
that Rembrandt had personal sympathy for their
people and an interest in their faith. A remarkable
testimonial of another kind was paid to Rembrandt
by Rabbi Abraham Kook (1865–1935), one of the

founders of modern ultra-Orthodoxy. "When I lived
in London," he is quoted as saying,

I used to visit the National Gallery and my favorite
pictures were those of Rembrandt. I really think that
Rembrandt was a Tzadik (a righteous person).
Do you know that when I first saw Rembrandt's
works, they reminded me of the legend about the
creation of light? We are told that when God created
light it was so strong and pellucid, that one could see
from one end of the world to the other, but God was
afraid that the wicked might abuse it. What did He
do? He reserved that light for the righteous when the
Messiah should come. But now and then there are
great men who are blessed and privileged to see it.
I think that Rembrandt was one of them, and the light
in his pictures is the very light that was originally
created by God Almighty.[46]

Judaism has more to offer to Rembrandt than he to it.

Vices and virtues, thought and action

Rembrandt was not interested in iconographic systems or codes. He never set out to cover all the items in any particular category. Rather, he returned again and again to certain themes, ignoring others. Human weakness and – especially – human strength inspired him. He found it not only in heroic action but also in resignation and introspection. In his art, Rembrandt was optimistic about human nature.

The five senses are hard-wired into our frame. The four temperaments are programmed per individual for life, but the combination of the four humors associated with them can be influenced by medicine and exercise. The Sun and the moon, the six known planets and the twelve signs of the Zodiac each have their own determining effect on our nature. The passions, not usually counted, overtake us unexpectedly, but can be controlled through exercise of the will. Seventeenth-century observers analyzed human behavior in these terms among others, as well as through characterology, a kind of behavioral profiling that defines particular professions or types.

Rembrandt's contemporary Charles Le Brun (1619–90) created influential systems for depicting passions and human types in art. Rembrandt was not a systematician, and although his work contains traces of some of these classifications, he was less susceptible to their charms than most of his contemporaries. If there is one arrangement of psychological categories that did appeal to him, it was the virtues and vices and their operation on personal strengths and weaknesses.

In his *Nicomachean Ethics*, Aristotle identified twelve domains of action and feeling. In each of them a person can go too far or fall short, leading to blameworthy behavior. Virtue is the result of proper balance between the extremes. For example, in the domain of Fear and confidence one can be reprehensibly rash or cowardly, or else virtuously courageous.

In Christianity the dominant model was bipolar rather than dialectic. The Seven Virtues, including St. Paul's Faith, Hope and Love, were pitted against Seven Vices. Depictions of the virtues and vices in art were mainly personifications or allegories – Humility, for example, being a woman with her hands crossed over her breast – or examples – the biblical Susanna, for example, representing Chastity. Vast repertoires of attributes and symbolic references, in colors, animals, plants, heavenly bodies and historical figures developed around programs of the virtues and vices.

In the seventeenth century, these classical and Christian systems, reinvigorated by philosophers like Lipsius, Coornhert and Spiegel, were still alive and kicking. Artists like Hendrick Goltzius and Peter Paul Rubens made full use of allegory, exemplum and symbol in work of all kinds. Indeed, no artist who creates images of mankind in the Western tradition, down

546
Rembrandt
Christ and the woman taken in adultery
Unsigned. Inscribed *soo jachtich om Christus in zijn antwoordt te verschalken konden schrifterlick antw[oord] niet afwachten* (so eager [were they] to catch Christ up in his answer [that they] could not wait for a written answer). Undated.
Ca. 1659
Three different shades of brown ink, washes by a later hand, 17 x 20.2 cm. Drawn on the back of an invitation to the funeral of Aegtje Nagtglas, 14 May 1659. Inscription in Rembrandt's handwriting on a strip of paper pasted to the card
Benesch 1047 recto
Munich, Staatliche Graphische Sammlung München

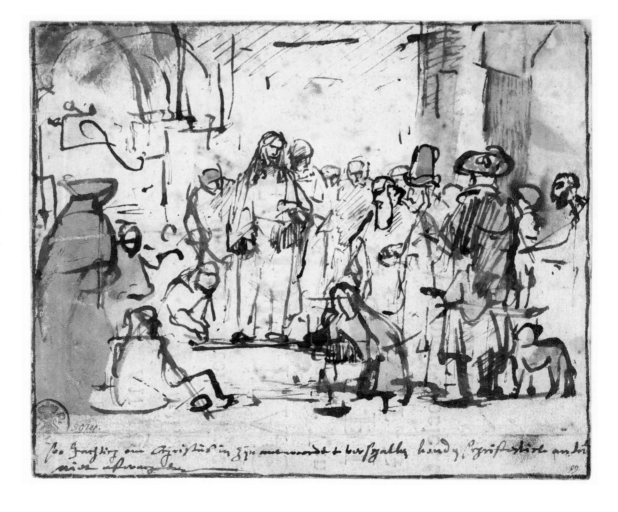

547
Jan Gillisz. van Vliet
(1600/10–68) after Rembrandt
Bust of a man grieving
Inscribed *RH, jnventor JG.v.vliet
fec. 1634.*
Etching, 22.5 x 18.9 cm.
Bartsch 22
Amsterdam, Rijksmuseum

548
Rembrandt
Detail of *Judas returning
the thirty pieces of silver* (fig. 255).
Inscribed *RHL 1629*
Panel, 76 x 101 cm.
Bredius 539A
Mulgrave Castle,
private collection

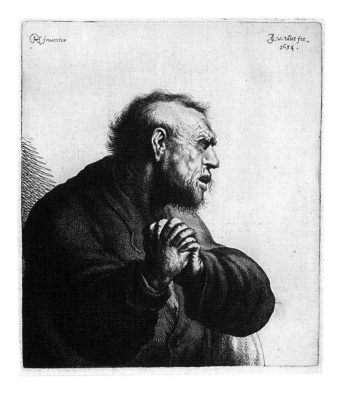

549
Rembrandt
Detail of *Anna accused by Tobit
of stealing the kid*
Inscribed *R.H. 1626*
Panel, 39.5 x 30 cm.
Bredius 486
Amsterdam, Rijksmuseum

550
Rembrandt
Bearded old man
Inscribed *Een vroom gemoet acht
eer voor goet | Rembrandt |
Amsterdam. 1634.* (A pious spirit
values honor above
possessions). Inscription
in the friendship album
of Burchard Grossmann,
accompanying a motto
by Hendrik Uylenburgh dated
18 June 1634.
Ink and wash, 8.9 x 7.1 cm.
Benesch 257
The Hague, Koninklijke
Bibliotheek

to our own day, can avoid reference to this complex
of meanings.

There is therefore nothing unique about Rembrandt's
interest in the moral features of humanity. In his art,
it takes the form mainly of low-key examples, that is
examples assimilated into everyday behavior or action
in a story. This is the chief quality for which Rembrandt
was praised by Constantijn Huygens (p. 149) and for
which he was emulated by his contemporaries and fol-

lowers. In 1634 Rembrandt's collaborator Jan Gillisz.
van Vliet extracted half the figure of Judas, the one
about which Huygens wrote, for reproduction in an
etching on its own (fig. 547).

Finding the right poses and facial expressions for
conveying a particular strong feeling is not only not
easy, in most cases it is impossible. As we have seen
in the "*Leiden history painting*" (p. 110), Rembrandt
did not always succeed in conveying unequivocally

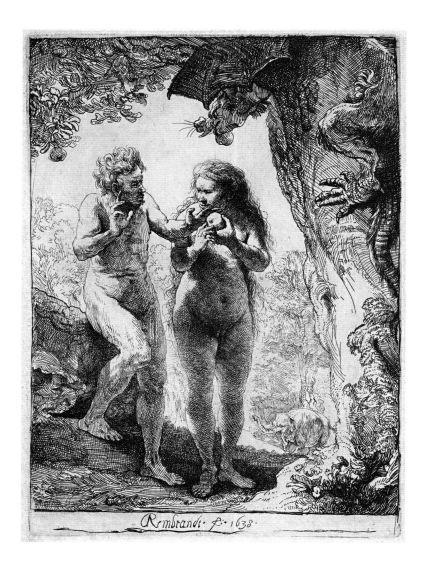

551
Rembrandt
Adam and Eve
Inscribed *Rembrandt f. 1638*
Etching, 16.2 x 11.6 cm.
Bartsch 28 ii(2)
Haarlem, Teylers Museum

552
Rembrandt
*Death appearing to a wedded
couple from an open grave*
Inscribed *Rembrandt. f. 1639*
Etching, 10.9 x 7.9 cm.
Bartsch 109 i(1)
Haarlem, Teylers Museum

553
Rembrandt
*A monk making love to a woman:
"The monk in the cornfield"*
Unsigned, undated. Ca. 1646
Etching and drypoint,
4.7 x 6.6 cm.
Bartsch 187 i(1)
Haarlem, Teylers Museum

the nature of emotions. Context is an essential ingre-
dient for proper understanding. Comparing Judas
to Rembrandt's old Tobit, it is doubtful that an unin-
formed viewer could guess that one is the betrayer
of the Lord and the other an archetype of blameless
innocence. Even the drawing in the friendship album
of Burchard Grossmann of an old man with his hands
clasped might be hard to distinguish from those others
without its caption, speaking of honor.

Rembrandt was not completely disinclined to sym-
bolism and allegory. Death and Time take on the form
of a skeleton holding up an hourglass to young newly-
weds in an etching of 1639. The year before Rembrandt
showed the first couple, Adam and Eve, in an encounter
with a serpent that seems to personify Evil. A year
or two later he assembled a military company for his
Concord of the state (fig. 17), and in 1658 created an
etching of a phoenix that has not yet been convincingly
deciphered.

Rembrandt created exemplary depictions of the vices
of immoderacy and lust in the form of the drunken Lot
and a monk breaking his vow of chastity in a wheatfield.
Images of this kind are in the minority, however. Human

weakness and strength are ubiquitous in Rembrandt's
art, integrated in more subtle form into histories, por-
traits and scenes of daily life. He tends to take a forgiv-
ing view of weakness. In his choice of Bible texts having
to do with sin, he favors those that end in pardon and
reconciliation, like the stories of Joseph's brothers and
Christ and the woman in adultery, and the parable of
the prodigal son.

A survey of the human condition in Rembrandt's art
shows some interesting patterns. The more agitated

554
Rembrandt
Study for Lot drunk
Inscribed *Rembrandt f. 1633*
Black and some white chalk, 25.1 x 18.9 cm.
Benesch 82
Frankfurt, Städelsches Kunstinstitut und
Städtische Galerie

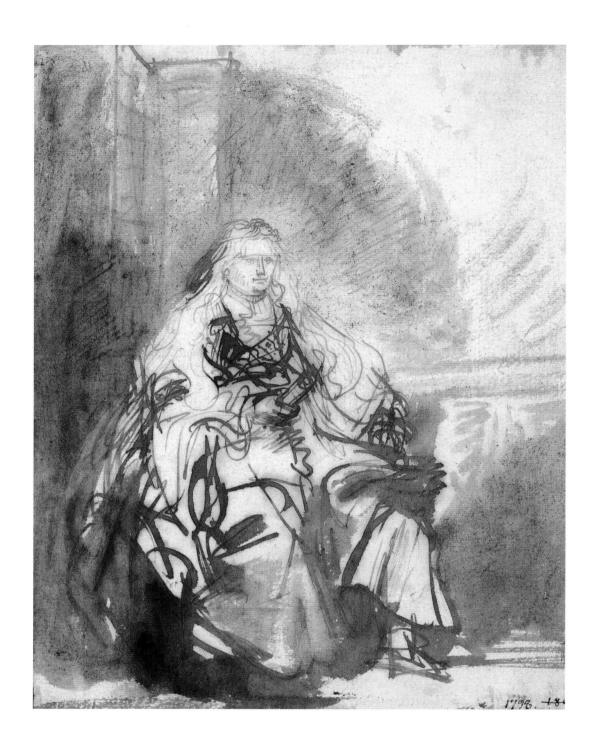

555
Rembrandt
Study for "The great Jewish bride"
Unsigned, undated. Ca. 1635
Black ink and wash,
23.2 x 18.2 cm.
Benesch 292
Stockholm, Nationalmuseum

556
Rembrandt
Saskia as Flora
Inscribed *Rem..a 1635.*
Canvas, 123.5 x 97.5 cm.
Bredius 103
London, National Gallery

states, such as anguish, rage, fright, lust and amazement tend to be concentrated in the 1630s, resignation and relaxed smiling in the 1650s and 60s. The 1640s, following the death of Saskia, are notably deficient in expressive behavior compared to the years before and after. Outspokenly dramatic behavior is relatively rare in Rembrandt's work of any period, as are instances of saintliness or viciousness. Surprisingly for a man with his record of conflicts in real life, in his art he shows an overwhelmingly positive picture of humanity.

Rather than the specific forms of human behavior, what seemed to grab Rembrandt was the mental state behind action. In fact, there did not have to be action at all. By far the most common expressions in Rembrandt's figures are attentiveness, concentration, resolve and contemplation. (See the chapters on Crafts

and trades and Readers and writers, pp. 284–85, 290–94.) The occasion that gave rise to such an image could actually be interchangeable with another. A spectacular instance is a picture in which Rembrandt changed the hacked-off head of Holofernes in a painting of the triumphant Judith into a basket of flowers held by the same woman, but who now was transformed into Flora, the goddess of flowers (fig. 556).

A corollary to the theme of the figure deep in concentration is that of someone disturbed at their work. This device, by which eye contact with the viewer or another figure in the composition is made, broadens the scope of the image and dramatizes it. It also creates an opening for anecdotal, even interactive interpretations of otherwise closed-off images. As in the case of the anguished Judas and Tobit, the expressions of these

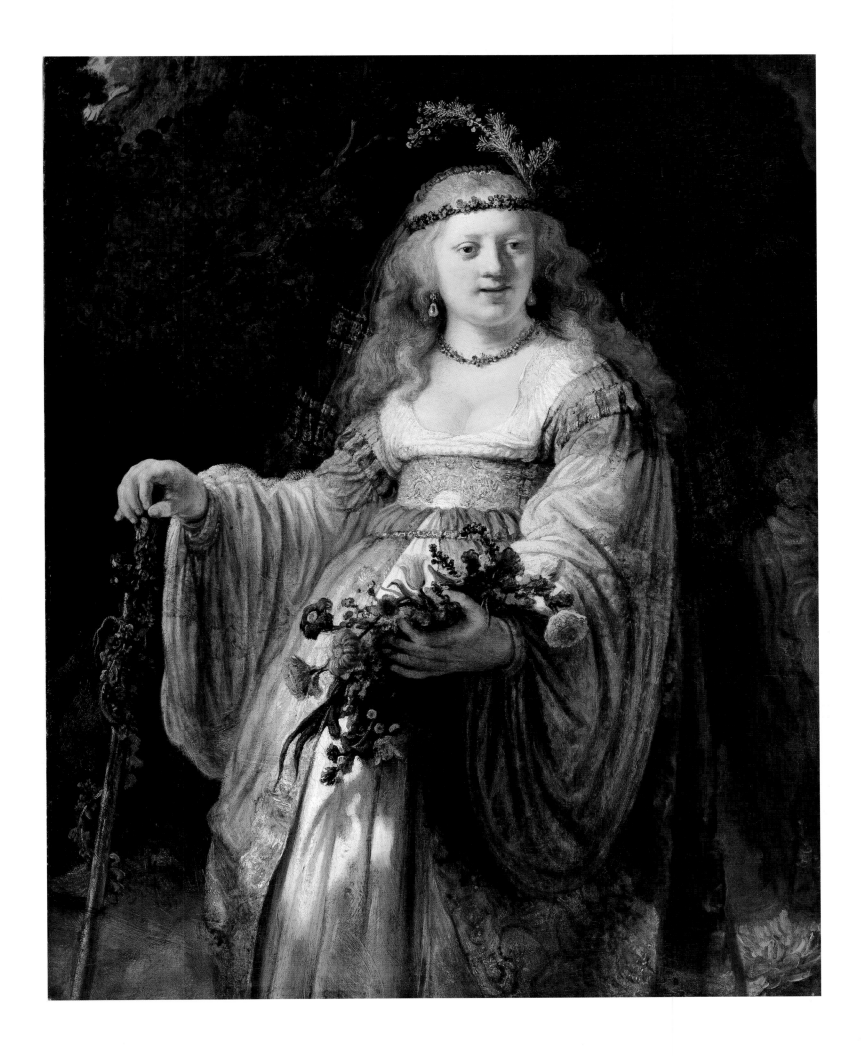

557
Rembrandt
Detail of *Jan Rijcksen and his wife Griet Jans* (fig. 341)
The Royal Collection,
Her Majesty Queen Elizabeth II

558
Rembrandt
Detail of *Lieven Willemsz. van Coppenol* (fig. 493)
Haarlem, Teylers Museum

559
Rembrandt
Detail of *Young man at a desk, transcribing a document* (fig. 491)
St. Petersburg, State Hermitage Museum

560
Rembrandt
Detail of *The five sampling officials of the drapers' guild and the guild steward* (fig. 301)
Amsterdam, Rijksmuseum

figures are rather general, more expressive of sheer vibrancy than anything else.

Rembrandt's action paintings, drawings and etchings are nearly always marked by upbeat feelings. Their counterparts in the inactive sphere of contemplation – their hands folded together, unlike those of the interrupted active figures – lack their vitality but not their intensity. The inward gaze of Rembrandt's listening and thinking men and women may close them off from direct contact with us, but this makes them no less appealing. On the contrary, these brown studies draw out sympathetic responses. Rembrandt's thinkers – his scholars at their desks, his Aristotle and monks and old men and women staring into the middle distance, his apostles and finally himself – admit in their poses to a certain helplessness and vulnerability. But they are able to look life in the face. As I see Rembrandt's people, the one emotion that has least grip on them is despair.

561
Rembrandt
Self-portrait
Inscribed *... f. 1669*.
Canvas, 86 x 70.5 cm.
Bredius 55
London, National Gallery

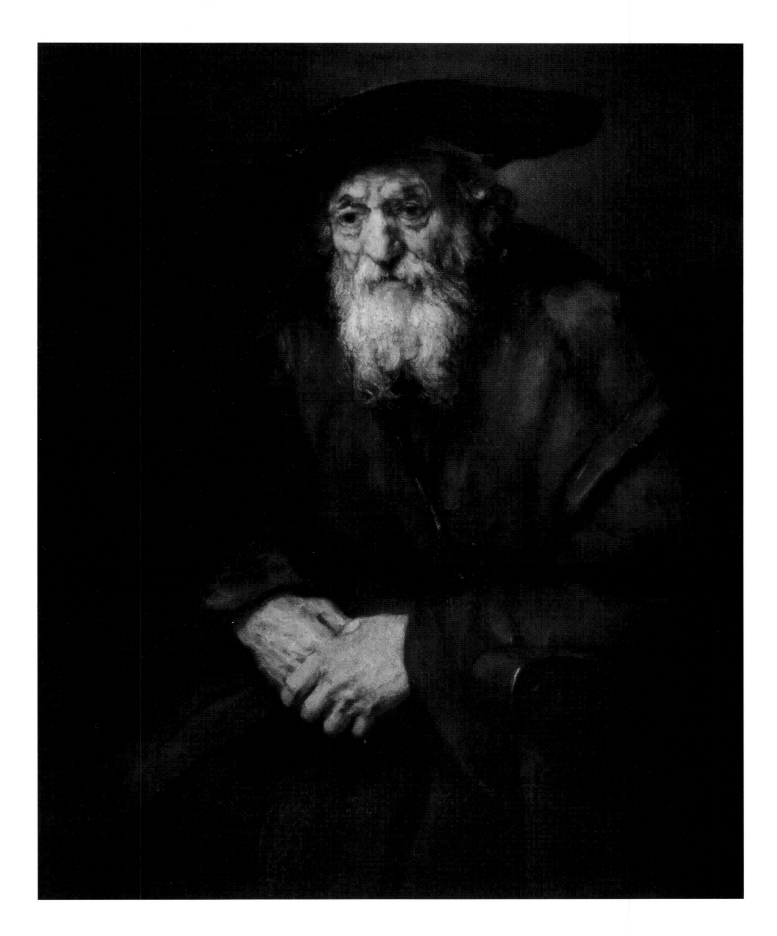

562
Rembrandt
Old man in an armchair
Inscribed *Rembrandt f. 1654*
Canvas, 109 x 84 cm.
Bredius 270
St. Petersburg, State Hermitage Museum

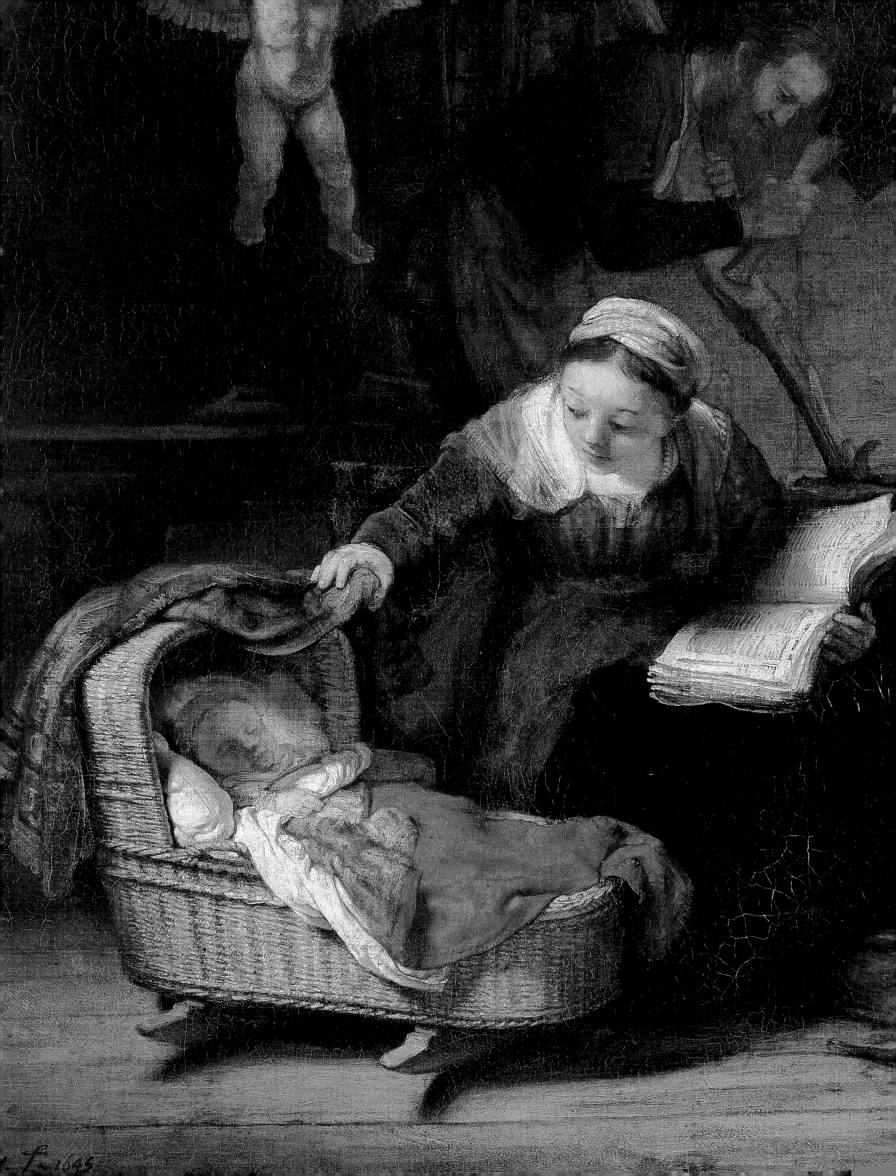

9

Man and God

Holy Family

REMBRANDT could have been a relative if not a member of the Holy Family. In his imagination he lived with Mary, Joseph and Jesus all his life, from his first etchings to his final painting. His many depictions of the infancy and childhood of Christ evoke feelings not only about families but also about the mystery of the incarnation.

A recent survey of art in the Dutch Republic has the title *A worldly art*. This cannot be right.[1] It is true that Dutch artists depicted the things of this world, perhaps more than any school of art before them. But the main dictionary meaning of "worldly" is "earthly rather than heavenly or spiritual," and this distinction is too sharp to cover the case. Seventeenth-century Europe was still so unquestioningly and deeply Christian that no Dutch artists or patrons could shut out heavenly or spiritual values if they wanted to, and there is no indication that anyone wanted to. Certainly not Rembrandt.

If the family is the basic unit of the human world, Rembrandt was assuredly not a worldly artist. He painted one group portrait of a family and liked to draw households, "the life of women with children" and grandparents with children. But when it came to the family of husband, wife and child, Rembrandt funneled all of his intense attention through Scripture. The families of Tobit, Samson and Joseph were imagined and evoked by him repeatedly and lovingly. No family engaged him as frequently and passionately as the Holy Family, a family in which the father of the child is not the husband but the Holy Spirit. Nothing could be further from worldliness.

Throughout his life, Rembrandt loosed his imagination again and again on the great Holy Family themes: the nativity, the adoration of the shepherds, the adoration of the Magi, the circumcision, the presentation in the Temple, the angel appearing to Joseph in a dream, the flight into Egypt, the rest on the flight, the Holy Family in the manger, in the carpenter's shop, on the way to Jerusalem down to the moment when the twelve-year-old Jesus, in debating with the Pharisees in the Temple, enters upon his mission. The first

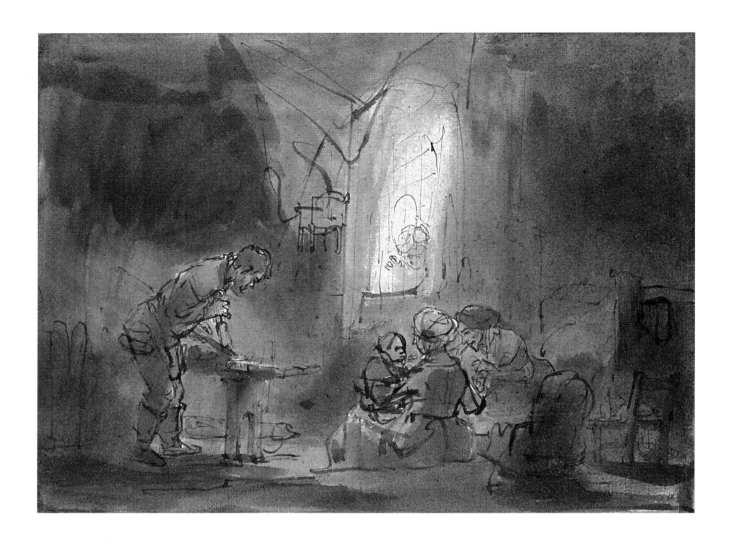

566
Rembrandt
The Holy Family in the carpenter's workshop
Unsigned, undated. Ca. 1640
Brown ink, brown and black washes, 18.4 x 24.6 cm.
Benesch 516
London, British Museum

chapters of Matthew and Luke, where these stories are told, are overloaded in Rembrandt Bibles.

Three attempts to draw a line between humanity and divinity in Rembrandt's Holy Families show how divided opinion is on the subject. Mariët Westermann writes of the *Holy Family, with painted frame and curtain* (fig. 568) that "Christianity's first family here recalls the newly popular domestic paintings of peasant and urban life" and that it "follows a Netherlandish convention for emphasizing the earthly relationship between the Virgin and Christ."[2] Egbert Haverkamp Begemann disagrees: "Every detail and every action [of Rembrandt's Holy Families] seems determined in the first place by the religious idea that Rembrandt wanted to represent."[3]

W.A. Visser 't Hooft, who in 1956 as secretary of the World Council of Churches wrote an impressive book on religion in Rembrandt's art, sees more spirituality in Rembrandt than Westermann and more worldliness than Haverkamp Begemann. He too however draws a categorical distinction between these realms, which he divides chronologically. The Dutch translation of his book, which was written in French as *Rembrandt et la Bible*, expresses the author's message more pointedly: *Rembrandt's weg tot het Evangelie*, Rembrandt's way to

the Gospel. According to 't Hooft, the young Rembrandt was not a biblical artist at all. "That restless style, those exaggerated gestures and that rhetorical approach do not match the spirit of the Bible story," he wrote of Rembrandt's early Bible scenes. Not until the dark years following the death of Saskia did he find "the great simplicity and the great, attentive ease of mind that match the story of the Bible.... The Holy Family stood in the center of his work in these years." Only then, by reeducating himself through a fresh understanding of the Bible, did Rembrandt learn that "beauty must serve that which is higher, namely truth." In his choice of examples, Visser 't Hooft helps this conclusion along in a way that makes it vulnerable to criticism.

The attempt of all three authors to distinguish between the human and godly elements in Rembrandt's Holy Families is a fascinating recapitulation of Early Christian debates about the nature of Christ. Was he man? Was he God? Westermann insists on the complete humanity of Rembrandt's Christ, Haverkamp Begemann on his complete divinity, Visser 't Hooft on both, but in sequence, not simultaneously. In the spirit of theology, I would make a case for the solution that the early church ended up adopting, the Chalcedonian view (451) that Christ is completely divine *and* com-

1 Westermann 1996.
2 Westermann 1996, p. 184.
3 Haverkamp Begemann 1995, p. 20.

567
Rembrandt
The Holy Family with angels
Inscribed *Rembrandt f. 1645*
Canvas, 117 x 91 cm.
Bredius 570
St. Petersburg, State Hermitage
Museum

pletely human and – this is the crux – that no separation
between the two is possible. The melding of physical
presence and spiritual significance in Rembrandt's
depictions of Christ is too complete to allow for
distinctions of the kind the three authors make.
Although Rembrandt was not a theologian, I think
that his instincts, aided by borrowings from artistic
tradition, come close to this Christian dogma.
Throughout the great variety of emphases that
Rembrandt places on differing aspects of the themes,
from the most seemingly personal images of Jesus

to the most spiritual or liturgical ones, he never chal-
lenges the viewer to question the dual nature of Christ
as man and God.

Rembrandt's Holy Family is not a closed unit. The
bond between Mary and Jesus is the central theme,
whether she is suckling him, rocking his cradle or just
cuddling him. (In the *Holy Family, with painted frame
and curtain,* if I am not mistaken, the child is resisting
a cuddle, kicking and whining.) Once, adapting a com-
position by Federico Barocci (figs. 43–44), Rembrandt
etched the Virgin and child in the sky. Most Holy

568
Rembrandt
The Holy Family, with painted frame and curtain
Inscribed *Rembrandt fc 1646*
Panel, 48.5 x 68.5 cm.
Bredius 572
Kassel, Staatliche Museen
Kassel, Gemäldegalerie Alte
Meister

Families by Rembrandt are however peopled with Scriptural staffage like adoring shepherds and barnyard animals or non-Scriptural but traditional adjuncts such as Mary's mother St. Anne, a flight of angels or a cat. His motifs tend to go back to models in older Netherlandish, Italian and even Byzantine art, but one of them has been identified as unique: all three members of the Holy Family asleep together (fig. 521).[4] The way Rembrandt varies and combines elements in his many

depictions of the Holy Family, scenes that are not described or even mentioned in the Bible, should be a warning to us in our interpretations of Rembrandt's biblical compositions. Although he sometimes adheres fairly literally to the text, the fact that he sometimes departs from it quite freely should be taken more seriously than it sometimes is in Rembrandt Bibles and discussions of Rembrandt's biblical themes. Rembrandt spent a good part of his imaginative life – which overlapped his religious life and part of his personal life – among the personages of the Bible. In his art he brings them to life in his own way, without a philologist's regard for the words of Scripture.

Painting the Bible was not unproblematic for a Christian artist in an age of doctrinal and sectarian division. The field was mined with taboos. In the bordering territory of the theater, the Calvinist church council regularly protested against the staging of biblical themes. In 1650, the radical Reformer Gisbertus Voetius wrote that only ministers were qualified to comment on God's word. "It was their divine mission to bring 'holy' matters 'to life' in their sermons."[5] Probably as a result of this kind of pressure, Dutch playwrights avoided subjects from the New Testament. To a lesser degree, this applies to visual artists as well. One group that did not abide by this restriction were Catholic artists working for Catholic patrons. The many Catholic house churches in the Netherlands were furnished with altarpieces and other art works depicting Christ, the Virgin and the saints, in liturgically tinted iconographies that Protestant artists would never touch.

In one instance, Rembrandt displays what might be a certain ill-at-easeness with the portrayal of holy

569
Rembrandt
The Holy Family
Inscribed *Rembrandt f. 1640*
Panel, 41 x 34 cm.
Bredius 563
Paris, Musée du Louvre

4 Haverkamp Begemann 1995, pp. 10–12.
5 Henk Duits, "11 november 1621: De Amsterdamse kerkeraad stuurt twee afgezanten naar de burgemeesters te klagen…," in Erenstein 1996, p. 181.

	−1630	1631–40	1641–50	1651–60	1661–69
The annunciation Fig. 618		1		1	
Adoration of the shepherds Fig. 564		2	2	3	
Adoration of the magi	1			1	
		2	1	3	
Presentation in the Temple Simeon with the Christ child Figs. 176, 639–47	1	1			1
	1	1		1	
	1		4	4	1
The circumcision Fig. 565	2			1	1
		1	2		
The angel appearing to Joseph in a dream			1	2	
The flight into Egypt Figs. 477, 480	4	1			
	1	2		3	
			1	1	
The rest on the flight Fig. 400		1	1		
	1		2	1	
The Holy Family The Virgin and Child Figs. 40, 44, 497, 521, 566–69		2	4		
		1	1	1	
	4		3	3	

Table 6
The Holy Family

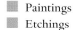

■ Paintings
■ Etchings
■ Drawings

6 Tümpel 1986, pp. 244–46.
7 This table of 81 drawings, etchings and paintings includes works that are no longer attributed to Rembrandt. They are included because they probably derive from Rembrandt inventions of the period indicated.

matters. In the *Holy Family, with painted frame and curtain* he shows the viewer that his scene is not as real as it might appear. "What you are seeing," the painting could be saying, "is not the Holy Family itself, but only an artist's picture of it." But it might be coincidence that Rembrandt chose a Holy Family to play a game with the viewer that has been popular since ancient times. As we have seen, he also used a painting of a housemaid to deceive the eye of the beholder. Rembrandt's pupils Samuel van Hoogstraten and Carel Fabritius applied techniques like that of the *Holy Family, with painted frame and curtain* for secular subjects as well.

In the *Holy Family* in the Louvre (fig. 569), St. Anne is holding a book. She is not the only reader in the Family. In *The Holy Family with angels* (fig. 567), Mary is reading, and in an etching of 1632 Joseph. Christian Tümpel has interpreted this motif as an instance of recognition. The holy person, reading in the Jewish Bible about the Messiah, realizes that Jesus is he.[6]

My own understanding of the meaning of the book in these compositions is different. I do not see why, fol-lowing the annunciation, the adoration and the recognition by Simeon and Hannah in the Temple of Christ's divinity, a Bible text should have had revelatory importance for the Holy Family. Although the proposition cannot be proven, I prefer to see in this motif a reference to the famous opening words of the Gospel of St. John: "In the beginning was the Word, and the Word was with God, and the Word was God." Just as the divinity and humanity of Christ are whole and inseparable, so is his spiritual and physical existence. Once more, I believe, Rembrandt is overriding categories, ignoring barriers and bringing into his art all of his experience as an artist, a human being and a Christian.

See also the section on the related iconography of Simeon with the infant Christ (pp. 362–67).

In this section, only a few of Rembrandt's many depictions of the Holy Family could be discussed and illustrated. The chart above provides a more complete picture of his involvement with the subject, with a recommendation to the reader to look at and compare these unsurpassed works.[7]

570
Rembrandt
Christ driving the money changers from the Temple
Inscribed *Rembrandt. f. 1635*
Etching, 13.6 x 16.9 cm.
Bartsch 69 ii(2)
Haarlem, Teylers Museum

571
Rembrandt
Christ driving the money-changers from the Temple
Unsigned, undated. Ca. 1626
Panel, 43 x 33 cm.
Bredius 532
Moscow, Pushkin Museum

8 Three other miracles and four parables are identified by Benesch as the subject of a single drawing apiece, but since the iconographies and/or the attributions are disputable, I leave these out of consideration. For the analysis of themes from the Gospels, see the website of the Blue Letter Bible.

Christ's ministry

Rembrandt depicted a limited number of themes from the career of Christ on earth after his youth and before the Passion. One of his most ambitious prints, *The hundred-guilder print,* was an iconographic invention by Rembrandt. The chosen themes tend to highlight Christian antagonism towards Jewry.

The significance of the nativity and infancy of Christ would seem to be apparent without argument. Two of the four evangelists, however, Mark and John, found it possible to write their accounts of the life of Jesus with no reference to his birth or his parents. Alongside the mysterious Christ of the incarnation, there is also the moral master. The Gospels are full of Jesus's prophecies and miracles, parables and sermons, confrontations and examples.

While Rembrandt milked the childhood of Christ for all the Gospels told and more, he did not do very much with the two-hundred-odd themes pertaining to his ministry, miracles and parables. Of the thirty-six miracles tallied by Bible interpreters, Rembrandt depicted only seven. Four of the thirty-nine parables found their way into his work.[8] If we limit our scope to the themes that he both painted and etched, the sample is reduced

still further, to about one in twenty of the potential number of themes. The most spectacular of them are the driving of the money-changers from the Temple and the raising of Lazarus. The latter was the subject of collegial competition between Rembrandt and Lievens in the Leiden period.

This is quite a different picture than the exhaustive depiction of Baby Jesus and the Holy Family in Rembrandt's work. The difference is largely explained by the pictorial traditions he inherited. Rembrandt's starting point, to put it bluntly, was not the Bible but artistic convention. The image of Rembrandt poring over the Bible in order to illustrate its themes is attractive but incorrect. There is every reason to believe that he read the Bible text of a subject he depicted, but the reason for his choice was not the mere fact that it is in the Bible.[9]

Neither statistics, texts nor traditions, however, prepare us for the fact that one of the greatest efforts

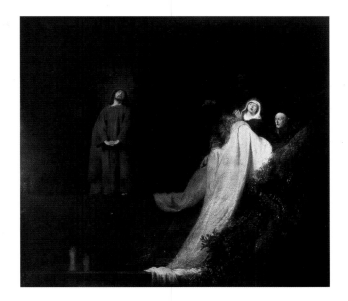

572
Jan Lievens (1607–74)
The raising of Lazarus
Inscribed *IL | 1630*
Canvas, 103 x 112 cm.
Schneider 31
Brighton, Brighton Museum
& Art Gallery

573
Rembrandt
The raising of Lazarus
Inscribed *RHL van Ryn f.*
Undated. Ca. 1632
Etching and burin,
36.6 x 25.8 cm.
Bartsch 73 x(10)
Haarlem, Teylers Museum

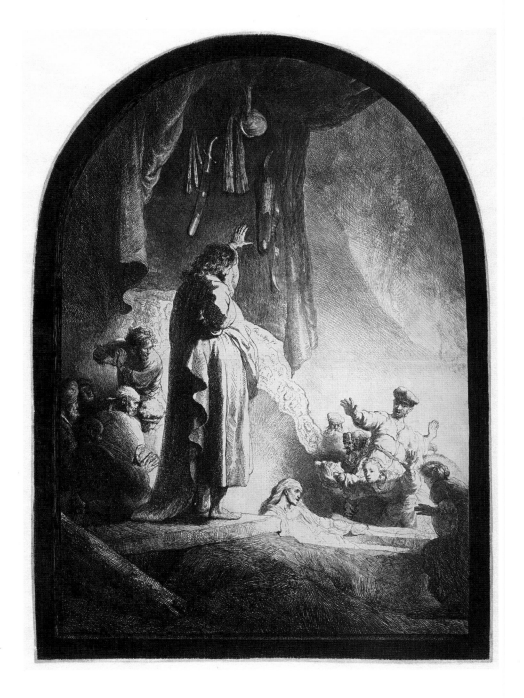

9 Bruyn 1958.

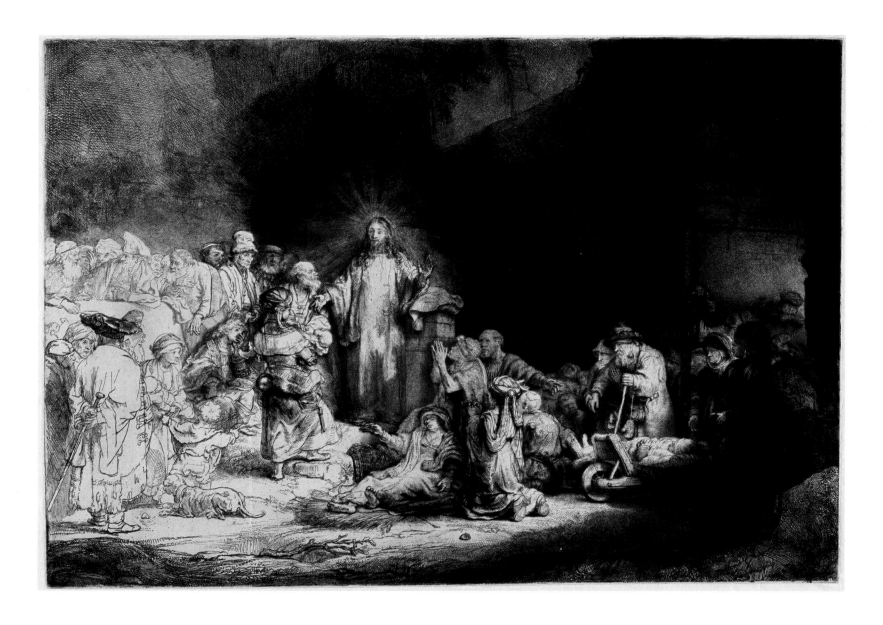

574
Rembrandt
Christ among the sick, allowing the children to come to him: "The hundred-guilder print"
Unsigned, undated. Ca. 1649
Etching, drypoint and burin, 27.8 x 38.8 cm.
Bartsch 74 ii(2)
Haarlem, Teylers Museum

10 Martin Royalton-Kisch, in Hinterding et al. 2000, pp. 255, 258. The letter was published in a Belgian magazine in 1880, but remained unknown in Rembrandt studies until 2000.
11 Gersaint 1751, p. 60.

Rembrandt ever exerted on a single work of art, perhaps the greatest of any, deals with the ministry of Christ. What is more, it has a subject that is unprecedented in pictorial tradition. It is the etching known by the unfortunately mundane nickname *The hundred-guilder print*. That sum was mentioned in connection with the etching within five years of its creation, in a recently rediscovered letter of 1654 from an Antwerp art dealer to the bishop of Bruges.[10] Jan Meyssens calls it "the most exceptional print by Rembrandt that there is" and informs the bishop that it had been sold in Holland several times for a hundred guilders and even more. He asks no more than thirty guilders for it, still more than the average price of a painting, let alone a print. In 1751, in the first catalogue of Rembrandt's etchings, by Edmé François Gersaint, the print (*La Piece de Cent Florins*) is called "réellement la plus belle qui soit sortie de la pointe de ce Maître" (truly the most beautiful [print] to emerge from the [etching] needle of this master).[11]

Perhaps the pecuniary sobriquet would not have stuck quite so tenaciously to the print if it also had

a readily identifiable iconography. It does not, however. It is an invention of Rembrandt's, concocted from various biblical and non-biblical sources.

Three of the motifs seem to relate to Chapter 19 of the Gospel according to St. Matthew. Jesus has left Galilee and crossed the Jordan River into Transjordan. In succession, he comes into contact with two groups and one individual from the "great multitude" that followed him. His interchange with each of them concerns the mysterious realm called the kingdom of heaven.

The Pharisees (verses 3–12). They enter into debate with Christ about marriage and divorce. He tells them that a man and wife are "no more twain, but one flesh," and what "God hath joined together, let not man put asunder." The only grounds on which a man can divorce his wife are adultery, he contends. Jesus would have all men marry, except eunuchs and those who renounce marriage for the kingdom of heaven. (In the *Hundred-guilder print*, the group that looks like Pharisees is debating more with itself than with Jesus.)

The little children (13–15). They are brought to Jesus to be blessed by the laying on of hands. His disciples

"All these things have I kept from my youth up: what lack I yet?" Jesus said unto him, If thou wilt be perfect, go and sell that thou hast, and give to the poor, and thou shalt have treasure in heaven: and come and follow me. But when the young man heard that saying, he went away sorrowful: for he had great possessions. Then said Jesus unto his disciples, Verily I say unto you, That a rich man shall hardly enter into the kingdom of heaven.

One function of the Christ of the *Hundred-guilder print* is then to serve as the bridge between the kingdom of the earth and the kingdom of heaven. This accords with his pose, one hand extended to mankind, the other pointing on high, and his place in the composition, between the deep shadow on one side and blanched brightness on the other.

575–77
Rembrandt
Details from *Christ among the sick, allowing the children to come to him: "The hundred-guilder print"* (fig. 574)
Haarlem, Teylers Museum

tried to keep them away, but Christ overruled them, uttering the immortal words, "Suffer little children, and forbid them not, to come unto me: for of such is the kingdom of heaven." (In Rembrandt's print, only two children are brought to Jesus, with no apparent resistance.)

Between the children sits *the rich but sorrowful young man* (16–22) who wants Christ to tell him how to earn eternal life. Christ refers him to half of the Ten Commandments and the Golden Rule. The young man says,

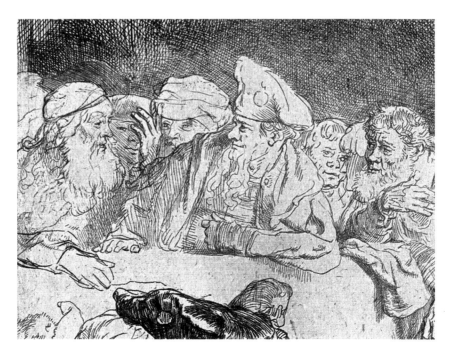

That however does not exhaust the details or message of the print. The blind man being led to Christ by an old woman would be the one he cured in Bethsaida in Mark 8:22.

The woman on the ground at Christ's feet: is she the "woman which had a spirit of infirmity eighteen years, and was bowed together, and could in no wise lift up [herself]" (Luke 13:11)? If so, Christ is about to cure her.

578
Rembrandt
*Blind old man guided
by a woman*
Unsigned, undated. Ca. 1645
Brown ink, 12.2 x 9.8 cm.
Benesch 185
Paris, Musée du Louvre,
Cabinet des Dessins

579
Rembrandt
Detail from *Christ among the
sick, allowing the children to
come to him: "The hundred-
guilder print"* (fig. 574)
Haarlem, Teylers Museum

580
Rembrandt
Two sick women
Unsigned, undated. Ca. 1645
Brown ink and wash,
10 x 12.5 cm.
Benesch 183
Amsterdam, Rijksmuseum

581
Rembrandt
Detail from *Christ among the
sick, allowing the children to
come to him: "The hundred-
guilder print"* (fig. 574)
Haarlem, Teylers Museum

The figure on the wheelbarrow and the woman ges-
turing behind him, leading a small procession through
a stone gate, are they from the town of Nain? "Now
when he came nigh to the gate of the city, behold, there
was a dead man carried out, the only son of his mother,
and she was a widow: and much people of the city was
with her" (Luke 7:12). Jesus raises the man from the
dead and returns him to his mother.

Whether or not these references are intended literally,
the figures of the blind and maimed add new dimen-
sions to the Christ of the print. Besides pointing the
way to the kingdom of heaven, he also works miracles
and heals mankind here on earth.

Not all the multitude steps straight out of the writ-
ings of the Evangelists. Three figures who are not
arguing with Christ or supplicating him for help are

visitors from other places and times. The black man
on the right, not to be found in the Gospels, stands
for the universality of Christ's message to mankind.
To the left are the heads of two men whose features
reveal Socrates (470–399 BC); Rembrandt's inventory
included a bust of Socrates) and Desiderius Erasmus
(1466/69–1536). They not only illustrate the time-
lessness of Christ's guidance but also that the most
critical thinkers of the ages are respectful of him.[12]
Their presence marks Christ as a teacher and leader
of mankind.

An impression of the second state of the print,
in the Bibliothèque Nationale, Paris, is inscribed with
four quatrains by a man from Rembrandt's circle,
H.F. (Hendrick) Waterloos (d. 1664). Waterloos, like
Rembrandt a close friend of Jeremias de Decker, had

12 The identification of Socrates and
Erasmus is due to Theo and Frans
Laurentius, to whom I am grateful
for permission to publish their
discovery. Since 1893, when Alb.
Jordan made the connection
between the *Hundred-guilder print*
and Matthew 19, this has been
repeated constantly in the literature,
with no notice of the other passages
that seem to be implied. Tümpel
1970, nos. 86–77.

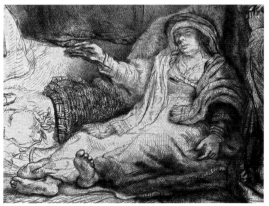

 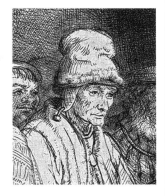

582–83, 585
Rembrandt
Details from *Christ among the sick, allowing the children to come to him: "The hundred-guilder print"* (fig. 574)
Haarlem, Teylers Museum

584
Roman (1st century), perhaps a copy of a lost bronze statue of Socrates made by Lysippos
Marble, 33.5 cm. high
Paris, Musée du Louvre

586
Anthonie van Dyck (1599–1641) after Hans Holbein (1497–1543)
Detail of portrait of Desiderius Erasmus (1466/69–1536)
Inscribed *Anth. Van Dyck fecit aqua forti.* Undated. Ca. 1630
Etching, 24.8 x 15.9 cm.
Mauquoy-Hendrickx 5

modest appointments in the Nieuwe Kerk as a *voor-zanger*, someone who sang in church services to help the congregation keep the tune and timing, and *zieken-trooster*, a comforter of the sick. Waterloos stood close to Rembrandt in the late 1650s and 1660s. In a poem on Rembrandt's portrait of Jeremias de Decker he wrote, "My poetry thus lives in your beautiful painting, and your art through my poetry." This may be a cliché, but it is nonetheless a public claim by Waterloos to be the interpreter in poetry of Rembrandt's art.

His verses – undated, but written between 1650 and 1664 – say the following things:

1 This is how Rembrandt portrays the son of God from life, placing him in a crowd of sick people, to show the world, sixteen centuries later, the wonders he performed for all of them.

2 Here Jesus's hand helps the sick. And the children (that's God for you!) he blesses: and he punishes those who hinder them. But (alas!) the young man is sorrowful. The Pharisees belittle the faith of the saints and the radiance of Christ's godliness.

3 This Messiah performed a thousand miracles out of goodness, with no vengeance [in contrast to Jehovah, the God of vengeance], for the benefit and salvation of the Jews. But alas! they crucified, alas! the One who was sent, God's son. And so his blood remains on their hands, and we are now his limbs. [That is, the Christians are now God's people, not the Jews.]

4 He who appeared to Israel in our flesh [in human guise], so gentle, now blazes in the full majesty of his divinity in the clouds and is adored by the angels in the Trinity, until he appears again to judge all the peoples.

587
Rembrandt
Christ among the sick, allowing the children to come to him: "The hundred-guilder print"
Unsigned, undated. Ca. 1649
Etching, drypoint and burin, 27.8 x 38.8 cm. With handwritten poem by H.F. Waterloos
Bartsch 74
Paris, Bibliothèque Nationale

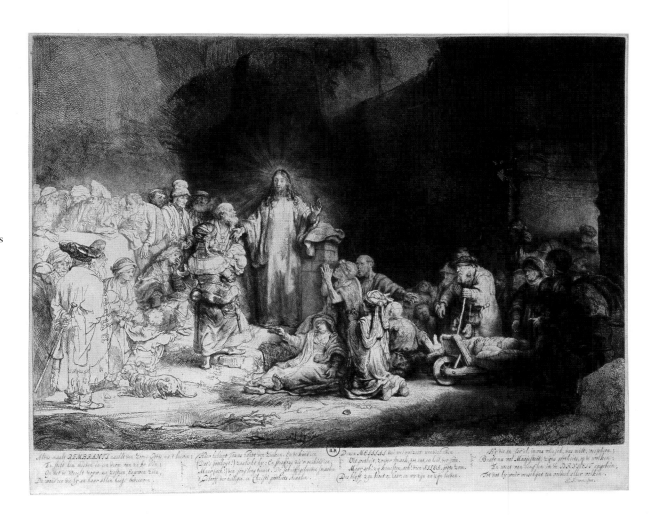

588
Rembrandt
*St. John the Baptist preaching,
study for frame*
Unsigned, undated. Ca. 1655
Brown ink and wash, some
white body color,
14.5 x 20.4 cm.
Benesch 969
Paris, Musée du Louvre,
Cabinet des Dessins

Here are the themes that we have identified in the print: the kingdom of heaven, Christ as the ruler of all people, as a miracle-maker, as a healer. The latter, coming from a *ziekentrooster,* is a touching tribute. The identification of ordinary believers as "saints" is in keeping with Protestant doctrine. Less touching is another, overriding theme in the second and third poems. Waterloos sees the personages in the *Hundred-guilder print* in a certain light, and that is the light of Christian anti-Judaism. The beneficiaries of Christ's supernatural goodness are Jews. However, the poet says, the Pharisees among them denied Christ and his believers, and the Jews as a people crucified the son of God. The Jews of the poet's own day are still guilty of that murder, by which they forfeited God's grace to the followers of Christ.

We could call this a personal interpretation by Waterloos and leave it at that. But these thoughts were not personal. They were the standard conception of the Jew to a seventeenth-century Christian. By the customs of the day, Waterloos would have read his poems to Rembrandt or would have written them only after talking to the artist about the *Hundred-guilder print.* The placing of the poems on the lower margin of the print suggests that they may have been intended to be bit

into the plate as their caption. Insofar as the poems by Waterloos correspond to Rembrandt's attitude toward the Jews, we can only conclude that he shared "the typical attitude [toward the Jews] of the self-satisfied Calvinists in the seventeenth-century Republic."[13] The self-satisfaction consisted of the certainty of being in possession of the one and only truth about God.

In this context, it may be significant that in his choice of subjects from the mission of Christ, Rembrandt shows a preference for the two stories in the New Testament concerning Samaritans, a non-Jewish Palestinian people who were discriminated against by Jews. The good Samaritan of the parable (figs. 8, 9, 394) cares for a victim of violence who had been left on the roadside by passing Jews. The story of the Samaritan woman to whom Jesus speaks at Jacob's well concerns the bypassing of the Jews in the attainment of salvation (fig. 441).

There is only one other work in Rembrandt's oeuvre that comes close to the extraordinary *Hundred-guilder print: John the Baptist preaching* (fig. 185). Here too a holy figure addresses a multitude including Jews, among them Pharisees, and the peoples of the earth. The format and tonality of that painting of the mid-

13 D.M. Swetschinski, in Blom et al. 1995, p. 69.
14 Martin Royalton-Kisch, in Hinterding et al. 2000, pp. 76–80, 257–58.
15 Docs. 1652/7 and 1658/18.

589
Rembrandt
Man standing, a cap in his outstretched right hand
Unsigned, undated. Ca. 1639
Brown ink, 12.7 x 5.8 cm.
Benesch 184
London, Courtauld Institute of Art Gallery

591
Rembrandt
Study for the group of the sick to the left of Christ in the Hundred-guilder print
Unsigned, undated. Ca. 1645
Brown ink and wash, white body color, 14.4 x 18.5 cm.
Benesch 188
Berlin, Staatliche Museen, Kupferstichkabinett

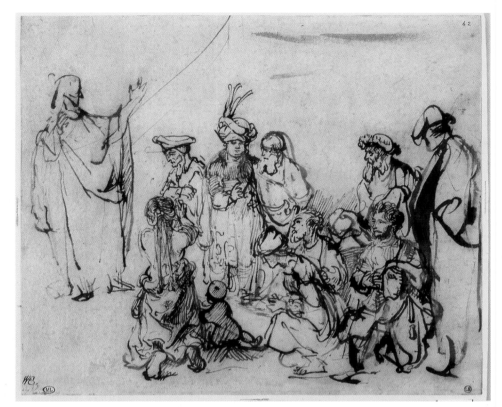

590
Rembrandt
Christ preaching
Unsigned, undated. Ca. 1643
Brown ink, 19.8 x 23 cm.
Benesch 543
Paris, Musée du Louvre, Cabinet des Dessins

1630s have given rise to the theory that it was intended to serve as the model for an etching that was never executed. This brings it even closer to the *Hundred-guilder print*. The drawings for that composition – unusually many survive, just as for the *Preaching* – have been dated by some specialists to the late 1630s, although more recent opinion brings them up to the mid-1640s.[14] The plate was not completed until 1649 or 1650.

It would seem that from the mid-1630s, when he began work on *John the Baptist preaching*, until mid-century Rembrandt was searching for a way of visualizing the promulgation to humanity of the Christian message. The *Hundred-guilder print*, on which Rembrandt worked intermittently for at least five years, was the triumphant climax of that search.

Following the completion of the *Hundred-guilder print*, Rembrandt sold the painting of *John the Baptist preaching* to his patron and friend Jan Six, designing a frame for it in the process (fig. 588).[15] One wonders whether Six played a role in the genesis of the print of Christ. Rembrandt's work for Six ties into at least one key aspect of the *Hundred-guilder print*, the technique. Rembrandt's etched portrait of Six, dated 1647, was the earliest print in which he combined etching, drypoint and burin. He did this again, far more assertively, in the *Hundred-guilder print*, which was in the making when Rembrandt made his etched portrait of Six. The portrait represented a vital step in the technical innovations that found full expression in the *Hundred-guilder print*.

The print contains another powerful reminiscence of Rembrandt's work for – or should we say with? – Six. The three techniques combine to produce an incredibly rich variety of lights and darks, with some figures defined by pure outline drawing and others carved out of deep shadows. This is comparable to Rembrandt's accomplishment in the painted portrait of Jan Six. In that work too he joins minimum and maximum means, in various parts of the composition, into a seamless whole (figs. 163–65). That Rembrandt and Six discussed these features of his own portraits can

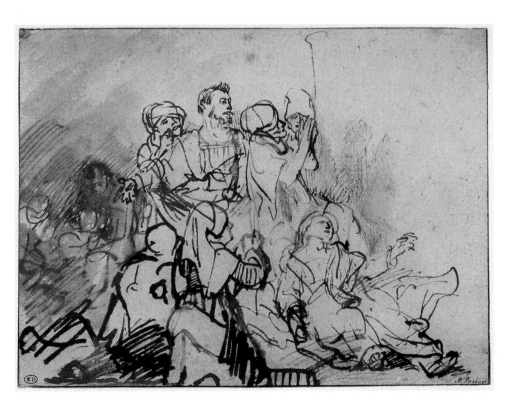

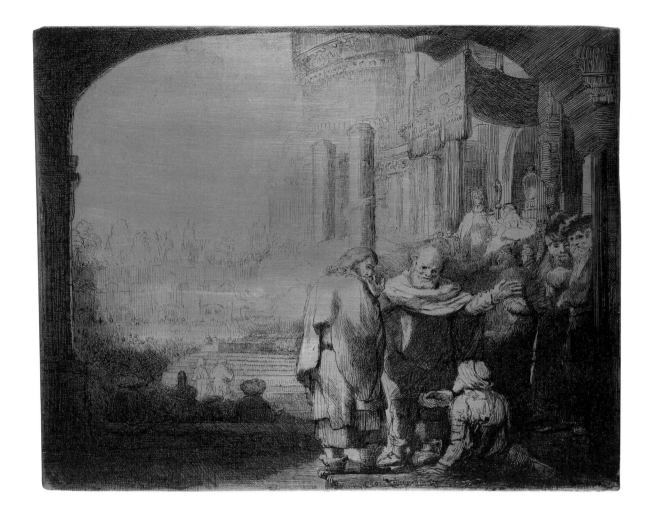

592
Rembrandt
Copper plate of *Peter and John
healing the cripple at the gate
of the Temple*
Inscribed *Rembrandt f. 1659*
Etching, drypoint and burin,
18 x 21.5 cm.
Bartsch 94
Braunschweig, Herzog Anton
Ulrich-Museum

593
Rembrandt
*Peter and John healing the cripple
at the gate of the Temple*
Inscribed *Rembrandt f. 1659*
Etching, drypoint and burin,
18 x 21.5 cm.
Bartsch 94 ii(4)
Haarlem, Teylers Museum

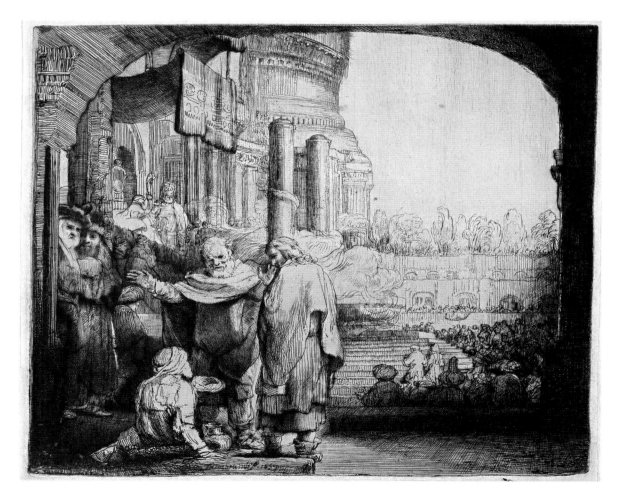

594
Rembrandt
Christ on the Cross
Inscribed *RHL 1631*
Canvas on panel, 100 x 73 cm.
Bredius 543A
Le Mas d'Agenais, Collégiale
Saint Vincent

The further point of the story, however, is that the Jews, who were surprised over the healing, were only surprised because they did not believe in Christ, whom they had betrayed. Chapters 3–4 of the Acts of the Apostles, where the story is told, are the main source for Christian repudiation of the Jews through the ages. "You handed him over to be killed, and you disowned him before Pilate, though he had decided to let him go. You disowned the Holy and Righteous One" (Acts 3:13). Here too is the source of Hendrick Waterloos's poem saying that Jesus must remain in heaven until the time comes for him to return to earth. Rembrandt's choice of this particular motif does nothing to allay our unease over his attitude toward the Jews. The same is true for John the Baptist preaching. John's first message, before even heralding the arrival of Christ, is that the Pharisees and Saducees, the Jewish leadership, were "a generation of vipers."

The ties here suggested between *John the Baptist preaching*, the *Hundred-guilder print* and *Peter and John healing the cripple* carry an additional significance. Although Christ is the hero of the *Hundred-guilder print*, he and his mission are not obligatory for bringing across the message of Christianity. His precursor John the Baptist and his successor Peter are also fit bearers of the Savior's message. And that message is not all sweetness and light.

Passion, death and afterdeath

Twice Rembrandt undertook major series of the Passion of Christ: five paintings for the stadholder in the 1630s and in the 1650s two majestic drypoint prints of a projected sequence. The commission for the early series was supervised by Constantijn Huygens; the later one is related to a poem on the Passion by Jeremias de Decker. Although they belong to his most enduring and penetrating works, Rembrandt abandoned the subject in his final years.

If the Nativity appeals mainly to the sentiments and Christ's mission to the sense of morality, the Passion speaks to the essence of Christian faith. Although the theology of the death of Christ is extremely subtle, to most believers it boils down to the belief that Christ died on account of our sins and for our salvation.

That dogma was linked decisively to vivid written, spoken and painted pictures of Christ's capture, trial, torture, death and resurrection, and of the doings of his friends and enemies throughout the drama. Fascination with the details of martyrdom added to the power of such imagery. This helped believers to relive the Passion in imagination and meditation, practices that are furthered in different ways by Protestant and Catholic churches alike. The creations of artists are intrinsic to this central feature of Western culture.

Rembrandt initially shied away from the great challenge of depicting the death of God. When he did take it on, it was the result of a commission from the court,

hardly be doubted; I would suggest that the *Hundred-guilder print* as well was the subject of lively discussion between them, in content as well as technique.

When on 5 October 1652 Jan Six bought *John the Baptist preaching* he and Rembrandt signed an agreement that contained a provision for a penalty "in case one or other of the parties came to act contrary to the content of [the agreement]." This has been interpreted to refer to the right to make a print after the painting. In 1658, Six and Rembrandt annulled the penalty clause. If Rembrandt was planning to produce an etching of his old composition, he did not follow through. He did, however, create a variant of it in his last copious etching, *Peter and John healing the cripple at the gate of the Temple*. The resemblance, which begins with the upper framing and the division of earth and sky, is more visible in the original etching plate than in the reversed impressions. The action is the miraculous healing by St. Peter, in the company of the apostle St. John, of a crippled beggar at the gate of the Temple.

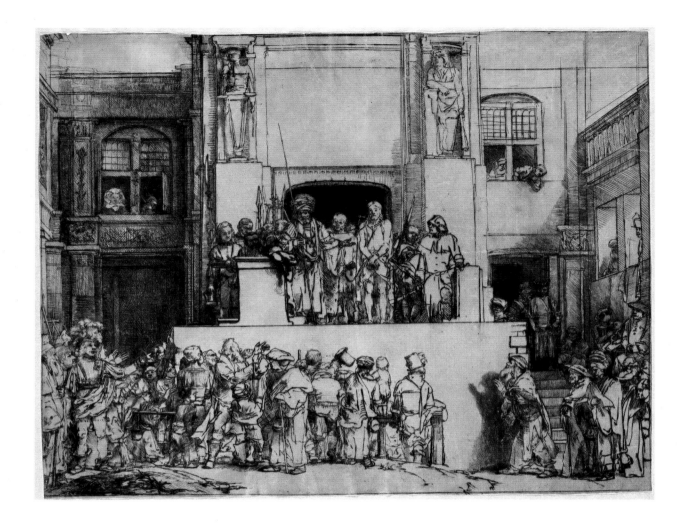

595
Rembrandt
Christ presented to the people
Inscribed *Rembrandt f 1655*
Drypoint, 38.3 x 45.4 cm.
Bartsch 76 i(5)
Amsterdam, Rijksmuseum

596
Rembrandt
Christ presented to the people
Inscribed *Rembrandt f 1655*
Drypoint, 38.3 x 45.4 cm.
Bartsch 76 v(5)
Haarlem, Teylers Museum

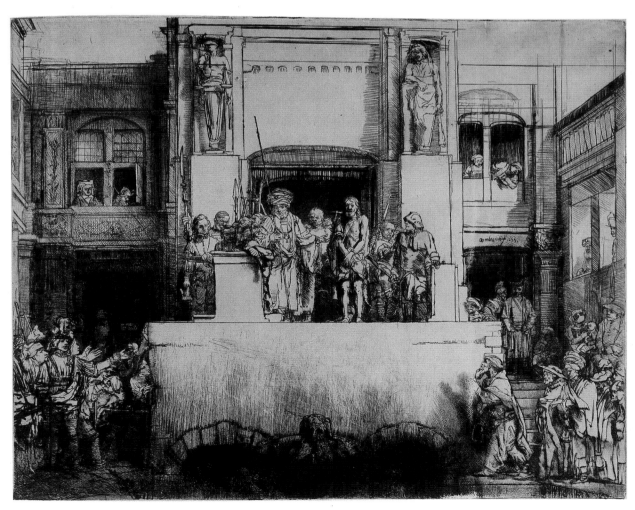

through Constantijn Huygens. This resulted, between 1633 and 1639, in an abbreviated Passion series of five paintings, preceded in 1631 by a *Christ on the Cross* that seems to me to have functioned as a trial piece for the series. An unusual feature of the first three of these paintings is that the artist seems to have lent his own features to his subjects. The Christ in *Christ on the Cross* resembles etched self-portraits of the time (figs. 483–84). In the *Raising of the Cross* (fig. 261) he helps erect the Cross and in the *Descent* (fig. 262) we see him as one of the devastated helpers lowering the body to the ground.

It was not unprecedented for artists to give their own features to biblical figures, but not that common either. After 1633 Rembrandt never did it again. Whose idea was it? It is hard to imagine a young artist inserting himself unasked into an official commission. Knowing as we do that the order came from the hands-on patron Constantijn Huygens, we must assume that he agreed to the move, or conceived of it himself. As it happens, in this very time Huygens translated from English into Dutch John Donne's brilliant poem "Good Friday: riding westward." This confessional meditation plays with the idea of the poet being present on Golgotha at the Crucifixion.[16] Huygens will also have known Dutch poems on the Crucifixion like that of 1630 by the Deventer poet-*predikant* Jacobus Revius, which begins: "It's not the Jews, Lord Jesus, who crucified you … It's me, O Lord, I'm the one who did it to you."[17] For Rembrandt to paint himself into the picture was personal, then, but it was a religiously programmatic, not a psychological personalness.

In the 1650s Rembrandt returned to the Passion in another incomplete series, this time of large drypoint prints. Only *Christ presented to the people* and *Christ crucified between the two thieves: "The three crosses"* were completed. A number of other plates were polished in preparation for additions to the series that were never executed. They were owned by the Amsterdam entrepreneur Dirck van Cattenburgh, who seems to have financed the series.[18]

The spiritual impulse for the printed Passion may well have been provided by Rembrandt's other poet friend, alongside Constantijn Huygens. In 1651 Jeremias de Decker published his most highly regarded poem, "Good Friday, or the Passion of our Lord Jesus Christ."[19] It was reprinted several times in the decade to come. Following the introduction, it treats nine stages in the inexorable sequence so well known to every Christian, from the Last Supper to the Resurrection. One reason for thinking that Rembrandt's Passion series was related to de Decker's has to do with a departure from Scripture in *Christ presented to the people*. The choice by the Jews for sparing the life of Barabbas and executing Christ, described in different terms by all four Evangelists, evokes from de Decker the following outcry: "Infuriated Pharisees, you acquit Evil and deal a death blow to Virtue … How, cruel wretches, how can you fearlessly sentence to death that Physician who with a word, a blink of the eye cured your sick and resurrected your dead?"[20]

In Rembrandt's print, which is based on an engraving of 1510 by Lucas van Leyden, de Decker's allusion to the sick and the dead takes on concrete form.[21] Lucas's crowd in front of the dais consists of aggressive men gesturing angrily, the Barabbas fans of Scripture, the Jews of whom Matthew wrote "*All* the people answered, 'Let his blood be on us and on our children!'" (27:25) and Luke "*With one voice* they cried out, 'Away with this man! Release Barabbas to us!'" (23:18) (my italics). The corresponding group in the Rembrandt does not look angry at all to me. They look like men, women and children who could have walked out of the *Hundred-guilder print* after Christ healed them: the sick miraculously cured and the resurrected dead, the very people Jeremias de Decker introduces into the story of the sentencing of Christ.[22]

In later states of the print the entire group is removed and replaced by a blank wall with two gaping arches. This is usually seen as a further development in Rembrandt's artistic vision of the subject or a technical measure to camouflage the deterioration of the print. I would suggest that it is also an iconographic correction, an elimination of the Jewish believers in Christ who according to the Bible were most emphatically *not* present at the scene. Even so, the remaining figures on the right are still gentler than the usual cast of characters in an *Ecce homo*. Only the two leftmost figures resemble "infuriated Pharisees." The man beside them, with a plumed hat, looks more a Roman centurion.

The other Passion print, *The three crosses*, was made shortly before *Christ presented to the people*. Both are executed entirely in drypoint, giving the prints greater contrast than otherwise between sharp drawing and lush modelling and between light and dark.

As in *Christ presented to the people*, Rembrandt put the etching through a radical remake in which he eliminated most of the foreground figures. The first states are markedly copious. They show about thirty-five figures, including a troop of cavalry, reacting in various ways to the event. It is a showpiece that Rembrandt printed by preference, with different applications of plate tone, on the expensive support of vellum.[23] In the fourth state all of that changed. Individuals and groups of extras were burnished out, replaced by larger, more imposing elements or covered with heavy modelling. In the printing, much of what was left was blacked out with tone. The troop of military horses is played down in favor of a new horseman riding toward the Cross rather than away from it. (See also figs. 238–39.) This figure replaces the kneeling centurion of the first state, the heathen who spontaneously recognizes Christ's divinity.

The early states of *The three crosses* depict the pandemonium on earth brought about by the Crucifixion. Jeremias de Decker describes it through the eyes and ears of Christ: "See what your Lord had to see and hear there … two murderers he sees here with him, on either side … with half-broken eyes he sees his mother here …

16 Schwartz 1985, pp. 108, 118.
17 "T'en sijn de Joden niet, Heer Jesu, die u cruysten, … Ick bent, ô Heer, ick bent die u dit hebt gedaen…." From "Hy droegh onse smerten," in *Over-ysselsche sangen en dichten*, on Internet at www.dbnl.nl. This is sometimes read to mean that Revius exonerated the Jews from responsibility for the death of Christ. That is not so, as is clear from any number of other poems on the Passion in the same collection. Revius sent Huygens a copy of his book in 1642, but Huygens may have known it earlier. Worp 1911–17, vol. 3, 1914, p. 265. Stronks 1996, p. 173, interprets Huygens's thank-you note to Revius to mean that he had not earlier heard of the Deventer poet, but the words do not bear out that interpretation. Stronks reports that twenty-five copies were available in a leading bookshop in Leiden from 1631 on, so Rembrandt too might have read Revius. There, pp. 173–74.
18 White 1969, vol. 1, p. 227.
19 An annotated edition of this work as well is available on Internet at www.dbnl.nl.
20 "Verwoede Phariseen, ghy spreekt de Boosheyd vry,/ En steekt de Deugd na 't leven./… Hoe kond ghy, wreed gebroed, hoe kond ghy onverschrikt/ Dien Artz ter dood verwijsen,/ Die met een woord, een wenk uw' kranken heeft verquikt,/ Uw' dooden doen verrijsen?"
21 Hinterding et al. 2000, pp. 316–22, provides a fascinating analysis of the printing history of the plate, with the various papers on which the different states were printed.
22 Other commentators on the print, who relate it to the Bible text alone, do not seem to share this view of the people in the foreground.
23 Hinterding et al. 2000, pp. 297–304, reports that "fourteen of the nineteen known impressions of the first state [are] on vellum."
24 "En sie wat uwen Heer hier sien en hooren moet:/ Twee moorders siet hy hier met sich ter wedersijden …/ Hy siet sijn' moeder hier met half gebroken' oogen/ Tot in haer siel bewogen …/ Hier hoort hy: Dit 's de man die raed wist tot elcx pijne,/ En suft hy op de sijne?"

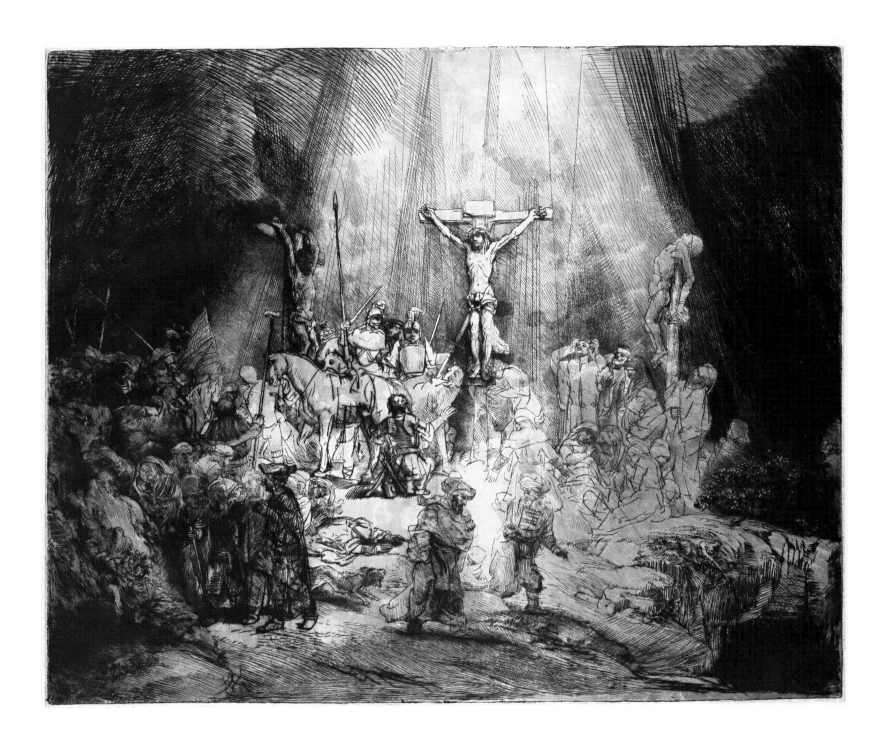

597
Rembrandt
Christ crucified between the two thieves: "The three crosses"
Inscribed *Rembrandt. f. 1653*
Drypoint and burin,
38.5 x 45 cm.
Bartsch 78 i(5)
Haarlem, Teylers Museum

25 White 1982, pp. 105–07, no. 161.

Here he hears: this is the man who knew how to deal with the pain of everyone, is he helpless with his own?"[24]

The late states are plunged into the darkness that fell over the earth after Christ died. Mankind is now represented mainly by the single, silent horseman before the Cross, contemplating the dead divinity. The printing of these states was handled very differently from the early ones. The fifty-two known impressions show little variation in tone, and none is printed on vellum. The precious, collector's-item feeling of the early states surrenders to sheer graphic power.

The idea that Jeremias de Decker and Rembrandt shared thoughts about the Passion of Christ in art

and poetry is substantiated by a writing of the poet on a theme related to the Passion. In a poem first published in 1660, de Decker wrote that he looked over Rembrandt's shoulder as the artist painted *The risen Christ appearing to Mary Magdalene* (fig. 393). His description matches the version painted in 1638, which has a manuscript of the poem on the back of the panel.[25] Christ has risen from the tomb and walks the earth (John 20:14–17). Mary Magdalene comes to his burial place, where she finds two angels in white at the head and foot of the empty tomb. A man she takes for a gardener startles her.

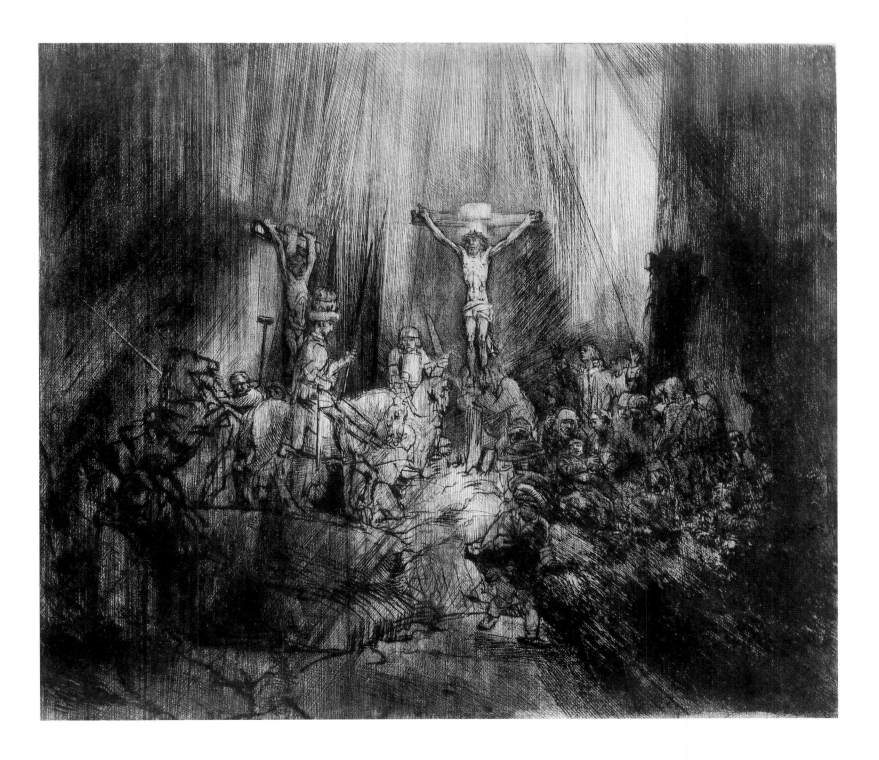

598
Rembrandt
Christ crucified between the two thieves: "The three crosses"
Inscribed *Rembrandt. f. 1653*
Drypoint and burin,
38.5 x 45 cm.
Bartsch 78 v(5)
Haarlem, Teylers Museum

On the depiction of the risen Christ and Mary Magdalene, painted by the outstanding master Rembrandt van Rijn, for H.F. Waterloos

When I read St. John's description of this scene
And turn to see it in this splendid painting, then
I ask myself if brush has ever followed pen
As aptly, or dead paint so near to life has been.

Christ seems to say "Marie, don't tremble. I am here,
It's me. Your master's free of Death's authority."
Believing, though not yet with all her heart and mind, she

Seems poised between her joy and grief, her hope and fear.

As art dictates, the tomb's a tall and rocky tower,
Rich with shade, thus lending sightliness and power
To all the rest. Because, friend Rembrandt, I once saw
This panel undergo your deft and expert touch,
I wished to rhyme a verse on your most gifted brush,
To add praise with my ink to the paints with which you draw.

De Decker praises the painting for following the text closely, for its lifelikeness, for capturing the mixed

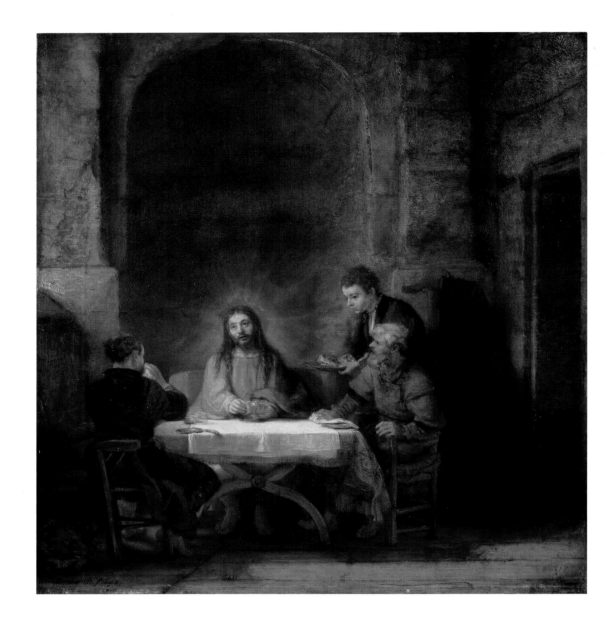

599
Rembrandt
Christ at Emmaus
Inscribed *Rembrandt f. 1648*
Panel, 68 x 65 cm.
Bredius 578
Paris, Musée du Louvre

600
Gerbrand van den Eeckhout
(1621–74)
The Last Supper
Inscribed *G.V.Eeckhout fe.*
Ao 1664
Canvas, 100 x 142 cm.
Sumowski 443
Amsterdam, Rijksmuseum

emotions of the confused Magdalene and for the effective use of light and dark. His presence in the studio when the painting was being made, I submit, was no accident; nor was Rembrandt's decision to make prints of the Passion following the publication of "Good Friday."

Jeremias de Decker and Hendrick Waterloos, along with a number of Rembrandt's pupils and other relations of the artist, belonged to a circle of poets who met in a religious circle and exchanged verses on holy themes.[26] With respect for the Bible text and Calvinist theology, they explored more personal meanings of Scripture, challenging each other to come up with new variations. The way in which Rembrandt varied his Passion prints can be compared to this way of probing sacred matters. Neither he nor any other artist of his age ever again attempted an experiment as daring as this.[27]

After 1660 there is not a single known work by Rembrandt depicting any of the twenty-odd Passion themes that he took on earlier. Nor did he interpret all the classic iconographies of Christ's death and the events that followed. The Last Supper is represented

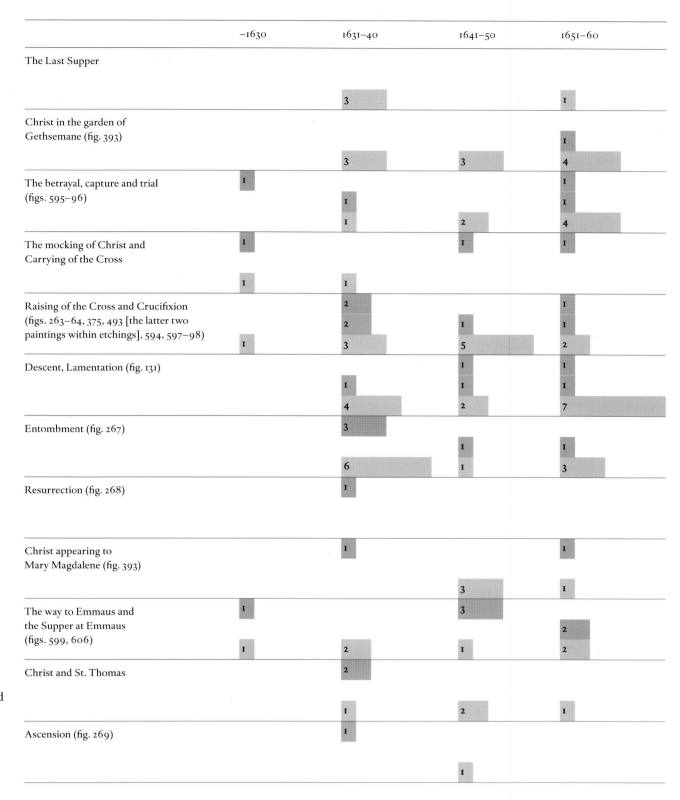

	−1630	1631–40	1641–50	1651–60
The Last Supper		3		1
Christ in the garden of Gethsemane (fig. 393)				1
		3	3	4
The betrayal, capture and trial (figs. 595–96)	1			1
		1		1
		1	2	4
The mocking of Christ and Carrying of the Cross	1		1	1
	1	1		
Raising of the Cross and Crucifixion (figs. 263–64, 375, 493 [the latter two paintings within etchings], 594, 597–98)		2		1
		2	1	1
	1	3	5	2
Descent, Lamentation (fig. 131)			1	1
		1	1	1
		4	2	7
Entombment (fig. 267)		3		
			1	1
		6	1	3
Resurrection (fig. 268)		1		
Christ appearing to Mary Magdalene (fig. 393)		1		1
			3	1
The way to Emmaus and the Supper at Emmaus (figs. 599, 606)	1		3	
				2
	1	2	1	2
Christ and St. Thomas		2		
		1	2	1
Ascension (fig. 269)		1		
			1	

Table 7
Rembrandt's depictions of themes from the Passion of Christ and the resurrected Christ, by decade

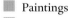 Paintings
■ Etchings
■ Drawings

26 Visser 't Hooft 1956, pp. 64–68.
27 Margaret Carroll calls attention to the meditational aspect of the sequence of states in these prints. She brings them into connection with poems by Constantijn Huygens that lack the direct tie that existed in these years with respect to Jeremias de Decker. Carroll 1981.

in his work only in the form of a number of variations on Leonardo, the Resurrection and Ascension only in the commissioned series for the stadholder, the Transfiguration not at all. The single subject from the death and afterdeath of Christ that most appealed to Rembrandt was Christ's revelation to his followers at Emmaus that he had risen from the dead. His mysterious evocations of that scene were among the most influential in his work. In the 1660s, a pupil like Gerbrand van den Eeckhout transformed a Rembrandt

Christ at Emmaus of 1648 into a *Last Supper* of his own (figs. 599–600).

The frightened Magdalene, the incredulous St. Thomas, the apostles visited by the risen Christ on the road to Emmaus are subjects that tie into an inclination so strong we can call it nearly an obsession: the interference of God in the doings of men. See the following section.

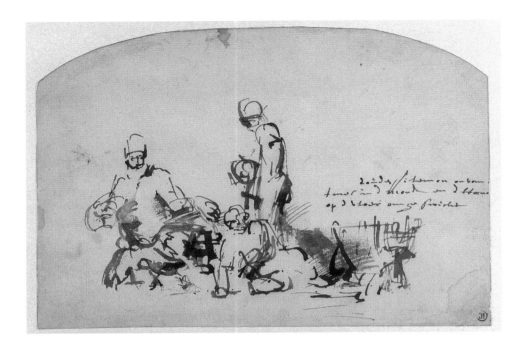

The gods Jupiter and Mercury visit the earth in mortal guise to test the virtue of humanity. Going from door to door, they are shut out by everyone except the pious old couple Philemon and Baucis, who invite them into their modest cottage and begin preparing a meal for them. After refilling their wineglasses a few times, they notice that the pitcher never empties and begin to catch on to the identity of their guests. Ovid (*Metamorphoses*, Book 8, in the translation of Brookes Moore):

> And now, persuaded by this strange event
> such visitors were deities unknown,
> this aged couple, anxious to bestow
> their most esteemed possession, hastily
> began to chase the only goose they had—
> the faithful guardian of their little home—
> which they would kill and offer to the Gods.
> But swift of wing, at last it wearied them,
> and fled for refuge to the smiling Gods.
> At once the deities forbade their zeal . . .

In an annotated drawing, Rembrandt shows old Philemon on his knees chasing the goose, a knife between his teeth (see also the butcher in fig. 470), the hand indeed twisted. Those details are not in the text; they seem to come from Rembrandt's imagining of the situation. The story goes on: the gods take the old couple up a hillside, where they watch as the entire countryside is destroyed, except for their house. Their requested reward is twofold: that they may serve in the temple of the gods as long as they live and that when they die, they both go at the same time. The intervention of Jupiter and Mercury in the life of man is disastrous for humankind, but is told by Ovid and portrayed by Rembrandt as a feel-good story, a moment of trust,

601
Rembrandt
Jupiter and Mercury visiting Philemon and Baucis
Unsigned. Inscribed *d'ouden filemon onvan*[g]*t mes ind*[e] *mon en dHaend op de vloer omgeswicht* (The old Philemon takes [the] knife in his mouth and twists his hand on the floor). Undated. Ca. 1655
Reed pen and brown ink, in some places rubbed with the finger, white body color,
13.1 x 19.2 cm.
Benesch 960
Berlin, Staatliche Museen, Kupferstichkabinett

Divine intervention

Rembrandt lived on a fault line between the here and now and a realm where the supernatural is real. The gods of the ancients, God the Father of the Jewish Bible, God the Son of the Christian Bible, angels of the Lord, in human, animal and nearly immaterial guise, are everywhere in Rembrandt's work. They intervene in the doings of man sometimes as sexual predators, sometimes as agents of correction and sometimes as loving helpers.

602
Rembrandt
Jupiter and Mercury visiting Philemon and Baucis
Inscribed *Rembrandt f. 1658*
Panel, 54.5 x 68.5 cm.
Bredius 481
Washington, National Gallery of Art

28 Hofstede de Groot 1906a, p. 421.
Roscam Abbing 1999, pp. 49–58.
His translation and interpretation of the passage correct the previous assumption that the paintings were painted on the walls of the merchant's house.
29 Tümpel 1991, pp. 8–23.

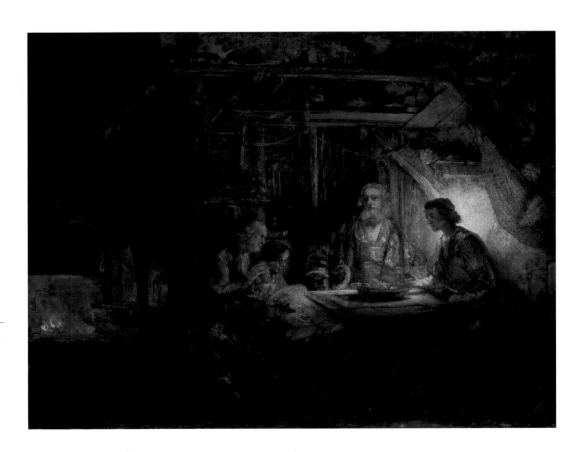

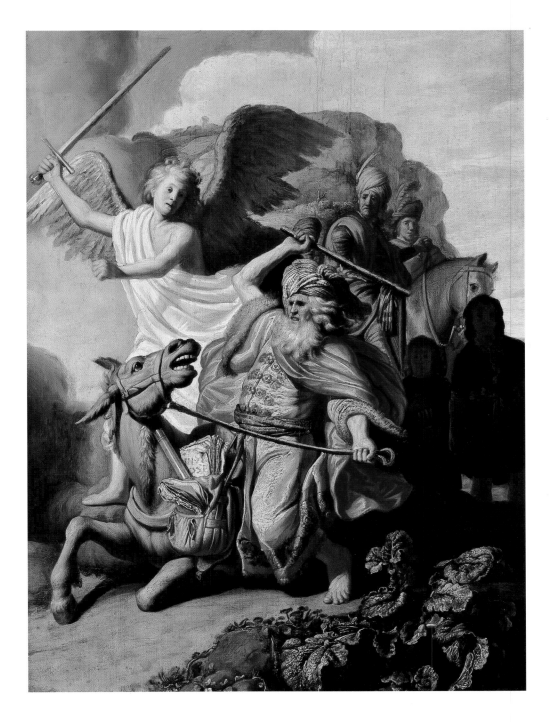

603
Rembrandt
*The ass of Balaam protesting
to its master*
Inscribed *R f. 1626*
Panel, 65 x 47 cm.
Bredius 487
Paris, Musée Cognacq-Jay

604
Pieter Lastman (1583/84–1633)
*The ass of Balaam protesting
to its master*
Unsigned, undated. Ca. 1622
Panel, 41.3 x 60.3 cm.
Jerusalem, Israel Museum

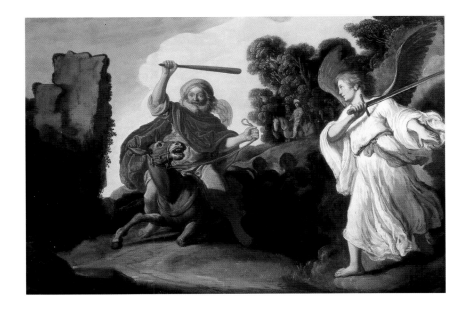

piety and mutual respect, bridging the gap between
divinity and humanity.

In 1686, Filippo Baldinucci wrote in his life of
Rembrandt: "In casa un Mercante del Magistrato
condusse molte opere a olio sopra muro, rappresen-
tanti favole d'Ovidio" (In his house a merchant who
belonged to the town government brought many works
in oil depicting myths from Ovid on his walls).[28]
Although no such ensemble has come down to us,
the considerable number of drawings by Rembrandt
of subjects from Ovid lends credence to the report.

Like his master Pieter Lastman (and most other
artists who depicted Bible subjects), Rembrandt painted
angels and visions.[29] One of Rembrandt's earliest paint-
ings shows an angel interfering in human life, and it is
derived from a similar work by Lastman. Both show a
certain moment in the strange story of Balaam, a story

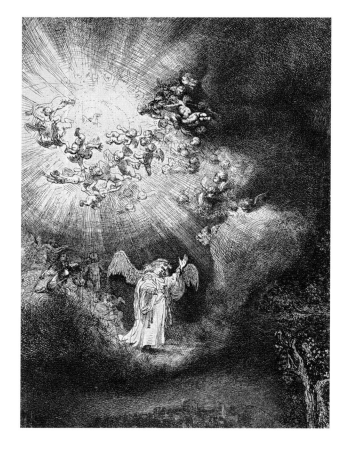

605
Rembrandt
Detail of *The angel appearing
to the shepherds*
Inscribed *Rembrandt f. 1634*
Etching, burin and drypoint,
26.2 x 21.8 cm.
Bartsch 44 iii(3)
Haarlem, Teylers Museum

30 Frijhoff 1995, pp. 21–25.
31 Frijhoff 1995, p. 408.
32 Frijhoff 1995, p. 470.
33 Frijhoff 1995, pp. 417–20.
34 Hoet 1752, vol. 1, p. 309, in
auction of the paintings belonging
to the Vrouwe van Ste. Anneland,
sold in The Hague on 6 November
1725. Suzanne Huygens-Doublet
acquired that title through her
marriage to her cousin Philips
Doublet, Heer van Ste. Anneland.
35 Schwartz 1985, pp. 48, 51.

of four-way contact between a human, God, an angel
and an animal. Told very briefly: the heathen prophet
Balaam was summoned by Balak, the king of Moab,
to curse the Jews. Balaam at first refused, and when
he relented and set off God sent an angel to block his
way. The angel is at first visible only to the donkey, not
the prophet.

> When the donkey saw the angel of the Lord, she lay
> down under Balaam, and he was angry and beat her
> with his staff. Then the Lord opened the donkey's
> mouth, and she said to Balaam, "What have I done
> to you to make you beat me these three times?"
> Balaam answered the donkey, "You have made a fool
> of me! If I had a sword in my hand, I would kill you
> right now."

The action in the paintings by both Lastman and
Rembrandt, with their swords and staffs, the bent knees
and open jaws of the donkey, correspond well with
these verses. The end of the story is that Balaam did
not curse the Jews but blessed them.

Even though it was a major part of his artistic inher-
itance, the prevalence in Rembrandt's work of recogni-
tions and confrontations with the divine, angels and
visions, demands closer attention. Part of their force
and hold over him, there is good reason to believe, derive
not from the studio and the Bible but from real life.

On 17 September 1622, in the town of Woerden,
a few hours up the Oude Rijn from Leiden, the fifteen-
year-old orphan Evert Willemsz. Bogaert was visited
by an angel of the Lord. For months, the boy had been
suffering torments of various kinds, including deaf-
and-dumb and blind spells. The visit of the angel, over-
whelming as it was, nonetheless brought him back
to his senses. In the throes of ecstasy, he wrote down
the sayings of the divine visitor, admonishing mankind
to repent and warning it that the end of days was near.[30]
In January 1623 he had another visitation and a waking
dream during which he mouthed the words of the
angel. The occurrences had the power of a conversion.
Evert decided then and there to give up his apprentice-
ship to a tailor and devote his life to God as a *predikant*.

Evert's angel did not have a single, unequivocal form.
In his allusions to it, "he wavers between an angelic
being, the Spirit of the Lord, a divine power and
a blinding light."[31] The miraculous experiences of Evert
Willemsz. were published in two pamphlets by the
head of the Latin school in Woerden, Lucas Zas, who
became his protector. The title-print of the second
pamphlet, brought out in February 1623 by a prominent
Amsterdam printer of holy writings, illustrates a recur-
ring reference in Evert's visions: the Road to Emmaus,
with Christ appearing to two of his followers.[32] At that
moment, the risen God is there, but he is not recog-
nized at all.

In 1627 the township sent its ward to Leiden, to the
distinguished Latin school under Theodorus Schreve-
lius. He arrived there within a year of the time when
we found Schrevelius showing off his Rembrandt paint-
ing to Arnoldus Buchelius (pp. 143–45). If Schrevelius
did not introduce these two young contemporaries to
each other, both protégés of his in different spheres, he
missed a trick. Even if he did not, however, the experi-
ences of Evert Willemsz. illuminate Rembrandt's
depictions of angels. These experiences were far from
unique. Angelic visits occurred with a certain regularity
all around Rembrandt. While there were always skep-
tics who refused to credit them, most people, including
scholars, churchmen and government officials, took
them with utmost seriousness. In the week before
Christmas 1629, the "quiet and capable" basketmaker's
apprentice Pieter Dircksz., who lived not far from
Rembrandt on the Mare, was awoken by a blinding
light and visited by an angel who told him that the end
of days was nigh. He then lost the power of speech,
which he regained on Christmas Day.[33]

To judge by his choice and treatment of subjects
having to do with angels, visions, appearances of God,
divine interventions in human affairs and conversions,
Rembrandt was no skeptic. Rembrandt and Evert
Willemsz. would have had a lot to talk about. What
would Christ have looked like to his disciples at
Emmaus? Luke 24:31 only says "Then their eyes were
opened and they recognized him." What opened their
eyes? In his first depiction of the subject, painted during
the two years between 1627 and 1629 when Evert was
a pupil of the Leiden Latin School, it is a brilliant light
beside Christ (fig. 606). The result is puzzling, since
we expect in compositions of that kind a natural source
of light, in a candle or a lamp. In later paintings and

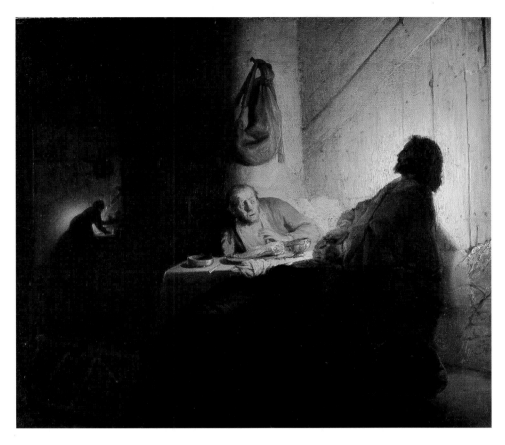

606
Rembrandt
Christ at Emmaus
Inscribed *RHL.*
Undated. Ca. 1628
Oil on paper on panel,
39 x 42 cm.
Bredius 539
Paris, Musée Jacquemart-André

607
Hendrick Goudt (ca. 1583–
1648) after Adam Elsheimer
(1578–1610)
*Jupiter and Mercury visiting
Philemon and Baucis*
Inscribed *H. Goudt 1612,*
with a Latin dedication to
the artist's father
Engraving, 16.4 x 22 cm.
Haarlem, Teylers Museum

608
After a lost work by Rembrandt
Christ at Emmaus
Unsigned, undated.
Original ca. 1648–49
Pen and brown ink, brush and
brown wash, white body color,
19.8 x 18.3 cm.
Benesch C47
Cambridge, Fitzwilliam
Museum, University of
Cambridge

etchings, Christ is the source of light, and in a lost
drawing known only from copies, he is a blinding light,
like the angel seen by Evert Willemsz. and Pieter
Dircksz. (fig. 608).

First-person reports were of course not Rembrandt's
only source. As has long been recognized, a print by
Hendrick Goudt after Adam Elsheimer provided
Rembrandt with the *mise-en-scène* for the represen-
tation, with Jupiter in the position of Christ and
Philemon in the kitchen where Rembrandt painted
a maid (fig. 607).

What does not seem to have been noticed is a poss-
ible connection in this regard to Constantijn Huygens.
When his daughter Suzanne Huygens-Doublet died
in 1725, the auction of her paintings included "A candle-
light scene depicting the story of Baucis and Philemon,
by H. Goudt." Because the auction contained other
paintings linked to Constantijn, this one too may have
been in his possession and may have provided
Rembrandt with part of his inspiration.[34] The painting
has similar dimensions to Goudt's print of 1612 and
may have been a painting after the print. Rembrandt's
Christ at Emmaus, painted in oil on paper, is not much
larger. That painting is closely related to the *Hannah
and Simeon in the Temple* in Hamburg, which is believed
to be the version of the subject that was owned by the
stadholder[35] (fig. 176). These circumstances all add sub-
stance to the supposition that *Christ at Emmaus* as well
as *Hannah and Simeon* came into being as part of
Rembrandt's budding relationship with Huygens.

The assumption that Rembrandt's experimental
Christ at Emmaus is connected to Huygens is strength-
ened by a passage in a letter that Huygens wrote on
8 July 1647 to the Utrecht scholar Anna Maria van
Schurman. He refers enthusiastically to "the amazing

collection of the prince of Salm-Salm is combined with a *Diana and Actaeon*; the woman in bed reaching out to a divine visitor, if she is Danaë, is the only one in painting to be ravished not by a shower of coins but by a ray of light.[38]

Rembrandt's abductions of Proserpina (fig. 609) and Europa (fig. 381) are the first paintings of these subjects in the northern Netherlands.[39] The *Proserpina*, having entered the Berlin museum from the collections of the House of Orange, is identified as a painting that belonged to Frederik Hendrik in 1632.[40] The composition of Diana and her nymphs is close to that of a nymph painting by Alexander Keirincx and Cornelis van Poelenburgh (figs. 382–83), a duo who also delivered work to the stadholder at the time. Just as in the case of *Christ at Emmaus*, then, the most likely target audience for at least some of the mythologies was the court at The Hague. This is no more than we should expect; comparing the market for art in Leiden, The Hague and Amsterdam, the three cities to which Rembrandt had access, the interest in mythology was by far the greatest in The Hague, specifically at court. Not exclusively, however. We happen to know that the *Abduction of Europa* (together with four other paintings by Rembrandt) was owned by a former governor-general of the Dutch East Indies named Jacques Specx, who lived in Amsterdam following his return to the Netherlands in 1633.[41]

The most unusual of these paintings is *The abduction of Ganymede*. According to ancient authors, followed by all artists who depicted the scene before Rembrandt, Ganymede was an irresistibly beautiful youth whose

609
Rembrandt
The abduction of Proserpina
Unsigned, undated. Ca. 1632
Panel, 84.8 x 79.7 cm.
Bredius 463
Berlin, Staatliche Museen, Gemäldegalerie

610
Rembrandt
The abduction of Ganymede
Unsigned, undated. Ca. 1635
Brown ink and wash,
18.3 x 16 cm.
Benesch 92
Dresden, Staatliche Kunstsammlungen, Kupferstich-Kabinett

painting in my possession by your fellow townsman, the deranged painter Goudt," hoping that she would get to see this "treasure."[36] If this is the same painting by Goudt that was owned by Huygens's daughter, then we know that it was a painting that Huygens especially admired and discussed with his friends. The fact that Goudt's composition was based in turn on a painting by the German-Italian artist Adam Elsheimer, a legend in his own time, would have added to its magic.[37] Rembrandt too returned to the Elsheimer composition in a painting of the 1650s of Philemon and Baucis (fig. 602).

Christ at Emmaus is a Christian subject based on a depiction of a story from Ovid's *Metamorphoses*. But Christianization was not a prerequisite for drawing on this source. Rembrandt also drew directly on Ovid and other classical authors in a number of paintings of the 1630s. Unlike the tale of Philemon and Baucis, these deal mainly with violence and sexual predation. Although the subjects are well known and are included in Karel van Mander's moralized Ovid in his *Schilderboeck*, Rembrandt was either the first Dutch artist to depict them or else gave his versions a twist of his own. His *Andromeda chained to the rocks* in the Mauritshuis has no redeeming Perseus; his *Diana and Callisto* in the

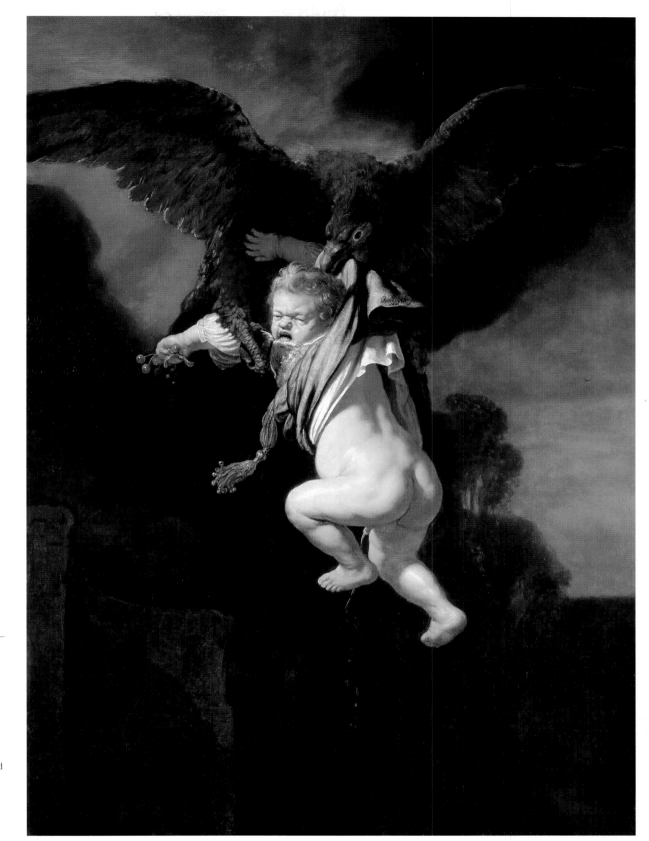

611
Rembrandt
The abduction of Ganymede
Inscribed *Rembrandt ft. 1635*
Canvas, 171 x 130 cm.
Bredius 471
Dresden, Staatliche
Kunstsammlungen,
Gemäldegalerie Alte Meister

36 Worp 1911–17, vol. 4, 1915, p. 411.
Rasch, commentary on letter 4617.
37 For the Elsheimer painting, in
Dresden, and a painting after it that
may or may not be by Goudt, see
Andrews 1977, pp. 38–39, figs. 87,
134.
38 In Schwartz 1985 a number of
theories were posed concerning
these subjects: Andromeda is related
to the constellation Andromeda in
a print by Jacques de Gheyn; rather
than Danaë, the woman in bed is
identified as Aegina. See note 43.
39 Sluijter 1986, p. 94.
40 Drossaers and Lunsingh
Scheurleer 1974–76, vol. 1, p. 184,
no. 82. This sits a bit uneasy, as the
painting of that subject in the
inventory is said to be by Jan
Lievens. However, the inventory
makes several switches of that kind.
More problematical is that it is listed
as "Een groot stuck schilderie,"
the only painting in the room that
is called large; the painting in Berlin
is not particularly large.
41 Schwartz 1985, pp. 99–102.
42 Some are mentioned in the most
recent entry on the drawing,
in Dittrich and Ketelsen 2004,
pp. 182–74, no. 102.

charms captivate Jupiter. As he was out picking cherries, the great god descended on him in the form of an eagle and carried him off to heaven, where he became cupbearer on Olympus. Rembrandt depicts the young male victim of divine rapacity as a crying, pissing baby. The variety of interpretations that have been lavished on this painting and its preparatory drawing are enough to sap one's faith in art history as a scholarly discipline.[42] What makes the variety possible is the lack of sufficient evidence to make any given interpretation

stick. If that is so, it is better to refrain for the time being from coming out for any specific explication, except to say that it is more likely than not that the painting had a symbolic or moral meaning. The urge to interpret Ovid in a Christian sense was simply too powerful for an artist to ignore. Karel van Mander devotes a full page of the *Schilder-boeck* to explanations of Ganymede, for example: "By Ganymede is intended the human soul, the being least stained by the bodily impurities of evil desire: this [being] is chosen by God

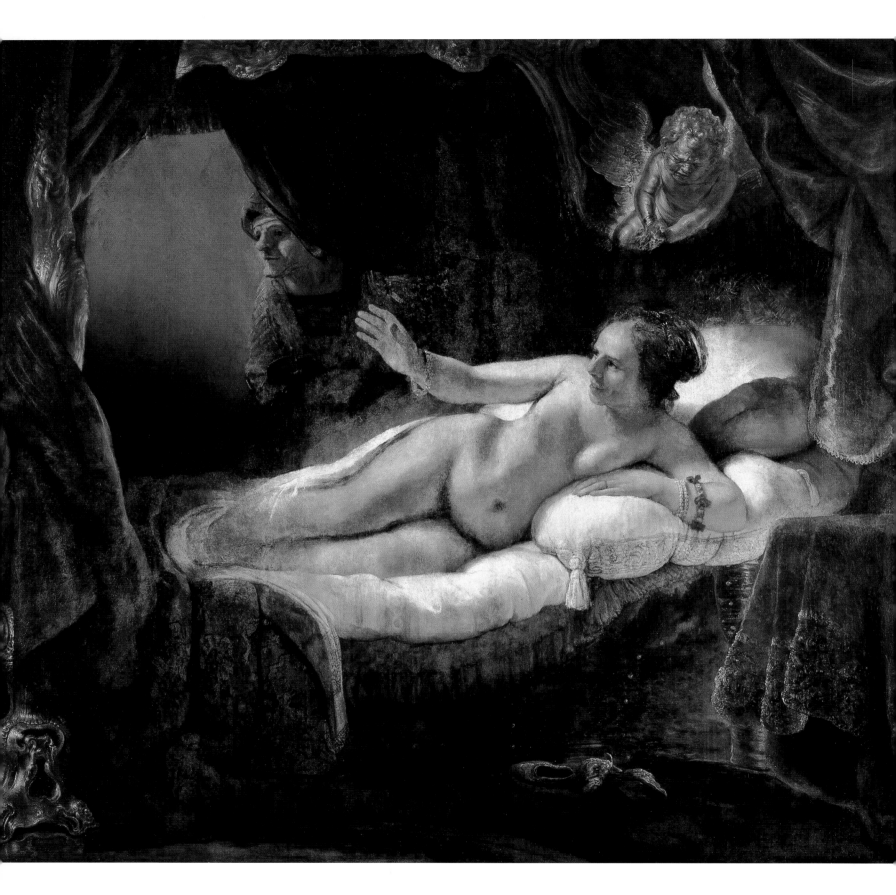

612
Rembrandt and restorers, *Danaë* [43]
Inscribed *Remb*[…] *f. 1*[..]*6*.
Interpreted as *Rembrandt f. 1636*
Canvas, 185 x 203 cm.
Bredius 474
St. Petersburg, State Hermitage Museum

The attribution of this painting to "Rembrandt and restorers" is a tribute to the honesty of the Hermitage in documenting and publicizing the damage to its great painting. In fact, nearly all of the paintings illustrated in this book and many of the drawings and etchings as well should properly be labelled Rembrandt and restorers.

and taken up to him." Rembrandt's choice for a truly innocent baby rather than a tasty teenager may be nothing more than an attempt to do justice to van Mander's characterization.

One interesting particular deserves mention. Aside from its place in the row of Ovidian abductions, the *Ganymede* belongs to another small subgroup in Rembrandt's work: paintings, etchings and drawings showing a crying child. As Rembrandtesque as the motif may be, it has a quite limited place in his work. We find it only in the years 1635 and 1636, in works in all techniques. It has been suggested that the "hout kintgen" (little child of wood) that Rembrandt bought at auction on 22 February 1635 stood model for all these works.[44] If this were a crying child, the reasoning goes, Rembrandt was so taken with it that he introduced it into two history paintings (figs. 611–12), a genre etching (fig. 472) and even a drawing, among several, that looks for all the world like a scene from real life (fig. 94). More surprising than this concentration is the subsequent disappearance of the motif. Let this serve as a reminder that at this level of detail, our information concerning Rembrandt's life and art is very fragmentary.

The most beautiful of Rembrandt's images of divine sexual predation, *Danaë*, has alas itself been victimized by an attacker. In 1985 an unbalanced Latvian nationalist slashed it twice with a knife and threw acid over it. The acid damage in particular was severe; the surface of the painting as we see it is in large part the work of Hermitage restorers and artists. The lengthy, intensively documented process, supervised by a state committee, resembled the repair campaign on the *Night watch* after it was slashed in 1975. At such junctures a famous work of art becomes more than ever an object of emotional attachment for the public and of special care for the government.

This last (until the 1650s) and largest subject from the *Metamorphoses* differs from the rest in that the human lover of the god is in love as well. The pose, gesture and smile of the nude woman speak of welcoming a lover into her bed, to her body. The form of the god is also gentler, not a bird of prey, a bull or a prince of darkness but a golden glow. Two phases of work are detected in the painting. After it was initially completed in 1636, the figure of the woman was painted over in the early 1640s.[45] The original size was also larger, with cuts on all sides. Originally, it was approximately eight by ten Rhineland feet, the size of a painting that Rembrandt sent to Huygens in January 1639, which I believe was returned by the courtier. Such a present would fit the picture that emerged above of Huygens's connection with Rembrandt's paintings of contact between mankind, God and the gods.[46]

The mythologies were a passing thing in Rembrandt's evocations of supernatural intrusion in the life of man. That is not true of the biblical themes where such things happen. All his life, Rembrandt seems to have been on the lookout for an angel or Jesus or the Lord to appear to him and change everything.

The most forceful intrusion of all, one of the most often depicted Bible stories in art and one that continues to horrify, is the near-sacrifice of Isaac. To Bob Dylan, God's demand and Abraham's response to it were so inconceivable that he fills out the story with a threat that wasn't there.

"Aw," God said to Abraham, "Kill me a son."
Abe say, "Man, you must be puttin' me on."
God say, "No." Abe say, "What?"
God say, "You can do what you want Abe, but
The next time you see me comin' you better run."
"Well," Abe say, "Where do you want this killin' done?"
God say, "Out on Highway 61."[47]

In Genesis Abraham is so unquestioningly obedient that he says no more than "Here I am." He says it twice, first to God who comes to test him by ordering the sacrifice of his son, and then to the angel who comes to stop him at the last minute. Abraham did not have to ask where God wanted the killing done. The Lord told him without his asking where it was to take place: not on Highway 61, where the blues – and Bob Dylan – were born, but on Mount Moriah, where Solomon later built the temple where the Jews practiced animal sacrifice. Not human sacrifice, as the Bible protests again and again. As in fact it protests too much, since on a hill east of Mount Moriah the same King Solomon "built a high place for Chemosh the detestable god of Moab, and for Molech the detestable god of the Ammonites." Reading between the lines of Leviticus 18 and 20 and 1 Kings 11, we understand that a Jew in Solomon's time could choose between bringing an animal sacrifice to Jehovah in Jerusalem or a human sacrifice to Molech just outside the city.

This may seem very distant from the Dutch Golden Age as we know it, with its cozy family life, children enjoying the shelter of a loving home and a society free from civil violence. Although that was all blessedly so, child sacrifice nonetheless preyed on the Dutch imagination. The stories of Isaac, telling of an aborted sacrifice, and of Jephthah, who actually did sacrifice his daughter, were a living part of Dutch culture in Rembrandt's time, in art, on the stage, on the pulpit. Both stories were painted by Lastman, along with the story of Orestes and Pylades, a tale of child sacrifice from classical antiquity, as was Iphigeneia. The Christian meaning of the theme played into this. After all, what is Christianity about if not the sacrifice by God of his only son (pp. 329–31)? Yet there is more to it than that. The theological meanings are shadowed by a dark fascination with human sacrifice. Murder, sacrifice, even cannibalism feature with surprisingly high frequency in the works of Dutch poets and artists – as, for that matter, in that of English poets of the Tudor and Stuart periods.

In 1635, Rembrandt painted a large and powerful *Angel stopping Abraham from sacrificing Isaac*, now in the Hermitage. It is based closely on a grisaille of 1612 by his master Pieter Lastman, who had died two years before, in 1633. The vertical composition,

43 In Schwartz 1985, pp. 129–30, I made a case for identifying the subject as Aegina rather than Danaë. The source to which I alluded was incorrect, as was kindly pointed out by the second reviewer of the book in *Oud Holland*: the text by Franciscus Junius in which he wrote that the inhabitants of Aegina's island, Delos, fashioned copper bedposts was not published until 1693. Since neither the Hermitage nor most of my colleagues agree with the theory and continue to call the painting *Danaë*, to avoid confusion I will confine my reference to it to this note. I continue to believe that there is something to be said for interpreting the subject as Aegina visited by Jupiter in the form of fire.

44 Bruyn 1983, pp. 52–53.

45 Bruyn et al. 1982–, vol. 3, 1989, pp. 209–23.

46 This suggestion, first advanced in Schwartz 1985, pp. 129–31, has to my mind not been taken sufficiently seriously by my colleagues, who continue to believe that the present was the somewhat smaller *Blinding of Samson*. Indeed, that painting too has ties to Huygens. Broekman 2005, pp. 40–42.

47 Bob Dylan, "Highway 61 revisited," title song to album of the same name, 1965.

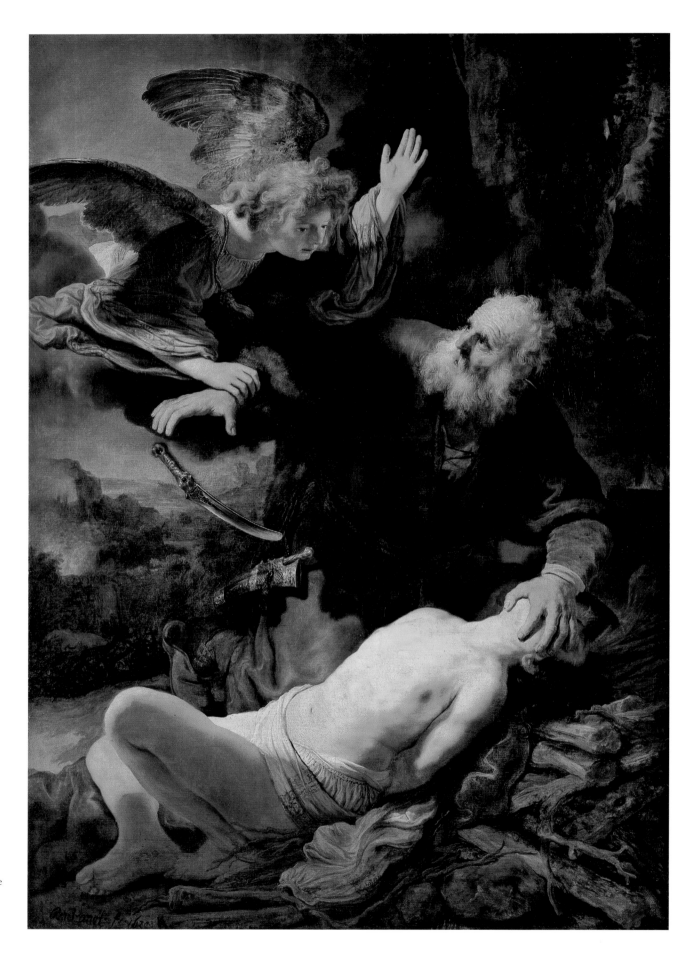

613
Rembrandt
The angel stopping Abraham
from sacrificing Isaac
Inscribed *Rembrandt f. 1635*
Canvas, 193 x 133 cm.
Bredius 498
St. Petersburg, State Hermitage
Museum

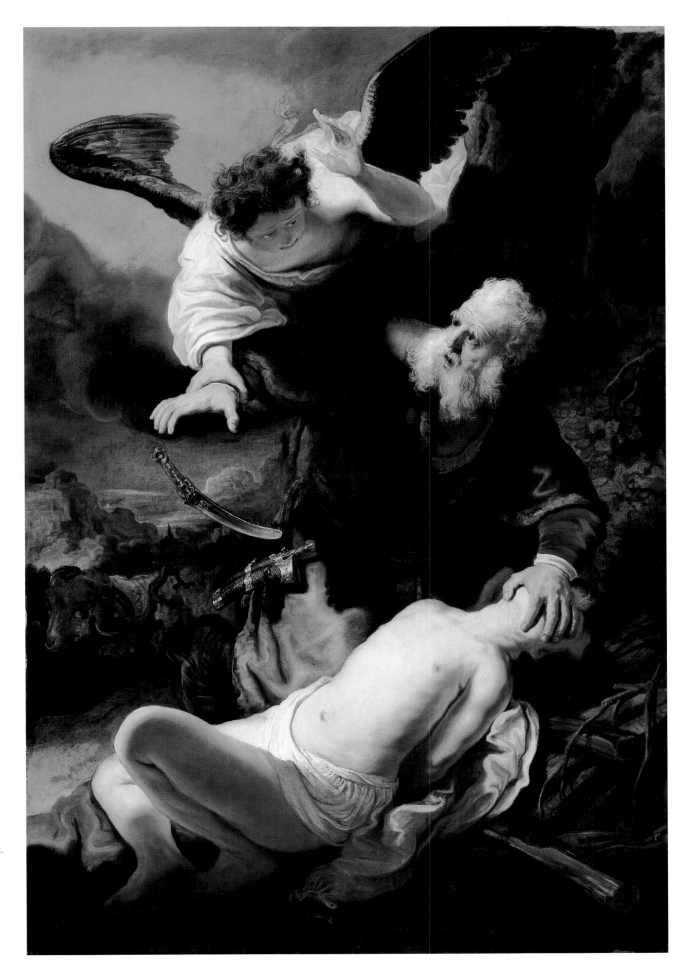

614
Rembrandt and apprentice
*The angel stopping Abraham
from sacrificing Isaac*
Unsigned. Inscribed *Rembrandt.
verandert. En over geschildert.
1636* (Rembrandt changed.
And over painted. 1636)
Canvas, 195 x 132.3 cm.
Not in Bredius
Munich, Alte Pinakothek

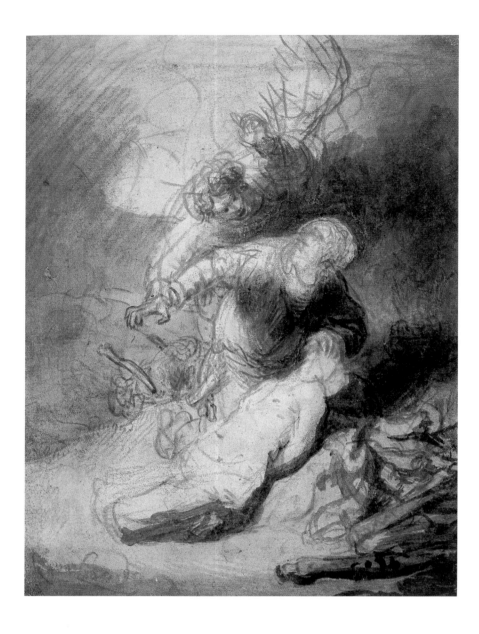

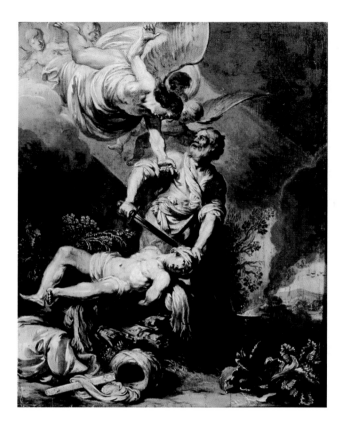

615
Rembrandt
The angel stopping Abraham from sacrificing Isaac
Unsigned, undated. Ca. 1635
Black and red chalk, wash,
19.4 x 14.6 cm.
Benesch 90
London, British Museum

616
Pieter Lastman (1583/84–1633)
The angel stopping Abraham from sacrificing Isaac
Unsigned, undated. Ca. 1612
Panel, 40 x 32 cm.
Amsterdam, Museum het Rembrandthuis (on loan from the Rijksmuseum, Amsterdam)

the setting, the types and placing of the figures are very close to each other. The main difference is that Rembrandt creates physical contact between the angel and Abraham. Beside calling out to the patriarch, the angel also seizes his wrist, causing him to drop the knife with which he was about to kill his son. Both Lastman and Rembrandt close in on the aspects of the scene that to Aristotle were the indispensable elements of tragedy, fear and pity.

In 1636 a second version of the composition emerged from Rembrandt's workshop, possibly the work of his star assistant Govert Flinck, with the unusual inscription "Rembrandt changed. And over painted." In this painting, in the Alte Pinakothek in Munich, the angel comes straight at Abraham from the depth of the picture space rather than from one side, as in the Lastman and Rembrandt's earlier version. This solution is also found in a drawing in the British Museum. The relation between the two canvases and the drawing has been debated over the years. The discussion has been enriched by the recent discovery that the Munich painting began as a faithful copy of that in St. Petersburg, and was later changed, as the inscription says.

What seems to have happened is that a copy of the St. Petersburg painting was made, Rembrandt made a drawing to suggest that it be revised, and that one of his best assistants executed the changes, perhaps with a little help from the master.[48]

This succession of images does not begin with Pieter Lastman. His composition incorporates elements of paintings by Caravaggio that Lastman could have seen in Rome, most strikingly *The angel appearing to St. Matthew* (1602) in San Luigi dei Francesi, which was put in place during the Dutch artist's stay in the Eternal City. Looking at them beside each other, the grisaille by Lastman, the drawing and painting by Rembrandt, the copy and supervised revision by Flinck beg to be viewed as an instance of what Keith Roberts, before the invention of post-modernism, called art into art. The images seem to lead one into the next, drawing themselves out of artists rather than being invented by them. The role of the artist, even an artist as great as Rembrandt, is to transmit to his heirs and audiences inherited images, stories, feelings and beliefs. He is not an innovator but a perpetuator, at most a renewer. His margins for lending individual identity to his work are narrow; even then, he does not always touch them. Personal expression is altogether beside the point. His effort, even his genius, is at the service of something bigger than himself. In these works, that something is contact with the divine in the touch of an angel.

617
Rembrandt
*The angel leaving Tobias
and his family*
Inscribed *Rembrandt f. 1637*
Panel, 68 x 52 cm.
Bredius 503
Paris, Musée du Louvre

48 Dekiert 2004. For arguments
against the assumption that the
drawing in the British Museum
was made after the painting in the
Hermitage was completed, see
Royalton-Kisch 1992, pp. 57–58,
no. 13. Constantijn Huygens's last
descendant, Susanna Louise
Huygens (1714–75), owned an
"Abraham's sacrifice powerfully and
copiously painted by Pieter Lastman"
that is thought to have belonged to
Huygens. Broekman 2005, p. 16.
49 Held 1969, pp. 104–29, p. 118.

"Throughout his career Rembrandt was fascinated by those biblical stories in which God's will was communicated to man through the visible intercession of angels. The angel's function as guide and guardian, so central to the story of Tobit, he found also in Lot's flight from Sodom, in Elijah's rest on Mount Horeb, in Joseph's dream, and in the liberation of Peter from prison. The angel as messenger and interpreter makes sudden and brief appearances in the story of Manoah's Sacrifice, Hagar in the Desert, Daniel's Vision, and the Annunciation to the Shepherds. In other incidents the angel plays an active and dramatic role, as when he stays Abraham's hand before it can slash Isaac's throat with the sacrificial knife, or wrestles with Jacob, or sword in hand, stops Balaam's ass, or sustains Christ in the Agony in the Garden." From Julius Held's lovely essay "Rembrandt and the book of Tobit."[49]

618
Rembrandt
The annunciation
Unsigned, undated. Ca. 1635
Brown ink, 14.4 x 12.4 cm.
Benesch 99
Besançon, Musée des Beaux-
Arts et d'archéologie

619
Rembrandt
*Studies of a Mater Dolorosa and
other mourners beneath the cross*
Unsigned. Inscribed *een dijvoot
thresoor dat in een fijn harte
bewaert wert tot troost harer
beleevende siel* (A devout
treasure to be preserved in
a tender heart to comfort
her compassionate soul).
Undated. Ca. 1637
Brown ink, red chalk,
20 x 14 cm.
Benesch 152
Amsterdam, Rijksmuseum

620
Rembrandt
*Peter and John at the gate
of the Temple*
Unsigned, undated. Ca. 1629
Etching, 22.1 x 16.9 cm.
Bartsch 95 i(1)
Amsterdam, Rijksmuseum

Holy people

**Protestants like Rembrandt and most people in his
milieu repudiated the cult of saints. They rejected
the idea that any mortal could mediate between
God and man. But that did not prevent them from
honoring certain fellow humans as more holy than
others. Theologians even speak of Protestant saints.
In his art, Rembrandt honored apostles, evangelists,
prophets and, especially, Mary the mother of God.**

As unquestioningly as Rembrandt and his contempo-
raries may have believed in direct intervention from
on high, they realized that it was not the main vehicle
by which God influenced mankind. In general, it was
a fellow human being, imbued with the spirit of the
Lord, who would perform the blessed deed or point
the right way.

In early Christianity, all believers in Christ formed
a communion of saints. This belief was honored in
Protestantism; H.F. Waterloos called the poor and
sick in the *Hundred-guilder print* saints because they
placed their trust in Christ. However, some humans
are saintlier than others, and this was not denied by
Protestants. The prophets of the Hebrew Bible and the
apostles of the Gospels were among the mortals who
were considered particularly holy. The church held
them up as an example to the faithful, while warning
in no uncertain terms not to confuse respect and emu-
lation, which were encouraged, with worship, which
was strictly forbidden. The answer to question thirty
of the Heidelberg Catechism makes this clear in the
plainest of terms, saying that anyone who seeks salva-
tion in "saints, themselves or anywhere else" is guilty
of denying that Christ is the only Savior.

Within the allowable margin, and occasionally going
over it, Rembrandt gladly paid respect to holy men and
women. In one of his earliest (fig. 60) and one of his lat-
est etchings (figs. 592–93), Rembrandt depicted one of
the most touching scenes in the iconography of the
saints. It is also a scene that uniquely glorifies the sense
of sight and the intense exchange of gazes. Acts of the
Apostles 3:1–7:

One day Peter and John were going up to the temple
at the time of prayer – at three in the afternoon. Now
a man crippled from birth was being carried to the
temple gate called Beautiful, where he was put every
day to beg from those going into the temple courts.
When he saw Peter and John about to enter, he asked
them for money. Peter looked straight at him, as did
John. Then Peter said, "Look at us!" So the man gave
them his attention, expecting to get something from
them. Then Peter said, "Silver or gold I do not have,
but what I have I give you. In the name of Jesus Christ
of Nazareth, walk." Taking him by the right hand,
he helped him up, and instantly the man's feet and
ankles became strong.

Normally, artists showed the miracle of the healing.
In Rembrandt's etchings, it has not yet happened.
Judging by the poses of the apostles and the speaking

621
Rembrandt
*The prophet Jeremiah mourning
the destruction of the Temple*
Inscribed *RHL 1630*
Panel, 58 x 46 cm.
Bredius 604
Amsterdam, Rijksmuseum

622
Rembrandt
The apostle Peter in prison
Inscribed *RHL 1631*
Panel, 58 x 48 cm.
Bredius 607
Jerusalem, Israel Museum,
Gift of Michael and Judy
Steinhardt, New York

gesture of St. Peter, he seems to have chosen the moment when Peter says, "Look at us." Peter's own gaze, framed by his open arms, is the focus of both compositions.

Rembrandt's highly detailed vision of the Temple court in his print of 1659 deserves comment. A few blocks from Rembrandt's house, on Vlooienburg Island, lived the Jewish scholar Jacob Judah Leon, called Templo. He owed his nickname to a remarkable achievement: the building of a scale model of the Temple in Jerusalem, based on biblical, post-biblical and modern sources. He published a book about the model as well as some gloriously illustrated broadsheets of the Tabernacle and Temple. From the early 1640s on, he showed the model in a private house museum.[50] There is however nothing in Rembrandt's circumstantial depiction of the Temple court that refers to this major enterprise in his own neighborhood. He seems to have remained in the thrall of generic Orientalism.

Narrative scenes from the lives of prophets and apostles are an exception in Rembrandt's iconography. More often, he shows them as individual figures, as in four closely related paintings from around 1630 of Jeremiah, Peter and Paul in the grip of powerful emotions.

The Temple where Peter and John cured the cripple was the Second Temple. The First Temple, the Temple of Solomon, is seen in flames in the background of a dramatic painting of Jeremiah, the prophet who

foresaw but could not prevent its destruction by the Babylonians. Jeremiah and his Book of Lamentations were felt to have topical resonance in the Dutch Republic. In 1623 an English commentary on *Lamentations* was published in Dutch translation, and in 1629 *Lamentations* itself was published in a new Dutch translation by Samuel Ampzing, a Reformed *predikant* from Haarlem. A strict Calvinist like Ampzing would have been testing his own powers of prophecy and preaching against those of Jeremiah. Could he convince his countrymen to repent of their evil ways before God allowed the Spaniards to destroy their cities?

If Jeremiah's pose, in the painting by the young Rembrandt, seems to say, "I did what I could; tragically, it was not enough," that of St. Peter evinces regret at doing the wrong thing, denying Christ in the hour of his need. In the Bible, the two moments are distinct. In Luke 22:62, Peter is said to go outside and weep bitterly. Rembrandt combines that scene with one of his brief imprisonments. In the two paintings of St. Paul[51] – who remarked in more than one epistle, "I, Paul, write this with my own hand" – the apostle is struggling with his writing, hampered in his task of bringing the divine message across. The holy men are thrown back upon their own resources. They are undergoing the opposite of divine intervention – the withdrawal of divine help.

50 Offenberg 2004.
51 In addition to the illustrated
painting in Nürnberg there is another
in Stuttgart, somewhat earlier.

The spiritual heroes of Protestantism were mainly men, but women, although they could not be preachers, were not excluded from sanctity. In the same format and same period as Jeremiah, Peter and Paul, Rembrandt also painted a saintly old woman reading in a book we take to be Scripture.[52] The figure lacks identifying attributes; she is thought to be the widowed, eighty-four-year-old prophetess Anna or a personification of Faith.[53] Whether or not she is, to a religious viewer in Rembrandt's time as in our own, she would have been seen as a "Mother in Israel." This biblical phrase, a designation of the prophetess Deborah, was applied to saintly contemporaries as well as to the matriarchs, prophetesses and heroines of the Bible.[54] It is an inspiring phrase, evoking moral courage and maternal care as well as indestructible faith.

These compositions and one of St. Anastasius, known only from copies, have about the same dimensions and there is an understandable desire to see them as a series. However, they do not add up to one iconographically or in terms of their provenance. Instead, they give evidence of Rembrandt's disinclination to make series of anything. Even when painting a similar subject in a similar format, he does not line the works up in conventional fashion.[55]

The same thwarted suggestion of a series attaches to a larger group of half-lengths of holy figures from the late 1650s and the 1660s. Between 1657 and 1661, Rembrandt created fifteen or twenty paintings of this kind. Some show Christ or the Virgin, others recognizable apostles, evangelists or saints, and yet others unidentified figures bearing signs of religious dedication.

What did these paintings mean to Rembrandt and why did he paint them at this juncture? In 2005, the National Gallery of Art in Washington, under its curator of Dutch painting, Arthur Wheelock, launched a rare full-scale attack on the problem in an exhibition entitled *Rembrandt's late religious portraits*. The emphasis in the catalogue is on the spiritual and religious meanings of the paintings in terms of Protestant theology. At the end, however, Wheelock's conclusion is honestly inconclusive: "Just how Rembrandt conceived of these paintings in relation to each other is a question that may never be fully answered …"[56]

Two aspects of the set – a more neutral term than series – have not received the attention they deserve. One is that it includes outspokenly Catholic subjects. The model for one of these paintings, showing a Franciscan monk, actually seems to be Rembrandt's son Titus. Similar habits are also worn by an older man in two other paintings.[57]

623
Rembrandt
An old woman reading, probably the prophetess Hanna
Inscribed *RHL 1631*
Panel, 60 x 48 cm.
Bredius 69
Amsterdam, Rijksmuseum

624
Rembrandt
St. Paul at his desk
Unsigned, undated. Ca. 1627
Panel, 47 x 39 cm.
Bredius 602
Nürnberg, Germanisches Nationalmuseum

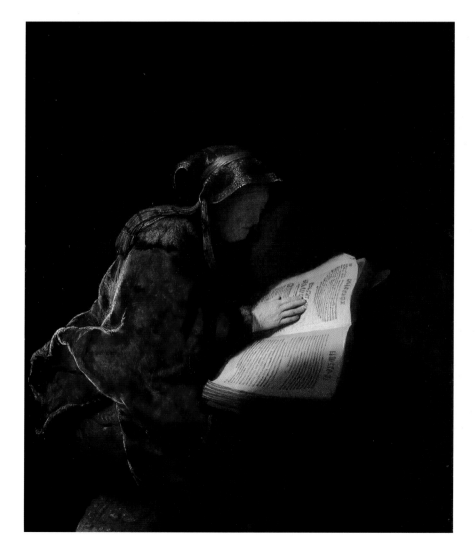

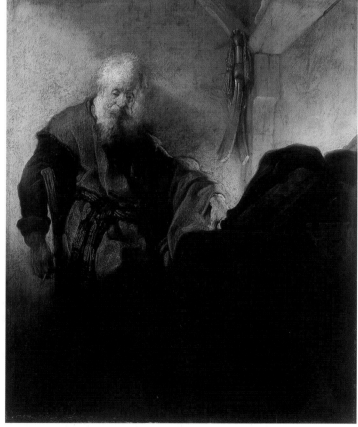

625
Rembrandt
The death of the Virgin
Inscribed *Rembrandt f. 1639*
Etching, 40.9 x 31.5 cm.
Bartsch 99 iii(3)
Haarlem, Teylers Museum

The holy human Rembrandt came closest to worshiping was the Virgin, and in this he was not alone. The Reformation dethroned her as Queen of Heaven, but maintained the exceptional status of the mother of God as a "model of faith." The Mennonites, especially the Waterland community with which Rembrandt had closest contact, cultivated a particular devotion for the Virgin.[58] The etchings by Rembrandt that clearly lift her above the mortal realm may have been inspired by Rembrandt's contacts with Waterland Mennonites such as Hendrick Uylenburgh, Cornelis Claesz. Anslo and Lieven van Coppenol.

52 The letters cannot be read. The Rijksmuseum calls them Hebrew, but since the text on the page closest to us reads from left to right, the image of the book cannot be based on a book printed in Hebrew.
53 She is also often called Rembrandt's mother, though on insufficient grounds. See above, pp. 47–50. Vogelaar and Korevaar 2005, pp. 110–13.
54 Exalto 2005, pp. 139–41.
55 See the analysis in van de Wetering 2000.
56 Wheelock 2005, p. 34.
57 Blankert 1997, pp. 154–57, offers a typically rich and acute entry on the painting.
58 Exalto 2005, p. 140.
59 Wheelock 2005, p. 126, in an entry by Peter Sutton.
60 Evenhuis 1967, vol. 2, pp. 190–91. See also the fascinating interpretations, apparently unknown to the authors of the Washington catalogue, in Hedquist 1994.
61 Evenhuis 1967, vol. 2, p. 203. Hedquist 1994, p. 22.
62 Hedquist 1994, pp. 26–27.
63 Hedquist 1994.

The place of Catholics in Dutch society is the subject of considerable misunderstanding. The Washington catalogue considers it a simple "fact that all Catholic religious orders, monasteries and clerical celibacy had been banned in Protestant Holland."[59] This is too flat a statement. The historian of Reformed Amsterdam, R.B. Evenhuis, tells us that "on 26 May 1578 [the Franciscans] were ejected from the city together with the Catholic government and several members of the regular clergy, but one of them returned to the city that very day!" In 1622, three Franciscans were given official permission to work in the city, and several more remained there without the permission of the authorities.[60] Sufferance of Catholic worship went much further. In 1656, the Calvinist clergy of Amsterdam counted no fewer than fifty-six "solemn meeting places, decorated with altars and all kinds of Popish ornaments."[61] Two of the largest of these meeting places were Franciscan establishments opposite each other on the Sint Antoniesbreestraat, where by 1652 two thousand people could attend services.[62] Rembrandt was surrounded by Catholics, and by painting his son in the guise of a monk he demonstrated personal sympathy for them. Valerie Hedquist, who wrote an excellent, little-known article on this subject, identified the garb of Titus and the older man as the habit of the Friars Minor Observant.[63]

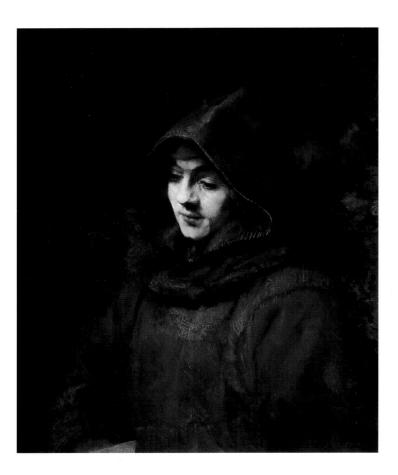

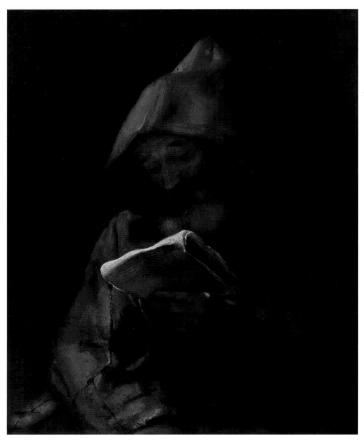

626
Rembrandt
Titus as a Franciscan monk
Inscribed *Rembrandt f. 1660*
Canvas, 79.5 x 67.5 cm.
Bredius 306
Amsterdam, Rijksmuseum

627
Rembrandt
Franciscan monk reading
Inscribed *Rembrandt f.,*
date formerly read as *1661*
Canvas, 82 x 66 cm.
Bredius 307
Helsinki, Sinebrychoff Art
Museum

64 Wheelock 2005, pp. 70–73.
This entry, by Peter Sutton,
expresses justified doubt about
the ethnicity of the model.
65 Wheelock 2005, pp. 117–19.
66 Schwartz 1985, pp. 117–18.

The explicit and dignified depiction of Catholic monks – some scholars even see them as St. Francis himself – attests to a respect for Catholics that Rembrandt does not pay to Jews. The Washington catalogue repeats the often-heard assertion that Rembrandt used a neighborhood Jew as the model for at least one of the half-lengths, though not one of the apostles or evangelists.[64] Even if this is so, which is not proven, it is still a far cry from painting Titus as a monk in a cowl. The equivalent would have been to paint himself or Titus – or even an Amsterdam Jew – wearing a well-drawn prayer shawl and phylacteries. No such image by Rembrandt is known or readily imaginable. Rembrandt's Jews, in his history paintings and prints, are the stereotype Pharisees of classical Christian iconography. When it came to holy figures such as those in the early and late sets of saints and apostles, Rembrandt avoided giving the figures the look of contemporaneous Jews.

The strong Catholic coloring of these two paintings is absent in the rest of the set, which is more generically Christian, if not Protestant. A painting of a woman with her hand on her heart, of similar format and date as the apostles and evangelists, is considered a Virgin of Sorrows with the usual attributes of that figure.[65] In her bearing, which seems to express barely endurable pain, she resembles the suffering Madonnas Rembrandt painted and drew in the 1630s. On a precious sheet in the Rijksmuseum (fig. 619), Rembrandt drew the Virgin several times, standing and sitting on the ground, with an inscription referring to a tender heart, consolation, a compassionate soul. The emotions of the Virgin, put into words here, were a shibboleth dividing Catholics from Protestants in the seventeenth century. Samuel van Hoogstraten wrote in 1678 that "we painters are accustomed, in [scenes of] the bitter Passion of Christ, to depict Mother Mary, as the one closest to the Savior, the *grootste beweeging* [the greatest emotion]," close to the words with which Rembrandt characterized his own *Entombment* and *Resurrection*. Hoogstraten is incensed that Catholics should find it inappropriate that the sorrow of the Virgin takes physical form. Rembrandt finds a powerful yet dignified way of depicting her grief, one that would satisfy Protestants without offending Catholics.[66]

The second neglected aspect of the set is that no two of the paintings in it share a common provenance, as one would expect if they had originally been delivered as a group, or even as two or three groups. Moreover, nearly all of the seventeen paintings in the 2005 exhibition first turn up outside the Netherlands, in Italy, Spain, France, Germany and England. What this suggests is that they were sold one by one abroad. That notion fits in with other known facts about the sale of Rembrandt's half-lengths while his bankruptcy was in the courts, between July 1656 and December 1660.

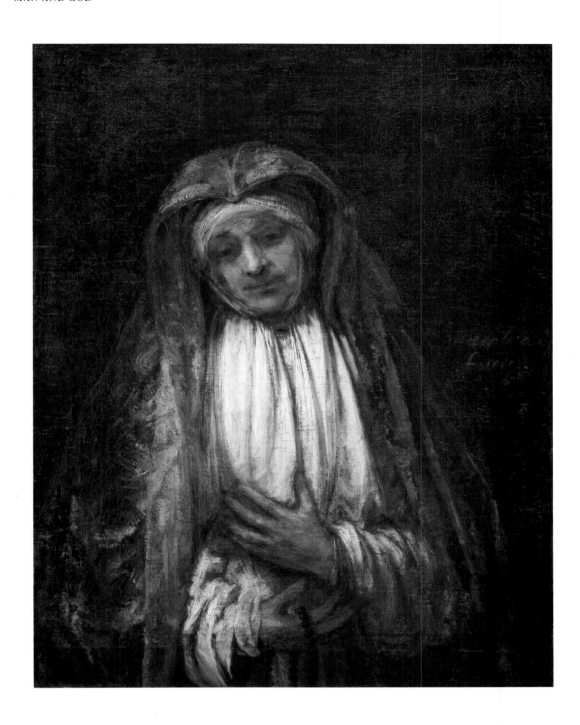

628
Rembrandt
The Virgin of Sorrows?
Inscribed *Rembrandt f. 1661*
Canvas, 107 x 81 cm.
Bredius 397
Epinal, Musée Départemental
d'Art Ancien et Contemporain

67 Schwartz 1985, pp. 314, 316, 347–48. Only one seventeenth-century owner of this group has been identified, if tentatively: the Paris banker Everhard Jabach. Wheelock 2005, p. 136, no. 11. We know Jabach as a major business associate of Gerrit Uylenburgh, who we assume was selling work by Rembrandt in these years.

All the paintings of that type and period of which we have documentation were sold to Italy via a Dutch agent. The reason Rembrandt would have preferred this tactic is not pretty. He owed money to creditors, art dealers and collectors, some of which he had agreed to pay off with works of art. In March 1659, for example, Rembrandt promised to deliver to Lodewijk van Ludick, within three years, 1200 guilders' worth of paintings. By 1661 he still had not sent him a single work. None of the new half-lengths went to van Ludick. By selling them out of the country behind his back, as I think he did, Rembrandt was able to get cash for the paintings rather than just a returned marker.[67]

This less than spiritual view of the religious half-lengths provides concrete answers to the questions raised above, questions that can otherwise only be answered with wishy-washy generalities. Rembrandt painted these works in the period concerned as a source of cash income outside his bankruptcy. He began making them within a year after he went into bankruptcy, and stopped in the months after he emerged and was once more able to sell his work legally in the Netherlands, at better prices than through the dealers, agents and brokers of the export market. The subject matter was chosen because apostles, evangelists and prophets were recognized and saleable throughout Christendom.

This disenchanting theory says nothing about the quality of the paintings, some of which are among his greatest achievements. The *Self-portrait as the apostle Paul* (see also pp. 8–9) symbolizes an artist who, like St. Paul, has transcended individuality to become all things to all men. This is especially true of Rembrandt's religious art. The inheritor of an all-pervasive tradition of Christian European art, Rembrandt reworked its great themes and iconic images with an intensity that no artist after him was ever to match. The Christianity

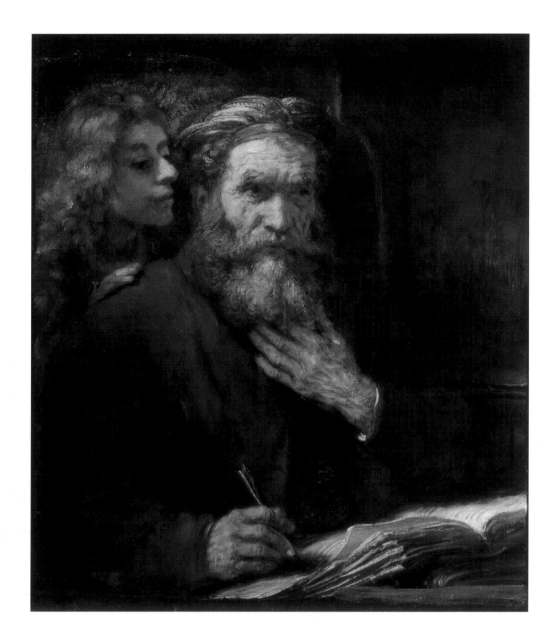

629
Rembrandt
The evangelist Matthew inspired
by an angel
Inscribed *Rembrandt f. 1661*
Canvas, 96 x 81 cm.
Bredius 614
Paris, Musée du Louvre

630
Rembrandt
Self-portrait as the apostle Paul
Inscribed *Rembrandt f. 1661*
Canvas, 91 x 77 cm.
Bredius 59
Amsterdam, Rijksmuseum

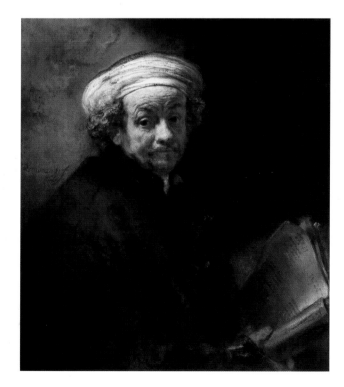

he conveyed was not institutional but confessional, a matter of personal experience rather than ecclesiastical authority. And in this painting, of all the many images he created, the person is himself. He adopts the guise of a saint who transmitted the message of Christianity to the world in speech and writing. No man of action ever did this more effectively than Paul, no artist more than Rembrandt.

Holy people represented in this book are:
Jeremiah (fig. 621)
Mothers in Israel (figs. 67, 623)
The Virgin (fig. 628)
Peter (fig. 622)
Peter and John (figs. 592–93, 620)
Peter and Paul (fig. 22)
Paul (figs. 1, 630)
Paul and Barnabas (figs. 6, 14)
Matthew (fig. 629)
Jerome (fig. 418)
St. Francis and Franciscans (figs. 154–55, 626–27)

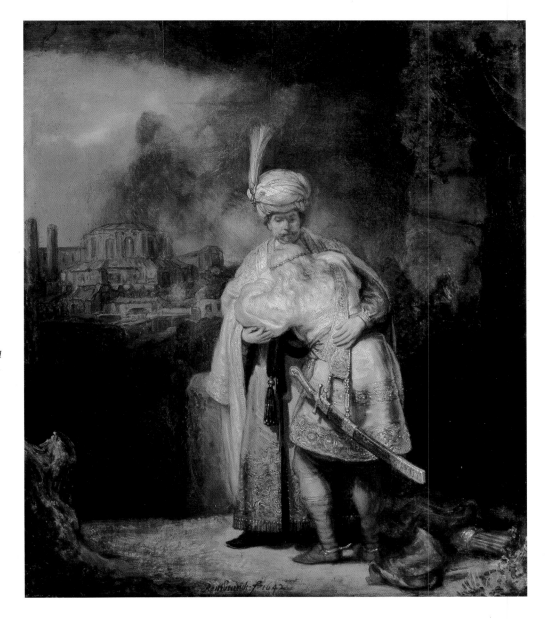

631
Rembrandt
David and Jonathan or *David and Jonathan's son Mephiboseth*
Inscribed *Rembrandt f. 1642*
Panel, 73 x 61.5 cm.
Bredius 511
St. Petersburg, State Hermitage
Museum

632
Rembrandt
David presenting the head of Goliath to King Saul
Inscribed *RH. 1627*
Panel, 26.5 x 38 cm.
Bredius 488
Basel, Öffentliche
Kunstsammlungen

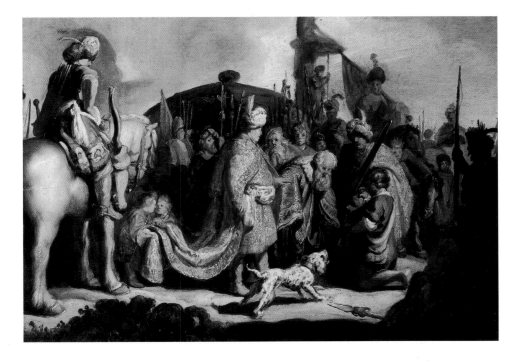

Moral examples from the Old Testament

The Jewish Bible provided Rembrandt with a number of striking themes. Some of the heroes he depicted, like David and Samson, were as famous for their weaknesses as well as their strengths. Rembrandt shows both, in keeping with popular religious writings of the time. His depictions of Joseph are less ambivalent, even when the Bible faults him. Tender relationships between fathers and sons recur again and again, particularly in his subjects from the book of Tobit.

As cautious as a Christian artist might be to stay on this side of idolatry and the cult of saints, for some critics he could never be cautious enough. That was especially true of images of holy people and of stories from the Gospels. Only two generations earlier – and across the border in the Spanish Netherlands still – such images were the object of venerations that the Reformation was invented to ban. To hold up a saint or the Virgin as a model for the good life might tempt

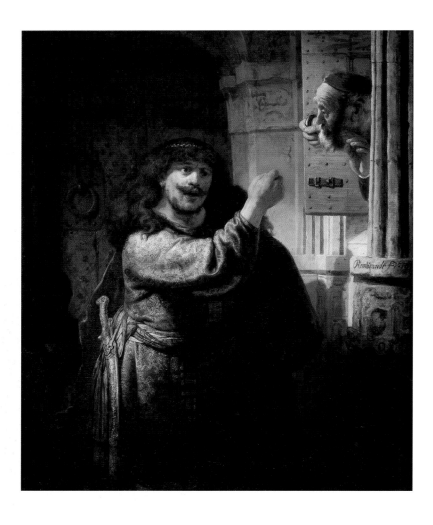

633
Rembrandt
*Samson threatening his
father-in-law*
Inscribed *Rembrandt ft. 163[5]*
Canvas, 156 x 129 cm.
Bredius 499
Berlin, Staatliche Museen,
Gemäldegalerie

68 Protestant iconoclasts were
sometimes advised to cover paint-
ings of saints in churches with stor-
ies from the Old Testament. Exalto
2005, p. 120. For other reasons for
the popularity of Old Testament
themes in the Dutch seventeenth
century, see Tümpel 1991, pp. 8–23.
69 Exalto 2005, p. 117.
70 For the proposal to rename *David
and Jonathan* as *David and Jonathan's
son Mephiboseth*, in connection with
a play by Vondel, see Schwartz 1985,
p. 224 and Schwartz 1985b.
71 Tümpel 1991, pp. 194–206.
Golahny 2003, pp. 164–79.
72 Exalto 2005, p. 39.
73 From the dedication of *Simson der
held Gods*, p. 3, to Bonifacius de
Jonge, pensionary of Zeeland.
Consulted in the copy of the
Amsterdam University Library, 1658
edition.

a pious soul to pray to them as an intercessor, and that
was anathema.

The alternative was obvious. Biblical heroes for
which no cults existed were there for the asking, in all
varieties, in the Jewish Bible. A pious Reformed artist
like Jan Victors (1619–76), whose work owes so much
to Rembrandt that he is considered a disciple if not
a pupil of the master, fell back on this solution to the
exclusion of all others. In a lengthy career as a history
painter he only painted Jewish and mythological sub-
jects. This should not be taken as a sign of special
attachment to Judaism any more than paganism.
It is a mode of hero worship that is permissible exactly
because it can never lead to excessive admiration.[68]
The Jewish Bible provided Protestants with examples
of uprightness but also of moral compromise and sheer
debasement, often in one and the same person. The Old
Testament – the word says it – was read always and only
in New Testament terms.[69]

The patriarchs Abraham and Joseph, Samson the
judge, King David, Queen Esther, pious old Tobit and
pious young Tobit from the Apocrypha: this cast of
characters provided Rembrandt with material for moral
dramas throughout his life. The nice thing about these
heroes for an artist is that, in contrast to Christian
apostles and evangelists, they committed colorful sins

and got themselves into picturesque kinds of trouble.
They provided outstanding opportunities for illustrat-
ing the ambiguity of moral choices, the difficulties of
real life.

Poets and playwrights like Abraham de Koning and
Joost van den Vondel too preferred themes from the
Old Testament, sometimes the same themes depicted
by Rembrandt. To my mind there is no doubt that
the poets and painters knew and drew inspiration
from each other's work. (See pp. 214–22.[70]) Visitors
to the theater and owners of paintings would have seen
the same theological and moral messages in works of
visual and literary art, the meanings they also heard in
church sermons.

The Bible is of course the ultimate source for
these stories and their meanings. However, it was not
the unique source. Among the few books listed by name
in Rembrandt's inventory was "A Flavius Josephus in
German, illustrated with figures by Tobias Stimmer."
Flavius Josephus was a first-century Jewish military
commander who played an ambivalent role in the revolt
of the Jews against Rome. He ended his days in Rome,
where he wrote books of Jewish history for Roman
readers. His writings were immensely popular in the
sixteenth and seventeenth centuries, and were consult-
ed by artists alongside the Bible.[71] In the illustrations
by Tobias Stimmer Rembrandt showed hardly any
interest at all.

There is another question to be answered. With all
those Old Testament sources – pictorial tradition, the
text of the Bible, plays and poems, sermons – there
was an immense number of subjects to choose from.
How did Rembrandt arrive at the subjects of his
choice? There is a fifth source, not yet addressed in the
Rembrandt literature, that provides at least a partial
answer. The very heroes that Rembrandt depicted
most often were also the favorites in the popular reli-
gious writings that ordinary Christians would read
even before the Bible.

In the first quarter of the seventeenth century, the
Zeeland *predikant* Willem Teellinck (1579–1629) pub-
lished a number of widely read books of this kind.
Among his heroes were Balaam (1611), David (1622)
and Samson (1625). He held these men up as positive
and negative examples, under the motto "de woorden
wecken/ maer d'exempelen trecken" (words incite, but
models invite).[72] The more exemplary characteristics
a hero and his stories display, however contradictory
they may be, the better. In this regard, one of the most
useful models in the Bible is Samson (Judges 13–15),
who was both phenomenally strong and uncommonly
weak. About him Teellinck wrote *Simson de held Gods,
ofte Stichtelijke verklaringhe van de wonderbare historie
van Simson der richter Israels* (Samson the hero of God,
or Moral explanation of the wondrous story of Samson
the judge of Israel).

On the bright side, Teellinck writes in the dedication
of the book, Samson "was mercifully allowed to die
in order to serve God's people."[73] This unmistakable
allusion to Christ comes straight out of the medieval

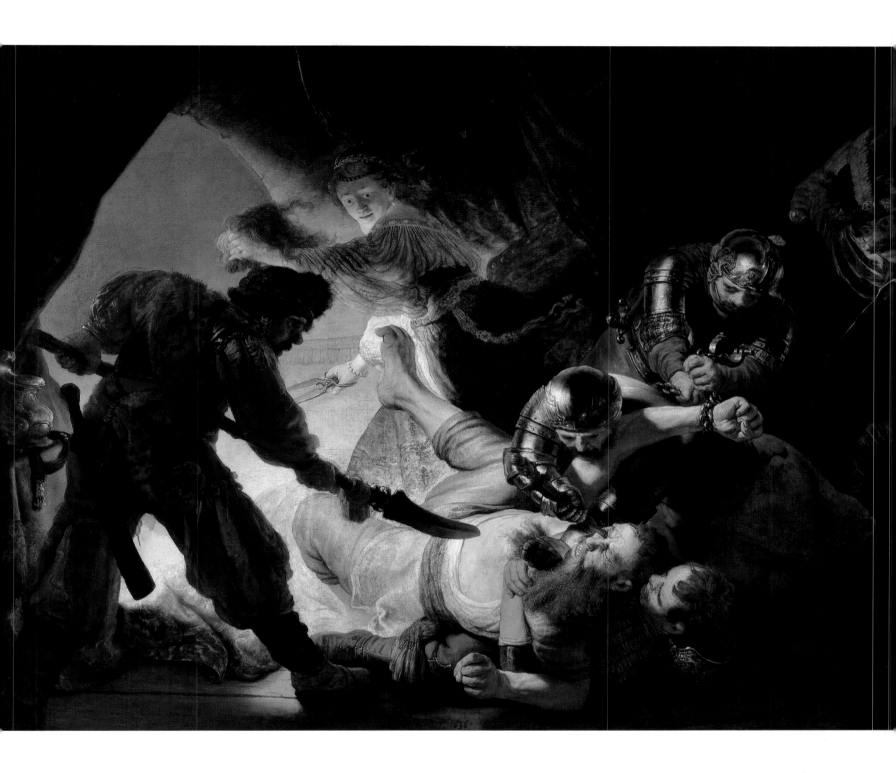

74 For the survival in modern times
of medieval habits of thought,
see Bakker 2004.

634
Rembrandt
The blinding of Samson
Inscribed *Rembrandt f. 1636*
Canvas, 236 x 302 cm.
Bredius 501
Frankfurt, Städelsches
Kunstinstitut und Städtische
Galerie

system of typology, in which stories and personages
– types – from the Old Testament were related to the
New, especially to Christ. Seventeenth-century Protest-
ants did not cast off this habit of thought. In a certain
way, they even expanded it.[74] The very concept of God's
people or Israel, as used by Teellinck, refers not to the
Jews but the members of the Reformed church.
Another powerful typological moment in the story of
Samson is the annunciation of his birth by an angel.
Samson's parents, notwithstanding the faults of their
son, were held up as a model for the Christian family.

Then there is the dark side. Samson's lack of control
over himself led to a series of sins and crimes involving
pride, lust, wrath and violence. His weakness for non-
Jewish women was his undoing. The Passion of Samson
began when he was betrayed to his enemies the
Philistines by his wife Delilah, a member of that nation.
They overpowered him in an attack that Rembrandt
rendered with nearly unbearable directness in a paint-
ing of 1636 in Frankfurt. Delilah rushes off in high
excitement, holding up the hair that she cut from the
head of her besotted husband, thereby robbing him of
his superhuman strength. An armed Philistine soldier
plunges an Oriental dagger into Samson's right eye.
To Willem Teellinck, this terrible punishment fits
Samson's crime. The hero sinned, after all, with his

357

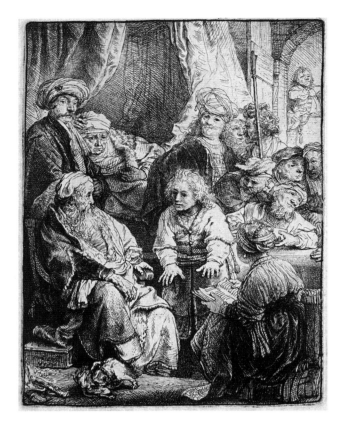

635
Rembrandt
Joseph telling his dreams
Inscribed *Rembrandt f 1638*
Etching, 11 x 8.3 cm.
Bartsch 37 ii(3)
Haarlem, Teylers Museum

75 Exalto 2005, p. 131, citing Volker Manuth.

76 Judith van Gent and Gabriël Pastoors, "Het tijdperk van de rechters," in Tümpel 1991, pp. 69–72, 81. Tümpel 1991, pp. 198–99. The authors of that excellent catalogue offer no special reason for Rembrandt's interest in these particular stories. Van Straten 2002, pp. 242–43. In Schwartz 1985 I suggested that political motives played a role in Rembrandt's Samson subjects. Those arguments still stand; they are not mutually exclusive with the present interpretations.

77 *De historie van Joseph de vromen ende godtvruchtighen jonghelinc. Allen goeden ende vromen Jongheren tot eenen spieghel ende onderwijsinghe van godtvruchtlijn| eerbaerlijc ende deuchdelijc te leven.* Copy consulted in Amsterdam University Library, 2435 E 7 (4).

78 With thanks to John Exalto for directing my attention to this note (*kanttekening*) in the Statenbijbel. For an interpretation of the painting in terms of Rembrandt's patronage, see Schwartz 1985, pp. 269–71. There I also offer an explanation for the presence of Joseph's wife, who is not mentioned in the Bible.

79 Held 1969, pp. 104–29: "Rembrandt and the book of Tobit," first published in book form in 1964, is the classic and always illuminating study of the subject.

eyes, by following his lustful gaze. In a judgment that no artist could ignore, Teellinck wrote: "The eye is a window that admits all vanity into the heart."[75] Samson was an artist's sinner and an artist's hero. Rembrandt depicted at least eight scenes from the story of Samson and his parents, including obscure incidents such as Samson's fury at his father-in-law (fig. 633) and the wedding banquet at which he posed a riddle to the guests (fig. 199). No other artist is known to have painted these scenes.[76]

A goodie-goodie biblical model with hardly a smirch on his moral escutcheon was Joseph, whose story was told in a book of 1617 as "The history of Joseph the pious and religious young man, a mirror for all good and pious young people and an education in how to live religiously, honestly and virtuously."[77]

Rembrandt went for this version of the story of Joseph, to the point of whitewashing his shortcomings. This applies particularly to the relations between Joseph and his father Jacob. In two stories that Rembrandt depicted, the Bible speaks of irritation between the two (Genesis 37:9–10).

Then he [Joseph] had another dream, and he told it to his brothers. "Listen," he said, "I had another dream, and this time the sun and moon and eleven stars were bowing down to me." When he told his father as well as his brothers, his father rebuked him and said, "What is this dream you had? Will your mother and I and your brothers actually come and bow down to the ground before you?"

In Rembrandt's etching there is no sign of rebuke on the part of Jacob or pride on that of Joseph.

For Joseph's brothers, who were jealous of him because he was Jacob's favorite, the dream was the last

straw. They sold him into slavery; he ended up in Egypt, where his better qualities helped him both to succeed and, by rejecting the sexual advances of his master's wife, to get arrested. (See pp. 276, 282.) He eventually became an important government official, allowing him to bring his family to Egypt, where they indeed bowed down on the ground before him.

When Jacob was old and sick, Joseph brought his two sons to him to be blessed. Jacob favored the youngest child, Ephraim, by placing his right hand on his head rather than on that of his older brother Manasseh. "When Joseph saw his father placing his right hand on Ephraim's head he was displeased; so he took hold of his father's hand to move it from Ephraim's head to Manasseh's head. Joseph said to him, 'No, my father, this one is the firstborn; put your right hand on his head'" (Genesis 48:17–18). Joseph's displeasure with his father was taken by some artists – Guercino, for example – as the central fact of the story, and they show him with an angry expression. Rembrandt suppresses that aspect of the theme. If anything in his work gives occasion to psychoanalytical interpretation, it would be his repeated avoidance of the show of irritation between father and son. There is however also a theological side to the matter. In the Christian interpretation, Ephraim stood for the church, the Christian. Chapter 31 of Jeremiah, with the touching verse

"Is not Ephraim my dear son,
the child in whom I delight?
Though I often speak against him,
I still remember him.
Therefore my heart yearns for him;
I have great compassion for him,"
declares the Lord.

is interpreted by translators of the States version, the approved Calvinist translation of the Bible, to refer to "the general church of elect Jews and heathens." In this reading, Manasseh is a Jew who did not belong to the elect. His rights, in the action of Jacob, were transferred to his younger brother. By giving Manasseh dark hair and Ephraim long, golden, non-Semitic locks, Rembrandt seems to endorse this message, which was also the message that Hendrick Waterloos saw in the *Hundred-guilder print.*[78]

The father and son in the book of Tobit are so close that they even share the same name.[79] (Sometimes they are both called Tobias, sometimes the father is called Tobias and the son Tobit and sometimes the other way around. Do not allow yourself to become confused.) From the early sixteenth century on, *Die historie van den ouden Tobias ende van synen sone den jonghen Tobias* (The story of the old Tobias and of his son the young Tobias) was one of the great evergreens in the education of Christian children. It provided examples for proper behavior not only on the part of a child, like Joseph, but of parents as well. Reformed theologians may have had a distinct aversion to the book, with its devils and angels and miracles (it is given a downright insulting preface in the States version, where it is called

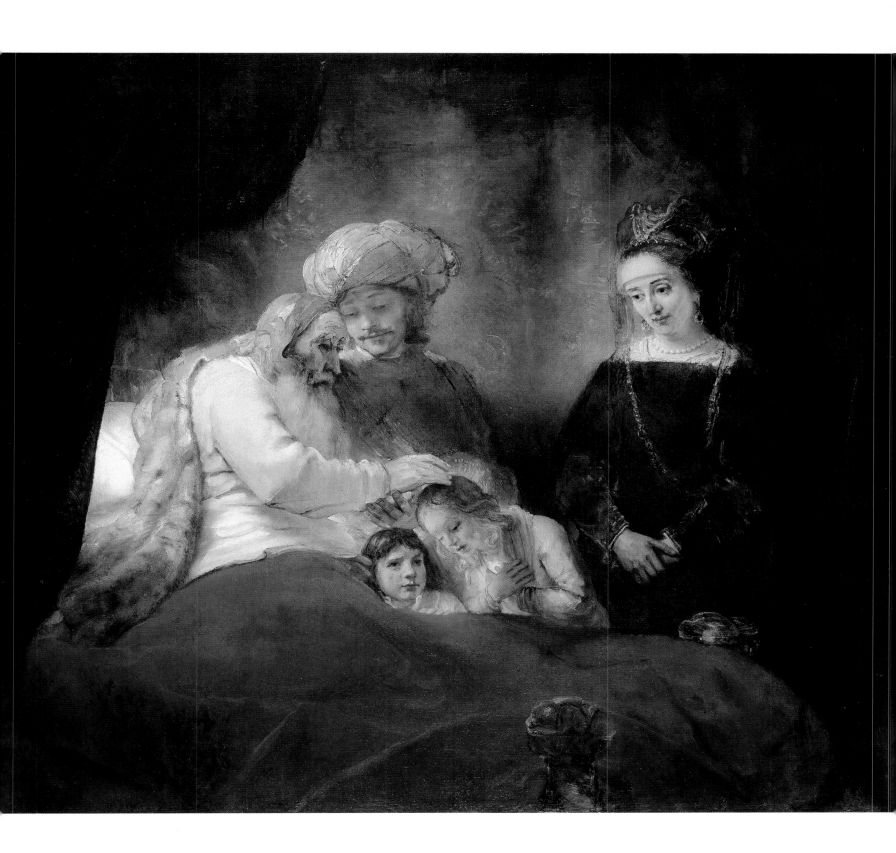

636
Rembrandt
Jacob blessing the children of Joseph
Unsigned, undated. Ca. 1656
Canvas, 175.5 x 210.5 cm.
Bredius 525
Kassel, Staatliche Museen Kassel,
Gemäldegalerie Alte Meister

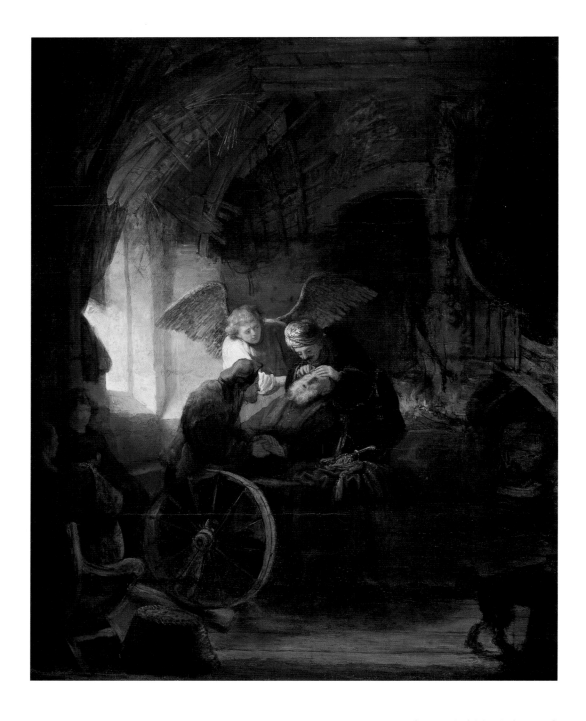

637
Rembrandt
*The young Tobit healing his
father's blindness*
Inscribed *Rembrandt f. 1636*
Panel, 48 x 39 cm.
Bredius 502
Stuttgart, Staatsgalerie

638
Rembrandt
*The young Tobit healing his
father's blindness*
Unsigned, undated. Ca. 1642
Brown ink and wash, some
white body color, 21 x 17.7 cm.
Benesch 547
Cleveland, Cleveland Museum
of Art

80 Exalto 2005, p. 119.
81 Frijhoff 1995, pp. 348–49.
82 Frijhoff 1995, p. 348, based on the
findings of John Michael Montias.
83 Exalto 2005, pp. 89–158.

a batch of "Jewish fables"), but Reformed pedagogues
were attached to the family values with which the book
is overflowing.

Die historie van den ouden Tobias ... was most often
published or bound together with popular moral texts
on Esther, Susanna, Judith or Daniel.[80] It was the kind
of reading that would appeal to a God-fearing child like
Evert Willemsz. "Evert identified with heroes from
Scripture; he visualized them the way present-day
teenagers might hang pictures of pop stars or sport
heroes on the wall of their room."[81] As grown-ups,
these children would move on to paintings of those
or similar personalities. Orthodox Reformed art collec-
tors "remained transfixed throughout the seventeenth
century by a long row of Old Testament archetypes,
in the first place Abraham, Lot, Moses, Jacob, Joseph,
Jephta, David and Tobias."[82]

Father and child relations are of great importance
in some of these stories, so no special explanation is

Table 8 — Moral examples from the Old Testament

Subject	Type	−1630	1631–40	1641–50	1651–60
Adam to Lot (figs. 551, 554)	Paintings		1		
	Etchings/Drawings		6	5	5
Abraham (figs. 57, 463, 613–15)	Paintings		4		
	Etchings		2	1	3
	Drawings		7	16	10
Isaac – Jacob – Esau (figs. 51, 134–35, 195, 536, 636)	Paintings			1	1
	Etchings				1
	Drawings	10		11	10
Joseph (figs. 455, 468, 494, 635–36)	Paintings		1		3
	Etchings		3		
	Drawings		14	5	8
Moses, other subjects from Genesis to Judges except Samson (figs. 533, 603)	Paintings		1		1
	Drawings		3	5	6
Samson and his parents (figs. 54, 199, 633–34)	Paintings	1	3		
	Drawings		7	2	6
Solomon (three drawings in the 1630s only) and David (figs. 197, 466–67, 537, 631–32)	Paintings	2	1	2	3
	Etchings				1
	Drawings		6	4	8
Kings (one painting and four drawings only) and prophets (fig. 621)	Paintings/Etchings	1	1	1	
	Drawings		4	3	9
Tobit (figs. 172, 482, 549, 617, 637–38)	Paintings	1	2	2	1
	Etchings	1		43	42
	Drawings		8	22	10
Esther and Ruth (fig. 36)	Paintings	1	2		3
	Etchings			40	
	Drawings	1	6	6	2
Daniel, Susanna, Judith (figs. 213, 448, 457–62, 534–35, 538)	Paintings/Etchings		4	2	2
	Drawings		4	4	8

Paintings
Etchings
Drawings

Table 8
Moral examples from the Old Testament

needed for the fact that they also occur in Rembrandt. Yet, following our observation of a certain consistency in the way Rembrandt played down tensions between Jacob and Joseph, it is legitimate to ask whether his preference for Tobit stories does not have the same psychological background. In particular, one is struck by the tenderness between father and son in Rembrandt's drawings and paintings of the scene in which the young Tobit, following the instructions of the archangel Raphael, heals his father's blindness.

Old Testament models did not enjoy Rembrandt's attention on an equal basis throughout life. He depicted very few in Leiden. In numbers, the 1630s are the decade of Joseph and Samson, the 1640s of the old and young Tobit, the 1650s of David, although he treated all these motifs and others in each decade. The table of occurrences above brings one surprising fact to light. After 1660 Rembrandt depicted not a single subject from the Old Testament, unless one accepts the theory that the *Jewish bride* is a painting of Isaac and Rebecca. That in itself, I believe, weakens that theory.

Rembrandt's heroes from the Jewish Bible are among the most prominent models of Christian belief of his time. They belong to the "cloud of witnesses," dead and living, that helped Dutch Protestants keep the faith.[83] Yet, Rembrandt's concentration on narrative, drama and emotion makes me doubt that he was thinking of doctrine at all. Like Willem Teellinck, he was out to rouse his audience, but unlike him Rembrandt brings about – to this member of his audience, at least – an emotional rather than a religious experience. It is part of his achievement in becoming all things to all men that, even while painting himself as St. Paul and dedicating himself so intensely to religion in art, he could also be loved by unbelievers.

The man of God: Simeon

The single theme that recurs with the greatest insistence in Rembrandt's work, decade after decade, was Simeon with the Christ child in his arms. He pondered it deeply and showed it from all sides. One of his renditions of the subject, a spare drawing in the friendship album of an Amsterdam theologian, inspired a poem on deathbed thoughts that might well have been shared by Rembrandt.

In a lifetime of depicting subjects from the Bible, Rembrandt seldom took new departures. He found inspiration enough in the range of subjects, and often in compositions and figures that had already been painted by his master Pieter Lastman.[84] Within that group, he gave preference to heroes from popular religious tracts. That makes it all the more remarkable that these rules do not apply to the single Bible story that above all others preoccupied Rembrandt from the beginning to the end of his life in art. It is a story from the infancy of Christ. The incidents in that story are many, and from them Rembrandt made decided choices (p. 319). A number of themes that were prominent in the iconography of the incarnation and nativity in sixteenth-century Netherlandish art, such as the Annunciation, the Massacre of the Innocents and the Adoration of the Magi, all painted by Lastman, find little or no place in Rembrandt's work.

The theme that so preoccupied Rembrandt was never depicted by Lastman and was not the subject of popular Protestant writings. It is described in the second chapter of the Gospel according to St. Luke and only there.

Verses 22–39 tell of Mary and Joseph bringing their month-old baby Jesus to the Temple in Jerusalem and of the things that happened there. Because paraphrasing the Bible almost invariably leads to misunderstandings, I quote here the complete text, from the New International Version:

[22] When the time of their purification according to the Law of Moses had been completed, Joseph and Mary took him [Jesus] to Jerusalem to present him to the Lord [23] (as it is written in the Law of the Lord, "Every firstborn male is to be consecrated to the Lord"), [24] and to offer a sacrifice in keeping with what is said in the Law of the Lord: "a pair of doves or two young pigeons."
[25] Now there was a man in Jerusalem called Simeon, who was righteous and devout. He was waiting for the consolation of Israel, and the Holy Spirit was upon him. [26] It had been revealed to him by the Holy Spirit that he would not die before he had seen the Lord's Christ. [27] Moved by the Spirit, he went into the temple courts. When the parents brought in the child Jesus to do for him what the custom of the Law required, [28] Simeon took him in his arms and praised God, saying:
[29] "Sovereign Lord, as you have promised, you now dismiss your servant in peace.
[30] For my eyes have seen your salvation,
[31] which you have prepared in the sight of all people,
[32] a light for revelation to the Gentiles and for glory to your people Israel."
[33] The child's father and mother marveled at what was said about him. [34] Then Simeon blessed them and said to Mary, his mother: "This child is destined to cause the falling and rising of many in Israel, and to be a sign that will be spoken against, [35] so that the thoughts of many hearts will be revealed. And a sword will pierce your own soul too."
[36] There was also a prophetess, Anna, the daughter of Phanuel, of the tribe of Asher. She was very old; she had lived with her husband seven years after her marriage, [37] and then was a widow until she was eighty-four. She never left the temple but worshiped night and day, fasting and praying. [38] Coming up to them at that very moment, she gave thanks to God and spoke about the child to all who were looking forward to the redemption of Jerusalem.
[39] When Joseph and Mary had done everything required by the Law of the Lord, they returned to Galilee to their own town of Nazareth.
[40] And the child grew and became strong; he was filled with wisdom, and the grace of God was upon him.

In iconographic terminology, this scene is usually called the Presentation in the Temple. However, that designation is incorrect. So is Luke's suggestion that the law requires a newborn male child to be presented to the Lord in the Temple in Jerusalem. There is no such requirement in Jewish law. The pertinent rituals, referred to in the notes to the States version, concern

639
Rembrandt
Simeon with the Christ child in the Temple, with an angel
Inscribed *RHL 1630*
Etching, 12 x 7.8 cm.
Bartsch 51 ii(2)
Haarlem, Teylers Museum

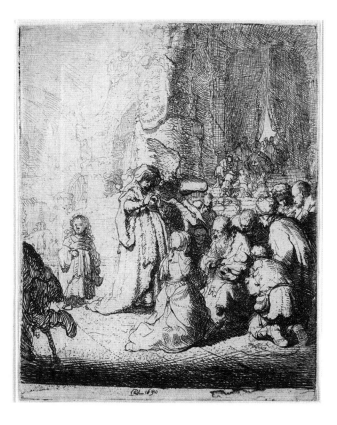

84 Bruyn 1959, p. 10.

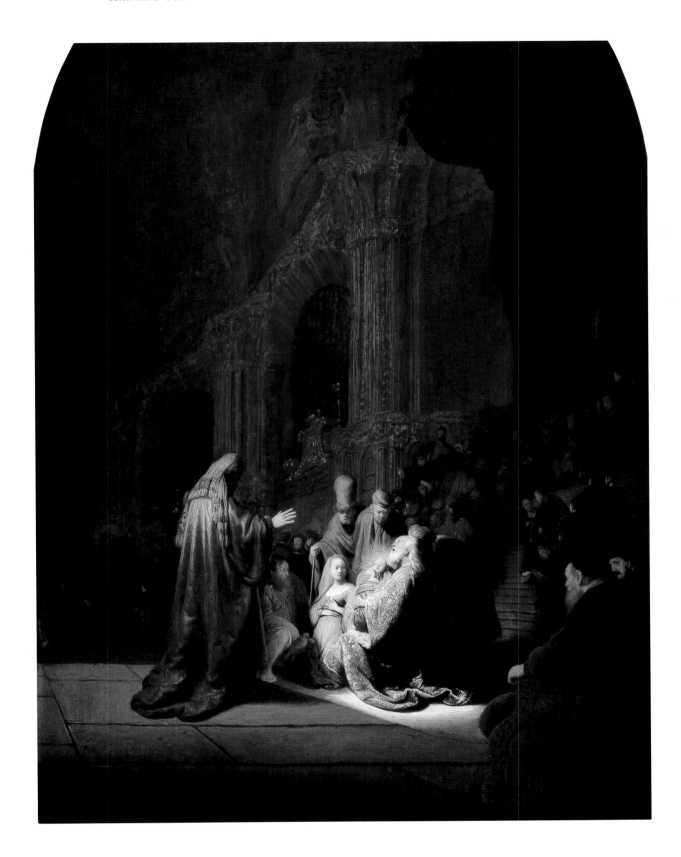

640
Rembrandt
*Simeon with the Christ child
in the Temple*
Inscribed *RHL 1631*
Panel, 61 x 48 cm.
Bredius 543
The Hague, Koninklijk Kabinet
van Schilderijen Mauritshuis

two kinds of sacrifice. One is the redemption of first-born male children at the age of one month. This is done by giving five silver shekels to a priest (Numbers 18:14–16). The other (Leviticus 12:6–7) concerns the purification of the mother, which cannot take place until thirty-three days after the delivery of a male child. (For a girl child, the term is sixty-six days.) A lamb is called for, but "if she cannot afford a lamb, she is to bring two doves or two young pigeons, one for a burnt

offering and the other for a sin offering. In this way the priest will make atonement for her, and she will be clean." Before then the mother cannot enter the Temple.

Rembrandt's interpretations – and this is true of the entire iconography of the scene in the art of his time – correspond to neither of these rituals. The presence of Mary means that we are not witnessing a redemption ceremony, while the child has no place – certainly

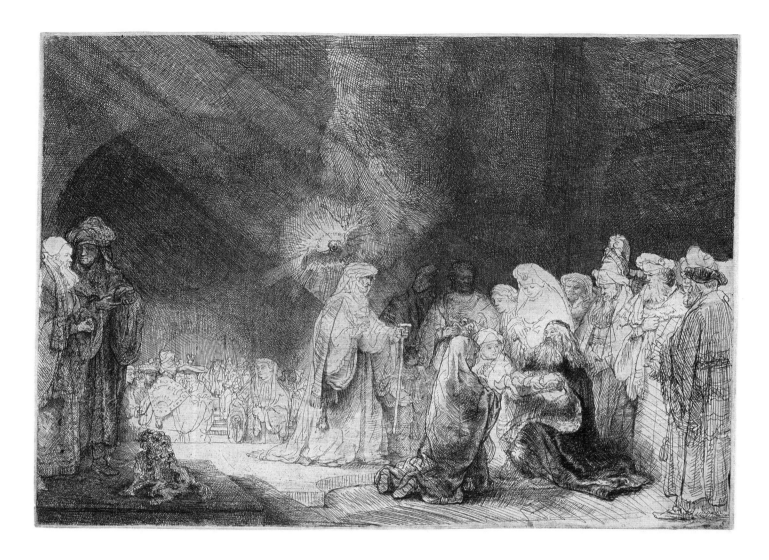

641
Rembrandt
*Simeon with the Christ child
in the Temple*
Unsigned, undated. Ca. 1639
Etching and drypoint,
21.3 x 29 cm.
Bartsch 49 ii(3)
Haarlem, Teylers Museum

642
Rembrandt
*Simeon with the Christ child
in the Temple*
Unsigned, undated. Ca. 1639
Dark brown ink, 18 x 19 cm.
Benesch 486
Amsterdam, Amsterdams
Historisch Museum

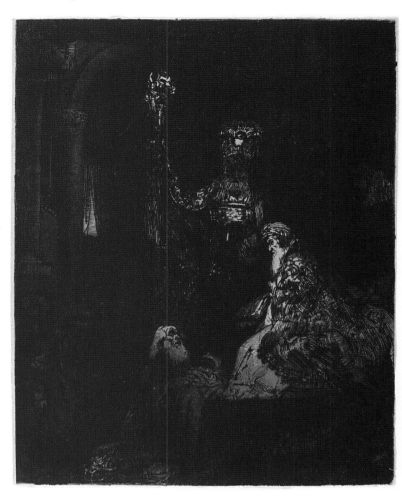

643
Rembrandt
The presentation in the Temple
Unsigned, undated. Ca. 1647
Ink and wash, some black chalk,
heightened with white,
23.8 x 20.8 cm.
Benesch 589
Paris, Musée du Louvre,
Cabinet des Dessins

644
Rembrandt
*The presentation in the Temple
in the dark manner*
Unsigned, undated. Ca. 1654
Etching and drypoint, printed
with plate tone on Japanese
paper, 21 x 16.2 cm.
Bartsch 50 i(1)
Haarlem, Teylers Museum

85 The comparison of Rembrandt's
successive representations of this
theme, especially of the etchings,
is a set piece in the literature. They
have benefited from close attention
by Wolfgang Stechow, Christopher
White, Christian Tümpel, Egbert
Haverkamp Begemann and Michael
Zell, among many others.

not the central place of the usual iconography – in the
purification sacrifice. What Rembrandt does is to bring
together a varying choice of the cast of characters in
Luke in assorted settings and styles. He sometimes adds
significant features not to be found in Luke or in earlier
art. An angel accompanies the prophetess Anna in the
etching of 1630; a priest or even the high priest is seen
in the painting of 1631, drawing of 1647 and etching of
1654.The latter also has a gigantic Temple guard tower-
ing over the priest and Simeon. In this plate the Christ
child, far from being a shining light, is mostly covered
in shade. Most remarkable of all are the additions to
the 1639 etching. Although Luke writes that Simeon
was moved by the Holy Spirit to visit the Temple,
Rembrandt never provides him with an indication that
this is taking place. In the 1639 etching, however, Anna
has a bird with an aureole above her head, while a sec-
ond bird flies into the aureole from behind. What could
Rembrandt possibly mean by this?

Twentieth-century Rembrandt scholarship, imbued
with the Modernist doctrine that less is more, praises
the master whenever possible for eliminating extrane-
ous or dispensable detail. When he does the opposite,
art historians tend to look politely the other way. Anna's
angel and birds have not been the subject of serious

study. Perhaps they do not merit heavy interpretation.
If they do not, this reflects on the other details in these
compositions as well, which are sometimes interpreted
very heavily indeed.[85]

Luke 2 and the iconographies based on it provide
material for representations of very different kinds.
An artist can bring out – I name a few possibilities
only – the personal or spiritual, metaphysical or ritual
aspects of the theme, its major place in the history
of salvation or its confrontation of old age with new
life. The artist can stress Simeon's relation to the child,
to the priest, to Mary and Joseph, to Mary alone, to the
Lord, to his prophetic vision, to the death for which he
longs. A theme I would add to these is the father–son
relationship that came up in the previous chapter.
By taking the child from his parents, Simeon assumes
a fatherly role, even performing ceremonies one
assumes were otherwise the task of Joseph. Could this
displacement of the father have formed an unconscious
attraction of the subject for Rembrandt? However that
may be, he rang the changes on the story of Simeon
in all senses sketched in above.

On 30 March 1661, a certain A.L. wrote a poem
in the friendship album of Jacobus Heyblocq (1623–90),
the headmaster of one of the two Latin schools in

645
Rembrandt
*Simeon with the Christ child
in his arms*
Inscribed *Rembrandt f. 1661*
Brown ink and wash, white
body color, 12 x 8.9 cm.
Benesch 1057
Opposite: poem on the
drawing, signed *AL* and dated
Anno 1661 den 30 maert
The Hague, Koninklijke
Bibliotheek

646
Rembrandt
*Simeon with the Christ child
in his arms*
Inscribed *Rembrandt f. 1661*
Brown ink and wash, white
body color, 12 x 8.9 cm.
Benesch 1057
The Hague, Koninklijke
Bibliotheek

86 Doc. 1661/3. Thomassen and
Gruys 1998. See the introduction,
pp. 7–35, and the entries on
pp. 69–70.
87 Cavalli-Björkman 2005,
pp. 413–16, no. 419.

Amsterdam.[86] Heyblocq's album was unusual in its
kind. Some of the contributors were indeed friends of
the owner, but more were not. His main aim was to col-
lect entries by famous and worthy contemporaries.
Another uncommon feature of Heyblocq's album is
that many of those who wrote and drew in it read the
rest of the contents first. In more than any other album
of its kind, we find cross-references. This is also the
case with the poem by A.L. He took as his subject the
entry on the opposite page, a drawing by Rembrandt
dated 1661, thus within three months of the poem,
perhaps made on the same day. Heyblocq had a degree
in theology from Leiden University and was a licensed
candidate for a ministry, a calling he preferred not to
follow.

A.L. is also thought to be a Calvinist theologian,
Arnoldus Lieranus (ca. 1637–1703). According to
a poem that Heyblocq wrote in 1658 for Lieranus's
academic disputation, the younger man was a former
pupil of his. The disputation was on divine grace,
which also informs the poem.

> Here Rembrandt shows us how old Simeon
> Takes with joy his savior and Messiah in his arms;
> And wishes now to die, because the sun of his grace
> Has appeared, who protects all people
> (trusting staunchly in him) against hell and eternal
> death:
> This teaches that the pious are not at all afraid to die,
> For the dread of the evil is a help in need for the good;
> What then, o Heyblocq, can be more comforting
> to us?

Eight years later, when death came to Rembrandt,
a painting of that subject, in the same spare mode,
was on his easel, unfinished.[87] After all the pain he
endured in the intervening years, with the early deaths
of Hendrickje and Titus, one can believe that the end
came as a help in need.

As personal as are these life-and-death issues, strictly
personal they were not. In the practice of art, as in all
spheres of life in Rembrandt's time, the border between
private and public was far more porous, and located
far deeper in the public realm, than are art and life
today. One of Rembrandt's first Simeons was made
for the court of Stadholder Frederik Hendrik and his
secretary Constantijn Huygens (fig. 176). However
assertively or reservedly they may have chosen to
exercise their influence, they had a say in the conception
and execution of the work. The last Simeon was
made for a business partner, Dirck van Cattenburgh
(1616–1704), and was probably worked on by a second
hand. It was the subject of discussion between
Rembrandt and not only the patron but also the
painters Allaert and Cornelis van Everdingen,
who talked to the artist about it in the months before
his death. The values in the painting were affected
by the opinions of Leiden theologians on the drawing
that preceded it. The etchings Rembrandt created

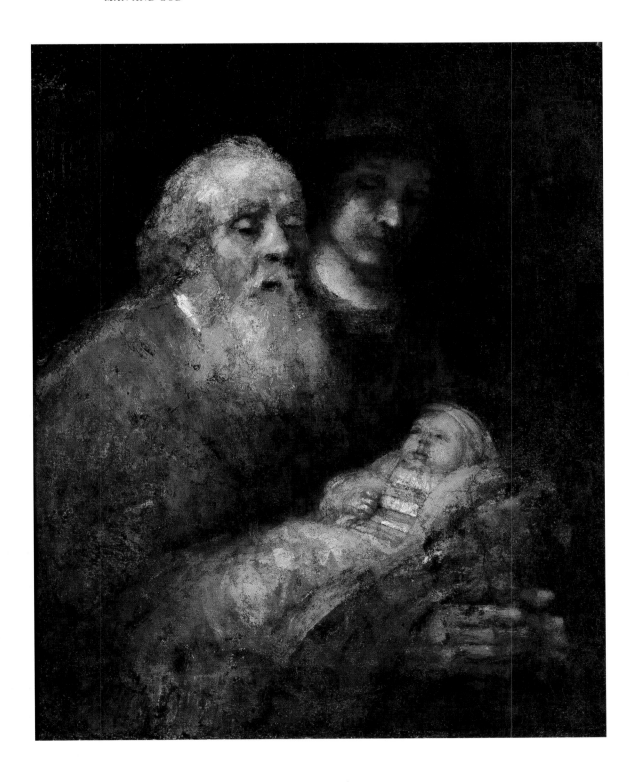

647
Rembrandt
*Simeon with the Christ child
in the Temple*
Unsigned, undated. Ca. 1669
Canvas, 99 x 78.5 cm.
Bredius 600
Stockholm, Nationalmuseum

in the intervening decades between the first and last paintings of Simeon, whatever personal feelings they may express, were not confessional statements; they were publications aimed at a wide, multi-faith international audience. It was thanks to circumstances like these that Rembrandt's art became such a prominent part of Western culture, and of our own consciousness.

Yet there came a moment when the curtain fell, and Rembrandt was alone with his mortality. Forty eventful years had passed since he first painted Simeon with the Christ child in his arms. In his early depictions of the subject, the old man's wish to die is not apparent, as it is in the final ones. Nonetheless, it is always there, an essential ingredient of Rembrandt's favorite theme from the Bible. As a comfort to us, it is good to have the

testimony of A.L., which Rembrandt was sure to know and perhaps to have incorporated in his terminal nonfinito. The story of Simeon does not teach us to yearn for death, like that tired old man himself. Rather, it tells us not to fear it, to trust it to be there when the time comes, a friend in need. In taking leave of Rembrandt, I allow myself to imagine that the last image in his mind was of his unfinished painting, the last thought Simeon's yearning for death, the last movement at the end of that vital life Rembrandt's arms closing in the blissful embrace of an infant.

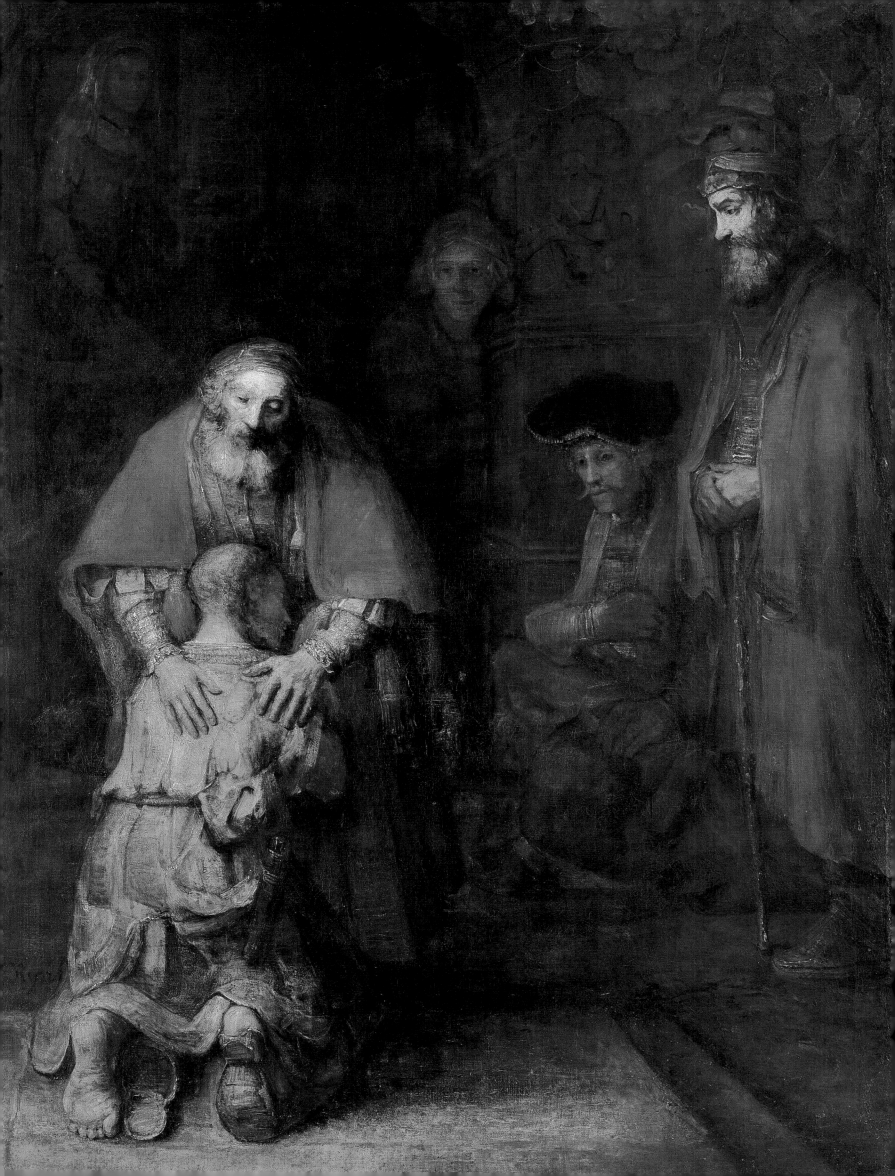

Afterlife

Rembrandt's posthumous fame was not an historical anomaly. He placed himself in the grand tradition of Western art and made good on his ambition. The various controversies that have surrounded him, concerning his social standing, relation to patrons and the uncertainties with regard to the attribution of his paintings, have only gone to bolster his reputation, which for the moment seems imperishable.

When Rembrandt died, many of the ingredients that made for an epic reputation were in place. His paintings were owned by influential collectors all over Europe. Magnificent group portraits by him hung in semi-public spaces in Amsterdam, where they went into the guidebooks. Self-portraits by the master were owned by the king of France, the Holy Roman Emperor and the grand duke of Tuscany. The export trade in precious goods from the Netherlands sustained a buoyant market in Rembrandt paintings, which in the course of the two centuries after his death were nearly all sold abroad. His etchings were even more widely distributed. Even during his lifetime they were the object of impassioned collecting, and they have remained that ever since. Print publishers continued to pull impressions from his plates until they were worn away, and even beyond that point. In other words, large stretches of the art world of Europe had a stake in perpetuating Rembrandt's reputation and price level after his death. These circumstances may be banal, but they do count. Johannes Vermeer, whose equally outstanding art was not distributed widely, remained unknown for two centuries after his death entirely for that reason.

More poetry was written about Rembrandt and his work than about any other Dutch artist of his time. He was never missing in the handbooks, especially those on the art of etching.

Perhaps most important of all, Rembrandt was an inspiration to other artists, just as he let himself be inspired by others. Three generations of disciples passed through his studio, and although not all of them continued to work in his style, it was they who established the Rembrandt look as a norm or anti-norm. Many other artists adopted or played with that look in their own work, for all time to come. They are the ones who turned Rembrandt into an icon, something that no one can do for oneself. Even uncertainty concerning attributions redounds in the end to Rembrandt's fame. This interesting phenomenon was noticed by the historian Willem Frijhoff in relation to another great icon, the theologian Thomas à Kempis (1380–1472).

> He was known mainly for his spiritual writings, most of all for the one of which his authorship is not firmly established…: The imitation of Christ. This is only an apparent paradox, since uncertainty of this kind is inherent in iconic functions: as a result of the battle concerning authorship and the search for intimate ties between the author and the text, the person is bound far closer to the text than in the case of a signed writing.[1]

Applying these words to Rembrandt, we have seen the same thing happen in the public debates about the attribution of *Saul and David* in the Mauritshuis, *The Polish rider* in the Frick Collection in New York, which is probably by Rembrandt, and the *Man with the golden helmet* in Berlin, which is probably not. The heated disputes on these paintings indeed heightened the profile of the artist among the participants and their readers.

The effect of these factors can be reduced to a happy cliché: if in the 1650s Rembrandt's finances were a disaster waiting to happen, when he died his future glory was a blessing waiting to transpire.

Needless to say, the full effect of these benefits was not felt equally at all periods. The ebb and flow of taste are only part of the story. There were also weaknesses in Rembrandt's case and counterforces working against his reputation. These issues too date from the start of his career. "Sed ante tempus" – but that is premature: the first written record of praise for Rembrandt's work, by Arnoldus Buchelius (p. 143), is qualified praise. Many admirers of Rembrandt were critical of one or another aspect of his art. Some complained about his questionable taste, others about his excessive naturalism, the ugliness of his nudes, his undisciplined technique. These and other negative attitudes kicked in from time to time in the ensuing centuries.

Rembrandt's personality, it must be said, was also quite a problem. Few artists' biographers had anything nice to say about him as a person. In 1686, Filippo Baldinucci wrote that Rembrandt "era un umorista di prima classe, e tutti disprezzava" (he was a first-class crank and he looked down on everyone). Arnold Houbraken, the pupil of a pupil, who preferred to say nice things about fellow artists when he could, told somewhat derisive anecdotes about Rembrandt, especially about his love of money. As later authors copied and embroidered on his remarks, Rembrandt came out looking worse all the time.

Certain historical circumstances worked against him as well. Rembrandt's scale of artistic values was defined in the 1620s, when the grand tradition of European art was still dominant. He measured himself against giants like Titian and Rubens on their own terrain of sacred history, landscape and portraiture. After 1650 a radical shift occurred in Dutch painting. The future lay with genre painting, city views, allegories, wall and ceiling decorations, not grand but petit specialties that Rembrandt did not practice. He was still admired greatly as a hero of the old school, but that is not where

648
Rembrandt
Return of the prodigal son
Unsigned, undated. Ca. 1662
Canvas, 262 x 206 cm.
Bredius 598
St. Petersburg, Hermitage

1 Frijhoff 1998, p. 74. "Hij werd vooral bekend door zijn geestelijke geschriften, en wel het meest door dat waarvan zijn auteurschap niet onomstotelijk vaststaat doch slechts bij traditie is overgeleverd: de *Navolging van Christus*. Hierin ligt slechts een schijnbare paradox, want zo'n onzekerheid is eigen aan iconische functies: door de strijd om het auteurschap en het zoeken naar intieme banden tussen auteur en tekst wordt de persoon veel nauwer aan het werk vastgemaakt dan bij een gesigneerd geschrift het geval zou zijn geweest."

new talents were looking for inspiration. Even in the field of history painting things changed. The new ascendancy of French academicism led to a preference for values like clarity of drawing and decorum, values for which Rembrandt was more a negative than a positive model. This weakened but never destroyed his appeal. The etchings held up through thick and thin.

The great shift for the better in the appreciation for Rembrandt that took place in the nineteenth century had a different background in different countries. A German Rembrandt was born out of G.W.F. Hegel's (1770–1831) view of national destinies. Dutch art of the seventeenth century, he wrote, was the herald of European emancipation in the nineteenth. It marked the moment when art freed itself from the shackles of church and state and turned to life itself and art itself. Rembrandt marched at the head of the troop. A certain possessiveness took hold of the Germans with regard to Rembrandt, a feeling that he was actually one of them. This led to nasty excesses before and during the Nazi period, but it also contributed to making Rembrandt studies a premier specialization for German art historians in the century when the Germans led the field.

Rembrandt's lesson for the French was more political than philosophical. For the first half of the nineteenth century, the image of Rembrandt was largely defined by a stage play that was first performed in 1800 and republished in 1846: "Rembrandt, ou la vente après décès" (Rembrandt, or the posthumous sale). The plot embellishes on Rembrandt's reputation for money-grubbing and turns him into a complete finagler. For the writers of the play, however, Rembrandt was more than a figure of fun. He was a symbol for the writer who is disdained during his lifetime and only honored after his death. "This vaudeville comic opera introduced Rembrandt to the French public as the paragon of the misunderstood and unappreciated artist."[2] On the eve of Romanticism and *La vie de Bohème* this was not a bad reputation for an artist.

As the revolutionary year 1848 approached, it was a short step to enlisting Rembrandt in the fight against the establishment. Critics like Charles Blanc (1813–82), Edgar Quinet (1803–75) and Théophile Thoré (1807–69), Alison McQueen has written, "were particularly attracted to Rembrandt because they believed he embodied the anti-Catholic, anti-monarchic, pro-democratic and pro-republican sentiments they wanted to promote in their own country," that he was a populist and a reformer.[3]

The great Dutch sellout of Rembrandt paintings provided the galleries of St. Petersburg, Berlin, Munich, Kassel, Paris and London with some of the glorious staples of their collections, alongside overoptimistic attributions that never seemed to harm the artist's repute. The first outbreak of demonstrative love for Rembrandt in the Netherlands was incited by nationalistic competition with Belgium, which broke away from the Kingdom of the Netherlands in 1830 and promptly adopted Rubens as its main national hero. The Dutch responded by dusting off Rembrandt, polishing up his

reputation in reaction to *La vente après décès* and erecting a statue to him in Amsterdam in 1853. A more substantial tribute was the founding in 1883 of the Rembrandt Society, devoted to keeping important art in the country or, as in the case of Rembrandt, buying it back. The competition for Rembrandt paintings over the next hundred years between the Dutch and the Americans enlivened the scene and stimulated Rembrandt studies in both countries.[4]

Over and above study, Rembrandt has claimed a place in the emotions and imaginations of countless people all over the world. This effect is particularly strong in Russia, where the Dutch artist has been taken up in the Russian soul. The head of the department of Dutch painting at the Hermitage, Irina Sokolova, has spoken and written eloquently on this subject.[5] One of the most famous poems in modern Russian literature, Ossip Mandelstam's "One red word" (1937), she writes, begins:

Like Rembrandt, martyr of chiaroscuro,

I've disappeared deep into the dimming times. According to the poet's widow Nadezhda, the image in the poem "I shall abandon the land – raspberry caress – which magically colors the gesture of touch" was a recollection of the color of the father's clothing in Rembrandt's *Return of the prodigal son* in the Hermitage (fig. 648). Sokolova goes on:

The stormy and tragic history of Russian culture in the twentieth century transformed Rembrandt's *Return of the prodigal son* into a deeply symbolic work, turning it from a biblical scene into a symbol of the end of earthly sufferings. One confirmation of this is to be found in the recollections of the historian Nikolay Antsiferov (1889–1958), author of the renowned book *The soul of St Petersburg*. An outstanding scholar passionately devoted to the Italian Renaissance, he was arrested in the early 1930s and spent five years in the camps on the Solovetsky Islands. Years later he was allowed to return to Leningrad. This is how he describes his return to his native city: "We arrived so early that the trams were still not running. With sacks over our shoulders we set off to the Grevses [the family of an old university professor, Antsiferov's tutor]. Ivan Mikhaylovich opened the door and embraced me. And at that moment I recalled Rembrandt's *Prodigal son*. Here was I, exhausted by a long journey of almost five years, kneeling before him, and he lovingly placed his hands upon me." Thus Rembrandt's painting entered not only the artistic consciousness but the whole Russian outlook in the twentieth century.

In this way, Rembrandt became a national treasure for many nations and an indestructible icon of Western culture. Really indestructible? That is not a word that an historian should use. But I am willing to bet that Rembrandt's five-hundredth birthday in 2106 will be celebrated even more lavishly than the four-hundredth, which sparked the writing and publication of the present book.

649
Photograph, ca. 1885, of the gallery of honor of the Rijksmuseum, from the main hall to the *Night watch* room.

The resemblance to a church, with the *Night watch* as altarpiece, was intended.

2 McQueen 2003, pp. 47–53.
3 McQueen 2003, p. 109.
4 See Scallen 2004 for an excellent reconstruction of the relations of scholarship, connoisseurship and the market.
5 Text first spoken at the CODART TWEE congress in Amsterdam, 14–16 March 1999. Sokolova 2005. Published in French as "Rembrandt dans le miroir de la culture russe," in Sokolova et al. 2003, pp. 64–79. For an extraordinary spiritual animation of the *Return of the prodigal son*, see Nouwen 1992.

Rembrandt as a Christian rhetorician of the brush

There can be no neat summary of the content of this book any more than of Rembrandt's life and work. In each of the nearly one hundred sections, most of them provided with a brief précis, I have tried to find the right examples to illustrate the point being made and to put into a few words the most appropriate things to say about them. It was my aim in nearly each section to add something new to the existing store of knowledge and ideas about Rembrandt.

Yet there is one theme that does need to be rounded off. At the start of the book, I singled out the *Self-portrait as the apostle Paul* as an emblem for this book, writing that in it, "the artist's first-person depictions are … not lined up one after the other in isolation. They are juxtaposed with portraits, heads and figures of others. I regard Rembrandt's self-portraits less as assertions of a strong personal identity than as a means to help the artist, like St. Paul, become more like other people."

Those comparisons have now been made, and they reveal a wide assortment of Rembrandts. He created images of himself in the guise of or closely related to:

the poet Ludovico Ariosto (pp. 214–15),

military men (p. 195),

the artists Lucas van Leyden (p. 25),

cavaliers (pp. 34–35),

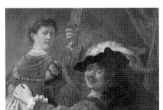 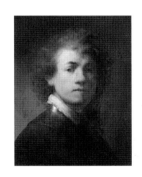

and **Peter Paul Rubens** (p. 152);

 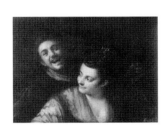

settled burghers (p. 198),

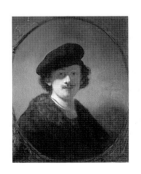

official personages (p. 208),

even a **great industrialist** (pp. 210–11).

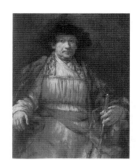

In early history paintings, not later ones, he assumed the guises of **participants in a martyrdom** (p. 146),

an **historical scene** (p. 147),

the **Crucifixion itself, as Christ** (p. 289),

and a **mortal helper** (p. 154).

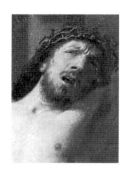

In non-portrait etchings, Rembrandt lent his own features to **exotic personages** (p. 197),

character types (p. 289)

and **beggars** (p. 289).

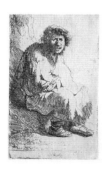

Some of the later self-portraits breathe the same spirit as the meditative old people he painted, creations of a Rembrandt Robert Hughes has called "the supreme depictor of inwardness, of human thought."[1]

pp. 312–13

Svetlana Alpers has studied some of these images, concluding that "when Rembrandt makes repeated self-portraits, he is … pursuing, attending to, and presenting himself as a model in the theatrical mode."[2] The theater of which she speaks is the artist's own studio, where the master and his pupils live the parts they paint. Samuel van Hoogstraten describes a practice of this kind in his own studio, which Alpers assumes quite reasonably he learned from Rembrandt.

What we find in Rembrandt goes beyond this, however. In many self-portraits he establishes ties to other individuals, other values than those of emotion or dramatic persuasion. It embraces but also goes beyond empathy and bonding. Rembrandt works with his appearance in different ways from what is usually understood by self-portraiture. As I hope to have shown in the course of the book, the pictures of the artist that are usually isolated and illustrated as if they were an autobiography in images, derive their meaning not from each other but from the entire range of interests by which Rembrandt lived and worked. I do not know of another artist of any period who with perfect seriousness molded his features into identities as diverse as these. From the very start, he developed the habit of gazing into the mirror, seeing there not only Rembrandt van Rijn but also reflections of others. Other human beings, from his richest patrons to his humblest models, other kinds of beings than humans: biblical personages and Christ himself. By the same token, when looking at others, he also saw something of himself.

This mode of working is closely related to a discipline recommended by the ancient rhetorician Quintilian and embraced wholeheartedly by a modern one, Constantijn Huygens. In a Latin poem on his life, written when he was eighty-two years old, Huygens says this about how he practiced speaking in Latin:

I defended the innocent, took the helpless under my protection, pilloried lawbreakers and mercilessly attacked crime while also holding eloquent eulogies and festive speeches in which I showered baskets full of violets and lilies, always assuming a different role whenever, upon authority of Quintilian, I changed personality like Proteus, in order to bolster my young spirit in all possible arenas.[3]

If Rembrandt, as I believe, was a rhetorician of the brush, he was a Christian one. Once more, I return to the figure with whom Rembrandt identified himself most unambiguously, St. Paul, the saint who said "Though I am free and belong to no man, I make myself a slave to everyone…. I have become all things to all

p. 354

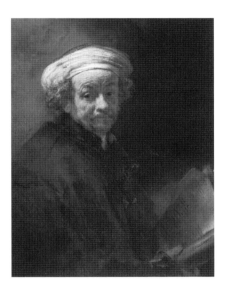

men." The saint does not exploit or flaunt his freedom. He offers it to his fellow beings in the name of God. Rembrandt's use of himself in art too, I feel, entailed sacrifice, in a form and measure that would not be brought by an artist who was a professional and a professional only. This applied not only to his appearance and not only to the hundred or so creations showing his features. In all his work, Rembrandt dispensed, even relinquished parts of himself to those around him, to become more like them, and to us, to become more like us.

1 Hughes 2006, p. 10.
2 Alpers 1988, p. 39.
3 Huygens 2003a, vol. 1, p. 71.

References

References to entries on Rembrandt documents in Walter Strauss and Marjon van der Meulen, *The Rembrandt documents*, New York (Abaris) 1979, are abbreviated as Doc. or Docs., with the number of the document.

Ackley 2003 Clifford S. Ackley et al., exhib. cat. *Rembrandt's journey: painter, draftsman, etcher*, Boston (MFA Publications) 2003

Adams 1997 Ann Jensen Adams, "The three-quarter length life-sized portrait in seventeenth-century Holland: the cultural functions of 'Tranquillitas,'" in: *Looking at seventeenth-century Dutch art: realism reconsidered*, ed. Wayne Franits, Cambridge et al. (Cambridge University Press) 1997, pp. 158–74, notes pp. 234–38

Ainsworth et al. 1982 Maryan Wynn Ainsworth et al., *Art and autoradiography: insights into the genesis of paintings by Rembrandt, Van Dyck, and Vermeer*, New York (Metropolitan Museum of Art) 1982

Alexander-Knotter 1999 Mirjam Alexander-Knotter, "An ingenious device: Rembrandt's use of Hebrew inscriptions," *Studia Rosenthaliana* 33 (1999), pp. 131–59

Alpers 1988 Svetlana Alpers, *Rembrandt's enterprise: the studio and the market*, Chicago and London (University of Chicago Press) 1988

Andrews 1977 Keith Andrews, *Adam Elsheimer: paintings, drawings, prints*, Oxford (Phaidon) 1977

Angel 1642 Philips Angel, *Lof der schilder-konst*, Leiden (Willem Christiaens) 1642. Reprint Utrecht (DAVACO) 1969 and other reprints

de Baar 1992 P.J.M. de Baar, *De Leidse verwanten van Rembrandt van Rijn en hun Leidse afstammelingen tot heden*, 2nd improved edition, Leiden (Gemeentearchief Leiden) 1992

Bakker et al. 1993 Boudewijn Bakker, Huigen Leeflang et al., *Nederland naar 't leven: landschapsprenten uit de Gouden Eeuw*, Amsterdam (Rembrandthuis) 1993

Bakker et al. 1998 Boudewijn Bakker, Mària van Berge-Gerbaud, Erik Schmitz and Jan Peeters, *Landscapes of Rembrandt: his favorite walks*, Bussum (Thoth), Amsterdam (Gemeentearchief) and Paris (Fondation Custodia) 1998

Bakker 2004 Boudewijn Bakker, *Landschap en wereldbeeld van van Eyck tot Rembrandt*, Bussum (Thoth) 2004

Bangs 1977 Jeremy Dupertuis Bangs, *Church art and architecture in the Low Countries before 1566*, Sixteenth Century Essays and Studies, vol. 37, Kirksville, Missouri (Sixteenth Century Journal Publishers) 1997

Barbour 1963 Violet Barbour, *Capitalism in Amsterdam in the seventeenth century*, Ann Arbor (University of Michigan) 1963; first edition 1950

Beijer et al. 1991 T. Beijer et al., *Nicolaes Tulp: leven en werk van een Amsterdams geneesheer en magistraat*, Amsterdam (Six Art Promotion) 1991

Benesch 1973 Otto Benesch, *The drawings of Rembrandt*, enlarged and edited by Eva Benesch, London (Phaidon) 1973, 6 vols. First edition London (Phaidon) 1954–57

van Berge 1997 Mària van Berge-Gerbaud, *Rembrandt en zijn school: tekeningen uit de collectie Frits Lugt*, Paris (Fondation Custodia) and Haarlem (Teylers Museum) 1997. French edition: *Rembrandt et son école: dessins de la Collection Frits Lugt*

Berger 2000 Harry Berger, Jr., *Fictions of the pose: Rembrandt against the Italian Renaissance*, Stanford (Stanford University Press) 2000

Bergvelt et al. 2004 Ellinoor Bergvelt et al., exhib. cat. *De Hollandse meesters van een Amsterdamse bankier: de verzameling Adriaan van der Hoop (1778–1854)*, Amsterdam (Amsterdams Historisch Museum and Rijksmuseum) and Zwolle (Waanders) 2004

Bevers et al. 1991 Holm Bevers, Peter Schatborn and Barbara Welzel, exhib. cat. *Rembrandt: de meester en zijn werkplaats: tekeningen en etsen*, Amsterdam (Rijksmuseum) and Zwolle (Waanders) 1991

Bijl 2005 Martin Bijl, "The portrait of Theodorus Schrevelius," in van den Doel et al. 2005, pp. 47–55

Blankert 1982 Albert Blankert, *Ferdinand Bol (1616–1680), Rembrandt's pupil*, Doornspijk (Davaco) 1982

Blankert 1997 Albert Blankert et al., exhib. cat. *Rembrandt: a genius and his impact*, Melbourne (National Gallery of Victoria) et al. 1997

Blankert et al. 1983 Albert Blankert, Ben Broos et al., exhib. cat. *Rembrandt: a genius and his impact*, Amsterdam (Waterman) 1983

Blom et al. 1995 J.C.H. (Hans) Blom, *Geschiedenis van de joden in Nederland*, Amsterdam (Balans) 1995

Bober 1981 Harry Bober, *Jan van Vliet's Book of crafts and trades: with a reappraisal of his etchings*, Albany (Early American Industries Association) 1981

Bomford et al. 1988 David Bomford, Christopher Brown and Ashok Roy, exhib. cat. *Art in the making: Rembrandt*, London (National Gallery) 1988–89

van den Boogert 1999 Bob van den Boogert, Charles Dumas et al., *Goethe & Rembrandt: tekeningen uit Weimar*, Amsterdam (Rembrandthuis and Amsterdam University Press) 1999

Boxer 1965 C.R. (Charles) Boxer, *The Dutch seaborne empire, 1600–1800*, London (Hutchinson) 1965

Brandt 1704 G. [Geeraard] Brandt, *Historie der reformatie en andre kerkelyke geschiedenissen*, 4 vols., [various cities and publishers], 1671–1704

Bredius-Gerson 1969 Abraham Bredius, *Rembrandt: the complete edition of the paintings*, revised by Horst Gerson, London (Phaidon) 1969. The third edition of a catalogue published first in 1935 in German and in 1940 in English

Broekman 2005 Inge Broekman, *De rol van de schilderkunst in het leven van Constantijn Huygens (1596–1687)*, Hilversum (Verloren) 2005

Broos 1974 B.P.J. (Ben) Broos, "Rembrandt's portrait of a Pole and his horse," *Simiolus: Netherlands Quarterly for the History of Art* 7 (1974), pp. 192–218

Broos 1977 B.P.J. (Ben) Broos, *Index to the formal sources of Rembrandt's art*, Maarssen (Gary Schwartz) 1977

Broos 1981 Ben Broos, *Rembrandt en tekenaars uit zijn omgeving, Oude tekeningen in het bezit van de Gemeentemusea van Amsterdam, waaronder de collectie Fodor*, vol. 3, Amsterdam (Amsterdams Historisch Museum and Meulenhoff/Landshoff) 1981

Broos 1982/83 B.P.J. (Ben) Broos, review of Walter L. Strauss and Marjon van der Meulen, *The Rembrandt documents, Simiolus: Netherlands Quarterly for the History of Art* 12 (1982/83), pp. 245–62

Broos 1985 Ben Broos, exhib. cat. *Rembrandt en zijn voorbeelden | Rembrandt and his sources*, Amsterdam (Rembrandthuis) 1985

Broos 1993 Ben Broos, *Liefde, list & lijden: historiestukken in het Mauritshuis*, The Hague (Mauritshuis) and Ghent (Snoeck-Ducaju & Zoon) 1993

Broos 2000 Ben Broos, "Rembrandts eerste Amsterdamse periode," *Oud Holland* 114 (2000), pp. 1–6

Broos 2005 Ben Broos, "Rembrandts Zeeuwse connectie: François Coopal en Titia Uylenburgh," *Kroniek van het Rembrandthuis* 2005/1–2, pp. 24–33

Brown 1981 Christopher Brown, *Carel Fabritius*, Oxford (Phaidon) 1981

Brown et al. 1991 Christopher Brown, Jan Kelch and Pieter van Thiel, exhib. cat. *Rembrandt: the master and his workshop: paintings*, Berlin (Gemäldegalerie), Amsterdam (Rijksmuseum) and London (National Gallery). New Haven and London (Yale University Press) 1991

Brulez 1986 W. (Wilfried) Brulez, *Cultuur en getal: aspecten van de relatie economie–maatschappij–cultuur in Europa tussen 1400 en 1800*, Amsterdam (Nederlandse Vereniging tot beoefening van de Sociale Geschiedenis) 1986

Brusati 1995 Celeste Brusati, *Artifice and illusion: the art and writing of Samuel van Hoogstraten*, Chicago and London (University of Chicago Press) 1995

Bruyn 1959 J. (Josua) Bruyn, *Rembrandt's keuze van Bijbelse onderwerpen*, Utrecht (Kunsthistorisch Instituut der Rijksuniversiteit Utrecht) 1959

Bruyn et al. 1982– Josua Bruyn, Bob Haak, Simon H. Levie, Pieter J.J. van Thiel and Ernst van de Wetering, *A corpus of Rembrandt paintings*, 3 vols., The Hague, Boston and London (Martinus Nijhoff Publishers) 1982. Vol. 1 (*1625–1631*) published in 1982, vol. 2 (*1631–1634*) in 1986 and vol. 3 (*1635–1642*) in 1989. For vol. 4 see van de Wetering 2005

Bruyn 1983 J. (Josua) Bruyn, "On Rembrandt's use of studio-props and model drawings during the 1630s," in: *Essays in Northern European art presented to Egbert Haverkamp-Begemann on his sixtieth birthday*, Doornspijk (Davaco) 1983

Bruyn 1987–88 Josua Bruyn, "Towards a scriptural reading of seventeenth-century Dutch landscape paintings," in: Peter Sutton, ed., exhib. cat. *Masters of 17th-century Dutch landscape painting*, Amsterdam (Rijksmuseum) et al. 1987–88, pp. 84–103

Carroll 1981 Margaret Deutsch Carroll, "Rembrandt as meditational printmaker," *Art Bulletin* 63 (1981), pp. 585–610

Cavalli-Björkman 2005 Görel Cavalli-Björkman, *Dutch and Flemish paintings* [in the National-museum], vol. 2: *Dutch paintings, c.1600–c.1800*, Stockholm (Nationalmuseum) 2005

Chapman 1990 H. Perry Chapman, *Rembrandt's self-portraits: a study in seventeenth-century identity*, Princeton (Princeton University Press) 1990

Clark 1976 Kenneth Clark, "Rembrandt's 'Good Samaritan' in the Wallace Collection," *The Burlington Magazine* 1118 (December 1976), pp. 806–09

van der Coelen 2004 Peter van der Coelen, "De Bataven in de beeldende kunst," in: *De Bataven: verhalen van een verdwenen volk*, Amsterdam (De Bataafsche Leeuw) and Nijmegen (Museum Het Valkhof) 2004, pp. 143–93

de Decker 1958 Jeremias de Decker, *Goede vrydag, ofte Het lijden onses Heeren Jesu Christi*, ed. W.J.C. Buytendijk, Zwolle (Tjeenk Willink) 1958. The poem was first published in *Verscheyde Nederduytsche gedichten*, 1651

Dekiert 2004 Marcus Dekiert, *Rembrandt, Die Opferung Isaaks*, Munich (Alte Pinakothek; Monographien der Bayerischen Staats-gemäldesammlungen) 2004

van Deursen 1978 A. Th. van Deursen, *Het kopergeld van de Gouden Eeuw*, vol. 1, *Het dagelijks brood*, Assen and Amsterdam (van Gorcum) 1978

Dickey 1986 Stephanie S. Dickey, "'Judicious negligence': Rembrandt transforms an emblematic convention," *Art Bulletin* 68 (1986), pp. 253–62

Dickey 2004 Stephanie S. Dickey, *Rembrandt: portraits in print*, Amsterdam and Philadelphia (John Benjamins) 2004

Dickey 2006 Stephanie S. Dickey, "Inscriptions and the reception of Rembrandt's etchings," in Roscam Abbing 2006b

Dittrich and Ketelsen 2004 Christian Dittrich, Thomas Ketelsen et al., *Rembrandt: die Dresdener Zeichnungen 2004*, Cologne (Walther König) 2004

van den Doel et al. 2005 Marieke van den Doel, Natasja van Eck, Gerbrand Korevaar, Anna Tummers and Thijs Weststeijn, eds., *The learned eye: regarding art, theory, and the artist's reputation: essays for Ernst van de Wetering*, Amsterdam (Amsterdam University Press) 2005

Domselaar 1660 T[obias]. v[an] Domselaar, ed., *Hollantsche Parnas, of verscheide gedichten gerijmt door J. Westerbaen, J. v. Vondel, J. Vos, G. Brant, R. Anslo, en andere voornaamste dichters onzer eeuwe*, Amsterdam (J. Lescaille) 1660

Drossaers and Lunsingh Scheurleer 1974–76 S.W.A. Drossaers and Th. H. Lunsingh Scheurleer, *Inventarissen van de inboedels in de verblijven van de Oranjes en daarmede gelijk te stellen stukken, 1567–1795*, 3 vols., Rijks Geschiedkundige Publicatiën, Grote Serie nos. 147–49, The Hague (distributed by Martinus Nijhoff) 1974–76

Dudok van Heel 1977 S.A.C. (Bas) Dudok van Heel, "Ruim honderd advertenties van kunstverkopingen uit de *Amsterdamsche Courant* 1712–1725," *Jaarboek Amstelodamum* 69 (1977), pp. 107–22

Dudok van Heel 1978 S.A.C. Dudok van Heel, "Mr. Joannes Wtenbogaert (1608–1680): een man uit remonstrants milieu en Rembrandt van Rijn," *Jaarboek Amstelodamum* 70 (1978): *Liber amicorum I.H. van Eeghen*, pp. 146–69

Dudok van Heel 1986 S.A.C. (Bas) Dudok van Heel, "'Twe gebosseerde konterfijtsels na grootvader en grootmoeder na Rembrand gecopieerd,'" *Maandblad Amstelodamum* 73 (1986), pp. 114–15

Dudok van Heel 1993 S.A.C. (Bas) Dudok van Heel, "Rembrandt en Menasseh ben Israel," *Kroniek van het Rembrandthuis* 93/1 (1993), pp. 22–29

Dudok van Heel 1995 S.A.C. (Bas) Dudok van Heel, "Borgstelling van Titus van Rijn voor de ontvangst van het geld van de verkoop van het Rembrandthuis: de Hollandse tekst van een verloren gegaan document," *Kroniek van het Rembrandthuis* 95/1 (1995), pp. 23–28

van Eeghen 1958a Isabella H. van Eeghen, *Een Amsterdamse burgemeestersdochter van Rembrandt in Buckingham Palace*, Amsterdam (Stadsdrukkerij) 1958

van Eeghen 1958b I.H. van Eeghen, "Frederik Rihel, een 17de eeuwse zakenman en paardenliefhebber," *Maandblad Amstelodamum* 45 (1958), pp. 73–81

van Eeghen 1969a I.H. van Eeghen, "Rembrandt aan de Amstel," in: *Rembrandt aan de Amstel*, Amsterdam (Genootschap Amstelodamum) 1969

van Eeghen 1969b I.H. van Eeghen, "Het Amsterdamse Sint Lucasgilde in de 17de eeuw," *Jaarboek Amstelodamum* 56 (1969), pp. 65–102

van Eeghen 1969c I.H.v.E., "Wat veroverde Rembrandt met zijn Claudius Civilis?," *Maandblad Amstelodamum* 56 (1969), pp. 145–49

van Eeghen 1969d I.H.v.E., "De restauratie van het voormalige Anslohofje," *Maandblad Amstelodamum* 56 (1969), pp. 199–205

van Eeghen 1971 I.H. van Eeghen, "De vaandel-drager van Rembrandt," *Maandblad Amstelodamum* 58 (1971), pp. 173–81

van Eeghen 1977 I.H. van Eeghen, "Rubens en Rembrandt kopen van de familie Thijs," *Maandblad Amstelodamum* 64 (1977), pp. 59–62

Ekkart 1998 Rudolf E.O. Ekkart, *Isaac Claesz. van Swanenburg, 1537–1614, Leids schilder en burgemeester*, Zwolle (Waanders) 1998

Elias 1903–05 Johan E. Elias, *De vroedschap van Amsterdam, 1578–1795*, 2 vols., Haarlem (Vincent Loosjes) 1903–05

Emmens 1965 J.A. Emmens, "'Ay Rembrandt, maal Cornelis stem,'" *Nederlands Kunsthistorisch Jaarboek* 7 (1965), pp. 133–65

Erenstein 1996 R.L. Erenstein, ed., *Een theater-geschiedenis der Nederlanden: tien eeuwen drama en theater in Nederland en Vlaanderen*, Amsterdam (Amsterdam University Press) 1996

Evenhuis 1967 R.B. Evenhuis, *Ook dat was Amsterdam*, vol. 2: *De kerk der hervorming in de gouden eeuw*, Amsterdam (W. ten Have) 1967

Exalto 2005 John Exalto, *Gereformeerde heiligen: de religieuze exempeltraditie in vroegmodern Nederland*, n.p. [Nijmegen] (Vantilt) 2005

Franken 2004 Michiel Franken, "Changing direction: the reconstruction of the genesis of Rembrandt's *Conspiracy of the Batavians under Claudius Civilis* reconsidered," *Art Bulletin of Nationalmuseum Stockholm* 11 (2004), pp. 75–82

Freise 1911 Kurt Freise, *Pieter Lastman, sein Leben und seine Kunst: ein Beitrag zur Geschichte der holländ. Malerei im XVII. Jahrh.*, Leipzig (Klinkhardt & Biermann) 1911

Fremantle 1959 Katharine Fremantle, *The Baroque town hall of Amsterdam*, Utrecht (Haentjens Dekker and Gumbert) 1959

Frijhoff 1995 Willem Frijhoff, *Wegen van Evert Willemsz.: een Hollands weeskind op zoek naar zichzelf, 1607–1647*, Nijmegen (SUN) 1995

Frijhoff 1998 Willem Frijhoff, *Heiligen, idolen, iconen*, Nijmegen (SUN) 1998

Fuchs 1968 Rudi Fuchs, *Rembrandt en Amsterdam*, Rotterdam (Lemniscaat) 1968

Gans 1971 Mozes Heiman Gans, *Memorboek: platenatlas van het leven der joden in Nederland van de middeleeuwen tot 1940*, Baarn (Bosch & Keuning) 1971

van Gelder 1953 J.G. van Gelder, "Rembrandt's vroegste ontwikkeling," *Mededelingen der Koninklijke Nederlandse Akademie van Wetenschappen, afd. Letterkunde*, N.R., vol. 16, no. 5, pp. 273–300 and 14 plates

Gersaint 1751 *Catalogue raisonné de toutes les pièces qui forment l'œuvre de Rembrandt, composé par feu M. Gersaint, & mis à jour, avec les Augmentations nécessaires, par les sieurs Helle & Glomy*, Paris (Hochereau) 1751

Gerson 1968 Horst Gerson, *Rembrandt paintings*, Amsterdam (Meulenhoff International) 1968

Gerson 1961 H. (Horst) Gerson, *Seven letters by Rembrandt*, transcription Isabella H. van Eeghen, translation Yda D. Ovink, The Hague (L.J.C. Boucher) 1961

Giltaij 1988 Jeroen Giltaij, cat. *De tekeningen van Rembrandt en zijn school in het Museum Boymans-van Beuningen*, Rotterdam (Museum Boymans-van Beuningen) 1988

Giltaij 1999 Jeroen Giltaij, *Ruffo en Rembrandt: over een Siciliaanse verzamelaar in de zeventiende eeuw die drie schilderijen bij Rembrandt bestelde*, Zutphen (Walburg Pers) 1999

Giltaij 2003 Jeroen Giltaij, "'Der Münchner Fälscher' auch in Rotterdam und Amsterdam gesichtet?," in: *Rembrandt-Zeichnungen in München: Beiträge zur Ausstellung Rembrandt auf Papier – Werk und Wirkung*, Munich (Staatliche Graphische Sammlung München) 2003, pp. 75–82

Golahny 2003 Amy Golahny, *Rembrandt's reading: the artist's bookshelf of ancient poetry and history*, Amsterdam (Amsterdam University Press) 2003

Goossens 2001 Marion Goossens, *Schilders en de markt: Haarlem, 1605–1635*, dissertation defended at the University of Leiden, 22 March 2001

Grasman 1997 Edward Grasman, "The Rembrandt Research Project: reculer pour mieux sauter," *Oud Holland* 113 (1999), pp. 153–60

Grimm 1991 Claus Grimm, *Rembrandt selbst: eine Neubewertung seiner Porträtkunst*, Stuttgart and Zürich (Belser) 1991

Grimm 1999 Claus Grimm, "Arbeitsteilung in der Werkstatt Rembrandts: Beobachtungen zur Rückkehr des Tobias," unpublished paper written for Rembrandt symposium in the Mauritshuis, December 1999, but not delivered there

Groeneweg 1995 Irene Groeneweg, "Regenten in het zwart: vroom en deftig?," *Nederlands Kunsthistorisch Jaarboek* 46 (1995), *Beeld en zelfbeeld in de Nederlandse kunst, 1550–1750*, pp. 199–251

de Groot and Vorstman 1980 Irene de Groot and Robert Vorstman, *Sailing ships: prints by the Dutch masters from the 16th to the 19th century*, Maarssen (Gary Schwartz) 1980

Haak 1984 B. (Bob) Haak, *Hollandse schilders in de Gouden Eeuw*, Amsterdam (Meulenhoff/Landshoff) 1984 (also translated into English as *The Golden Age: Dutch painters of the seventeenth century*, New York [Abrams] 1984)

Haverkamp Begemann 1982 Egbert Haverkamp Begemann, *Rembrandt: The nightwatch*, Princeton (Princeton University Press) 1982

Haverkamp Begemann 1992/93 Egbert Haverkamp Begemann, "Rembrandts Simeon och Jesusbarnet (Simeon and the Christ child)," in: exhib. cat. *Rembrandt och hans tid: Människan i centrum (Rembrandt and his age: focus on man)*, Stockholm (Nationalmuseum) 1992–93

Haverkamp Begemann 1995 Egbert Haverkamp Begemann, *Rembrandt, The Holy Family, St Petersburg*, Groningen (Gerson Lectures Foundation) 1995

Haverkamp Begemann 2005 Egbert Haverkamp Begemann, "Rembrandt's drawing *The raising of the Cross* in the Museum of Fine Arts, Boston," in van den Doel et al. 2005, pp. 39–46

Heckscher 1958 William S. Heckscher, *Rembrandt's Anatomy of Dr. Nicolaes Tulp: an iconological study*, New York (New York University Press) 1958

Hedquist 1994 Valerie Hedquist, "Rembrandt and the Franciscans of Amsterdam," *Dutch Crossing: A Journal of Low Country Studies*, Summer 1994, pp. 20–49

Held 1969 Julius S. Held, *Rembrandt's Aristotle and other Rembrandt studies*, Princeton (Princeton University Press) 1969

Heller 1988 Joseph Heller, *Picture this*, New York (Putnam) 1988

[Hinterding] n.d. [Erik Hinterding], "Nooit gedacht," typescript *Rembrandt als etser: de praktijk van productie en verspreiding*, (winning) submission for Teylers Prize, also doctoral dissertation, Utrecht University, 23 January 2001

Hinterding 1993 Erik Hinterding, *De lotgevallen van Rembrandts koperplaten*, Amsterdam (Rembrandthuis) 1993

Hinterding 1993/94 Erik Hinterding, "The history of Rembrandt's copperplates, with a catalogue of those that survive," *Simiolus* 22 (1993/94), pp. 253–315

Hinterding et al. 2000 Erik Hinterding, Ger Luijten and Martin Royalton-Kisch, *Rembrandt the printmaker*, Amsterdam (Rijksmuseum) and Zwolle (Waanders) 2000

Hoet 1752 Gerard Hoet, *Catalogus of naamlyst van schilderyen, met derzelver pryzen…*, 3 vols., The Hague [different publishers] 1752–70

Hofstede de Groot 1906a C. (Cornelis) Hofstede de Groot, *Die Urkunden über Rembrandt (1575–1721)*, The Hague (Martinus Nijhoff) 1906

Hofstede de Groot 1906b C. (Cornelis) Hofstede de Groot, *Die Handzeichnungen Rembrandts: Versuch eines beschreibenden und kritischen Katalog*, Haarlem (Erven F. Bohn) 1906

Hofstede de Groot 1915 C. (Cornelis) Hofstede de Groot, *A catalogue raisonné of the works of the most eminent Dutch painters of the seventeenth century…*, vol. 6, London (Macmillan) 1916; first published in German in 1915

Hoogewerff 1947 G.J. Hoogewerff, *De geschiedenis van de St. Lucasgilden in Nederland*, Amsterdam (P.N. van Kampen & Zoon) 1947

Hoogewerff and van Regteren Altena 1928 G.J. Hoogewerff and J.Q. van Regteren Altena, *Arnoldus Buchelius, "Res pictoriae": aanteekeningen over kunstenaars en kunstwerken, 1583–1639*, The Hague (Martinus Nijhoff) 1928

van Hoogstraten 1678 Samuel van Hoogstraten, *Inleyding tot de hooge schoole der schilder-konst: anders de zichtbare werelt*, Rotterdam 1678

de Hoop Scheffer 1974 Dieuwke de Hoop Scheffer, "Petrus Sylvius par Rembrandt," *Album amicorum Karel G. Boon*, Amsterdam (Zwets & Zeitlinger) 1974, pp. 96–101

Horn 2000 Hendrik J. Horn, *The Golden Age revisited: Arnold Houbraken's Great Theatre of Netherlandish painters and paintresses*, Doornspijk (Davaco) 2000

Houbraken 1718–21 Arnold Houbraken, *De groote schouburgh der Nederlantsche konstschilders en schilderessen …*, Dordrecht (Arnold Houbraken) 1718 (vol. 1), 1719 (vol. 2) and 1721 (vol. 3)

Hughes 2006 Robert Hughes, "The god of realism," *The New York Review of Books* 53/6 (6 April 2006), pp. 6–10

Huisken et al. 1995 Jacobien Huisken, Koen Ottenheym and Gary Schwartz, eds., *Jacob van Campen: het klassieke ideaal in de Gouden Eeuw*, Amsterdam (Architectura & Natura and Stichting Koninklijk Paleis Amsterdam) 1995

Huygens 2003a Constantijn Huygens, *Mijn leven, verteld aan mijn kinderen in twee boeken, ingeleid, bezorgd, vertaald en van commentaar voorzien door Frans R.E. Blom*, 2 vols., Amsterdam (Prometheus/Bert Bakker) 2003

Huygens 2003b Constantijn Huygens, *Journaal van de reis naar Venetië, vertaald en ingeleid door Frans R.E. Blom*, Amsterdam (Uitgeverij Prometheus/Bert Bakker) 2003

Ingamells 1992 John Ingamells, *The Wallace Collection: catalogue of pictures*, vol. 4: *Dutch and Flemish*, London (Trustees of the Wallace Collection) 1992

Israel 1989 Jonathan Israel, *Dutch primacy in world trade, 1585–1740*, Oxford 1989

Israel 1995 Jonathan Israel, *The Dutch Republic: its rise, greatness and fall, 1477–1806*, Oxford (Clarendon Press) 1995

de Jongh and Luijten 1997 Eddy de Jongh and Ger Luijten, exhib. cat. *Spiegel van alledag: Nederlandse genreprenten, 1550–1700*, Amsterdam (Rijksmuseum) and Ghent (Snoeck-Ducaju) 1997

Jorissen 1873 Theodore Jorissen, *Mémoires de Constantin Huygens*, The Hague (Martinus Nijhoff) 1873

Junius 1991 Franciscus Junius, *The literature of classical art*, vol. 1, *The painting of the ancients: De pictura veterum*, vol. 2, *A lexicon of the artists and their works: Catalogus architectorum* etc., eds. Keith Aldrich, Philipp Fehl and Raina Fehl, 2 vols., Berkeley et al. (University of California Press) 1991

Kelly 2004 Tony Kelly, "Tricksters, vagrants and outsiders: economic delinquents in painting," a paper presented at the symposium *Representation and regulation: seventeenth-century economics in the Dutch Republic*, Amsterdam (University of Amsterdam), 12 November 2004

Klein 1965 Peter Wolfgang Klein, *De Trippen in de 17de eeuw: een studie over het ondernemersgedrag op de Hollandse stapelmarkt*, Assen (Van Gorcum) 1965

Knuvelder G.P.M. (Gerard) Knuvelder, *Handboek tot de geschiedenis der Nederlandse letterkunde*, ed. DBNL 2003, vol. 2: http://www.dbnl.org/tekst/knuv001hand02/index.htm

Koester 2000 Olaf Koester, cat. *Flemish paintings 1600–1800*, Copenhagen (Statens Museum for Kunst) 2000

Kok 1967 M. (Marijke) Kok, "Rembrandts Nachtwacht: van feeststoet tot schuttersstuk," *Bulletin van het Rijksmuseum* 15 (1967), pp. 116–21

Konstam 1977 Nigel Konstam, "Rembrandt's use of models and mirrors," *The Burlington Magazine* 119 (February 1977), pp. 94–98

Kozak 1998 S. Kozak, *Rembrandt and the masters of the 15th–17th century Netherlandish drawing*, Wrocław (Ossoliński National Institute-Museum of the Princes Lubomirski) 1998

Kuretsky 1974 Susan Donahue Kuretsky, "Rembrandt's tree stump: an iconographic attribute of St. Jerome," *The Art Bulletin* 54 (1974), pp. 571–80

de Lairesse 1817 Gerard de Lairesse, *A treatise on the art of painting, in all its branches …, revised, corrected and accompanied by an essay, by W.M. Craig*, 2 vols., London (Edward Orme) 1817

Landsberger 1946 Franz Landsberger, *Rembrandt, the Jews and the Bible*, Philadelphia (Jewish Publication Society of America) 1946

Laurentius 1993 Theo Laurentius, "Rembrandt in a new light," in: exhib. cat. *Rembrandt: Rembrandt's etchings in a new light*, Machida (Machida City Museum of Graphic Arts) and Kawamura (Kawamura Memorial Museum of Art) 1993, pp. 162–80

Liedtke 1989 Walter Liedtke, *The royal horse and rider: painting, sculpture, and horsemanship, 1500–1800*, New York (Abaris Books in association with the Metropolitan Museum of Art) 1989

Liedtke et al. 1995 Walter Liedtke, Carolyn Logan et al., exhib. cat. *Rembrandt/Not Rembrandt in the Metropolitan Museum of Art: aspects of connoisseurship*, vol. 2, *Paintings, drawings, and prints: art-historical perspectives*, New York (Metropolitan Museum of Art and Harry N. Abrams) 1995

Liedtke 2004 Walter Liedtke, "Rembrandt's 'workshop' revisited," *Oud Holland* 117 (1984), pp. 48–73

Lugt 1915 | Lugt 1920 Frits Lugt, *Wandelingen met Rembrandt in en om Amsterdam*, Amsterdam (van Campen) 1915; published in German in 1920 as *Mit Rembrandt in Amsterdam*, Berlin (Bruno Cassirer) 1920

Luijten 2000 Ger Luijten, *Rembrandt's etchings*, Amsterdam (Rijksmuseum) and Zwolle (Waanders) 2000

van Maarseveen 1998 Michel P. van Maarseveen, Jos W.L. Hilkhuijsen and Jacques Dane, eds., exhib. cat. *Beelden van een strijd: oorlog en kunst vóór de Vrede van Munster, 1621–1648*, Zwolle (Waanders) and Delft (Stedelijk Museum Het Prinsenhof) 1998

MacLaren and Brown 1991 Neil MacLaren, revised and expanded by Christopher Brown, *The Dutch school, 1600–1900* (National Gallery Catalogues), 2 vols., London (National Gallery Publications) 1991

McQueen 2003 Alison McQueen, *The rise of the cult of Rembrandt: reinventing an Old Master in nineteenth-century France*, Amsterdam (Amsterdam University Press) 2003

van Mander 1604 Carel van Mander, *Het schilderboeck waerin voor eerst de leerlustighe ieught den grondt der edel vry schilderconst in verscheyden deelen wort voorghedraghen*, Haarlem (Passchier van Wesbusch) 1604. Translations and modern editions of parts of the work have appeared with some regularity since the eighteenth century. A complete edition is available on Internet on the Digitale Bibliotheek voor de Nederlandse letteren (DBNL): http://www.dbnl.org/tekst/mand001schio1/.

van Mander 1994–97 Karel van Mander, *The lives of the illustrious Netherlandish and German painters, from the first edition of the Schilder-boeck (1603–1604)*, edited by Hessel Miedema, 6 vols., Doornspijk (DAVACO) 1994–97

Meder 1923 Joseph Meder, *Die Handzeichnungen: ihre Technik und Entwicklung, zweite, verbesserte Auflage*, Vienna (Kunstverlag Anton Schroll) 1923. First edition 1919

Middelkoop 1998 Norbert Middelkoop, Petria Noble, Jørgen Wadum and Ben Broos, exhib. book *Rembrandt onder het mes: de anatomische les van Dr. Nicolaes Tulp ontleed*, The Hague (Mauritshuis) and Amsterdam (Six Art Promotion) 1998

Middelkoop 2002 Norbert Middelkoop, exhib. cat. *Kopstukken: Amsterdammers geportretteerd 1600–1800*, Bussum (Thoth) and Amsterdam (Amsterdams Historisch Museum) 2002

Miedema 1973 Hessel Miedema, *Karel van Mander, Den grondt der edel vry schilder-const*, 2 vols., Utrecht (Haentjens Dekken & Gumbert) 1973

Miedema 1994–99 See van Mander 1994–97

Montias 2002 John Michael Montias, *Art at auction in 17th century Amsterdam*, Amsterdam (Amsterdam University Press) 2002

Montias 2004/05 John Michael Montias, "Artists named in Amsterdam inventories, 1607–80," *Simiolus: Netherlands Quarterly for the History of Art* 31 (2004/05), pp. 322–47

Möller 1984 George J. Möller, "Het album Pandora van Jan Six (1618–1700)," *Jaarboek van het Genootschap Amstelodamum* 76 (1984), pp. 69–101 (also http://www.dbnl.org/tekst/moll013albuo1/)

Münz 1952 Ludwig Münz, *Rembrandt's etchings: reproductions of the whole etched work* (vol. 1) and *A critical catalogue of Rembrandt's etchings and the etchings of his school formerly attributed to the master* (vol. 2), London (Phaidon) 1952

Münz 1952a Ludwig Münz, "Eine unpublizierte Zeichnung Rembrandts," *Alte und Neue Kunst* 1 (1952), pp. 152–58

Nevitt 1997 H. Rodney Nevitt, Jr., "Rembrandt's hidden lovers," *Nederlands Kunsthistorisch Jaarboek* 48 (1997; published in 1998), pp. 162–91

de Nijs and Beukers 2002 Thimo de Nijs and Eelco Beukers, eds., *Geschiedenis van Holland*, vol. 2: *1572 tot 1795*, Hilversum (Verloren) 2002

Nouwen 1992 Henri J. M. Nouwen, *The return of the prodigal son: a meditation on fathers, brothers and sons*, New York (Doubleday) ca. 1992

Nowell-Usticke 1967 G.W. Nowell-Usticke, *Rembrandt's etchings, states and values*, Narberth, Pa. (Livingstone Publishing Co.) 1967

Nystad 1999 Saam Nystad, "Der Goldhelm," *Jahrbuch der Berliner Museen*, N.F. 41 (1999), pp. 245–50

Offenberg 2004 Adri Offenberg, "Dirk van Santen and the Keur Bible: new insights into Jacob Judah (Arye) Leon Templo's model Temple," *Studia Rosenthaliana* 37 (2004), pp. 401–22

Ornstein and Schatborn 1983 Eva Ornstein and Peter Schatborn, *Landschappen van Rembrandt en zijn voorlopers*, Amsterdam (Rembrandthuis) 1983

Orlers 1641 Jan Jansz. Orlers, *Beschrijvinge der stadt Leyden*, 2nd ed., Leiden 1641

van Os 2005 Henk van Os, "Rembrandts *Offer van Abraham* in de Hermitage," published online only on the website of the Royal Netherlands Academy of Arts and Sciences, www.knaw.nl

Perlove 1993 Shelly Perlove, "An irenic vision of Utopia: Rembrandt's Triumph of Mordecai and the New Jerusalem," *Zeitschrift für Kunstgeschichte* 56 (1993), pp. 38–60

van der Ploeg 1999 Peter van der Ploeg, "Over Rembrandts *Portret van een oude man*, nu in het Mauritshuis (1)," *Mauritshuis in Focus* 12/2 (1999), pp. 7–15

van der Ploeg and Vermeeren 1997 Peter van der Ploeg and Carola Vermeeren, exhib. cat. *Princely patrons: the collection of Frederick Henry of Orange and Amalia of Solms in The Hague*, The Hague (Mauritshuis) and Zwolle (Waanders) 1997

Postma and Blok 1991 Hugo Postma and Marjo Blok, "Duidelijkheid over de Amsterdamse St. Lukasfeesten in 1653 en 1654," *Oud Holland* 105 (1991), pp. 32–38

Rasch Rudolf Rasch, *Driehonderd brieven over muziek van, aan en rond Constantijn Huygens,* Hilversum (Verloren) in press

Roodenburg 2004 Herman Roodenburg, *The eloquence of the body: perspectives on gesture in the Dutch Republic,* Zwolle (Waanders) 2004

Roscam Abbing 1999 Michiel Roscam Abbing, *Rembrant toont sijn konst: bijdragen over Rembrandt-documenten uit de periode 1648–1756,* Leiden (Primavera Pers) 1999

Roscam Abbing 2006a Michiel Roscam Abbing, *Rembrandts olifant, het verhaal van Hansken,* Amsterdam (Leporello) 2006

Roscam Abbing 2006b Michiel Roscam Abbing, ed., *Essays about Rembrandt,* Leiden (Foleor) 2006

Rosenberg 1948 Jakob Rosenberg, *Rembrandt,* 2 vols., Cambridge (Harvard University Press) 1948

Röver-Kann 2000 Anne Röver-Kann, exhib. cat. *Rembrandt, oder nicht? Zeichnungen von Rembrandt und seinem Kreis aus den Hamburger und Bremer Kupferstichkabinetten,* Bremen (Kunsthalle Bremen) and Ostfildern-Ruit (Hatje Cantz) 2000

Royalton-Kisch 1992 Martin Royalton-Kisch, *Drawings by Rembrandt and his circle in the British Museum,* London (British Museum Press) 1992

Rutgers 2003 Jaco Rutgers, "Sijn' kunst-faem over 't spits der Alpen heen gevlogen': Rembrandts naam en faam in Italië in de zeventiende eeuw," *Kroniek van het Rembrandthuis* (2003) 1/2, pp. 2–19

Sabar 1993 Shalom Sabar, "Ketav ivri be-yetsirato shel Rembrandt" (in Hebrew), in exhib. book Martin Weil and Rivka Weiss-Blok, *Holland shel Rembrandt,* Jerusalem (Israel Museum) 1993, pp. 169–90

Sandrart 1994 Joachim von Sandrart, *Teutsche Akademie der edlen Bau-, Bild- und Malereikünste,* 3 vols., Nürnberg 1675–79, reprint Nürnberg (Uhl) 1994

Scallen 2004 Catherine Scallen, *Rembrandt, reputation and the practice of connoisseurship,* Amsterdam (Amsterdam University Press) 2004

Schama 1987 Simon Schama, *The embarrassment of riches: an interpretation of Dutch culture in the Golden Age,* New York (Alfred A. Knopf) 1987

Schama 1999 Simon Schama, *Rembrandt's eyes,* New York (Alfred A. Knopf) 1999

Schatborn and Ornstein-van Slooten 1984–85 [Peter Schatborn and Eva Ornstein-van Slooten], exhib. cat. *Rembrandt in de leer | Rembrandt as teacher,* Amsterdam (Rembrandthuis) 1984

Scheller 1961 R.W. Scheller, "Rembrandt's reputatie van Houbraken tot Scheltema," *Nederlandsch Kunsthistorisch Jaarboek* 12 (1961), pp. 81–118

Scheller 1969 R.W. Scheller, "Rembrandt en de encyclopedische kunstkamer," *Oud Holland* 84 (1969), pp. 81–147

Schnackenburg 2004 Bernhard Schnackenburg, "Knabe im Atelier und *Bücherstilleben,* zwei frühe Gemälde von Jan Lievens und ihr Leidener Kontext: Rembrandt, Jan Davidsz. de Heem," *Oud Holland* 117 (2004), pp. 33–47

Schneider 1990a Cynthia P. Schneider, *Rembrandt's landscapes,* New Haven and London (Yale University Press) 1990

Schneider 1990b Cynthia P. Schneider, with contributions by Boudewijn Bakker, Nancy Ash and Shelley Fletcher, exhib. cat. *Rembrandt's landscapes: drawings and prints,* Washington (National Gallery of Art) 1990

Schröder and Bisanz-Prakken 2004 Klaus Albrecht Schröder and Marian Bisanz-Prakken, exhib. cat. *Rembrandt,* Vienna (Albertina) 2004

Schulze 1993 Sabine Schulze et al., exhib. cat. *Leselust: Niederländische Malerei von Rembrandt bis Vermeer,* Stuttgart (Gerd Hatje) 1993

Schwartz 1985 Gary Schwartz, *Rembrandt, his life, his paintings: a new biography,* New York (Viking) 1985. Dutch and German editions appeared in 1984 and 1987, respectively

Schwartz 1985a Gary Schwartz, "Rembrandt's 'David and Mephiboseth': a forgotten subject from Vondel," *A tribute to Lotte Brand Philip, art historian and detective,* New York (Abaris Books) 1985, pp. 166–74

Schwartz 1986 Gary Schwartz, exhib. cat. *The Dutch world of painting,* Maarssen (Gary Schwartz) and Vancouver (Vancouver Art Gallery) 1986

Schwartz 1995 Gary Schwartz, "Apelles, Apollo en The Third Man: schilderkunst, letterkunde en politiek rond 1650," *De Zeventiende Eeuw* 11 (1995), pp. 122–31

Schwartz 1996 Gary Schwartz, "Rembrandt bij het grofvuil," *NRC Handelsblad, Cultureel Supplement,* 10 May 1996, p. 6

Schwartz 1998 Gary Schwartz, "'Though deficient in beauty': a documentary history and interpretation of Rembrandt's 1654 painting of Bathsheba," in: *Rembrandt's Bathsheba reading King David's letter,* ed. Ann Jensen Adams, Cambridge (Cambridge University Press) 1998, pp. 176–203

Schwartz 2000 Gary Schwartz, "City fathers as civic warriors," in: Jacques Thuillier and Klaus Bussmann (coordinators), *1648: Paix de Westphalie: l'art entre la guerre et la paix | 1648: Westfälischer Friede: die Kunst zwischen Krieg und Frieden,* Paris (Louvre and Klincksieck) and Münster (Westfälisches Landesmuseum) 2000, pp. 201–25

Schwartz 2001 Gary Schwartz, "Here's not looking at you, kid: some literary uses of Vermeer," *Art in America,* March 2001, pp. 104–07, 143

Schwartz 2002 Gary Schwartz, *The night watch,* Amsterdam (Rijksmuseum) and Zwolle (Waanders) 2002. Published in eight languages

Schwartz and Bok 1989 Gary Schwartz and Marten Jan Bok, *Pieter Saenredam: the painter and his time,* Maarssen and The Hague (Gary Schwartz | SDU) 1989

Scriverius 1738 Simon Doekes, ed., *Gedichten van Petrus Scriverius,* Amsterdam (Jan Hartig) 1738

Sellink 1994 Manfred Sellink, exhib. cat. *Cornelis Cort: "constich plaedt-snijder van Horne in Hollandt,"* Rotterdam (Museum Boymans-van Beuningen) 1994 (reprinted in 2000)

Shelley 1983 Marjorie Shelley, "Rembrandt's inks" [synopsis], *Paper and Book Group Annual* 2 (1983) of the American Institute for Conservation (http://aic.stanford.edu/sg/bpg/annual/v02/bp02–12.html)

Silver 1996 Larry Silver, "Pieter Bruegel in the capital of capitalism," *Nederlands Kunsthistorisch Jaarboek* 47 (1996), *Pieter Bruegel,* pp. 125–79

Singer 1906 Hans Wolfgang Singer, *Rembrandt: des Meisters Radierungen, Klassiker der Kunst,* vol. 8, Stuttgart and Leipzig (Deutsche Verlags-Anstalt) 1906

Slatkes 1983 Leonard Slatkes, *Rembrandt and Persia,* New York (Abaris Books) 1983

Slive 1953 Seymour Slive, *Rembrandt and his critics, 1630–1730,* The Hague (Martinus Nijhoff) 1953

Slive 1970–74 Seymour Slive, *Frans Hals,* 3 vols., London (Phaidon) 1970–74

Slive 1989 Seymour Slive, exhib. cat. *Frans Hals,* Munich (Prestel) 1989

Sluijter 1986 Eric Jan Sluijter, *De "Heydensche Fabulen" in de Noordnederlandse schilderkunst circa 1590–1670: een proeve van beschrijving en interpretatie van schilderijen met verhalende onderwerpen uit de klassieke mythologie,* dissertation (Leiden University) 1986

Sluijter 2000 Eric Jan Sluijter, *Seductress of sight: studies in Dutch art of the Golden Age,* Zwolle (Waanders) 2000

Sluijter 2001 Eric Jan Sluijter, "'All striving to adorne their houses with costly peeces': two case studies of paintings in wealthy interiors," in Westermann 2001, pp. 103–27

Smith 1836 John Smith, *A catalogue raisonné of the works of the most eminent Dutch, Flemish, and French painters…,* vol. 7, London (Smith and Son) 1836

Snoep 1975 Derk Snoep, *Praal en propaganda: triumfalia in de Noordelijke Nederlanden in de 16de en 17de eeuw,* Alphen aan den Rijn (Canaletto) 1975

Sokolova 2005 Irina Sokolova, "The perception of Rembrandt and his work in Russia," in: *Dutch and Flemish art in Russia,* ed. Lia Gorter et al., Amsterdam (CODART and Stichting Cultuur Inventarisatie) 2005, at www.codart.nl>Special features>Dutch and Flemish art in Russia

Sokolova et al. 2003 Irina Sokolova et al., exhib. cat. *Rembrandt et son école: collections du musée de l'Ermitage de Saint-Pétersbourg,* Dijon (Musée des Beaux-Arts de Dijon) and Paris (Réunion des Musées Nationaux) 2003

Spaans 1989 Joke Spaans, *Haarlem na de Reformatie: stedelijke cultuur en kerkelijk leven, 1577–1620,* Hollandse Historische Reeks, vol. 11, The Hague 1989

Spaans 2002 Joke Spaans, "Religious policies in the seventeenth century Dutch Republic," in: Ronnie Po-chia Hsia and Henk van Nierop, eds., *Calvinism and religious toleration in the Dutch Golden Age,* Cambridge (Cambridge University Press) 2002, pp. 72–86

Starcky 1988 [Emmanuel Starcky], *Rembrandt et son école, dessins du Musée du Louvre,* 93e exposition du Cabinet des dessins, Paris (Musée du Louvre) 1988

van Stipriaan 2002 René van Stipriaan, *Het volle leven: Nederlandse literatuur en cultuur ten tijde van de Republiek (circa 1550–1800),* Amsterdam (Prometheus) 2002

van Straten 2002 Roel van Straten, *Iconclass indexes, Rembrandt and his school,* vol. 3: *Rembrandt drawings: an iconographic index to O. Benesch, The drawings of Rembrandt (2nd ed. 1973),* Leiden (Foleor Publishers) 2002

van Straten 2005 Roelof van Straten, with contributions by Ingrid Moerman, *Young Rembrandt: the Leiden years, 1606–1632,* Leiden (Foleor) 2005

Stratton 1986 S. Stratton, "Rembrandt's beggars: satire and sympathy," *The Print Collector's Newsletter* 17 (1986), pp. 77–82

Strauss and van der Meulen 1979 Walter R. Strauss and Marjon van der Meulen, *The Rembrandt documents,* New York (Abaris) 1979

Stronks 1996 Els Stronks, *Stichten of schitteren: de poëzie van zeventiende-eeuwse gereformeerde predikanten,* Houten (Den Hertog) 1996

Sumowski 1979– Werner Sumowski, *Drawings of the Rembrandt school,* 10 vols. to date, New York (Abaris) 1979–

Sumowski 1983–92 Werner Sumowski, *Gemälde der Rembrandt-Schule,* 6 vols., Landau-Pfalz (PVA) 1983

Taylor 1998 Paul Taylor, "The glow in late sixteenth and seventeenth century Dutch paintings," *Leids Kunsthistorisch Jaarboek* 11 (1998), ed. Erma Hermens, *Looking through paintings: the study of painting techniques and materials in support of art historical research,* pp. 159–78

van Thiel et al. 1976 Pieter J.J. van Thiel et al., *All the paintings of the Rijksmuseum in Amsterdam: a completely illustrated catalogue,* Amsterdam (Rijksmuseum) and Maarssen (Gary Schwartz) 1976

Thomassen and Gruys 1998 Kees Thomassen and J.A. (Jan Albert) Gruys, *The album amicorum of Jacob Heyblocq,* Zwolle (Waanders) 1998

Tümpel 1969 Christian Tümpel, "Studien zur Ikonographie der Historien Rembrandts: Deutung und Interpretation der Bildinhalte," *Nederlands Kunsthistorisch Jaarboek* 20 (1969), pp. 107–98

Tümpel 1970 Christian Tümpel, with the help of Astrid Tümpel, *Rembrandt legt die Bibel aus: Zeichnungen und Radierungen aus dem Kupferstichkabinett der Staatlichen Museen Preussischer Kulturbesitz Berlin,* Berlin (Verlag Bruno Hessling) 1970

Tümpel 1986 Christian Tümpel, *Rembrandt,* Antwerp (Mercatorfonds) 1986

Tümpel 1988 Christian Tümpel, "De Amster-damse schuttersstukken," in: M. Carasso-Kok and J. Levy-van Halm, *Schutters in Holland: kracht en zenuwen van de stad,* Haarlem (Frans Halsmuseum) and Zwolle (Waanders) 1988

Tümpel 1991 Christian Tümpel et al., exhib. cat. *Het Oude Testament in de schilderkunst van de Gouden Eeuw,* Zwolle (Waanders), Amsterdam (Joods Historisch Museum) and Jerusalem (Israel Museum) 1991

Tümpel 2003 Christian Tümpel, "Jesus und die Ehebrecherin und Rembrandts Notizen auf Zeichnungen mit Historien," in Vignau-Wilberg 2003, pp. 161–75

Tümpel and Schatborn 1991 Astrid Tümpel and Peter Schatborn, *Pieter Lastman, leermeester van Rembrandt (Pieter Lastman, the man who taught Rembrandt),* Amsterdam (Rembrandthuis) and Zwolle (Waanders) 1991

Vaeck 2001 Marc van Vaeck, "Adriaen van de Vennes bedelaarsvoorstellingen in grisaille," *De Zeventiende Eeuw* 17 (2001), pp. 164–73

van der Veen 1997 Jaap van der Veen, "Faces from life: tronies and portraits in Rembrandt's painted oeuvre," in Blankert 1997, pp. 69–80

Velthuis 2005 Olav Velthuis, *Talking prices: symbolic meanings of prices on the market for contemporary art,* Princeton and Oxford (Princeton University Press) 2005

Vermeeren 1978 Karel Vermeeren, "Constantijn Daniël van Renesse, zijn leven en zijn werken (1)," *Kroniek van het Rembrandthuis* 30 (1978), pp. 3–23

Verscheyde Nederduytsche gedichten *Verscheyde Nederduytsche gedichten van Grotius, Hooft, Barlaeus, Huygens, Vondel en anderen, versamelt door JV. JS. TVD. B. GP. CLB.,* Amsterdam (Lodewyck Spillebout) 1651

Vignau-Wilberg 2001 Thea Vignau-Wilberg, exhib. cat. *Rembrandt auf Papier: Werk und Wirkung | Rembrandt and his followers: drawings from Munich,* Munich (Hirmer Verlag) 2001

Vignau-Wilberg 2003 Thea Vignau-Wilberg, ed., *Rembrandt-Zeichnungen in München (The Munich Rembrandt drawings): Beiträge zur Ausstellung Rembrandt auf Papier – Werk und Wirkung (Rembrandt and his followers – drawings from Munich),* Munich (Staatliche Graphische Sammlung München) 2003

Visser 't Hooft 1956 W.A. Visser 't Hooft, *Rembrandts weg tot het Evangelie,* Amsterdam (ten Have) 1956

Vogelaar 1991 Christiaan Vogelaar et al., exhib. cat. *'Een jong en edel schildersduo': Rembrandt & Lievens in Leiden,* Zwolle (Waanders) and Leiden (De Lakenhal) 1991

Vogelaar and Korevaar 2005 Christiaan Vogelaar and Gerbrand Korevaar, exhib. cat. *Rembrandt's mother: myth and reality,* Leiden (Stedelijk Museum de Lakenhal) and Zwolle (Waanders) 2005

Volkenandt 2004 Claus Volkenandt, *Rembrandt: Anatomie eines Bildes,* Munich (Wilhelm Fink Verlag) 2004

Vondel 1927–40 *De werken van Vondel,* 10 vols., Amsterdam (Maatschappij voor Goede en Goedkoope Lectuur) 1927–40

Vos 1978 Rik Vos, *Lucas van Leyden,* Bentveld (Andreas Landshoff) and Maarssen (Gary Schwartz) 1978

Voûte 1989 J.R. Voûte, "Twee etsen nader bekeken," *Kroniek van het Rembrandthuis* 89/1 (1989), pp. 25–28

van de Waal 1952 H. (Henri) van de Waal, *Drie eeuwen vaderlandsche geschied-uitbeelding, 1500–1800: een iconologische studie,* 2 vols., The Hague (Martinus Nijhoff) 1952

van de Waal 1974 H. (Henri) van de Waal, *Steps towards Rembrandt: collected articles, 1937–1972,* Amsterdam and London (North-Holland Publishing Company) 1974

Wagenaar 1760– Jan Wagenaar, *Amsterdam in zijn opkomst, aanwas, geschiedenissen, voorregten, koophandel, gebouwen, kerkenstaat, schoolen, schutterije, gilden en regeering,* 3 vols., Amsterdam 1760, 1765 and 1767. I have used the photomechanical reprint published in Alphen aan de Rijn and Amsterdam in 1971–72

Warnke 1993 Martin Warnke, "Kleine Perzeptionen an der Anatomie des Dr. Tulp von Rembrandt," in: *Polyanthea: essays on art and literature in honor of William Sebastian Heckscher,* ed. K.-L. Selig, The Hague 1993, pp. 27–32

Wegner 1957 Wolfgang Wegner, *Rembrandt-Zeichnungen: Ausstellung der Staatlichen Graphischen Sammlung,* Munich (Prestel Verlag) 1957

Westermann 1996 Mariët Westermann, *A worldly art: the Dutch Republic, 1585–1718,* London (George Weidenfeld) 1996

Westermann 2000 Mariët Westermann, *Rembrandt,* London (Phaidon) 2000

Westermann 2001 Mariët Westermann, exhib. cat. *Art & home: Dutch interiors in the age of Rembrandt,* Denver (Denver Art Museum), Newark (The Newark Museum) and Zwolle (Waanders) 2001

Weststeijn 2005 Thijs Weststeijn, "Rembrandt and rhetoric: the concepts of *affectus, enargeia* and *ornatus* in Samuel van Hoogstraten's judgement of his master," in van den Doel et al. 2005, pp. 111–30

van de Wetering 1997 Ernst van de Wetering, *Rembrandt: the painter at work,* Amsterdam (Amsterdam University Press) 1997

van de Wetering 2000 Ernst van de Wetering, "Remarks on Rembrandt's oil-sketches for etchings," in Hinterding et al. 2000, pp. 36–63

van de Wetering 2005 Ernst van de Wetering, *A corpus of Rembrandt paintings,* vol. 4: *The self-portraits,* Dordrecht (Springer) 2005

Index to works by Rembrandt

The numbers in roman type following the titles
refer to pages | *those in italics refer to illustration
numbers.*

Drawings

Etchings

General index

Photographic credits

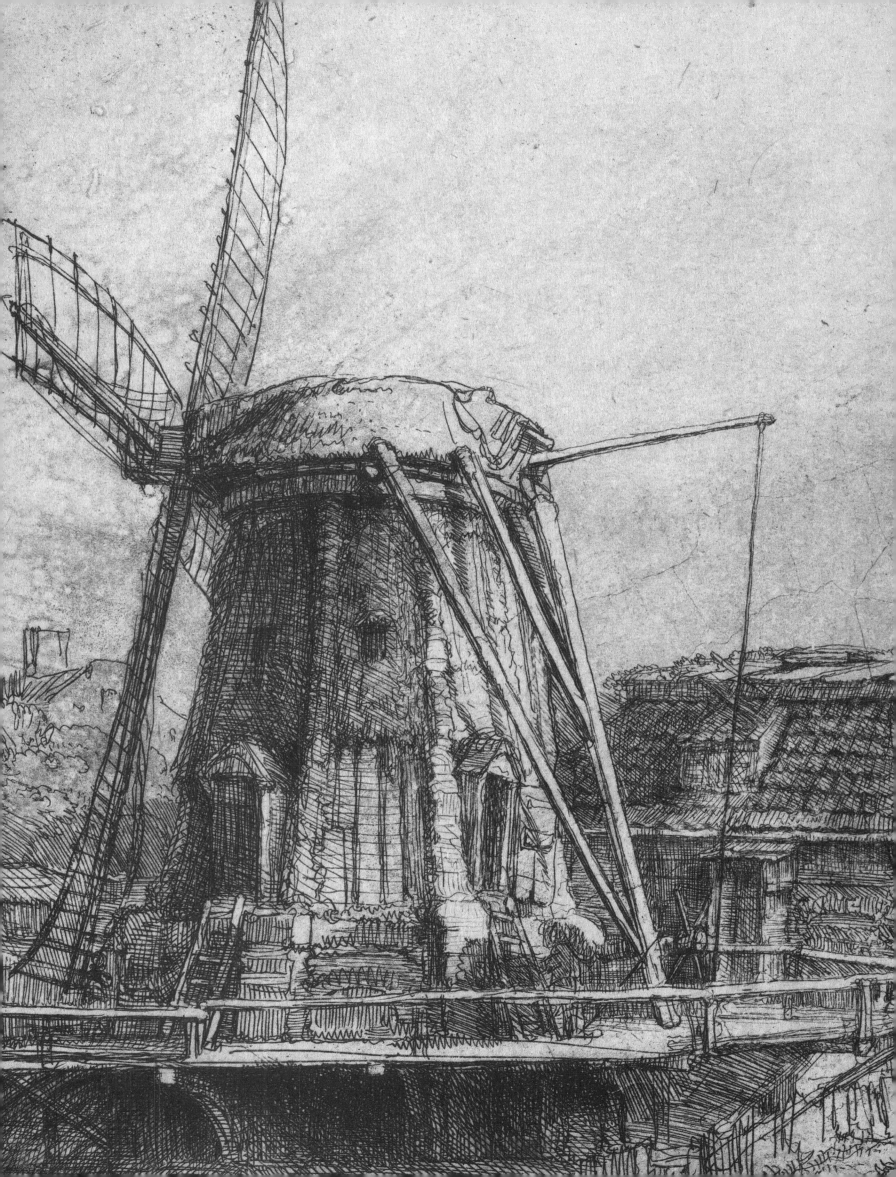